GREAT
WOMEN
MASTERS *of* ART

GREAT
WOMEN
MASTERS *of* ART

JORDI VIGUÉ

WATSON-GUPTILL PUBLICATIONS/NEW YORK

First published in the United States in 2002 by
Watson-Guptill Publications,
a division of VNU Business Media, Inc.,
770 Broadway, New York, N.Y. 10003
www.watsonguptill.com

Original title: Grandes Maestros de la Pintura. Maestras
© 2003 Gorg Blanc, S.L.
Via Augusta, 63
08006 Barcelona, Spain
www.gorgblanc.com

Library of Congress Control Number: 2002109821

ISBN: 0-8230-2114-9

Editor-in-chief: Virgin Stanley
Collaborators: Estrella Massons, Stefanie Pick, Xavier Agramunt,
Jaume Barrera, Cristina Fontserè, Jordi Álvarez
Introduction text: Estrella Massons
Photographic archive: Arxiu Gorg Blanc
Graphic design: Paloma Nestares
Photographic documentation: Albert Muñoz
Publishing coordinator: Miquel Ridola

Printed in Spain
Gráficas Iberia, s.a., Barcelona

1 2 3 4 5 6 7 8 9 / 09 08 07 06 05 04 03 02

Preface

This publication is a source of great satisfaction for me and all of the team that was involved. In all humility, it can be said that this is a generous contribution to a difficult and delicate subject with few works of a similar nature, obliging us to explore uncharted territory where there are large lagoons of oblivion and contradicting opinions.

We will not discuss the condition of women throughout the centuries, nor the role that, due to various circumstances, they were obliged to play in the history of art. The place assigned women by society, the limits placed on their practice of painting, the few spheres into which they were allowed, the genre they were relegated to and even their prohibition to attend art schools kept them in a long, dark tunnel with substantially reduced artistic options where their activity was controlled and interfered with, and the value of their works questioned and nearly always relegated to the background.

All of this gives rise to a vacuum of information, which implies considerable difficulty for the researcher who embarks on an adventure like the one we undertook in this volume. The little information available in many cases and the poor results often provided by exhaustive investigation have forced us not to exclude certain artists from this book and has created doubt regarding the veracity of some information.

Research is an adventure full of risks, in which the dividing line between intrepidity and temerity often fades. But the researcher is, in addition to an adventurer, an idealist, an ambitious and insatiable explorer, a long-distance runner, always attempting to accomplish the impossible mission of reaching the horizon and touching the sky. Despite feeling our way through the dark, despite the inevitable frustration involved in writing this book and the many hours of effort that went unrewarded, I sincerely believe that the satisfaction felt by the entire team with the results obtained in this volume is legitimate and much deserved.

This book constitutes a significant contribution to the study of an obscure portion of the history of art, a singular, innovative work with hundreds of new contributions through firsthand research.

In our travels through the labyrinth of this subject, we believe that we have not only paved the way, but also created a reliable map that we hope will provide a basis and a reference point, especially for researchers to enter the territory explored by us, make new discoveries and confirm certain opinions, going far beyond the present results. It goes without saying that there is still a great deal to be done in this field.

This book is a homage to the female painters of the world, whether or not they are included here, who, throughout the centuries and in societies where equality did not always prevail, managed to etch out a name, some of them never knowing or even suspecting it. The volume we offer you today is irrefutable proof that, despite the time that has transpired, their work was not in vain, it has not been lost to oblivion. Certainly, as artists, women have a place in the history of art, in spite of the condition and the role to which they were relegated throughout history. We hope this book will contribute to giving them the recognition they deserve for their work, which was often denied them during their lifetimes.

Jordi Vigué

Contents

One of the objectives of this book is to bring together the best women painters in the history of Western art in a single volume, with a short monograph on each artist that includes a brief bibliography and a selection of their most significant works with commentary. Unfortunately, the lack of information and available documents on their lives and works have forced us to exclude not only medieval artists but also others who have been researched very little or not at all. This introductory chapter attempts to fill in the gaps with a succinct overview of women painters over the centuries.

Women in art is a controversial subject open to a great deal of research. The first studies on female artists were done by American feminist historians during the 1960s and 1970s. Since then, studies and essays have continued to be published, and museums have shown progressive interest in organizing exhibits on female artists. This is certainly a positive step forward, but there is clearly still much to be done. This book attempts to pay homage to those female painters who, like their male counterparts, significantly contributed to the history of art, enriching our artistic heritage.

Antiquity

Women took up the brush many centuries ago. The first document mentioning female painters was by Pliny the Elder. This Roman scholar (25-79 A.D.), a tireless worker endowed with an insatiable intellectual curiosity, included a chapter on painting in his *Natural History*, in which he mentioned Timarete, Irene, Aristarete, Olympia, and Iea of Cicico (a city on the Sea of Marmara). The latter executed a self-portrait, and Pliny said of her, "There has never been a faster hand at painting, and her art was so magnificent that its prices were beyond those of the most famous portraitists of her time, Sopolis and Dionisius, whose paintings fill art galleries."

The Middle Ages

During the High Middle Ages, many educated abbesses from the nobility ran monasteries where manuscripts were copied and illuminated. In the year 800, for example, the Chelles Convent, directed by Gisela, the sister of Charlemagne, produced thirteen manuscripts.

In 975 an exceptional codex, the *Beato de Tábara*, was completed at the Monastery of Tábara, located in the Christian domains of northern Spain. It was signed by the female painter Ende ("Ende pintrix et Dei aiutrix...") and the monk Emeterio, who was its author. Nevertheless, there is no sign of Emeterio's style in the illuminations, which leads to the belief that Ende was the principal artist, her artistic quality greater than her colleague's.

In the High Middle Ages, from the fall of the Western Roman Empire (5th century) to the rise of feudalism in the 11th century, there were monasteries inhabited by both monks and nuns and the Monastery of Tábara was probably one of these. The codex

mentioned, which contains illustrations different from other *Beatos*, is called the *Beato de Girona* because the chanter Juan donated the book to the Girona cathedral in his testament in the year 1078. One of the characteristics of a *Beato* codex is the great expressive and artistic force of the color, which often appears in strips and on the figure's garments, where there are well-defined color areas. Other distinctive features are the enormous, staring eyes and penetrating pupils of the figures represented. The image reproduced here is from the Apocalypse (XIII, 1-10) and explains how two evil beasts with seven heads emerged, one from the sea and the other from land, and were worshipped by humans.

The tradition of female hands illustrating manuscripts continued to flourish in monasteries during the 12th century. One of the most ancient self-portraits in Western art is that of the nun Guda, the author of the *Homiliary of Saint Bartholomew*. In it, Guda appears in an initial ornamented with plant motifs, indicating that it was she who wrote and illuminated the manuscript. The fact that she holds out the palm of her open hand would seem to indicate that she was proud of her work. Romanesque artistic language was basically gestural, and showing the palm of her hand meant that she swore, accepted, and fully assumed the authorship of the book. The self-portrait of Diemudis that appears in the initial *S* of a codex on display in Munich is from the same period.

Nevertheless, the two most notable works of the 12th century were executed by the abbesses Hildegard von Bingen, who began a book of mystical visions entitled *Scivias* in 1142 or so, and Herrad von Landsberg, author of an illustrated encyclopedia entitled *Hortus Deliciarum* (*The Garden of Delights*, from approximately 1160-1170). Both Hildegard and Herrad were the creators of their respective works, but until

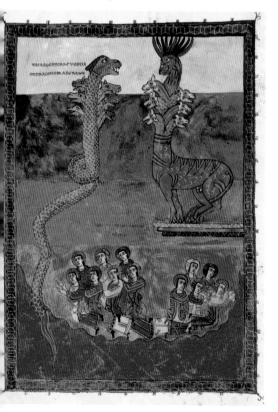

recently, it was unclear whether they had also illuminated their own manuscripts. However, the latest research demonstrates their participation in creating the miniatures, hence we include them here.

Hildegard von Bingen (1098-1179) was born in Mainz, the daughter of a nobleman, Hildebert von Bermersheim. At the age of 8 her parents brought her to the Disibodenberg Convent. She became the abbess of the Rupertsberg

Ende, The Book of the Apocalypse, El Beato de Girona, *miniature on parchment,* folio 176 v, s X, *Chapter Archives of Girona, Inv. 7 (11).*

Hildegard von Bingen, Hildegard Writing, *miniature on parchment, 1142-1152, Scivias, folio 1 r.*

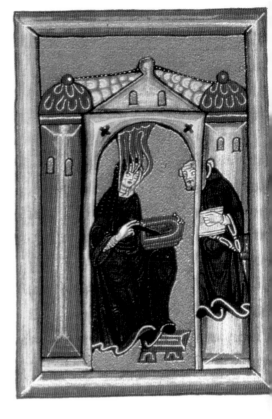

Monastery. A talented writer recognized throughout Europe, she wrote the *Book of the Merits of Life* and the *Book of Divine Works*, and composed a musical piece, *Ordo Virtutum*. She founded the Bingen Monastery and another called Eibingen Monastery, where her tomb is located. In her *Scivias (Know the Ways of the Lord)*, she renders herself writing on a wax tablet with a stylus, attended by her secretary, Brother Vollmar. Hildegard von Bingen probably set the scene in her monastery, as she is seated in a building flanked by two towers. Flames descend from the heavens, referring to divine inspiration: "From the sky came a brilliant fire and a voice said to me: Write what you see...." In other miniatures from the *Scivias*, Hildegard illustrated her visions, as in the folio of the fourth vision in the first section. In the lower panel, angels and demons are struggling to take possession of a deceased person's soul, represented as a nude body emerging from the corpse's mouth. In the central panel is a demon that stands above the entrance to hell, where the souls of the damned suffer amid the flames and are tormented by evil creatures. In the upper panel are the souls of the righteous in paradise and in celestial Jerusalem, crowned by the hand of God.

Herrad von Landsberg was appointed abbess of the Convent

Hildegard von Bingen, Visions, *Scivias, miniature on parchment, 1142-1152, folio 5 v.*

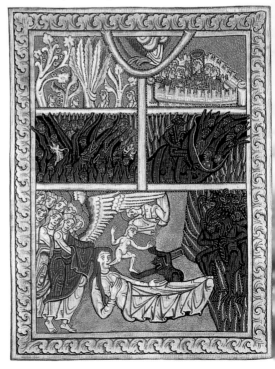

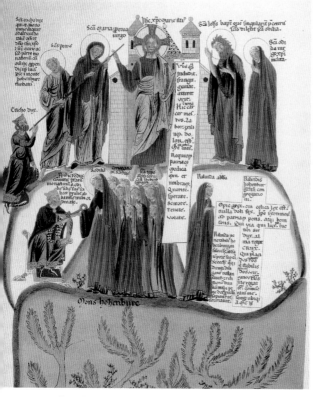

Herrad von Landsberg,
Hortus Deliciarum,
The Founding of the Convent,
miniature on parchment,
d 1170.

of Saint Odile in Hohenburg, near Strasbourg, in 1167. Her *Garden of Delights* is a veritable encyclopedia of the knowledge of her times, both secular and religious, which the abbess dedicated to her nuns in order that they become knowledgeable. The extant illustrations are tracings of the original codex, which was lost in the bombardment of 1870 that caused the Library of Strasbourg to burn. The miniatures contained magnificent drawings with colors distributed in symmetric and harmonic rhythm. Herrad dedicated a folio to the founding of the convent that she directed, dividing it into two parts. The upper part contains highly significant people, such as Christ, who is between the two towers of the monastery, taking a staff, a symbol of authority, given to him by Duke Eticho and passed along by Saint Peter and the Virgin Mary. On the other side of Christ are Saint John the Baptist and Saint Odile, the patron saints of the monastery. The lower part shows Mount Hohenburg, the place where the monastery was built, and Duke Eticho, its founder, giving the keys to Saint Odile and her nuns. On the other side is Relinda, Herrad's predecessor as abbess, who had reorganized the convent according to the canons of the Augustinian order.

The top picture on page 13 illustrates the Seven Liberal Arts. In the first circle is Philosophy, wearing a crown shared by Ethics, Logic, and Physics, and from whose chest emerge the seven sources of wisdom. At the figure's feet are the philosophers Socrates and Plato. In the second circle are seven beautiful women in an arcade, incarnating Grammar, Rhetoric, Dialectics, Music, Arithmetic, Geometry, and Astronomy, with their respective attributes, symbolizing the seven liberal arts. The lower area shows poets reflecting, writing, reciting, and preparing their writing tools.

The Psaltery of Augsburg, from approximately 1200, contains a playful self-portrait of Claricia, who is swinging and serves as the foot of the richly decorated initial Q. Her head is uncovered, her hair is in long braids, and she is dressed fully in keeping with fashion, which would indicate that she was a lay pupil of the convent.

Herrad von Landsberg, The Seven Liberal Arts, *Hortus Deliciarum*, *miniature on parchment, d 1170.*

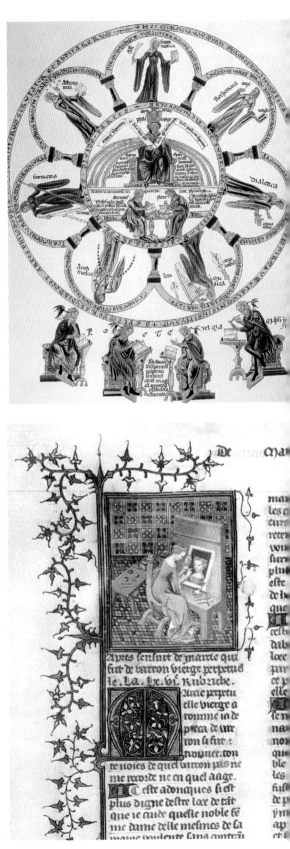

In the 14th century, Bocaccio wrote *De claribus mulieribus (On Illustrious Women*, 1355-1359), with 150 biographies of real and legendary women, whom he designated as exceptional, considering the lack of talent he attributed to women in general. The French edition of the *Livre des Femmes Nobles et Renommées* contains a folio executed in 1402 in which, for the first time in Western art, a woman is rendered painting a self-portrait before a mirror. The image represents lea of Cicico, a painter of antiquity mentioned by Pliny and whom Bocaccio called Marcia. In 1405, Christine de Pisan wrote *Cité de Dames* in response to Bocaccio's disdainful opinion of women, mentioning a contemporary Parisian miniaturist named Anastasie. Bourgot was another famous French illuminator who executed a *Book of Hours* with her father, Jean le Noir, in 1353 or so.

Bocaccio, Marcia Painting a Self-Portrait, *Livre des Femmes Nobles et Renommées (detail), miniature on parchment, folio 101 v, 1402, Bibliothèque Nationale, Paris, Inv. Ms. Fr. 12420.*

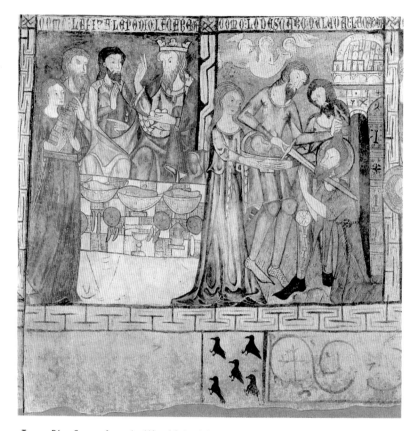

Teresa Díaz, Scenes from the Life of Saint John the Baptist, *fresco, 1310-1320, Convento de las Clarisas, Toro, Spain. It has been transferred onto canvas.*

In monumental painting, the only known European female artist was Teresa Díaz, from the Kingdom of Castille, who, in approximately 1310-1320, painted frescoes for the Convento de las Clarisas in Toro, Zamora, signed with the phrase *"Teresa Dieç me fecit"* (*"Teresa Dieç created me"*). These frescoes represent the adoration of the magi and various episodes from the life of Saint Catherine and Saint John the Baptist, which Teresa divides into two panels. The first panel represents King Herod at a banquet, impressed by the dance Salome has just executed and promising to give her whatever she requests. At the request of her mother, Herodias, Salome asks the king for Saint John the Baptist's head. The second panel represents the executioner decapitating Saint John and handing the head to Salome while the saint's soul ascends to Heaven on a sheet held by two angels. These frescoes by Teresa Díaz are in linear Gothic style, which, in contrast to the volume achieved by Giotto, is characterized by linear harmony and rhythm, acquiring poetic shapes in these intensely colored paintings. The paintings in the Church of San Sebastián de los Caballeros and in the Collegiate Church of Toro have been attributed to Teresa Díaz, as well as the frescoes of the principal wall in the Church of Hiniesta, province of Zamora. This woman's artistic background is unknown, though she was most likely the daughter of a painter and would therefore have studied in her father's studio, a frequent occurrence in the history of women in art from remote times and lasting well into the 19th century.

The Renaissance

Caterina dei Vigri (Saint Catherine of Bologna) was born in 1413 into a noble family of Bologna. Her father, Giovanni dei Vigri, a doctor of law and professor at the Studio of Bologna, was a diplomatic agent for Nicolas d'Este, Marquis of Ferrara. Her mother, Benvenuta Mammolini, belonged to a noble family from Ferrara. At the age of 11, Caterina was sent to the Court of Margarita d'Este, where she was educated. In 1427, she entered the Convent of the Poor Clares, where she distinguished herself for her knowledge of Latin, music, and manuscript illumination. She was appointed abbess of the Poor Clares Convent and in 1456, decided to return to her native city of Bologna, where she founded the Convent of Corpus Domini. She illuminated her most renowned work, *The Seven Spiritual Weapons*, and, as her friend and biographer, the nun Iluminada Bembo, explains, she also illuminated other manuscripts for different monasteries as well. A *Virgin with Child*, dated approximately 1456-1463 and located in the Convent of Corpus Domini in Bologna, is attributed to her, as well as a painting entitled *Madonna del Pomo*, in which the Virgin is holding an apple. She died at 49 years of age on March 9, 1463, and was canonized in 1707.

In the 15th century, new ideas on art and artists were emerging in Florence, with far-reaching consequences. Painting ceased to be considered a manual art and became one of the liberal arts, as it was then considered a science based on the scientific study of the outside world, especially employing the new sciences of perspective and anatomy. Artists were inspired by classical art, and a canon of ideal beauty emerged.

In 1528, Baldassare de Castiglione published the *Libro del Cortegiano*, holding that both men and women of noble lineage should know and practice music, dance, and painting as part of their education. This would benefit female artists—hence the artistic renown attained by Sofonisba Anguissola, who worked for the Spanish court of Philip II. She specialized in portraiture, a genre that would particularly be the domain of women painters for centuries. Humanist ideas also reached northern Europe, and Caterina van Hemessen was appointed court painter to Mary, the queen of Hungary and sister of the emperor, Charles V.

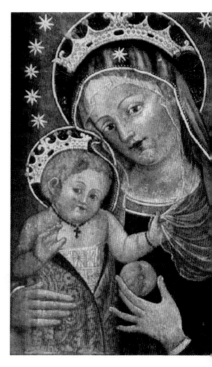

The third female painter to enjoy royal patronage was Levina Bening (Teerlinc), born in approximately 1510-1520. She was the eldest daughter of Simon Bening, an important illuminator from Bruges, and of Catherine Stroo. In 1545, Levina married the painter George Teerlinc, by whom she had a son, Marcus. In January of 1546, King Henry VIII of England appointed her as a miniaturist and portraitist. Following the monarch's death, she continued working at the

Caterina dei Vigri, Madonna del Pomo, *paint on wood, 1455-1465.*

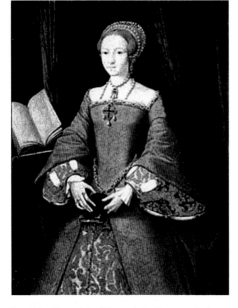

Levina Bening *or* Teerlinc, Elizabeth I, *oil on panel, ~1565.*

English court, under the patronage of Edward VI, Mary I, and Elizabeth I. She received an annual salary of 40 pounds until her death, in London in 1576. Levina Bening appears to have been a highly esteemed painter; indeed, the English miniaturist Nicholas Hiliard, who entered the English court in 1570, had to wait until 1599 to obtain the same salary as Levina.

In her pictorial oeuvre, Barbara Longhi reflected the ideas of the Counter-Reformation with simple images that evoked piety in the viewer. In the 1590s, her works, of refined chromatic sensibility, acquired a monumental air. Lavinia Fontana received an impressive intellectual education, which encouraged her to become the first woman to paint biblical and mythological scenes, as well as execute nudes, something unheard of for women. Fontana, who, despite having eleven children, was able to develop her artistic career, was appointed official court painter for Pope Clement VIII in 1603. But not all artistic careers were so brilliant.

Marietta Robusti, the daughter of Tintoretto, inherited her father's artistic talent and worked in the family studio. Emperor Maximilian II and King Philip II wanted to appoint her court painter, as they knew that her artwork was on a par with her father's. But Tintoretto refused to give his permission, deciding instead to marry her to Jacopo d'Augusta, a member of the silversmith's guild of Venice, on the condition that she never stop working at her father's studio. Four years later, she died in childbirth. Her

death in 1590, when she was only 30 years old, devastated her father. The painting *Portrait of an Elderly Man and a Boy*, considered for many years one of Tintoretto's best works, was actually executed by Marietta Robusti; her signature was discovered in 1920.

Marietta Robusti, Portrait of an Elderly Man and a Boy, *oil on canvas, 40.6 x 32.9 in (103 x 83.5 cm), ~1585, Kunsthistorisches Museum, Vienna.*

The Baroque

During the 17th century, the number of women involved in art continued to increase. At this time, painting was characterized by greater naturalism and a tendency toward theatricality. Chiaroscuro, (or Tenebrism), a pictorial style that creates perspective and volume through the interplay of light and shade, introduced in the early 17th century by Caravaggio, contributed to this dramatic aspect, and in the Low Countries, new genres were invented that would substantially enrich the history of art.

In Italy, Fede Galizia was a pioneer in still lifes. Another great still-life specialist was Giovanna Garzoni, painting works in tempera and watercolor on parchment, whose colors resembled enamel. Among her clients were the Duke of Alcalá, viceroy of Naples, and the powerful aristocratic families of Florence and Rome. Artemisia Gentileschi was an extraordinary painter of great character who painted stunning biblical scenes. Thanks to her extraordinary talent, in 1616 she became the first woman to be admitted to the Accademia Vasari del Disegno. Elisabetta Sirani, born in Bologna, eventually directed her father's studio and earned a living for the entire family. Although she died at the age of 27, she executed 150 paintings, which she recorded in an accounts ledger. Another important contribution she provided was opening a studio that admitted women in 1658, palliating somewhat the age-old ban on women's access to art education.

The tradition of nuns who were artists continued. Giustina Fetti, the sister of the painter Domenico Fetti, entered the Convent of Poor Clares of Saint Ursula in Mantua in 1614, changing her name to Lucrina. Through her contacts at the court of the Gonzaga family, she executed the portrait of *Eleanora I de Gonzaga* and other portraits of the duke's family and other women of the nobility of Mantua. She also executed religious scenes such as *Saint John the Evangelist* accompanied by an eagle and holding a chalice, two traditional attributes of this saint. Lucrina Fetti died in Mantua in 1673.

In Holland, women painters also flourished. Clara Peeters specialized in still lifes and enjoyed great prestige in her time. Judith Leyster painted genre scenes, demonstrating her superb skill in daring, quick brushstrokes. She ran her own studio and had students, and she was the first woman to enter the Guild of Saint Luke in Haarlem. Maria Van Oosterwijk attained so much fame for her still lifes that her renown reached beyond the Dutch borders. She had clients as illustrious as Louis XIV of France,

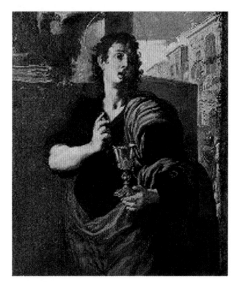

Lucrina Fetti, Saint John the Evangelist, ~1622, Venice.

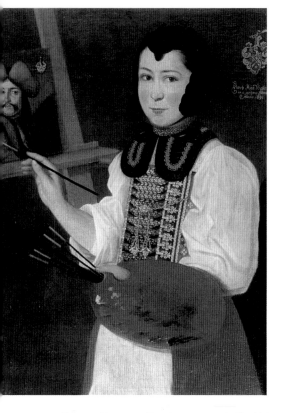

Anna Waser, Self-Portrait at
the Age of 12, *oil on canvas,
32.7 x 26.8 in (83 x 68 cm),
1691, Kunsthaus, Zurich.*

Emperor Leopold, William of Orange,
and Augustus II of Saxony. Maria
Sibylla Merian published three books
comprising a botanical catalogue on
flowers in 1675, 1677, and 1680,
known as the *New Book of Flowers.*
Later, she published the treatise
*Metamorphosis Insectorum
Surinamensium* (Metamorphosis of
the Insects of Surinam), which was
translated into several languages for
its scientific value.

But not only Italy and Holland
produced great women painters. In
England, Mary Beale was an excel-
lent portraitist and became a profes-
sional after marrying Charles Beale,
who promoted her artistic career
and even acted as her representa-
tive, a rather exceptional occurrence in the history of art, considering that in the
majority of cases, women gave up the brush when they married.

The French still-life painter Louise Moillon had ten students in her studio and
received a great many commissions.

Josefa Gomes de Ayala was born in Spain but settled in a manor house in the
Portuguese village of Óbidos, where she obtained great fame as a portraitist and still-
life painter. She was so famous that she even rejected an offer from the Portuguese
court, stating that she did not want to leave her mansion.

As throughout history, there were also prodigal girls in this period. Anna Wasser
was born in Zurich in 1678 and at the age of 12 executed a self-portrait in which she
rendered herself painting a portrait of her teacher, Johannes Sulzer, who encouraged
her to paint the self-portrait. From 1692 to 1696, she studied under Joseph Werner in
Bern and later settled in Zurich as a miniaturist, where she attained such renown that
she received commissions from Germany, England, and Flanders.

Michaelina Woutiers, from the southern Low Countries, executed monumental
paintings and mythological scenes with such excellence that Archduke William
Leopold was her client. This implied that she mastered large-format compositions and
anatomy, spheres that were systematically denied women artists.

Françoise Duparc, Woman Sewing,
*oil on canvas, 30.6 x 25 in (77.8 x 63.5 cm),
Musée des Beaux-Arts, Marseilles.*

The Enlightenment

During the first decades of 18th century, the rococo prevailed, an exquisite style that defined the prevailing taste of the aristocratic classes until the 18th century. The Dutch painter Rachel Ruysch painted in this style in her still lifes of fruit, flowers, and insects. Ruysch entered the painter's guild of The Hague in 1701, worked for the royal court of that city, and attained such international prestige that her works were sold for high prices.

The Venetian Rosalba Carriera was also a distinguished painter. She was the first person to paint pastel portraits in the rococo style, which she executed with exquisite mastery. She set up a studio in Venice that was highly dynamic, receiving many commissions, not only from Italy but also from the nobility and courts of other parts of Europe. In 1705, she was appointed honorary member of the Accademia de San Luca, Rome, and in 1720, her career reached its zenith when she was elected a member of the Académie Royale in France. However, the Académie, which had admitted seven women by 1682, stopped admitting them after 1720.

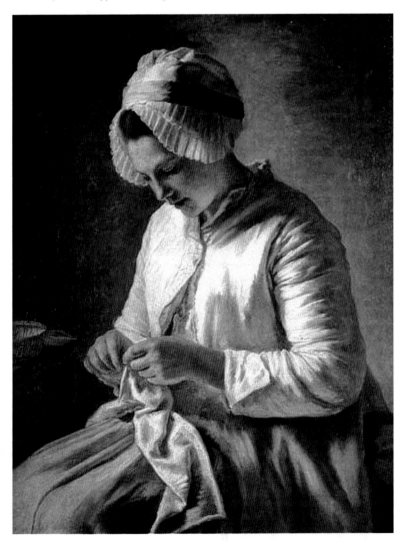

Françoise Duparc was born in Spain in 1705, the daughter of a Spanish mother and a sculptor from Marseilles, Antoine Duparc. In contrast to artists who worked exclusively for the aristocracy, Duparc painted simple people, as in her painting *Woman Sewing*. After studying under her father, she became a pupil in the studio of Jean Baptiste van Loo, who taught her the art of portraiture. After van Loo's death, she decided to move to Paris, where she became rightly renowned. Later, she settled in London and was significantly successful, receiving commissions from important people there. She was able to save a small fortune and return to Paris, where she resided for some time. In 1771, she returned to Marseilles, where she remained until her death in 1778. Her works are characterized by a violent, very southern light and a nearly brutal brushstroke that lend them warmth and charm.

Toward the mid-18th century, new aesthetic ideas emerged that influenced European taste. The ideas expressed by the German archeologist and theorist Johann Joachim Winckelmann in his book *The History of Art in Antiquity* sparked an interest in classical Greece. So powerful was the book's influence that artists began to paint in a neoclassical style. Learned people associated rococo with the decadence of the court and the aristocracy and began lauding virtue and honesty as the new ideals of the bourgeoisie. As always, iconography illustrated the ideas of the time.

The academies that were created throughout the 18th century controlled access to artistic training, dictating a hierarchical scale of values on the subjects to be painted, and struggled to impose a specific style. Women painters who were appointed members of these academies attained not only social prestige but also recognition as artists. Nevertheless, historians indicate that it was little more than an honorary position and a gesture of courtesy toward these women. The academic authorities regarded women executing classicist or historical scenes in a bad light, since according to their hierarchy of values, these were the most noble genres of highest aspiration, reserved only for the greatest of artists. It was well accepted that women executed portraits, a traditional genre for them, as well as floral still lifes, generally associated with femininity and delicacy.

Angelica Kauffmann was bent on defying rigid academic concepts. The daughter of a Swiss church painter, she was able to copy the great masters of the Renaissance in Italy. She met Winckelmann in Rome in 1763, an important factor in the evolution of her art toward neoclassicism. In 1768, she exhibited historical scenes at the Royal Academy along with the North American painter Benjamin West. The critics identified both as the initiators of neoclassicism in England. In the same year, she was elected a founding member of the Royal Academy. Kaufmann painted classical subjects in an elegant style with rich colors, and she painted innovative scenes from medieval English history and antiquity.

In France, there were also female painters of international renown, such as Adélaïde Labille-Guiard, who worked as a portraitist for the French monarchy and aristocracy and who was admitted to the Académie Royale des Beaux-Arts of Paris in 1783. Labille-Guiard had outstanding students, including Gabrielle Capet, the author of interesting portraits in oil and pastels and miniatures, as well as one of the most distinguished official painters under Napoleon's Consulate government. In 1801, she received honorable mention from the Commission of Artists. Her best work, from 1808, represents her teacher, Adélaïde Labille-Guiard, in her studio executing a portrait

of the artist-senator Vien, surrounded by her principal students. Capet rendered herself in this painting holding her professor's palette and watching the viewer.

Marie-Anne Gérard (1745-1823) was the eldest of seventeen siblings. As she demonstrated exceptionally promising artistic ability, she became the student of Jean Honoré Fragonard, whom she eventually married. She basically dedicated herself to miniatures. Her sister Marguerite also studied under Fragonard and by the end of the 1780s, she had attained great prestige as a painter. She participated in all the annual salons until 1824, and her artwork dealt with a mother's love toward her children. Her iconography referred to bourgeois women who ruled the territory of their homes and dedicated themselves to caring for their children, as Jean-Jacques Rousseau proclaimed in his new ideal of motherhood. This model was far removed from that of aristocratic ladies who left their children in the hands of servants. Constance Mayer also created this type of tender, domestic art, much in keeping with the style of Jean Baptiste Greuze, one of her first teachers, though her art would evolve after her meeting in 1802 with Pierre-Paul Prud'hon.

One of the greatest portraitists of the 18th century was Élisabeth Vigée-Lebrun, who worked for Marie Antoinette and in 1783 was admitted to the Académie Royale de Peinture et Sculpture. Vigée-Lebrun, also in keeping with Rousseau's ideas, painted herself as a loving mother with her daughter. Following the French Revolution (1789), she was forced into a long, twelve-year exile, during which she visited all of the courts of Europe, where she was well received for the excellent quality of her portraits.

A distinguished student of Vigée-Lebrun was Marie Guillemine Leroulx de la Ville (1768-1826), whose father was a government official. After studying for a year with

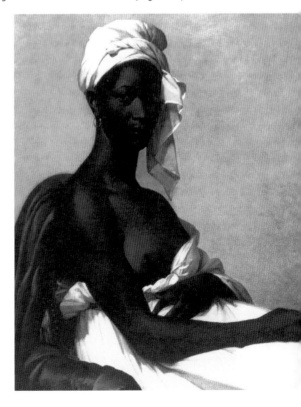

Vigée-Lebrun, she became a student of Jacques-Louis David for four years (1782-1786). She specialized in historical scenes and genre painting and participated for the first time in the 1791 Parisian Salon, where she exhibited three works. Two years later, she married Pierre Vincent Benoist and had two children, in 1794 and 1796. At the 1800 Parisian Salon, she exhibited *Portrait of a Negro Woman*, considered her masterpiece, representing a highly stylized, beautiful woman whose dark skin contrasts with her luminous white turban and dress. Leroulx executed portraits of Napoleon, and

Marie Guillemine Leroulx de la Ville *o* Benoist, Portrait of a Negro Woman, *oil on canvas, 25.5 x 31.4 in (65 x 80 cm), 1800, Musée du Louvre, Paris.*

the Museum of Versailles exhibits her portrait of the *Princess Paulina Borghese*. She was an honorary member of the Société des Arts of Ghent, and her portraiture showed the rigor that she learned from Jacques-Louis David.

As in England, women artists in France also received various honors and awards, though the restrictions imposed by public institutions continued to exist. In 1770, the Académie Royale admitted Anna Vallayer-Coster and Marie Giroust-Roslin as members, but decided to limit the total number of female members to four.

In 1751, the Académie de Saint-Luc was established in Paris, emerging as a powerful rival to the Académie Royale, admitting many members and organizing exhibits in which women could participate. Élisabeth Vigée-Lebrun and Adélaïde Labille-Guiard began their careers exhibiting works at the Salon of the Académie de Saint-Luc until the Académie Royale appointed them members in 1783. The French Revolution (1789), despite its lofty ideals, did not bring the rights that women so desired. When the Salon of the Académie Royale was reorganized, women obtained the right to exhibit their works, but free training at the École des Beaux-Arts and the possibility of receiving the Rome Award continued to be offered exclusively to males.

In clear contrast to what was occurring in other countries, in Spain, at the Academia de San Fernando in Madrid, established in 1752, academic painters did not occupy purely honorary positions. The ideas of the Enlightenment were well received by the society of the time and members of the academy took their responsibilities seriously. In fact, the Academia followed the policy introduced in the 18th century of aesthetically educating citizens, creating honorary academic positions and merit positions without distinguishing between the genders.

With regard to female painters, the works they exhibited and their artistic trajectories were evaluated like those of males, so that there were not only honorary academic members but also meritorious members. The oldest portraits extant at the Academia de San Fernando were executed by Faraona María Magdalena Olivieri, the daughter of the sculptor Juan Domingo Olivieri, who was unanimously elected a meritorious member of the Academia in 1759. The Academia informed her that one of the reasons she had been admitted was her exceptional use of colors. María Josefa Caron was

elected meritorious member in 1761. She presented a pastel portrait of outstanding iconographic value, representing Diego de Villanueva, architect who executed the portal of the Academia de Bellas Artes in Madrid. The same year, Catherina Cherubini Preciado, already a member of the Roman academia, was also elected a meritorious member.

María Josefa Caron, D. Diego de Villanueva *(detail)*, pastel, 21.7 x 17.7 in *(55 x 45 cm)*, ~1761, Museo de la Real Academia de San Fernando, Madrid.

In 1790, Francisca Meléndez (1770-1825), who was a miniature portraitist of the court, was admitted as a meritorious member, as was Ana María Mengs (1751-1793), the daughter of the famous painter Antonio Raphael Mengs. She studied under her father and by the age of 7 was painting and drawing with extraordinary skill. In 1761, her family moved to Madrid because the monarch, Charles III, had requested the services of her father. Three years before her death, she presented three pastel portraits to the Academia de San Fernando and was admitted as a member of merit on August 29, 1790. The position of member of the Academia allowed female painters the opportunity to teach young women art.

The 19th Century

During the course of the 19th century, the number of professional female painters continued to increase, yet they continued to be prohibited from painting nudes from models. The mentality of the time could not conceive of a woman,

Sophie Frémiet *(1797-1867)*, The Duchess of Burgundy at the Gates of Bruges, *oil on canvas, 72.4 x 59.1 in (184 x 150 cm), 1841, Musée des Beaux-Arts, Dijon.*
This artist was a student of Jacques-Louis David and in 1821, married the sculptor François Rude. She specialized in portraiture and historical scenes with a Romantic aesthetic.

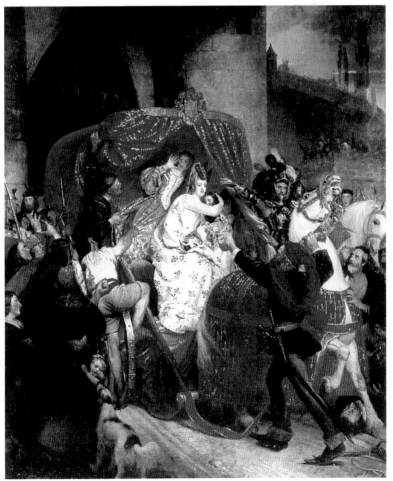

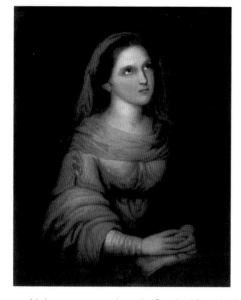

Rosario Weiss,
The Virgin Praying, ~1840,
oil on canvas, 32.3 x 25.6 in
(82 x 65 cm), Museo de la
Real Academia de San
Fernando, Madrid.

whose maximum value was supposed to be virtue, entering into contact with the nude, because it was associated with sin and perversion. For this reason, women were generally relegated to painting portraits and floral or other types of still lifes, devoid of nude figures. Nevertheless, there were artists who managed to avoid these genres, such as the Spaniard Rosario Weiss, who executed allegorical scenes and was taught by an exceptional master, Francisco de Goya.

Weiss was born in Madrid in 1814, the daughter of Leocadia Zorrilla, the woman who lived with Goya during the last years of his life. He took charge of her daughter's education, teaching the girl to read, write, and draw. In 1823, Goya went into self-imposed exile in Bordeaux, leaving Rosario Weiss in the charge of a friend, the architect Tiburcio Pérez, under whom Weiss improved her drawing skills even more. Goya sent for her from Bordeaux, and from 1828 to 1833, she studied painting with Monsieur Lacour, the director of the Bordeaux Académie des Beaux-Arts. In 1833, she returned to Madrid, where she made a living executing copies of paintings in the Museo del Prado on commission, but she was forced to stop this work, suffering serious financial difficulties. Weiss painted still lifes, portraits, and allegorical scenes such as the lithograph presently in Bordeaux, *The Spirit of Liberty*. She also executed significant drawings, such as the portraits of Manuel José Quintana and the great Romantic poet José de Espronceda, published in *El Diablo Mundo*. In 1840, she entered the Academia de Bellas Artes de San Fernando in Madrid, and two years later, was appointed drawing professor to Queen Elizabeth II of Spain and her sister, the Infanta Luisa Fernanda. Rosario Weiss died in Madrid in 1843, at only 29 years of age.

The French artist Rosa Bonheur was the greatest painter of animals in the history of Western art. Her father, a professor of art and follower of Saintsimonisme, a movement in favor of women's rights, had a decisive influence on her artistic career. In 1853, she attained international renown for her work *The Horse Fair*, and in 1865, she became the first woman to be appointed Knight of the Legion of Honor. Elizabeth Jane Gardner, born in Exeter, New Hampshire, was the first American woman to obtain the gold medal at the Parisian Salon, and in 1897, along with Rosa Bonheur, she managed to sway the École des Beaux-Arts of Paris to admit women.

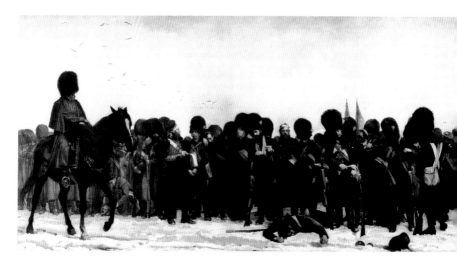

Elizabeth Thompson, Roll Call After a Battle, Crimea, *oil on canvas, 36 x 72 in (91.5 x 183 cm), 1874, Kensington Palace, London.*

The Englishwoman Elizabeth Thompson, like Rosa Bonheur, took up unusual subject matter for women at the time. Her masterpiece represented an aspect of the Crimean War, rendering wounded, ill, and exhausted soldiers after a battle with great realism. The painting impressed the Royal Academy so much that it awarded her an honorary plaque.

Beginning in 1850, many painters took up realism, becoming interested in social subjects. The Englishwoman Emily Mary Osborn painted *Nameless and Friendless*, representing a female painter attempting to sell her work to a gallery owner who appears reticent. If the art market was difficult, it was even worse for a woman with no influential friends or contacts, who in addition had to struggle against a great deal of prejudice. The London painter Rebecca Solomon also evoked social aspects affecting women in her artwork. She painted the role of the governess and symbolic paintings such as a dove that cannot fly, denouncing the restrictions placed on women in the 19th century.

Another artist outstanding for her excellence and the sensibility reflected in her social subjects was the Belgian Louise de Hem. In her

Emily Mary Osborn, Nameless and Friendless, *oil on canvas, 34 x 44 in (86.4 x 111.8 cm), 1857, Private collection.*

canvas *Misery: The Destitute*, she offered a realistic look at the tragic urban misery affecting women.

Another outstanding figure was that of Lilly Martin Spencer, who arrived with her family in the United States in 1830 and was a self-taught painter. Her artwork, of a Realist nature, was more spontaneous and fresher than the academic art prevailing in Europe. She focused on scenes of everyday life, showing her great sense of humor and significant doses of tenderness that the American public appreciated. In 1850, she was elected an honorary member of the National Academy of Design.

Also significant was the artwork of the Peale sisters, who belonged to a dynasty of artists from Philadelphia and whose uncle, Charles Wilson Peale, was a naturalist painter and museum curator. Margaretta Angelica Peale (1795-1882) and her sister, Sarah Miriam Peale (1800-1885), were born in Philadelphia, the daughters of James Peale, a miniaturist, still-life painter, and portraitist. The Peale sisters were able to attend anatomy classes for artists at the Philadelphia College of Physicians in 1819. Margaretta Angelica specialized in still lifes and was one of the founding members of the Academy of Fine Arts of Pennsylvania.

The most popular portraitist was Sarah Miriam Peale, who in 1822 worked with her cousin, who had been educated in Paris and London. In 1824, she was appointed a member of the Academy of Fine Arts of Philadelphia. Sarah Miriam left that city in 1825 and moved to Baltimore, where she became famous as a portraitist, with members of Congress and important figures such as the Marquis of Lafayette among her clients. The portrait of Senator Thomas Hart Benton, executed in 1842, is a luminous, Realist painting subtly combining light and shadows to obtain the image of a self-satisfied man.

The most important portraitist of the United States was Cecilia Beaux, who studied at the Académie Julian in Paris. Beaux's art was striking for different viewpoints, and her paintings were viewed from unusual perspectives. In 1896, she became a member of the Société Nationale des Beaux-Arts.

In Europe, women artists participated in the various artistic movements that coexisted during the latter half of the 19th century. Elizabeth Siddal, who was not born into an artistic milieu—her father was a knife-maker in London—belonged to the Pre-Raphaelites.

Sarah Miriam Peale,
Senator Thomas Hart Benton, *oil on canvas, 29.9 x 25.2 in (76 x 64 cm), 1842, Missouri Historical Society, Saint Louis.*

Victorine Nordenswan, Woman Crying Before Christ's Tomb, *oil on canvas,*
38 x 51.2 in (96.5 x 130 cm), 1868, Museum of Finnish Art Ateneum, Helsinki.

Siddal met Dante Gabriel Rossetti in 1849 and began painting intense watercolors of medieval inspiration.

Another painter who was remarkable for the beauty and spirituality of her scenes was the Finnish artist Victorine Nordenswan (1838-1872), who created serene landscapes permeated by a profound religious sensation. Mary Lizzie Macomber was the only North American to join the Pre-Raphaelites. In London, she discovered Victorian art and was fascinated by Rossetti's artwork. Her work is characterized by the combination of the charm and serenity of English painting of that time with the profound spirituality of Rossetti's art. She was a poet as well as a talented painter and published a book of poetry in 1914.

The symbolist movement emerging throughout Europe during the second half of the century also captivated women. In England, Evelyn De Morgan executed clearly symbolist works with highly studied compositions that evoked the influence of Italian Renaissance painting, tending toward monumentality.

Margaret MacDonald and Frances MacNair were members of the group The Four, from Glasgow, who exhibited their works at the Arts and Crafts Fair of 1896 and were characterized as eccentric but original. Margaret MacDonald developed a very personal style with flat figures, strangely empty backgrounds, and sinuous curves. Frances MacNair also executed original watercolors with unique structures.

One of the best representatives of Impressionism was Berthe Morisot, whose painting *Refuge in Normandy* was a pioneer landscape of this movement. Morisot executed this painting before meeting Édouard Manet, which disqualifies the erroneous belief that she was his student. Morisot always remained faithful to Impressionist ideology and her oeuvre was characterized by intimist scenes, as her social condition as a married woman prevented her from working on other subjects.

Suzanne Valadon, The Fishermen, *oil on canvas, 1914,*
Musée National d'Art Moderne, Paris.

Another Impressionist was the American painter Mary Cassatt. Beginning in 1868, she exhibited both in Paris and the United States, and in 1879, Degas invited her to exhibit with the Impressionists. Cassatt settled in Paris and encouraged North American collectors to buy works executed by her colleagues.

Eva Gonzalès was a student of Manet. She exhibited regularly at the Salon beginning in 1870, where she obtained positive reviews that granted her recognition in England and Belgium, but her artistic career was brief as she died at the age of 34. Marie Bracquemond participated in the Parisian Salon of 1874 and later exhibited her works with the Impressionists in 1879, 1880, and 1886. Her artistic career broke off when she married the engraver Felix Bracquemond, who pressured her to stop painting. Another frustrated career was that of Edma Morisot (1839-1921), also known as Edma Pontillon, Berthe Morisot's sister. She was artistically talented and exhibited in the Salon from 1864 to 1868. But after her marriage, she stopped painting.

There were also painters with a great sense of liberty and independence. The Finnish artist Elin Danielson arrived in Paris at the age of 22 and entered the Impressionist circle. She became involved in the bohemian world to such an extent that she represented the female version of the charming 19th-century dandy. She was consistent in her ideology and her work reveals her as a free woman who had cast aside the restrictive conventions of her time. Another independent woman was the Belgian painter Anna Boch, who worked in the pointillist and Neoimpressionist styles and was the only woman to be a member of the Group des XX, in Brussels. With the aim of attaining greater freedom, she bought a car and began to travel in order to paint the southern light and atmosphere on site.

The force of Impressionism reached the Scandinavian countries. In Norway, Kitty Kielland observed the Impressionist movement in Paris, which she combined in her canvases with a Scandinavian light. In Finland, there were such outstanding female painters as Fanny Churberg, who trained in Helsinki, Düsseldorf, and Paris, executing landscapes with an Impressionist brushstroke in her mature period. Finland distinguishes itself because it accepted women painting nudes and participating in classes with nude models long before the rest of Europe. Something similar occurred at the Pennsylvania Academy of the Fine Arts in Philadelphia, which accepted women as students in 1846; but they were not allowed to paint female nudes until 1871 nor male nudes until 1877.

During the closing decades of the 19th century, interesting new female artists appeared on the art scene, such as the Dutchwoman Suze Robertson, who painted in a harsh, tormented style approaching expressionism. She was painting nudes, beginning at the turn of the century, and her self-portrait, in which she appears turned slightly toward the front and in a reflective mood, is remarkably original. The German Käthe Kollwitz's expressionism is strikingly moving and tormented. Another talented artist with great personality was the Frenchwoman Suzanne Valadon, who began in the world of the circus and taught herself painting, encouraged by Edgar Degas.

Lluïsa Vidal, considered a master of Catalan Modernisme, or Art Nouveau, like other female European painters, studied at the Académie Julian in Paris. She became a portraitist, but she also executed scenes of urban life in Barcelona with a clear, fresh, and luminous brushstroke. She was respected by critics and was internationally recognized.

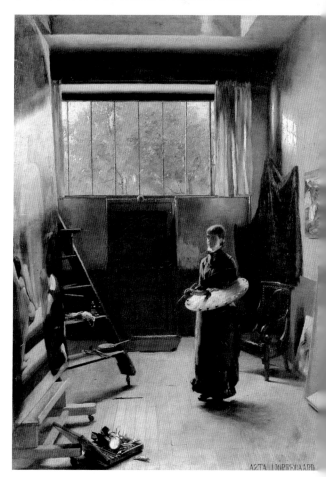

Asta Nørregaard, The Studio, *oil on canvas, 25.6 x 18.9 in (65 x 48 cm), 1883, Private collection.*

Critics generally considered women's art, but often showed a paternalistic tendency. It was frequently affirmed that, though the woman in question was a painter, she was nonetheless a virtuous woman and a good wife who fulfilled her duties. There was also a sort of fear that women artists would become masculine and lose their femininity. And one of the best praises that a woman painter could aspire to was that she painted as well as a man.

Gradually, toward the end of the 19th century, public education in the fine arts began admitting women, both in Europe and North America, eliminating the ancient taboo of painting nudes from models. This eliminated what could be considered the worse grievance that women artists had had to endure for centuries, since the lack of training in prohibited spheres had been a strong handicap to their artistic and professional careers. Now, at the dawn of the new century, everyone had equal opportunities. Nonetheless, historiography forgot the women artists of bygone centuries, unfortunately burying them in oblivion.

The 20th Century

During this century, there are so many known, outstanding women artists that covering them all would require an entire book. In this book, we are limited by space to including only some. The Russian women who were militant participants in the avant-garde movements of the early 20th century are some of the most interesting. Natalija Sergeevna Goncharova was inspired by medieval Russian art, which she fused with the new movements of European painting. As a result of her studies, Rayonism was born, consisting of a network of lines and brushstrokes giving rise to abstract works. Olga Rozanova executed spectacular suprematist works. She also wrote poetry and art theory, proposing various theories on the absence of perspective and rejection of figurativism, defining her paintings as Color Art. She also established the basic concepts of Russian constructivism and cubo-futurism.

Women continued to be present in the avant-garde. Paula Modersohn-Becker studied from 1896 to 1898 at the School of Drawing and Painting of the Association of Berlin Women Artists, founded to educate women in the fine arts. A friend of the poet Rainer Maria Rilke, her artwork was expressionist though her career was short, as she died at 31 years of age. Marianne von Werefkin was born into an aristocratic Russian family, but her artistic career developed primarily in Germany, where she participated in the expressionist movement, like Gabriele Münter, who was born in Berlin. In 1909, with Vasily Kandinsky's encouragement, the two women founded the Neue Künstlervereinigung München (New Association of Artists of Munich). Two years later, along with Kandinsky, Alexej Jawlensky, Franz Marc, August Macke, and Alfred Kubin, they founded the group Der Blaue Reiter (The Blue Rider). The expressionist art of Marianne von Werefkin and Gabriele Münter denotes a search for abstract compositions in which color plays a fundamental role.

The artwork of Georgia O'Keeffe is characterized by the synthesis of forms and the elimination of accessory elements. Her talented, sensitive art is lucid, minimalist, and theatrical. Tamara de Lempicka understood her Neo-Cubist art as the reconciliation between modern art and academicism. She represented the prototype of the modern woman, as in her 1925 self-portrait, she rendered herself driving a car.

Lee Krasner was born in New York to an educated Jewish family. In 1932, she graduated from the National Academy of Design as part of the first generation of artists of the New York School. She abandoned figurativism in search of new paths of expression, and in 1937, she began exhibiting with the American abstract artists. Helen Frankenthaler, also from New York, was part of the second generation of abstract expressionists. In the early 1950s, she invented a pictorial technique that would become the basis of color field painting, and her style comprised free improvisation that was quite lyrical.

Montserrat Gudiol was born in Barcelona, the daughter of the art historian Josep Gudiol, who encouraged her to take up art. She is a self-taught figurative artist who has attained international renown. Her symbolist artwork is characterized by figures immersed in sorrow and resignation. Another self-taught artist was Frida Kahlo, who, in 1946, won the National Painting Award of her country, Mexico, for *Moses*. Her work is associated with surrealism, but she always rejected this label. She autobiographically revealed the anxiety and suffering of her life in her canvases.

There are basically two myths about art executed by women. First of all, there is a general belief that a painting executed by a woman radiates a sort of feminine aura, a delicate and subtle air that indicates that the work was created by a woman. Nothing could be further from the truth, as history has demonstrated over the centuries. Can we distinguish a female from a male hand in medieval miniatures? Can we really affirm that the vast majority of paintings by Artemisia Gentileschi emanate a delicate, feminine air? Are Suze Robertson's nudes or Käthe Kollwitz's drawings amiable? Are Berthe Morisot's landscapes feminine and Claude Monet's masculine?

The second myth is the belief that a painting created by a woman is second class, in other words, of inferior quality, as compared to those by male artists. This falsehood has been propagated throughout the centuries, as women's intellectual capacity has always been questioned. The omission by 20th-century scholars and historians of female painters from past centuries has effectively contributed to the underestimation of art by women. The best demonstration that this belief is false is the confusion, unfortunately common, as to authorship. To cite only a few examples, Sofonisba Anguissola's portraits were attributed

Élisabeth Nourse, The Closed Windows, *oil on canvas, 39.6 x 39.6 in (100.5 x 100.5 cm), 1910, Musée d'Orsay, Paris.*

to Alonso Sánchez Coello and El Greco, Artemisia Gentileschi's paintings were attributed to Caravaggio, and the paintings by Judith Leyster were long considered the work of Frans Hals.

There are some constants that are repeated throughout history. Until well into the 19th century, for example, an overwhelming majority of female artists were the daughters of painters, and in the few exceptions in which the father was mentioned, he was directly or indirectly related to the world of art. Those women not only inherited paternal or maternal artistic talent, but also had a unique opportunity to study in their parents' studios. Over the course of the centuries, experience demonstrates that the role of the father was fundamental in his daughter's artistic training and early career, at least until the mid-19th century.

Another aspect is the diligence, care, and love that women artists put into signing their works. It is an ancient characteristic that has existed from the Middle Ages to the present. It is a manner of affirming their professionalism in a difficult world monopolized by men. Something similar can be said of the persistent tendency toward the self-portrait.

Another feature is the high percentage of women artists who refused to marry, remaining celibate or single. It is easy to understand that familial obligations and child care take precious time from an artistic career. Hence many of these women placed their priorities in their dedication to art, rejecting a more conventional lifestyle.

The last characteristic is the tenacity of women painters and their capacity to struggle in the face of adversity. Over the centuries, they proved difficult to discourage. In order to overcome their educational shortcomings, they took private classes in artists' studios and later at art academies. They repeatedly defied the conventions of their times. Lavinia Fontana painted female nudes in the 16th century, and in the 17th, Artemisia Gentileschi mastered perspective. Michaelina Woutiers, who probably studied in Italy, executed mythological scenes with a perfection that required a thorough knowledge of the male anatomy. In the 18th century, female artists of the Enlightenment struggled to gain access to academies on their own merits, and in the 19th and 20th centuries, they participated in the vanguard movements, struggling, more or less openly and with great strength, to defend their rights. All of this constitutes a magnificent obstinacy that has given rise to works of art that are the heritage of Western art and of humanity in general.

Painting, like the angels, has no gender. Any student of art history knows that the concept of "art" is so complex and abstract that it cannot be labeled as masculine or feminine. There is no feminine body of art; there is only art executed by female artists, each expressing her individual personality on canvas.

The aforesaid could be completed by a statement by Leonardo da Vinci: "Painting is in the mind." Art is not a matter of gender, but of the intellect.

CATERINA VAN HEMESSEN

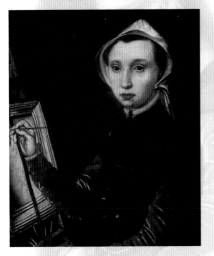

Self-Portrait *(detail), oil on canvas, 13.8 x 10.4 in (35 x 26.5 cm), 1548, Hermitage, Saint Petersburg.*

Caterina van Hemessen was the second daughter of the painter Jan van Hemessen, who in 1524 became a master in Antwerp and, in 1548, senior member of the guild in that city. She studied in her father's studio and then specialized in religious scenes and portraits that were more accessible than her father's. She married Christian de Morien, organist for the Antwerp cathedral, on February 23, 1554. In 1555, she was recorded as a maid of honor in the official lists of the court of Brussels.

Van Hemessen's mastery of painting and her association with the court led Mary of Austria, the sister of Emperor Charles V, to grant her and her husband access to the court of Castille in 1556. Ludovico Guicciardini explained in his book, published in 1567, that Christian and Caterina, "for their rare and excellent virtues are both invited to Spain and shall receive an endowment for the rest of their lives." After the death of Mary of Austria, Christian and Caterina returned to Flanders. It is unlikely that van Hemessen's artistic career stopped there. Caterina van Hemessen, Sofonisba Anguissola, and Levina Teerlinc, who worked for the English court, formed a trilogy of women painters who enjoyed the patronage of royal courts in the 16th century. Guicciardini mentioned van Hemessen as one of the five most famous living women painters. Giorgio Vasari included her in his *Vite* (1568), in the chapter concerning

- **1527-1528** Born in Antwerp, in Flanders, the Low Countries.
- **1548** Paints a self-portrait. She also paints her older sister Christina at 22 years of age playing the virginal. Executes the portrait of a young woman (Rijksmuseum, Amsterdam).
- **1549** Paints two portraits as a set: One is of a 42-year-old man and the other is of a 30-year-old woman (Musées Royaux, Brussels).
- **1552** Executes the portrait of a man and signs and dates it as follows: "Caterina filia Joannis de Hemessen pingebat 1552" (National Gallery, London).
- **1554** On February 23, she marries the organist Christian de Morien.
- **1555** Mentioned in the lists of people holding court titles in Brussels as maid of honor. Paints *The Flagellation of Christ* (William A. Rudd Collection, Ohio) and *Repose of the Holy Family on the Flight to Egypt* (Lescart Collection, Mons).
- **1556** Mary of Austria becomes the patron of Caterina and Christian, and brings them to the court of Castille.
- **1558** Mary of Austria dies in Cigales, Valladolid. The couple returns to the Low Countries.
- **1567** Ludovico Guicciardini mentions van Hemessen in his work *Descrittione de tutti i paesi bassi*, published in Antwerp this year.
- **1568** Giorgio Vasari's *Le vite de' più eccellenti pittori, scultori ed architettori* is published in Florence, and Caterina van Hemessen is mentioned in the chapter on Flemish artists.
- **1581** Dies sometime after this year. Some historians believe she dies after 1587.

Flemish painters, as an excellent miniaturist—although information provided by Vasari should always be taken with caution. Somewhat later, a Dutch doctor, Van Beverwyck (1594-1647), from Dresden, mentions her.

At present, though there are no certain known works by her dated after 1555, Simone Bergmans attributes to her the painting entitled *The Wife of the Levite of Guibna,* containing the monogram CVH with the partially legible date 156–. Also attributed to her is a portrait of a young lady dated 1560 (Baltimore Museum of Art). The hypothesis also exists that Caterina was the artist known as the "Monogramist of Brunswick." In any case, there is ample terrain for research.

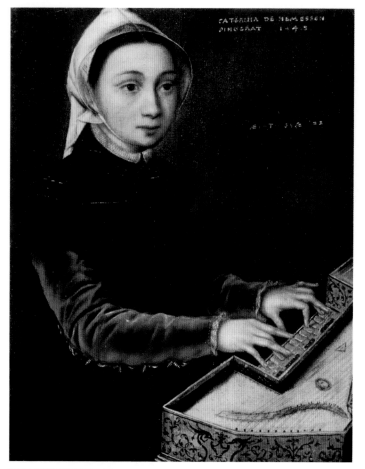

Young Woman with Virginal

(1548)
oil on wood
12.6 x 10.1 in (32.2 x 25.7 cm)
Wallraf-Richartz Museum, Cologne

The three extant self-portraits by Van Hemessen and this painting are signed and dated. In this case, the inscription reads: "Caterina de Hemessen Pingebat 1548. Aetatis Suae 22" ("Caterina de Hemessen painted it in 1548, at the age of 22"). The great similarity of this woman playing the virginal with the self-portrait of Caterina at the age of 20 appears to confirm that the model was her sister Christina, who was two years older than the artist. Both paintings are similar in size and the two sisters are wearing the same headdress and top, with the type of sleeves adorned with a fringe that were much in fashion at the time. The two paintings were probably designed as a set.

Caterina represents her sister against a dark background, her face lit in warm colors, with the headdress and musical instrument placed on a diagonal and in the corners of the work. The spinet and the virginal, derived from the psaltery, were the preferred instruments for domestic use from the early 16th to the end of the 17th centuries. (In the spinet and the virginal, the strings are plucked, rather than struck as in the clavichord and the piano.) In keeping with the Flemish tradition, the artist paid meticulous attention to detail. Thus, the virginal is adorned in an elaborate style revealing how Italy, at the vanguard of European art, exported its instruments to northern countries. In Flanders, there were excellent musicians who traveled, playing for the courts of France, Italy, Spain, and Germany, seeking musical interchange. It was considered prestigious for the educated upper classes to show their skill in dancing, singing, and playing music. Both Caterina's self-portrait (one of the oldest by a woman in Western art and certainly the oldest in the Low Countries) and the portrait of her sister playing the virginal illustrate the humanist ideals of the period. Van Hemessen attempted to demonstrate in these two paintings that she and her sister were educated women.

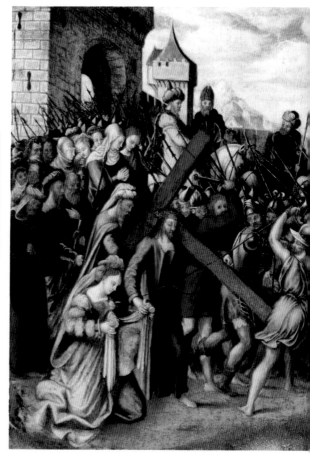

Ascent to Calvary and Encounter with Veronica

oil on wood
15 x 11 in (38 x 28 cm)
Collection H. Boeyckens,
Nieuwerkerken

The iconography of this panel is very rich. The scene shows Jesus with the cross on the way to Calvary, aided by Simon of Cyrene, as described in the Scriptures. Behind and above Simon is the mother of Jesus, walking with John. Both bear expressions of contained sorrow. Three women who are not mentioned in the canonical Scriptures follow behind them, bunched together. The painting is based on an apocryphal text, *The Gospel According to Nicodemus*, also called *The Acts of Pontius Pilate*, which said that Jesus was accompanied on his way to Calvary by his mother, John, and three women, Martha, Mary Magdalene, and Salomé.

The apocryphal scriptures were pious texts that abounded in medieval libraries and gave rise to a rich iconography in Christian art. Doubtless a powerful instrument for spreading these beliefs was *The Golden Legend* by Giacomo da Varazze—Holly Lives Series—written about the year 1264. After the appearance of Protestantism and the Council of Trent (1563), the Scriptures and apocryphal texts began to fall into oblivion.

The most interesting aspect of this scene is the figure of Veronica, kneeling on the ground holding a cloth with the image of Jesus' face. The apocryphal text *The Death of Pilate* explains that Veronica was bringing a cloth to an artist to request a portrait of Jesus. While on her way to the artist's studio, she met Jesus who, knowing the woman's wishes, took the cloth and returned it to her with his image on it. During the Middle Ages, this version was modified, placing the encounter on the path to Calvary. Veronica took pity on Jesus and dried his sweating, battered face with a cloth, whereupon the image of his face appeared on it. Beginning in the 15th century, due to the influence of medieval theater, the legend of Veronica became very popular, which explains its frequent appearance in paintings.

In terms of composition, this work follows more ancient models from the medieval tradition, using the gates to the city in the background, the crowd following Jesus, and even the position of the soldier (with his back to the viewer in the foreground near the cross) to reinforce the construct. But the painting also contains innovative elements. The position of Veronica, parallel to Jesus and devoutly contemplating the cloth with the image, is more natural than other representations of the time, which render her in a rather theatrical demeanor. Van Hemessen achieves consistent volumes with her paintbrush. The loose technique in the sleeves and in the folds of Veronica's tunic is striking, particularly if compared with other figures in the panel. The scene is dramatically contained, evoking a more serene spirituality far from exaggerated representations such as the one on the same subject by her father. This panel has medieval elements and a great deal of charm. It also has a bit of the air of a miniature.

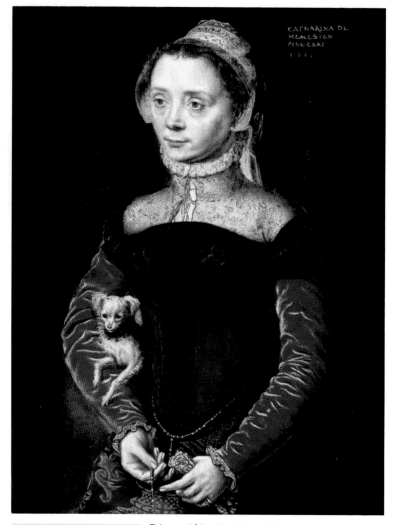

Portrait of a Lady

(1551)
oil on oak
9 x 7 in (22.9 x 17.8 cm)
National Gallery, London

This panel (signed and dated "Caterina de Hemessen pingebat 1551"), is probably one of the most appealing portraits of the 16th century. The elegance and quality of her clothes clearly indicate this woman's upper-class status. She is wearing a beautiful blouse of fine lace, a bodice with an open collar that emphasizes her shoulders, red velvet sleeves, and an embroidered skirt. She is holding the end of a chain hanging around her waist in one hand, and what appears to be a small lacework handkerchief in the other. The fact that the woman is playing with the chain and holding an object eliminates the possibility that her pose implies a hierarchical position. In *The Beauty* (1536) by Titian, an artist who exercised a great deal of influence on the portraiture of the period, the lady is playing with the chain of her belt. In court portraits after this one by van Hemessen, a multitude of queens, princesses, and noble ladies hold a glove, or a handkerchief, or a necklace.

A charming element is the lapdog, wearing a collar with bells and resting on the woman's velvet sleeve and next to her bodice. Lapdogs abound in portraiture from this period, represented as animals that provide company. They are a sign of luxury and perhaps a symbol of fidelity. Nevertheless, in this painting, the dog is rendered even more tenderly. Its small size and position imply a precious, beloved toy.

CATERINA DE HEMESSEN

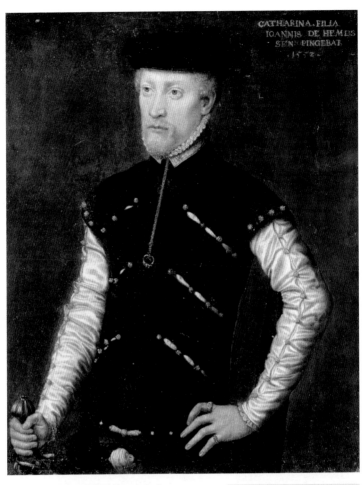

This portrait is signed and dated. In this period, there was a true passion among the upper classes throughout Europe for dressing richly, so richly that their expenses for clothing were very high. This nobleman is wearing a flattened hat, a style appearing during the turn of the 16th century as a variety of the bonnet. He has very short hair and a beard that began to be in fashion around 1530. Previously, men had always shaved. In fact, the beard came into fashion when Charles V married Elisabeth of Portugal in 1526, as he let his beard grow and was quickly imitated.

Portrait of a Man

(1552)
oil on oak
14.3 x 11.5 in (36.2 x 29.2 cm)
National Gallery, London

The figure is wearing a doublet, an item of clothing that was worn by men over their shirts, with precious stone decoration. The black of the doublet contrasts with the light ocher and golden buttons of the elegant sleeves. The ring hanging from the figure's neck and the other rings on his left hand leave no room for doubt as to his social status. This excellent portrait shows an energetic man, as he is decisively gripping a sword, a gesture that appears in many portraits, but not always in such a decided manner. The left hand is in a more relaxed position, the arm bent, helping to prevent possible rigidity in the sitter.

This is a somber portrait with no anecdotal aspects, exquisitely combining rigorous black with the warm, luminous tones of the sleeves. Both this and the previous portrait were probably influenced by Titian. Caterina van Hemessen was a maid of honor in the Brussels court ruled by Mary of Austria, Queen of Hungary and sister of the Emperor Charles. A highly educated woman who enjoyed music, literature, and the arts, the queen collected portraits by Titian and Moro that reveal the tastes of the House of Austria, portraits that van Hemessen must have seen. When Mary gave up the throne in 1555 and traveled to Spain, taking Caterina and her husband with her as her protégés, she took her art collection with her, including the portraits by Titian and Moro, as indicated in the Inventory. At her death, Philip II bought the paintings, which would become the foundation for the Portrait Gallery of the Prado.

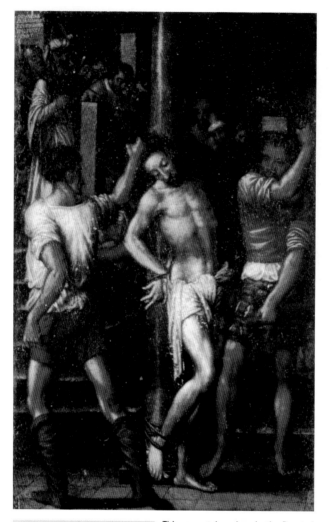

The Flagellation of Christ

(1555)
oil on wood
13.7 x 9 in (34.9 x 23 cm)
William A. Rudd Collection, Ohio

This scene takes place in the Praetorium, or palace where the Roman Praetors held court cases. In this painting, the scene occurs outside the palace of the governor, Pontius Pilate, who orders Christ to be flagellated before being crucified. In accordance with the Scriptures, a crowd of people appears in the background, consisting of the leading priests, elders, soldiers, and an individual with his head bent, probably Barabbas. Jesus is in the center of the composition, tied to a column and flanked by his tormentors.

The painting reveals Caterina van Hemessen's artistic maturity: the placement of the stairs on the left of the panel elevates the crowd, providing excellent depth. The composition is much more relaxed and removed from the Gothic formula of a flat, bunched crowd, as in the previous work. The artist's style here is more modern and Italianized. The figure of Christ is mannerist in the flexed knee, the head bent to the left, and the hand tied to the column; His fingers are writhing in pain. The soldier with his back turned is also mannerist, with his arm foreshortened. Study of the human body is evident in the nude figure of Christ and in the soldiers beating him. As is habitual in works by van Hemessen, the panel emanates a contained, somberly dramatic air, enhanced by the illumination and contrasting dark shadows, as in the background and the pavement reflecting the shadows of the soldiers.

SOFONISBA ANGUISSOLA

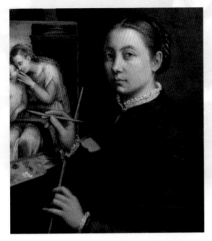

Self-Portrait Painting the Virgin with Child
(detail), oil on canvas, 26 x 22.4 in (66 x 57 cm),
1556, Zametw Lancucie Museum, Lancut.

Sofonisba Anguissola was the greatest female
Italian painter of the Renaissance. Like her
Flemish contemporaries, Caterina van Hemessen
and Levina Teerlinc, she also enjoyed royal
patronage and protection. Her father, Amilcare,
belonged to the nobility and was the senator of
Cremona. An educated man who loved the arts,
he followed the guidelines on education put
forth by Baldassare de Castiglione in The
Courtesan (1528). Hence, Sofonisba, the eldest,
and her sisters studied Latin, music, the humani-
ties, and painting. She studied under the artists
Bernardino Campi and Bernardino Gatti, who
introduced her to a soft, blended technique in
the style of Correggio. At 15, she was already
famous for her portraits, and her father arranged
to have Michelangelo view one of her works. The
master asked for an image of a boy crying, and
Sofonisba sent him a drawing of a boy being
pinched by a crab.

 In 1559, she left Cremona to work as a
painter in the court of Philip II. Appointed maid
of honor to Queen Elizabeth of Valois, she
worked in the Spanish court for thirteen years,
until, in 1573, Philip II decided to marry her to
the Sicilian nobleman Fabrizio de Moncada. The
marriage lasted only three years. Fabrizio under-
took a sea voyage to request the help of Philip II,
but his ship was attacked by pirates and sunk.

 A year and a half after she had become wid-
owed, when Anguissola was traveling by ship,
she fell in love with the captain, Oracio

- **1535-1536** Born in Cremona, the eldest
daughter of Amilcare Anguissola and Bianca
Ponzona. Except for Elena, who became a nun,
Sofonisba's sisters—Minerva, Anna Maria,
Europa, and Lucia—also became painters.
- **1546** Studies under the portraitist
Bernardino Campi, until he moves to Milan to
execute a
commission.
- **1549** Continues studying under Bernardino
Gatti. Begins to gain fame for her portraits.
- **1559** King Philip II requests her services. She
sets sail from Genoa to reach Guadalajara.
- **1568** After the death of Queen Elizabeth of
Valois, Anguissola takes charge of the education
of the Infantas, Isabel Clara Eugenia and
Catalina Micaela.
- **1573** King Philip II marries her to the Sicilian
nobleman Fabrizio de Moncada and Anguissola
moves to Palermo. The king grants her a dowry
of 12,000 escudos and assigns her an annual
stipend of 1,000 ducats.
- **1577** Her husband drowns when his ship
sinks following an attack by pirates.
- **1579** On December 24, she marries the
Genovese nobleman Oracio Lomellini, in Pisa.
- **1584** Settles in Genoa, where she establishes
a school of painting.
- **1585** The Infanta Catalina Micaela arrives in
Savoy with her husband, the Duke of Savoy. The
representatives of the Serene Highness of
Genoa, Anguissola and Oracio Lomellini, go
there to pay tribute.
- **1599** The Infanta Isabel Clara Eugenia visits
her in Genoa.
- **1624** On July 12 the painter Anthony Van
Dyck visits her in Palermo.
- **1625** In early November, she dies in Palermo,
almost at the age of 90. Buried on November
16 in San Giorgio dei Genovesi.

Lomellini. They married immediately, without
requesting the permission of King Philip II or of
her father. To the Great Duke's disapproval of
their union, Anguissola replied, "Marriages are
made in heaven and not on Earth."

 She painted many portraits, self-portraits, and
religious scenes. In his Lives (1681), Filippo
Baldinucci compared her with Titian. For many
years it was believed that Baldinucci was exag-
gerating, but the truth of his statement is gradu-
ally coming to light.

The Chess Game

(1555)
oil on canvas
27.5 x 37 in (70 x 94 cm)
Museum Nardowe, Poznan, Poland

This signed and dated group portrait of three of Anguissola's sisters is a familiar scene imbued with dynamism and grace through the figures' varied attitudes and poses. Lorenzo Lotto painted a work, *Zuane de la Volta, His Wife and Two Children* (National Gallery, London), with a similar composition, as the figures are also located around a table with a landscape in the background. However, the gestures are so affected that his painting is not very credible.

In this painting, Lucia is on the left. She has just killed her opponent's queen. The other player is Minerva, who is lifting a hand, perplexed and rather serious, since she has nearly lost the game. The young Europa smiles openly in the center, enjoying the situation. The psychological rendering of the figures is perfect. The expression of the servant gazing at the game is also remarkable. Occupied in her domestic tasks, she nevertheless has time to notice matters affecting the girls. This painting reveals Anguissola's human spirit. The young women are wearing elegant silk clothing with lace cuffs, high collars with a ruff, and necklaces and tiaras with precious stones and pearls adorning their heads. Anguissola paints a landscape in the background that adds depth to the painting. The canvas has a soft light throughout, with the indistinct, misty landscape in the background characteristic of Northern Italian painting in a technique called sfumato. The drawing is solid and the strokes of color are not very detailed, but rather suggestive and subtle, as is the case in Flemish painting. This can be observed in the complexions, in the magnificent golden highlights on the sleeves, and in the highlights on their pearls.

Giorgio Vasari mentioned this painting and explained that when he was writing his *Vite*, he went to Cremona to visit the artist's father. Seeing the painting, Vasari was profoundly impressed at its vividness, to the point where he assured readers that the girls might begin speaking at any moment. Chess was reserved for men of the nobility or upper classes. Anguissola did not paint her sisters sewing or embroidering, but rather exercising an intellectual activity, that is, playing chess. This scene refers to the thorough humanist education that Amilcare Anguissola provided his daughters.

This group portrait represents the artist's father, Amilcare, her sister Minerva, and her brother, Asdrubal. Amilcare had the same Carthaginian name as his grandfather, who wanted to indicate the family's independence from Rome and Lombard heritage. Hence, the eldest daughter was called Sofonisba, the name of a Carthaginian princess who was considered "exceedingly beautiful and notable, both in music and in writing." It is not surprising that the young Asdrubal also had a Carthaginian name. Amilcare dedicated his life to his public duties and fol-

Family Portrait

(~1557)
oil on canvas
61.8 x 48 in (157 x 122 cm)
Nivaagaards Malerisamling, Niva, Denmark

lowed the guidelines on education proposed by Castiglione in his book *The Courtesan*. An unsuccessful businessman, Amilcare struggled to give his daughters a thorough, intellectual education.

In this painting, the loving relationship between the figures is very pleasant to the eye because of its sincerity. The imposing and majestic figure of the father stands out in the center, dressed in black. With a serious expression, he places his hand on his son's shoulder as the boy looks at him with admiration. Minerva gazes downward, contemplating the scene while she touches some flowers in her doublet or bodice and gathers her skirt in a delicate feminine gesture. In the background, a window with a landscape is integrated into the scene. In the foreground of the landscape, the colors are defined, with a bluish, misty sfumato appearing only in the distance. The red drapes framing Amilcare's face are also interesting. In court portraits, landscapes and draperies often allude to dignity, presence, and nobility.

Nonetheless, the painting is not finished, as is evident in details, such as the boy's left hand and the bottom of the work. In 1566, Vasari saw this painting in Anguissola's father's house and qualified it as "extremely vivid." Anguissola achieved a composition that is eminently natural and devoid of rigidity. It reveals that she long reflected on the attitudes of the sitters. She represented different postures and expressions, without eliminating the sense of family love. The figure's faces are well lit and the brushstrokes are soft and diaphanous.

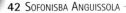

Elizabeth of Valois

(1563-1565)
oil on wood
46.9 x 33.1 in (119 x 84 cm)
Museo del Prado, Madrid

Anguissola executed many paintings at the Spanish court. Royal houses often commissioned portraits to send to other European courts as gifts to decorate their palaces. It was therefore important for the sitter to have a good image, transmitting authority, respect, and dignity. Elizabeth of Valois (1545-1568) was the daughter of Henry II of France and Catherine de Médicis, and she was Philip II's third wife. On June 22, 1559, Philip and Elizabeth were married in the cathedral of Notre Dame in Paris. The young queen, 15 years of age at the time, left for Spain in November. Elizabeth had been educated in the Parisian court and had learned music and painting. As Sofonisba Anguissola was a young aristocrat and good painter, the Duke of Alba suggested to the king that he appoint her maid of honor to the queen, and so, in November 1559, Anguissola left for Spain with Elizabeth.

She painted her first portrait of the queen in 1561 at the palace of El Alcázar in Madrid, as well as another that was sent to Pope Pius IV. In this later portrait, erroneously attributed to Alonso Sánches Coello and to his disciple Pantoja de la Cruz, Elizabeth of Valois has a coiffure full of pearls, decorated on the left with a large emerald, a ruby, and a tear-shaped pearl. She is wearing an elegant black dress from which emerges a red embroidered silk sleeve. Two pearl necklaces hang from her neck, and she is wearing a belt and other exquisite adornments with all sorts of precious stones. As was the fashion, red ribbons with lace hang from the upper sleeve and skirt. The chain she is holding in her hands breaks her rigidity. There are curtains in the background, and Elizabeth is resting one hand on a chair used as her throne. These are symbolic elements that indicate the sitter's status and were required by protocol.

As was common in her art, Anguissola illuminated the figure's face, giving the lips a light red color. Though protocol dictated that the sitters radiate coolness and distance, the artist rendered an intimate image of Elizabeth with little idealization. The ostentation of her luxurious attire and magnificent jewelry serves to establish an image and show the riches of the royal house as part of its political propaganda.

Prince Charles of Austria

(~1560)
oil on canvas
43 x 37.4 in
(109 x 95 cm)
Museo del Prado,
Madrid

Prince Charles (1545-1568) was the only child of Philip II and his first wife, Elizabeth of Portugal, who died in childbirth. He was a sickly, deformed child with mental imbalances. In 1560, he was proclaimed Prince of Austria and heir to the throne. Two years later, after a fall, a doctor performed trephination on his skull, forcing Charles into a long convalescence.

In the autumn of 1567, John of Austria warned Philip II that Charles was conspiring to take the government of the Netherlands. Later, the prince attempted to assassinate John of Austria and was imprisoned by the king, where he died on July 24. This story incited the imagination of Romantic writers, who elevated Charles to the category of hero, adding to the rumors that Philip II was cursed.

This painting was attributed to Alonso Sánchez Coello. Unlike her male colleagues who were court painters, Anguissola was paid for her paintings with luxurious gifts, making the historians' task of attributing works to her more difficult, since accounts rarely showed her "payments." From a stylistic point of view, both the brushstrokes and the colors used are more in keeping with Anguissola's style than with the detailed technique of Sánchez Coello. Raffaello Soprani mentions this work in an 1874 book, and in 1681, Filippo Baldinucci wrote that Anguissola received a precious stone valued at 1,500 escudos for this painting.

The most probable theory is that, from this original portrait by Anguissola, copies were made, as recorded in a document published by Berroqui and now at the Simancas Archives, reading, "Six portraits of His Highness Prince Charles all in the same manner and taken from one executed by Sofonisba, lady to the Queen...from the knee upward dressed in white and with a cloak lined in wolf's skin." It most certainly refers to the precious ermine cape. Even so, the authorship of this work is still debated.

Charles is wearing a hat adorned with feathers and a lovely doublet with gold thread buttoned to the neck with a discreet starched ruff. He wears a belt and breeches with vertical pleats in a loose material very much in fashion in the 1550s; it quickly spread throughout the rest of Europe, which imitated the attire of the Spanish royal court. In the background, a window opens onto a landscape with Jupiter and an eagle holding a column, symbols of the power and dynasty of the House of Austria, relating to the prince as heir to Philip II. Anguissola enhanced Charles's appearance. According to descriptions from the period, one leg was shorter than the other, his mouth was always open, his eyelids partially closed, and he had a protruding forehead. He was also hunchbacked due to scoliosis. All of this is concealed by Anguissola, though she renders other physical aspects. Charles has the pale, practically inert hands of a sickly person.

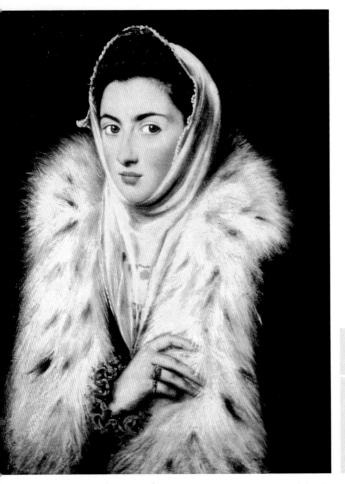

Infanta Catalina Micaela, *or* The Lady in Ermine

(~1590)
oil on canvas
24.4 x 19.7 in
(62 x 50 cm)
Pollock House,
Glasgow, Scotland

Catalina Micaela (1567-1597), Duchess of Savoy, was the second daughter of Philip II and Elizabeth of Valois. In 1568, her mother died when she was one year old. This was a hard blow for Philip II, who deeply loved his wife and lost his son, Charles, in the same year. The death of Elizabeth of Valois also affected Anguissola, who remained at court some years longer, caring for the young infantas. In 1585, Catalina Micaela married the Duke of Savoy.

This portrait has long been the object of controversy. At first it was attributed to El Greco, and the sitter was assumed to be Jerónima de las Cuevas, the painter's wife and mother of Jorge Manuel, their son. In the early 20th century, Elias Tormo and Salazar Cantón already noted the great similarity of this lady with the portrait of Catalina Micaela executed by Anguissola and exhibited at the Museo del Prado. In the 1980s, Carmen Bernis upheld the same theory and concluded that it should be dated at approximately 1590. Even so, the polemic continues and historians do not agree. According to Maria Kusche, the work should be attributed to Anguissola. The infanta's face is well lit, the contours are soft, and her lips and cheeks are rosy. The brushstrokes in the ermine lining are very loose, and identical to those in Prince Charles's cape.

The painting may have been a gift from Philip II to his son-in-law, the Duke of Savoy, who visited Spain in 1591. At an exhibit held in Vienna in 1995, this painting appeared in the catalogue as Anguissola's work. In the catalogue of the exhibit "Philip II: A Renaissance Prince," held at the Museo del Prado, Madrid, from 1998-1999, the painting is attributed to El Greco, though the arguments put forth are not very convincing. The portrait lacks the coolness, presence, and distance typical of court portraits. Nonetheless, there are several more private portraits by Anguissola of Philip II and his fourth wife, Ana of Austria (Museo del Prado), whose authorship is certain and which are very unassuming. In addition, there was a close friendship between the painter and the infantas, which may explain Catalina Micaela's gaze of complicity. Anguissola knew the infanta well.

LUCIA ANGUISSOLA

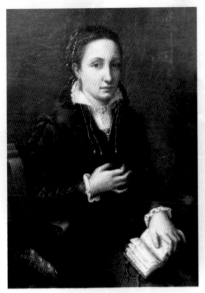

Self-Portrait, *oil on panel, 1557,*
Castello Sforzesco, Milan.

- **1536-1538** Born in Cremona, Italy, to Amilcare Anguissola and Bianca Ponzoni. Her sisters Sofonisba, Minerva, Europa, and Anna Maria were also painters; her sister Elena became a nun, and her brother, Asdrubal, did not practice the arts.

- **~1550** Studies under the painter Bernardino Gatti..

- **1555** Executes a *Virgin with Child* (signed and dated), whose whereabouts is unknown.

- **1557** Paints a self-portrait.

- **1558-1560** Some works attributed to her have been dated to this period.

- **1565** She probably dies this year, since the next year, when Giorgio Vasari visited her father in his home in Cremona, he mentions Lucia as having died.

Lucia was born into a noble family from Cremona, the third daughter of Amilcare Anguissola, senator of that city, and of Bianca Ponzoni. Like her sisters, she received an excellent education and studied music, painting, Latin, and the humanities, as her father heeded the pedagogical ideas of Baldassare de Castiglione according to his book *The Courtesan* (1528). Giorgio Vasari mentioned her in his *Vite,* published in 1568, comparing her pictorial expertise to that of her sister Sofonisba, who shone in the field of portraiture in the second half of the 16th century. Lucia was also mentioned by Antonio Palomino (1655-1726) in his *Lives* and by Filippo Baldinucci (1681). Nevertheless, little is known about her life, which was very short, as she died between the age of 27 and 29.

Lucia liked music very much, and she knew how to play chess, an intellectual activity that was normally reserved for men and rarely practiced by women. This is reflected in the painting that Sofonisba executed of her sisters Lucia and Minerva playing chess.

She must have also enjoyed reading, as can be inferred from her self-portrait, a canvas with predominantly dark colors representing a girl with a melancholy gaze, an aura of spiritual sorrow, and a fragile, vulnerable aspect. Lucia signed two works: her *Self-Portrait* and *Portrait of Dr. Pietro Manna.* According to Vasari, she also painted the Duke of Sesa. In fact, she specialized in portraiture, although she also executed a *Virgin with Child* that has all of the tenderness of a work by Raphael. Her work is characterized by its high quality, the excellent rendering of the sitter's psychology, and a soft, evocative brushstroke.

Although not as many of her works as those of her sister Sofonisba are known, she was, as her sister, a paradigm of a cultured and distinguished woman. Her works are charged with emotions and constitute examples of meticulousness, delicacy and great attention to detail.

LVCIA ANGVISOLA

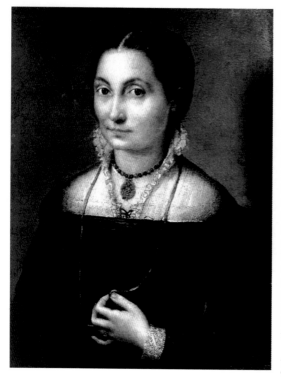

Bianca Ponzoni

(~1556)
oil on canvas
11 x 7.9 in (28 x 20 cm)
Galleria Borghese, Rome

There is a cloth glued to the back of this painting stating: SUPHONISBA CREMONENSIS ET NOBILI FAMILIA ANGUSCIOLA PINXIT ANNO MDLVI. The problem is that the inscription is not from the 16th century, giving rise to doubts as to the certainty of that information. Some historians believe the work to be Sofonisba's, as was traditionally believed. From its style, though, others believe it to be Lucia's. In fact, as Gilardi remarks, the position of the hand playing with the necklace is identical to Lucia's self-portrait.

There is also disagreement as to the identity of the sitter. Some believe it is Sofonisba before she left for the Spanish royal court, an opinion that is difficult to accept since the woman in this portrait is older, and Sofonisba was young at that time, and because the physical features do not coincide with the many self-portraits executed by Sofonisba. Through them, for example, it is known that she had light-colored, slightly bulging eyes and that her lips were somewhat fleshy. The lady in this portrait has dark, almond-shaped eyes and thin lips. As indicated by Maria Kusche, the sitter is most likely Bianca Ponzoni, Lucia's mother. Indeed, the portrait of her mother presently in Berlin is extraordinarily similar to the lady in this canvas. The portrait has a green background, a common color for Lucia, as can be seen in her self-portrait, the portrait of Pietro Manna, and the tondo of Europa. There is a delightful chromatic interplay between the black dress, the white lace shirt, and the woman's dark hair. As was habitual, the gesture of the hand breaks the hieratic attitude of the woman, who is wearing a necklace with a luxurious pendant. The face is not evenly lit, but rather sprinkled with a light that lends it volume and vivacity. It is a profound, superb portrait.

Right: This painting is one of Lucia's most important works, and on the armrest of the chair is the inscription LUCIA ANGUISSOLA AMILCARIS F. ADOLESCENS F. At first, the figure in the painting was identified as Dr. Pietro Maria, as indicated by Giorgio Vasari in 1566 when he visited Lucia's father, Amilcare Anguissola, in his home in Cremona. Later, the hypothesis arose that it was Lucia's maternal grandfather, in other words, Bianca Ponzoni's father. Nevertheless, the latest research shows that this figure resembles the portrait in a medallion of a famous doctor from Cremona, Pietro Manna.

This work is included in the 1686 inventory of the Alcázar Palace in Madrid. In the 18th century, after the palace burned down in 1734, the canvas was moved to the collection of Charles III in the Buen Retiro Palace. Vasari states that this work "is so well executed that it could not be improved upon." The agreement of art historians on its excellence is unanimous.

Lucia renders a doctor dressed in a rich blue toga lined with furs, lending the figure great majesty. His gaze is sharp, intelligent, profound, and not lacking in generosity. The psychological rendering of the figure is remarkable. The doctor pays homage to his profession through the two books in the background, probably treatises on medicine. In his right hand he is holding a stick around which a snake is entwined, the true symbol of the god of medicine, Asklepios, the son of Apollo and Coronis, who became known as Aesculapius to the Romans. This god of medicine was traditionally represented as a mature man with a beard holding a cane with a snaked entwined around it. In this case, according to Alexander Wied, the serpent is a *coluber viridiflavus*, a snake typical of Lombardy.

Europa

(~1556-1558)
oil on wood
5.7 in (14.5 cm) in diameter
Pinacoteca Tosio Martinengo,
Brescia

There is much contention as to
the identity of the sitter in this
painting. Some believe it could
be Minerva, another one of the
artist's sisters. The problem is
that the approximate dates of
birth of Europa and Minerva put
forth by art historians do not coin-
cide. On the back of the painting, an
old note is adhered reading EUROPA A
LUCIA SORORE PICT (...) (AMILCARIS ANGUI(S)SOLA
F.F.?). In any case, we have used the cata-
logue published in 1995 for the exhibit in Vienna
on Sofonisba and her sisters as a reference. Unless fur-
ther documents are discovered, the sitter's identity will remain uncertain. Insofar as the authorship,
the stylistic characteristics indicate that Lucia painted it. This panel represents a girl with a sweet
aspect, an intense and tender gaze, wearing a dark outfit with wide sleeves contrasting with the
white shirt emphasizing her neck. She is wearing two gold chains and a pink ribbon in her hair, rein-
forcing her youthful and feminine air.

Europa, whose name denotes her father's humanist tastes, was also a painter. Giorgio Vasari
referred to Europa in 1568 as: "all grace and virtue, she is inferior neither to Sofonisba nor to Lucia,
neither in drawing nor in painting." He wrote that she executed many portraits with sitters in
Cremona, of illustrious people as
well as one of her mother,
Bianca Ponzoni, which was sent
to the Spanish royal court.
Baldinucci (1681) adds that,
from a very early age, she was
an extraordinary draftsman, and
that she executed two panels—
one of Saint Francis and the
other of Saint Andrew, both at
the Church of Santa Elena in
Cremona. She married a noble-
man from that city named Carlo
Schinchinello, Lord of
Casalbuttano, and documents
state that she died on January
18, 1578.

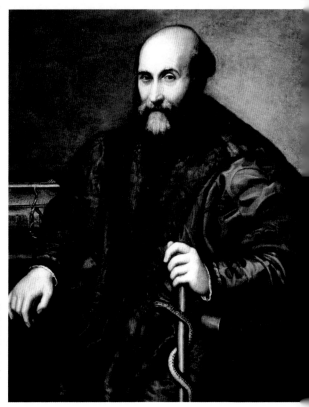

Pietro Manna

(~1557)
oil on canvas
37 x 30 in (95 x 76 cm)
Museo del Prado, Madrid

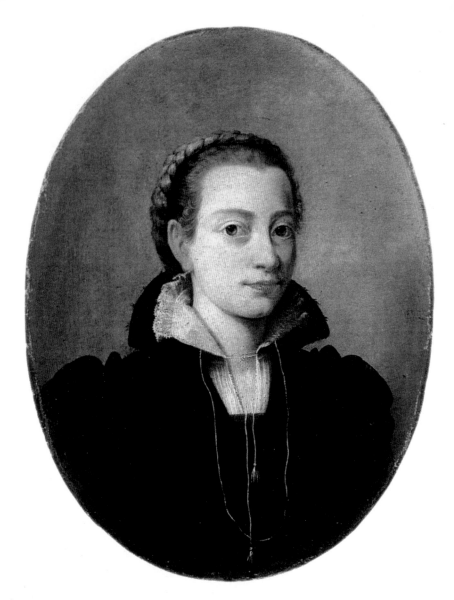

Minerva

(~1558-1560)
oil on canvas
17.6 x 13.5 in
(44.8 x 34.2 cm)
Museo Poldi Pezzoli, Milan

It was originally believed that this painting was a self-portrait by Sofonisba, but recent studies have led to a change of opinion. Presently, the work is attributed to Lucia, and the sitter is most likely her sister Minerva. There is a portrait at the Pinacoteca di Brera by Sofonisba of Minerva. If we compare the two paintings, it is clear that the sitter is the same person, though this cannot be proven.

Minerva was the fourth daughter in the Anguissola family and was represented in three works by Sofonisba: *The Chess Game, Family Portrait,* and a portrait in which she is wearing two bracelets, a red coral necklace, and a pendant of the goddess Minerva (Museum of Art, Milwaukee). Minerva was a painter, but she also wrote. Filippo Baldinucci (1681) stated that she was an excellent writer, both in Latin and in the common language, but that she died in the flower of her youth.

The composition of this portrait shows a great affinity with the tondo of the young Europa. Like the portrait of the women's mother, this one is somber, though the background is ochre instead of the dark green Lucia usually employed. The light is diaphanous and the brushstrokes are evocative and subtle, especially in the lace on the shirt and the fine white strings against the dark dress. With its light background, this portrait emanates warmth.

LAVINIA FONTANA

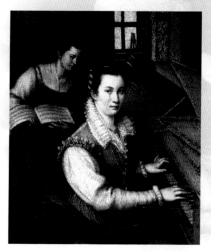

Self-Portrait dated 1577.
The artist is playing the clavichord.

- **1552** Baptized on August 24 in Bologna, her birthplace. She is the daughter of the renowned Italian painter Prospero Fontana.

- **1570** Begins to develop a solid reputation in the field of portraiture.

- **1575** Executes her first engravings and small paintings for private collections.

- **1577** Marries Gian Paolo Zappi, a student of her father. Shortly thereafter, he leaves his artistic career to help his wife in her studio and to raise the 11 children they would have, of whom only 3 lived longer than their mother.

- **1584** Receives the commission to paint *Assumption of the Virgin with Saints Peter Crisólogo and Cassiano.*

- **1590** Focuses on religious scenes and paints a series of altarpieces, including *The Holy Family with Jesus Sleeping and Saint John the Baptist* (Monastery of El Escorial, Madrid).

- **1597** Her father dies.

- **1603** Accepts the invitation of Pope Clement VIII to move to Rome and become official painter of the pontifical court. There she paints one of her most famous works, *The Stoning of Saint Stephen Martyr*, an altarpiece for San Paolo fuori le Mura, one of the seven pilgrimage churches of Rome. The work was destroyed in a fire in 1823.

- **1614** Dies on August 11 in Rome, a year before her husband.

Trained and educated by her father, the painter Prospero Fontana, Lavinia Fontana took some time to develop her artistic talent. She did not gain a reputation as a portraitist until she was 20.

Influenced by and, in a sense, continuing the Florentine mannerist style of her father, she studied the masterpieces of Michelangelo, Raphael, Parmigianino, and Niccolò dell'Abbate, among others. Her sensibility with colors and the importance she lent to details were fundamental features of her art, characterized by an antiquated, uninnovative style from an artistic point of view, but within which she created her own distinctive style.

A fashionable portraitist in Bologna and Rome, the artist also executed biblical and mythological scenes, her compositions filled with both female and male figures, something unusual for women artists at that time, as it implied the study of nudes and their integration into her paintings.

Considered the first woman to have a normal, successful artistic career, a strange phenomenon until the latter 18th century, Lavinia Fontana deserves a distinguished place in any work on the role of women in art and history.

Her oeuvre is difficult to study, as a large part of it is lost, its whereabouts unknown, or it is in private collections that are rarely shown to the public. According to some experts, 135 works by the artist are extant, of which only 32 are signed and dated.

LAVI FON-F

Carlo Sigonio

(1578)
oil on canvas
Museo Civico, Modena

Fontana was principally distinguished for her portraiture. The fact that she was a woman and that Bologna, her native city, had no great specialists in that genre until the 16th century increased her importance and the general recognition she received. In portraiture, she was able to combine precision and a fine richness of detail with a respectful distance from her models that allowed her to render their psychology.

Painted only several months after her marriage, this canvas is an excellent example of Lavinia Fontana's work and demonstrates the artist's mastery of the genre. There are three particulars in this portrait that are important: the view of a bustling outdoor scene in the background, visible through an open door and indicating that Sigonio was involved in artistic, humanist, and university circles; the pose of the sitter's right hand, which, in addition to lending volume to the work, is a reference to the sitter's social dedication and service; and, no less important, Lavinia's interest in certain elements to describe the context of the sitter, manifest in the desk, pen, and inkwell, instruments that symbolized the important work in which this distinguished Bolognese scholar of Cicero was involved.

Right: The subject of Venus and Cupid appears several times in Fontana's works, the goddess always rendered with significant differences in each painting. This work is important because it represents a nude female body, something rather unusual in art at that time. Lavinia reveals her great ability to combine different aspects in a kaleidoscopic effect to define Venus. Hence, the intensely dark background that invades part of her anatomy helps to cover her nudity and increases the sense of mystery inherent to the goddess' erotic connotations. Her pose shows her attention and protective affection towards her son Cupid, but also allows her to generously exhibit her body, full of curves and emanating voluptuousness. Despite her evident maternal instinct, Venus seems unpreoccupied that the viewer should see her nudity, and her intimacy is only barely concealed by young Cupid, who covers his mother's pubic area with a cloth. The work, striking for its chiaroscuro, a combination of artistic technique and sensual intention, is a beautiful example of Lavinia Fontana's high quality art.

The Dead Christ with Symbols of the Passion

(1581)
oil and tempera on wood
14.3 x 10.6 in (36.2 x 27 cm)
Conell Fine Arts Museum
at Rollins College, Florida

Used as a private altar, this small painting describes the passion of Christ, one of the most widely represented biblical subjects in art. The culminating points of Jesus' martyrdom are the flagellation, the crowning of thorns, and the crucifixion, here symbolized by the whip and the crown of thorns at the bottom of the painting, and by the column on a diagonal to the right and the cross on the left. This work has a peculiar composition: The cross and the column form the sides of an imaginary triangle with Jesus in the center, his head inclined and partially hidden in the shadows, clear signs of his suffering. This work is the second version of the painting *Christ with the Symbols of His Passion* (Museo de Arte, El Paso, Texas, Kress Collection).

Venus and Cupid

(1585)
oil on canvas
Private collection

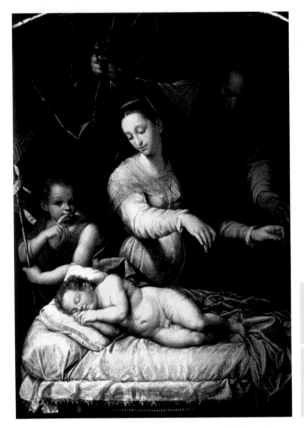

Holy Family with Jesus Sleeping and Saint John the Baptist

(1589)
oil on canvas
Monastery of El Escorial, Madrid

In the 16th century, people began to seek a type of religious figure more closely associated with humanity and more removed from the spiritual. This idea, which manifested itself in artistic disciplines as well as in other fields, grew rapidly and was particularly visible in painting. A good example is this work, in which Mary is not concentrating on thoughts such as redemption, nor is she profoundly linked to spirituality or mysticism. With a serene expression, she contemplates her child as any mother would. Another characteristic is the use of a dark background, so that the figures stand out as if they were beams of light, a characteristic that can be associated with a prelude to tenebrism and places us on the threshold of the baroque era.

The triangular composition focuses attention on the sleeping child and Mary, figures whose details are very thorough. The child and his bed are especially carefully rendered: There is a great deal of realism in the folds of the sheets and the silken texture of the bedspread, and the re-creation of the plump child's body is striking. For the precision of its structure, the sense of wholeness it reveals, and its triangular composition, this work recalls the style of Raphael, and one of his paintings in particular, *The Madonna of Loreto*, by which it seems Fontana was inspired for this work.

Right: At this time, Fontana held the post of official painter of the Pontificate of Rome, and she temporarily stopped executing large altarpieces and religious scenes to focus on more mundane subjects. Probably the fruit of a commission, this close-up of a child has nothing to do with the portraits for which the artist was renowned. The painting consists of the head of a child in the foreground and a plain, uniform background in a tone approaching the boy's complexion.

A striking feature is the androgynous beauty of the boy, with his childish, sincere gaze and meticulously executed curls. One of the characteristics of mannerism is that the protagonists appear in unnatural positions, such as the boy's twisted neck here. The work seems more like a preliminary study of a larger composition than a finished piece.

Venus and Cupid

(1592)
oil on canvas
Musée des Beaux-Arts,
Rouen

Mythological representations are a significant part of Fontana's oeuvre, and she painted scenes of Venus and Cupid on several occasions. In this one, the goddess appears in the same posture that the artist often used for portraits of members of the Italian nobility, with the body slightly turned to one side and the eyes gazing at the viewer. The artist used the technique of placing an arm before Venus's breast, which visually pushes the body back and provides volume, a technique often employed in the 15th and 16th centuries.

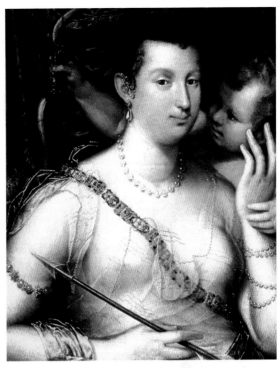

This canvas reveals the artist's mastery in rendering details (contrasts in the fabrics, as the smoothness of the silk, the transparency of the gauze, and so on) and small complementary items such as the jewelry (bracelet, necklace, earring) or the arrow Venus is holding in her right hand. Because of this gift for detail, Fontana has been compared to her predecessor Sofonisba Anguissola. The dark atmosphere of this painting is broken by the light that seems to emanate from both figures, which, along with Cupid's tender gaze at his mother, lends the work some warmth.

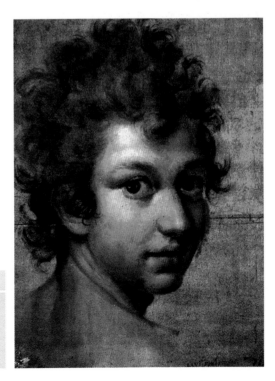

Head of a Boy

(1606)
tempera and watercolor
on paper
Galleria Borghese, Rome

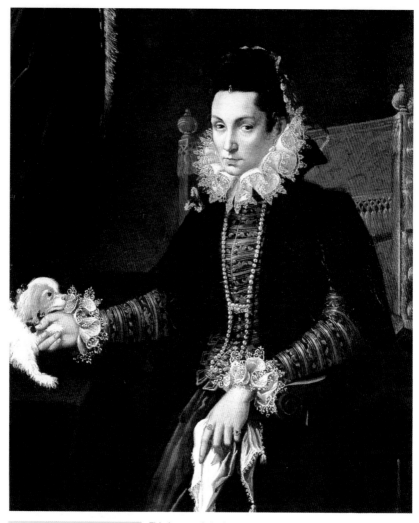

Woman with Lapdog

(~1600)
oil on canvas
Walters Art Gallery, Baltimore

This is one of the last portraits that Lavinia Fontana executed before dedicating herself nearly exclusively to large altarpieces and purely religious subjects. Completed toward the end of the 1590s, this painting shows an aristocrat against a nearly black background, standing three-quarters length, her body turned slightly to the right and looking toward the viewer. In her right hand she is holding the paw of a lapdog, while her left holds a lace handkerchief with ornamental tassels. Both the dog and the handkerchief are white, as are the lace cuffs and ruff collar, contrasting with the typically dark dress of the period.

The preceding description, although with some alterations, could be applied to portraits by other artists of the period and even to other paintings by the same artist, such as *Portrait of a Noblewoman*, from 1584, which is among her most important works. In all of them, the pose of the sitter and the colors employed are similar, which is not surprising, as they were standard options for these types of paintings.

What is striking here, apart from the obvious influence of Titian, is the meticulous attention to detail: the collar, the embroidery, the tassels on the curtains, the coiffure. This elegance is characteristic of Fontana, and she almost always used it to describe the social and cultural status of the sitter. Qualified at times as a "nutritional work"—that is, executed to make a living, although the results are professional—this canvas demonstrates an extremely important aspect: Fontana's skill in revealing the subjective and personal character of her protagonists. Here, the steadfast tranquility of the lady and her dignity and self-confidence are manifest in her expression.

BARBARA LONGHI

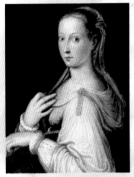

Saint Catherine of Alexandria, oil on canvas, 1590, Sant'Apollinare in Classe, Ravenna. This painting is considered a self-portrait.

Barbara Longhi was a precocious painter who lived her entire life in Ravenna, far from the important artistic centers of Italy. She trained in her father's studio and adopted his style during this time, distinguishing herself pictorially for her sensibility and melancholy. Both were provincial and dependent on the Schools of Rome and Bologna. Barbara Longhi probably had to copy works by her father as an exercise, like other artists of her time who neither had access to the academy nor to studies of human anatomy from models.

Her works reveal the influence of painters such as Correggio and Parmigianino, and of Roman engravers such as Marcantonio Raimondi and Agostino Veneziano. But the most profound influence she received was from Raphael, especially his Florentine period (1506-1508), when he was himself influenced by Leonardo da Vinci and Fra Bartolomeo. Assimilating these influences, Longhi developed her own style, characterized by the delicate modeling of figures and a refined chromatic sensibility. Her first works were simple compositions with a limited palette, with the line predominating over the modeling of forms and volume. In her mature period, her palette grew rich in tonal ranges and the colors became brilliant and smooth. The figures acquired a monumental character and the volumes, well modeled, were placed in architectural settings accompanied by dramatic drapery and background landscapes. During this period, she used the technique of sfumato and pyramidal compositions through the influence of Leonardo da Vinci. Beginning in 1600, she substituted the representations of entire figures for simple and pious images, focusing on the close relationship between the figure and the viewer.

Longhi's pictorial work reflects the religious and propagandistic ideas of the Counter-

- **1552** Born in Ravenna to a family of painters. She was the daughter of Lucca Longhi (1507-1580), a provincial mannerist painter, and became his student and assistant for numerous large-format altarpieces. Her brother, Francesco Longhi (1544-1620), was a painter and poet. She became a fundamental collaborator in her father's studio, though her fame never went beyond her native city.
- **1570** Particularly appreciated for her portraits, she paints that of Mónaco Camaldonese (Galleria dell'Accademia, Ravenna), which is the only extant work signed by the artist and the only one to represent a male figure, with a clear Raphaelesque influence. The years 1570 to 1590 can be considered the artist's period of stylistic development, during which she simplifies compositions, limits the modeling of forms, and places emphasis on the linearity of the drawing. Her most important works from this period are *Virgin with Sleeping Child* (1570), *The Virgin of the Baldaquin* (1570-1573), and *The Virgin Reading* (1570-1575), all at the Pinacoteca de Ravenna, and *Virgin and Child with Saint John the Baptist* (1589-1590, private collection). During this time, like other female painters such as Artemisia Gentileschi, Elisabetta Sirani, and Fede Galicia, Longhi paints the subject of Judith holding Holofernes's head.
- **1590-1595** These years are regarded as the artist's mature period, as there are no later works attributed to her. Her works become more complex, often including a column with drapes and background landscapes. The figures acquire monumentality, the colors gain brilliance, and devotional elements are added to the lyrical treatment of scenes. Works from this period include *Virgin and Child with Saint Agatha and Saint Catherine* (1590-95, Pinacoteca de Ravenna), *The Healing of Saint Agatha* (1595), executed for the church of San Vitale in Ravenna, presently Santa Maria Maggiore de Ravenna, and *Mystic Nuptials of Saint Catherine with Saint John the Baptist* (1600, Museo Biblioteca, Bassano del Grappa).
- **1638** Dies in Ravenna. Fifteen known works are attributed to her, among which 12 are small compositions of the Virgin with Child created for private collections.

Reformation and the subsequent period, according to which religious images had to be simple and represented in domestic and intimate settings to elicit the viewer's devotion.

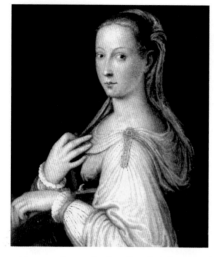

Saint Catherine of Alexandria

(1590)
oil on canvas
Sant'Apollinare in Classe,
Ravenna

This work can be ascribed within the artist's first stylistic period, which lasted from 1570 to 1590 and was characterized by simple compositions with a reduced palette. The value of the line and the drawing are more important than the modeling of forms, and they lend the scenes a lyric, intimate treatment. The saint is rendered with her traditional attribute, the wheel on which she was tortured when she refused to renounce her faith. Her figure, painted in warm tones, stands out against the smooth black background with no concrete spatial references. The saint's long hair mingles with the cascade of linear folds in her clothes.

Her hand gesture and her fixed gaze, directed at the viewer, give rise to the conjecture that this is a self-portrait. Images of female artists were as rare as written references. With the exception of the occasional appearance of a woman in works personifying allegories, it was the artists themselves who had to leave evidence of their existence through self-portraits. They proliferated as time went on throughout the century, as women began gaining an awareness of their identity.

The Virgin and Child

(1598-1600)
oil on canvas
34.8 x 30 in (88.5 x 71 cm)
Pinacoteca de Ravenna

This work, from the artist's mature period, represents the culmination of her style: a pyramidal composition centering the family scene within the painting in the manner of Raphael; a soft, delicate modeling of the children's bodies; the sfumato technique in the treatment of the background landscape, in the style of Leonardo da Vinci, lending the impression of depth; and the use of the draped column as a framing element in the manner of Correggio and Parmigianino.

The devotional intention of the work reflects the ideals of the Counter- and Post-Reformation period. The Virgin is depicted as a young woman, delicate and maternal, embracing the two boys tenderly. Her earthly nature is emphasized by her monumental presence and the terseness of her body. The artist employed iconographic elements such as the cross held by John the Baptist, a symbol announcing the coming of the Messiah and his fateful destiny. During this historical period, it was forbidden to represent sacred figures nude, so that Madonnas, as in this work, only partially reveal a breast. The union of femininity and maternity is characteristic of the artist's mature period, showing all of the artist's talent and mastery in the treatment of color. The forms are modeled delicately, particularly on the face and neck of the Virgin. The shortcomings arising from women's lack of opportunities to study the nude from models are evident in the anatomy of the boys' bodies and their positions. Longhi painted another work with the same subject. In both, she shows an assimilation of the predominant styles of the 16th century.

In the 16th century in Italy, the repertoire of genres in painting consisted of portraits, religious scenes, and historical scenes. Women artists of this time limited themselves to genres in which they could be sure of success instead of venturing into those for which they had not received adequate training. Furthermore, women were not admitted to academies, nor were they allowed the opportunity to study the nude, much less so the male nude. As a result, many of them specialized in religious portraiture, especially representations of the Virgin and Child. It was not that they lacked ambition; rather, they grasped the realities of the artistic world. An

The Virgin and Child Crowning a Saint

(1590-1595)
oil on canvas
12.8 x 15.4 in
(32.5 x 39 cm)
Musée du Louvre, Paris

example of this specialization is Barbara Longhi, twelve of whose fifteen attributed works are on this subject. This work, belonging to her mature period (1590-1605), is a typical scene created to meet the demands of the Counter-Reformation and the period immediately thereafter, in which religious figures had to be represented in a domestic, intimate atmosphere familiar to the viewer.

The three figures are set within an architectural framework with a column and drapery, and a landscape in the background. The seated Virgin, slightly turned to the side and gazing downward, tenderly holds her son on her knees while he crowns a saint. A prime element of the painting is the Virgin and Child, and another is the kneeling saint, who lends the work a devotional character. The artist's stylistic features are evident in the Virgin's monumentality and volume, and in the soft modeling of her face, hands, and neck. Despite its delicacy, the boy's body reveals the shortcomings in drawing typical of female artists of that time. The legs resemble those of an adolescent rather than a child. Nevertheless, the work evinces serenity and subtlety. The refined and brilliant tones in the figures' clothing contrast with the dark treatment of the saint.

Longhi's patrons are unknown, and the identification of the saints she represented is often speculation. In this case, the saint's Franciscan habit would indicate that she is Elisabeth of Hungary, who belonged to that order. Barbara Longhi was not an innovative artist. She knew of the works of leading artists from the important artistic centers of Italy only through her father, who in turn was a provincial artist. Nevertheless, her works emanate gracefulness and subtlety, and they deserved to be recognized as outstanding examples of their time.

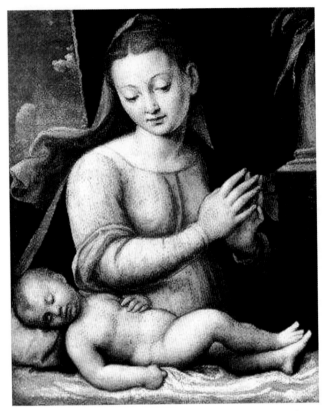

The Virgin with Sleeping Child

(1600-1605)
oil on canvas
Walters Art Gallery,
Baltimore

This may be one of the artist's most devout works, and it is one of the last that she was known to have executed in this genre. The figures are placed in an interior limited by a draped column and a window that reveals a background of sky and clouds. The Virgin emotionally contemplates her sleeping son, whose slumber is also a foreboding of his death. The composition bears a certain reminiscence to works by Bellini and Lavinia Fontana, but Longhi eliminates Bellini's classicism and Fontana's elaborate mannerism in order to focus on the intimate and spiritual relationship between the Virgin and the viewer, who simultaneously worship the child. The monumentality of forms, especially in the figure of the Virgin, lend this extremely mystical work a serene air. Longhi renders the Virgin as a tender, devout mother who is familiar to the viewer. The palette contains a subtle chromatic richness, and the modeling of the face and neck of the mother is particularly striking. The dress is slightly low-cut, as required by the standards of the time for representing religious figures.

Women artists of that time did not use models, hence their representations of figures often lacked credibility, corresponding to accepted conventions rather than to a real study from nature. This is evident in the Child's body: Though he is sleeping, his legs are crossed, a physiologically unlikely position more appropriate to an adult.

The 16th century was a period of artistic revolution, but it was not manifested in the same way by men as by women. The male revolution was related to new ideas on art, especially in drawing from models and nature, mathematical knowledge related to the new science of perspective, rivalry with the great artists of the past, and particularly in the appearance of the concept of genius and creativity. Women's training remained outside the margins of these innovations. First, to be acceptable like painters, they had to train and practice until they attained the same level as their colleagues.

In this painting, the artist lends the work a sense of depth through the background elements, such as the column with drapery behind the figures and the window with a view of the sky. Leonardo da Vinci's sfumato technique, consisting of blending the landscape in the background to create a sense of distance and spatial depth, was frequently used by the artist in her mature period.

FEDE GALIZIA

Judith Holding Holofernes' Head *(detail)*, oil on canvas, 21.7 x 16.5 in (55 x 42 cm), 1596, John and Mable Ringling Museum of Art, Sarasota, Florida. This painting is considered a self-portrait.

- **1578** Born in Milan. Her birth date is extrapolated from an inscription on her portrait of *Paolo Morigia*, stating that she was 18 years old in 1596.

- **1590** Thanks to her work, mainly as a portraitist, Galizia begins to gain recognition in artistic circles.

- **1596** Already famous as a portraitist and religious painter, she gains a certain degree of international recognition. She completes *Paolo Morigia* and *Judith Holding Holofernes' Head*, two of her most renowned works.

- **1602** Completes a still life, which she signs (Anholt Collection, Amsterdam). It is considered the first still life executed by an Italian artist.

- **1616** Paints *Noli Me Tangere*, commissioned for the Mary Magdalene altarpiece in the church of Santo Stefano in Milan.

- **1621** At approximately this time, her father, who presumably instructed her in art, dies.

- **1630** She dies in Milan, shortly after an epidemic that affected a large part of Italy.

The daughter and student of Nunzio Galizia, a painter and miniaturist from Trent, Fede Gallizi, better known as Galizia, began her artistic career with portraits and religious scenes. But she excelled especially in still lifes, a genre in which she was a pioneer.

Born in Milan, Fede Galizia showed ability for painting from an early age. Giovanni Paolo Lomazzo, a painter, art theorist, and friend of her father, recorded this fact, affirming in one of his works: "This girl dedicates herself to imitating our most extraordinary artists."

By the time she reached her sixteenth birthday, the artist had already gained a reputation as a portraitist, with a style derived from the naturalist traditions of the Italian Renaissance and the influence of artists such as Moretto da Brescia, Giovanni Battista Moroni, and Lorenzo Lotto.

But the most important part of her oeuvre, the part for which Fede Galizia earned her place in art history, were her still lifes. Yet her paintings were not given the recognition they deserved until well into the 20th century, when specialists such as Stefano Bottari in 1963-1965 and Flavio Caroli in 1989 discovered them and rescued them from oblivion. A still life by Fede Galizia from 1602 (Anholt Collection, Amsterdam) is the first dated still life painted by an Italian artist.

Flavio Caroli, a specialist on the Milanese artist, has catalogued sixty-three works as the artist's extant oeuvre, of which forty-four are still lifes. In the remainder of her work, consisting fundamentally of altarpieces and other religious scenes, Fede Galizia shows a style related to the Lombard mannerism of the latter 16th century, based in Mantua, and renowned internationally, especially in France, where two of its foremost representatives, Francesco Primaticio and Fiorentino Rosso, created the School of Fontainebleau.

Inscription appearing in the top photograph on page 63, of the work Paolo Morgue, which establishes the painter's date of birth.

FIDES GALLICIA VIRGO PVDICISS·ÆTAT·SVÆ ANN·XVIII OPVS HOC.
·PAVLI MORIGII SIMVLACRVM, ANN·7Z GRATI ANIMI ERGO EFFINXIT
ANNO 1596

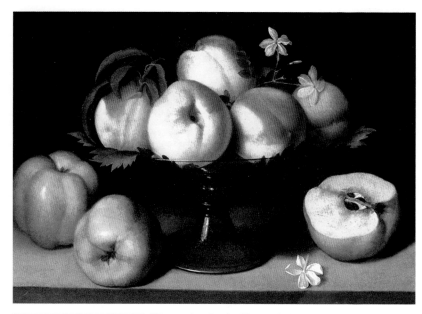

Glass Bowl with Peaches and Apples

(~1595)
oil on wood
French & Company Gallery, New York

Women played a significant role in the European still life during the first half of the 17th century. Fede Galizia in Italy and Clara Peeters in the Netherlands significantly influenced the development of the genre, which was considered secondary at the time. Compositions were frequently repeated with slight variations in Fede Galizia's work, a common tendency in the first decades of the 17th century. It allowed artists the opportunity to perfect their technique and experiment with a single subject by introducing slight differences.

This work represents a glass bowl containing peaches, with some green apples next to it, one cut in half. Jasmine was added as a complement to the scene. There are several known versions and replicas of this work with slight variations: a replica that was sold in Paris in 1960; a version in a private collection in Bassano; another replica similar to the former but smaller (Silvano Lodi Collection, Campione); a signed version with no flowers on the table (Museo Cívico Ala Ponzone, Cremona); and another version in which a flower was substituted by a grasshopper and some yellowish quinces take the place of the apples (Silvano Lodi Collection). The specialists Mauro Natale and Alessandro Morandotti attributed many of these versions and replicas to Panfilo Nuvolone, a contemporary and follower of Galizia's. In any case, this work, as with the majority of still lifes by Fede Galizia, is a frontal, symmetrical composition distinguished by its simplicity and austerity of design—features for which she has been frequently compared with the Spanish painter Francisco de Zurbarán.

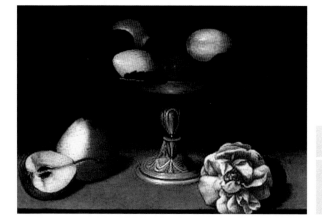

Bowl with Plums, Pears, and a Rose

oil on wood
Private collection

Judith Holding
Holofernes' Head

(1596)
oil on canvas
21.7 x 16.5 in
(55 x 42 cm)
John and Mable
Ringling Museum of
Art, Sarasota, Florida

The subject matter of this painting, the biblical story of Judith and Holofernes, is taken from the Book of Judith. The story recounts how the Assyrian king Nebuchadrezzar (7th century B.C.), sent a powerful army under the command of General Holofernes to conquer the land of the Hebrews. The army surrounded the city of Betulia, which resisted the siege until, when the city was on the verge of capitulating, the beautiful widow Judith devised a plan to kill Holofernes. With skillful deception, Judith managed to seduce the general, get him drunk, and decapitate him, becoming the great heroine of her people.

Botticelli, Giorgione, Andrea Mantegna, Michelangelo, and Correggio, to name only a few, painted this episode, but perhaps the most famous painting on this subject is that of Caravaggio. The extreme violence of his Judith and Holofernes made it the center of a scandal when it was shown in public.

By contrast, Galizia's work celebrates the victory of faith in the face of the enemy. It reflects the power of the female weapons of seduction, fully capable of victory even in the cruelest battles. The heroine and her victory, here represented by Holofernes' head, are the obvious protagonists of the canvas. Galizia makes only the figure of Judith stand out, as she occupies the entire central area of the composition, with a serene gaze and a proud pose, turned slightly to the left. The depth reinforces her protagonism: The heroine is painted in bright tones against a middle ground and background that are much darker. The elaborate brushstrokes, the detail in the garments, and the meticulous coloring of the work, among other aspects, recall the most realistically oriented style of Renaissance painting, a style in vogue at the time this painting was executed. There is a signed version of this painting in Rome dated 1601, five years after this one was completed.

Left: This is another example of Galizia's still lifes. The fondness for botany that she had demonstrated since childhood and the elegance of her art are evident in this work, which reveals great skill and excellent technique. One of the most outstanding features is the unity. Galizia superbly combines the elements of this still life (the bowl and fruit) with the background, giving the entire painting a unique atmosphere. This unity is also manifest in the chromatic harmony achieved by the artist. Considering the restricted subjects to which female artists were relegated, it is not surprising that many of them, upon concentrating on specific motifs, should reach the level of perfection evident in this work.

FIDES GALLICIA VIRGO PVDICISS ÆTATESVE ANN XVIII OPVS HOC.
T:PVLI MORION SIMVLACRVM, ANN·72 GRATI ANIMI ERGO EFFINXIT
ANNO 1596

Still Life with Peaches

(1600-1605)
oil on canvas
Silvano Lodi Collection
Campione, Italy

During the Renaissance, admiration for the works of classical antiquity, along with the revival of realist art, gave way to the reappearance of the still life. The oeuvre of Fede Galizia is striking for the large number of still lifes she executed. This one represents a white ceramic fruit bowl with several peaches against a black background. The artist shows a great interest in symmetry: The peaches, apparently lying in the fruit bowl in a haphazard manner, were actually placed in studied positions so as to achieve a harmonious and balanced effect. Playing a secondary role, several plums on the table complete the frontal composition. The light seems to emanate from the peaches and lends them a fresh, juicy aspect and a great deal of color. The perfect blending of colors and the finesse of the treatment of the surface place this still life in a distinguished position among the artist's repertoire.

Paolo Morigia

(1596)
oil on canvas
34.6 x 31.1 in
(88 x 79 cm)
Ambrosiana, Milan

Judith Holding Holofernes' Head and *Paolo Morigia* are the oldest extant works painted by Fede Galizia. Holding an important position among the congregation of Jesuits, Paolo Morigia (1525-1604) was a multifaceted ecclesiastic who, among other things, studied the origins of religious orders and wrote short biographies of the Milanese nobility (*La nobiltà di Milano*, 1595). He was also one of the most distinguished admirers of Fede Galizia's art, which he lauded in several of his writings, some of which (two poems that Morigia dedicated to Galizia in the years 1605 and 1609) were published by Bottari in 1965. In this painting, Paolo Morigia is approximately 70 years old. He is gazing at the viewer with his body turned slightly, holding a lorgnette in his left hand and writing with his right. Important elements are the books among which the figure is portrayed, his use of the pen, and the fact that he is seated at a desk, a setting that illustrates the subject's life and his profound interest in knowledge and studies.

Other interesting factors are the position of Morigia's hands in front of his body, creating a natural effect of depth, and the nearly black background, devoid of details, forcing the viewer to concentrate solely on the figure and his work. Many experts believe that this painting was influenced by Giovanni Battista Moroni (1525-1578), an artist who was considered one of the masters of naturalist painting and whose portraits are characterized by their fidelity to the model. The inscription along the top allows Fede Galizia's birth date to be established.

Ceramic Fruit Bowl with Grapes, Plums, and Pears

oil on wood
8.7 x 13.8 in (22 x 35 cm)
Silvano Lodi Collection,
Campione, Italy

Fede Galizia's specialization in the still life increased during the course of the 17th century. The majority of her still lifes are symmetrical compositions in which a fruit bowl, vase, or pitcher holds various pieces of a single type of fruit. Around this central group of fruit, there is almost always a different type of fruit, meticulously placed, and often a flower or an insect to provide contrast. In this work, however, pears and plums are indistinctly mixed with the grape bunches in search of a compositional harmony that appears casual. As in nearly all of Galizia's still lifes, depth is achieved by placing other fruit behind the principal ones and gradually diminishing the light.

Noli Me Tangere

(1616)
oil on wood
Santa Maria
Magdalena Altarpiece
Church of Santo Stefano,
Milan

Although it was commissioned, this *Noli Me Tangere* is one of Galizia's most personal works. Executed as part of the altarpiece of Saint Mary Magdalene in the Church of Santo Stefano in Milan, the artist's native city, this painting established her reputation as a painter of religious works. From the artist's mature period, this composition represents a Biblical scene, an episode rendered on innumerable occasions (by Giotto, Fra Angelico, Titian, Giovanni Battista Franco, Agnolo Bronzino, Maurice Denis, and many more), extracted from the gospel according to John (20:17). *"Noli me tangere"* can be translated as "Don't touch me" or "Let me go" and the biblical text continues with "as I have not yet risen to the Father." The painting refers to the respectful tradition of not touching sacred things and evokes a moment in time after the resurrection of Christ. Mary Magdalene visits the tomb, but does not find Jesus' body there. After she has asked some guardian angels where he is, the resurrected Jesus appears before her. It is dusk, excellently rendered by Galizia through a pallid light and the yellowish sky in the background.

The most esteemed *Noli Me Tangere* in the history of art was probably that by Correggio, executed about 1525, with which Fede Galizia must have been familiar and which she may have used as a model for this one. The pyramidal composition, characteristic of the classical Renaissance, and the marked diagonal line, a feature that presages the baroque, are factors that are present in both the work by Correggio and this painting by Galizia, with slight differences. Approximately fifteen years later, in 1640, Alonso Cano painted a *Noli Me Tangere* very similar to Galizia's.

ARTEMISIA GENTILESCHI

Self-Portrait *(detail), oil on canvas, 38 x 29 in (97.4 x 74 cm), 1630, Kensington Palace, London. Collection of Her Majesty the Queen.*

From a very early age, Artemisia began to display her artistic talent. Her father, Orazio Lomi Gentileschi, ignoring the conventions of the day, which forbade women from working in a profession, took her on as his assistant. The young woman's training in her father's workshop was ended following a period in which her art teacher, one of her father's friends, repeatedly raped her—an experience that had a lasting effect on her life and work.

Her oeuvre combines realism and academic traditionalism with subjects that display ex-tremely human expressions. Her painting is markedly influenced by Caravaggio, from whom she embraced certain motifs and a passion for the chiaroscuro in order to heighten the expressiveness of her subject matter and achieve a dynamism through the interplay of light and shadows.

Artemisia Gentileschi was one of the first women to become a professional painter. Even her family disapproved of her artistic ambitions, but her father negotiated a marriage contract with a young Florentine that would allow her to continue working. The culture of the day strictly forbade woman from certain professions. Gentileschi, one of the first examples of dissatisfaction with and rebellion against this restriction, became a supporter of women's rights.

- **1593** Born in Rome on July 8 to the painter Orazio Lomi Gentileschi, in whose studio she begins to study painting.
- **1610** Paints her first work, *Susanna and the Elders.*
- **1611** Gentileschi's father asks his friend Agostino Tassi to teach her daughter perspective. During the lessons, Tassi sexually abuses her repeatedly and tries to buy her silence with a promise to marry her.
- **1612** Tired of constantly being raped by Tassi and of his failure to fulfill his promises of marriage, she takes him to court. During the trial, she is subjected to various humiliating medical examinations and interrogatories with the excuse of proving the veracity of her accusations, all of which marks her profoundly for the rest of her life. In November she marries the Florentine artist Pierantonio di Vicenzo Stiattesi and moves to Florence to live with her husband.
- **1616** Becomes a member of the Accademia del Disegno. She is the first woman to achieve this.
- **1617** Separates from her husband.
- **1620** Moves to Tuscany with her daughter, Prudenza.
- **1621** Paints a series of frescoes for the Galleria Buonarroti in Florence. Throughout this period, she begins to develop a unique style, extremely influenced by the traumas of the sexual abuse to which she was subjected and the ensuing trial. She shows a predilection for biblical scenes, especially those that include women heroines who confront powerful and domineering men. Hence, she frequently paints scenes of Judith and Holofernes, Susanna and the Elders, and other heroines. She returns to Rome and lives with her sister and two maids. From there she travels to Genoa and Venice to execute various commissions.
- **1622** Meets Antoon Van Dyck.
- **1630** Travels to Naples, where she stays for two years undertaking many commissions. There, with her singular style, she paints works of a religious nature (*The Annuciation,* Museo del Prado, Madrid).
- **1636** Paints *The Adoration of the Magi* (Catedral de Pozzuelo).
- **1637** Short of money, she looks for new patrons.
- **1638** Together with her father, she travels to England, where she executes a number of portraits in the court of Charles I.
- **1641** Returns to Naples, where she remains until her death.
- **1653** Dies in Naples. Cruel graffiti is painted on her tomb, accusing her of nymphomania and adultery.

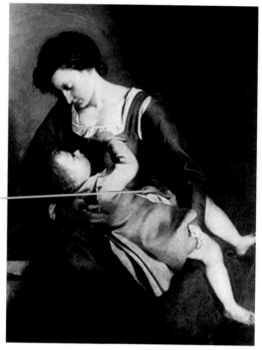

Madonna and Child

(1609)
oil on canvas
Galleria Spada, Rome

Gentileschi painted this work at the age of just 16, after watching her father paint a commission on the same theme. This work, unlike the rigid expressions and unnatural bodies so frequent in 17th-century Italian painting, renders the subjects in a highly natural manner, in a pose that underscores the bond between mother and child. The intimacy between the two subjects, as the mother appears to be about to feed her child, gives way to a very innovative scene. The mother holds her son while he observes her and places his hand on her breast in a gesture of sensibility nonexistent in European baroque painting—which says much about the painter's powers of observation and the qualities she brought to her work. Later, when her condition as a woman artist caused her many problems, Gentileschi painted subjects that her male peers normally overlooked or painted in a less tender and natural way.

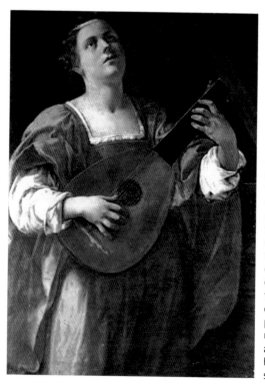

Lute Player

(1610)
oil on canvas
Galleria Spada, Rome

The woman is presented playing the lute under faint zenithal lighting that creates a chiaroscuro effect very much in the manner of Caravaggio. Through the illumination of the model's forms, Gentileschi develops an interplay of light and shadow that creates the work's realism. The expression of the woman's face, her eyes directed upward in a spiritual gesture, contrasts with the painter's concern for rendering scenes in which the subject's gestures and expressions are devoid of all mysticism and moral import. The figure takes up almost the entire surface of the canvas, in the manner of a portrait. The composition and the use of very somber and dull tones are characteristic features of the baroque style that Gentileschi had seen firsthand in Rome.

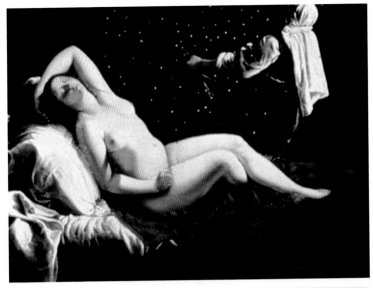

According to Greek mythology, Danaë was the daughter of Acrisius, king of Argos. When Acrisius learned through a dream that his grandson would dethrone him and assassinate him, he locked his daughter in a heavily guarded tower, so that she would never bear a child. Thus he thought he had avoided his fate. But Zeus fell in love with Danaë and, in order to possess her, he turned himself into a golden rain, which fell on the heroine—and so Danaë gave birth to Perseus. Still trying to stop the prophecy, Acrisius locked mother and baby in a trunk, which he dumped into the sea. The waves took it to the shores of the island of Serif, where they saved themselves. Years later, Perseus fulfilled the prophecy of the oracle.

Danaë

(~1612)
oil on canvas
16 x 20.7 in
(40.5 x 52.5 cm)
St. Louis Art Museum,
Missouri

This episode, so frequently represented in painting, is rendered by Gentileschi in keeping with her other work. She depicts Danaë completely nude, exhibiting her powerful anatomy bursting with sensuality. The somewhat mannered pose brings out her body's female attributes and enhances its attractiveness, as well as reflecting on canvas a scene of highly charged eroticism, passion, and desire. The way in which the golden rain is rendered recalls a starry sky, with sparkles falling softly like snowflakes over the body of Danaë. The perplexed servant, in a natural and spontaneous reaction, spreads her apron in an attempt to capture the luminous pearls.

From a compositional standpoint, the work has been devised so as to divide the scene diagonally, from the top left corner to the bottom right corner. The lower half of the canvas is taken up by the figure of Danaë, whose recumbent body is illuminated with an intense source of lighting. She is perfectly modeled with a subtle interplay of light and shadows. The painting is permeated by an irrepressible passion, accentuated by the red velvety drapery, executed with multiple folds, on which she reclines.

The artist's use of chiaroscuro highlights the heroine still further by contrasting her body with the deep dark background against which the sparkles of golden rain acquire additional luminosity. With the composition, the figure's pose, and the treatment of the light and color, the painter achieves a work of outstanding drama. In this and in her other works, Gentileschi renders her subjects with noteworthy force, underscored by a painstakingly studied backdrop, and so creates scenes of great solemnity and forcefulness.

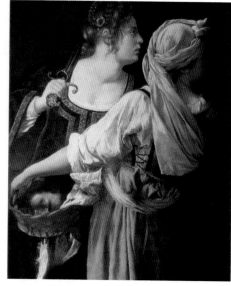

Judith and Her Maidservant

(1613-1614)
oil on canvas
44.9 x 36.7 in (114 x 93 cm)
Palazzo Pitti, Florence

Gentileschi always identified with the biblical story of Judith and Holofernes, and she painted the tale on numerous occasions. She first depicted the heroine shortly after she had been raped by Agostino Tassi, a friend of her father and her teacher of perspective.

In the works containing this subject matter, the artist presents Judith as a woman of strong character who, with the help of a servant, frees her people by killing Holofernes. In these works, the placement of Judith together with her servant on the same compositive plane indicates less the artist's desire to idealize her heroine than to vindicate the woman's role. She is saying that women's might is able to overwhelm male supremacy.

This scene, which depicts the moment just after to the decapitation of Holofernes, is treated with the utmost realism and tension. The drama is underscored by the expressions on the faces of the two women, who are oblivious to the spectator.

Gentileschi implies the danger through gestures. She portrays Judith, caught by surprise, as she turns her head toward a point outside the confines of the composition. The significance of Judith's expression and the gestures of the subjects are also reflected in their movement and in the drape of their clothing. The artist makes use of chiaroscuro to emphasize the shadows and the movement of the fabric, thus adding emotion and gravity to her painting.

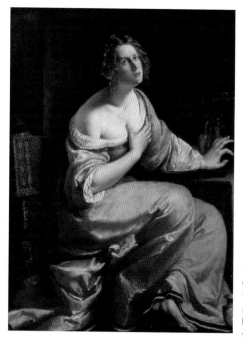

The Penitent Magdalene

(~1618)
oil on canvas
62.5 x 49.4 in
(158.8 x 125.5 cm)
Galleria degli Uffizi, Florence

This painting, one of the last that Gentileschi executed in Florence, shows a sensual and inviting Mary Magdalene in a splendid golden dress. According to tradition, Mary Magdalene was a prostitute who, after meeting Jesus, gave up her profession in order to follow him. Her expression and gesture, with her hand placed over her breast, appear to indicate the moment in which she makes the final decision to abandon prostitution. The contrast between the sumptuous dress and her pale face reinforces the solemnity. The chiaroscuro, so recurrent in the works of Gentileschi, is combined with the intense light that falls on the body. The golden sheen of the dress dims in comparison with the brightness of the flesh, in an exaltation of the values of a person who has risen above worldly goods. The artist's father taught her the importance of color, which she employed very sagaciously in all her works.

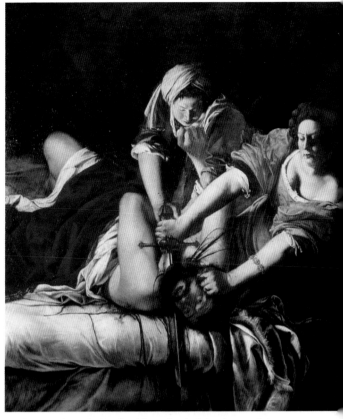

Judith Slaying Holofernes

(~1620)
oil on canvas
78.7 x 64.2 in
(200 x 163 cm)
Galleria degli Uffizi,
Florence

Judith slaying Holofernes is a frequent theme in Gentileschi's works, doubtless because it let the artist express her feelings of protest and anger, the result of the sexual abuse she has been subjected to by her former teacher Agostino Tassi. Here the painter depicts the moment when Judith decapitates Holofernes. She is helped by her maid, who holds the head of the Assyrian general in place.

This work is highly representative of the painter's values as a woman who fought all life to develop her artistic skill. In the 17th-century Italian baroque period, women were only allowed into the world of painting as a distraction. They were encouraged to paint country scenes and family portraits. Artemisia had an added impediment, given that the trial that took place following her rape earned her a licentious and perverted reputation, which was further damaged by the fact that she moved in artistic circles.

In this work, the artist identifies with Judith, who slays the tyrant who has wreaked such harm. The two women have been given equal importance in order to underscore the vindication of women as a collective rather than as individuals. The use of chiaroscuro contributes to the drama being played out. Holofernes, helpless, is killed by two women, unwavering and relentless. His gaze is directed to the spectator. Judith, with remarkable nerve, is shown serious and concentrated on her task. This painting was regarded as too violent to have been painted by a woman, which led some to speculate that the work was not of her hand. But, by taking into account Gentileschi's bitter experiences, the hatred they instilled in her, her decisiveness, and her determination to succeed, the striking aggressiveness of this painting seems perfectly justified.

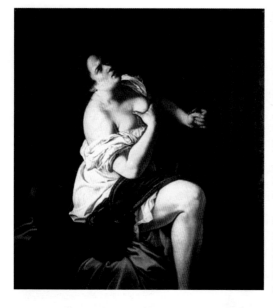

Lucretia

(~1621)
oil on canvas
60 x 50.8 in (137 x 129 cm)
Palazzo Cattaneo-Adorno, Genoa

According to tradition, Lucrece, the wife of Colatino in ancient Rome, was raped by Sextus, the son of Tarquin the Proud. She decided to commit suicide to cleanse her honor and not have to live in disgrace.

Identifying with the heroine, Gentileschi renders a completely unidealized, normal woman. Despite her strong character, Lucrece shows her contained anger by gripping her breast. The image is striking, dramatic, and expressive.

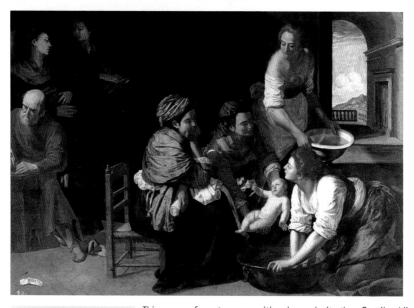

The Bath of Saint John the Baptist

(1635)
oil on canvas
Museo del Prado, Madrid

This scene, of greater compositional complexity than Gentileschi's earlier works, was painted during the last years of the artist's life. The distribution of the elements, which are set on three differentiated compositional grounds, show the baby John being bathed by a group of women, who are placed in the right foreground.

A second group of people appears on the far left to complete the scene; this group is counterbalanced by the architectural structure that appears at the top right corner, allowing the room to be illuminated with daylight. The design of this work was undoubtedly a challenge for Gentileschi, who was accustomed to painting canvases with a single protagonist. This work, on the other hand, called for a composition in which the viewer's eye must span the whole. The result is a painting in which the dynamism of the subjects is framed within a highly decorative setting. The scene contains two clearly distinguishable points of light: the illumination in the center, which immerses the bath scene in an atmosphere that isolates the major characters, and the brilliant light coming from the exterior by way of the arch, which accentuates the intimacy of the interior and contrasts it with the world outside.

CLARA PEETERS

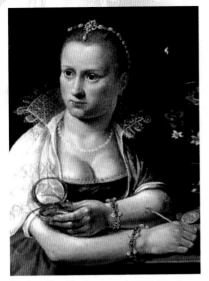

Vanitas *(detail), oil on panel, 1640, Private collection. Believed to be a self-portrait.*

- **1594** Baptized in Antwerp, which would indicate that she was born a year earlier.

- **1608** Her first dated works are from this time.

- **1611** She completes her three most representative works, in the same format and executed simultaneously.

- **1612** Visits Amsterdam and Haarlem. Her artwork is clearly influenced by artists from these cities.

- **1617** She is referred to in documents in The Hague.

- **1620** Completes a dated still life, today exhibited at the Ashmolean Museum in Oxford.

- **1639** On May 31, she gets married in Antwerp, according to some sources to Jan Peeters, whose name she took, according to others to Hendrick Joosen.

- **1657** Completes her last work, a still life, whose whereabouts is unfortunately unknown. The date and place of her death, sometime after this year, is unknown.

Very little biographical information is available about this painter, whose period of artistic activity was brief. She was active between about 1607 and 1621.

In the early 17th century, the still life emerged with singular force, becoming an independent genre. Peeters trained specifically in this genre. She painted fine, detailed canvases with great originality, portraying flowers, food, banquets, fish, game, and more, combined with ceramic, glass, and other objects typical of table and dining room scenes. This type of painting was widely accepted among artisan and bourgeois society, constituting an important market for baroque artists throughout Europe.

Clara Peeters's first works are small in format and instinctive. They lack the unusual qualities of her later works, which constant references to her ideas and feelings in the elements introduced in her still lifes.

This mingling of the private in her work, along with her unique compositions, considerably influenced the evolution of the Dutch still life in the 17th century. Her style was followed by others, such as Marguether de Heer and Maria Van Oostenwijck, in a genre that was considered specifically feminine for its focus on flowers, the home, and other traditionally womanly subjects.

Nevertheless, still-life painting also produced great artists among men. One of these was Pieter Claesz, whom Clara Peeters met on a prolonged trip to what is now the northern Netherlands and northwestern Germany, and with whom she had many discussions because of their mutual creative influences. The extent of such influences is unclear, due to the great weight given to men's art over that of women's at the time, so much so that the commentaries on women's work within the world of art are not very reliable.

This artist's extant works demonstrate an independent style, a unique palette, and meticulous execution of detail, both in the chromatic scale and in the articulation of line. These, along with her special manner of creating the impression of death in the natural elements she chose, make her one of the great artists of the Flemish and European baroque. She was indebted only to the genius of oil painting, Jan van Eyck, from whom she learned her virtuoso technique and how to render the reflection of light and color on objects.

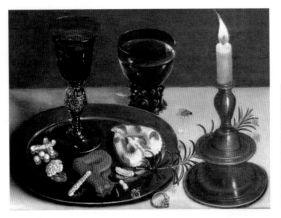

Still Life with a Venetian Glass, a Rummer, and a Burning Candle

(1607)
oil on panel
10.5 x 16.3 in (23.7 x 36.6 cm)
Hoogsteder & Hoogsteder, Netherlands

The date on this work leads critics to believe that this is one of Peeters's first solid contributions to her oeuvre. It reveals her mastery over the rendering of small details and her elegant brushstroke in the execution of color and surface texture. The composition still remains within the academic canons: The light falls on the objects from above, the elements are symmetrical, and the visual frame is dictated by tradition, both in terms of tone and the background-to-figure ratio. There is a clear influence from various established artists of Peeters's time, such as Floris van Schooten or Floris van Dijck.

The artist has not yet fully developed her particular conception, in which she links the subject of the still life with her private life. The objects that comprise the still life are located on a plate made of pewter (an alloy of tin, zinc, and lead), accompanied by the cup in the middle ground and the candleholder. The concept of space without vanishing points directs the viewer's gaze toward the Venetian wineglasses and then into the dark, undefined background. The candle's flame imbues the work with a special aspect, as it leads the eye beyond the horizon of the tablecloth in a viewpoint higher than that established by the conventions of the time. The influence of Osias Beert, possibly Peeters's teacher, is undeniable (particularly in the transparency of the crystal and the metallic highlights), but the inclusion of objects of a small size in the work is unique to the artist.

There are various interpretations concerning the symbolism of this work. One of them refers to the juxtaposition between life, as embodied by the light, and death, symbolized by the inanimate objects. The viewer is urged to look beyond the material world to the spiritual world, through the light falling on the various objects. Other symbolic elements are the wineglass (related to the blood of Christ and redemption) and the rosemary (a symbol of eternity referring to marriage). All of this makes this work far more than a simple representation of a table with various objects. It is the poetic manifestation of the distance existing between life and death, light and darkness, and it marks the beginnings of Peeters's unique style: the combination of material elements with the artist's personal sentiments.

Still Life with Fish

(1611)
oil on panel
22.2 x 32 in (50 x 72 cm)
Museo del Prado, Madrid

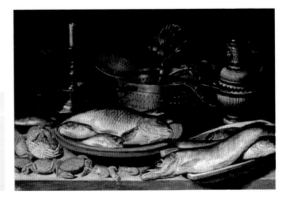

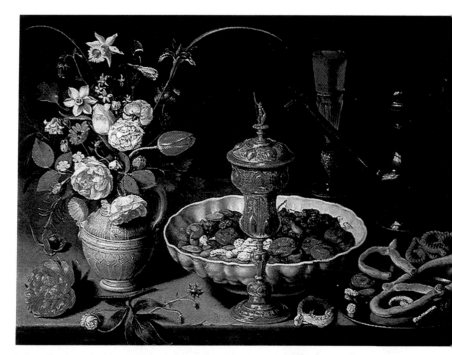

In its collections, the Museo del Prado has three of the most representative works by Clara Peeters (*Still Life with Raisins, Still Life with Fish,* and *Still Life with Pie*). All three were probably executed at the same time, as can be deduced from the uniformity of format, technique, formal structure, and dates. All have characteristics approaching tenebrism, and the distinctiveness of this *Still Life with Raisins* resides in a contribution very typical of Peeters but unusual for her time: the destruction of the compositional symmetry so typical of works by her contemporaries.

Still Life with Raisins

(1611)
oil on panel
20.4 x 28.7 in (52 x 73 cm)
Museo del Prado, Madrid

Apart from this, the painting contains all of the typical elements of the genre: the repetition of objects, a casualness in the placement of some of them, and the theatricality of the trompe-l'oeil, which gives a sense of realism and three-dimensional space. All of this reflects Peeters's great technical mastery and her knowledge of the artistic trends occurring in other countries.

From a compositional point of view, an asymmetrical, diagonal distribution regulates the entire painting. The bright colors corresponding to the bouquet of flowers initiate an intuitive choreography of fallen objects: flowers, branches, pastries. Through the compositional diagonal, the artist directs the viewer's eye toward the lower area, where the weight of the work rests. This design aim is enhanced by the void caused by the shadow on the falling tablecloth and its connection with the dark, indefinite background.

Left: The influence of the tenebrists, especially Caravaggio, on the European baroque was decisive. (In tenebrist paintings, most figures are in shadow, but some are dramatically illuminated.) In Utrecht, tenebrism gave rise to a movement, and Clara Peeters tried the technique. In this work, against a dark background that unifies the scene, fish, crabs, and shrimp are placed before three objects typical of still lifes: a candleholder, a pitcher, and a bowl. The technical quality is superb. The sinuous longitudinal lines of the foreground contrast with the vertical elements in the middle ground. This is a stereotypical composition emphasizing the material nature and weight of the dead fish and crustaceans.

The chromatic richness of the foreground contrasts with the darkness of the background and expresses the concept of all still lifes from the 16th and 17th centuries: the death of nature and the birth of pictorial language. This idea, present on a creative level but latent in baroque society, would gradually gain ground until it culminated in Romanticism. By that time, artists were exploring the separation between the human and the divine, and the conception of the individual as something separate from nature.

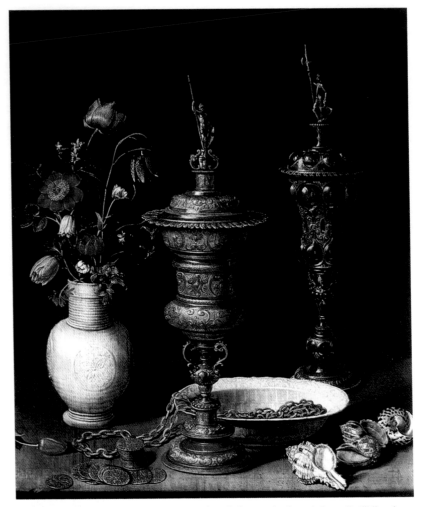

Still Life with Flowers and Goblets

(1612)
oil on panel
26.4 x 21.8 in
(59.5 x 49 cm)
Saatliche Kunsthalle,
Karlsruhe

A reduced number of elements in the artist's small still lives is a key concept in this work. This formal cleansing is accompanied by a rigorous composition that accentuates balance, proportion, and symmetry. The perfect order and hierarchy are the result of a clear association between the painter's art and her manner of conceiving the world. In composing the objects in the painting, the artist is organizing her inner world, which is free of unknowns and contains small details. A goblet is in the center of the foreground, and a similar one repeats the motif in the middle ground, to the right. Between them, a white ceramic vase and plate accumulate the little light there is in the scene. Apart from being elements that help the artist balance the composition, according to some, they contain certain allegories. The goblet symbolizes the male, with his power and personification of order. The plate would represent the female, more in contact with the earth (i.e. with life), constituting a depository of all types of sentiments. Coins and seashells lend weight and continuity to the bare wooden table surface. Richness confronting simplicity is the juxtaposition that lends this work interest and codifies it symbolically as a representation of the artist's intimate feminine world, where austerity and mystery are a manifestation of her spirit.

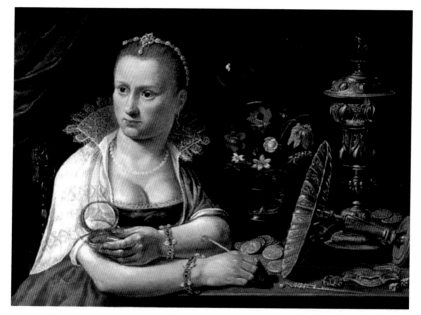

By definition, a self-portrait is the image that an artist creates of herself or himself. In this painting, believed to be a self-portrait, Clara Peeters represents herself surrounded by the objects commonly appearing in her still lifes to indicate the close relationship between her artwork and her life. All of Peeters's most important works manifest the same characteristic: the inclusion of her belongings, her values, and her symbols. The fact that she does not establish any borders whatsoever between the artist and the world in which she lives constitutes a modern facet of her work that is highly unusual for her time.

Vanitas

(1640)
oil on panel
Private collection

The artist looks away from the center of the painting, and is surrounded by various personal objects (jewelry, needles, coins) on a small table. A bowl with a high pedestal lies on its side, indicating depth and helping to direct the viewer's gaze toward the background, where there are several elements typical of Peeters's still lifes: floral details, metallic goblets, and so on. The rear area balances and unifies the composition with a curtain on the left and a small, concave mirror in the center similar to those appearing in works by Jan van Eyck. The symbols of this vanitas are clear: the coins and the luxury of the attire, jewelry, and cloth. All indicate the superficiality of material goods. Devoid of a spiritual counterpoint, unlike other works by this painter, this painting refers exclusively to the values of the physical world. It is the vanitas par excellence, with the artist herself placed within the bourgeois society to which she belongs, though she attempts to dissociate herself from the opulent material objects near her.

C LARA . P .

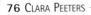

Still Life with Olives

(1640)
oil on panel
Private collection

This work is from one of Peeters's last productive periods, which were isolated, and it does not contain the characteristics most illustrative of her uniqueness as a painter. Here, she does not refer to her inner world. Rather, she shows a great influence from the male painters who dominated the artistic scene of the time, as if she had let herself be engulfed by them, especially by the fame of Pieter Claesz and Jan de Heer. In any case, the technical quality of the work is superb. On a richly brocaded damask tablecloth and against a dark background are various dishes and platters containing lavish foodstuffs that were accessible only to those of high social condition. Oranges, for example, were only available to very powerful families. (In *The Arnolfini Wedding*, by Jan van Eyck, the presence of citrus fruit can be interpreted as a symbol of the high society to which the family belonged.) In this painting, there are also shellfish, refined pastries, cutlery made of fine metals, liquor—and olives. Imported from far-off lands, in addition to representing the family's excellent financial situation, these olives also symbolize spiritual peace. Certainly all of these items could only be associated with upper-middle-class families in Antwerp. The work is very well composed, though it lacks the most significant elements generally appearing in Peeters's art: a simplified composition and the inclusion of personal, feminine objects that never appeared in traditional still lifes.

Still Life with Cat and Fish

oil on panel
13.5 x 18.5 in (34.3 x 47 cm)
National Museum of Women in the Arts, Washington, D.C.

This work is unsigned and undated, though its authorship is clear. It is a representation of objects typical of Clara Peeters. It belongs to her last period, as it lacks the personal objects she included in works from previous periods. Still, it is rendered with her distinctive simplification and technical elegance.

The painting contains fish, shellfish, and a cat, with strong contrasts in color, light, and surface texture. The asymmetrical composition is crossed by a diagonal in chiaroscuro that groups the objects to balance the weight and provides movement that juxtaposes the dead fish with the living cat. The depth is executed with great intelligence: The undefined background, the receding lines of the fish under the cat's claws, and the overlapping grounds of the table, the plate with the oyster and the shrimp, and the elevated platter with the large fish gradually lead the spectator's eye from the foreground to the background and from right to left. Also remarkable is the symbolism of the cat holding the fish, an image that appeared in works by other artists of the baroque as well: It evokes the material and animal desires that inevitably trap human beings and prevent them from establishing a more dignified, spiritual life.

GIOVANNA GARZONI

Plate of White Beans *(detail), tempera on parchment, 9.8 x 13.5 in (24.8 x 34.3 cm), 1650-1662, Palazzo Pitti, Florence.*

Giovanna Garzoni was active in Italy during the baroque period. She began her artistic career painting religious, mythological, and allegorical subjects, with a monumental style and Venetian colorism. But she is most renowned for her still lifes, her specialty during the 1640s. Her works are characterized by the varnished quality of their colors, executed in tempera or in watercolor on parchment, with a fine pointillist technique.

Unlike the drawings of Maria Sibylla Merian, Garzoni's works were inspired by her profound interest in nature and her exquisite powers of observation. They cannot be classified as scientific illustration, with the exception of her herbarium (~1650-1655, Dumbarton Oaks, Washington), with forty-nine botanical drawings. Garzoni defined herself as a miniaturist, in reference to her painting technique, and was familiar with Dutch painting, as well as the style of the Roman successors of Caravaggio. She painted elaborate floral scenes, including butterflies, insects, and seashells. The works of the Lombard painters, such as Fede Galizia and Panfilo Nuvolone, had an immense influence on her.

Giovanna Garzoni never married and was one of the few women artists who had the option of traveling to be educated. She was very successful, which allowed her to settle in Rome. There she painted her unusual still lifes, a fact that is corroborated by Lione Pascoli in his *Vite* (1730-1736), in which he affirms that the painter was able to ask any price for her works and that she had the most powerful families of Rome and Florence among her clientele. For some years, she worked and lived under the patronage of the Medici family.

- **1600** Presumably born in Ascoli Piceno, Marche. Her parents, Giacomo Garzoni and Isabetta Gaia, came from a family of Venetian painters. Little is known of her training, but she may have begun her apprenticeship under her uncle, Pietro Gaia, a painter and etcher.
- **1615** Presumed intermittent stay in Rome during the next fifteen years.
- **1616** Receives a commission from the chemist Giovanni Vorvino in Rome to paint a herbarium.
- **~1620** Paints *Saint Andrew* (Museo dell'Accademia, Venice), one of the canvases of the apostles for the Church of Ospedale degli Incurabili in Venice. This remarkable commission suggests that Garzoni studied under an important master, possibly Jacopo Negretti, known as Palma il Giovane.
- **1625** In Venice, she paints the miniature *Portrait of a Young Man*, now owned by the queen of the Netherlands. This work illustrates her delicate technique and careful color gradations, which produce a highly refined surface.
- **1630** Following her stay in Rome, where she painted for clients such as Taddeo Barberini, the city prefect, she moves to Naples. During a one-year stay, she paints under the patronage of the Spanish viceroy, the Duke of Alcala.
- **1632** Invited by Christine of France, the Duchess of Savoy, to work for her in Turin, where she has her first contact with the painting of the Netherlands and that of Northern Italy. The portrait of Vittorio Amadeo I, Duke of Savoy (Galleria degli Uffizi, Florence), shows an interest in naturalism, inspired by the Schools of the North and her knowledge of English portraiture, and remains in Turin for five years.
- **1633** Probably enters the Accademia di San Luca, an artists' guild in Rome.
- **1642** Stays in Florence. Begins to work for the Medici family. Receives commissions from Grand Duke Fernando II, the duke's brothers, and the Grand Duchess Vittoria della Rovere. She also paints her lapdog.
- **1651** Moves to Rome, where she gains recognition as an artist.
- **1666** Her will establishes that she will bequeath her entire estate to the Accademia di San Luca on the condition that her tomb be enthroned within its church.
- **1670** Dies in Rome; her remains are laid to rest in the Church of the Saints Luca and Martina, in the Accademia, in a mausoleum built in 1698.

Dish with a Pomegranate, a Grasshopper, a Snail, and Two Chestnuts

(~1650-1662)
tempera on
parchment
10.6 x 13.8 in (27 x 35 cm)
Palazzo Pitti,
Galleria Palatina,
Florence

Situated in the center of the work, on a low platform, a simple white dish holds a pomegranate placed among yellow leaves, together with a grasshopper and a snail. The wall on the right side of the background shares similar chromatic characteristics. The work is outstanding for the ostentatious reddish yellow fruit, ripe and bursting with brilliant red seeds, which has been sliced into three pieces. In this composition, Garzoni combines round forms with long ones, a weighty volume with a number of fragile elements. The artist juxtaposes dark colors with light ones and rough surfaces with smooth ones.

The round fruit provides a link to the separated and elongated shape of the leaves, and the fragility of the grasshopper accentuates the roundness of the dish, the snail, and the hazelnuts, in the foreground. In order to create contrast, the artist paints the background dark; the three pieces of pomegranate provide a counterpoint to the grasshopper, light and transparent, whose color is adapted to the autumnal hue of the leaves. With this interplay of densities of forms, with related and subtly modulated colors within the numerous tones, this small painting is brought to life through a dazzling display of colors and an enchanting, almost poetic effect.

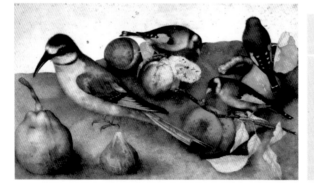

Still Life with Birds and Fruit

(~1650)
watercolor with
graphite and lead
white on parchment
10.2 x 16.4 in
(25.1 x 41.6 cm)
Cleveland Museum
of Art, Ohio

In this still life, Giovanna Garzoni paints a charming composition containing two species of indigenous birds together with a number of local fruits. She achieves an extremely faithful rendering of the birds' plumage. The textures of the fruits have been painted with painstaking precision, including the leaves and branches. These elements are seemingly tumbled on a stonelike surface.

At first sight, this composition appears to be a view of living nature, but a closer inspection reveals the work's true purpose. With this seemingly chance arrangement, Garzoni illustrates the small birds from three points of view—from above, from the right, and from the left. The fruits provide a reference that establishes the real size of the birds. The biggest bird is rendered in profile, something that indicates the artist's scientific interest in the subject. It is accepted that the scientific illustrations of the Veronese painter Jacopo Ligozzi provided a significant reference for Garzoni's works of this subject matter. Ligozzi's elegant and precise works in tempera, from about 1576, flaunt a refinement and formal clarity that is also found in Garzoni's still lifes and botanical drawings. Indeed, her works were attributed to Ligozzi until 1964, when the researcher Mina Gregori cleared up this inaccuracy.

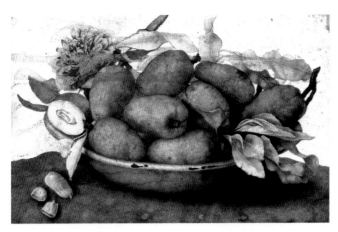

Garzoni presents a simple plate of ripe green medlars, together with their leaves and fruit, to which a dash of red is added in the guise of a red rose. One of the medlars on the far left has been sliced into two, showing the fruit with and without its seed, which appears to have just fallen out. In the foreground, the elaborate yellow leaves become gradually sketchier as they recede into the background. The rose is partially enveloped in a yellow color, softly varnished over the parchment.

Plate with Almonds, Nespole, and a Rose

(1650-1662)
tempera on parchment
9.8 x 13.5 in (25 x 34.2 cm)
Palazzo Pitti, Galleria Palatina, Florence

This work's botanical motifs attest to the scientific interest the Medici had in the produce from their land and country gardens. Both Duke Fernando II (1610-1670) and his brother, Cardinal Leopoldo de Medici (1617-1670) were friends of Galileo's and had an important art collection containing numerous botanical and fauna motifs. This still life, comparable to Garzoni's other exquisite still-life works of flowers, fruits, and vegetables, offers an attractive illustration of the botanical produce of the period, painted in a realistic and decorative style. The works of this artist continue to be closely linked to those of Jacopo Ligozzi of Verona. Garzoni's work also constitutes a prelude to the larger and more baroque compositions of Bartolomeo Bimbi.

Plate of White Beans

(1650-1662)
tempera on parchment
9.8 x 13.5 in (24.8 x 34.3 cm)
Palazzo Pitti, Galleria Palatina
Florence

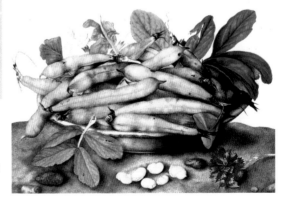

This still life, a plate of beans, forms part of the works that the Medici family commissioned the artist to paint. The centered dish is piled high with ripe beans, which are arranged together with several long leaves, painted with so remarkable a naturalism that they bear the marks of decay. Hence Garzoni conceals nothing in her endeavor to achieve an accurate description of nature. The foreground is occupied by some kidney-shaped seeds, white and peeled or with streaky brown skin markings. The other element in the foreground, the red carnation, is rendered with the same degree of detail. The two beans in the left foreground, however, are merely sketched.

This work reveals much about Garzoni's technique, which is based on sketchy contour lines that are then delicately filled in with varnished colors. Finally, tempera was applied in fine parallel lines or stripes, with tiny short strokes and tiny patches of color combined with pure color. These parallel lines can be seen in the veins of the beans. The mottled streaky texture of the seeds with skin, and a granular texture, which she renders with a pointillist technique, are most evident at the bottom of the painting.

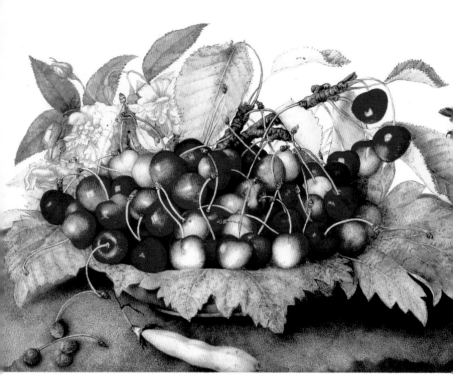

Cherries on a Plate, Broad Beans, and Bumblebee

(~1665)
tempera on parchment
9.6 x 14.8 in (24.5 x 37.5 cm)
Palazzo Pitti, Galleria Palatina, Florence

This work is one of many that Garzoni painted for the Medici. The artist once again reveals her talent for rendering natural elements with such extraordinary detail. Like the others in the series, this work falls somewhere between a naturalist illustration and a pictorial work. The elements shown here reveal the amount of time the artist spent observing nature, studying it in all its facets —shapes, colors, textures— down to the last detail, whether it be leaves, fruit, or a bumblebee. Everything is fashioned with the utmost naturalism, even if it is part of an unmistakably artistic vision. Indeed, its exactitude is equal if not superior to a photographic reproduction.

This work is also remarkable for the protagonism and meticulousness that the artist lent each element. Despite the quantity of cherries and leaves included, close observation reveals that each one of them has been afforded an extremely elegant treatment and, even though they form part of a whole, each cherry displays its own individuality. All of this is executed within a unified and balanced composition, which organizes all the elements in the form of a spiral. The shape of the whole composition has been treated so that, although the elements are circumscribed neatly within this imaginary spiral, the work exudes great freedom and dynamism.

Another outstanding factor here is the illumination. The still life is illuminated by a soft, diffused light that appears to emanate from somewhere above the spectator's head. The softness of the lighting mitigates the shadows, but this does not prevent the elements from revealing a wealth of hues in a varied chromatic symphony, scrupulously studied and delicate. The lavish array of brilliant and matte textures is the hallmark of the artist's superb technical dexterity.

ANNA MARIA VAN SCHURMAN

Self-Portrait *(detail), engraving, Anna Maria van Schurman at the age of 26.*

During the Golden Age of Dutch science and culture, Anna Maria van Schurman was an important symbol of Late Humanism. She was called the Sappho of the Low Countries, a reference to one of the most important figures in the poetry of antiquity.

Though education was not usual for women in van Schurman's time, her father quickly discovered her extraordinary intelligence and gave her the same education as her brothers. This allowed her to study between twelve and fifteen languages, several of which she became fluent in; she wrote poetry in Latin. Among her friends were the philosopher and scientist René Descartes (1596-1650) and Queen Christina of Sweden.

The remarkable child became famous and was praised by poets such as Jacobus Revius, Daniel Heinsius, and Constantin Huygens. Anna Maria van Schurman's inquiring nature led her to study all of the arts, from painting to music and calligraphy to embroidery. She painted several high-quality portraits and was a student of Gerard van Honthorst (1590-1656). According to Descartes, it was due to Voetius (Gijsbert Voet), her theology professor, that she stopped painting to concentrate on the subtleties of theology and dedicate herself to a life revolving around religion and science.

There are more than twenty portraits, paintings, and engravings extant by her, today in different collections in Europe and the United States.

- **1607** Born in Cologne, Germany, the daughter of Flemish immigrants from Antwerp. Along with her two older brothers, she receives a splendid education from her father and a private tutor, especially in languages such as Latin and Greek, but also in mathematics, geography, and astronomy.

- **1615** For religious reasons (they were Calvinist), her family moves to Utrecht, in the Netherlands.

- **1620** Rejects the wedding proposal made by the poet Jacob Cats (1577-1660) on her father's advice, to avoid the conventionality of secular life.

- **1623** Her father dies. On his deathbed, he extracts a promise from Anna Maria that she will never marry. She remains in Utrecht, living with her mother and two aunts. The university of this city, founded in 1636, admits her as a student, though she is forced to conceal herself in a niche behind a curtain. She studies theology and Oriental languages with Gijsbert Voetius, who exercises a great influence on her. She graduates in law and studies history, philosophy, and medicine.

- **1636** Despite her shyness and encouraged by her intellectual friends, she begins to publish poems, letters, and small treatises.

- **1648** Publishes *Opuscula Hebraea Graeca, Latina et Gallica Prosaica et Metrica* with a selection of letters addressed to her from her educated admirers. The new editions published in 1650, 1651, and 1749 are proof of the interest that the work aroused.

- **1666** Meets Jean de Labadie, a Jesuit who converted to Protestantism and founded a sect. Van Schurman, fascinated by his ideas, joins him and his followers. She is soon considered a dreamer after declaring the uselessness of knowledge for grasping the concept of God. She follows Labadie from Middelburg to Amsterdam.

- **1670** The community formed by the sect moves to Herford, Germany, where the princess-elect, Elisabeth Stuart, offers Anna Maria asylum.

- **1672** Travels to Altona, near Hamburg, then part of Denmark. A year later she publishes her autobiography, *Eucleria,* with Labadie's support.

- **1674** After Labadie's death in Altona, she settles with his followers in Wiewerd, in West Frisia, preaching her ideas in the Netherlands.

- **1678** Dies in Wiewerd. Shortly before her death, she destroys her ample correspondence as proof of her rejection of her secular past.

Self-Portrait

(1633)
engraving

Anna Maria van Schurman rendered herself in 1633 as a bourgeois woman wearing a fine dress with luxurious lace and an elegant collar. She portrayed herself with loose curly hair like a single young woman, though in her time, it was normal to be married by the age of twenty-six. But ten years earlier, she had promised her dying father that she would never marry, in order to dedicate herself exclusively to God and to science.

The artist did not portray herself in a very positive light; rather, she seems to have faithfully represented her real features, with an energetic chin, a large nose, and sparkling, vivid eyes. This portrait reflects the humanist tradition, in which education and knowledge constituted important achievements and virtues of the bourgeoisie. The writing on the lower part of the engraving refers to the artist's intellectuality and self-reflection. Constantijn Huygens wrote several poems about an engraving in this series, referring to the fact that van Schurman never showed her hands in her self-portraits. There was a rumor that the artist's hands had become ugly after executing many engravings with corrosive substances. But it is more likely that van Schurman did not represent her hands in order to emphasize the idea of her intellectuality, which for her was much more important than her skill.

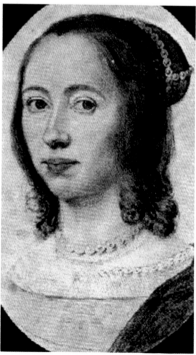

Self-Portrait

pastel on paper
Museum t'Coopmanshus,
Franeker

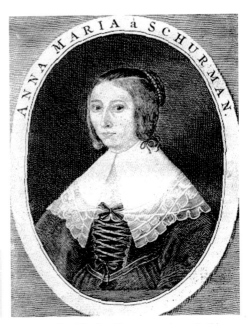

Self-Portrait

engraving

Engraved portraits were often used to send to friends with correspondence. In this case, the self-portrait was included in van Schurman's book *Opuscula Hebraea, Graeca, Latina, Gallica, Prosaica et Metrica,* the first edition of which was published in 1648 in Utrecht under the modest title *Opuscula* (*Small Works*). The work contains a selection of texts such as the theological treatise "De Vitae Termino" ("On the End of Life") and a dissertation on women's right to study. It also includes letters in Latin, French, Greek, and Hebrew, followed by poems in Latin and French.

Van Schurman engraved her self-portrait within an oval in the form of a medallion framed by a strip with her name written on it. It is a half-body portrait, with her face slightly turned toward the viewer. The artist is wearing an elegant dress gathered at the waist, adorned with ribbons, wide sleeves, and a large collar of fine white lace. Her coiffure consists of two parts dividing the hair, two braids at each side, and a bun held in place by a pearl collar. Her serious gaze is directed straight at the spectator. Van Schurman's portraits, whether self-portraits or portraits of other artists, are striking for their great similarity. In spite of the debatable quality of her works, she is notable because of her strong personality and for the fact that producing this type of work as a woman was something unheard of at the time.

Left: In this self-portrait, Anna Maria van Schurman portrays herself as an attractive young woman, though this was not the artist's objective. She was attempting to represent herself as she really was. The pastel technique permits softer and more natural results than engraving, which is based solely on line.

Here, her hair, adorned with ribbons and pearls, falls partially in soft curls onto her shoulders, and neither the lines nor the shadows of her face are as severe as in her engraved portraits. The technique is so fine that the transparent cloth of her collar covers her skin like a delicate mist and her pearl collar shines naturally. Though van Schurman resembles a sweet young woman, her eyes reveal a strong character and temperament. She was a woman who knew her objectives and did not accept the limits imposed on her by society. In order to attend the master's theology classes given by Gisbertus Voetius in Utrecht, she published a pamphlet justifying women's rights to attend the university. Though this possibility was unheard-of for a woman, she succeeded in gaining access to Voetius's courses. She was allowed to listen to them from an adjacent room with a hole in the wall, or at times, sitting in a niche concealed behind a curtain. Thus, Anna Maria van Schurman was the first female university student in the Netherlands.

Two Self-Portraits

(1640)
left: etching
right: drypoint engraving
each 8 x 5.9 in (20.3 x 14.9 cm)
National Museum of Women in
the Arts, Washington, D.C.

At first sight, these two self-portraits of Anna Maria van Schurman are very similar. The artist is thirty-three years old here, in a position slightly turned toward the viewer and inscribed within the white oval frame typical of her portraits. The frame, which stands out in both portraits against a dark background, contains the artist's name and a date. The two engravings have the same inscription underneath: CERNITIS HIC PICTA NOSTROS IN IMAGINE VULTUS: SI NEGAT ARS FORMA, GRATIA VESTRA HABIT. A. M. DE S. TE. This is reputedly a sentence pronounced by Antonio Maria de Sancta Trinitate, a thinker that in his day was very famous and whose ideas had many followers.

The two engravings have some differences, such as the dress, the hairstyle, and even the woman's face. The different techniques used in each give rise to varying effects, such as the intensity of the shadows and the thickness of lines. The engraving on the left was executed with a burin, a steel cutting tool, on a varnished metal plate that was partially treated with aquafortis (nitric acid) before printing. The lines are straight and hard, as can be observed in the eyebrows, the pearl crown, the hair, and the detailed lace of the dress. To enhance the effect of the aquafortis, the plate was covered in resin and submerged in an acid bath to corrode the uncovered areas. Thus the incisions are deeper and the background darker.

In the drypoint engraving on the right, the acid was not used. This allows for more spontaneous, softer lines, because the metal plate is incised directly with a sharp point of steel, diamond, or ruby, as if it were a pencil on paper. Depending on the angle of incision and the pressure applied, rough edges can be obtained that produce soft lines. These rough edges cannot be removed by polishing the plate (as the acid bath polishes the plate in the burin technique). In drypoint, during printing or stamping, this edge is quickly worn away, reducing the lines. This spontaneous quality can be observed in the face, hair, and shadows on the sleeves, and in the transparency of the subject's large collar.

JUDITH LEYSTER

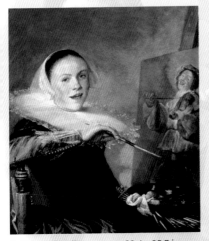

Self-Portrait, oil on canvas, 29.4 x 25.7 in (74.7 x 65.3 cm), ~1633, National Gallery of Art, Washington, D.C.

• **1609** On July 28, Judith, the daughter of Jan Willemsz and Trjin Jaspers, is baptized in the Grote Kerk in Haarlem.

• **1628** Samuel van Ampzing mentions her as one of the artists working in Haarlem in *Description and Tribute to the City of Haarlem, Holland*. Her parents move to Vreeland, near Utrecht.

• **1629** In September, the Leyster family returns to Haarlem. She paints *The Merry Drunkard* (Rijksmuseum, Amsterdam).

• **1630** Paints *Carousing Couple* (Musée du Louvre, Paris).

• **1631** Attends the baptism of Frans Hals's first child.

• **1633** Enters the Saint Luke Guild of Haarlem. Paints *Woman Sewing by Candlelight* (National Gallery of Ireland, Dublin).

• **1635** Establishes her own studio and has three students. Executes watercolors for a tulip catalogue, including *Yellow and Red Tulip* (Frans Hals Museum, Haarlem). She successfully sued Hals for breach of ethics after he took on one of her students.

• **1636** On June 1, she marries the painter Jan Miense Molenaer (~1609-1668). They settle in Amsterdam.

• **1637** The first of their five children is born. They would have three boys and two girls (born in 1637, 1639, 1643, 1646, and 1650).

• **1649** Moves to Haarlem.

• **1655** The couple buys a house in Amsterdam and later, another one in Haarlem.

• **1660** On February 10, she dies in her country home in Heemstede at 50 years of age.

Judith Leyster must have been quite precocious as she was only 19 years old when Samuel Ampzing cited her as one of the important artists of Haarlem. Her father bought a bar in 1618 and called it Ley-Ster (The North Star), which Leyster began using as her pseudonym.

She studied in the studio of Frans Peter de Grebber, a well-known traditional painter from Haarlem, who specialized in portraiture and historical paintings. When Leyster decided to pursue her own artistic career, she became associated with Frans Hals, an innovative painter whom she admired, and they established a studio together. Toward 1629, she became professionally independent; this was indicated by the fact that she signed the painting *The Merry Drunkard* with her own monogram.

She was the only woman to enter Haarlem's Saint Luke Guild of painters and the only one to have her own studio, where she taught three students. Leyster painted a great deal when she was single, but after her marriage to the artist Jan Molenaer, her production decreased considerably. She was also involved in selling works of art and took charge of the family's financial and real estate matters.

Her works depict scenes of everyday life. They reveal a sure hand and sound composition, and often incorporate a figure or two. Leyster executed still lifes, portraits, and watercolors.

Following her death, her work fell into obliv-ion until 1893, when Cornelis Hofstede de Groot studied her works and discovered her monogram. Judith Leyster developed her own artistic style and was not a mere follower of Hals, as was formerly believed. Her artwork has been highly regarded by 20th century art historians. Although both treat similar subjects, it is clear that in her works, Leyster gives particular emphasis to details of persons and in giving them a special sensitivity. In 1937, Juliane Harms published the first serious studies on Leyster, and in 1989, Frima Fox Hofrichter wrote her doctoral thesis on Leyster. In 1993 the Frans Hals Museum and the Worcester Art Museum held an exhibit on her.

Serenade, *or* Lute Player

(1629)
oil on panel
17.9 x 13.8 in
(45.5 x 35 cm)
Rijksmuseum,
Amsterdam

This is one of Judith Leyster's early works, dated and signed with her monogram. When she painted it, she was sharing a studio with Frans Hals, who executed an identical painting with the same title (Alain Rothschild Collection, Paris). The most likely explanation is that Leyster's work was a copy done on commission.

The panel represents a young man dressed in a spectacular manner and playing the lute. His slightly open mouth not only indicates that he is singing but also lends the painting sensuality. The light entering from the left illuminates the young man's face and, especially, his white shirt cuffs and collar, yet there is no dramatic chiaroscuro. Though Leyster received the influence of Caravaggio, she did not apply it assiduously. In contrast to Italian painting, the figures in Dutch art are fresher and more spontaneous. In this panel, the brushstrokes are daring. The red fringes of the young musician's attire, appearing at the bottom of the painting, are boldly sketched in, as are the highlights on the silky, striped top.

This festive iconography present was widely accepted and successful in Dutch art at the time. Already in 1622, Dick van Baburen had painted a bust of a singing lute player (Central Museum, Utrecht) wearing a brightly colored outfit. Other artists in Utrecht and Haarlem also painted the same subject. From times immemorial, the lute had been closely associated with love songs and was a popular instrument evoking sentiments that were familiar to everyone. By 1626, Judith Leyster had already painted a *Lute Player* (Rijksmuseum, Amsterdam). The panel shown here is a copy of another executed by Hals between 1620 and 1626 (Rothschild Collection, Paris). The difference is that Hals's model corresponds to a more popular figure, and his attire resembles that of a buffoon.

The fact that Leyster executed a copy should not be viewed pejoratively, as it was probably commissioned. At this time, Leyster and Hals were associates and shared a studio. This is an excellent copy and demonstrates the artist's talent.

At this time in the Netherlands, the great majority of artists had to supplement painting with some other trade in order to make a living. There were many artists and the competition was fierce, such that painters went to fairs, markets, and even exhibited their works from small stands. The great variety of subjects in Dutch painting during its Golden Age—including seascapes, landscapes, floral and other still lifes, genre scenes, and more—arose, among other reasons, due to a bourgeoisie made wealthy through commerce that demanded scenes with which it could identify. The strong competition and the desire to make oneself known in order to sell works to this new, demanding public led artists to specialize in specific subjects.

Young Man Playing the Flute

(~1630-1635)
oil on panel
28.7 x 24.4 in (73 x 62 cm)
Nationalmuseum, Stockholm

Leyster opted for genre scenes—in other words, scenes of everyday life. Here she represents a young flutist playing his instrument while gazing at an undefined point outside the painting. The violin and flute hanging from the bare wall form parallel lines with the backrest of the chair, contributing to the harmony of the painting and providing a frame for the boy. His shirt is divided at the bottom, giving rise to two diagonals that make the figure dynamic and lend it volume. The light enters from the left and illuminates part of the face and especially the back of the boy's right hand, in foreshortening.

In general, the brushstroke is very meticulous, detracting from the spontaneity of the work and making the scene somewhat severe. Daring, quicker brushstrokes are visible on the collar. There is much greater artistic quality in the artist's self-portrait, in which, with some quick brushstrokes, she defines the clothing, lace collar, brushes, and palette. Dutch 17th-century painting is characterized by its attention to detail and the loving depiction of objects. Here, the paint on the upper part of the chair is worn due to use, and one of the slats on the back-rest is broken, which has been interpreted as a negative symbol regarding the musician, but this is disputable.

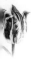

Right: The competition between artists caused prices for their paintings to fall. Thanks to this, the middle and upper middle classes could fill their houses with paintings at very reasonable prices, a luxury that was previously reserved for the upper classes. Something similar happened with portraiture, closely linked to social prestige. This led to the invention of guild or corporate portraits, whose sitters felt proud of their financial progress. Good portraitists were sought.

This portrait fits into that historical context. Like the painting above, it is signed and dated, though the name of the sitter is unknown. She is a person with character, reflecting serenity and sternness, with a perfect complexion and a healthy face. Her gaze is direct and intelligent, and her slight smile lends her an amiable air. The combination of the dark dress, the radiant white collar, and the absence of other vivid colors denote that this is a discreet woman. She wears no rings on her hands, which are large and rough due to work. The book she is holding, probably a religious one, is an interesting element for its symbolic connotations. From very early in the history of art, it had been traditional to associate symbolic attributes with religious figures. An example is Saint Peter, usually portrayed with the keys to heaven, or martyrs, who were represented with the instruments of their torture, such as Saint Lawrence with the grill. In the 1400s, the first portraits appeared of laymen who, recalling this tradition, had themselves painted with some object in their hands, generally related to their trade, profession, or beliefs, as in this panel. All of this implies that the sitter wanted to confirm her religious ideas and leave proof of her devotion.

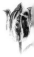

The Proposition

(1631)
oil on wood
12.2 x 9.5 in (30.9 x 24.2 cm)
Mauritshuis, The Hague

Left: This painting represents a man accosting a young woman, placing his hand on her arm while offering her money in exchange for sexual favors. It is an ambiguous scene, as it is moralizing—that is, it warns us against what we should not do—yet on the other hand, it is sensual. This ambiguity in moralizing scenes containing eroticism was not new. It arose in the Middle Ages and was therefore part of tradition in the creative arts.

Leyster places the two figures somewhat off center, without producing an unbalanced painting. The light from the oil lamp illuminates the faces, creating a chiaroscuro effect and lending the scene a disturbing nocturnal atmosphere. The young woman is embroidering or sewing, and the fact that she does not even lift her eyes from her work indicates her categorical rejection of the proposition.

Leyster's novel treatment of the subject is remarkable and unprecedented in Dutch painting. Though the literature of the time conceived women as being dangerous temptresses, Leyster interprets this woman as a victim. She embodies the "virtuous woman," a reflection of a prosperous, orderly society, a standard type often portrayed sewing, knitting, or occupied with her housework, as in Leyster's *Woman Sewing by Candlelight*. This woman is far from lazy or dissolute, unlike the women in the paintings of brothels abounding during this period. Sewing and lacework or embroidery were closely associated with the virtuous woman, whether she was from the upper, middle, or lower classes. This subject would not become popular until the 1650s. Later, Gabriel Metsu would paint *An Offering of Wine* (1650) and Gerard Ter Borch *The Gallant Officer* (1662-1663). Jan Vermeer would also execute several works on similar subjects. This panel is splendid for its composition, the brushstrokes that comprise the folds in the woman's blouse, and the majestic volume of her large skirt. The innovative subject reflecting the human condition is also striking. The composition combines serenity and beauty with a troubling air of mystery.

Portrait of a Lady

(1635)
oil on wood
21 x 16.3 in
(53.3 x 41.5 cm)
Frans Halsmuseum,
Haarlem

Vroeghe Brabanson Tulip,
from Tulip Book

(1643)
watercolor on parchment
Folios 29 and 30
Frans Halsmuseum, Haarlem

In the 16th and 17th centuries, herbarium books were the principal source of knowledge on medicinal and floral plants. The *Herbarium Vivae Eicones,* by Otto Brunfels, with woodcuts by Hans Weidnitz, was published in 1530-1532. At this time, there was a great interest in the natural sciences and zoology. The microscope, invented in the Netherlands in the late 16th century, encouraged the study of plants and animals, which began to be classified. Another factor favoring the appearance of books on flora was the tendency of the upper middle classes to dedicate leisure time to horticulture. In the 17th century, the boats that transported spices and other products from overseas to Dutch ports also brought seeds and bulbs of all sorts. In 1614, the publication in Utrecht of Crispijn van de Passe's *Hortus Floridus,* with more than 200 images of flowers, butterflies, and other insects, was very successful.

This explains the emergence in the 17th century of schools specializing in floral oil painting and the presence of excellent flower painters in the Netherlands, a subject that became an independent genre. In the 1630s, a true passion for the tulip arose, the related speculation moving fortunes. Sellers needed catalogues to show their merchandise and, therefore, good illustrators. In 1635, Leyster had painted a superb tulip in watercolor on parchment (*Yellow and Red Tulip,* Frans Halsmuseum, Haarlem). These two folios show images of a red tulip with white areas. At the bottom of the page, Leyster indicated the type of tulip, her name, and the date. On folio 29, the flower is closed and the two illuminated leaves, in different tones of green, wrap around a fragile, slightly sinuous, and highly realistic stem. On folio 30, the petals of the flower are open and the leaves are more rounded. The tulip becomes dynamic through the marvelous swirling petals and the curved leaves that balance gracefully in an open embrace.

MICHAELINA WOUTIERS

Saint Joseph *(detail), oil on canvas, 29.9 x 26 in (76 x 66 cm), ~1657, Kunsthistorisches Museum, Vienna.*

Little is known about the life of this painter. She was from Mons (in the southern Low Countries), but searches in the archives of that city have revealed little information— not even a christening certificate was found. All that is known for certain is that Woutiers was a single woman active as a painter between 1640 and 1660, and that Archduke Leopold William bought four works from her, as recorded in his inventory.

Archduke Leopold William (1614-1662) was the second son of Emperor Ferdinand II. He was one of the great art collectors of the 17th century and one of the most illustrious of baroque art lovers. Appointed governor of the southern Low Countries from 1647 to 1656, he was greatly interested in creating an art collection integrating the best works, from Jan van Eyck to contemporary artists. In 1656, he resigned as governor of the Low Countries and moved to Vienna, taking his art collection with him. In 1659, an inventory was taken of his collection in which 1,400 works were recorded. One of the entries is a *Saint Joachim Reading,* described in the inventory as "Original von Jungfraw Magdalena Woutiers von Mons oder Berghen,

- **1600-1630** Born in Mons, in the region of Hainaut in the southern Low Countries.

- **1646** Executes *Portrait of a Man* (Musées Royaux de Belgique, Brussels).

- **1647-1656** The Archduke of Austria, Leopold William, who would collect some of Woutiers's works, is appointed governor of the Low Countries.

- **1656** Paints *The Education of Mary,* which she signs and dates as follows: MICHAELINA WAUTIER, INVENIT, ET FECIT 1656 (Michaelina Wautier conceived and painted it in 1656).

- **1659** Paints *The Annunciation.* Signed and dated MICHAELINA WAUTIER FECIT 1659. In the inventory of the Archduke Leopold William, four works by Michaelina Woutiers are recorded: two paintings of Saint Joachim, one of Saint Joseph, and a Bacchanal.

Henegaw i Niderlandt"; a Saint Joseph seen from the torso up, described as "Original von der Jungfrawen Magdalena Woutiers"; a third painting of Saint Joachim, also described as "Original von Magdalena Woutiers"; and finally, a Bacchanal, which is mentioned as "Original von N. Woutiers." The archduke made a name for himself in history as the true founder of Kunsthistorisches Museum of Vienna.

The paintings of Michaelina Woutiers are of unquestionable pictorial excellence. Her portraiture is surprising and her works tend to be monumental. Her style would indicate that she studied in Italy. She focused on portraiture, flowers, and religious and mythological scenes. Furthermore, she is one of the few female painters of the 17th century who executed historical paintings. Though she was prestigious in her time, she later fell into oblivion. The care she took in signing her works and the 1659 inventory of Archduke Leopold's collection have contributed to lending her a place in the history of Western art in the 17th century.

Portrait of a Man

(1646)
oil on canvas
24.8 x 22.2 in
(63 x 56.5 cm)
Musées Royaux des
Beaux-Arts de Belgique,
Brussels

This is a surprising portrait. Woutiers renders a very realistic image of the person, who seems very approachable. This painting, especially the manner of conceiving and representing the sitter, is similar to another portrait at the Musées Royaux of Brussels, executed by a certain C. Wautier in 1656. This is probably her brother, since a Charles Woutiers appears in documents as having studied in Italy and entering the Guild of Saint Luke in Brussels in 1651. The identity of this noble official wearing a pink sash edged in silver lace is unknown. The light pervading his face is soft, the curls of his abundant hair are graceful and fall naturally, and the brushstrokes defining the texture of his clothes are remarkable. The pink sash in the foreground is striking for its dynamism and its delicate folds. The precise, bold brushstrokes in the pom-poms at the collar and the silver lace that cascades down the sitter's back on the right denote the artist's skill. The work is signed with the artist's full name: MICHAELINA WOUTIER/1646 in the upper right. This painting was purchased by the museum in 1812 from a Brussels art dealer, Thijs. It is an impeccable portrait for its light, composition, brushstrokes, and selection of colors. The figure is highly expressive, perfectly transmitting the sitter's mood and character.

This canvas represents Bacchus, in the center, accompanied by his entourage. The scene is inspired by *The Metamorphosis*, by Ovid (43 B.C.-17 A.D.), a Roman poet who lived in times of Augustus and who put the stories of Greek mythology into verse. The image of Bacchus is borrowed from a painting by José de Ribera entitled *Silenus Drunk*, executed in Italy in 1626 (Museo di Capodimonte, Naples). It was common for artists to be inspired by works painted by other artists. Diego de Velázquez himself was inspired by Caravaggio's Bacchus when he painted his renowned work *The Triumph of Bacchus* (Museo del Prado, Madrid). Nonetheless, the great difference is that Ribera focused his attention solely on Silenus, who lifts his glass for it to be refilled, surrounded only by a boy, a donkey, and the god Pan.

Michaelina Woutiers, on the other hand, makes the scene much larger, achieving a work monumental both for its proportions and for the deliberately busy composition, with the many figures imbuing the canvas with vitality. The background is a wide landscape against which a trumpeter and a faun are outlined, the latter laboriously dragging the cart on which Bacchus, a fat, flabby, and drunken god, reclines. Pan, identifiable by his goat's legs, holds the cart accompanied by a donkey, fauns, nymphs, and cherubs playing with a goat kid. Woutiers brilliantly reflects the dynamic, playful entourage of Bacchus, the god of wine, who embodies a festival of senses, drunkenness, and passion. It is not surprising that this Italianized painting was part of the collection of Archduke Leopold William, a man educated to appreciate Italian tastes, with a serious, pensive character. He did not like lavish, decorative paintings, choosing instead works dense in artistic value, profoundly meditated and created for the connoisseur.

Bacchanal

oil on canvas
106 x 139.4 in (270 x 354 cm)
Kunsthistorisches Museum,
Vienna

The Education of Mary

(1656)
oil on canvas
57.9 x 48.8 in (147 x 124 cm)
Kunsthandel Hoogsteder &
Hoogsteder, The Hague

The canvas represents the Virgin Mary, still a girl, learning to read with her parents, Joachim and Anne. The apocryphal texts contribute information on the Virgin Mary's parents, explaining that they had deeply desired to have a child, but thought that Anne, who was growing old, was sterile because the couple had not succeeded in having children. The subject of the Virgin Mary reading is an invention from the Low Middle Ages, and in the 15th century, the female saints and the Virgin began to be represented with books in their hands, looking like avid readers. The subject was well received by the faithful because it reflected a palpable social reality: In the 15th century, it was the mothers who taught their children to read. For this reason, the scene of the education of Mary was widely accepted, women identified with it, and it continued to be painted until the 17th century.

Woutiers placed the figures against a classical background and prioritized the image of Mary, wearing a white tunic, evoking her purity, and a blue cape. The chiaroscuro illumination of this canvas is in a Caravaggiesque style, as is the naturalism of Mary's candid expression, contrasting with her mother's wizened facial features. The folds in the clothing are somewhat rigid yet contain movement, as in Anne's wide green tunic. Joachim's attitude, on the other hand, with a hand on his chest and looking up toward heaven, is quite theatrical. In this matter, Michaelina Woutiers followed the guidelines of the Counter-Reformation, which proposed decorous religious images—that is, images devoid of anecdotes, banalities, and superstitions and which, above all, would encourage the emotion, piety, and religiosity of the faithful. These premises, carried over to the creative terrain in which the emotions play a fundamental role, encouraged highly theatrical representations. Naturally, there were exceptional artists who succeeded with singular mastery in creating exciting, emotionally profound works within the dictates of the Counter-Reformation. Francisco de Zurbarán and Bartolomé Esteban Murillo are good examples. But in general, baroque art tended toward the spectacular and theatrical.

The Annunciation

(1659)
oil on canvas
78.7 x 52.8 in
(200 x 134 cm)
Musée Promenade
de Marly-le-Roi,
Louveciennes

This painting is from Saint-Vigor de Marly and for many years was attributed to the painter Pierre Bedeau, who in 1686 had executed a work for Louis XIV in Marly. One of the favorite subjects of Christian iconography is the Annunciation, in which the Archangel Gabriel informs Mary that God has selected her to bear a child by intercession of the Holy Spirit, as explained in the gospel according to Luke and the apocryphal texts. The version rendered by Woutiers is based on a Flemish tradition from the Low Middle Ages, i.e. from the 12th century, which places Mary in her bedroom on a kneeler with an open book before her. In Italy, on the other hand, the Annunciation was usually set in a portico that sometimes opened onto a garden. During the Middle Ages, there was a great variety in the representation of this subject. At times, a dove rested on Mary's abdomen; at others, the Holy Spirit was symbolized by a unicorn, a subject taken from an apocryphal text. But the most picturesque version was that executed by Martin Schaffner (Alte Pinakothek, Munich), in which an angel appears in the background, reduced to the role of servant making the Virgin's bed! As of the Council of Trent in 1563, the Church attempted to prevent, at all costs, a subject as transcendent as the Annunciation from being converted into a simple genre scene. This painting follows the post-Trent postulates of the Counter-Reformation, as the angel appears on a cloud and the dove flies through the air accompanied by rays of light, according to the dictates of the time. The colors in this canvas are striking, with a great contrast between the cobalt blue of Mary's cape and the intense red of the angel's tunic. With regard to the emotional aspect, Mary's natural pose, spreading her arms and showing the palms of her hands as a sign of acceptance, is remarkable. There is a great plasticity in the figures, despite the painting's monumental size.

Saint Joseph

(~1657)
oil on canvas
29.9 x 26 in (76 x 66 cm)
Kunsthistorisches Museum, Vienna

This painting belonged to Archduke Leopold William. It went with a Saint Joachim and was painted before 1659. The archduke felt great devotion for Saint Joseph, as did his grandmother, Eleonora Gonzaga. At this time, the image of Saint Joseph became very popular, a novelty in art history. The gospels hardly mention Saint Joseph, though he appears in all of the apocryphal texts narrating Jesus' childhood. These explain that Saint Joseph, having reached an advanced age, was selected as the chaste husband and protector of a 14-year-old virgin mamed Mary. During the Middle Ages, a great deal of emphasis was placed on the chaste, virginal role of Jesús' earthly father, in order to reinforce the idea that Mary became pregnant through the intercession of the Holy Spirit. Otherwise, Joseph was assigned a secondary, irrelevant role.

Medieval theater popularized the figure of Joseph, representing him as a ridiculous old man, a poor fool—a pathetic and denigrating image that lasted until the Renaissance. Beginning at the Council of Trent (1563), a great sensibility arose regarding such matters, and a campaign was begun to dignify the figure of Saint Joseph.

For this reason, the point of view is low in this work, which makes the saint appear lofty. Woutiers represents a man with a beard and rather unkempt hair, wearing simple clothes in somber earthtones. Nevertheless, the man's gaze has great dignity. He has a high forehead and, with his white beard and dark hair, is of indeterminate age. He holds a precious bouquet of lilies, an ancient detail taken from an apocryphal text that explains that Joseph was chosen as Mary's husband when his walking stick sprouted flowers, an unequivocal sign of his divine selection. Lilies symbolize purity and chastity, supporting the campaign to dignify Joseph begun by theologians in the 16th century. Woutiers placed the flowers in the foreground, obtaining a surprising effect through the contrast between the white petals and the dark tunic. Saint Joseph is represented with warmth and presence. Once again, the visual arts were faithful to the prevailing ideas of the time.

LOUISE MOILLON

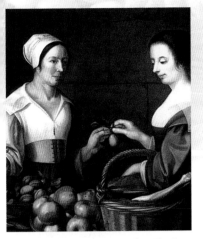

Market Scene with Pickpocket *(detail), oil on canvas, 45.7 x 65.2 in (116 x 165.5 cm), ~1630, Private collection.*

The still-life genre in France and the Netherlands during the 17th century embodied a rejection of religious art by Calvinists. Louise Moillon, a member of a Calvinist family, developed a pictorial style based entirely on an elaborate technique and the meticulous representation of objects.

Though Moillon was born in France, she soon became interested in the type of still lifes executed in the Netherlands. By the first half of the 17th century, the cities of Utrecht and Antwerp had become centers of the still life in oil on botanical subjects. In France, several painters, headed by Loupin Baugin, attempted to develop that realist style, though by Academic standards, the still life was considered unworthy of true artists. In the Netherlands, on the other hand, art had become a consumer item for the bourgeoisie, who had begun collecting porcelain, pieces in gold and silver, and small still-life paintings.

Moillon's realist art was based on her excellent capacity for observing the details of the natural elements she represented. The religious allegories that she executed based on simple fruit reveal thorough, detailed studies of botanical items.

One of the notable aspects of Moillon's painting is the combination of still life and figures. With the excuse of presenting a series of still lifes, the artist incorporates very elaborate, dignified, and elegant figures.

- **1610** Born in Paris, Louise is the first of seven children born to the well-off family of Nicolas Moillon, a portraitist and landscapist, and Marie Gilbert, the daughter of a goldsmith.

- **1619** Her father dies. Moillon had presumably begun to study painting in his studio.

- **1620** Five months after becoming a widow, her mother marries François Garnier, a painter and art dealer. Moillon adopts her stepfather's style, and she continues her artistic training with him.

- **1629** She sells her first painting, a small still life.

- **1630** She joins the circle of painters working clandestinely in Saint-Germain-des-Prés, a neighborhood of Paris where Dutch artists escaping religious persecution take refuge. Her mother dies this same year, and three still lifes painted by her daughter Louise appear in the inventory of her possessions. By this time, the artist is well known as a talented painter. She teaches ten students at her studio and, considering the quantity of commissions she receives from private collectors, begins to think of setting up a business to intensify the production and sale of her works. She paints *Basket of Fruit and Asparagus* (Art Institute of Chicago).

- **1640** In November, she marries Etienne Girardot de Chancourt, a Calvinist wood merchant from Paris with whom she will have three children. As with other female artists of her time (including Lavinia Fontana, Marguerite Bahuche, and Rachel Ruysch), her new situation leads to a considerable reduction of her pictorial production.

- **1641** Her first child is born.

- **1646** She comes into contact with the artists Georges de Scudéry and the brothers Linard and Pierre Van Bouche.

- **1648** She fails in her attempts to be admitted to the Académie Royal of Paris.

- **1680** Her husband dies.

- **1682** Paints the still life *Peaches and Grapes* (Musée de Strasbourg).

- **1685** The persecution of Protestants brings Moillon serious financial difficulty. A victim of religious harassment, she is obliged to convert to Catholicism to avoid being arrested and having her goods confiscated.

- **1696** Alone and abandoned, she dies in Paris.

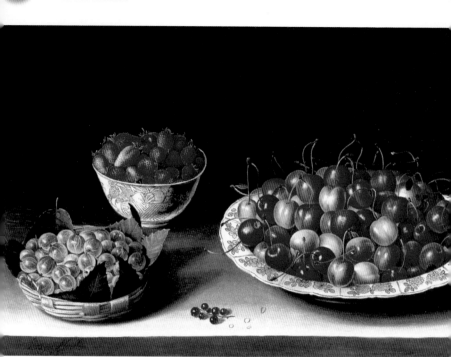

Still Life with Cherries, Strawberries, and Gooseberries

(1630)
oil on wood
12.2 x 19.1 in (31 x 48.5 cm)
Norton Simon Museum, Pasadena

Moillon experimented in this painting, representing different types of intensely colored fruit. She used a realist technique, attempting to create a composition in which the similarities of colors and forms would be aesthetically attractive. In this work, the artist, ignoring her French colleagues, sought the type of still life being executed in the Netherlands. With no symbolic connotations, the painting has been created as an exercise in observation and realism, creating a composition rich in color and balanced in tones. The decorative aspect of the work is remarkable as Moillon creates a more elaborate space than in her previous works. The scene is composed of three containers brimming with small fruit, all painted with great realism and distributed across a lit, highly defined surface used by the artist to experiment with depth and perspective. The absence of an elaborate, defined background focuses attention on the fruit. The formal complexity of each bowl of fruit contrasts with the simplicity of the empty space around it.

Right: Moillon introduces subtle religious details and symbolism. In this painting, the artist places the two female figures on a wholly separate plane of light that can be interpreted as an allegorical detail referring to the biblical episode of Christ in the house of Martha and Mary. The humbleness of the figures and their highly static poses lend the work a religious character, which Moillon uses to create a composition very different from her previous works. The scene recalls an experience that the artist had in London, rendered in a modern fashion with the figures carrying out their daily tasks in innovative positions. Moillon executed few works in the genre of portraiture, but when she did, she followed the patterns of her still-life compositions. Here, though the figures seem to be moving their hands, their placement in the center surrounded by fruit and vegetables makes the general character of the work static. The palette also recalls Moillon's fruit compositions. In the center, the seller acquires protagonism through her white shirt, below which is an elaborate world of colorful details in a scene with a characteristically dark background.

Market Scene with Pickpocket

(~1630)
oil on canvas
45.7 x 65.2 in
(116 x 165.5 cm)
Private collection

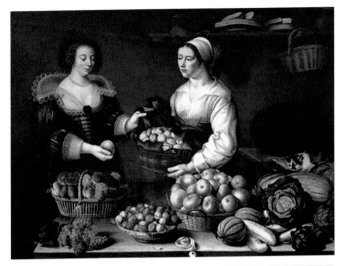

Moillon developed a style based on realism that found no response in her native France. The still lifes that were so widely admired in Flanders complied with neither the demands of the French public nor of the Academy, which was much more interested in the portrait genre. Moillon attempts to unite both genres in this painting, composing a scene in which the two female figures share protagonism with a bountiful exhibit of produce. The colorful fruit, executed in meticulous detail, constitutes a completely independent scene. The compositional structure used by Moillon is striking for the absence of a homogenous visual trajectory. In executing a scene with a story—the contrast between the humble fruit seller and the elegant opulence of the lady—plus a complex, highly realistic fruit-and-vegetable still life, the artist has created two compositional areas that can be observed separately. To avoid breaking this visual trajectory, Moillon uses light and color as structural elements, distributing the different elements throughout the painting to attract the viewer's attention to both scenes.

The Fruit and Vegetable Monger

(1630)
oil on canvas
47.2 x 65 in
(120 x 165 cm)
Musée du Louvre, Paris

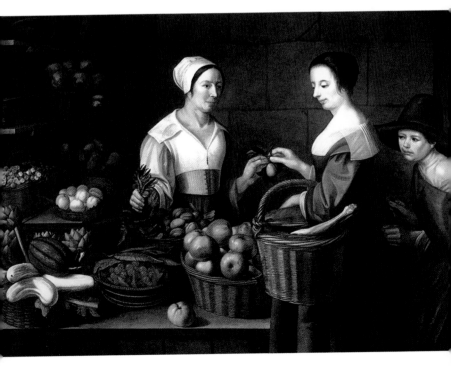

Basket of Fruit and Asparagus

(~1630)
oil on wood
Art Institute of Chicago

Moillon dedicated a substantial part of her artistic production to executing still lifes with fruit and other produce as the principal motif. They are bountiful images, as in this painting, that indicate the artist's interest in rendering exuberance. This work, however, is not oppressively congested nor unbalanced in composition or color. Moillon applies an intense black background to enhance the relief of the fruit, whose masses are well balanced in a symmetrical structure executed with a great deal of color and realism. The dark background contrasts with the well-lit foreground of the table, while the poetry and dynamism of the fruit find a counterpoint in the bundle of asparagus. With such superb results, it is not surprising that the artist was already famous by this time, despite her youth—she was just 20 years old when she painted this still life.

Moillon's aesthetic style produced works apparently lacking in metaphysical meaning. In most of her paintings, the artist dispenses with the allegorical meanings of flowers or fruit and simply represents what her eyes see. In this painting, she distributes the elements in search of a balanced composition. On the wooden table is a porcelain bowl filled with cherries. Next to it are some pears and a sliced melon. The visual trajectory along the surface of the table is interesting due to the incorporation of very different tones that are balanced by the varied colors. The red of the cherries in the center of the painting becomes the protagonist, which Moillon projects downward through the brilliance of the ceramic bowl. The grayish green of the pears on the illuminated table is interlaced with shadows that increase until they lose themselves in the background, while the intense orange of the melon completes the visual path in an exercise in meticulous detail and compositional balance.

Bowl of Cherries and Melon

(1633)
oil on canvas
18.9 x 25.6 in (48 x 65 cm)
Musée du Louvre, Paris

Basket with Peaches and Grapes

(1631)
oil on panel
18.9 x 26.8 in (48 x 68 cm)
Staatliche Kunsthalle, Karlsruhe

Left: In this work, Moillon plays with the symbology of fruit, creating an allegory of good and evil. During the 17th century, peaches were considered a variety of apple and therefore represented original sin and evil. The grape, on the other hand, was the source of eucharistic wine, a symbol of good. This juxtaposition of good and evil in the same basket evokes the idea of the moral decision that the human being must make between the two. Curiously, peaches were also long considered a preventive element against the effects of too much wine. These various allegories, used by Moillon to create a deeper level of meaning in her art, contrast with the simple aesthetic vision that she usually lent her still lifes. It was the influence of Dutch painting, much more immersed in an intentional use of allegorical meanings, that led the artist to create such works.

Basket with Apricots

(~1635)
oil on panel
15.7 x 20.5 in (40 x 52 cm)
Mr. & Mrs. François Heim, Paris

Moillon's fruit paintings correspond to a decorative sense in which the work appears to be a simple exercise in aesthetics. The different types of fruit represented by the artist throughout her artistic career show her interest in the different botanical species, which in many cases appear whole or split in half. In this painting, the apricots appear in three different stages, as they would in a scientific study. In front of the exuberant basket of fruit is an apricot split in half, showing its interior with and without the pit, while another two are portrayed on the right still on the branch with leaves. The scientific sense that still lifes from Flanders and the Netherlands acquired during the 17th century was due to the interest in nature existing there. The city of Antwerp was characterized during the 16th and 17th centuries for its tradition of publishing books on botany. Moillon, attracted by this duality of meaning in Flemish and Dutch still lifes, experimented with the artistic possibilities of natural studies. Her works on fruit and vegetables are like catalogues, much like those of the Flemish painter Brueghel de Velours, who executed an extensive range of floral paintings in which he exhibited an endless variety of flowers in large bouquets and garlands.

Fruit

(1672)
oil on panel
17.3 x 22.8 in (44 x 58 cm)
Musée des Augustins
Toulouse, France

The term "still life" first appeared in Flanders about 1650. Before that, small-format still lifes, floral motifs, or botanical subjects were titled according to the image they represented, but there was no term for the genre itself. Another painter, Clara Peeters, introduced a type of still life she generically called "breakfast pieces." This type of still life, often showing fruit and rolls or pastries, was widely accepted among the middle classes, promoting consumer art removed for the first time from the royal courts and the Church. Demand for such paintings encouraged many artists to specialize in this genre, including Louise Moillon, who, in view of the contempt she received from French academicists, took her art to the Netherlands. In this painting, as in many of her compositions, Moillon used light to make fruit appear shiny, experimenting with the effect of light and shadow. In this case, the light source is from a single lateral point outside the painting, and the artist has immersed the scene in a dense chiaroscuro that dims the intensity of the colors. She plays with the forms of the fruit peeking out of the darkness.

JOSEFA DE ÓBIDOS

Mystical Wedding of Saint Catherine *(detail),*
oil on copper, 11 x 14 in (28 x 35.5 cm),
1647, Museo Nacional de Soares dos Reis,
Porto, Portugal.

- **~1630** Born in the neighborhood of the San Vicente Parish in Seville. Daughter of the Portuguese painter Baltasar Gomes Figueira and Catalina de Ayala y Cabrera, who was Spanish.

- **1634** In the month of April, the family leaves Seville and moves to Óbidos.

- **1644** She studies at the Augustine Convent of Santa Ana in Coimbra.

- **1653** Returns to Óbidos and lives with her family in a house on the street called Rua Nova. Later, she moves to a manor house that belongs to her, called Quinta da Capeleira.

- **1684** On July 22, dies in her manor house in Óbidos. She refused to marry, as indicated in her will.

Josefa de Óbidos was a baroque painter active during the second half of the 17th century. She gained great renown in Portugal and won a privileged place in the history of art through her still lifes. Born to a family of artists, her father was a tenebrist painter of altarpieces and still lifes who trained in Seville. Her maternal uncle, probably Bernabé de Ayala, was a follower of Francisco de Zurbarán, and her godfather, Francisco Herrera the Elder, painted religious scenes. Her Sevillian grandfather had a significant collection of paintings, and her sister married a Portuguese painter.

In 1634, the family moved from Seville to Óbidos, a village in the Portuguese province of Extremadura. Josefa owned a manor house, Quinta da Capeleira, located on the outskirts of the medieval town of Óbidos, where she divided her time between painting and her duties as a landholder.

She attained great fame as a painter in her time and she even allowed herself the luxury of rejecting offers from the Portuguese court because she did not want to leave her manor house in Óbidos.

Dãmiao Froes Perym wrote about her in 1734 in his book *Theatro Heroino...Datálogo das Mulheres Illustres.* "Josefa was visited by many women...who wanted to speak with her, see her paint or have their portraits painted by her."

Her religious works emanate devotion and tenderness, her nonreligious oeuvre is jovial, and in the majority of her paintings, the colors shine strongly. Her compositions indicate that she knew narrative texts well and, like her contemporaries, was inspired by Spanish art and Flemish engravings. She painted religious scenes, altarpieces, still lifes, miniatures, and portraits, and she also mastered etching.

The year 1670 began her most productive decade, and her reputation insured that she received important commissions, especially from religious orders.

Her extensive work is distributed among different museums in Portugal and various private collections. She was always very careful to sign her works and preferred to use her mother's last name, Ayala.

Though she developed her own artistic style, it is clear from her paintings that Zurbarán, a master from the Spanish Golden Age, profoundly impressed her.

Mystical Wedding of Saint Catherine

(1647)
oil on copper
11 x 14 in (28 x 35.5 cm)
Museo Nacional de Soares dos Reis, Porto

This copper plate is one of Óbidos's first works and the quality is notable. The story of Saint Catherine recounts that a hermit showed her an image of Jesus and suggested she take him as her only husband, as he would be worthy of a young woman of such high birth, as beautiful and intelligent as she. This gave rise to the legend of the Mystic Nuptials in the mid-15th century, but which was not present in the first version of *The Golden Legend* by Lacopo da Varaze (1266), a book of stories about the lives of religious figures.

Seventeenth-century literature considered the story a vision, and the recommended iconography at that time, with its moralistic criteria, was to represent the divine groom as the Child Jesus in the arms of his mother, as in this painting. Óbidos frames the scene in red drapery, and a window illuminates the room with neither chiaroscuro nor dramatic light.

This naturalist scene represents Mary, the mother of Jesus, her cousin Isabel, and a tender Child holding Saint Catherine's hand. Catherine is wearing a luxurious cape embroidered in gold thread that spreads onto the floor yet leaves the spiked wheel of her martyrdom in view. In the background, two angels and Saint Joseph, reclining on a chest, contemplate the mystical wedding. Both Mary's and Catherine's faces are oval, with straight noses, small mouths, rosy complexions, and thin, arched eyebrows over dark eyes. This type of face resembles the Virgins painted by Zurbarán, for example, in his *Christ and the Virgin in the House of Nazareth* (Museum of Art, Cleveland, Ohio). Óbidos's work often includes everyday details, such as a sewing basket or a pet, frequently found in baroque painting of Flemish tradition. This early work emanates sweetness and religious fervor, and the palette is remarkable for its wide range of colors and tones.

The altarpiece to which this scene belongs was an important commission in the artist's career. In addition to this panel, Óbidos painted four more scenes: *The Coronation of Saint Catherine, The Mystical Wedding, The Penitence of Mary Magdalene,* and *The Inspiration of Saint Theresa of Ávila.* The entire work made up an altarpiece dedicated to Saint Catherine of Alexandria. The legend of this saint originated in the Near East and gained force in the 9th century, when monks found her relics in a monastery in the Sinai. The Crusaders spread the story, propitiating her worship throughout Europe. Catherine of Alexandria, the daughter of a king, was renowned for her beauty and precocious wisdom. Emperor Maxentius proposed matrimony, but she rejected him, stating that she was "the wife of Christ." As usual in hagiography, the emperor had her tortured, subjecting her to dismemberment by two spiked wheels, which broke due to divine intervention. The emperor then decided to decapitate her.

Saint Catherine Reasoning with the Doctors

(1661)
oil on canvas
Iglesia de Santa María de Óbidos, Portugal

The scene shows Catherine wearing pearls and a crown, as appropriate for a princess, having a discussion with some wise men. Within a clearly emphasized hierarchy, she defends her faith in the gospel with philosophical arguments, as evident in the gesture of her right hand. The doctors open their arms, surprised at the young woman's words. The story goes that the saint's words convinced the men, who converted to Christianity and were thus sentenced to be burned to death. Óbidos places Catherine at the peak of a pyramidal composition, achieving a theatrical result. The treatment of light reinforces the image, with a strong illumination of the saint's pink tunic that stands out against the dark drapes and contrasts with the austere ochres, browns, and blacks worn by the men. Nevertheless, the flaming red of a turban and one of the tunics breaks the somber color scheme and balances the composition.

Josepha em Obidos.

Right: This work is impressive for its elegance and beauty. Óbidos represents a series of objects against a completely black background, in keeping with the Spanish taste and as Sánchez Cotán had done. The weight of the composition lies on a tray replete with marzipan and other sweets, partially covered with napkins, and on a red terra-cotta jug decorated with ribbons and flowers. In the foreground are a silver sugar bowl with a gold spoon, a box of candies, and another red earthenware vessel resting on a floor covered in candy, flowers, and loose petals. The light strikes the objects strongly, making them much more attractive. There is an interplay of reds and whites that confer life, joy, and force. The abundant tray of marzipan, the overflowing sugar bowl, the box full of candy, and the profusion of delicate little flowers are factors that help create an exuberant, generous space.

This canvas shares the violent light and black backgrounds of Spanish still lifes. Like Flemish still lifes, it contains a seductive exhibition of objects, desserts, and flowers, but the results are very different. The studied composition of these objects within the space, their accentuated horizontality, the treatment of light, and the joyful daring of the reds and whites produce a still life that is far removed from conventional models. Óbidos created an exquisite, captivating, and profoundly original work.

Still Life

oil on canvas
17.7 x 26.8 in (45 x 68 cm)
Museu Nacional de Arte
Antiga, Lisbon

Left: Represented in this painting, on a horizontal axis, are two boxes of sweets and a jar of honey. On a vertical line are a jug hanging from a ribbon and a red earthenware bowl. These objects are modest and commonplace. At this time, such terra-cotta pieces were ubiquitous, a typical product of Guadalajara, Mexico, imitated by the population of Extremoz in Portugal. In this painting, it is believed that Óbidos was inspired by a work by a Spanish painter of Flemish origin, Juan van der Hamen. Indeed, Van der Hamen executed a still life in 1621 with a similar composition, today at the Fine Arts Museum in Granada. But there are significant differences that reveal Josefa de Óbidos's individuality. Van der Hamen distributed the space into two well-defined masses: a jar of jam on two boxes of sweets and an earthenware jug with a spoon breaking the symmetry. In Óbidos's canvas, the compositional lines form a cross, its vertical axis saturated in terra-cotta reds while the horizontal one contains whites, beiges, and browns. In any case, the simplicity of this work is imbued with the mysticism of Spanish still lifes. The light circulates freely throughout the canvas, enveloping these commonplace objects in an aura of mystery that makes them distinctive in the eyes of the viewer.

Still Life with Sweets and Flowers

(1676)
oil on canvas
33.1 x 63.2 in (84 x 160.5 cm)
Biblioteca-Museo Braancamp,
Santarém, Portugal

The Mystic Lamb

oil on canvas
34.6 x 46.3 in (88 x 117.5 cm)
Museo Nacional de Évora,
Portugal

The lamb is one of the most ancient symbols in Christian iconography. It was adopted by the first Christians as a symbol of Christ on his mission of sacrifice to redeem humanity. Óbidos represents the Lamb of God, surrounded by a wreath of flowers, under the gaze of a cherub extending its wings. The painting contains the inscription OCCISUS AB ORIGINE MUNDI (Deceased since the beginning of the world), referring to the redemption of humanity through Christ's sacrifice. The Museo del Prado, Madrid, and the Fine Arts Gallery of San Diego each have an Agnus Dei executed by Francisco de Zurbarán, whose greatest success lay in lending an ancient Christian symbol monumentality. Óbidos's mystic lambs are derived from the model created by Zurbarán. One of them is at the Walters Art Gallery in Baltimore, the only painting by Óbidos in the United States. Edward J. Sullivan, an art historian, believes the painting in Baltimore is probably earlier than this one, which is much more ornate.

Unlike Zurbarán, Óbidos surrounds the Agnus Dei with roses and lilies, perhaps as symbols of purity and chastity. Furthermore, under each of the cherub's wings is a bunch of red and white grapes. Luis de Moura Soubral, another art historian, believes this fruit has a symbolic meaning. According to him, the white grapes allude to the water that poured forth from Christ's wound, as John the Evangelist recounts, and the red grapes evoke the eucharistic wine. All of these ideas and references revolve around Christ's sacrifice to redeem the sins of the world. In any case, and despite Zurbarán's model of the lamb, Óbidos demonstrates her own artistic personality and creates a devotional image that emanates candor and beauty.

MARIA VAN OOSTERWIJCK

Vase of Tulips, Roses, and Other Flowers (detail), oil on wood, 18.6 x 15.1 in (47.3 x 38.4 cm), 1669, Cincinnati Art Museum.

- **1630** Born on August 20 (according to some, the 27) in Nootdorp, near Delft, the daughter of a Protestant preacher. At a very young age, her father takes her to the studio of the still-life painter Jan Davidsz de Heem, through whom Maria would discover her interest in flowers and her capacity for creating a vivid, realistic style.
- **1658** Records show that the artist is working professionally with Jan Davidsz de Heem, her teacher, at this time.
- **1667** Executes her first independent professional piece.
- **1669** Jan Davidsz de Heem leaves the studio and moves to Antwerp, where he resides until returning to Utrecht in 1672, which implies a change in Van Oosterwijck's professional life, allowing her to work independently. There are several dated paintings by her from this period.
- **1672** Moves to Amsterdam.
- **1685** Executes a still life that is now housed in the Royal Museum in Copenhagen.
- **1686** Paints a still life (Collection of Her Majesty. the Queen, Kensington Palace, London).
- **1689** Executes her last known work, a still life (Collection of Her Majesty. the Queen, Kensington Palace, London).
- **1693** On November 12 (according to some sources, December), she dies in her home in Uitdam, north of Amsterdam.

Having studied under Jan Davidsz de Heem, Maria Van Oosterwijck painted in the tradition of Flemish specialized art. Like her teacher, her interest in flower compositions and allegorical still lifes led her to focus on that genre at a time when it was in high demand in Central Europe.

Van Oosterwijck's art is characterized by a detailed description of the different elements rendered in her works and by the use of luminous colors. Her floral compositions reveal an independent style with a prevailing monumentality (monumental paintings, though relatively small in size, "feel" large and compelling), free of any narrative intention. On the other hand, her ability to create allegorical still lifes with studied compositions far surpasses the evident symbolism appearing in de Heem's work. This characteristic, though little exploited by the artist, is manifested in her profound study of the effects of light and shadow, with a clearly Caravaggiesque air that recalls 16th-century Flemish painting.

Considered the most distinguished painter of still lifes in the Low Countries, along with Rachel Ruysch, her work earned her great admiration among the bourgeoisie and courtesans. Among her clients were King Louis XIV of France, Emperor Leopold, William of Orange, Queen Mary, and Augustus II of Poland—a list that reflects her fame and high esteem.

Still Life

oil on wood
17.7 x 14.6 in (45 x 37 cm)
Private collection,
London

The influence of Caravaggio's chiaroscuro technique on Dutch painters is evident here, in the use of shadow to define the contours of objects and to create the illusion of space. Van Oosterwijck meticulously paints the grapes using light and color, creating a visual space based on the sensation of volume perceived through the round shape of each grape. The evident symbolism of the work is accentuated through a religious reading of the grapes. In many baroque, Central European works, they carry a religious connotation because grapes are used to make the eucharistic wine. Here, the bunch of grapes hangs gracefully, tied with multicolored ribbons at the top of the painting in a clear allusion to the characteristics of Jesus when he drank the cup of his passion: the white of innocence, the yellow of divinity, and the red of martyrdom.

Van Oosterwijck augments this allegorical meaning by placing two brightly lit flowers prominently. One of them is like an eye, observing the viewer with a steady gaze as if it were a portrait, thus becoming the focus of attention. This flower can be associated with the moral idea of a God who sees and scrutinizes everything, and whose appearance is disturbing. To complete the composition, the artist places a single, wilted leaf, falling toward the ground as if it were fainting, representing the ephemeral nature of all worldly things.

The apparent mixture of sensuality underlying form and the moralizing intent of this work illustrates the style of still lifes in the Netherlands in the 17th century. Like de Heem, who had become a master of allegories, Van Oosterwijck incorporated symbolic elements in some of her works. The still life was born in the Low Countries in the year 1600 or so, when a new vision of art arose that freed it from religion. There was a new conception of historical painting incorporating more commonplace and anecdotal subject matter such as kitchen or living-room scenes, the richness of a fruit and vegetable market, or simply the floral diversity of the country. Though Van Oosterwijck's extant identified works number no more than twenty or so, the majority of them floral compositions, her biographer, Arnold Houbraken, has determined through study of historical material that the artist executed many still lifes.

In this painting, Maria Van Oosterwijck represents different objects characteristic of 17th-century Flemish and Dutch iconography, all of a markedly allegorical nature. This vanitas is a very specific type of still life, highly stereotyped among artists of the time. Vanitas are paintings of great symbolic force that serve the moralizing function of recalling the ephemeral nature of all that is worldly. Hence, such works often include books and objects of learning, portraits, flowers, and even skulls.

Vanitas

(1668)
oil on canvas
28.7 x 34.8 in
(73 x 88.5 cm)
Kunsthistorisches
Museum, Vienna

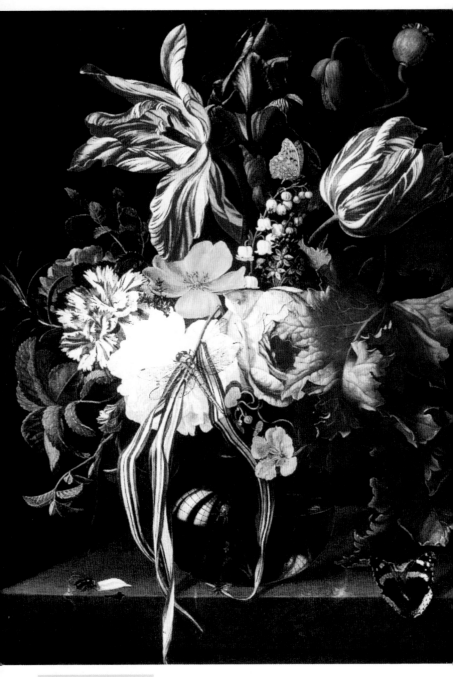

Vase of Tulips, Roses, and Other Flowers

(1669)
oil on wood
18.6 x 15.1 in
(47.3 x 38.4 cm
Cincinnati Art Museum,
Ohio

Left: A passion for flowers as an object of botanical study, as artistic details, or simply as a decorative elements, arose in the Low Countries in the 16th century. It was at this time that importing exotic flowers from the Near East, Asia, or the Americas became commonplace and familiar to those in every class. The first tulips appeared in Europe, quickly arousing a great passion in the Netherlands and Flanders, and they became a frequent motif in art.

The combination of the pictorial tradition of Dutch and Flemish masters with an element as modern and sophisticated as this new flower from distant lands made floral still lifes a popular genre, giving rise to a large group of true specialists. Two of the most preeminent were Van Oosterwijck and Rachel Ruysch. The floral still life was an ideal genre for the society of the Low Countries, as a single work combined the essence of beauty with the ephemeral nature of worldly goods. Van Oosterwijck developed the genre, transforming it into a realist exercise that sought to re-create the trompe l'oeil of the great 16th-century Dutch masters. The realism of floral still lifes was adopted by some artists to show off their technical abilities, though they were often criticized for becoming "mere imitators" of nature.

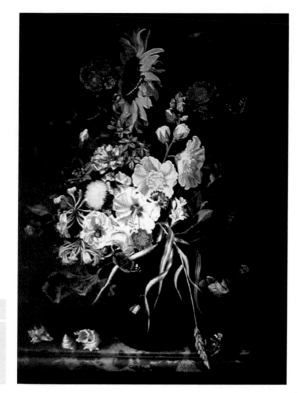

Flowers and Shells

(~1680)
oil on canvas
Private collection

Jan Davidsz de Heem was born in the Netherlands in 1606, and his style had a great influence on 17th-century Flemish art. Specializing in still lifes and floral compositions, de Heem had studied the technique of Van der Ast, Pieter Claesz, and Willem Heda, executing his works in an unusual tonal style with a nearly monochromatic palette. Van Oosterwijck, who acquired de Heem's ideas on color and tone, admired and assimilated her teacher's capacity to create a luxurious, magnificent still life in the small format typical of Flemish painting in the 17th century.

In this painting, the insects constitute an allegory of evil while the flowers are symbolically related to God. Van Oosterwijck created a vertical composition that culminates in the brilliance of the yellow-and-orange sunflower in the center. The entire painting becomes a mystical representation of good and evil, rendered in a simple and comprehensible manner. An intense light enhances the beauty of the flower in the upper area, while the light dims as the viewer reaches the bottom of the painting and the small, worldly insects. This is a very characteristic painting, a prototype for what was being produced in the Netherlands and Flanders in the 17th century, which followed allegorical standards and reached its greatest splendor in the still life.

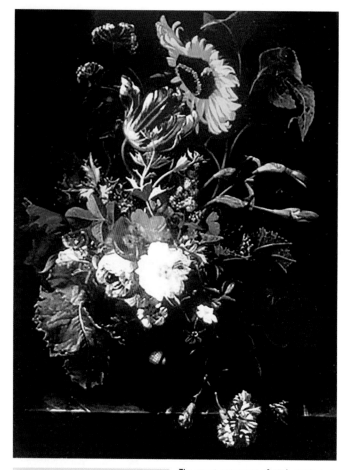

Bouquet of Flowers in a Vase

(~1670)
oil on canvas
29 x 22 in (68.5 x 52.9 cm)
Denver Art Museum, Colorado

The great precursor of 17th-century genre painting was Pieter Brueghel the Elder, who, with his paintings of banquets and interiors, had managed to awaken the enthusiasm of the public for the small, highly decorative paintings produced in Flanders in the 16th century. The still life had reached its apogee, thanks to the interest that the bourgeoisie showed in acquiring and collecting these paintings. Artists had realized that large, monumental works could only be afforded by the state or church, which limited sales. This motivated professional artists to devote themselves fully to the production of small-format works.

In this small work, the artist's personal compositional style, in which the flowers cover the great majority of the surface area in an apparently disorderly and asymmetrical manner, seeks to create movement and vividness based on the details of color and shadow dispersed throughout the work. In her paintings, Van Oosterwijck often used a dark background to enhance the brilliance of her compositions. The artist's treatment of light allowed her to play with the tones in the different flowers, distributing them throughout the composition according to their chromatic qualities. In this painting, she concentrated various light-colored flowers in the center as a focus of attention. The flowers in the upper area, crowning the bouquet, on the other hand, are striking for their independent illumination, lending them a moralizing aspect accentuated by their upward movement—that is, toward God.

MARY BEALE

- **1633** Mary Cradock is born in Barrow, Suffolk, the daughter of John Cradock, the rector of Barrow.

- **1643** Her mother died.

- **1652** On March 8, she marries the painter Charles Beale.

- **1654** Her first child dies.

- **1656** Her son Bartholomew is born. Moves with her family to Covent Garden, London, where she begins her artistic career as a semi-professional.

- **1660** Her son Charles is born.

- **1670** She establishes herself professionally as a portraitist. Her husband becomes her representative and assistant after losing his comfortable job in a patent office.

- **1699** Dies in her home in Pall Mall.

Self-Portrait, (detail), oil on canvas, ~1675, Manor House Museum, Kettering, UK.

As a response to the elaborate mannerist portraiture style, a new portraiture model based on plainer composition arose during the course of the 17th century. The new style, focusing on the figure and its personality, put less emphasis on the details and additions of earlier portraits. The simpler look was especially popular in the Netherlands, where many portrait artists established themselves, taking advantage of the flourishing economy and the financial well-being of the upper middle class.

Something similar occurred in England beginning in the 17th century, when art acquired a new value, reaching beyond court and church circles. With this appeal to a more modest clientele, the number of professional artists specializing in small-format paintings and in portraiture increased considerably.

Mary Beale established herself as a professional portraitist after many years as an amateur. At first she executed small portraits of relatives and friends, but when the patent office where her husband worked closed, she considered the possibility of dedicating herself exclusively to painting in order to earn a living for the family.

Beale's portraits were well received by the public, and she became a prestigious artist thanks to her realism and expressiveness. She adopted a classical vision approaching the Dutch portraiture style. Her paintings were based on compositional sobriety, which she used to emphasize the sitter's gestures and expression as her principal objective.

Charles Beale

(1663)
oil on canvas
9.5 x 8.3 in
(24.1 x 21cm)
National Portrait
Gallery, London

In this portrait of her husband, the artist experimented with different formal aspects. An octagonal format was used by various artists of the period to lend their works greater distinction. Charles Beale is rendered in an obscurantist composition in which only the face is visible. This austere use of light became a recurrent resource employed by the artist to enhance the expressiveness of her paintings. The strong contrast of tones created between Charles's face and the background lends the figure greater luminosity without the artificiality of excessively bright illumination.

Beale studied the different effects produced by the light striking the figure's face, adapting the whole to reinforce the apparent intensity and brilliance. This style, frequent in Beale's early works, was gradually replaced by a more decorative sense. The development of complex backgrounds, which produced a more elaborate and complete portrait, led the artist to experiment with different visions that allowed her to move away from the obscurantist aesthetic of her early works.

George Saville

(1674-1676)
oil on canvas
49 x 39.5 in (124.5 x 100.3 cm)
National Portrait Gallery, London

In England, portraits of the aristocracy were part of a long artistic tradition that reached its zenith in the artwork of Antoon Van Dyck, whose traditional vision was adopted in this work. Yet the intimate refinement of this portrait of the first Marquis of Halifax also reveals the clear influence of the work of Peter Paul Rubens in the stylization of forms and the more sophisticated compositional approach. The rivalry between Rubens and Van Dyck produced an interesting effect in young English artists, giving rise to a type of artwork that reinterpreted both great masters' styles.

The influence that the two artists exercised in England was a consequence of the distance created in Europe between the Reformist Church and that of the Counter-Reformation, which had given rise to two different mentalities, two styles, and two different markets for art. England, the Netherlands, and Flanders were within the same cultural sphere. During the 17th century, the majority of artists worked on commission and by contract, and the aesthetics of Rubens and Van Dyck, highly esteemed among clients, were in permanent demand. Beale opted for a symbiosis of the two artists' styles: On the one hand, she adopted Van Dyck's aesthetic in the composition of the scene, but on the other hand, the style in which the figure is portrayed is clearly closer to Rubens.

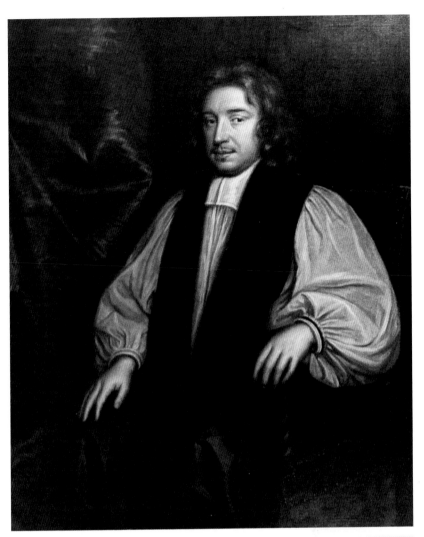

This portrait clearly defines the characteristics of a specific period in Mary Beale's career. Like many other portraitists, the artist created a standard model that she adapted to all of her portraits with slight variations. It was a sample of the type of portrait she executed and offered to her clientele. This prototype constituted the basis of her commissions, which the clients either accepted "as is" or, prompted by the artist herself or of their own accord, requested the inclusion of a specific detail or characteristic that they had seen in other works.

John Wilkins

(~ 1670)
oil on canvas
48.8 x 39.4 in
(124 x 100 cm)
Bodleian Library, Oxford

The figure represented here is an Anglican ecclesiastic. The artist created a dark background that differs from other works in that it is not plain. There is a dark red cloth that lends the background texture, enriches it in a restrained manner, and creates a reference to the dignity and noble status of the sitter. It also provides a dark tone perfect for making the well-lit figure stand out and for capturing the spectator's undivided attention. Logically, the greatest intensity of light strikes the subject's face, here framed by an abundant head of curly hair. The light gives rise to a series of shadows that lend the facial features and other details great realism. The concern for the formal and technical aspects of the work did not eclipse the artist's interest in rendering the figure's character and expression, and the posture and execution of the hands contribute to this. The texture of the garments, the treatment of the folds, and the light and color on the cloth are simply magnificent. The compositional scheme, the palette, and the study of the figure make this portrait a work of great balance and expressive force.

Young Woman

(1681)
oil on canvas
21 x 18 in (53.5 x 46 cm)
Tate Gallery, London

As Mary Beale's artistic career advanced, her pictorial quality increased through a more meticulous treatment of space and growing attention to detail. In her first paintings, the artist gained all of her expressive force from a marked chiaroscuro, employing strong contrasts and the effects of light to emphasize the figure's face and expression. Later, during the 1670s, she began to move toward a more decorative and complete style.

In this painting, the artist renders a young woman in profile looking toward the right. The woman seems to observe the viewer discreetly from the corner of her eye. There is a considerable difference in conception, aesthetic, and technique between this portrait and those by her husband or by George Saville. The figure is sophisticated, somewhat distant, and idealized. There is a marked interest in representing her with a beauty that does not go unnoticed by the viewer. Indeed, it attempts to capture the viewer's full attention and sentiments.

Beale thus treated the very last detail with great care, from the complexion to the facial features, sophisticated and modern coiffure, and the somber, elegant, and distinguished dress made of expensive fabric. The care with which the artist executed the facial features in order to convey a specific expression is enhanced by the dress. Its soft white combines perfectly with the sitter's delicate skin and creates a strong contrast with the black silk scarf. The folds of the scarf give rise to an interesting interplay of light and shadows, acquiring a sense of texture accentuated by the fleeting highlights of the fabric. Similarly, for the model's bare shoulder, Beale used the effect of the light to transmit the tactile sensation of the young woman's skin.

A new element is introduced in this painting: The posture adopted by the woman is neither random nor circumstantial. The artist's attention to detail serves to intensify the artist's efforts to create an image with a dual reading in which elegance is combined with sensuality, an attitude of distance with subtle flirtatiousness, and the delicate beauty of skin and dress with refined eroticism, all conveyed by placing the principal point of light on the model's shoulder and stylized neck. The artist gathers the woman's hair on top of her head in order to reveal her rosy cheeks and best use the effect produced by the light as it strikes her skin.

ELISABETTA SIRANI

Self-Portrait *(detail), oil on copper,
Pinacoteca Nazionale, Bologna.*

During and following the Counter-
Reformation, female professional artists pro-
liferated in Bologna. Sirani is considered one
of the initiators of this group of artists,
active in Bologna during the 17th century.

As most female painters of the time were
not admitted to academies, she trained in
the studio of her father, a follower of Guido
Reni.

Sirani's work reflects familiarity with clas-
sical antiquity and a profound knowledge of
the most distinguished artists of Rome,
Florence, and Bologna from the 16th and
17th centuries. She was influenced by the
artists belonging to the Bolognese Academy
of the Carracci, such as Guido Reni and
Francesco Albani. Like theirs, Sirani's work
shows an elegant and refined classicism.
With her direct organization, the lyrical qual-
ity of her paintings, and her use of light and
dramatic movement, she is a clear exponent
of the baroque.

Sirani interpreted classical themes in an
intimate and personal manner. She also cre-
ated works based on her own ideas, earning
her great recognition and eventually leading
to her being considered an equal of male
artists of her time. She most frequently
painted mythological, allegorical, religious,
and historical scenes, to which she con-
tributed naturalism, tenderness, elegance,
and, above all, a virtuoso brushstroke and
chromatic sensuality. Her recognition
throughout Europe was due to her talent and
skill as a portraitist, especially of women.

- **1638** Born in Bologna, the daughter of the
painter Giovanni Andrea Sirani, who was a student
of Guido Reni. She studies voice, the harp, and poet-
ry composition, as well as the Bible and mythology.
As she shows promising talent, the art collector and
director of the Academy of the Nude, Count Carle
Cesare Malvasia, intercedes, asking her father to
teach her painting and take her into his studio. Her
two sisters, Ana Maria and Barbara, also study with
her father and later with her.
- **1655** Begins her professional career. Her father
retires due to arthritis, and Elisabetta begins to direct
the studio and becomes the breadwinner of the fam-
ily. From the beginning, she keeps records of her
works, which are posthumously published in 1678 by
Malvasia in *Felsina Pittrice, Vite de Pittori Bolognesi,*
where approximately 150 paintings by her appear.
- **1657** She begins working on her first commis-
sion, *The Baptism of Christ,* a large-format mural
painting for the charterhouse of San Girolamo della
Certosa in Bologna, which she completes in the fol-
lowing year.
- **1658** Opens her studio to other women, whom
she accepts as students, an extraordinary occurrence
for the 17th century. Thanks to training in her studio,
artists such as Ginevra Cantofoli, Vincenza Fabbri,
Vincenza (or Veronica) Franci, Lucrezia Scarfaglia,
Elisabetta's sisters, and several others learn the pro-
fession, and in a short time, Bologna becomes an
important center of women artists. Works by these
artists are distributed today throughout various
churches and convents in Bologna and its province,
and some can even be found on Malta.
- **1660** Commissioned by Giambattista Cremonese,
she paints *Saint Jerome* and *Mary Magdalene,* both
at the Pinacoteca Nazionale in Bologna.
- **1662** Paints *Saint Anthony of Padua* (Pinacoteca
Nazionale, Bologna).
- **1663** On commission by Paolo Poggi, she paints
Virgin and Child (National Museum of Women in the
Arts, Washington, D.C.).
- **1664** She has become so famous that Prince
Leopold of Tuscany commissions her to paint his
portrait. Grand Duke Cosimo III de Medici visits her
studio and commissions a painting of a Madonna.
- **1665** Executes the portrait of Ana Maria Rasuzzi,
her last work (Casa di Risparmio, Bologna). In August,
at the age of 27, she dies in Bologna. There is much
conjecture concerning the cause of her untimely
death (grief, lovesickness, poisoning), though she
probably dies of an ulcer. Receives a ceremonious
burial. Her tomb is in San Domenico, Bologna, next
to that of Guido Reni.

Judith Holding Holofernes' Head

(1660)
oil on canvas
92.9 x 72 in (236 x 183 cm)
Walters Art Gallery, Lakeview
Museum, Peoria, Illinois

This monumental work is one of Sirani's most important paintings. The subject is taken from the Book of Judith, which was very popular during the Renaissance. It describes the liberation of the Israelites in their struggle against the Assyrian army of Nebuchadnezzar, whose commander in chief, Holofernes, had besieged Betulia. He was slain by Judith, a young Hebrew widow of extraordinary beauty, who went to his military camp, seduced him, got him drunk, and decapitated him. She then returned to the city and showed Holofernes' soldiers his head as irrefutable proof of the Israelites' victory over them.

In this painting, Judith is standing in a setting resembling a fort, in the center of a pyramidal composition, holding Holofernes' head with both hands. Her servant is next to her, kneeling, with an expression of disgust, helping her take the head out of a bag before showing it to the soldiers. The heroine is holding the head by its hair. In the middle ground are two children holding torches, looking at the head with some misgiving and keeping a safe distance. Despite the dark, cloudy, partially starry sky, glowing slightly from the moonlight in a clear indication that the action occurs at night, Judith is fully illuminated, with an adorned turban and imaginative garments in radiant white and blue, plus a red cape, contrasting with the matte color of the servant's dress. The self-assured heroine stares directly at the viewer and stands like a triumphant warrior.

In this work, Sirani reveals her mastery of the composition with a variety of poses, each of which expresses a different emotional state. Judith is rendered as a kind, delicate woman discreetly holding the general's head, which constitutes just another element of the scene. The painting is devoid of the usual violence and drama of such biblical representations. The servant is older here, unlike the figures appearing in works by Artemisia Gentileschi, where the maids are young and robust and actively participate in the action. The draftsmanship in this work, the economy of statement in the line, is far removed from the method upheld by Giorgio Vasari, the painter and art historian, who recommended thorough, rigorous preliminary studies. The artist employs rapid, decided brushstrokes in a method closer to the Venetian style than that used in 17th-century Bologna, which was characterized by being very linear and giving great attention to detail.

Right: This painting is significantly different from the previous one of the same title. Here, instead of breastfeeding her child, both mother and child seem to be busy observing the viewer, who would presumably have been a believer. This is a typically votive painting, in which it seems that Mary is ready to intercede on behalf of the devout before God. The composition is very simple and only includes the two protagonists, with no other elements to distract the observer's attention. Although Mary is wearing the traditional blue cape, red tunic, and white veil, her complexion is somewhat pallid and contained, lighter than those that the artist usually used in her works. The figures' expressions are imbued with sentiment.

Virgin and Child

(1663)
oil on canvas
33.9 x 27.6 in (86 x 70 cm)
National Museum
of Women in the Arts,
Washington, D.C.

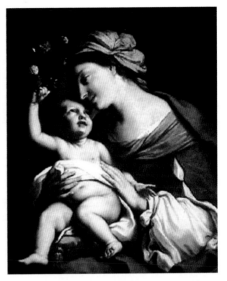

This painting, commissioned by Paolo Poggi, reveals Sirani's superb technique and the ease with which she painted. The scene shows a moment of intimacy and immediacy between the two figures: The Child, seated on a pillow in the Madonna's lap, gazes tenderly at his mother and, as if playing, places a crown of roses on her head. She holds him affectionately, inclining her head toward him. This tender relationship is typical of the baroque and reflects the influence of Guido Reni. The fine treatment of the skin and the details of the faces, in juxtaposition to the sweeping, flowing brushstrokes used in the garments, are remarkable technical achievements. With refined naturalism and chromatic richness, the artist subtly differentiates between the baby's soft skin and that of his mother through a tonal difference within a limited palette. The movement in the folds in the garments lends the protagonists a lively aspect. Traditional colors were used in Mary's dress, though they are intensely radiant, bringing the figure out from the dark background. The Virgin has a natural appearance, human and approachable, with the classical veil replaced by the turban typical of Bolognese women, in accordance with the ideas of the Counter-Reformation, which encouraged the representation of religious figures in everyday situations. The consideration of maternal love as a Christian virtue lends this painting a spiritual and intimate dimension, reinforced by the composition. Although Sirani's untimely death places her paintings in a single early period, this work reveals great maturity.

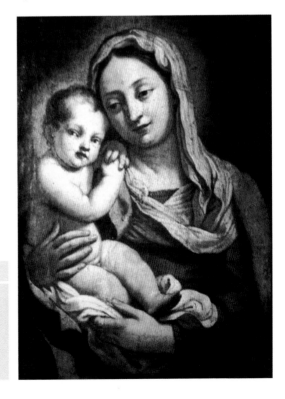

Virgin and Child

(~1663)
oil on canvas
28.7 x 21.9 in
(73 x 55.5 cm)
Statens Kunstmuseum,
Helsinki

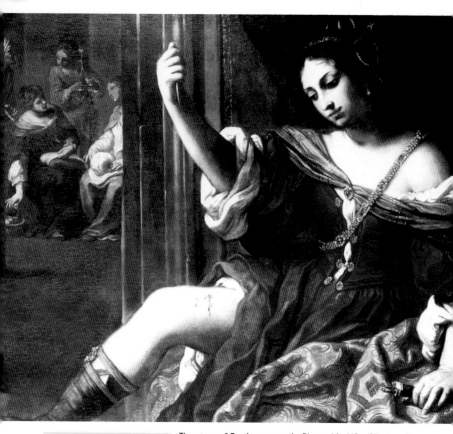

Portia Wounding Herself in the Thigh

(1664)
oil on canvas
39.4 x 54.7 in (100 x 139 cm)
Spencer A. Samuels & Company, New York

The story of Portia appears in Plutarch's *Life of Brutus*. She was a Roman lady, the daughter of Cato and Utica, who married Bibulus and, after he died, Lucius Junius Brutus, Caesar's deputy in the war in Gaul. After the Senate proclaimed Caesar emperor, numerous conspirators were ready to kill him—among them Portia's husband.

The painting is a night scene in the house of Brutus, who appears in the background, scheming with Cassius to assassinate Caesar. In the foreground, Portia, showing a great deal of sangfroid and inner strength, stabs herself in the thigh to test her capacity to stand the pain that the death of her husband would inflict on her should his plan fail. Brutus managed to assassinate Caesar, but, condemned by the Senate, his army abandoned him and he died on the battlefield of Philippos in the year 43 B.C. When Portia heard of his death, she committed suicide by swallowing hot coals.

Sirani's composition establishes a clear distinction between the foreground and the background through the great protagonism she lends Portia and the use of light to increase the dramatic nature of the scene, characteristics typical of the baroque. Portia is represented as a noblewoman, dressed in red and white attire, with abundant folds creating a sense of movement. The woman is lifting her dress to reveal her right leg. While she raises the knife that she is about to thrust into her thigh, her brocaded golden cape has slipped from her shoulder. Her light complexion and radiant garments contrast with the dark background. Sirani describes the woman as a heroine and not as a masochist. The composition of the painting is perfect, well adjusted to show the two simultaneous scenes. The scene is imbued with sensuality heightened by the presence of Portia's powerful body in the foreground, the rich and varied chromaticism of her garments in bright, warm colors, and the pureness of her skin.

Due to the skill and speed with which Sirani executed her works, she was accused by her male rivals of being assisted in her painting. To refute these accusations, on May 13, 1664, the artist invited various dignitaries to witness how she was capable of painting the portrait of Prince Leopold of Tuscany in a short time.

Delilah

oil on canvas
26.8 x 31.5 in (68 x 80 cm)
Private collection

Delilah was the lover of Samson, who, according to the Old Testament, was a judge with superhuman strength, which led him to play all sorts of practical jokes and ridicule the Philistines. The latter convinced Delilah to determine the secret of Samson's strength. After seducing her lover several times and asking him to unveil his secret, she finally achieved her objective. Samson gained his strength from his abundant head of hair. The Philistines persuaded Delilah to cut his hair. She did, and thereby sapped him of all of his strength, whereupon the Philistines blinded and chained him. But when his hair grew back, Samson recovered his strength and destroyed much of the Philistines' city, burying many of them in the rubble.

Sirani renders Delilah as a beautiful, seductive woman in red silk attire typical of the artist's time. Her blouse reveals her breasts, while her underclothes are made of a fine, white, transparent material. The scissors and hair she hold allude to her betrayal. Her innocent gaze is framed by curly locks. As is common in Sirani's paintings, Delilah stands out against a dark background. The light was used in a subtle fashion: The woman is lit only from one side, the light projecting darkness on the opposite side.

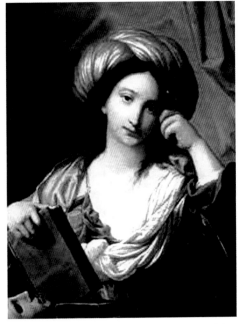

Melpomene

oil on canvas
National Museum
of Women in the Arts,
Washington, D.C.

In a portrait format, Sirani renders Melpomene, the muse of tragedy. As her attributes, a mask is lying on the table and she is holding two books. The background consists of red drapery with large folds. The muse's head is covered by a blue turban, under which her long hair is visible. Her dress consists of three materials in different colors, twisted so that they give rise to the soft, abundant folds typical of Sirani. With a melancholy air, the protagonist gazes pensively at the viewer, perhaps immersed in existential thoughts on destiny and its nature, lying somewhere between guilt and expiation, between humanity and God.

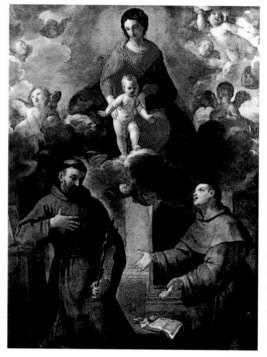

Virgin and Child with Angels, Saint Francis, and Saint Anthony

oil on canvas
103.5 x 70.9 in (263 x 180 cm)
Chiesa dei Santi Nazario
e Celso, Vignola

The painting is divided into two areas. The four protagonists are distributed in the form of a pyramid, with the Virgin and Child at the apex, flanked by a celestial area filled with angels among clouds flooded in a golden light. Mary, on a cloud, holds her naked child. At the bottom are the Saints Francis and Anthony, dressed in the brown habits of the Franciscan order. The founder of the order meditates before the cross he is holding in his left hand, while he places his right hand, with its stigmata, on his chest; it carries the same wound that the crucifixion produced on the hands of Christ. Saint Anthony, the first theology professor of the order, attentively contemplates Jesus. Legend has it that he had been seen praying while holding the Child Jesus in his arms, illuminated by a shaft of light, as he often appears in paintings, though Sirani opted for a more subtle representation.

The Holy Family with Saint Elizabeth and Saint John the Baptist

etching
11.8 x 8.7 in (30 x 22 cm)
Fine Arts Museum,
San Francisco

This painting illustrates an everyday scene in the life of the Holy Family. Mary and Elizabeth are seated in the foreground. The latter is working while Mary breastfeeds Jesus and plays with young John, who is between both women. In the background, Joseph raises an ax, about to chop a piece of wood. The walls of the room and a staircase are barely visible in the background. In the foreground, on the other hand, the bed and the attire and faces of the women are rendered with great attention to detail. Sirani meticulously portrays the physiognomies of Mary, young and delicate, and Elizabeth, old and concentrated on her task. This work was signed SIRANI IN., and then scratched out. This etching may have been based on a work by the artist's father.

MARIA SIBYLLA MERIAN

Sphinx Butterfly from *Dissertation in Insect Generations and Metamorphosis in Surinam* *(second edition)* *(detail)*, hand-colored engraving on paper, *12 x 9 in (30.5 x 22.9 cm)*, *1719*, *National Museum of Women in the Arts, Washington, D.C.*

Merian's work could be defined as an attempt to order the world and organize it into hierarchies to reveal its beauty. She seeks the best angle from which to reduce pictorial language to a minimum expression and represent nature free from rhetorical elements, revealing its pure essence. Merian magnifies the archeology of true forms in a catalogue that combines science with aesthetics. Merian was the first person to creatively represent the metamorphosis of caterpillars, to cite one example. She continued an ancestral tradition that united artists with scientists in their search for absolute knowledge. Hence, from Aristotle to Pliny, from Leonardo da Vinci to Dürer, all of these people had combined the image with the imagination, knowledge with representation. In Merian, it is particularly interesting to compare the method she adopted in her works with the research process typical of the empirical sciences: hypothesis, observation of the element to be studied, analysis and synthesis of the observations, conclusions and verification or rectification of the initial hypotheses. In the same manner, she approaches the element to be studied, be it a plant, an insect, or another type of animal, observes it, converts what she sees into a graphic model, and arrives at conclusions as categorizations of perceived reality. That which separates the two disciplines, science and art, is the aesthetic with which Merian documents her experiments: The idea of beauty as filtered through stylistic approximations (the baroque). Her style is schematic and

- **1647** Maria Sibylla Merian is born in Frankfurt, Germany, the daughter of Johanna and Matthias Merian, an artist and publisher.
- **1650** Following the death of her father, her mother contracts a second marriage with Jacob Marrel, a still-life painter and art collector.
- **1665** Marries the artist Johan Andreas Graff, a student of her stepfather.
- **1675-1677** Under the title *Florum Fasciculi*, Jacob Marrel publishes the work Maria had been executing on European flora in two volumes.
- **1680** He again publishes her work, under the title of *Neues Blumen Buch*. Later, 186 of her studies on European insects, plants, and other flora are also published in *The Metamorphosis of Butterflies*. This publication revolutionizes botany and zoology, as it portrays the processes of insect metamorphosis and provides a perfectly documented and illustrated catalogue of species.
- **1685** She leaves her husband, Johan, and joins the Calvinist sect of Jean de Labadie. Moves to Amsterdam with her daughters, where she attains great prestige as a professor and naturalist painter.
- **1699** After observing insect collections from the Dutch colonies in South America over the course of several years, she decides to move there. She thus travels to Surinam, in northern South America, returning several years later to compile the information she gathered there.
- **1705** Publishes the drawings she drew during her stay in Surinam in the volume *Metamorphosis Insectorum Surinamensium*. The edition is so successful that she is obliged to publish a second volume, *Dissertation in Insect Generations and Metamorphosis in Surinam*.
- **1717** Merian dies and her daughter, Dorothea Maria, sells all of her mother's works—paintings, writings, compilations—to the Dutch publisher Johannes Oosterwijk, who continues to promote Merian's works for several years through new publications and translations.

conceptual. Always searching for simplification, she did not reach her full potential due to the baroque influence from the still lifes of her contemporaries. Nevertheless, her work is far removed from the language of 17th-century Europe, since the meticulous description in her paintings, drawings, and engravings excludes all superfluous elements. She was baroque in context, yet modern in formalization and concept, both as a woman and as an artist.

Banana from
*Dissertation in Insect
Generations and
Metamorphosis in
Surinam* (first edition)

(1717)
hand-colored
engraving on paper
12 x 9 in (30.5 x 22.9 cm)
City Hall of
Amsterdam

In the visual culture of the artist's time, the image of the fruit of the banana tree was understood in a profoundly baroque manner, if only because it was so exotic. In this case, the plenitude with which the artist has filled the surface of the drawing with organic morphological elements lacking any geometrical aspect refers with great force to a symbolic baroque order. Yet it would not be correct to say that Merian's production was solely baroque, as an incipient realism is evident in her work—a style that became more entrenched later, when society was prepared for it.

The technique employed by Merian was most appropriate for expressing her illustrations with great simplicity and a pedagogical spirit. Hence, over some contour lines and shadings executed in etching, she would color the elements by hand—the bananas, butterflies, and caterpillars—leaving the background undefined. Clearly, she was not interested in representing a landscape or a still life. She was attempting to represent reality as her eyes saw it, as faithfully and intelligently as possible.

Right: There is a marvelous engraving by Albrecht Dürer (1471-1528) showing an African rhinoceros in profile. The interesting anecdote that accompanies that work is that the Renaissance painter had never seen such an animal, and his engraving was based on the verbal description made by a friend who had been to Africa. Dürer represented the rhinoceros through the eyes of another, and the results appear very strange by today's standards.

Merian never used such a method to represent reality. When she wanted to discover and describe plants, animals, and insects, she would travel to the places where they could be found in order to observe them with her own eyes and draw notes from nature. In other words, she used a system that constitutes the basis of modern biology, botany, and zoology. This engraving is absolutely faithful to the real appearance of the crocodile and the snake, though aesthetically it goes beyond a strictly scientific vision. The composition, however, is not naturalist: curves fill the entire surface of the work and divide two areas of unequal density: The lower area with a greater weight, and the upper area filled with the rococo curls of the snake to prevent a void. Again, there is no landscape, and an undefined white background removes the animals from their natural context. Here, science goes hand in hand with art.

The idea of illustration is always present in Merian's oeuvre. Her drawings corroborate a model that describes nature and organizes it, giving it a name and an elemental form. In this case, the artist represents the process of metamorphosis in a nocturnal butterfly. From caterpillar to adult butterfly, including the intermediate stages, everything occurs on a section of grapevine that, in addition to providing context, serves as a decorative element. All of the elements in the image are represented from the angle best suited to show their most illustrative aspects to the viewer. Hence, the leaves appear frontally and perfectly distributed, and the butterflies are drawn with their wings spread to better illustrate their colors and shapes. The images clearly take the place of words, and the composition of disseminated elements around a denser central area—the grape bunch and largest leaf—simulates the random movement of the insects around the fruit. Beside her interest in the subject matter and her desire to depict a natural scene, the artist clearly wished to send a pedagogical message to the observer.

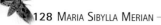

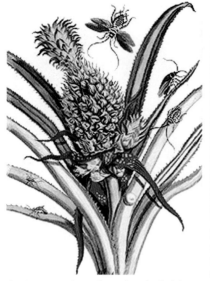

Pineapple from
*Dissertation in Insect
Generations and
Metamorphosis in Surinam*
(second edition)

(1719)
hand-colored
engraving on paper
12 x 9 in (30.5 x 22.9 cm)
National Museum of Women
in the Arts, Washington, D.C.

In reference to the pineapple plant, the painter wrote: "It is small and with varied foliage united directly to the fruit, with the appearance of red silk decorated with yellows; small shoots grow on its surface when the fruit is mature." This chilly description lacks the charming poetry transmitted by the illustration. Doubtless, Merian felt herself to be an illustrator much more than a writer. This hand-colored engraving possesses the wisdom of the artist who distinguishes between the superficial and the basic aspects of a narration: "From the density of the lower central area, lines radiate toward the periphery." This drawing is rich in color and volume, and the sense of growth of the plant is morphologically very successful. The idea of the still life is also present, though the fruit is not placed on a table. Nevertheless, this is not a rendering of lifeless objects, but rather an exuberant representation of life. Hence, the insects buzzing about on the surface of the paper indicate the presence of life. It is nature in all of its splendor that is being represented here.

Punica Granatum from
*Dissertation in Insect
Generations and Metamorphosis
in Surinam* (new edition)

(1726)
hand-colored
engraving on paper
12 x 9 in (30.5 x 22.9 cm)
City Hall, The Hague

This illustration describes the flower of the pomegranate and the insect *Fulgona Lanternaria* in various phases of its metamorphosis. The intense contrast between the complementary colors red and green, against a white background, lend a singular beauty to these dispersed elements. The insects, with their wings spread, resemble petals of the plant, lending the whole spaciousness and movement. Their colors play off the flowers so well that the viewer is not repulsed by their appearance. This intelligent strategy converts ugliness into something attractive in a dialectic in which life is triumphant.

RACHEL RUYSCH

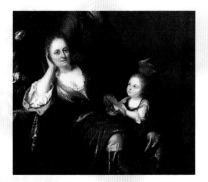

Juriaan Pool, Self-Portrait with His Wife, Rachel Ruysch, and One of Their Children (detail), oil on canvas, 30 x 24.6 in (71 x 62.5 cm), Staadtgeschichtliches Museum, Düsseldorf.

Rachel Ruysch, who specialized in floral still lifes, was one of the most exquisite Dutch painters. A student of Willem van Aelst, from Delft, she developed a unique style, often including insects in her flower scenes and colors that stood out in a luxuriant atmosphere. A botany professor, her father had a sizable collection of plants, and Rachel probably consulted him often. Fruit, flowers, and insects are faithfully represented in her paintings and reproduced correctly from a botanical point of view. With her skillful composition of light effects and her manner of painting textures, the objects seem real, though a still life must always be understood as a constructed reality. Her combinations of flowering plants with ripe fruit would be impossible in nature. And flowers such as tulips, which were very expensive, would hardly have been acquired by an artist to use as a model. From a symbolic point of view, Ruysch's paintings, like her colleagues', were representations of vanitas. In the visual culture of 17th-century Netherlands, there was less interest in the evocation of the celestial world than there was in the creation of earthly symbols, that is, allegories of real objects. Hence a subject arose that until then was practically nonexistent. Prior to the 17th century, the still life barely existed as an independent genre, since in earlier paintings, they were integrated in other scenes. Merchants and the upper middle class greatly appreciated still lifes, and Ruysch attained elevated prices for her works.

- **1664** Born in The Hague or in Amsterdam. Grows up in Amsterdam, living on Bloemgracht (literally, Flower Canal). Her father, Frederick Ruysch, is a famous professor of anatomy and botany, while her mother, Maria Post, is the daughter of the renowned architect Pieter Post, who built the royal residence in The Hague.
- **1665** Her sister Anna Elisabeth is born. She will also take up floral still lifes, though she was not destined to attain as much fame as Rachel.
- **1679** Rachel studies under Willem van Aelst, from Delft, an excellent specialist in floral still lifes from Amsterdam. From him, she not only learns asymmetrical composition, but also his precise, fine manner of painting to such a degree that the work creates the illusion of tangibility. He also teaches Anna Elisabeth.
- **1693** She marries the portraitist Juriaan Pool.
- **1701** Along with her husband, she becomes a member of the Confrerie Pictura, the painters' guild of The Hague, where the royal court, her most important client, is located. Over the following years, Ruysch establishes an international reputation.
- **1708** Along with her husband, she works as a painter for the royal court of Prince Johann Wilhelm II von der Pfalz, though she continues to live in Amsterdam. The majority of works dated from this period become part of the prince's collections, except for several paintings that he gives to the Great Duke of Tuscany (for example, *Fruit, Flowers, and Insects*, 1716, Palazzo Pitti, Florence).
- **1710** Visits Prince Johann Wilhelm II in Düsseldorf, from whom she receives a medal, in addition to payment for several works.
- **1713** She again visits the court in Düsseldorf, accompanied by her husband, to receive payment for some paintings.
- **1716** Johann Wilhelm II, her best client, dies. Evidently, this forces her husband to go into the lace business.
- **1745** Her husband, Juriaan Pool, dies.
- **1750** Dies in Amsterdam. In spite of being a mother of 10 children, she painted regularly for over 70 years. Some 100 works are attributed to her.

Some even surpassed the price paid for works by Rembrandt.

Stylistically, her artwork, with its irregular placement of flower bouquets and brilliant colors, was already part of the rococo, clearly distinguished from previous 17th-century floral still lifes. She and Jan van Huysum carried the floral still life to its apogee.

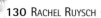

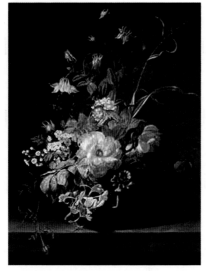

Flowers in a Vase

(1690)
oil on canvas
22.4 x 17.1 in (57 x 43.5 cm)
National Gallery, London

In this painting, Ruysch represents a bouquet of flowers in profound detail. Caterpillars and other insects are included along with the flowers and vase, and a small grasshopper is painted on the shelf. In general, insects were considered destroyers of beauty and thus symbolized death. Among the flowers are peonies, roses, and orange tulips. Some, intense in color, are still buds, while others are flowering in all of their splendor, and yet others are beginning to wilt. A floral still life is always a reference to the warning of classical Rome, *"Memento mori"*—that is, "Remember that you will die." The paintings represent both the beginning and the end of the person and, above all, of life. This work is considered one of Ruysch's first. Its composition recalls works by Willem van Aelst, her professor. As in his still lifes, the distribution of the bouquet is not symmetrical. The artist directs the viewer's eye through her flower montage from the lower left to the upper right of the painting, beginning with the small flowers and moving along to the most attractive flower, the large pink peony.

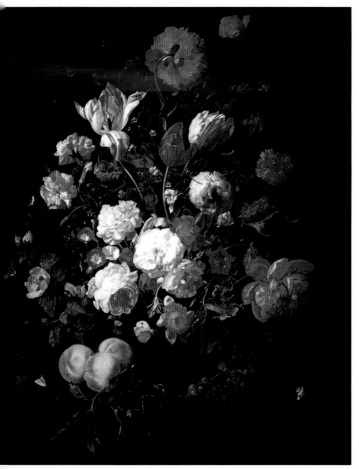

Vase with Flowers

(1706)
oil on canvas
39.4 x 31.9 in
(100 x 81 cm)
Kunsthistorisches
Museum, Vienna

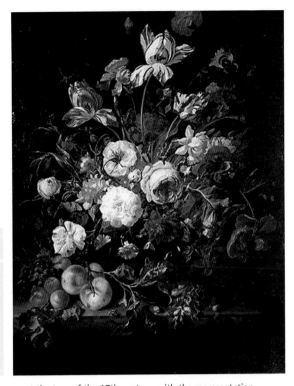

**Still Life with
Flowers and Fruit**

(1707)
oil on canvas
38.2 x 31 in (97 x 78.5 cm)
Maximilian Speck von
Sternburg Stiftung,
Museum der Bildenden
Künste, Leipzig

The floral still-life tradition began at the turn of the 17th century, with the representation of highly symmetrical and vertical bouquets that, over time, grew more exuberant, with freer, more natural compositions. The effect of perspective also gained importance. Ruysch contributed a great deal to the progress and development of floral still lifes. She adopted her teacher Van Aelst's asymmetrical compositional style with dark backgrounds and his delicate technique. After his death, she began developing her own style. She perfected her fine technique and handled the brush with such command that she faithfully represented the true textures of objects.

In this painting, it is as if she had chosen to portray peaches, with their velvety peel and delicate colors, to better exhibit her skill. Ruysch employed a lighter palette than her teacher, although, unlike her contemporary, Jan van Huysum, she never painted light backgrounds. Thus, her oeuvre has a more traditional character. The use of a dark background from which flowers in light colors emerge is an excellent technique to lend the flowers relief and intensify the realistic effect.

Left: This is a luxurious composition of fruit (peaches, grapes, and red currants) and flowers in a great variety of colors (roses painted in all tones ranging from red to pink, and white tulips tinged with red).

In addition to their excellent visual quality, highly gratifying for the viewer, all of the elements have a symbolic sense. Hence, the carnations, with their naillike shape, refer to the crucifixion of Christ. The small snail, with its slow pace, is a symbol of the passage of time, and the butterflies evoke the life awaiting the soul after its resurrection. Ruysch did not compose this painting on a diagonal like the one she executed in 1690 (National Gallery, London), but in an elegant S shape. In any case, she never placed flowers symmetrically, as was habitual among early 17th-century painters; she grouped them loosely. Thanks to her treatment of light, she achieved vivid chiaroscuro effects, demonstrating her affinity with the late baroque and rococo.

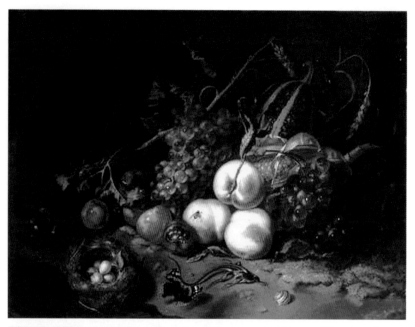

Fruit and Insects

(1711)
oil on panel
17.3 x 23.6 in (44 x 60 cm)
Galleria degli Uffizi, Florence

Prince Johann Wilhelm von der Pfalz gave this and another painting to the Duke of Tuscany, Cosimo III de Medici, probably in 1712—a fact that demonstrates Ruysch's fame.

Rather than a floral still life, this seems to be a still life placed in a forest setting on a wooden platform covered with moss. It contains a great variety of fruit and sprigs of wheat and other produce. As in other still lifes by Ruysch, there is a small, dramatic insect scene, in this case, between a lizard and a butterfly. The former, considered a symbol of decomposition, is clearly confronting the butterfly, symbol of beauty, hope, and charm, and ephemeral, awaiting the end of its short life. They are flanked by a nest of small eggs on one side and a snail shell on the other, symbolizing the different ages of life. This work can be understood as referring to the cycle of life.

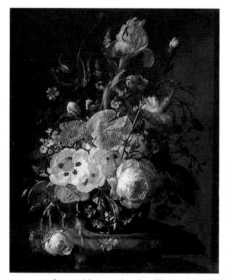

Still Life with Flowers on a Marble Table

(1716)
oil on canvas
19.1 x 15.6 in (48.5 x 39.5 cm)
Rijksmuseum, Amsterdam

On a marble table resting on a column is a vase filled with flowers. Roses, poppies, and other blooms are placed within a diagonal composition typical of the artist's early period. The eye is particularly directed to the longest flowers due to the intense light that Ruysch applied. Pale yellow, orange, and pinkish orange stand out against the dark background. Attentive observation reveals the presence of several insects: beetles, flies, and a caterpillar. In still lifes, artists such as Ruysch painted not only to represent the beauty of nature and thus obtain a visually gratifying image. The incorporation and detailed representation of such small elements as insects or flowers were also a sign of recognition and veneration of God through his works, as based on a physical-theological concept.

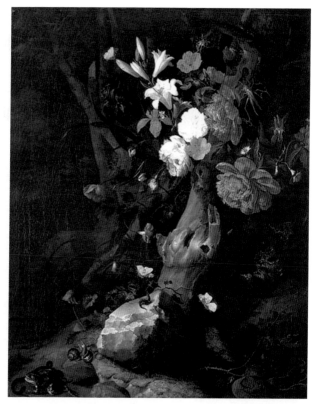

In this painting, Ruysch combines elements of nature in a natural setting with a series of flowers. They seem to grow out of a dead tree trunk. This unrealistic placement of a bouquet of flowers consisting of roses, peonies, irises, and other intensely colored flowers on a dried tree stump is a symbol of life and death in and of itself. The scene is complemented by various elements typical of forests, such as mushrooms, moss, and roots. Although Ruysch shows more details in the background of this work than usual, it is still quite dark, so that the foreground captures the viewer's attention. The scene is filled with animals: a frog next to a small serpent; farther up, two snails like lovers; on the stone, a lizard watching the butterflies flutter; and on the flowers, several more insects, among them a grasshopper. All of them constitute separate dramatic scenes in miniature, magnificently enriching the painting. Ruysch has created a still life with a rich series of living elements.

Flowers on a Tree Trunk

oil on canvas
36.6 x 29.1 in (93 x 74 cm)
Staatliche Museen, Kassel

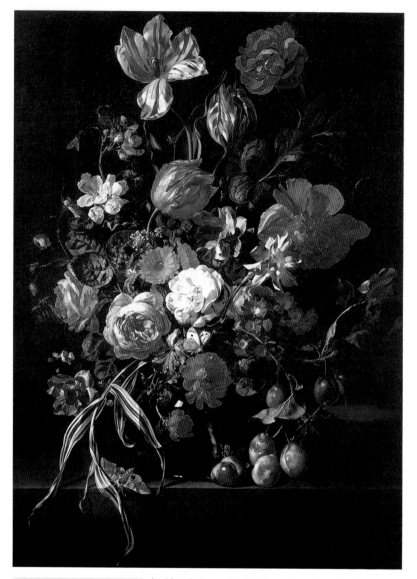

Still Life with Flower Bouquet and Plums

oil on canvas
36.2 x 27.6 in (92 x 70 cm)
Musées Royaux des Beaux-Arts, Brussels

In this painting, as in all of Ruysch's works, objects are painted so meticulously that even the veins on the leaves can be counted. Furthermore, as very few flowers interlace within the bouquet, it is easy to identify each one. The manner in which the artist has painted the fruit, insects, and flowers is nearly scientific and could probably be attributed to her father's work as a botany professor. Though the flowers and fruit in this still life appear real, the combination of, for example, tulips in flower with ripe plums does not occur simultaneously in nature. It is assumed that Ruysch, like other still-life painters from the Dutch Golden Age, took notes and drew detailed studies before she began painting, sketches which unfortunately are no longer extant.

Painting still lifes was a manifestation of liberty for this artist. Instead of satisfying a client with a portrait or dutifully representing a biblical or mythological scene, she was able to give free rein to her imagination in the still life, selecting the elements to the last detail.

ROSALBA CARRIERA

Self-Portrait like Invierno, pastel, 1731, Gemäldegalerie, Dahlem, Berlin.

Rosalba Carriera initiated her artistic career painting delicate miniature portraits on tiny objects made of ivory and snuffboxes, using a highly elegant technique, which she was later to employ in her portraiture in pastel. Studying first under G. A. Lazzari and later under G. Diamantini and A. Balestra, she quickly displayed her mastery of the pastel technique, highlighting an unusual stroke and the utilization of subtle and delicate tones. Her portraits enjoyed much success in Venice, eventually leading to commissions in Paris and Vienna, among other cities. The success of her portraits, especially among the Viennese aristocracy, compelled her to return to her native Venice, where she set up a studio to paint the commissions that were pouring in.

Carriera made significant inroads into pastel, a technique that in the artist's day was regarded as little more than a medium for sketching and making copies of oil paintings. Carriera demonstrated her prowess in this medium, achieving results second to none.

Carriera's copious artistic legacy in this medium, together with the novel art scene in the Venice of the day and her mastery of soft and delicate tones, manifests a serene and deliberate rococo style. She was a leading exponent of this style, sharply contrasting with the rolling landscapes and cityscapes painted by her colleagues.

- **1675** Born on October 7 in Venice, the daughter of a lowly civil servant learned in the arts, Andrea Carriera. She was initiated in the arts at an early age and she took lessons from Guiseppe Diamantini, Antonio Balestra, and, later on, probably the miniaturist Coll.
- **1700** Receives a commission from the Duke of Mecklembourg.
- **1703** Begins painting in pastel.
- **1704** Paints in Venice a portrait of Maximilian II of Bavaria, who commissions her to paint a large collection of portraits of ladies of the Venetian court.
- **1705** Made a member of the Academy of St. Luke, Rome.
- **1706** Receives various comissions from the Palatine Elector Christian Louis of Mecklenburg, Carlos VI of Spain, and Frederick IV of Denmark.
- **1709** Receives a commission from King Frederick IV of Denmark.
- **1717** Receives a commission from Elector of Saxony.
- **1720** Visits Paris, where she decorates the Bank of France and makes her name as a painter. In October, she is made a member of the Royal Academy of Paris. Makes the acquaintance of a number of painters: Jean Antoine Watteau, Pierre Crozat, Antoine Coypel, Hyacinthe Rigaud.
- **1721** In the spring, she returns to Venice, where she remains for much of the rest of her life.
- **1723** Works in Modena, in the court of Este, where she paints portraits of Duke Rinaldo's two daughters.
- **1729** Paints Count Nils Bielke (Nationalmuseum, Stockholm), one of her most famous portraits.
- **1730** From Venice, she travels to the courts of Vienna and of Dresden, from where she has received commissions.
- **1738** The death of her sister leaves her in a depression that prevents her from working for several months.
- **1741** Angela, Rosalba Carriera's sister, goes to live with her.
- **1745** Becomes gravely ill and as a consequence loses her sight.
- **1747** Partially recovers her sight, although she is unable to continue painting.
- **1749** Following a series of unsuccessful operations, she definitively loses her sight, leaving her immersed in a deep depression.
- **1757** Dies in Venice on April 15.

Self-Portrait Holding a Portrait of Her Sister

(1715)
pastel
Galleria degli Uffizi, Florence

This canvas, together with many others in her oeuvre, reveals Carriera's mastery of the pastel medium in the multitude of details of the composition. The treatment given to the hair and the lace of the garment are just two examples of the degree of sophistication she was able to achieve through this medium. Carriera lays great emphasis on facial expression. The tiny works on decorative objects that she painted at the beginning of her career paved the way for the painstaking attention to detail she gave the eyes, the jewels, the tiny floral adornments that she included in her subjects' hair.

Portrait of Watteau

(1721)
pastel
Museo Civico, Treviso

In 1720 Carriera went to live in Paris for a year, where she met Watteau and Crozat. The latter, impressed by the artist's work, commissioned her to paint a portrait of his friend. Carriera conveys her subject's distinction and elegance, the main attributes of the Rococo.

The subject stares arrogantly at the spectator, an attitude that was highly regarded among the aristocrats who commissioned portraits from Carriera. As always, the painter expresses the preoccupation with complex elements that made her works so successful. In this canvas, Watteau's hair has been treated very fluidly, with the shine and reflections of the light. Equal attention has been given to his attire, in which the textures and transparencies of the material reveal the potential of the pastel medium.

Carlota Gauthier

(~1730)
pastel
19.7 x 15.7 in (50 x 40 cm)
Galleria dell'Accademia,
Venice

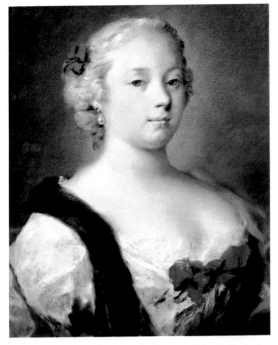

It was not long before Carriera began to lend her works an elegant and sophisticated treatment, both in the facial expression and features and in the other elements, such as the garments. It is clear from the outset that Carriera was a leading exponent of 18th-century Venetian painting. The utilization of color, the settings, the balance of the whole, and the loving care and meticulousness with which she flatters her subject constitute a catalogue of characteristics that situates her subject matter somewhere between realism and allegory, elegance and idealization (for example, in many of her portraits the subject appears to be enveloped in a type of aurora that brightens the colors of the adjacent areas). These features, characteristic of the true rococo, perfectly suited to the taste of high society, were duly reflected in her works.

Young Woman of the Leblond Family

(~1730)
pastel
13.4 x 10.6 in (34 x 27 cm)
Galleria dell'Accademia, Venice

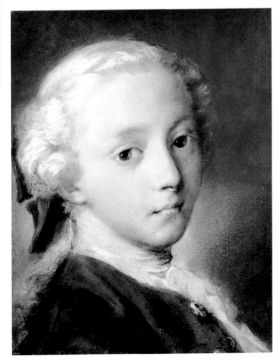

This portrait contains all the elements that characterize Carriera's works: a meticulous work, a distinguished personage, and smooth white skin, with the textures of the flesh, hair, and garments given the utmost attention to detail.

With an aureole of distinction, Carriera renders her subjects with vaporous and warm colors. These provide a sophisticated setting, distant in relation to the spectator, and a timeless quality, as if the subject were made of china. The cold sensuality, studied expression, and meticulous clothing are in keeping with the subject's social standing.

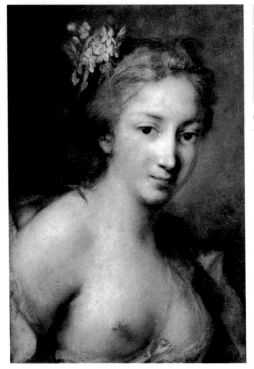

Flora

(1730)
pastel
18.5 x 12.8 in (47 x 32.5 cm)
Galleria degli Uffizi, Florence

Carriera reveals a refined eroticism with this work. The model appears to be leaning slightly to one side, with her breasts exposed, in a highly atypical composition for this painter. The work, painted in the rococo style, is remarkable for its realism. The translucent dress and the loose blond hair create a fragile Flora, enveloped in an ethereal ambience. This style was very much in accordance with 18th-century Venetian painting, whose landscapes portray idealized scenes, hazy and atmospheric. The style had a strong impact in Europe. Fully aware of this, Carriera exploited it in her works. The importance of the backgrounds, with which she created an effect of complementary contrasts, is apparent in the complex distribution of the colors and the light that complements the figure.

America

(1730)
pastel
National Museum of Women in the Arts, Washington, D.C.

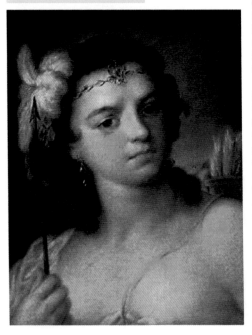

Carriera painted this allegory of America based on strength and personality. It can be interpreted in a number of ways. The representation of the female gender as individuals who manifest their freedom, in contrast to the traditional notion of women as people of lower standing, is reflected in all paintings this artist executed of women.

Another feature common to all Carriera's female subjects is the way they appear to stare directly at the spectator. Flora's eroticism and the air of ease of Carriera's self-portraits are conveyed through gesture and expression; there is no attempt at hidden meanings. Yet here Carriera succeeds in conveying the character and strength of the New World. All over Europe at this time, there was an enormous interest in the exotic. For the first time on the continent, in 1751, a live rhinoceros was exhibited in Venice, an event that was extremely popular with the public.

The canvas portrays the American continent, distant and exotic, as an untamed yet powerful land.

Cardinal Melchior de Polignac

(1732)
pastel
22.4 x 18.1 in (57 x 46 cm)
Galleria dell'Accademia,
Venice

Carriera portrayed aristocrats, kings, and leading members of the clergy. For the cardinal in this work, the artist uses intense colors such as red and blue. The rendering of the transparent material around his neck indicates the artist's thorough grounding in the pastel medium. Unlike any of her previous works, in this painting, the artist uses the light as an expressive element that immerses the face in a mystical air. The composition is executed in a style that was very popular among church dignitaries. The absence of a background leads the viewer's eye directly to the cardinal's stern and adamant expression. As a portraitist of the aristocracy, Carriera had access to a segment of the wealthy, whom she avidly sought as patrons. With this type of portrait, she was able to significantly increase her income, which mainly derived from painting miniatures on boxes.

Elderly Lady

(1740)
pastel
19.7 x 15.7 in (50 x 40 cm)
Galleria dell'Accademia, Venice

During the beginning of the 1740s, the artist was afflicted by a grave illness that resulted in her losing her sight in 1745, the year in which her last works are dated. These later works provide a graphic account of the artist's development of color. The flesh tones of this elderly lady have been given a very natural treatment. In keeping with the rococo aesthetics of paleness being an element of virtuosity, Carriera generally presents her women with whitish skin. Here she settles for a more natural approach, using warmer colors.

Her work showed a greater naturalness than the aristocratic portraits painted during the 1730s. The expression of the woman is relaxed and informal and the affected impressions produced by the poses are turned into confidence and serenity.

Portrait of the Dancer Barbarina Campani

(~1740)
pastel
22.2 x 18.3 in (56.5 x 46.5 cm)
Staatliche Kunstsammlungen, Dresden

Although Rosalba Carriera became famous through her works as a whole, this one is especially worthy of note. The subject is represented in all the splendor that so characterized the aristocracy of the day, very much in keeping with the context of the rococo. In accordance with the techniques the artist had adopted from Venetian painters, the work is a paragon of chromatic softness, filled with restraint and delicacy, and both the whole and the meticulous details of dress and floral headdress transmit the dancer's elegance. The distribution of forms, the distinction of the figure, and the atmospheric halo work together to give the subtle impression of idealization of the subject.

Doubtless, this is also thanks to the texture and quality of the pastel, a medium that owes much to Carriera. She was one of the first artists to work solely in this medium. Thanks to her exploration of the technique and to the innovations that came about as a result, Carriera was able to achieve the sensibility of this type of work. Her greatest pastels, like this one, are enveloped in a vaporous atmosphere in which the light colors and pure colors stand out. The success of Carriera's pastel paintings led in great part to the medium's increased popularity in the 18th century.

ANGELICA KAUFFMANN

(MARIA ANNA ANGELICA CATHARINA KAUFFMANN)

Self-Portrait *(detail), oil on canvas, 1787, Galleria degli Uffizi, Florence.*

Born in Switzerland, Angelica Kauffmann spent her childhood in Italy, where she lived almost her entire life, except for a 15-year period in London. She developed a simple, classicist style with rococo qualities, influenced by Roman neoclassical painters such as Anton Raphael Mengs and later by English portraitists, especially Joshua Reynolds. Her style was in keeping with the taste of that period, characterized by sentimentalism and neoclassical ideals, and she became one of the most renowned and sought-after painters of her time. She particularly excelled in portraiture, a genre in which she gained international recognition. The architect Robert Adam commissioned her several times to decorate walls. Skillful in what would today be called marketing and merchandising, she disseminated her paintings and engravings, which she also used to decorate fans and porcelain, far and wide.

Thanks to her financial success, she was soon able to dedicate herself to historical painting, a highly prestigious genre. But her works were difficult to sell, since at the time, it was exclusively the reserve of male artists. She studied the male body, something that women were generally forbidden to do. Open to the intellectual life of her time, she had contact with many figures in art and literature. Her house in Rome was a meeting place for enthusiasts of European art who shared Kauffmann's ideas and assessment of classical art. She painted more than 500 works over the course of her life.

- **1741** Born in Chur, Switzerland, to the painter Joseph Johann Kauffmann. She begins artistic training under him. As a child, she shows great aptitude for music and painting.
- **1757** After the death of her mother, she travels with her father from Milan to his native village, Schwarzenberg, where she paints the interior of the local church.
- **1760** Returns to Milan. Undertakes a study trip from Parma to Bologna, then Florence.
- **1762** Appointed a member of the Academy of Florence. There she paints a self-portrait for the Galleria degli Uffizi.
- **1763** Begins a period in Rome.
- **1765** Appointed a member of the Accademia di San Luca in Rome.
- **1766** Moves to London, where she remains for 15 years. For a year and a half she paints solely portraits, after which she is able to buy a house and invite her father to live there.
- **1767** Kauffmann and the famous painter Joshua Reynolds paint portraits of each other as a symbol of respect, an important factor in the development of her style and of sound commercial relations. Kauffmann's social and economic position attract a con man, who manages to marry her. She annuls the marriage, but not without scandal. She continues to paint portraits, and also executes large-format historical and mythological scenes, genres usually reserved for male artists.
- **1768** Elected a founding member of the Royal Academy of London. For many years, she and Mary Moser are the only women admitted to the Academy.
- **1779** Exhibits her historical paintings at the Academy exhibition with great success. Despite this, she finds it difficult to sell them.
- **1781** Marries the Venetian painter Antonio Zucchi. With him and her father, she moves to Venice via Vorarlberg.
- **1782** Following the death of her father, Kauffmann moves to Rome with her husband. She paints for the courts of Naples, Russia, and Austria, among others.
- **1795** Antonio Zucchi dies. Kauffmann falls into a state of profound remorse, and this leads her to abandon the brush and weighs upon her until the end of her days.
- **1807** Dies in Rome. Her tomb is in S. Andrea delle Fratte.

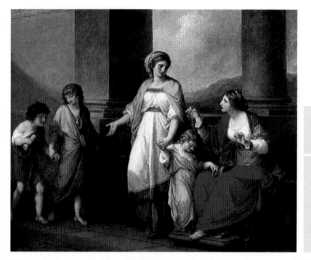

Cornelia Shows Her Children as Her Treasures

(1785)
oil on canvas
40 x 50 in
(101.6 x 127 cm)
Virginia Museum of Fine Art, Richmond

This work shows the virtue of the loving mother in an episode from the Roman story. In a room decorated with classical architectural elements opening onto a landscape in the background are two women and three children dressed in Roman clothes. Next to a wealthy Roman woman is the patrician Cornelia, the mother of Tiberius, Gaius Gracchus, and a daughter. The seated woman holds up her jewelry and looks at Cornelia in an inquisitive and tempting fashion. As a reply, Cornelia confesses that her treasures are her children. Kauffmann selected virtuous women as protagonists of her historical paintings, women full of love and self-sacrifice, such as Penelope, Andromache, and Cornelia, or women in mourning, such as Dido, Ariadne, and Calypso, but she also painted Venus and nymphs from Greek mythology who played with love.

Lady Elisabeth Foster

(1786)
oil on canvas
50 x 40 in (127 x 101.5 cm)
Ickworth, The Bristol Gallery, U.K.

The Duchess of Courland

(1785)
oil on canvas
30.3 x 25 in
(76.85 x 63.5 cm)
Los Angeles County
Museum of Art,
California

Anna Charlotta Dorothea Medem, Duchess of Courland (1761-1821), was married to the Polish duke Peter II, Baron of Courland, a country which he ruled over from 1769 until 1795, when it became part of Russia (today it forms part of Lithuania). Following the death of the duke in 1800, the duchess went into exile, settling principally in Paris. During her Roman period, Kauffmann received many commissions from the aristocracy of Eastern European countries.

This painting is a typical portrait commissioned by a nobleman fond of art. The oval shape and pastel colors are rococo elements that were still highly appreciated at the time. The painting also shows an excellent combination of landscape and portraiture typical of English portraitists. The Duchess of Courland is wearing a white neoclassical-style dress that enhances her lovely figure, intimated through the soft folds. The copper-colored scarf over her shoulder serves as a decorative element. Her hair is luxuriously arranged in keeping with the style of the time and decorated with a wreath of flowers. Her fine complexion and sweet smile render this woman in a sentimental light. She is neither portrayed with the attributes of nobility nor in a regal dress, as would befit her status. The artist's aim was to describe the sitter's personality.

Left: Lady Elisabeth Foster was born in 1759. She was the daughter of the fourth Earl of Bristol. A woman of exceeding beauty, she married Mr. Foster, a wealthy gentleman with important assets in Ireland, with whom she had a son. Kauffmann painted her portrait when Elisabeth was staying in Rome. The artist's stay in England afforded her excellent contacts with English clients. Lady Elisabeth Foster, who was also a dedicated painter, is portrayed here in a somewhat sophisticated pose and dressed in an elegant but simple white dress, neoclassical in style, in keeping with the fashion of the time.

Rather than defining this woman's social status, the work focuses on the sitter's individual characteristics, which are revealed here through her relaxed and absent expression. She is lost in her own private thoughts. An interest in spontaneity and a complete absence of references to social standing are characteristic features of the international style adopted by Kauffmann in her works. The landscape in the background clearly alludes to the English garden, with its natural groups of trees and serpentine pathways. The English garden, much in vogue toward the end of the 18th century, was characterized by the Romantic notion of turning a cultivated garden into a wild landscape with decorative elements such as rockery and waterfalls. Following the untimely death of her husband in 1809, Lady Foster married the fifth Duke of Devonshire and was thereafter known as the Duchess of Devonshire.

Johann Wolfgang von Goethe

(1787/88)
oil on canvas
25.2 x 20.5 in (64 x 52 cm)
Goethe-Nationalmuseum, Weimar

Angelica Kauffmann enjoyed painting her friends. For her, painting a portrait represented a demonstration of great affection, and she cherished her friendships. Captivated by Goethe, she executed this portrait. Rather than adopting a heroic pose, as Johann Heirinch Tischbein rendered him, he is captured as a young, wide-eyed dreamer. He thus recalls Werther, a character in one of Goethe's own novels, a symbol of the spiritual movement of sentimentalism. The extremely flattering painting, a model of the sentimentalist portrait, did not please Goethe.

He read his play in verse, *Iphigenia,* from which the artist painted several scenes, for the first time before a large audience at her house on Via Sistina 72 in Rome. Many a Sunday, with her husband, Goethe, and other friends, Kauffmann would visit art galleries, and in the evening, they would all discuss their impressions. In 1787, Goethe wrote of his friend, "She is not as happy as she deserves to be for her outstanding talent and heritage, which increases daily. She is tired of painting to sell. Nevertheless, her husband finds it only too lovely to cash in on so much money for such easy work...She would feel more satisfied if she could work with more tranquility, care, and study."

Right: With the help of her father, Angelica Kauffmann not only developed her talent as a painter, but also her musical aptitudes at a very early age, studying voice and the harpsichord. Some friends of the family thought she would have a brilliant career as a singer. Deciding between the two disciplines must have been very difficult for her. Already in her first self-portrait, she rendered herself as a singer holding a score instead of a painter. It would not be until many years later that she would finally choose painting. All of this is reflected in this self-portrait. The artist renders herself between the allegories of the two arts, touching Music, to whom she felt very close, yet letting herself be seduced by Painting, who urges her to follow a stony path toward an uncertain future. Kauffmann reaches out her hand to Painting and gets ready to leave Music. The allegories of Music and Painting in the form of two beautiful young women, like Kauffmann herself, represent her selection as if it were an inevitable parting from one good friend in order to continue her path in the company of another.

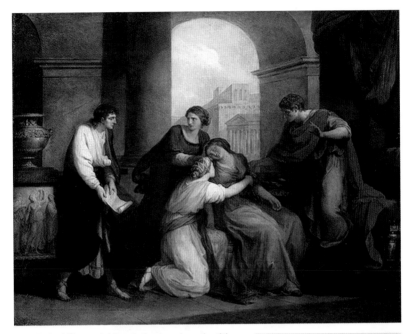

The principal figure of this painting is not, as the title could lead one to believe, the Latin poet Virgil, nor the Emperor Augustus, but his sister, Octavia. As if in a play, the scene represents Virgil on the left reading the last part of the hero Aeneas's vicissitudes. His story became the national epic of the Romans. It recounts the odyssey of the Trojan hero and the foundation of Lavinia, a symbolic reference to the government of the Emperor Augustus as fulfillment of divine destiny in the history of Rome.

Virgil Reading the Aeneid to Augustus and Octavia

(1788)
oil on canvas
48.4 x 62.6 in (123 x 159 cm)
The Hermitage,
Saint Petersburg

Through Virgil's verses, Octavia becomes aware of the premature death of her son Marcelo and faints from grief. Her servants hold her up while Augustus fearfully rises from his throne to help his sister. The compassionate Virgil gazes at Octavia with consternation. Kauffmann unites two determining factors of her work in this historical painting: sentimentalism and a love of classical antiquity, present here in the subject matter and the sumptuousness with which the setting in the imperial Roman palace was rendered. The harmonious composition of the whole—the central group of three women in front of the window through which the Capitol building and the temple of Jupiter can be observed—is typically neoclassical.

Self-Portrait Between Music and Painting

(1792)
oil on canvas
Pushkin Museum of Fine Arts, Moscow

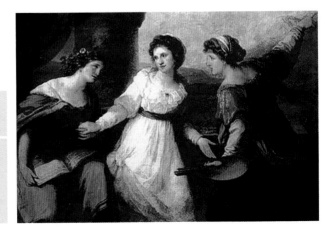

Miss Cornelia Knight
(or Self-Portrait)

(1793)
oil on canvas
Manchester City Art
Galleries, England

The young woman in the portrait was the daughter of an admiral friend that Kauffmann had in Rome. The artist made this painting to give to the sitter as a gift. Cornelia Knight was a very well-educated woman who wrote historical novels on ancient Rome and who was also a painter. She is gazing at the viewer, seated at a table on which lies her novel *Marcus Flaminius* and one of her drawings from a column commemorating Nelson's first victory. In her right hand, which she rests on her knee as if she were taking a short break, she is holding the instrument of her work. Her left elbow rests on the table while her hand romantically caresses her Greek-styled curly hair tied with a ribbon. In accordance with the neoclassical style, she is wearing a white dress with a blue scarf gently draped over her shoulders. Kauffmann intended to make a faithful copy of this portrait for a medallion representing Minerva, the goddess of wisdom, but then Cornelia Knight suggested that the artist use her own likeness instead, as this would be a just homage to her fame as an artist.

ANNE VALLAYER-COSTER

Self-Portrait,
Châteaux de
Versailles et
de Trianon,
Versailles.

Anne Vallayer-Coster, considered one of the best still-life painters of the 18th century, was a contemporary of Jean-Baptiste-Siméon Chardin (1699-1779), who lent the still life its own personality, breaking with the precepts of the Academy. Like Chardin, Vallayer-Coster executed paintings that were far from the ostentatious still lifes of the 17th century, though she did not relinquish formal richness. Unlike Chardin's, her paintings betrayed her situation as an aristocratic artist.

Despite the turbulent times during which she lived, her artwork did not change greatly in subject matter or style. Jacques-Louis David's neoclassical innovations hardly influenced her. In addition to painting still lifes and floral arrangements, she also executed miniatures, large decorative panels of animals and hunting trophies (often with a trompe l'oeil effect), bas-reliefs in stucco, and portraits of important people.

In view of the great criticism to which her portraits were subject after 1789—in the form of constant negative comparison of her works of this type with those of her colleagues from the Academy who specialized in the genre, Elisabeth Vigée-Lebrun and Adélaïde Labille-Guiard—she abandoned portraiture definitively.

Vallayer-Coster returned to the still life. In the last painting she exhibited at the Salon, *Table with Lobster, Fruit, and Game* (1817, Mobilier National, Paris), though far removed from the symbolism of 17th-century Dutch still lifes, the irises stand out as rather isolated elements, a symbol of the recently restored Bourbon monarchy. This allusion and the generous composition of luxurious food and utensils make this painting a sort of synopsis of the artist's oeuvre (more than 400 paintings) and homage to her clients, whose tastes she always satisfied with exquisite loyalty.

- **1744** Anne Vallayer is born in Paris to Joseph Vallayer, goldsmith of the Royal Tapestry Manufacture.

- **1757** Moves to central Paris with her family. Her father, now a master goldsmith, sets up his own establishment and obtains royal permission to produce military medallions, as well as the title of Merchant Goldsmith to the King. After his death, Anne's mother runs the business herself, yet Anne is not interested in it, as she wants to take up painting. Nothing is known about her artistic training.

- **1770** Though the Academy limits its female members to four, she is elected as a member after showing her still lifes *The Attributes of Painting* and *The Attributes of Music*. Perhaps it is through her family connections that she is able to enter the Academy at the young age of 26. This occurs a month after Jean-Baptiste Pierre is appointed First Painter to the King, which appears to indicate that he was a friend of the family.

- **1780** The queen grants Vallayer the title of Painter to the Queen. Furthermore, she is allocated one of the sought-after Louvre apartments, which she uses until 1806, when Napoleon evicts the artists because he is irritated by the smoke from their chimneys.

- **1781** She marries a lawyer and member of parliament, J. P. Silvestre Coster, from a noble family of financiers and courtesans. The wedding is held at Versailles and the marriage contract is signed by Queen Marie Antoinette. Though she is married to Coster, Vallayer continues to exhibit under her maiden name.

- **1789** During the turbulent years of the French Revolution, Vallayer-Coster does not exhibit. She is witness to the downfall of absolute monarchy, and her most important protector, Marie Antoinette, is executed in 1793.

- **1795** After the fall of Robespierre, the upper middle class comes into power. Vallayer begins exhibiting regularly again at the Salon until 1817.

- **1818** Dies in Paris at the age of 74 years.

Still Life with Tuft of Marine Plants, Shells, and Corals

(1769)
oil on canvas
51.2 x 38.2 in (130 x 97 cm)
Musée du Louvre, Paris

Though this is an early work, it already shows the maturity of an artist about whose training little is known. The image is a charming arrangement of exotic shellfish, represented in a highly successful combination of colors and light in an elegant, S-shaped composition. Vallayer's delicate style led her to represent objects with a great degree of realism. The brilliant pink mother-of-pearl conch shell, the deep red, branchlike coral, and the sponges on a simple stone table stand out against a dark background. This detailed reproduction of botanical objects not only illustrates the visual taste of the period, but also society's interest in knowledge, with precursors in scientific painters such as Maria Sibylla Merian. Indeed, the great protagonist of the Enlightenment, Denis Diderot, publisher and coauthor of the French *Encyclopédie* (1751-1772) was Vallayer's contemporary. This still life recalls her 17th-century Dutch predecessors, though the elements in 18th-century still lifes were generally free of symbolic meaning.

The Attributes of Painting, Sculpture, and Architecture

(1770)
oil on canvas
35.4 x 47.6 in
(90 x 121 cm)
Musée du Louvre, Paris

At first, the young artist was renowned for her still lifes. Vallayer was admitted to the Academy for two still lifes executed in 1770: *The Attributes of Painting, Sculpture, and Architecture* and *The Attributes of Music* (see below). These subjects had already been painted by Jean-Baptiste-Siméon Chardin, who, with his interesting still lifes, managed to enhance appreciation of the genre. At first glance, this composition by Vallayer seems to follow in the footsteps of Chardin, yet the technique is substantially different. The texture, color, and application of paint are rich, sensually tactile, and serve to enhance the visual aspect. The attributes of painting, sculpture, and architecture appear on the table. The colors on the palette and brushes representing painting appear still fresh. Sculpture is represented by modeled elements such as the head of a youth on a potter's wheel. Various portfolios, a ruler, and plans evoke architecture.

The Attributes of Music

(1770)
oil on canvas
34.6 x 45.7 in
(88 x 116 cm)
Musée du Louvre, Paris

In this still life, which forms a set with the painting *The Attributes of Painting, Sculpture, and Architecture*, Vallayer renders an allegory of music. On a table covered with a luxurious green velvet tablecloth lined in gold, different instruments have been harmonically placed to form a triangular composition. The well-studied areas of bright light stand out against a mottled brown background. Vallayer used warm colors for the wood in the violin and lute, as well as in the red velvet and gold on the bagpipes, which contrast with the cool color of the green tablecloth and blue ribbon. A flute and a wind instrument that resembles a sort of trumpet are also included. The lute rests against a music stand holding several scores. The blue ribbon, tied loosely and naturally, seems to indicate the presence of an individual and suggests the idea of movement. Thus rendered, this still life is a highly personal composition of a universal subject, a eulogy to the beauty of music.

Potted Hyacinth

oil on canvas
18.1 x 14.6 in (46 x 37 cm)
Musée Magnin, Dijon

This still life contains only a potted hyacinth with white flowers. It resembles a trompe l'oeil of a terra-cotta pot in a niche more than a floral still life. Like the white soup tureen, this is a personal interpretation of a classical composition that was usually painted as if it were an element of luxury. The artist not only limits the opulence of the scene but also employs subdued colors, with earthtones of brown, ochre, and terra-cotta predominating. The subtle variation of these tones and the natural light illuminating the hyacinth from the right lends the painting great realism.

White Soup Tureen

(1771)
oil on canvas
19.7 x 24.4 in
(50 x 62 cm)
Private collection,
Paris

Left: At the center of this still life is a white soup tureen, its contents not visible suggested by the rising steam. The scene represents simple, commonplace utensils and kitchenware. As appropriate to a table duly set for a meal, the knife is already in place and the soup tureen open for serving. Drinks are placed here and there, and on a white napkin is a loaf of bread. The artist has achieved a successful realist effect with striking chiaroscuro. The sensual manner of rendering the different textures, the steam, the shiny white porcelain, and the starched linen napkin reveal Vallayer's notable artistic talent. This still life was well received at the 1771 Salon. Diderot especially liked the way Vallayer painted the bread with such magnificent chromatic harmony in white and tan. The work is a rational interpretation of the real world and everyday life. The simplicity of the scene and the superb textures and materials recall 17th-century masterpieces by Pieter and Willem Claesz. Her technique is magnificent and on a par with Jean-Baptiste-Siméon Chardin, the principal representative of this genre, who had limited the number of objects in his works and rendered an enhanced view of everyday life before Vallayer.

Joseph-Charles Roettiers

(1777)
oil on canvas
26 x 21.3 in (65 x 54 cm)
Musée de Châteaux de Versailles
et de Trianon, Versailles

Right: In 1777, Vallayer executed a portrait of Joseph-Charles Roettiers (1692-1779), a sculptor, medallion engraver, and royal goldsmith. Considering his profession, it is highly probable that he was a friend of the Vallayer family. This is a typical rococo portrait in a soft style, of a figure in an oval format, turned slightly toward the viewer, which was still very fashionable at this time. Despite the softness of forms, Vallayer portrays Roettiers with dignity, though without concealing his age. Like Roettiers, Vallayer had many clients from the court. In addition to the queen herself, who greatly appreciated her skill as a painter, and high-ranking officials at court, her works were also collected by other influential people.

Still Life with Rooster and Hen

(1785)
oil on canvas
20.9 x 25.2 in (53 x 64 cm)
Musée de Tessé, Le Mans

This still life of a dead rooster and hen on a flat surface was exhibited at the 1787 Salon. It belonged to the Count of Angiviller's collection before being deposited by the French State at the Le Mans museum in 1872. In 1932, it was erroneously attributed to Melchior

d'Hondecoeter, an important 17th-century Dutch artist specializing in fowl. This subject, as well as game, was usually reserved for male painters. Vallayer came in for some harsh criticism when she exhibited such works at the Salon instead of floral still lifes. The composition is dominated by diagonal lines, in accordance with Vallayer's preferences. The rooster's tail and the hen's wing end these diagonals in elegant semicircles at opposite corners of the painting. The varied palette of grays and browns is broken only by the red of the rooster's crest and the blue feathers in its tail. The birds are lying lifelessly on a stone counter, the rooster tied by the leg. The hen's soft, fluffy plumage stands out against the dark gray background.

Madame de Saint Huberty in the Role of Dido

(1785)
oil on canvas
57.4 x 40 in (145.8 x 101.7 cm)

In this portrait of Madame de Saint Huberty playing the role of Dido, the tragic heroine of Carthage and lover of Aeneas, Vallayer-Coster shows a neoclassical portraiture style. Exhibited at the 1785 Salon, this painting represents a refined model in a stylized Greco-Roman dress standing in front of architectural elements inspired by the classical period, with columns, reliefs, and a statue of a nude figure enthroned in a niche. This work was completely in line with the aristocratic taste of the artist's clients, among whom were the highest dignitaries of the country. Nevertheless, Vallayer-Coster was severely criticized for her portraits by Salon critics such as Denis Diderot and Petit de Bachaumont. The latter expressed his particular disgust for the portraits exhibited at the Salon that year, in which Vallayer-Coster also exhibited the portrait of an anonymous bishop (the whereabouts of that painting are presently unknown). Bachaumont wrote that the bishop seemed embarrassed, relegated to a corner of the work, and that it was a shame that Vallayer-Coster had stopped painting still lifes, for which she demonstrated great skill, to take up a genre such as portraiture, in which she was greatly inferior to her competitors. This commentary and other similar ones illustrate the constant comparisons that were made between her portraits and those by Vigée-Lebrun and Labille-Guiard. They also demonstrate the increasing importance of the Salon, in which the works exhibited became the certain target of public opinion and the critics of the moment. In the end, these comments finally convinced the artist to abandon portraiture and return to the still life.

ADÉLAÏDE LABILLE-GUIARD

Self-Portrait with Two Pupils (detail), oil on canvas, 83 x 59.5 in (210.8 x 151.1 cm), 1785, Metropolitan Museum of Art, New York.

When an artist lives in a social context as turbulent as that of Adélaïde Labille-Guiard, it becomes difficult to establish a clear connection between her work and her life experiences. The contradictions between her social class, her aristocratic clients, and her sensibility frequently led her to betray the relationship between ethics and aesthetics. In order to satisfy her clients, she made many paintings that were not conceptually in line with her mentality as an artist.

Through her apprenticeship as a miniaturist, Labille-Guiard gained great technical mastery. Her work has a delicate charm resulting from a nervous brushstroke and the extraordinary detail she rendered. Her paintings were remarkably true to life, and her integration of the figure within the pictorial space was extraordinary.

She was a distinguished professor at the Académie de Saint-Luc. When it was dissolved in 1776, the artist already had a studio where she taught students, which gave her economic independence after she separated from Guiard.

Labille-Guiard was a prolific artist and received many commissions from the French aristocracy, the results of which constitute an important document on society of that time. Her abundant production had much to do with her ambition of attaining high social status—an attempt that was unsuccessful due to the French Revolution and the consequent loss of many of her clients, along with the destruction of some of her work by the revolutionaries. Her

- **1749** Born in Paris on April 11. She is the daughter of Claude-Edmé, who runs a fashion shop in Paris, and Marie-Anne Saint-Martin, a woman of delicate health.
- **1769** Her mother and one of her sisters die. She marries Louis-Nicolas Guiard, the administrator for the financier Bolliard de Saint-Julien, and she becomes the student of Maurice Quentin de la Tour.
- **1774** Participates for the first time in the Paris Salon with a miniature and a pastel, stirring the public's interest.
- **1776** Legally separates from her husband.
- **1777** Changes teacher, becoming an apprentice to François-André Vincent. By royal decree, the Académie is abolished, and with it, the Salon, thwarting her intentions to participate in it.
- **1783** On May 31, she is admitted to the Académie Royale des Beaux Arts in Paris, along with her eternal rival, Élisabeth Vigée-Le Brun, as well as Anne Vallayer-Coster and Miss Vien. She moves into an apartment on Rue Richelieu in Paris, where she sets up her studio and gives painting classes to several women.
- **1785** Has great success at the Salon and is awarded a stipend of 1,000 livres for her *Self-Portrait with Two Students*, in which she is accompanied by Marie Gabrielle Capet and Mademoiselle Carreaux de Rosemond.
- **1787** Her insistent request to be granted an apartment at the Louvre is unsuccessful because her students, young women from distinguished families, are considered morally dangerous for possible visitors. She executes a portrait of Louis XVI. Participates in the Salon with nine portraits of members of the royal family and the aristocracy.
- **1791** Exhibits seven portraits of members of the Assemblée Nationale, which give rise to bitter controversy due to their lack of idealization of the subjects .
- **1793** She divorces Louis-Nicolas Guiard.
- **1800** Marries her former teacher François-André Vincent.
- **1803** After being in a delicate state of health for a long time, she dies in Paris on April 24.

strong character abated with her change in social situation, which also weakened her health in her last years, and she stopped executing works of the magnitude of her previous periods.

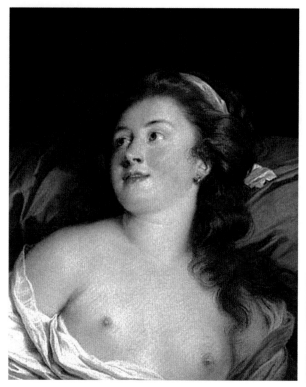

Delightful Surprise

(1779)
pastel on paper
21.5 x 17.5 in
(54.6 x 44.5 cm)
Getty Museum,
Los Angeles

This seductive feminine figure turns her head slightly to gaze at a visitor while reclining her head on a pillow. The movement is perfectly expressed despite its complexity and reveals the sensuality of the figure. There are many elements of great interest: the superb pastel technique; the sensuality of the female body; the chromatic range; the mysterious absence of the person seen by the woman; the coordination of the movement, caught as if in a snapshot; the atmospheric depth in all of the grounds; the composition, dominated by the tonal value moving from the center to the edges; the magnificent treatment of the clothing; and the masterful contrast between the soft, transparent, smooth texture of the skin and the organic roughness of the clothing.

None of these elements stands out above the others. Together, they comprise a perfect ensemble, full of lyricism and poetry, like the multiple instruments in an orchestra interpreting a musical symphony, and the beauty emanating from the work is the result of this harmony. The female figure, different from other works by Labille-Guiard, does not represent anyone in particular. The essential protagonism lies, in this case, in the frozen instant in time, the warm nudity of the woman's body against the black background, and the mystery of the unseen observer she is gazing at, which invites the viewer to complete the scene.

The Sculptor Augustin Pajou

(1782)
pastel on paper
30 x 22.8 in (71 x 58 cm)
Musée du Louvre, Paris

François-André Vincent

(~1780)
oil on canvas
28.7 x 23.2 in
(73 x 59 cm)
Musée du Louvre, Paris

François André Vincent (1746-1816) was Labille-Guiard's second husband and the brother of the miniaturist François-Elie Vincent. Considered the leader of the neoclassical movement until he was usurped by Jacques-Louis David, he had a great deal of influence on the artistic and institutional world. It is not surprising that this work, executed by his wife, falls fully within neoclassicism. Among the classical compositions typical of the artist, this painting is interesting for its wide range of colors, achieved with very little tonal variation.

Indeed, Labille-Guiard displays superb technical dexterity in color and tone, which allowed her to perfectly integrate the foreground with the middle and backgrounds and the outlines of the figure with the surrounding space. The interplay between the lateral illumination of the face, the darkness of the other side of the face, and the light in the background contributed to an atmospheric school that would extend throughout Europe.

Left: This pastel painting was exhibited at the Salon de la Correspondance, along with other works by members of the Académie, with whom Labille-Guiard maintained a friendly relationship. It was also exhibited at the Parisian Salon in May of 1783, along with works by her colleague and rival Élisabeth Vigée-Le Brun. The professional and personal confrontation between Labille-Guiard and Vigée-Le Brun lasted throughout their lives, as they were equally eligible for all awards for female artists.

The artistic quality of this portrait is on a par with all of Labille-Guiard's works. Once again, her thorough grounding in a medium as difficult as pastel is remarkable. She represents the sculptor at his work, modeling a nearly finished bust. The proximity of the figure and his hands on the sculpture produce a psychological portrait revealing the human qualities with which Pajou treated his works: His hands in contact with the work, constructing it and possessing it, fuse the artist with his sculpture. The touch of illumination places a particular emphasis on the protagonist's arms, emphasizing their importance to the sculptor's work and creating a compositional angle in the entire lower part of the pictorial surface. This illumination describes the link between the hands and the mind necessary to execute the piece, with their skill as the supreme factor in the creation of a sculpture.

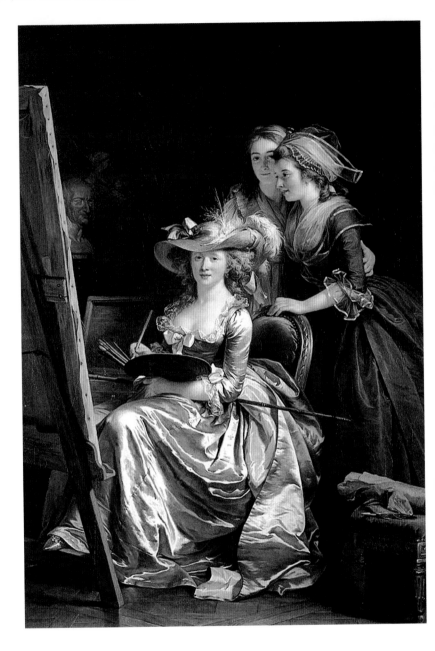

Right: This is a typical neoclassical representation of the aristocratic class. Its composition is based on medallions in the form of miniatures, part of a very old tradition whose modern-day equivalent is the family snapshot. The luxurious attire is characteristic of this codified manner of portraiture, and the artist exhibits her skill in creating transparency, wrinkles in the clothing, diaphanous feathers in the headdress, and so on. In this type of portraits it was very important to eliminate all elements in the background in order to focus the viewer's attention on the sitter. This is the case here, with only the change of light on the sides of Marie Hélène de France to emphasize her silhouette. Hence, the tonal brilliance and the layers of transparencies are the striking elements in a professional, commissioned work that followed the standards of the time, which dictated that the visual veracity of the representation was more important than psychological and conceptual aspects or creating an air of poetry.

Self-Portrait with Two Pupils

(1785)
oil on canvas
83 x 59.5 in
(210.8 x 151.1 cm)
Metropolitan Museum
of Art, New York

Left: In the year 1783, the Académie Royale admitted Labille-Guiard as a member, a position that only four women could hold at any one time. This filled her with satisfaction, as she had struggled to gain a name and a distinguished place in Parisian society. In return, as was the custom, she painted this work, in which she portrayed herself in the spacious apartment she had acquired that year on Rue Richelieu in Paris.

There she set up her studio and gave painting classes to various women, among them the two rendered here, Marie Gabrielle Capet and Mademoiselle Carreaux de Rosemond, who would become excellent portraitists. Labille-Guiard, seated in front of the easel, created a pyramidal composition defined by the three figures. While the teacher holds a palette and brushes and gazes at the viewer, her students observe her work attentively from behind.

The figures are well lit and stand out against the dark background, in which some of the objects of the studio can be seen, including sculpted busts and stretchers. With this minimal context, the work focuses on the figures, represented as distinguished people through their demeanor and clothing, executed with great realism and a wealth of details. The painting is compositionally and chromatically well balanced. The expressions are candid, transmitting serenity and exquisite sensuality, and the artist generously exhibits her savoir-faire. The success of the painting at the Salon is not surprising, nor is the award the artist was granted: a stipend of 1,000 livres.

Elisabeth Philippine Marie Hélène de France

(1788)
oil on canvas
31.9 x 25 in
(81 x 63.6 cm)
Château de Versailles, Versailles

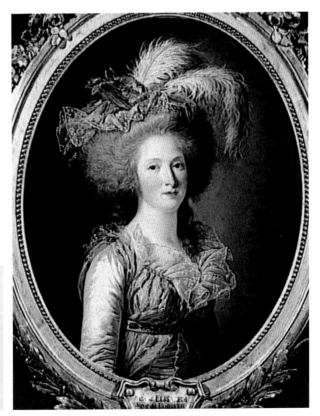

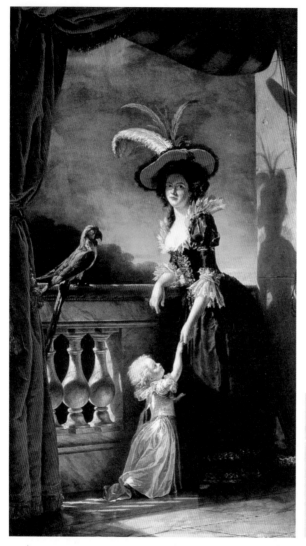

Posthumous Portrait of Louisa Elisabeth of France

(1788)
oil on canvas
108.3 x 63 in
(275 x 160 cm)
Château de Versailles, Versailles

This oil represents the Duchess of Parma (1727-1759) with her two-year-old son, Ferdinand, the future Duke of Parma (1751-1802). Though not one of her most famous works, this painting is probably one of Labille-Guiard's most interesting from a pictorial point of view, as it is a strange combination of the poetry of neoclassicism and the shadows of a Romanticism from which she was, in principle, far removed.

This fusion is present in both formal and symbolic aspects. The entire pictorial space is enclosed between the side and upper drapes and the shadow that the duchess casts against the wall to her right. This is a confrontation between natural and artificial worlds—in other words, between the light from the landscape in the background and the sophisticated culture of high society. It exhibits a very human and tender view of a mother and her child, confronted with unfathomable nature. Not only the figures' attitudes lead to this interpretation, but also the tonal relationship between the warm, nearly horizontal light and the shadow, profound and transparent, enveloping all of the elements in the work.

The technique of imbuing the various objects with volume through light is perfectly executed, and the sensibility with which the clothes are treated, illuminated by the brilliance of the ochres and yellows, is truly excellent. The artist's experience with portraiture and pastel allow her to successfully insert the scene within a dark yet intense landscape. The detail of the parrot lends the work a touch of exoticism that places the landscape within the mind rather than in a real place. It is nature dispossessed of God that leaves men at the mercy of their actions, as would be well demonstrated by the French Revolution. This is an exquisite painting, for both its technique and its psychological and spiritual intensity.

MARIE VICTOIRE LEMOINE

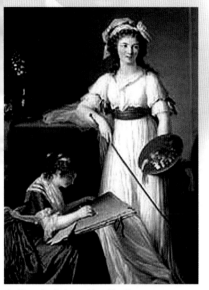

Atelier of a Painter *(detail), oil on canvas, 45.9 x 35 in (116.5 x 88.9 cm), 1796, Metropolitan Museum of Art, New York.*

A contemporary of Élisabeth Vigée-Lebrun, Marie Victoire Lemoine was part of the small group of women artists who specialized in society portraiture in 18th-century Versailles. The stylistic proximity between Vigée-Lebrun and Lemoine's artwork reflects the fact that they were close friends from the beginnings of their artistic careers.

Lemoine studied under François Ménageot, meeting the Vigée family through him, as he was an intimate friend of the well-known portraitist Louis Vigée, Élisabeth's father. In this artistic atmosphere, Lemoine learned the style of portraiture executed by Vigée, derived from the French academic tradition of the 17th century.

Though very few works are extant by Marie Victoire Lemoine, her art was remarkable for its thorough detail and outstanding realism, alongside that of Adélaïde Labille-Guiard, Anne

- **1754** Born in Paris.

- **1774** Studies academicist painting and portraiture in Paris under François Ménageot, her first known teacher. She sets up a studio in the city.

- **1779** Her first solo exhibit is held in the Salon de la Correspondance, in Paris, and she shows twenty or so works (including portraits, miniatures, and genre scenes with children).

- **1785** Holds her second exhibit at the Salon de la Correspondance.

- **1789** The beginning of the French Revolution ends representational portraiture. Though the majority of her colleagues emigrate to other countries, Lemoine continues to work in France.

- **1791** The Salon first allows women to participate this year. At the same time, Lemoine's works acquire great fame with the Parisian public.

- **1792** Travels to Italy with Ménageot.

- **1796** Exhibits for the first time in the Parisian Salon, five years after it began allowing women to participate.

- **1820** Dies in Paris.

Vallayer-Coster, and Vigée-Lebrun herself. These characteristics won her the approval of high society, which became her most devoted clientele.

Although the French Revolution threatened to wipe portraiture from the artistic scene, the genre evolved into a sort of historical portrait, and in that style Lemoine executed several works. Unlike her female colleagues, Marie Victoire Lemoine did not participate in politics and never took a stance either for or against the monarchy. As a result, her work in France was not affected by the Revolution.

Mademoiselle d'Holbach

(~1785)
oil on canvas
Ball State Museum of Art,
Muncie, Indiana

This is a traditional portrait of a woman. The oval shape of the work lends it a markedly classical air. The eminently aristocratic nature of portraiture during the 18th century faithfully reflected the manner in which the bourgeoisie that had relations with the French court wanted to be represented. But it should also be interpreted as a traditional art that was enriched by a familiar context, becoming a tribute to memory. In this sense, Lemoine's portraits were recognized and admired by the public as a reflection of the tastes of a certain social stratum at the time. Mademoiselle d'Holbach is in the middle ground, in a pose ideal for showing her beauty and exhibiting the aesthetic richness of her clothing. In an attempt to lend the model a gesture that would transmit spontaneity and movement, the artist studied the pose and represented the sitter against a dark blue background that creates a contrasting effect, focusing attention on the illuminated face and dress.

Young Woman with Dog

(~1796)
oil on canvas
National Museum of Art,
Bucharest

This painting, which for many years was ascribed to Elisabeth Vigée-Lebrun, is now considered to be the work of Marie Victoire Lemoine. The sitter's pose and the conception of the portrait are quite similar to those of Mademoiselle d'Holbach. This confirms that portraitists frequently had standard models, which they adapted to each commission with small variations, according to the tastes and interests of the client. Here, as in all of Lemoine's portraits, the figure is strongly illuminated, with a plain, dark background that focuses attention on the figure. The sitter is showing one breast. Among the upper classes, courtesans, and the French nobility, it became the fashion to introduce a more or less explicit eroticism into portraits. It was always refined and incisive, at times daring, and in addition to allowing the sitters to show their charm and create a flirtatious, equivocal language, it was considered a demonstration of liberalism and even a note of intellectual sophistication. Painters such as Jean-Antoine Watteau, François Boucher, and Jean-Honoré Fragonard explored this eroticism thoroughly. Naturally, in Lemoine's oeuvre, this type of portrait is well represented.

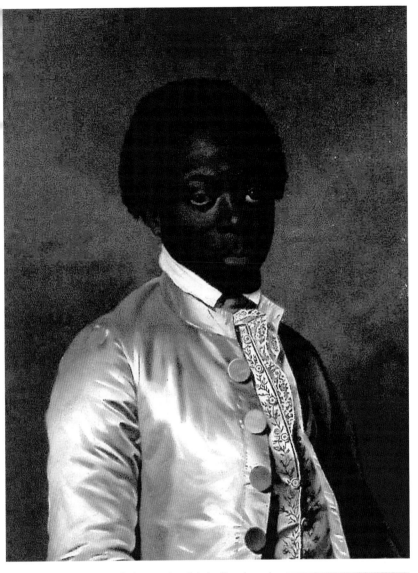

In 17th-century Paris, portraits of dark-skinned people constituted an exercise in sophistication and exoticism. Lemoine was commissioned to execute a portrait of Zamor after Élisabeth Vigée-Lebrun had turned down the offer. The sitter was an intimate friend and possible lover of Madame Du Barry, a distinguished figure who had close relations with the court of Louis

Zamor

oil on canvas
Cummer Museum of Art,
Jacksonville, Florida

XV and became the king's favorite, acquiring great popularity for her skill in relating to high society, her fascinating character, and her tumultuous, libertine life. For this portrait, the artist adopted the same style as that used for political figures. Zamor is luxuriously dressed and, although he looks less like a military leader or a statesman and more like a man with a rather sorrowful personality and a melancholic gaze, the painting is very formal in both conception and execution. Lemoine tended to use the middle ground in her portraits, setting her figures against simple backgrounds in order not to detract from the sitter's face, expression, and attire. These decorative details were highly appreciated by the high society of the period, and the importance lent to the clothing is a vivid example of the aristocracy's overwhelming concern for fashion. In this painting, Lemoine reproduces Zamor's pearly frock coat with great realism, achieving a complex effect of brilliance and corporeality in the cloth.

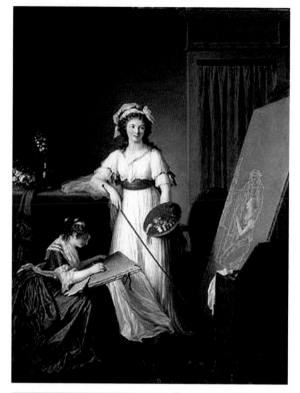

Atelier of a Painter

(~1796)
oil on canvas
45.9 x 35 in (116.5 x 88.9 cm)
Metropolitan Museum of Art, New York
Gift of Mrs. Thorneycroft Ryle

This work, exhibited by Lemoine the first time she participated in the Parisian Salon in 1796, was conceived as a sort of homage to Élisabeth Vigée-Lebrun, and to this day it remains uncertain which of the two is the artist represented in the painting. However, the majority of art historians assure us that it is a self-portrait of Marie Victoire Lemoine in her Paris studio, giving a lesson and supervising the work done by Vigée-Lebrun. This explanation seems the most plausible, since Lemoine was a year older than Vigée-Lebrun (here, Lemoine was 22 and her friend 21 years old). According to some, including Stella Blum, of the costume department of the Metropolitan Museum of Art, this work was painted near 1785, judging by the type of dress worn by the protagonist, which had gone out of fashion by 1790.

The two women are somewhat idealized here. The scene shows the artist in a melancholically reflective pose, contemplating her work while her pupil or disciple is rendered in a clearly inferior position. In a symbolic reading of this work, some critics believe Lemoine represents herself in this simple white dress as an evocation of innocence, as if she were a goddess giving a lesson and supervising her student's work, with a protective rather than judgmental attitude. Lemoine's art, principally consisting of historical portraiture of the most relevant figures of 18th-century Paris, acquires a more sentimental and emotive nature here, as she portrays herself next to her good friend while they work. Although the two painters always maintained a cordial relationship, Lemoine was slow to recognize her friend's skill—the skill that eventually led to Vigée-Lebrun being designated official portraitist to Queen Marie Antoinette in 1779. This elegant, delicate work is a synthesis of the interiors painted by Marguérite Gérard and the neoclassicist conception that Lemoine had learned in François Ménageot's studio.

ÉLISABETH VIGÉE-LEBRUN

Self-Portrait *(detail)*, oil on canvas, 39.4 x 31.9 in (100 x 81 cm), 1790, Galleria degli Uffizi, Florence.

Élisabeth Vigée-Lebrun was a fighter. She became an excellent portraitist after studying at her father's studio. For the quality and quantity of her works, she is one of the most important portraitists of all times. From her palette came excellent portraits of members of the European aristocracy, especially women and, above all, Marie Antoinette. The sitter is always portrayed in an idyllic, benevolent, and deeply emotional vision, with an extreme elegance that leaves nothing out. Vigée-Lebrun's artwork, precise, thorough, and always warm, flattered the sitter, concealed defects, and lent a touch of dignity with neither theatricality nor idealization. This made her highly sought after among the nobility, who were anxious to be portrayed by her.

It may have been her constant contact with that powerful stratum of society that led her to align herself with the French monarchy. During the French Revolution, she was accused by the reformists of being a bourgeois, mediocre painter and a social climber, staying close to those in power who were exploiting the people. She was forced into exile and suffered consequences. The pain that this caused her was compensated for by the enthusiastic welcome she received in other European countries. Italy, Austria, Belgium, Switzerland, England, and especially Russia opened their doors to her. After the political turmoil had died down, she returned to Paris, where she continued working.

Vigée-Lebrun's portraits exhibit an ancien régime style and a fondness for antiquity, which was in fashion in France near the end of the 18th century.

- **1755** Marie-Louise-Élisabeth Vigée-Lebrun is born in Paris on April 16 to the portraitist Louis Vigée and the hairdresser Jeanne Massin.
- **1767** After leaving the Couvent de la Trinité boarding school, she takes over her father's studio.
- **1774** As she has no degree, the Chatenet officials order her to close her studio. She becomes a member of the Académie Saint-Luc, in whose Salon she exhibits a series of works.
- **1776** Marries Jean Baptiste Pierre Lebrun, a rich art merchant.
- **1778** Paints her first portrait of Marie Antoinette; she would paint thirty or so in her lifetime. The Lebrun family receives assistance to purchase the Hôtel de Lubert, in whose halls the latest Parisian fashion trends are exhibited.
- **1779** Exhibits a collection of portraits at the hôtel, among which those of Marie Antoinette are outstanding.
- **1781** Beginning this year, exhibits frequently at the Salon de la Correspondance.
- **1783** Thanks to royal support, she is appointed member of the Royal Académie de Peinture et Sculpture, in whose Salon she exhibits for the first time, receiving mixed reviews.
- **1787** Her highly successful participation in the Paris Salon causes great commotion because she is a woman.
- **1789** Following the Revolution, she takes advantage of the fact that artists are allowed to travel. She leaves Paris and moves to Italy.
- **1794** Leaves Rome and returns to Paris, where she is informed that she is no longer a citizen. Gets divorced.
- **1795** Leaves Paris and visits various countries, including Belgium, Switzerland, and Austria. Invited by the Empress Catherine II to visit St. Petersburg, where she is appointed a member of the Academy of Fine Arts.
- **1802** Returns to Paris, where she receives a cool reception from the Bonapartes for having sided with the Bourbon monarchy.
- **1803** Following the signing of the Treaty of Amiens, she travels to London, where she paints various portraits, including those of the Prince of Wales, young Lord Byron, and Mrs. Chinnary.
- **1835-1837** Publishes her memoirs, *Souvenirs*, which has great success.
- **1842** Dies in Paris, probably due to arteriosclerosis.

Madame Grand

(1783)
oil on canvas
36.2 x 28.5 in (92 x 72.5 cm)
Metropolitan Museum of Art,
New York

Catherine Noele Verlee, called Worlee, was born in Tranquebar, India, in 1762, the daughter of a French officer. In 1778, at age 16, she married George Francis Grand. After various vicissitudes, she arrived in Paris, where Vigée-Lebrun executed this portrait. In 1802 Mme. Grand got divorced in order to marry Charles-Maurice de Talleyrand, Duke of Périgord and the last prince of Bénévent, from whom she separated in 1815. She died in 1835. When this portrait was executed, Mme. Grand was 21 years old. Vigée-Lebrun renders a somewhat idealized, sophisticated figure. The woman's pose, with her head turned, staring upward, her gaze lost in infinity, combined with the light entering from the upper left, precisely where her gaze is directed, lends the image a dramatic air. The sitter exhibits her beauty: a slender figure with smooth skin and a delicate, refined complexion, excellently dressed, with a fine hairdo and a healthy aspect. The dense colors used in both the background and a significant part of her dress constitute a frame that, with the intense light striking the figure, makes the fragile face and upper chest stand out. In the areas closest to the body, the dress becomes considerably lighter so as not to detract from the focus of attention. The woman projects an elegant image, with a great richness of colors and a fine sensuality.

According to mythology, the Bacchantes were women who formed Bacchus's retinue, whence their name. They were associated with all sorts of pleasures, especially those related to wine, food, and orgies. They were often represented in leopard skins, generously exhibiting their anatomical charms in voluptuous, arousing images. Regardless of the title, this painting is actually a portrait of the Countess of Vaudreuil, who commissioned it. Vigée-Lebrun was motivated by two basic interests: that the image safeguard the classical aspect of the mythological figure while resembling the sitter. This was a challenge that the artist had faced on other occasions as well (*Young Prince Lubomirsky, Love of Glory*; *Julie Lebrun as Flora,* 1799, Private collection).

Bacchante

(1785)
oil on panel
42.9 x 30.7 in (109 x 78 cm)
Museum Nissim de Comondo, Paris

She opted for a dark background to enhance the protagonism of the figure. The selected pose allowed the model to bring out her charm, which must have satisfied the wishes of the sitter, most certainly content with the image of her body. It is strong, voluptuous, and attractive, with turgid, nearly defiant breasts. Her right arm lifted over her head helps to exhibit her torso and introduces an element of ambiguity through the shadow that it casts on her face. Although it neither fully conceals her features nor impedes the subject from being identified, the shadow constitutes a sort of mask that safeguards the woman's modesty and increases the eroticism of the image. The careful details, delicate complexion, warm colors, and profound sentiment are other qualities that adorn this exceptional work. It was exhibited at the Paris Salon of 1785, where it enjoyed great success.

Marie Antoinette and Her Children

(1787)
oil on canvas
40.9 x 32.3 in (104 x 82 cm)
Château de Versailles,
Versailles

This is one of the last portraits that Vigée-Lebrun painted of the queen before Marie Antoinette was imprisoned and executed during the French Revolution. It was painted in one of the halls of the palace of Versailles, together with her children: Marie Thérèse Charlotte on the left; Louis Joseph, the dauphin, on the far right, who would die of natural causes shortly after the Revolution; and in his mother's lap, Louis Charles, Duke of Normandy, the second dauphin, who was not quite 2 years old. When his father died by the guillotine, he was recognized as Louis XVII by the royalists, but the Commune placed him in the care of a man by the name of Simon, a cobbler, who was to care for him as he would have for any other child. Although it was believed Louis Charles died of scrofula when he was 10 years old, forensic tests carried out in 2000 demonstrate that his death was due to malnutrition and neglect.

As in other portraits of the queen by Vigée-Lebrun, the artist emphasizes Marie Antoinette's human side, representing her more as a mother than a queen. The composition is in the shape of a pyramid within which the figures are inscribed, with Marie Antoinette as the protagonist. She is rendered as a matriarch, wearing an ample dress with a low, rounded neckline, in accordance with the style of the period, and a spectacular hat. Unidealized and devoid of sophistication, the figure radiates dignity and distinction and is particularly charming, especially in the presence of her children, who are placed in a studied distribution. Marie Thérèse Charlotte, the eldest of the three, is leaning against her mother in an affectionate manner, the young Louis Charles is sitting on her lap making typically infantile gestures with his arms, and Louis Joseph is placed at a slight distance for compositional reasons. The whole is balanced in masses, in a predominantly warm palette with unifying, all-encompassing overtones. The painting, imbued with sensibility and delicacy, reveals the maternal sentiments of the artist herself.

Right: While she was exiled from France, Vigée-Lebrun traveled throughout Europe, constantly receiving portrait commissions from the aristocracy. While some wanted a conventional portrait, others sought special connotations. Here, the artist associated the ingenuity and tenderness of Prince Henry, still a child, with Cupid, dispensing with the bow and arrows but including the wreath that Cupid placed on the heads of his victims. The expression on the face, crowned by a lovely head of hair, the delicate complexion, and the attributes that make the figure mythological (wings, the red gauze, and the wreath) constitute an allegory, justifying the nudity that the public would not otherwise have accepted.

Self-Portrait with Julie

(1789)
oil on canvas
47.6 x 74.8 in (121 x 190 cm)
Musée du Louvre, Paris

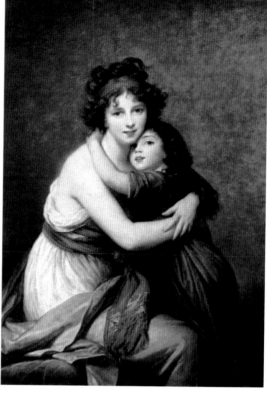

Julie (Jeanne-Julie-Louise) was the artist's only child, born on February 12, 1780. When Élisabeth divorced Jean-Baptiste-Pierre Lebrun in 1794, young Julie accompanied her mother on all of her travels through the various countries of Europe during their exile. In Russia, Julie met Pierre-Narcisse Guérin, a neoclassical painter, and fell in love with him, but, at her parents' insistence, she married Gaetan-Bernard Nigris in 1800, the secretary to the director of the Imperial Theater of Saint Petersburg. The marriage had fallen apart by 1804. Julie died in November of 1819, probably from pneumonia.

In this painting, the artist shows the beauty of her daughter, young, delicate, and sweet, and gives free rein to her maternal sentiments of tenderness. The embrace is an exquisite reflection of the affection existing between the mother and daughter. Although it is not an idealized representation, the type of dress that the artist is wearing and the exposed portion of her body recall allegorical or mythological figures. Julie's gesture and expression denote both love and her search for her mother's protection. The painting faithfully reflects the depth of the artist's feminine sentiments and transmits the tender harmony and happiness of both figures and the charm of family love. All of the sentiment with which Vigée-Lebrun imbues the painting is accompanied by virtuosity and a strength that is enhanced by the colors and composition. The artist manages to conquer the viewer's gaze and touch the inner person to transmit her sentiments.

Young Prince Lubomirsky, Love of Glory

(1789)
oil on panel
41.3 x 32.7 in (105 x 83 cm)
Gemäldegalerie Dahlem, Berlin

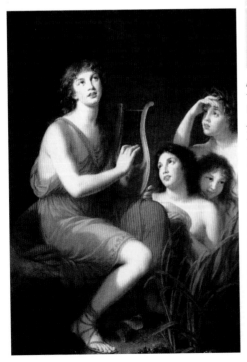

Bacchante

(1785)
oil on canvas
29.3 x 23.6 in (74.3 x 60 cm)
Clark Institute, Williamstown,
Massachusetts

This work is a portrait of Lady Hamilton. Emma Hamilton (~1765-1815) was a British lady who married the British ambassador to Naples, William Hamilton, in 1791. Known for her elegance and her various amorous affairs with members of high society, she became especially famous in 1798, when she became Admiral Nelson's lover. The artist knew the character of the sitter well and, attending to her wishes, rendered her in a splendid, somewhat idealized image, with an aspect that recalls representations of historical and mythological figures such as Cleopatra, Lucretia, and Flora. The woman's body is somewhat fleshy, the skin consistent, and the breast strategically located within the painting, constituting an invitation and a challenge at once. The image is extremely sensual.

Amphion Playing the Lyre

(1793-1795)
oil on canvas
Private collection, France

According to mythology, Amphion was the son of Antiope, the wife of Lycus, king of Thebes, through her union with Jupiter. Abandoned by his brother Zethus on Mount Cithaeron, Amphion was given a golden lyre by Apollo. Amphion proved to be such a marvelous poet that, upon hearing him play, the stones, spellbound, gathered and made themselves into the ramparts of Thebes. This painting is a typical mythological representation, in accordance with the artist's style and aesthetics. Amphion is accompanied by the naiads, nymphs inhabiting rivers and springs. As models for them, the artist used friends of her daughter (Guichets, Polignac), and her daughter, Julie. The work is elegant, compositionally meticulous, and chromatically balanced, transmitting tranquility.

GABRIELLE CAPET

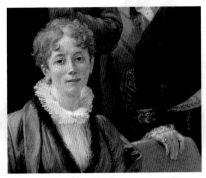

Studio Interior *(detail), oil on canvas, 1808,*
Bayerische Staatsgemäldesammlungen,
Neue Pinakothek, Munich.

Marie Gabrielle Capet was a renowned painter, especially for her medium-sized and miniature portraits in pastel, watercolor, and oil. At the age of 20, she became a student of Adélaïde Labille-Guiard, who was to become a good friend and whom she would care for until her death. Labille-Guiard was a famous painter who was well introduced into high society. This facilitated Capet's future and her possibilities for gaining good clients. Though she attained considerable recognition, she did not achieve it to the same degree as her teacher.

Capet exhibited in Paris on many occasions. Her first exhibit was held at the Salon de la Jeunesse in 1781. She participated in the Parisian Salon beginning in 1795. In 1785, Labille-Guiard was commissioned to portray Adélaïde and Victoire, aunts of Louis XVI, and Capet collaborated on the portrait. Testifying to this is a drawing of the outlines of the sitters, which S. C. Miger used for an engraving. Other royal portraits that she executed were those of Elisabeth and Marie-Thérèse, daughters of Louis XVI. The royal court was receptive to women artists and often commissioned them to paint portraits, leaving paintings of historical scenes to their male colleagues, as they were considered more complex.

The artist also revealed her talent in the art of miniatures, to which she lent freshness and veracity. Capet may have taken up this genre for economic reasons, and perhaps to help her teacher and friend as well, who was always weighed down with too many commissions to execute herself. Capet's work is a worthy representative of the type of art executed by French women artists between 1775 and 1825.

- **1761** Born in Lyons on September 6 to a servant.
- **1781** She is a student and assistant at Adélaïde Labille-Guiard's studio in Paris. She exhibits for the first time at the Exposition de la Jeunesse with her painting *Head of Expression.*
- **1784** Paints a self-portrait in which she is holding a brush and palette and looking at her male model. This painting causes the *Journal de Paris* to cite her among the best young women painters, praising her steady hand and the force of her drawing.
- **1785** The magazine *Mercure de France* mentions Capet's talent. She exhibits at Pahin de la Blancherie, Salon de la Correspondance. Labille-Guiard participates in the Salon with a self-portrait with two of her students, Capet and Mademoiselle Carreaux de Rosemond, which represents the official introduction of the young painters. Many of Capet's portraits of figures from high society date from this period, including those of the Marquis de Vauborel and members of the royal family under Louis XVI.
- **1791** Executes a miniature portrait of the Princess of Caraman-Chimay.
- **1793** She loses the royal patronage that she had enjoyed during the previous years.
- **1795** As of this year, she begins executing portraits of important people.
- **1799** Participates in the Salon with a portrait of a famous painter of historical scenes, Charles Meyneir, a significant subject for a female artist at the time.
- **1801** Participates in the Salon with two miniatures, one of her mother and another inspired by Labille-Guiard's portrait of Augustin Pajou. In Capet's miniature, the sculptor Jean-Antoine Houdon is working on a bust of Voltaire.
- **1808** Exhibits her masterpiece, *Study,* at the Salon, in which the artist appears with Labille-Guiard in the latter's studio, preparing a palette to execute the portrait of the artist Joseph-Marie Vien surrounded by his family.
- **1810** Capet is now a renowned large-scale portraitist, famous for her pastels and oils (*Portrait of a Woman,* Félix Doisteau Collection, Paris; *Madame Demet,* Henri Philippe Collection, Paris).
- **1814** Participates in the Salon for the last time with various portraits of artillery officials, and with her only historical-mythological painting, representing Hygeia, the goddess of health.
- **1815** Executes her last known portraits.
- **1817** Dies in Paris, November 1.

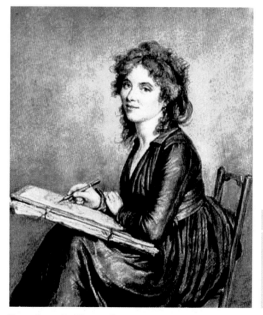

Self-Portrait

chalk and charcoal
on paper
13.4 x 11.5 in (34 x 29.3 cm)
Private collection

Throughout the history of art, women painters have practiced self-portraiture. From Artemisia Gentileschi in the 16th century to Tamara de Lempicka and Frida Kahlo in the 20th, a great number of female artists have felt inclined toward the self-portrait. Each artist executed these self-portraits from her own personal and sincere point of view, revealing intimate details that went unnoticed in written criticism.

In all of these self-portraits, the artists execute an interesting psychological exercise through which they show themselves before the public as they believe they are, in a sort of striptease revealing their character, sentiments, and hopes. They also show great artistic effort in an attempt to reflect their talent in a genre as personal as the self-portrait. As other painters camouflage the narrative messages of their paintings by representing other paintings within them (which in pictorial analysis is called the theory of a painting within a painting), these women artists show their own interiors in the figure of the woman they represent on canvas, often camouflaged as if it were a model having nothing to do with them.

This painting can be considered unique because the style is wholly distinct from that used in portraits of high society and in Capet's own promotional self-portraits. Using chalk as the medium here, which was still considered second class in the 18th century, Capet executed a free and sincere self-portrait that allowed her to render herself in an intimate manner. Seated on a chair, the artist gazes directly at the viewer while she sketches. The pose creates an ambiguous situation: We are not sure whether the artist is looking at the public or studying her model—that is, herself.

Though Capet painted many self-portraits, the majority of them can be understood as promotional works, in which she rendered herself in a specific manner, wearing clothing chosen to transmit a specific sensation and reflecting her social condition and her environment in order to insure commissions from her high society clients. Therefore, those self-portraits were fictitious and altered, like all publicity. This one, on the other hand, is an honest self-portrait. The artist renders herself alone and as she is, completely free of conventions and conditions of any type. The general sobriety, the background, the dress, her hair, and the expression on her face clearly show her degree of sincerity and transparency.

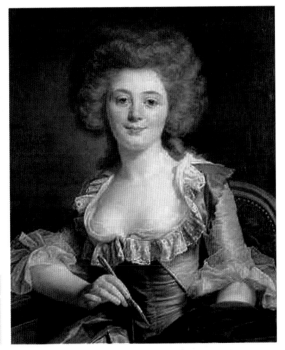

Self-Portrait

oil on canvas
Private collection

Though it is not certain that this is a self-portrait, it is generally considered as such. Through it, the artist transmitted the pompousness permeating the world of Parisian high society at the turn of the 18th century. Due to the social situation of the time, characterized by an upper class especially eager to commemorate itself in portraits, there were many artists, both male and female, who specialized in portraiture. Generally, portraitists were short of financial resources and had little possibility of making a living if they took up other genres. These painters, who lived off of the commissions they received, competed with one another in prices, styles, and attempts to gain wealthy clients. Especially desirable were those among the aristocracy and, if possible, the royal family itself, for they could give the greatest number of commissions and thus enhance recognition.

Capet obtained the same artistic success as Marie Victoire Lemoine, but she never attained the popularity nor the quality of Élisabeth Vigée-Lebrun, who was her eternal rival. In this painting, the artist renders herself as if she were one of the figures of the French court, members of which she portrayed on several occasions. Wearing an elegant dress, she paints herself frontally, holding a palette and brush in her hands while supposedly executing one of her paintings. Capet, like Vigée-Lebrun and Lemoine, executed other self-portraits representing herself in the course of executing a painting. In them, oddly enough, she is usually gazing at the viewer, establishing a sort of game in which the public appears to be the portraitist and the artist the sitter.

For Parisian painters of the latter 17th and early 18th centuries, portraiture was a tool for social and artistic promotion. This explains the frequency with which they portrayed themselves in their studios executing one of their works, dressed too finely for painting but very appropriately for promoting themselves among the public they sought as clients. Their clothing and the distinction transmitted through the painting made the wealthy identify with the person portrayed and imagine what their own portrait would look like. They would thus be more likely to commission a portrait. There was also a common factor among women artists: Their professional pride and a vanity led them to render themselves elegantly dressed and painting, as if this activity were a distinctive sign of high society.

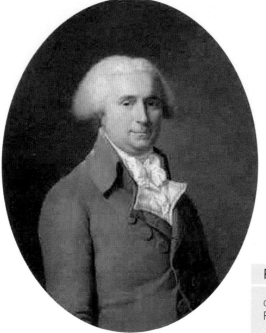

Portrait of a Figure

oil on canvas
Private collection

Like the artists Élisabeth Vigée-Lebrun and Marie Victoire Lemoine, Capet adopted the por-
traitist tradition emerging in France during the 17th century. In this painting, the character-
istic pictorial style of the time is evident, in which the nobility and upper middle classes
enjoyed a comfortable financial situation that allowed them to consider painting a consumer
product. In addition to being a sign of distinction, painting appealed to them because they
could immortalize themselves in a portrait.

During this time, various pictorial styles arose. Small-format works abounded and were
generally hung in the rooms of the client's home, whether or not it was a palace or mansion.
Portraiture and still lifes reveal this new concept of art as a decorative element. Until the
17th century, the so-called greater arts were reserved exclusively for royal palaces, churches,
and great patrons. When the public began to acquire greater social and financial indepen-
dence and the court showed an interest in transmitting a more enlightened image of them-
selves, painting began the process of becoming independent, which allowed artists greater
stylistic liberty.

In this painting, the artist executed a portrait very characteristic of the tastes of the time,
a work of great quality in details, in which the figure's luminosity stands out, inscribed with-
in an oval form. Traditionally, portraits of relevant figures of French society during the 17th
century were executed in dark tones, obliging the viewer's attention to focus on the face. In
this painting, however, the artist executes a very bright painting, allowing her to work with
different tones that lend realism and chromatic richness to the figure's corporeality.

Marguerite Gérard

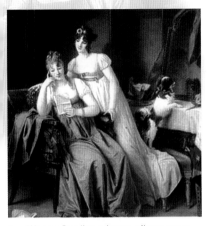

Two Women Reading a Letter, *oil on canvas, ~1805. Probably the seated woman is a self-portrait.*

There are two especially important events that had a bearing on Gérard's artistic career: her sister's marriage to Fragonard, and her decision to go and live in Paris with her brother-in-law and sister, as she was from a rural area with no possibilities for artistic training. A close relationship of friendship and professional veneration grew between her and her teacher, Fragonard. Their professional interchange would bear fruit, and Gérard's works were stylistically indebted to Fragonard.

The historical period in which she lived is also important. Social and ideological changes renovated the entire French political stratum, from the monarchy to the upper middle class and nearly reaching the lower classes as well. Instead of pronouncing herself in favor of the social changes taking place, she took refuge in intimate family life, changing her subject matter to indoor scenes of mothers and children, pets, and so on. She continued to represent the bourgeoisie and the economically powerful.

Gérard was in no rush to marry, which gave her the leisure and freedom to develop a polished style that she dedicated to scenes of illuminated women carrying out various activities, from playing music to caring for children or reading love letters. Her style was based on the powerful influence of 17th-century Dutch art and then became consolidated in a rococo technique approaching the ancien régime of Versailles and Louis XVI.

She shared artistic experiences with two

- **1761** Born in the town of Grasse, France.
- **1769** Her sister Marie-Anne marries Jean-Honoré Fragonard, which will radically influence her artistic development.
- **1775** Moves to Paris to live with her sister and brother-in-law. Unofficially Fragonard's apprentice, she becomes very active artistically.
- **1780** Fragonard collaborates on her work *The Beloved Child*, to the point where he executes the preliminary drawings. From this time on, they have a close relationship.
- **1785** Begins to develop an original style with a meticulous technique inspired by Gabriel Metsu, Gerrit Terborch, and other minor Dutch masters.
- **1789** The French Revolution starts. Though according to many she is one of the three most important female French painters of the time, along with Vallayer-Coster and Vigée-Lebrun, her upper-middle-class background and her classical principles on family and society call her artwork into question. She takes refuge in domestic and mother-child genre scenes.
- **1790** The Salon begins admitting works by women, and she exhibits regularly there until 1824.
- **1796** Though she becomes famous for her portraits and miniatures, this year and in 1798, she executes various illustrations for *Les Liaisons Dangereuses* and *Les Amours de Faublas*, in which she shows an inclination toward the innovations of neoclassicism. Based on the Dutch and French 17th-century style, Gérard's art anticipates the nostalgia of 19th-century Romanticism.
- **1824** With the death of her sister, she presides over the Fragonard clan, including the children of Alexandre-Evariste, Jean-Honoré Fragonard's brother, and the artist's brother, Henri Gérard.
- **1837** Dies in Paris.

other women contemporary with her, Adélaïde Labille-Guiard and Élizabeth Vigée-Lebrun. The three had a common style and subject matter, and they clearly shared the influence of the rococo painter Jean-Baptiste Greuze (1725-1805). Formally, Gérard's work is characterized by an intense ornamentation, which in some works constitutes the main interest, and which the artist cultivated with great meticulousness and attention to detail.

The Beloved Child

(1790)
oil on canvas
20.4 x 20.4 in
(51.9 x 51.9 cm)
Hillwood Museum and
Gardens, Washington, D.C.

One part of the artist's oeuvre depicts upper-class ladies in the guise of beautiful heroines, firmly rooted in puritanism and a delicate family happiness. This painting is a magnificent example. The mother, her child, and their companions are shown at play, dressed in satin and gauze, in an idealized world where people are amusing themselves outside their palaces. This is one of the artist's most important works from a technical and iconographic point of view. The landscape not only provides a background but also serves to lend the work the idea of space, of void and plenitude, as well as contributing to the sensation of movement in the central figures. Excess is another characteristic of this oil painting: undulating compositional lines, saturation of the surface area with all sorts of elements, sinuosity and curves in the clothing, bodies overflowing with materiality. All are within the rococo canons of the period.

Right: This work can be ascribed to Gérard's puritan style. The technique, applying the laws of clear color and half-light on the clothing and bodies, lends the painting a great deal of atmosphere. The composition is meticulously executed: The diagonals produced by the furniture direct the eye toward the center of the scene and beyond the figures into the nearly indefinite background. The subject of this painting is an everyday domestic scene of a young woman playing tenderly with her child before the attentive gaze of an assistant. The idea of tenderness represented in this enclosed space predominates, referring to a private world reserved exclusively for the mother-child relationship. The only thing that interested Gérard when she painted this work was the everyday intimate world that allowed her to escape what was occurring in post-Revolutionary Paris.

Blond Boy

oil on canvas
8.8 x 6.5 in
(22.4 x 16.6 cm)
Musée du Louvre, Paris

This work is undated, but was probably executed toward the end of the 18th century. It shows the clear influence of Gérard's sister, a specialist in miniatures. Baroque features can be observed in tonal and other essential aspects. Nonetheless, the subject matter is fully within the artist's intimist period. The perfectly centered placement of the unidentified sitter and the layered transparency technique make this portrait a significant advance over previous works. It seems to distance itself from the superficial influences of the rococo to enter into the soul of this figure, without the superfluous decorations and ostentation typical of the educated bourgeoisie to which the artist belonged. Furthermore, the fact that the identity of the model is unknown and that there is little in the painting adding context focuses attention on the boy's softly lit face and his inexpressive eyes. This is an example of a childhood seen from the point of view of comfort and well-being, with neither indications of sorrow nor joy. The expressive inhibition is in accordance with the delicate situation of the French upper classes toward the end of the century.

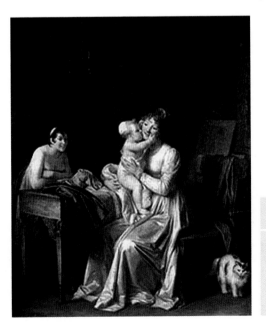

Young Woman with Her Child

(1799)
oil on canvas
25.2 x 20.9 in (64 x 53 cm)
Musée des Beaux-Arts, Dijon

Two Women Reading a Letter

(1804)
oil on wood
21.9 x 18.2 in
(55.6 x 46.3 cm)
Private collection

This work falls between two styles. It represents the initial moment when Gérard turned toward interior genre scenes. The two female figures in the center of the painting are reading a supposedly private letter together. The rest of the room is simply anecdotal, as it does not provide any information on the secret hidden in the letter, a secret that remains exclusively in their knowledge. Formally, the orange colors of the sides frame the greens near the middle in a combination of complementary colors, conferring lovely chromatic harmony to the work. The attire exercises a great weight on the bottom of the painting, and the artist compensates with the white light that predominates in the central area. The idea of a secret implicit in this representation and the painting's marvelous composition make this a spectacular work.

Young Woman Giving a Cat Milk

(1814)
oil on canvas
24.1 x 19.7 in
(61.2 x 50 cm)
Private collection

This painting was exhibited at the Parisian Salon the year it was created. It is a particularly significant work, as it indicates the moment when Marguerite Gérard stopped painting outdoor scenes and turned to interiors with women, children, and pets, where intimacy acquired protagonism. In this work, privacy regulates everything else: A squatting female figure offers a bowl of milk to a cat on a hassock. The background is dark and undefined, making the two figures illuminated from the right stand out, while the dog in the middle ground, the few objects in the foreground, and the cloth covering part of the hassock are secondary elements. The simplicity of this work contrasts with the complexity of previous outdoor scenes by the artist. This is not a fully rococo work; instead it lies somewhere between baroque and neoclassical art. The tenderness of this scene would have many followers, particularly a series of artists who, after the French Revolution, began painting intimate works describing triumphant bourgeois families.

CONSTANCE MAYER

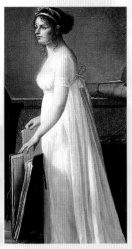

Self-Portrait with the Artist's Father *(detail), oil on canvas, 1801, Wadsworth Atheneum, Hartford, Connecticut, Sumner Collection Foundation.*

Constance Mayer's artistic career spanned twenty-five years of great political turbulence, including the French Revolution (1789-1799), Napoleon's empire (1804-1814), and the restoration of the Bourbon monarchy (1814-1848).

Her artwork especially concentrated on mythological and allegorical scenes, but she also executed lyrical portraits, miniatures, and genre paintings in oil and pastel. She was deeply influenced by her teachers' styles. Many of her works were erroneously attributed to her professor, Jean-Baptiste Greuze, a painter of melodramatic and moralizing genre scenes. Mayer was also interested in Jacques-Louis David's academic neoclassical style, so much so that she adopted his simplicity and included references to Raphael and antiquity, in both the selection and the style of the subject matter she painted.

Finally, in her teacher Pierre-Paul Prud'hon, she found a painter who had removed himself from a strictly classicist style and opted for a gentler, more sentimental style heralding Romanticism. Not only did she begin a personal relationship with him, but the couple also collaborated professionally. They worked on the same subject matter in a very similar style and executed many paintings jointly. Prud'hon would create the sketch or preliminary drawing, which she would then paint in oil. The paintings sold much better if they were signed by Prud'hon. For this reason, attributing a painting to Mayer alone or as a collaborator is difficult. During their period of collaboration, Mayer continually exhibited paintings signed by herself at the Salon.

- **1775** Marie-Françoise-Constance La Marinière-Mayer (or Mayer-LaMarinière) is born in Paris. The daughter of a customs officer, she remains close to him throughout her life. Receives her education in a convent in Paris.
- **1796** Studies under Joseph-Benoît Suvée. Participates in the Parisian Salon, which she will continue to do regularly. Exhibits portraits and self-portraits that include miniatures of her father, as well as domestic genre scenes. These paintings show her teacher's influence in the selection of subject matter and the soft brushstroke.
- **1801** After Suvée leaves Paris, she works briefly in the studio of Jacques-Louis David. Continues her training under Jean-Batiste Greuze, imitating his style very closely. She meets another of Greuze's female students, Jeanne Philiberte Ledoux, and establishes a lifelong friendship.
- **1802** In Greuze's studio, she meets the artist Pierre-Paul Prud'hon, under whom she begins to study shortly thereafter.
- **1803** After Prud'hon's wife has a nervous breakdown and is interned in a mental hospital, Mayer moves in with Prud'hon, where she takes care of him and his children. The teacher and his student fall in love and begin to collaborate professionally, though they conceal their affair in public. Mayer takes charge of Prud'hon's commercial relations with clients as important as the Empress Josephine. He becomes one of the most important painters in his genre.
- **1805** Greuze, her teacher, dies. Prud'hon paints a portrait of Empress Josephine. In addition to painting for the court, Mayer designs neoclassical furniture for Napoleon's family.
- **1810** Her father dies and she inherits a significant fortune, which allows her to rent a studio next to Prud'hon's at the Sorbonne. She places her fortune at the disposal of her new family, but Prud'hon refuses to marry her.
- **1816** In recognition of her artistic achievements, she receives an apartment in the Louvre.
- **1821** Commits suicide in her studio while Prud'hon is working next door. There are several theories as to the causes: Prud'hon's children did not accept her as their mother; he refused to marry her; and the Sorbonne was threatening to evict her. She is buried at the Père-Lachaise Cemetery in Paris, next to Prud'hon, who died two years later. Before he died, he organized a retrospective of her works in the Parisian Salon, including those on which they worked jointly.

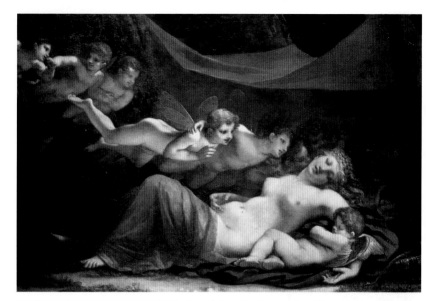

The Sleep of Venus and Cupid

(~1806)
oil on canvas
38 x 56.9 in (96.5 x 144.5 cm)
Wallace Collection, London

Commissioned by Empress Josephine with the title *The Dream of Psyche*, this painting was exhibited at the Salon in 1806 under the title *Venus and Cupid Sleeping, Caressed and Awoken by Zephyr.* Another painting went with it, today known as *The Torch of Venus,* though it was exhibited at the Salon under the title of *Psyche's Waking* and sold by Mayer for a modest sum. Later, this painting was attributed to Prud'hon, thanks to which it was sold at a much higher price. It thus entered the Wallace Collection and was exhibited until 1911 as a work by Prud'hon by the name of *The Dream of Psyche.* Today it is exhibited under the title with which it was exhibited at the 1806 Salon. Although it seems that this painting is based on the story of Cupid and Psyche, this subject is a diffuse version as compared to the story put forth in classical mythology, which served simply as inspiration for this classicist painting.

According to mythology, Cupid married the lovely Psyche against his mother Venus's wishes. Zephyr, the god of the west wind, carried Cupid's wife to his castle every night so that she could sleep with her husband on the condition that she never see him. Here, Zephyr, accompanied by several winged boys who recall baroque angels, flies in from the dark upper left, gazing tenderly upon the goddess and Cupid, asleep under a red cloth. Venus is partially nude, still sleeping with her arm around her son. It seems that she is about to wake up, lending the work a great deal of tension enhanced by the lively composition and Zephyr's movement. The light, with its chiaroscuro effect, focuses on Venus and Cupid and converts the scene into a moment of sweet intimacy.

Right: The happy mother is seated in a clearing in the forest, at the foot of some tall trees through which the rays of the sun filter, illuminating the woman as if she were a vision. Gazing tenderly at her child, who is sleeping in her lap, the mother is very similar to a Madonna, though she is not viewed frontally. Furthermore she is dressed in colors similar to those used in images of Mary, with a blue tunic and a red cape. Thus the artist does not only represent a mother, but also evokes the mother of Christ, the universal symbol of maternity within the Christian culture.

The allegory of maternal happiness was very popular at that time and was frequently adopted as a subject, especially by female painters, who, according to public opinion, were only supposed to paint genres such as still lifes, floral scenes, or, at most, family portraits. The subject of maternity thus constituted for many female artists the possibility of painting a universal and allegorical theme without having to suffer the criticism of the public. Toward the end of the 18th century, this subject was popularized by philosophers and politicians of the French Revolution. Until the early 19th century, there was a general interest in specific types of genre scenes (mothers nursing their children, children taking their first steps, and similar subjects), which can be associated with the experiences suffered by the French people during the Revolution and wars, creating a need to represent images evoking earthly paradise.

The Happy Mother

(1810)
oil on canvas
76.4 x 57.9 in (194 x 147 cm)
Musée du Louvre, Paris

The Unhappy Mother

(1810)
oil on canvas
76 x 56.7 in (193 x 144 cm)
Musée du Louvre, Paris

This painting, exhibited at the 1812 Salon, is the counterpoint to *The Happy Mother,* also from 1810. The unhappy mother, now alone without her child, is in a dark place resembling a cave. Like the figure in *The Happy Mother,* she is illuminated from above by tenuous light, this time moonlight, which does not reveal the unfortunate woman's surroundings. Leaning against a rock wall with her head bowed, she contemplates a cross in the ground, weighed down by the memory of her dead child. The color range is predominantly brown, beige, and black, emphasizing the sadness of her loss through a world devoid of vivid colors. The mother, tall and thin, is in mourning, and she presses her cloak against her empty lap. With her long black hair, white complexion, stooped posture, and sad expression, she is painted in the same manner as Melancholy was traditionally represented. She is wearing a white tunic with fluid lines gathered under her breasts in a Greco-Roman style. Thus this painting is not only in line with the classicist style, but also with the Empire style of the Napoleonic era.

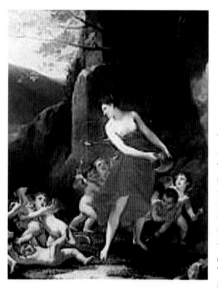

Young Naiad Rejecting Cherubs

(~1812)
oil on canvas
71.3 x 55.5 in (181 x 141 cm)
Musée Ochier, Cluny

The protagonist of this painting, exhibited at the 1812 Salon, is a naiad surrounded by various cherubs. In Greco-Roman mythology, naiads were river and fountain nymphs who personified the waters in which they lived. The nymph is in a natural setting, at the foot of a large rock on mountainous terrain. She is dressed only in a red veil that leaves her breasts in view, leading the observer to consider her a part of nature. The young, lovely nymph is besieged by a number of winged cherubs who merrily pull at her veil. The naiad defends herself playfully, throwing water on the cherubs from a clay jug. Some of the small creatures flee, falling over one another. This jovial scene inspired by mythology is quite charming, especially for the beauty of the nymph and the sweetness of the cherubs. This type of Romantic genre scene, with a woman surrounded by many children and a mythological story providing an excuse, was very popular in the early 19th century.

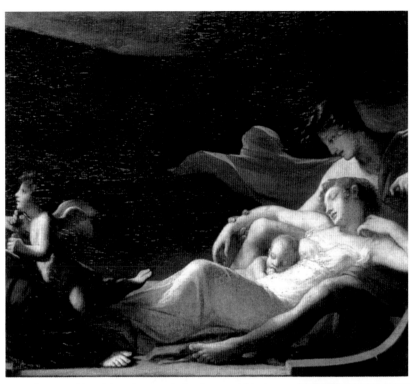

This is Constance Mayer's best-known painting. It was exhibited at the 1819 Salon under the title *Love and Fortune Travel by Ship in the River of Life*. A young man is seated at the prow, protecting his sleeping wife and child. The scene is set in a disturbing nocturnal landscape. The tree on the right acts as the conventional *repoussoir*, providing a boundary for the landscape and opening toward the boat floating down a dark river in gray and blue tones. Love, in the form of Cupid, and Fortune, personified in the robust body of a woman, are simply members of the family and play a secondary role in this melodramatic scene. The protagonists form a happy family protected by the father, emphasized above all by the radiant light reflected by the mother, dressed in white, and her child. The allegory expresses the fragile happiness of a family that is constantly in danger, threatened here by the sinister and dramatic atmosphere. Success can only occur when love and good fortune accompany them. Mayer's work is based on several sketches in oil, drawings, and preliminary compositional projects executed by Prud'hon. But the initial idea was probably taken from a drawing by Greuze, Mayer's former teacher, entitled *Allegory of Conjugal Happiness*, representing a young couple rowing a boat with the help of a cherub. Mayer's last painting, *The Unhappy Family*, can be interpreted as forming a diptych with *The Dream of Happiness*, just as *The Happy Mother* and *The Unhappy Mother*. After Mayer's death, it was finished by Prud'hon, who included it in the retrospective at the Parisian Salon.

The Dream of Happiness

(1819)
oil on canvas
52 x 72.4 in
(132 x 184 cm)
Musée du Louvre, Paris

Phrosine and Mélidor

oil on canvas
12.8 x 9.4 in (32.5 x 24 cm)
Musée Magning, Dijon

This dramatic painting of a couple kissing in the wilderness refers to the opera *Phrosine et Mélidor* by Étienne-Nicolas Méhul (1763-1817). The story is based on the legend of Hero and Leander and their doomed relationship. The prohibited kiss between the monk, wearing his habit, and the nude young woman is set in a nocturnal landscape consisting of a bit of earth, the sea, and a wide sky full of dark clouds. The colors are limited to brownish gray and matte blue. The young woman's nude body with her delicate white complexion stands out, a typical element in Mayer's as well as Prud'hon's works. The thin feminine figure seems to float on the water, allowing the monk to hold her in his arms without the least resistance. Her attitude enhances the dramatic effect of the moment and of their ill-starred destiny. This painting is based on a sketch by Prud'hon, who in the 1789 Salon had already exhibited an etching on the same subject. Though she did not change the scene very much, Mayer interpreted it with greater elegance and atmosphere.

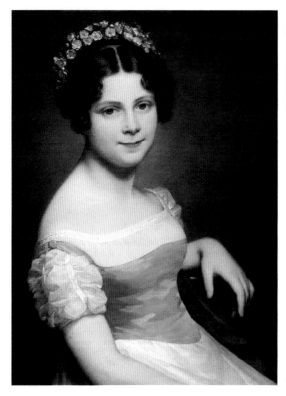

Sophie Lordon

(1820)
oil on canvas
23.6 x 19.3 in (60 x 49 cm)

Constance Mayer painted many portraits, especially with models from among friends of her female colleagues and of Prud'hon. In this case, she painted Sophie Lordon, whose father, Pierre Jerome Lordon, was a student and good friend of Prud'hon and frequently exhibited at the Salon between 1806 and 1838, the year of his death. Sophie married August Duquerre in 1824. In portraits it was also habitual for Prud'hon to execute a preliminary sketch, though Mayer maintained her own gentler, less dramatic style.

The young Sophie poses in a white, short-sleeved dress made of pleated tulle and a bodice of pink silk. Seated in an elegant chair, she turns her right shoulder toward the viewer and elegantly leans her left arm on the armrest. Her brown hair is combed straight, parted down the middle in a straight line, with curls on either side and crowned by a diadem of blue flowers that harmonize with the sheen of the dress. The background reflects the sitter's hair color, and is executed in a monochrome tone with a ray of light just behind her face. With her delicate smile, brilliant eyes, and rosy face, Sophie is portrayed as a tender, sensitive girl and appears as if she were from a noble family.

MARIE ELÉONORE GODEFROID

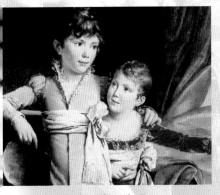

Marshal Ney's Children *(detail), oil on canvas, 63.8 x 68.1 in (162 x 173 cm), 1810, Staatliche Museen, Stiftung Preußischer Kulturbesitz, Gemäldegalerie, Berlín.*

Marie Eléonore Godefroid painted portraits for high society, and her clients were often from the nobility or the royal family. She specialized above all in portraits of women and children. The fact that she grew up in an artistic milieu as the daughter of a painter led her to adopt a delicate, refined style. Her oils, watercolors, and pastels possess a touch of elegance that was held in high esteem by her clients. Her artistic life was closely linked to that of Baron François Pascal Gérard (1770-1837), who was her teacher and later employed her as an assistant. Gérard attended painting classes given by Jacques-Louis David before working for clients such as Napoleon and Louis XVIII. He was particularly renowned as a portraitist of women, in addition to painting important historical scenes. Godefroid received various commissions to execute replicas of paintings by her teacher, but she also executed various portraits and participated regularly in the Salon organized by the Académie Royale.

She lived with the Gérard family, who organized one of the most elegant weekly gatherings in Paris, which allowed her to meet and share her teacher's clients and friends. She collaborated so closely with him that she not only adopted his style, but also even imitated his handwriting in order to reply to certain letters that he did not want to answer himself.

Despite the political changes that occurred in France during the artist's lifetime, she always managed to maintain close relations with each new governing body—as opposed to other painters, who not only lost their clients but were often forced into exile during those turbulent times.

- **1778** Born in Paris. Her father, the artist François Ferdinand Joseph Godefroid, has an apartment in the Louvre and Marie Eléonore practically grows up there, assisting her father and training as a portraitist. She was probably also a student of the portraitist and miniaturist Jean-Baptist Isabey (1767-1855).
- **1795** Beginning this year and for the following ten, she works as an art teacher at the girl's boarding school in Saint-Germain-en-Laye, an institute run by the famous educator Jeanne Louise Henriette Campan. Among her students are two of Campan's granddaughters, one of whom would marry Marshal Michael Ney, and various members of Napoleon's family. Godefroid attends painting classes given by Baron François Pascal Gérard, a friend of the family.
- **1800** Participates for the first time in the Parisian Salon, where she would exhibit her works regularly for 47 years.
- **1805** Quits her teaching job to devote herself solely to painting. Assists Gérard, with whom she remains friends until his death. She helps him to execute his portraits, many of them of women, as well as historical paintings, religious scenes, and allegories. In the meantime, she gradually becomes a successful portraitist.
- **1817** Though she had previously worked for Napoleon, she maintains good relations with the new government and the royal family. Gérard becomes a painter to the court of Louis XVIII.
- **1837** François Gérard dies. Nevertheless, Godefroid takes on commissions and continues to live with the painter's family.
- **1842** Paints *Our Lady of the Rosary* for a church in Senegal, in which she represents an African man praying next to a European before the Virgin.
- **1843** Paints the portrait of Novella d'Andrea, a woman of letters of the 14th century so versed in law that she occasionally substituted for her father, an important professor at the University of Bologna. At the Salon, Godefroid exhibits a painting executed according to one of Gérard's compositions.
- **1847** Participates for the last time in the Salon.
- **1849** Dies of cholera in Paris.

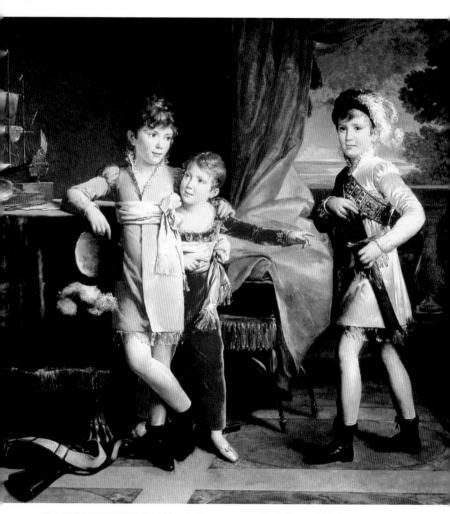

Marshal Ney's Children

(1810)
oil on canvas
63.8 x 68 in
(162 x 173 cm)
Staatliche Museen,
Stiftung Preußischer
Kulturbesitz,
Gemäldegalerie, Berlin

This painting represents the children of Michael Ney, marshal and duke under Napoleon, who was at the peak of his career when he commissioned this work from Godefroid, a friend of his wife, in 1810. Three years later Michael Ney was defeated by Hans Guido Von Bülow and in 1815, he was condemned under martial law as a traitor and executed by firing squad in Paris.

Godefroid painted the three children with sweet, childlike faces and placed them in a luxurious and sophisticated room. They are wearing elegant clothes of velvet and silk, befitting the social status of their parents. The eldest, Joseph Napoleon, on the right, is seven years old here, and he is the painting's principal protagonist, standing out against the landscape visible between the drapes behind him that resemble a theater curtain. He gazes at the viewer, adopting a heroic pose. Adorned with an elegant feathered hat, he proudly carries an enormous saber that belongs to his father. The evocation of his father's military victories can be clearly observed in the belt across his chest. This was the wedding gift given to his father by Napoleon, who had won it in Aboukir. Thus represented, the eldest son evokes his destiny of following in his father's footsteps. His brother, Louis Félix, born in 1804, leans against the table on the left, warmly hugging his two-year-old brother, Eugène. The youngest points at the saber while a less prestigious weapon, a rifle, lies on the ground. The portrait is a clear allegory of the father's career: Having begun his military career as a humble soldier, he had attained great military victories under Napoleon.

This painting of a baroness, Madame de Staël-Holstein (1766-1817), is a copy of a portrait by Gérard and demonstrates Godefroid's degree of collaboration in the studio of Gérard, who

Anne-Loise-Germaine Necker, *(or Madame de Staël)*

(~1820)
oil on canvas
45.7 x 32.7 in (116 x 83 cm)
Château de Versailles, Versailles

painted the original in 1818. The copy was most likely executed as a commission made by Madame Récamier in memory of her deceased friend, as the French state later bought it from the estate of Madame Récamier (1777-1849). Copying paintings was quite a frequent practice, especially in the engraving technique, a perfect medium to distribute the same portrait among friends and admirers of the sitter.

Godefroid's work follows Gérard's original closely. The erudite writer, who maintained close friendships with Goethe, Schiller, and Wieland, is rendered in a classical dress, wearing a turban and leaning against an angular podium. Godefroid only changed the color of the dress from red to white and painted the face so that the sitter looked more attractive.

The daughter of the Swiss banker and minister of finances of Louis XVI, Jacques Necker, and the wife of a Swedish diplomat, Baron Eric Magnus von Staël-Holstein, Madame de Staël was an opponent of Napoleon and was exiled by him in 1802. In exile, she wrote several books, such as *De l'Allemagne*, in 1810, which was not published in France until after 1814, when Napoleon abdicated and she was able to return to Paris. There, as during her exile in Coppet, Switzerland, she held intellectual gatherings in her home in which she received important guests from the world of culture.

Jacques-Alexandres-Bernard Law, Marshal of Lauriston

(1824)
oil on canvas
84.3 x 58.1 in (214 x 140 cm)
Musée National du Château de Versailles et de Trianon, Versailles

This portrait of Jacques-Alexandre-Bernard Law (1768-1828) is closely associated with a portrait of the same person executed by François Gérard. Both paintings were completed in the same year, though Gérard's was earlier and Godefroid's was made as a commission made later by Louis XVIII. This painting represents the sitter larger than life in size and wearing the uniform of Marshal of France, a title he was granted in 1823.

Gérard's portrait measured only about 12 x 8 inches (32 x 20 cm), though it contained practically the same elements as Godefroid's. In both cases, Law appears on a cliff. In the background is a strip of coastline and a cloudy sky. On the right, on a robust stone wall that serves as a podium, is the marshal's hat and a map on which the sitter signals a point with his left hand, as if exercising his function as a strategist and commander. Standing in a heroic pose and in slight *contrapposto*, he looks to his right where, in Gérard's original, the forelegs and heads of the horses of the armed forces at his orders appear. In Godefroid's painting, the horses are not rendered; there is only landscape and sky. Godefroid's version is certainly more elegant than Gérard's and also softer, gentler, and less spontaneous. The marshal has a handsomer and more expressive face. The grandson of the former French minister of finances, Law was born in India, studied for a military career in France, obtained the rank of general in 1802, and was the governor of Venice in 1807 and ambassador of France to Russia in 1811. In 1813, he was taken prisoner of war in Leipzig, and from 1815 he was at the service of the Bourbons.

Jacques-Louis David

(~1843-1848)
oil on canvas
24.8 x 20.5 in (63 x 52 cm)
Embassy of France, London

This portrait shows Jacques-Louis David (1748-1825) as a modest member of the bourgeoisie, dressed in a brown jacket with wide lapels, a vest of a similar color with a high collar, and a white cravat. Godefroid did not include any attributes that alluded to his profession as a painter. The painting has a general brown tone, and the sitter is portrayed against a smooth, monochrome background. Only the white cravat and gray hair stand out and accentuate the face of this man, who gazes proudly and with a nearly provocative air at the viewer. Commissioned by Louis-Philippe eighteen years before the artist's death, this painting was executed by Godefroid in order to form part of the Historical Museum of Versailles. Considered one of the most important painters of classicism, David was a politically committed artist who took the side of the Jacobins during the French Revolution. He was in great demand as a teacher, and it is believed that more than 400 artists attended his classes, one of whom was Gérard. Favored by Napoleon, David became the most distinguished painter of the court in 1796 and, in 1804, the emperor's first painter. He died in exile in Brussels in 1825, where he had retired after the downfall of Napoleon's empire.

Jeanne-Louise Campan

(1847)
oil on canvas
19.3 x 15.4 in (49 x 39 cm)
Musée National du Château de
Versailles et des Trianon, Versailles

This portrait of Jeanne-Louise Campan (1752-1822), painted twenty-five years after her death, is a replica of one painted during her lifetime, between 1795 and 1805. This copy was commissioned by Louis-Philippe for the Musée de Versailles. The format—an upper body portrait—and the range of colors make it very similar to the portrait of David.

As simple as that painting, there are no attributes here alluding to the sitter's profession as an educator and writer. The painting has the same monochrome brown background, and the face is accentuated through complements in white, such as the fine, nearly transparent lace collar and the extravagant feather that covers Campan's hair by way of a hat. As represented here, the famous educator and director does not look like a single governess at the service of the families of the nobility, but rather a cultivated, elegant lady.

Madame Campan worked for twenty-two years for Marie Antoinette, until the queen was imprisoned in 1792. When she lost her job, she opened a boarding school for girls in Saint-Germain that employed very modern pedagogical methods and was highly successful. Among her students was Hortense de Beauharnais, a girl adopted by Napoleon. In 1807, in recognition of her work, Napoleon appointed Campan superintendent of the Académie Impériale d'Ecouen, an educational institute for the daughters of Legion of Honor members. With the downfall of Napoleon's empire, the school was also shut down and, as its superintendent, Campan was accused of treason by the monarchists. From her retreat in Nantes, she wrote didactic and historic essays that were published in 1823, a year after her death. With this portrait, Godefroid helped to restore this figure, held by many to be a precursor of feminism, to her rightful place in French history.

ROSA BONHEUR

Rosa Bonheur photographed in her yard at Château de By.

Rosa Bonheur was one of the most renowned and representative French artists of her time. Famous in the field of art for her paintings of animals, especially horses, she was also famed for her nonconformist manner of thinking and lifestyle, which she bravely defended.

Artistically educated by her father, Raymond Bonheur, an art professor, and by Léon Cogniet, she learned everything about animal painting and visited fairs, markets, and farms from childhood on.

Her great memory, undeniable passion for animals, and extraordinary observational skills were basic elements in the development of her art in the fields of painting and sculpture.

Her oeuvre consists basically of paintings in which animals such as horses, deer, oxen, or dogs are the protagonists, but she also created scenes of country life, imbued with sensuality and painted in a delicate style. Chronologically, these canvases can be ascribed to the realism of the French Second Empire. Influenced by Théodore Géricault and Karl Bodmer, her art was often criticized for being very similar to that of Edward Landseer.

Conservative and traditional from an artistic point of view, her personal life was characterized by constant defiance of social customs, especially in her struggle for equal rights and in her relationships, first with Nathalie Micas, with whom she lived for more than fifty years, and later with Ana Elizabeth Klumpke. Rosa Bonheur was the first woman to become a Knight of the Legion of Honor.

- **1822** Marie-Rosalie Bonheur is born on March 16 in Quinsac, near Bordeaux, the daughter of Raymond Bonheur, an art professor, a man of liberal character, and a follower of Saintsimonisme, a French movement in favor of women's rights and liberties. Her mother, Sophie Marquis, was from an educated, well-off family. She was the eldest of four siblings: the sculptor Isidore Jules and the painters Auguste and Juliette.
- **1829** She and her family move to the French capital.
- **1832** Enrolls in a men's private school to take painting classes. To be allowed into certain places and be able to paint freely, she dresses as a man.
- **1834** Enrolls in the École de Paris, where she takes painting classes from Léon Cogniet.
- **1836** Meets and becomes involved with Nathalie Micas, with whom she lives for more than 50 years.
- **1841** Participates for the first time in the Parisian Salon, exhibiting two paintings: *Sheep and Goats* and *Rabbits*. After this, she exhibits frequently at the Salon.
- **1848** Obtains a golden medal at the Salon and a commission from the French government to paint a farming scene. The result is a painting called *Plowing in Nivernais*.
- **1849** Her father dies.
- **1853** Attains international renown through her work *The Horse Fair*, the ultimate example of her skill in painting animals.
- **1857** The French Secretary-General grants her special permission to dress as a man.
- **1859** Acquires Château de By, Fontainebleau, where she sets up a small zoo to observe animals in action.
- **1865** Thanks to special permission from Napoleon III gained through the intercession of Empress Eugenie, she is the first woman to become a Knight of the Legion of Honor.
- **1867** After a 12-year absence, she exhibits at the Salon again.
- **1889** Nathalie Micas dies. Years later, Bonheur meets Ana Elizabeth Klumpke, an American artist educated in Switzerland and France, whom by 1898 she calls her wife.
- **1899** Dies at Château de By on May 25 from pneumonia. Her ashes are buried at the Père Lachaise Cemetery in Paris, next to her two lovers, Nathalie and Ana Elizabeth.

Plowing at Nivernais

(1849)
oil on canvas
69 x 104 in (175.3 x 264.2 cm)
Musée Nationale
du Château Fontainebleau

In addition to the gold medal she received at the 1848 Salon, Rosa Bonheur obtained this commission of a tilling scene from the French government for the Luxembourg Gallery collection in Paris, which she completed the following year.

Her specialization in representing animals partially originated from the love of nature that her father taught her. When she was very young, he also encouraged her to visit farms, stables, and markets in order to practice painting animals. These excursions and the sketches she executed on site bore fruit, as evident in this canvas, the result of her profound observation work. The principal protagonists are the oxen in the right foreground. Perfectly integrated into the landscape—the rolling hills of Nevers—the animals are the true protagonists, while the human figures play a distant secondary role. One of the farmers is even partially concealed by the central pair of oxen. Rosa Bonheur lent this work great realism, representing an everyday scene with no subjective overtones. The ample strip of sky with some wispy remnants of clouds is a fundamental element of the work, as it increases the sense of tranquility and peace.

Wagon Pulled by Horses

(1852)
oil on canvas
13.5 x 24.6 in (34.3 x 62.4 cm)
Metropolitan Museum of Art,
New York

Bonheur was a specialist in paintings and portraits of animals, and especially horses. Works such as *The Horse Fair* or *Mourning* are good examples. In this painting, the artist portrays a wagon's momentary halt, offering a detailed study of the movements and postures of the horses. It was an image she had often observed on her excursions to the countryside and visits to various animal markets, especially the horse fair in Paris. Here, the horses are painted in different colors and each poses in a different manner, demonstrating Bonheur's great capacity for observation and profound knowledge of these animals. The fact that the wagon is stopped, the gentle movement of the horses, and the naturalness of the scene contribute to the decisively romantic air of the painting. The combination of warm colors and the simple lines that comprise the landscape enhance the realism.

This painting, the most important and well-known of Bonheur's works, represents the horse fair in Paris, held on Boulevard de l'Hôpital near the Salpêtrière Home, visible to the left in the background. For a year and a half, Bonheur visited the place twice a week to sketch. She dressed as a man so as not to attract attention. Exhibited at the 1853 Salon, was offered a year later to the municipal institutions of Bordeaux, near the artist's birthplace, for 12,000 francs, but they refused the offer. Two years later, a London collector paid 40,000 francs for it.

The Horse Fair

(1853)
oil on canvas
96.3 x 199.5 in
(244.5 x 506.7 cm)
Metropolitan Museum of Art, New York

There are several versions of this painting; this is the original. Of the others, one of the best is a smaller replica at London's National Gallery that, although signed and completed by Rosa Bonheur, was begun by Nathalie Micas. Before executing this painting, Rosa Bonheur had already demonstrated her gift for painting and sculpting animals. From the early 1840s, her paintings of lions, deer, oxen, and other animals became very popular, but it was her horses that brought her international recognition. The truly striking feature of Bonheur's art is her rendering of equine anatomy. The forms and positions of the horses' bodies confer great dynamism. Sober, energetic, and visually rich, The Horse Fair is remarkable for its balanced integration of the human figure within the whole, as well as by an excellent use of light and shadows.

The horizontal format of this painting leaves enough space for Bonheur to develop various scenes that could be independent but together form a unified whole. The misty landscape in the background, in which only some approaching riders can be distinguished, contrasts and enhances the scene of movement and bustle in the foreground, with dogs running about and barking nervously, hunters in various poses, warming themselves at the fire. In this canvas, the artist not only focuses on the animals—in this case, dogs

Meal During the Hunt

(1856)
oil on canvas
30.5 x 58.5 in (77.5 x 148.6 cm)
Pioneer Museum and Haggin Galleries, Stockton, California

and horses—but also places an emphasis on the human figure. The hunters, whether seated, standing, squatting, or on horseback, are also a fundamental part of this genre scene.

Sheep by the Sea

(1869)
oil on canvas
12.7 x 18 in (32.3 x 45.7 cm)
National Museum of Women
in the Arts, Washington, D.C.

This work is another example of Rosa Bonheur's persistent interest in painting animals in their natural context. It was not the first time, nor would it be the last, that the artist used a group of sheep as the principal element of one of her paintings. Yet each work has differentiating features, such as the inclusion of a human figure in the case of *The Mountain Shepherd*, the color treatment in *Flock of Sheep in the Pyrenees*, and the event portrayed in *Changing Pastures*, where shepherds are ferrying sheep on a boat. Another, earlier, work by the artist, *Sheep on the Mountain*, appears very similar to this one at first sight. Both represent sheep in a virgin landscape, and the paintings have similar compositions and frames. Nevertheless, the background landscape makes the two radically different. In the canvas from the late 1850s, the flock of sheep grazes and rests in high mountain pastures under a turbulent sky indicating an approaching storm; in this one, they graze on a natural lookout over a calm sea where time seems to have stopped. Nevertheless, both paintings emanate a sensation of repose and tranquility, an effect accentuated by the fact that sheep are associated with serenity.

Right: As of 1850, the number of paintings of agricultural scenes (sowing, harvesting, picking, plowing) designed for direct sale or exhibits increased considerably. Their most prominent element was the human figure, the instruments used by the farmer, and the beasts of burden, in that order. Rosa Bonheur also undertook such scenes, but differed from her colleagues in that the focus of her works was the artistic effect provided by the muscles in movement of the farm animals.

This canvas is a vision of farming and rural life, a realistic and completely nonbucolic interpretation of what is involved in a day's work during the hay harvest. Although the clear, nearly cloudless sky lends the painting a sensation of tranquillity, the scene perfectly reflects the effort, ardor, and energy that the farmers place in their work. As in nearly Bonheur's entire oeuvre, the animals occupy a privileged space within the work—in this case, the center. What is surprising is the inclusion of so many human figures, an unusual feature in Bonheur's art. Distributed throughout the canvas, there are a number of men and women working the fields, gathering and loading hay.

Deer at Fontainebleau

(1870)
oil on canvas
National Museum
of Wildlife Art,
Jackson Hole, Wyoming

This canvas was executed at a special time in the artist's life. The year 1870 was a turning point in Rosa Bonheur's artistic career. This was when the versatile artist began to abandon her successful career as a sculptor to leave room for her brother, Isidore Jules, and dedicate herself completely to her pictorial works. But 1870 was not only a turning point for the artist's trajectory and life—it was also a historically important year: It was an apogee for the French middle class, a period that brought spectacular advances in the field of painting, especially in landscape and animal scenes, and a gradual abandonment of academic painting, which had been in full force until this time.

Canvases where deer play the leading role, whether alone or in herds, are frequent in Bonheur's catalogue. Some examples are *Forest with Deer*, in which a young deer seems to pose and brazenly gaze at the artist, and *Roe Deer*, in which the animals are at rest in a magnificent dusk. But the painting here has an additional element—the perfectly balanced triangular composition. Against a forest background, three deer are placed in different grounds and in three different positions. This is no accident. It was thought out and studied to eliminate any imbalances within the frame: the number of deer, the pose adopted by each, and even their placement within the whole are all carefully considered.

The Return of the Harvesters

oil on canvas
9.9 x 27.5 in (25.2 x 69.8 cm)
Michael Galerie, Beverly Hills,
California

Brizo, a Shepherd's Dog

(1864)
oil on canvas
18.1 x 15.1 in (46.1 x 38.4 cm)
Wallace Collection, London

In the majority of Bonheur's animal paintings, one or various animals are rendered in their entire length and set within a natural background: forests, hills, meadows. This painting is an exception, with only part of the animal shown in the foreground against a plain background. The sheepdog is remarkably detailed—the texture of the animal's fur is executed in such a meticulous manner that it can almost be felt. This work called for an extraordinary exercise in observation and attention, and demonstrates the artist's great skill in rendering reality. Another striking factor is the animal's gaze, languid, profound, and sad, which Bonheur executed with singular precision. Probably the fruit of a commission, Brizo is one of the few examples in the artist's oeuvre that can be associated with what could be called a "photographic portrait," a style in which the artist does not provide any subjective contributions to the work, the results sought being an objective and faithful reproduction of reality.

LILLY MARTIN SPENCER

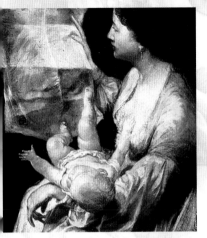

War Spirit at Home *(detail)*, *oil on canvas, 1866, Newark Museum.*

- **1822** On November 26, Angélique Marie Martin is born in Exeter, England, to a family of French origin.
- **1830** The Martin family emigrates to the United States, settling in the town of Marietta, Ohio.
- **1841** Holds her first individual exhibit at St. Luke's Episcopal Church in Marietta. She moves to Cincinnati with her father to study art.
- **1842** Studies under the portraitist John Insco Williams.
- **1844** Marries Benjamin Rush Spencer.
- **1845** The first of her thirteen children is born.
- **1847** Sells her first paintings at the Western Art Union in Cincinnati.
- **1848** Moves to New York, where she exhibits at the American Art Union. Beginning this year, she exhibits regularly at the National Academy of Design.
- **1850** Elected honorary member of the National Academy of Design.
- **1855** Exhibits at the Cosmopolitan Art Association.
- **1858** Moves to Newark, New Jersey.
- **1864** Exhibits at the Great Central Fair in Philadelphia.
- **1867** Establishes her studio on Broadway in New York.
- **1876** Exhibits at the women's pavilion of the Centennial Exposition in Philadelphia.
- **1879** Moves to Highland, New York.
- **1890** Her husband dies.
- **1900** Returns to New York City.
- **1902** Dies in New York on May 22.

The daughter of a French couple who immigrated to the United States due to their socialist ideology, Angélique Marie Martin, familiarly known as Lilly, began her art studies encouraged by her intellectual father. The family atmosphere determined her artwork, consisting principally of genre scenes inspired by her own experience in the home.

Spencer's art is clearly realist, combined with a Romantic sentiment that tends to exalt the family tradition as the central element of U.S. society. Though Romanticism as an aesthetic movement began in the early 19th century with the naturalists of the Hudson River School, who sought the roots of the ideal landscape in real scenes and monumental landscapes, this search eventually became a reflexive realism capable of portraying urban life as well as rural scenes and landscapes. Lilly Martin Spencer combined realist Romanticism with a special sensibility for representing genre scenes with children and life in the city. Her artwork is remarkable for its capacity to transmit atmospheric sensations of reality.

The expressive capacity of the figures created by Spencer is remarkable. With the same realism she uses in the rest of the composition, the artist captures the expressiveness of the faces, transmitted to the viewer through the vividness of her portraits. Each person appearing in her works is portrayed in a realist sense that is perfectly combined with anecdotal aspects.

Domestic Happiness

(1849)
oil on canvas
55.5 x 44.9 in
(141 x 114.9 cm)
Detroit Institute of Arts,
Michigan

Between 1840 and 1850, Lilly Martin Spencer focused on genre scenes with images of children. This canvas has a very modern approach. A couple observes their sleeping children in a highly sensitive composition. It is a typically feminine scene where the man and woman share the same feelings, a very progressive idea considering the artistic panorama at the time, in which men were rarely portrayed in their paternal facet and in such an intimate manner. The artist treats the work as a group portrait, with remarkable atmospheric quality. In her art, an intimist sense of the home prevails as a pictorial genre, very close to what would later be taken up and developed in France by Eva Gonzalès and Mary Cassatt, though Spencer's vision of domestic life is more modern. The portrait of the two adult figures constitutes a magnificent exercise in realism accentuated by the studied application of light and color. The mother's pose, leaning toward the husband, who is portrayed frontally, smiling with his head bent, is reflected in the gesture, while the idealized image of the sleeping children acquires a particular luminosity through the light tones. The artist employs light, brilliant colors to transmit the sensations of innocence and beauty implicit in the portraits of children.

Right: Though early 19th-century art in the United States contained a Romanticism based on the distinctive quality of the landscape, a group of artists headed by William Sidney Mount began to explore the artistic possibilities of everyday scenes in large cities. Though the distinction of this genre lies principally in the selection of subject matter and not in the style (which clearly follows the aesthetic of the Luminists), in a short time an urban pictorial style arose. It was based on highly realistic scenes transmitting the dense atmosphere of the city in a very particular tonal vision.

Lilly Martin Spencer represented domestic scenes throughout her artistic career, but she also found everyday aspects of the city in which she lived interesting. In this painting, the artist represents a husband returning from the market in the rain in a humorous light. This anecdotal vision became commonplace in this period of economic prosperity. The times invited optimism, creating an anecdotal school of art characterized by a nostalgic vision of a way of life that was rapidly disappearing in the wake of industrialization.

The importance of the facial expression for Spencer is evident. The young husband reveals his vexation at having to carry out a task that is not appropriate for him, while the gentleman with the umbrella observes him derisively. Spencer places all of the expressive capacity of her works in the figures' facial expressions, allowing a simple and direct reading.

Raspberries on a Leaf

(1858)
oil on wood
10.5 x 14.5 in (26.7 x 36.8 cm)
Widener Art Collection,
Alfred O. Deshong Collection.
Philadelphia

After the great success of the still life during the two previous centuries, artists in the 19th century attempted to create a completely new vision of the genre. From the American Realism of John Frederick Peto or William Harnett to Vincent Van Gogh's Postimpressionist sunflowers, there is a formal and aesthetic evolution in the still life, which adapts to each new artistic movement. In this painting, a cabbage leaf serves as a bowl for wild raspberries. The artist executes an exercise in originality, combining these two elements in an unusual manner.

Lilly Martin Spencer probably invented this particular use of large cabbage leaves to compose a fully realist work. The painting acquires a murmur of modernity through the combination of intense colors. Their brilliance arises from their natural contrast. The striking realism of the composition, playing with the contrast between the light and shadows in the background, can be observed in the meticulous rendering of the cabbage leaf, allowing the viewer to perceive aspects of its texture and form. Spencer also gives the still life a sensation of corporeality by emphasizing the circular forms of the fruit and the leaf. Straight lines predominate at the bottom of the painting and in the background, but the central composition consists of curved lines that lend realism and volume.

The Young Husband, *or* First Marketing

(1854)
oil on canvas
29.3 x 24.8 in
(74.3 x 62.9 cm)
Private collection

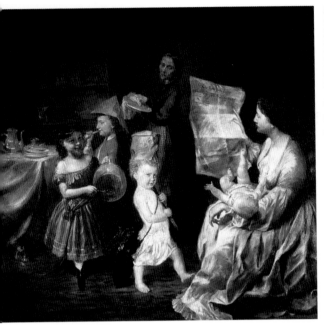

War Spirit at Home

(1866)
oil on canvas
Newark Museum

Lilly Martin Spencer, the mother of thirteen, frequently included children in her paintings. In the artist's oeuvre in general, children are rendered in a contemplative and idealized manner. Spencer paints like a mother observing her children, capturing intimate and ephemeral moments. In this painting, children are playing, marching around like soldiers while their mother reads an article in the newspaper about the war. The work seems to refer to the victory of General Ulysses S. Grant, later President Grant, at the Battle of Vicksburg. The unusual composition, combining a domestic scene with a contemporary and representative dimension, uses the parading children to direct the eye through the painting. The anecdotal aspect of children playing is employed here by the artist to incorporate an air of celebration and commemoration of an historical moment. The mother reading the newspaper seems to be a representation of the new role of women as an active part of society in the latter half of the 19th century.

Mrs. Fithian

(1869)
oil on canvas
72 x 53.7 in (182.8 x 136.3 cm)
Smithsonian American Art
Museum, Washington, D.C.

In this painting, which appears to be an allegory of feminine life, Lilly Martin Spencer reveals a decorative European aesthetic. The painting is framed with subdued tones, with a sumptuously dressed female figure in the center that seems to radiate all of the light in the painting. The woman's pose, leaning back in a strange gesture, provides a sensation of movement that imbues the work with life. The same is true of the meticulously executed dress. The variety of tones and the different effects produced on them by the light demonstrate the artist's rich realism.

This portrait of Mrs. Fithian, a friend of the Spencers, was an exercise in compositional experimentation for an artist little accustomed to full body portraits of adults. She preferred to compose scenes in which spontaneity and movement took precedence over portraiture. This painting is unusual in Spencer's oeuvre for its portraitist formality, in which the model is consciously posing, though her reflective gaze relieves the excessive formality of the work.

SOPHIE ANDERSON

The Turtle Dove, *oil on canvas, 14 x 11.3 in (35.6 x 28.8 cm), Maas Gallery, London.*

Although generically classified as Victorian, Sophie Anderson's style combines the different influences that she received during the course of her life. Born in Paris in 1823, she moved to the United States to escape the Revolution of 1848. Her artistic career was determined by her acquaintance with the British painter Walter Anderson, whom she would marry and with whom she would move to England. They lived in Britain until leaving for Capri in the 1860s for health reasons.

At first, Anderson focused on domestic scenes with children. Her early portraits, executed in England and the United States, reveal an unpretentious style and great technical skill. The artist quickly discovered and studied the works of the English Romanticists, adopting their aesthetic approach in her works.

Sophie Anderson's art reflects a variety of influences, beginning with French realism, then British Pre-Raphaelite art and, in her last works, the symbolism of Puvis de Chavannes and Edward Burne-Jones, though she incorporated it in a peculiar, more ingenuous and less pretentious manner.

- **1823** Sophie Gengembre is born in Paris, the daughter of a French architect and an English artist.
- **1848** The family moves to the United States, fleeing the Revolution of 1848.
- **1849** Marries the English painter Walter Anderson.
- **1854** The couple moves to England.
- **1855** Exhibits at the Royal Society of British Arts.
- **1856** Participates in various exhibits at the Royal Academy in London.
- **1860** Exhibits at the National Academy of Design in New York.
- **1864** Exhibits at the British Institution in London.
- **1870** Exhibits at the autumn exposition in Liverpool.
- **1871** Moves to Capri for health reasons, though she travels occasionally to England to participate in exhibits.
- **1878** Exhibits at the Grosvenor Gallery in London.
- **1894** Returns to England.
- **1903** Dies in the English town of Falmouth, where she had been living for several years.

Anderson's artwork includes elements characteristic of these artistic tendencies that she adapted to child portraits and fantastic scenes. Her paintings are full of children painted with great expressiveness and situated amid luxurious architecture or in intensely Romantic landscapes.

During Sophie Anderson's last artistic period, her art combined these artistic traditions. Her paintings of nymphs constituted symbolic allegories of natural beauty, and her portraits of children acquired a socially dramatic air, showing children as independent beings in a universe filled with fantasies and fears.

Elaine, *or* Lily Maid of Astolat

(1870)
oil on canvas
62.4 x 94.8 in
(158.4 x 240.7 cm)
Walker Art Gallery, Liverpool

This painting reflects the symbolic nature of English mythology. Also known as *Elaine Descending from Camelot*, it shows the influence of the artwork of John Everett Millais and Dante Gabriel Rossetti, and incorporates the complex visual code of Pre-Raphaelite painting. The formal similarity between this work by Sophie Anderson and Millais's *Ophelia*, from 1852, shows Anderson's interest in the symbolic possibilities of painting. In Millais's work, the heroine of Shakespeare's *Hamlet* appears in a river, drowned. As in this work, the figure is serenely beautiful and framed in a complex, meticulous network of vegetation on the enigmatic waters of a river. Anderson reflects the aesthetic influence she had gained in France and England. Though she adopted elements from the French symbolists such as Puvis de Chavannes and Odilon Redon, whose art was a reaction against Impressionism and the tyranny of pure naturalism, her symbolism was tinged by the influence of English art, based on an extreme idealization of beauty as an artistic response to the drab ugliness of the industrial revolution. She combined these two styles to create a visual language imbued with symbolism but with a more relaxed, intuitive style.

Untangling Her Hair

oil on canvas
109 x 93.3 in (277 x 237 cm)
Walker Art Gallery, Liverpool

Nymphs, fantastic beings of English legend inhabiting the forests and lakes of England, are a recurrent theme in the works of Sophie Anderson. She frequently used them as a model of natural beauty. As with the Pre-Raphaelites, the female aesthetic canon of accentuated facial features and long hair is common in symbolist art toward the end of the 19th century, manifested in the figure of Ophelia or nymphs.

Head of a Nymph

oil on canvas

In this painting, Anderson fills the space with a close-up of the model, constructing the composition on the basis of her suggestively undulating hair, which, in addition to filling the pictorial space, directs the viewer's gaze along the diagonal of the nymph's face and neck, descending from the upper left to the lower right corner. This formal simplicity and the absence of a background reinforce the symbolic importance of this woman, portrayed as an allegorical representation of Victorian beauty. Anderson painted nymphs on several occasions, using the opportunity to render suggestive portraits of sensual women, placing them either in the foreground or within a landscape. The motif of beauty was thus often rendered in typically English forests with abundant vegetation in humid settings full of shady corners.

Left: This unusual painting is a good example of the studies that the artist executed in the European portrait tradition. In her female or child images, formal allusions abound to styles and periods as disparate as French classicism, English Romanticism, and realism.

This image of a beautiful blond girl complies with the norms of the most classicist tradition in portraiture. The sensual sitter is centered in the foreground in an eminently posed position, combining perfectly with the sense of movement and visual attraction of her voluptuous hair. Anderson transmits an intimist sensation of femininity that recalls the artwork of the Impressionist, Eva Gonzalès, combined with a more realist and spontaneous vision. The choice of model complements Anderson's particular view of portraiture. The young woman with a white complexion, golden highlights in her hair, and generous, rounded forms brings to mind the work of classicist painters, while the steady gaze that she directs at the viewer, somewhere between innocence and mischief, lends the work an air of modernity.

Foundling Girls in Their School Dresses at Prayer in the Chapel

(1877)
oil on canvas
24.1 x 19.1 in
(61.3 x 48.5 cm)
Thomas Coram Foundation for Children, London

Although the artistic liberty that women enjoyed in the 19th century was greater than in the past, they were often rejected by galleries, or their work was considered appropriate only for minor expositions. This discrimination gave rise to a common style among female artists of different artistic movements and nationalities. Genre scenes were the only terrain in which women could establish themselves, creating charming scenes full of playing children and women combing their hair or doing housework.

This imposed subject matter was used by Impressionists such as Eva Gonzalès and Mary Cassatt to create a new vision of femininity from a more intimate viewpoint, lending the woman a new image as an individual, emphasizing aspects such as sensibility, innocence, and maternity. Sophie Anderson specialized in scenes of children, such as this one of a group of girls in church, the candidness and innocence of the children shown in their expressions. Anderson focused on everyday scenes of children playing or in the home, revealing their virtues and fears. In this work, the girls adopt a rigid formal position, reinforced by their serious expressions, a mixture of respect and fear, while they attend a regular religious service.

On her various trips, Anderson studied the art of each country and was easily influenced by it. In this painting, the young shepherd is rendered in profile in the foreground, recalling post-Renaissance foreshortening. The artist used the frame to reflect the candid and informal nature of life in the country, rendering this boy with tousled hair, apparently re-creating the bohemian aesthetic of the latter 19th century that prevailed in Paris. In this period, partly because it became fashionable, partly as a reaction against the academic art of officialdom, a type of painting emerged which was based on a more or less realistic representation of humble characters, especially the poor and the marginated.

The composition is characterized by a realistic portraiture style, magnificently combined with a structure that recalls English Romanticism. The expressive force of the boy, concentrated in his face and hands, is framed within a delicate, romantic landscape evoking Caspar David Friedrich or John Constable. The attraction the artist felt for Italy, where she moved in 1871, led her to study the English Romanticists, who had acquired the habit of traveling to the place of origin of the Renaissance to gain artistic inspiration.

Shepherd Piper

(1881)
oil on canvas
12 x 14.2 in (30.5 x 36 cm)
Fine Arts Society, London

A Day Without Work

(1890)
oil on canvas
19.8 x 15.7 in (50.2 x 40 cm)
Private collection

In this painting from Sophie Anderson's last period, the natural expressiveness of the child is striking. He is represented here as a prisoner in his own home, melancholically gazing outside. The title is a reference to the situation in which the girl finds herself, stuck inside at home and unable to attend school.

Anderson delved into the expressiveness of children, focusing on the most evident aspects, such as their eyes, mouth, and hands. In all of her works, the expression in the eyes is as important as the gestures of the hands. In this painting, the boy's head is tilted to the side in a typically childlike position, reinforcing the sad expression of his gaze while he delicately leans against the windowpanes. Sophie Anderson often complemented her scenes and portraits with elaborate backgrounds in which vegetation helps to structure the work. In this image, the artist added vegetation along the lower and right edges of the painting, creating space in an exercise of depth and perspective. In this manner, the visual interest of the work is moved to the right, while the upper left remains in darkness. This compositional approach, in which Anderson plays with the contrast in illumination between the various grounds, is a constant in her work.

ELIZABETH SIDDAL

(ELIZABETH ELEANOR SIDDALL ROSSETTI)

Self-Portrait, *oil on canvas, 9 in (22.9 cm) wide, 1853-1854, Private collection.*

Elizabeth Siddal lived during the Victorian period, at the height of the British Empire. She was part of the Pre-Raphaelite group, an artistic and literary movement that held painters previous to Raphael as their models because they felt that art was pure, spiritual, simple, and imbued with sentiment. They fought against the severe style imposed by the Academy, which seemed nearly sterile, especially with its new declaration in favor of reality and the faithful reproduction of nature. Like many other Pre-Raphaelite artists, Siddal was deeply influenced by literature and also wrote poetry. The subject matter of her watercolors and drawings were often Romantic illustrations of works by William Shakespeare, John Keats, Robert Browning, and Sir Walter Scott. In addition, she painted Christian scenes, and her favorite author was Alfred, Lord Tennyson. Following the Victorian fashion, her paintings were often stylistically inspired by the Middle Ages. Though her sketches were rudimentary, once completed, her works had imaginative and evocative force. During her artistic career, she executed over one hundred paintings and drawings.

After her death, her husband filed and photographed her drawings and sketches, through which her method and style can be reconstructed. This archive is now in an album at the Ashmolean Museum in Oxford. Her artistic oeuvre, whose acceptance was overshadowed for a time by her turbulent life during her years as a model, tragic muse, and mistress, has now acquired a significant degree of recognition.

- **1829** Elizabeth Siddall is born in London to a cutler who runs a small business in Sheffield. Nothing is known of her education.

- **1849** Works as a dressmaker for a shop near Piccadilly in London, where she attracts the attention of Walter Deverell, a member of the group of young, romantic Pre-Raphaelites founded a year earlier. Siddall's beauty, with her sensual lips, heavy eyelids, and, above all, radiant red hair reaching to her waist, fascinates the artist and his friends William Holman Hunt, Dante Gabriel Rossetti, and John Everett Millais. She begins to pose as a model for the Pre-Raphaelites, but the long sessions are so tiring that they affect her physically.

- **1852** Begins working informally with Dante Gabriel Rossetti (1828-1882), who promotes Romantic symbolism, and enters into a relationship with him. He paints and draws her obsessively. She also poses for Millais's famous work *Ophelia*, remaining in a bath of lukewarm water for hours every day, and thus developing pneumonia.

- **1853** Dedicates herself solely to painting. She changes the spelling of her last name to Siddal and stops working as a model.

- **1855** Rossetti shows Siddal's work to John Ruskin, who finances her purchase of painting materials (until then she had almost exclusively used pencil or ink). Ruskin also helps her to spend time in Paris and Nice to improve her health.

- **1857** Participates for the first time in the Pre-Raphaelite Salon at Russel Palace, organized by Ford Madox Brown. She exhibits three watercolors on literary subjects, a self-portrait in oil and four sketches. She sells the watercolor *Clerk Saunders*, which later forms part of an exhibit of British art shown throughout the United States that same year. Moves to Sheffield, where she studies under Young Mitchel, the director of the local art school, and travels to Matlock in Derbyshire.

- **1860** After being involved with him for seven years, and now ill, she marries Rossetti. The couple moves to London, where she continues to paint Romantic watercolors inspired by the Middle Ages. She collaborates on the decoration of William Morris's house, the Red House, and makes plans to collaborate on illustrations with Georgiana Burne-Jones. Despite being married to Elisabeth, Rossetti has relationships with other women.

- **1861** The birth of her stillborn daughter plunges her into depression.

- **1862** Dies of an overdose of laudanum.

Pippa Passes

(1854)
pencil
9.2 x 11.7 in (23.4 x 29.8 cm)
Ashmolean Museum,
Oxford

This pencil drawing is an illustration of the dramatic poem *Pippa Passes*, written by Robert Browning in 1841. It represents Pippa's encounter with two prostitutes who are discussing their clients. The attractive, well-dressed women are sitting on the stairs in front of a fence. They address the modest, timid Pippa, who stands before them in a simple dress. Geese accompany the three women, quacking at Pippa. As in Robert Browning's works, which focused on objectivity and the psychology of the characters, Siddal manages to reflect the personality of the protagonists with a few lines. For lack of financial resources, Siddal worked exclusively in pencil and ink at this time.

Sister Helen

(~1854)
drawing

This simple early drawing by Siddal is an illustration to the poem *Sister Helen*, written by Rossetti. The ballad, written in dialogue form, was published in 1851. The protagonist is Helen, seduced and abandoned, whose pain and injured pride melt a wax image of her. In the meantime, her brother, in the background, sees her unfaithful lover before becoming deathly ill. In a gesture of horror, Helen grasps her neck while she observes in shock how her image melts. At this time, even the heroines of ballads had to be punished for their "witchery." For this reason, in the poem, Helen's soul ends up in hell.

This painting contains several elements typical of Siddal's art: The scene is set inside a building with a view outside, and the woman is tall and thin, with long, straight hair and a simple dress. Curiously, twenty years or so later, Rossetti also drew a sketch to illustrate Sister Helen that was very similar to Siddal's.

Lady Affixing Pennant to Knight's Spear

(~1856)
watercolor on paper
5.4 x 5.4 in (13.7 x 13.7 cm)
Tate Gallery, London

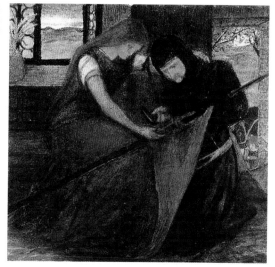

Elizabeth Siddal rendered a knight with his lady before he sets off for war. The refined woman embraces her knight while helping him to attach a pennant to his lance. She wears a blue skirt, a white shirt, and a doublet the same color as her long red hair. The soldier, clad in black armor and ready to leave, is hammering the red pennant into his lance. He has a cross on his chest and one of his gauntlets lies on the ground. The scene is set indoors, with the woman seated on a bench while he kneels next to her. Siddal employs warm colors—red and brown—for the interior, broken only by the cool intense blue of the skirt. In the background a door stands open, ready for the knight's departure. In the cool-colored nocturnal landscape, the full moon peers between the boughs of the trees, and the warriors, holding a standard, await the signal to depart. Through the open window behind the lady, dawn is breaking behind the mountains on the horizon, giving birth to a new day marked by parting and sorrow.

The Search for the Holy Grail, or Sir Galahad with the Reliquary of the Holy Grail

(~1855-57)
watercolor
11 x 9.4 in (28 x 23.8 cm)
Private collection

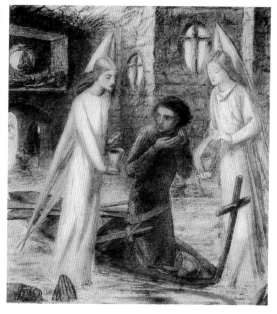

This work, signed jointly by Siddal and Rossetti, refers to Alfred, Lord Tennyson's poem *Sir Galahad*. One of the lines recounts Galahad's vision of finding a magic boat on which he embarks. It moves through the waters until it is surrounded by darkness. Suddenly there is a sweet sound and an intense light. Three angels holding the Holy Grail appear. Dressed in white stoles, they float with wings folded. In this watercolor, Siddal and Rossetti closely follow the poem, but instead of three angels, they portray two, who present Sir Galahad with the Holy Grail. He seems to exclaim, as in the poem, "Blessed vision! The Blood of God!"

The shape of the Grail and the setting are not faithful to the text. Here it is as if a river has flooded the castle of the Grail. The funerary sculpture in the water is striking, and the walls and arch do not reveal whether the scene is set in an interior or outside. The atmosphere is mysterious, in keeping with the mystery surrounding the legend of the Holy Grail.

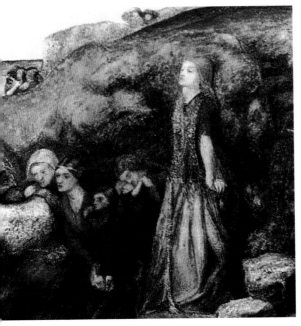

Sir Patrick Spens

(1856)
watercolor on paper
9.5 x 9 in (24.1 x 22.9 cm)
Tate Gallery, London

This watercolor, inspired by the ancient Scottish ballad *Sir Patrick Spens*, contains many elements of Pre-Raphaelite art, such as the subject derived from popular romantic literature and, above all, the detailed rendering of nature. In a typical coastal landscape of Scotland, where the green hills reach the beaches, both the sailors' wives and children and the noblewomen gaze out to sea, desolate because their husbands were shipwrecked on a voyage to Norway with Sir Patrick Spens. As in many Pre-Raphaelite paintings, there are incongruities of size and the perspective of space is shortened. All of this reflects the importance that Siddal lent to the richness of natural details. The cool blue-green of the meadows and the red in the dress and hair of some women predominate. The artist had a book of Scottish legends compiled by Sir Walter Scott, in which she marked the most interesting scenes as possible subject matter for her works.

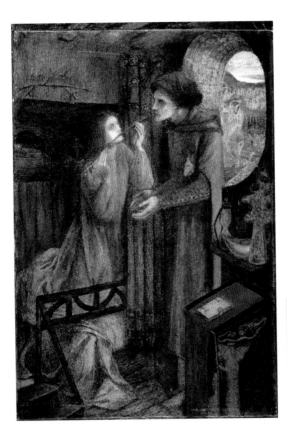

Clerk Saunders

(1857)
watercolor and
chalk on paper
11.2 x 7.1 in (28.4 x 18.1 cm)
Fitzwilliam Museum,
Cambridge

Lady Clare

(1857)
watercolor
Private collection

This watercolor refers to a poem by the same title by Alfred, Lord Tennyson. It is the story of the young Lady Clare, who realizes the day before her wedding that she is not of noble lineage but in reality the daughter of her nursemaid. Her cousin and future husband, Lord Ronald, is the legal heir to all of her possessions. Siddal paints a dramatic scene in which the nursemaid tells her daughter the truth and asks for her forgiveness and understanding. The predominant colors are reddish and brown, broken only by Lady Clare's blue dress and her mother's white handkerchief. The composition is dominated by an elegant line created by the kneeling woman, who reaches her arms upward, and Lady Clare, who bends her head and caresses her mother. The style of this watercolor is clearly influenced by medieval manuscript illumination. In contrast to many dramatic stories, this one has a happy ending. Lady Clare reacts with great dignity, dons a poor woman's garb, and confesses to the groom that she is ready to die if he rejects her. But he loves her deeply, and they marry on the following day.

Left: This scene refers to the *Ballad of Clerk Saunders* by Sir Walter Scott. It is a story of the ill-starred yet undying love between two people from different social classes.

The scene takes place in the bedroom of May Margret, the noble lover of Clerk Saunders. May Margret is kneeling while the ghost of her lover, assassinated by her brothers, enters through the wall to ask her to renew her vows. The predominating color in the interior is the reddish brown of the floor, ceiling, and walls. The woman has an abundant head of red hair in a similar color and wears a gray dress that harmonizes with her blue tunic. A window opens to the outdoors. Objects such as the small oratory allude to the Middle Ages and women's devotion.

This work traveled to the United States in an exhibit organized by Rossetti and was strongly criticized for being inferior to other Pre-Raphaelite paintings. The principal cause of the criticism was most likely the fact that the painter was a woman. Within the whole of Pre-Raphaelite art, this work can be considered a good example of its early period, characterized by rigidity and intensity.

The Holy Family

watercolor
7.8 x 6 in (19.7 x 15.2 cm)
Delaware Art Museum,
Wilmington

This watercolor represents the Christian subject of the birth of Christ in a stable. It shows Mary with the child, rendered as an amorphous white mass in her arms, and an angel in green whose wings are similar to those of the angels in the watercolor *The Search for the Holy Grail*. The interior of the stable consists of walls made of wooden planks, a watering trough for animals, and a window with a view of a green valley. Siddal employs elements typical of the medieval period, such as the functional perspective, in which the most important figures are larger in size. Here, Mary is seated and holding her child, yet she is still taller than the angel standing at her side. The colors Siddal chooses for Mary, red and blue, are part of traditional iconography. Siddal's figures have the same anatomical rigidity as in paintings and miniatures from the High Middle Ages (6th to 11th centuries). Siddal and the Pre-Raphaelites were not attempting to return to the archaic medieval style only because they were attracted to it. For them, it meant freedom in their art, different from the criteria put forth by the Academy. Siddal combined this style from the past with a Romantic intensity of expression and composition.

MARIANNE NORTH

Nephentes spec. *(detail), oil on canvas,*
Royal Botanic Gardens, Kew.

- **1830** Born in Hastings, England.
- **1869** Her father, Frederick North, dies.
- **1871** Visits the United States, Canada, and Jamaica, where she executes various botanical studies.
- **1872** Returns to England. Shortly thereafter, she moves to Brazil for eight months, where she executes more than 100 botanical paintings.
- **1875** Crosses the continent of North America on her way to Japan.
- **1877** Returns from Japan to England, stopping briefly in Sarawak, Java, and Ceylon. Fifteen months later, she travels to India, where she remains for fifteen months and paints more than 200 botanical paintings.
- **1879** After exhibiting her paintings in a London gallery, she has the idea of creating a botanical gallery at the Royal Botanic Gardens in Kew.
- **1880** Inspired by Charles Darwin's work, North visits Australia and New Zealand.
- **1882** Marianne North's Galleria Botanica is officially inaugurated.
- **1883** Moves to the Seychelles.
- **1884** Travels to Chile.
- **1890** Retires to Alderey, Gloucestershire, where she dies on August 30.

After the death of her father in 1869, Marianne North devoted herself exclusively to painting plants and flowers. Her interest in botany, encouraged by her father, led her to exhibit more than 850 botanical works of art in 1882, the majority of them shown at Kew Gardens in London.

In 1879, Marianne North founded the gallery at the Royal Botanic Gardens in Kew after spending several months studying and painting the various floral species of the Americas and Asia. The realist nature of her oeuvre led it to be considered of great botanical interest.

North's artwork is surprising for its vividness and originality. While the majority of British artists were painting in the Victorian or symbolist styles, North's work was fully independent, unlike any of the established aesthetic tendencies or styles. Nevertheless, fascinated by the exotic and capricious forms of many tropical plants and giving free rein to her creativity, in many of her works, the natural image is enriched by numerous symbolic, significantly erotic connotations, something quite daring for the period, especially from a woman. Undaunted, she began a trend that would be developed in a more sophisticated manner by female artists in the 20th century.

North was greatly attracted by flowers even without superfluous artistic considerations, which led her to undertake a long journey in 1871 through the United States, Jamaica, and Brazil. In 1875, she undertook another journey through America, Japan, eastern India, Ceylon, Australia, New Zealand, and South Africa. These trips provided her with a great deal of information, and directly observing exotic flower species in their natural environment served as a magnificent source of inspiration.

In the genre of flower painting, Marianne North can be considered one of the most extraordinary artists of all times.

Wild Flowers of the Casa Branca

oil on canvas
Royal Botanic
Gardens, Kew

Although Marianne North executed floral paintings of an artistic nature, they often had the characteristics of botanical illustrations. In this work, the artist represents several flower species, which she places on a single pictorial ground. The entire composition focuses on the forms and colors of the flowers themselves, executed in great detail and outlined in the manner of a drawing. The work acquires an air of modernity as it combines very brilliant colors with a discrete background. Thanks to this, the flowers, in addition to occupying the entire foreground, stand out against the background with intensity and relief.

It is evident that North's painting had neither technical nor structural considerations. In most cases, she executed her works from nature. In her botanical compositions for exhibit, the artist studied the best angle from which to view the plant, for which she would create a background that would provide a contrasting effect vis-à-vis the tones of the plant. In this work, the abundance of colors in the foreground led the artist to employ a neutral background to bring out each color.

Poinsettia, Brazil

oil on canvas
Royal Botanic Gardens,
Kew

**Nest of the Trabajor
Lesser Canestero (Chile)**

oil on canvas
Royal Botanic Gardens, Kew

North's interest in naturalist painting encompassed more than the plant world, as illustrated by this scene of a bird next to its nest. Though the painting is evidently descriptive, it was conceived with a pictorial aesthetic that led the artist to include an elaborate background landscape. In the foreground, as an element helping to establish perspective and color contrast—an important feature in the artist's paintings—are branches with vivid yellow flowers that reveal the species of tree on which the bird has built its nest. The bird and its nest, both in the foreground, complete the naturalist information. The background, executed in the same detail and degree of realism as the rest of the painting, provides context.

North composed this work with a more traditional artistic approach, placing the scene in a concrete location by designing a realistic mountainous background. The creation of an elaborate landscape posed no problem for the artist, who, faithful to her manner of conceiving art, again used her formula of a neutral background to emphasize the flora and fauna in the foreground. Though the subject matter is original, as the plants are not the protagonists, this work is executed with the same attention to detail and descriptiveness as in the artist's most characteristic works.

Left: In this painting, North represents the elements of the plants in a portraitist style, as if they were humans. The focus of attention lies in the small, delicate flowers surrounded by leaves in an attractive red. Though the artist's intention was not to reproduce nature, she composed her work such that its elements acquired a determined aesthetic and resembled illustrations, which did not cause her to obviate detail. Indeed, the work is rather euphuistic. In the interplay of red and green, North used the contrast between complementary colors to homogenize and chromatically balance the work. She establishes a visual path through it that begins halfway up on the right side and ends in the upper left corner after following a circular path. Thanks to the attraction that the red color exercises as the clear protagonist of this painting, the viewer's attention is drawn toward the small flowers in the center of the painting that appear to be swaying above the red leaves. In the upper left corner are two more red leaves that complete the visual path through the pictorial space. In the background, greenish brown leaves predominate, which, in addition to providing a natural tropical setting for the painting, enhance the color contrast that is its principal plastic feature.

N. Rafflessiana and N. Ampullaria

oil on canvas
Royal Botanic Gardens, Kew

North's characteristic works on different plant species are singular. She instituted a pictorial style that, in addition to representing plants in a specific manner, through its forms, exoticism, and colors, opened the door to creativity, interpretation, and the suggestiveness of specific symbols and connotations. This was something incipient that artists such as Georgia O'Keeffe, for example, would develop and employ in a more evident manner much later, with more daring creations and more explicit suggestion. Clearly, flora and fauna can be interpreted by an artist in many different ways. Simply consider the floral still lifes of the 17th and 18th centuries, permeated with a plethora of allegorical, religious and transcendental symbolism. In this work, North represents exotic plants whose forms imply a wholly symbolic eroticism. It is not surprising that this approach to sexuality through the form and color of certain plants is rendered in a somewhat timid, superficial, and ingenuous manner in North's work. The mentality of the time was rigid and official society would hardly have accepted a transgression of its moral codes. In the mid-20th century, on the other hand, this vision of floral sexuality as a reference or allegory of human sexuality is rendered in a direct and explicit manner, using the same typology of plant forms that North employed in her works. In this painting, North plays with the disturbing morphology of these plants, with an opening in their upper part. With regard to technical execution, the painting remains within the parameters that characterize this type of works by the artist: a foreground that focuses the viewer's attention, minute description of all the elements represented as if the work were a botanical illustration, and the establishment of color contrasts to create perspective and enhance each element.

Nephentes spec.

oil on canvas
Royal Botanic Gardens, Kew

Marianne North's primary interest in her paintings of flora and fauna was clearly to execute an in-depth stu-dy of nature, creating a bountiful catalogue of species from different geographic areas of the world as seen through the eyes of the artist. But, in view of certain works by North and with the perspective provided by the passage of time, there is no doubt that she incorporated evident erotic connotations, though this was not her primary aim. Hence, her paintings have a dual reading that enriches them.

The expositional and naturalist character of this painting is combined with a compositional style that plays with allegory and insinuation. An attractive and suggestive garland of white and pink flowers, whose color contrasts with the dull background tones, is located in the center of the painting, showing its charm and attracting the viewer's attention. A series of plant elements in partial darkness are distributed around it. North executed all of her works in a realist style with an acute interest in a descriptive and naturalist language, a clear sense of detail, and an excellent treatment of color to provide contrast and make each element stand out. The capricious and slender form of the garland and the bright colors of its flowers are a clear reference to sensual female coquetry and insinuation, seeking to make the woman attractive and desirable. The forms and colors of the plant elements surrounding the garland represent the response of the males, who, having received the woman's message, show themselves ready to comply and possess her. North's oeuvre is filled with paintings of a similar allegorical nature, in which the artist plays with the plant forms.

Nephentes Northiana

oil on canvas
Royal Botanic
Gardens, Kew

In this painting, North combines various characteristics of her art. In a descriptive exercise, she places the primary elements in the foreground, which appear to be two pods or strange pieces of fruit that stand out against the background landscape due to their color and size. This work illustrates the artist's personal compositional style, representing the two prime elements hanging from a branch very close to the viewer, while the landscape is lower in the painting and very distant. It is executed in a dull tone that contrasts with the intense, fiery colors of the foreground plant elements.

In this type of painting, the artist employed different resources to provide the maximum information possible in the work. The background lends context, so that the spectator can deduce whether these exotic species grow in mountainous regions or on the plain, as well as their environment and the season when they flower. Marianne North demonstrated complete mastery of the techniques for lending these plants relief and emphasizing their presence through the treatment of light and color. This painting's dual language is remarkable. Besides its naturalist interest, there is a clear reference to eroticism that becomes explicit through the forms of the two elements in the foreground and the warmth of the palette.

Flowers and Hummingbird

(1883)
oil on canvas
Royal Botanic Gardens,
Kew

This works reveals Marianne North's innovative pictorial sense. Though she was accustomed to laborious representations of plants, this work is thoroughly artistic. Without dispensing with her personal taste for naturalist elements, North approaches this representation in a very different manner. The vegetation in the foreground, with its magnificent pink flowers, occupies less space than in previous works and allows a full view of the landscape. Nevertheless, the painting is executed in accordance with the features typical of the artist: skillful draftsmanship, detail, realism, color, and precision. It depicts a small hummingbird taking nectar from a flower. This minute bird is used by the artist to show the real proportions of the flower, as the bloom would appear larger than normal since it is in the foreground with only a distant background behind it. Dispensing on this occasion with contrast as a method to emphasize the vegetation in the foreground, North renders an elaborate landscape in green and gray tones with light and perspectival effects. The tiny hummingbird's wings are static, producing the effect of a frozen image in which time seems to have stopped.

Olearia Argophylla

oil on canvas
Royal Botanic
Gardens, Kew

North began her artistic career as an illustrator for various English newspapers. Through this experience, she acquired her own vision of realist representation. In some of her paintings, North used a nearly photographic style of painting, with illustrations that perfectly reflect the appearance of different botanical species.

In this work, the artist fills the entire pictorial space with plants. They constitute the only content and are composed through a combination of the colors and forms of the different species. The meticulous work, reflecting even the last detail, acquires brilliance and luminosity through the dark background. Its contrasting effect makes the leaves gain greater tonal intensity as well as profile and definition. In the center, a set of small flowers comprises a complex white constellation that seems to engulf the entire plant in the foreground.

Undulating Flamencos, Lilac Cobras, and Venus Flies

oil on canvas
Royal Botanic Gardens, Kew

Oblivious to the art of her time, Marianne North was dismissed by some critics as a realist. This work shows an aesthetic that combines realism with the construction of a complex botanical landscape. The symbolism prevailing in France and England in the latter 19th century exercised an influence on North. References to eroticism or, as in this case, the creation of a scene with intriguing and capricious plant forms demonstrate the artist's interest in symbolism.

The complex title that the artist gave this work is a clear reference to the double meaning of the image. Hence, the flamencos refer to sensuality, cobras to astuteness, and the flies to their relentless harassment, which should be understood as sexual, considering the reference to Venus. The artist seems to be representing a sort of Bacchanal as a complex forest, an agglomeration of undulating forms full of mystery, sensuality, and fantasy, constructed with the strange morphology of the plants represented. She places a small, brighter tonal area in the center, from which everything seems to emerge.

JOANNA BOYCE

Bird of God *(detail), oil on canvas, 1861,*
Private collection.

As was the case with the majority of women artists of her generation, the influence of her family was a determining factor in Joanna Boyce's artistic career. Her brother, the artist George Price Boyce, decisively contributed to Joanna Boyce's training. They both began by executing portraits of their father and brothers during family vacations, and after George became a renowned artist, Joanna gained her parents' full support to become an artist as well. Her father, who dreamed that she would follow in her brother's footsteps, brought her to visit different art galleries, and in the winter of 1852, he also accompanied her to Paris, where Joanna settled to continue her art studies.

Joanna Boyce specialized in portraiture, with a realist style that contrasted with the symbolism of her contemporaries. Though her artistic trajectory was very brief, Boyce soon found her own style, becoming a portraitist held in high esteem by the public.

Her painting *Elgiva,* presently in a private collection, was acquired in 1855 by the Royal Academy, and was praised by the art critic John Ruskin and the Pre-Raphaelite painter Ford Madox Brown.

Elgiva

(1855)
oil on canvas
Private collection

The fact that this work was exhibited in 1855 and acquired by the Royal Academy brought the artist the unanimous recognition of the critics and public. John Ruskin, the critic and art theoretician, praised Boyce for this mature, balanced portrait. In this painting, the artist used color as a medium of expression. The woman, with a dark blue dress that covers her to the head, is located in the center of the painting, inclined toward the right. The contrast between the blue of the dress and the grayish color of the background is serene. It allows the artist to give the woman's face tonal protagonism, directing the viewer's attention to the face, which is more brightly illuminated than the rest of the painting. The woman has a downcast air, with a meditative, slightly sad expression. This subtlety in the facial expression is a characteristic element in Boyce's artwork. Her figures have their own personalities, transmitted to the viewer.

Sidney Wells

(1859)
oil on canvas
Tate Gallery, London

Though she was accepted by the Pre-Raphaelite circle headed by Ford Madox Brown, Joanna Boyce's style is a more unique view of the portraitist genre. In this painting, the child's portrait represents a completely new vision. The artist portrays the boy just as he eats, as can be deduced from the bib he is wearing. This portrait is extremely expressive, and the painter avoids the treatment usually given to child scenes, representing the boy frontally and in the foreground. This emphasizes the expressiveness of his eyes as he gazes directly at the spectator. Boyce dispenses with unnecessary ornamentation and focuses interest on the face. The details of the garments and background can hardly be observed, while the face is meticulous, with precise details and an interplay of light that allows the facial features and slightly serious expression to be observed perfectly. In her portraits, Boyce uses light as the principal expressive element to enhance the features and gestures of her figures. With a subtle combination of light and shadows, the artist captures the expressive capacity of her models' faces.

Mrs. Eaton

(1861)
oil on paper
on linen canvas
6.7 x 5.4 in (17.1 x 13.6 cm)
Yale Center for British Art,
New Haven

This painting, also entitled *Mulatto Woman*, illustrates the type of portrait that Boyce usually rendered. Mrs. Eaton's face appears with a rigid expression that transmits strength and character. The painting represents the model in profile and perfectly renders the stylized form of her neck and the details of her coiffure. In the center of the image is an earring that centers the composition with its brilliance.

On the basis of this small point of light, the artist designed a balanced and homogenous composition. The attention of the viewer is gained through a studied distribution of light. In the foreground, the light colors of the dress prevail and the eye ascends along the neck until it reaches the tenuous clarity of the face. In Boyce's art, this combination of different grounds of light is common, producing a very structured visual path through the pictorial space. The same is true of the quality of the brushstroke: Though there is fluidity in the dress and the background, the face is executed in a much clearer manner, complementing the expressive intention of the painting.

Gretchen

(1861)
oil on canvas
Tate Gallery, London

In the second half of the 19th century, English painting went through a period of great creativity, during which artists combined traditional styles with new ones. The Pre-Raphaelites acquired a certain Romantic conscience that allowed them to observe the pictorial tradition of their country, adapting certain elements to a new vision of painting. Boyce also employed the peculiar Pre-Raphaelite aesthetic, adapting it to her portraits. In this unfinished painting, she was influenced by the artwork of Dante Gabriel Rossetti.

She adapted the languid expression of the model to a markedly dramatic scene. The woman stands, observing the viewer frontally while she protects a frightened boy who takes refuge in her arms. Though the artist uses a clearly Pre-Raphaelite aesthetic, the influence of Romantic painting is evident in the woman's expressive stance.

In the formal conception of the painting lies a compositional simplicity that enhances the Romantic vision and emphasizes the maternal expression of the whole. The artist composed the work based on the expressiveness of gesture and emphasized the ephemeral instant of the embrace through tenuous illumination.

Bird of God

(1861)
oil on canvas
Private collection

Boyce clearly opted for portraiture, though she occasionally introduced elements of symbolism in her paintings. The composition of this work is traditional for a portrait. This angel's face is rendered in the foreground and is observed frontally, though without severity. On the contrary, it reflects a caressing candidness. The concentrated elements of the face, the expression of the gaze, the small mouth, and the rounded cheeks lend it a childlike, ingenuous, and candid air. Appropriately for an angel, the sex is indeterminate, and the figure has a certain timelessness, enhanced by the soft tones of the wings and the clouds in subdued tones that hardly allow the blue of the sky to show through. The soft pink tone of the face perfectly combines with the white tunic, whose folds are painted with great naturalism. Around the neck, a brocaded ribbon seems to hold a pectoral cross that is outside the frame, delicately breaking the uniformity and chromatic monotony of the lower area.

This aesthetic recalls the Pre-Raphaelites. The stylized neck and abundant red hair evoke the heroines of paintings by John Everett Millais and Dante Gabriel Rossetti. Boyce used the tonal intensity of the hair as an element of contrast to focus the viewer's gaze on the evocative face. The work is executed in light colors, with a series of different diaphanous textures in the dress, wings, and sky. In strong juxtaposition to them, the red hair is an element of maximum protagonism that chromatically determines the entire composition.

Boyce often created portraits with a symbolist atmosphere, which explains the candidness and simplicity in her approaches to allegory. In addition, the realist aesthetic used by the painter allows her to lend the faces great expressiveness.

REBECCA SOLOMON

The Wounded Dove (detail), watercolor, 1866, University College of Wales, Aberystwyth. According to some art historians, Rebecca Solomon painted her self-portrait in this work.

- **1832** Born in London into an established Jewish family with eight children. Two of her brothers, Abraham and Simeon, also become artists.
- **1850** Her first exhibit is held in London.
- **1852** Exhibits at the Royal Academy in London.
- **1854** Exhibits at the British Institution in London.
- **1855** Becomes the assistant to John Everett Millais.
- **1860** Works as an illustrator.
- **1862** Participates in an international exhibit held in London.
- **1865** Travels to Italy.
- **1866** Exhibits at the Dudley Gallery in London.
- **1874** Exhibits at the Society of Lady Artists in London.
- **1886** She becames an alcoholic and dies on November 20, run over by a taxi.

Throughout the 19th century in Britain, symbolism can be considered a single movement ascribed to an idealist philosophical program propounding the return to a naturalist Romanticism. Yet among the English artistic circles themselves there was no conscious attempt at unity. For this reason, when the first Pre-Raphaelites appeared in the mid-19th century, grouped under the Pre-Raphaelite Brotherhood formed in 1848, they were accused of being sectarian, and their art emerged as an underground movement, far from official venues and centers of culture. In this clearly hostile context, which gradually dissipated, Rebecca Solomon became John Everett Millais's assistant and model, and from him she received valuable artistic training.

Initially studying with her brother, Abraham Solomon, and later at the Spitalfields School of Design, Solomon developed her own style based on subjects inspired by literature, which she represented in an aesthetic approaching Impressionism.

Rebecca Solomon's compositional approaches are based on spontaneous scenes, with the Victorian mentality of the period often an underlying motif.

In the face of the restrictive situation of women in her time, conditioned by a repressive mentality based on stereotype, rigidity, and a very restricted definition of women's roles, Rebecca Solomon opted in many of her works for social criticism and protest. At times in a direct language and at others through evocation or allegory, the artist, discontent and inquiring, emitted intentional messages through her works.

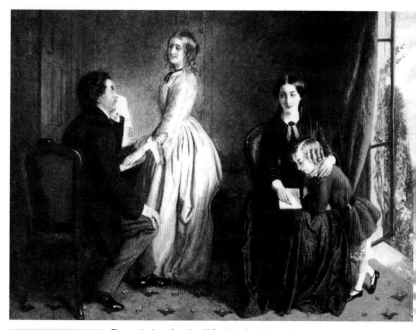

The Governess

(1854)
oil on canvas
26 x 34 in
(66 x 86.4 cm)
Yale Center for
British Art,
New Haven

The majority of well-off English families had a governess, a woman entrusted with educating the children, and she was also a common feature in Victorian literature. She was closely associated with a type of woman of great virtue who, in addition to being reserved and diligent, also carried out the functions of a second mother, housewife, and friend.

Solomon renders this figure in a familiar atmosphere. The scene takes place in the living room of a typically English home, with an elegantly dressed young couple on the left of the composition, while the right is occupied by a young governess with a child in her lap reading a book. In accordance with the role she was assigned by society, the governess appears as a member of the family. While the gentleman is seated in profile in a luxurious chair upholstered in red, the governess is seated in an identical chair but viewed frontally. The composition has two different pictorial grounds, each of which revolves around these two figures.

In the middle left of the painting, the husband tenderly observes his wife, who seems to want to leave the scene, yet responds with a loving gesture. On the right, the governess observes the viewer. Though the work is a harmonious whole, the figures form two independent groups with their own personality, represented together here. Indeed, each group is self-absorbed and there is no relationship uniting the two except that they are in the same room.

The static pose of all of the figures is striking, perhaps excessively studied and therefore somewhat cold and artificial. The artist designed the scene so that the light focuses on the wife, an emphasis reinforced by the bright, light-colored dress that strongly contrasts with the dark garments worn by the other figures and the smooth, dense background. The scene is an excellent reflection, not only of the figures but of the period. Curiously, far from evoking the stereotype of rigor and unpleasantness, this governess emanates kindness.

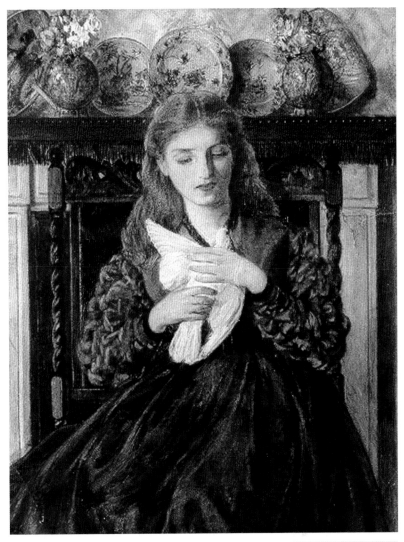

In this painting, the artist creates an allegory of femininity through a woman, possibly herself, seated frontally and holding and stroking a dove. The artist was always attracted by domestic scenes in which women were treated candidly. Like some female French Impressionists, Solomon was inclined to render an introverted vision of women in their domestic surroundings.

The Wounded Dove

(1866)
watercolor
University College of Wales,
Aberystwyth

Even in the 19th century, women were strongly conditioned by a social mentality that ascribed them nearly exclusively to the world of the home and the family. This sexism, which prevailed in Victorian society toward the end of the 19th century, was understood by some artists as a complex situation in which women themselves had to become aware of their responsibility and fight against society's closed mentality. For this reason, a few artists such as Solomon in England and Eva Gonzáles in France emphasized the most fundamental aspects of femininity in their works, representing them as priceless moral values. Deeply affected by the social situation, Solomon often painted domestic scenes in which women did not appear as victims but rather struggling for their own freedom.

In this work, Solomon places her protagonist in a domestic setting. Though she is caressing the dove, in reality, the woman is holding it prisoner while the bird vainly attempts to escape from its supposedly comfortable situation. The painting is clearly a reference to the social condition of many women.

Love's Labor Lost

oil on canvas
26.4 x 20.1 in (67 x 51 cm)
Private collection

Solomon represents a Romantic idea of childhood in this scene, which she imagines as a period of life in which feelings are profoundly genuine and spontaneous. This painting shows an idealized world in which childlike candidness acts as an example of serenity and beauty. Placing the point of view lower than usual, the artist seems to want to introduce the spectator into the world of children to render the scene from their point of view.

The painting shows a young shoeshine boy kneeling before a girl of humble origins. He gazes at her raptly as he shines her shoes. In the upper left is another child, a boy dressed as a coachman standing on the back of a carriage, watching the other two. The artist fills this transient and insignificant moment with color and vividness, converting the scene into a picturesque genre image.

The treatment of light, which seems to shine from above, contributes to creating a serene and orderly atmosphere that makes this everyday snapshot an apparently static vision. The girl looks toward a point outside the painting with a self-conscious expression, as if she knew she were being portrayed. The two boys, on the other hand, act in a more instinctive and spontaneous manner, dispensing with the artist and absorbed in their own worlds.

From a technical point of view, there are several remarkable elements: The artist executes an excellent exercise in perspective; and the painting has depth and lends each figure and element the importance it requires. The atmosphere created through the treatment of light, the garments and characterization of the figures, as well as the combination of colors, perfectly contribute to creating a popular, colorful, and attractive scene along the lines of the best of Flemish genre scenes from previous centuries, though naturally in a different style and conception.

ELIZABETH GARDNER

Elizabeth Jane Gardner.

For the majority of American artists active during the late 19th century, a stay in Paris was almost obligatory to complete their studies and learn about the prevailing standards and trends. Gardner was one of the people who began that tradition, especially among women. In Paris, she joined the emerging feminist movement that was a particularly strong force at the time, and with her friend Rosa Bonheur, she worked hard to open the doors of the École des Beaux-Arts in Paris to women. To affirm her personality and ideology in her struggle for full equality between men and women, she often wore men's clothes to stroll through the city, ignoring established conventions.

Unfortunately, her feminist struggle did not succeed in making her truly independent from the strong influences of her teacher, and later husband, William Adolphe Bouguereau, although this never seemed to bother her. Gardner affirmed: "I know I am criticized for not asserting myself as an individual painter; but above that, I prefer to imitate Bouguereau better than anyone else."

Gardner was an excellent professional with a fine technique, which, combined with the particular melodramatic sensuality of her scenes, afforded her a distinguished place in the world of art. Her style falls within the most classical tradition and she expresses her vast knowledge in her works. Particularly interesting are her manner of executing surfaces of different textures and of composing classical scenes in a style oscillating between Romanticism and realism. Her realism is far removed from that of Courbet, Daumier, and Millet, and, using Ingres as her role model, she employs the Romanticist concept when representing beauty. Her subject matter ranges from religious transcendence to loneliness, from maternity to a sublime vision of the human being in the wilderness.

- **1837** Elizabeth Jane Gardner is born in Exeter, New Hampshire.
- **1861** Begins her studies in the New England School of Art for Women.
- **1864** Travels to Paris with her professor, Imogene Robinson.
- **1872** Receives the golden medal at the Parisian Salon. She is the first North American woman to win this award.
- **1876** Receives an award at the Philadelphia Centennial.
- **1879** Lives with her teacher, William Adolphe Bouguereau. They do not marry until much later due to religious and other differences with his family.
- **1893** An important exhibition of her work is held at the Columbian Exposition in Chicago.
- **1889** Receives the bronze medal at the World Exposition in Paris.
- **1896** W. A. Bouguereau's mother dies and afterward, he and Elizabeth Gardner marry.
- **1897** Following a protracted struggle, she and her friend Rosa Bonheur succeed in having women admitted into the École des Beaux-Arts in Paris.
- **1905** Her husband dies and she continues to work, although increasing rheumatism makes painting difficult.
- **1922** She dies in her summer home in St. Cloud, France.

Elizabeth Gardner

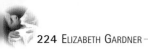

The Imprudent Girl

oil on canvas
Private collection

Related to symbolism, this work seems to be consciously aligned with the English Pre-Raphaelites. It is the theme of the unforeseen death of a girl that unites this Romantic work with symbolic realism. Death appears in many paintings by Adolphe William Bouguereau, the husband of and constant reference for the artist, as well as in many Romantic paintings, and is directly related to the dichotomy existing between humanity and nature. Also present in this work is another of the characteristics of Romanticism: the subtlety of the inanimate body, carrying the viewer beyond the spiritual.

An iconographic interpretation focuses attention on certain important signs: the yellow water lilies held by the dead girl, the arum lilies behind the girl trying to save her, and the highly dramatic relation between the light and the darkness of the central area. The center of the painting is occupied by the older girl, bathed in light and on a path moving from the darkness of the landscape to the light against a dark background.

There is no doubt as to the interpretation implied by the triple chain of symbols, as death is present in each of them: With their attractive and colorful appearance, the yellow flowers evoke an absurd death due to imprudence; the arum lilies are frequently in churches and cemeteries; and the confrontation of light with darkness refers to the earthly and spiritual worlds tragically related by death.

In the Woods

(1889)
oil on canvas
National Museum of Women in the Arts,
Washington, D.C.

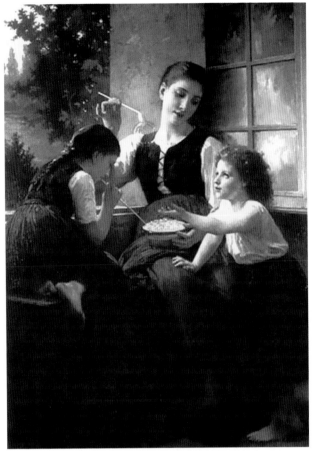

Soap Bubbles

(1891)
oil on canvas
Private collection

The artist represents the immaterial, the unreachable, the ephemeral (soap bubbles) in juxtaposition to the eternity of nature visible in the background. This is one of the few works that Elizabeth Gardner painted in the setting of a house. The manner in which the light falls on the figures recalls the high point of baroque art. It evokes Vermeer's work, for example, where the light, emanating from an unknown source, is always treated in a metaphorical sense and acts as a nexus joining inner and outer space—a fruitful relationship in art.

This work can be understood as an allegory of the fragility of humanity and the insignificance of our actions. Although it could be a commonplace, nontranscendent scene, the aspect and expression of the figures are nearly celestial. They are full of candor and tenderness, incapable of hurting anyone, because nothing that they do is sufficiently important or weighty. The painting represents an unexpected relationship between ethics and aesthetics: Beauty is a symbol of goodness.

The composition has great classical harmony, anticipating the general return toward classicism over the following years in Europe. The illuminated center distributes the increase in tonal values in the shape of a cross, with the majority of darkness and weight at the bottom of the painting. There is a scale of earthen colors juxtaposed to highly transparent whites and pinks applied in layers. The reflection of the exterior in the window completes the symmetry of the painting and of the initial metaphor: the natural order versus artificial order and hierarchy.

Left: The observation of nature from the point of view of a candid, fragile, and defenseless child is a constant in Gardner's iconography. In this painting, three children of different ages are looking at something outside of the frame while playing in the woods. Their attitude is one of surprise imbued with tenderness. Their attire and bare feet indicate that they belong to rural society. Although they are accustomed to living in the countryside, they have discovered something that surprises them and vividly wakens their interest. This nondisclosed mystery becomes the implicit protagonist of the work. It is something capable of overwhelming or making one feel insignificant. It is the idea of the sublime, so ever-present in the German painter Friedrich's ideology, the ideological framework of the most genuine Romanticism.

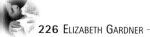

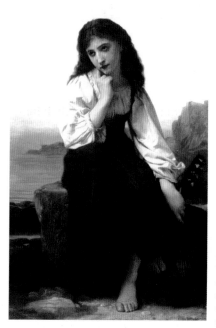

Waiting

oil on canvas
Private collection

Loneliness, religious transcendence, and the search for beauty are the keys to this painting. The lute, held in the shadows in the girl's left hand, acts as a unifying element for these concepts. The musicality of this painting is created by the linking of morphological rhythms.

In this case, the rhythm is clear: The female figure, seated on a stone with her back to the cliff in the middle ground, constitutes a counterpoint to the void. It is musical spirituality and the spirituality of thought and gaze juxtaposed to materiality.

The girl, simple and candid, has a melancholy air. A lost gaze is synonymous with introspection, and here both the eyes and the girl's expectant attitude are associated with a soul avid for essence. The immensity of the sea evokes how difficult it is for the human being to attain full perception of reality, as the atmosphere stretches from visibility to the eternal void. This is the melancholy of one who waits knowing neither for what nor for how long.

The Shepherd David

(1895)
oil on canvas
56 x 38.6 in (142 x 98 cm)
National Museum of Women
in the Arts, Washington, D.C.

The nod to classical antiquity that is typical of Romanticism passes through the filter of objectivity here. The refined technique that juxtaposes the softer textures of David and the lamb with the rough textures of the lion and the nearby terrain constitute the artist's most interesting work in this painting.

The composition, with principal elements grouped in the lower area to enhance the weightlessness of the upper area, transmits the sacred meaning of this work to the viewer: Good triumphs over evil (David's gaze toward the heavens is unequivocally significant).

This subject was one of the Victorian court's preferred scenes from the Old Testament. The historical period in which Elizabeth Gardner was living is also important in understanding this work: Humanity, removed from the spiritual world due to the value given to the individual, found itself alone in the world, represented by an extensive, meticulously rendered natural setting. This natural backdrop is given as much protagonism as David and the two animals without detracting from their importance. This work was exhibited at the 1895 Parisian Salon the year it was completed and a year before Elizabeth Gardner and W. A. Bouguereau married.

MARIE BRACQUEMOND

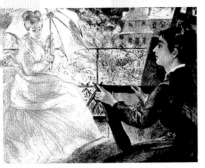

Self-Portrait. The artist is painting her sister, Louise ,in her own yard in Sèvres.

Marie Bracquemond followed the Impressionist principles of her youth. Her work is a reflection of the discursive joy motivating the artistic avant-garde that expanded throughout Europe from France. This shift marked the end of realism and the beginning of a new way of conceiving art as a result of a significant change in the concept of the human being. The industrial revolution and the idea of progress opened new lines of investigation that brought to a close six centuries of "traditional" art. It was the birth of a new era, and Bracquemond became involved with great enthusiasm. Her style led her to question the reality of perception, and, like Monet and Renoir, she discovered that it is possible to represent objects on the basis of fragmented impressions. Like the Impressionists, she recognized that artists are eyes that look and decipher the sensations that their emotions allow them to take in. Bracquemond shared the Impressionists' interest in light as well as the other ideas of the movement. Her principal contribution was a particular modulation of color and brushstroke. In her artwork, forms became elongated and adapted to the surface of the painting. She used a palette restricted to eight or nine basic colors that, without being physically mixed, became fused by the optical effect of the short, juxtaposed brushstrokes, producing hundreds of different hues.

She also had a special manner of approaching portraits. She painted the emotional and intimate essence of her sitters, often rendering their loneliness, their apparent worlds, and their contained intimacy—sensations that were always tinged by an underlying idea of beauty linked to aestheticism and good taste.

- **1840** Marie Quiveron is born in Argenton, Brittany. She spends her youth in the Jura Mountains in Switzerland, then moves to Auvergne with her family, later settling in Étampes, a village near Paris. She studies in the restoration workshop of M. Wasson and later in the Ingres Studio of Painting, where she trains as an artist and meets many of her contemporary colleagues.

- **1857** Participates in the Parisian Salon for the first time.

- **1869** Marries Felix Bracquemond. This is a turning point in her life, as it would eventually have dire consequences on her artistic career.

- **1870** Bears a child, Pierre, who was to become an artist as well years later. In his book *La Vie de Felix et Marie*, Pierre recounts the life and art of his parents.

- **1871** Bracquemond stoically supports her husband's career. Hence, when he is appointed director of the porcelain company Havilland, in Antevil, she moves to Sèvres with him, where she remains until her death.

- **1874** This year and the following, she participates in the Salon in Paris.

- **1876** Exhibits in the Exposition of l'Union Centrale des Arts Décoratifs.

- **1879** Exhibits with a group of Impressionists in Paris, along with Berthe Morisot and Mary Cassatt.

- **1880** Again participates in the Impressionist Exhibit.

- **1881** Travels to London, where she exhibits with success at the Dudle Gallery.

- **1886** Participates in the Impressionist Exhibit.

- **1890** Her marriage to Felix gives her access to many contacts in the art world, although they are fruitless, as her husband pressures her to stop painting. She definitively stops practicing her profession this year.

- **1916** She dies two years after becoming widowed. Three years after her death, her son, Pierre, organizes a retrospective in honor of his mother at the Galerie Bernhein-June in Paris.

Unfortunately, during the last twenty years of her life she did not paint. In keeping with the typical bourgeois tradition, she was relegated to the background and to obeying her husband's wishes.

The Woman in White

(1880)
oil on canvas
71.3 x 39.4 in
(181 x 100 cm)
Musée Municipale,
Cambrai, France

This work was shown at the Fifth Impressionist Exhibit, in 1880. The protagonist is the artist's sister, Louise, her favorite model. Bracquemond must have particularly liked this painting, as she kept it in her home until her death. Its beauty lies in the excellent bridging of technique and emotion, style and love for the sitter. The artist models the surface using light to dissolve the division that the mind establishes between real objects and our perception of them.

This painting allows the observer to interpret reality beyond that which the eye perceives in order to determine his or her own sentiments about nature. In a serpentine pyramidal composition, the image focuses on Louise's face. Although she appears to be gazing at the viewer, she is in reality in a reflective and introspective mood. She is brightly lit, the light emanating from her face and the white silk.

Bracquemond transforms this figure into the center of the universe. The balance between color saturation, luminosity, and transparencies by layers and by brushstrokes that fragment the surface of the painting constitute a magnificent display of technique and artistic maturity. Emotion, technique, and style are in perfect harmony, providing excellent results.

If the Impressionists, and in this case, Marie Bracquemond, succeeded in anything, it was in capturing and representing time and space as profoundly tinged by the artist's own sensations. In the manner of a snapshot, which freezes time, this work renders the tranquility of the afternoon light falling on the figures and the landscape in the background.

The principal protagonist, the man occupying the central point of the painting, and the two women with him constitute an informal portrait in the yard of the artist's house in Sèvres. Yet the work is, above all, a representation of the density of time seen through the light penetrating the entire scene. It is as if the world were no longer opaque to the sun and its rays, allowing the viewer to observe the interior of objects and people. There is no distinction between the edges of the faces, clothing, foliage. Everything is light, unifying and revealing, disrobing and superimposing.

According to the latest studies, the three figures, from left to right, are Marie Bracquemond herself in a self-portrait full of tenderness, her husband, Felix, who looks at her lovingly, although with a certain air of authority, and the artist's sister, Louise, in a concentrated, introspective and rather absent mood, as if her mind were occupied with something far away from the scene. Marie and Louise were very close, and the latter posed for many of Bracquemond's works. Her portraits emphasize this personal familiarity, combining luminosity with the spirit, real-life experience, and existence in the present.

The Terrace at Sèvres

(1880)
oil on canvas
34.6 x 45.3 in (88 x 115 cm)
Musée d'Art Moderne,
Fundación Oscar Ghez,
Geneva

The Three Graces

oil on canvas
Private collection

There is very little information on this work, despite the fact that the iconographic reference is evident: the Three Graces appearing in Botticelli's *The Spring* (ca. 1478, Galleria degli Uffizi, Florence). It is clear that this work by Bracquemond does not attain the degree of mastery of the Renaissance artist, but it is imbued with the charm of an interpretation from her time.

The bodies of the figures lack the movement and undulations of the Renaissance work—they are more solid and heavier. Far from being celestial, they are earthly creatures standing solidly on the ground, women from the upper middle class rather than profound mythological or spiritual beings lacking gravity. Light is employed as an element to silhouette the three young women in this centered composition emphasized by the tonal change in the middle figure, so that the other two appear to shield her with their bodies and parasols. A lovely movement of interwoven brushstrokes in the upper and lower part of the painting lend it rhythm and harmony, unifying and at the same time disrupting the effect of the impressions that permeate this work.

Louise and Pierre in the Yard at Sèvres

(~1880)
oil on canvas

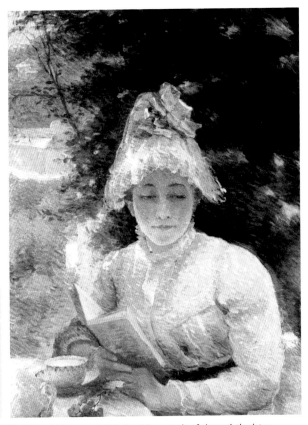

Louise Quiveron, or Tea Time

(1880)
32.1 x 24.2 in
(81.5 x 61.5 cm)
oil on canvas
Musée du Petit Palais,
Paris

Poetic Reading of an Inner World would be a good title for this portrait of the artist's sister. Louise is holding open a book that illuminates her face from below by reflecting the sunlight. The text is projected onto the sitter's face, who is lost in thought and looking away from the book, which acts more as a mirror of her inner world than a reference to physical reality.

The subject of the book matters little: In reality, the sitter is reading herself, absent from the real world in an introspective mood treated by the artist with great care. A small still life, consisting of fruit, a teapot, and the matching cup on a table in front of Louise, marks the beginning of a diagonal separating light and shadow. Naturally, the focal point of the painting is the woman's face, which serves as a compositional background and morphological nucleus that sets the tonal scale. Marie Bracquemond was able to transmit the emotion of forms and portray the world of women, so misunderstood in her time, through the representation of a relaxed moment full of seductiveness.

Left: In an informal scene, the artist's sister, Louise, is seated in the yard, occupying the entire lower left of the painting, while Marie's son, Pierre, stands next to her, creating a classical compositional counterpoint to the verticality of the canvas. The background is a corner of the yard with luxuriant vegetation, including bushes and flowers.

The entire scene is immersed in a warm light. The color temperature perfectly links the figures with the background through ochres, earth colors, burnt greens, and other shades. It is a typical Impressionist work recalling certain paintings by Renoir and some from Manet's early period. This work fits perfectly within Bracquemond's concept of art. "Impressionism is not just a novelty—it is a different way of seeing things. Isn't it true that when you open the window, the sun and air always rush into the house in torrents?" Bracquemond replied to her husband when he told her that she was crazy and that she should stop painting.

Sitting Room

(~1890)
watercolor
18.7 x 8.2 in (47.5 x 20.8 cm)
Musée du Louvre,
Cabinet des Dessins, Paris

The artist's fondness for portraying her sister is evident here in one of her few indoor scenes. It is set in Bracquemond's home, with the painting hanging on the wall—*The Woman in White*—serving as a back-drop to the composition. This painting becomes a window into the artist's family and personal refuge, where it seems that her sister, as a woman and close friend, was the person who best understood her.

The work's compositional structure is particularly important: The extremely elongated, vertical rectangular format gives rise to a vanishing point that continues into the painting within the painting. The space is the protagonist, representing a refined, high-class French home typical of the period: A rectangle limited by the harsh social restrictions weighing upon married women, within which Bracquemond found herself a prisoner.

This watercolor was executed quickly but not impulsively. Before beginning a work, the artist usually studied it meticulously, in a very traditional manner. She sought the appropriate setting, executed sketches and preliminary studies, studied the most adequate lighting. In this case, the unusual restricted framing of the sitting room is intentional and significant, establishing a parallel between the space represented and the artist's personal situation, which she had already expressed previously. This is a watercolor, but it closely resembles an oil painting involving long periods of study and gradual progress. It symbolizes the silence of female artists throughout the not-so-distant history of art.

BERTHE MORISOT

Self-Portrait with Julie *(detail), 28.35 x 35. 82 in (72 x 91 cm), 1885, Private collection.*

Reserved, educated Berthe Morisot had a great sense of irony and was an inquiring traveler. Painting was her raison d'être, and she was highly critical of herself.

She met Manet in the Louvre and he asked her to pose for *The Balcony*. This was the beginning of an enduring friendship, as they shared the same aesthetic ideas embodied by the new concept of painting called Impressionism. Manet introduced her to Charles Baudelaire, Zacharie Astruc, Émile Zola, Edgar Degas, Pierre Puvis de Chavannes, and many more. She is one of the few women to participate in a pictorial movement from the beginning. She exhibited her works in six of the eight Impressionist exhibitions, helped the movement financially, and stopped exhibiting at the Parisian Salon.

After her marriage, as a member of the Manet family, she had confrontations with her siblings, Tiburce, Edma, and Yves, who did not understand the type of life she led nor her ideas concerning religion, diametrically opposed to theirs, which led to tension between them.

Pierre-Auguste Renoir and Stéphane Mallarmé were her closest and most faithful friends. Like all the Impressionists, she received severe criticism, but she also reaped excellent opinions for her skill and sensibility. As Morisot could not attend meetings at cafés due to the social conventions of the time, in 1885 she began organizing lunches at her house every Thursday for her colleagues and friends.

Her work tends toward intimism and is well structured. Her canvases are poetic, sensitive, luminous, captivating, and often reveal a lucid observation of human nature.

- **1841** Born on January 14 in Bourges to an upper-middle-class family. She is the third daughter of Edme Tiburce Morisot, prefect of Cher, and of Joséphine Cornélie Thomas.
- **1857** With her two sisters, Edma and Yves, she takes her first drawing and painting lessons.
- **1860** Expresses her desire to paint out-of-doors, which scandalizes the history painter Joseph-Benoît Guichard, who considers this a sacrilege. Meets Camille Corot and the landscapist Achille-François Oudinot.
- **1864** Berthe and Edma exhibit their paintings for the first time at the Salon.
- **1866** Spends the summer in Pont-Aven.
- **1868** At the Louvre, she meets Édouard Manet, who proposes that she pose for *The Balcony*.
- **1872** With her sister Yves and Zacharie Astruc, she visits Toledo, El Escorial, and Madrid.
- **1874** On January 24, her father dies, leaving her an inheritance that allows her to live comfortably. On April 15, she participates in the First Impressionist Exhibit, held in the studio of the photographer Nadar in Paris. On December 22, she marries Eugène Manet, the painter's brother.
- **1875** Berthe and Eugène travel to England. They spend the summer on the Isle of Wight.
- **1876** Participates in an exhibit organized by the art dealer Durand-Ruel, in London, along with Edgar Degas, Edouard Manet, and Alfred Sisley.
- **1877** Rents an apartment in Paris to paint and to get away from family life.
- **1878** On November 14, her daughter, Julie, is born.
- **1882** Travels to Pisa and Florence. Spends the summer in Bougival.
- **1885** Morisot and her husband begin hosting Thursday meals at their home on Rue de Villejust, a truly artistic and intellectual meeting place, attended by people such as Degas, Claude Monet, Renoir, and Mallarmé.
- **1886** Berthe and Eugène spend the summer in Gorey, on the Isle of Jersey.
- **1892** On April 13, her husband dies. On May 25, she inaugurates her first individual exhibit at the Boussod and Valadon Gallery.
- **1894** On March 13, Berthe and Julie travel to Brussels, where she exhibits at the Salon de la Libre Esthétique. Her painting *Jeune Femme en Toilette de Bal* is acquired by the State.
- **1895** Dies in Paris on March 2 of pneumonia. On her death certificate, she is recorded as having "no profession."

Refuge in Normandy

(1865)
oil on canvas
18.1 x 21.7 in (46 x 55 cm)
Private collection

The historical painter Joseph-Benoît Guichard was scandalized when Morisot begged him to allow her to paint in the open air, something highly revolutionary for the time. So he introduced her to Corot and Oudinot. *Refuge in Normandy* is from that period and was painted in the summer, in Beuzeval, at a country house that the Morisot family had rented from León Riesener the previous year. Morisot was never a follower of Édouard Manet, a fact that is corroborated by this canvas. It was painted three years before Morisot met Manet, yet it already manifested the concepts of Impressionism in the treatment of the subject matter, the diffuse light that imbues the canvas, and the short brushstrokes.

This painting is considered Morisot's first masterpiece and one of the first Impressionist works. Morisot offers a rich range of ochres in the foreground, which she combines with both lighter and more intense greens. This delicate harmony of varied ochres and greens not only lends the work depth, but also describes the different illuminations within the forest and hence transmits its atmosphere. Indeed, the protagonists here are the slender white birch trunks that recede toward an imaginary clearing and continue the limits of the painting.

The most interesting aspect of this landscape is the frame. In that period, landscapes usually had broad, open skies or depicted large tracts of countryside or tranquil riverbanks. This painting, in contrast, illustrates only a small area of whitish sky, slightly illuminating the right side of the work. The left side, on the other hand, is filled with shadows in dark, intense greens. The low viewpoint gives rise to a close, immediate fragment of forest. This sense of immediacy is very modern.

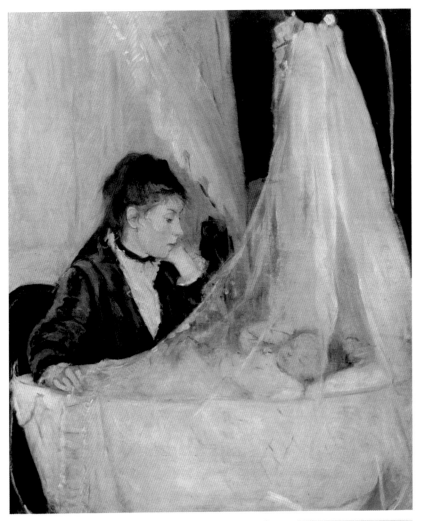

The woman in the painting is Edma, Morisot's sister. The two sisters studied drawing and painting together and, in 1864, exhibited their works at the Salon for the first time. Both of them were praised as excellent painters, but Edma married Adolphe Pontillon in 1869 and gave up art. Morisot represents her sister with her newborn, second child, her daughter Blanche, in the cradle.

The Cradle

(1872)
oil on canvas
22 x 18.1 in (56 x 46 cm)
Musée d'Orsay, Paris

This is a captivating painting, with interesting contrasts between the blacks on a diagonal and the predominating whites. The transparencies are magnificent in the tulle draped over the cradle, and the manner in which the whites become tinged with brushstrokes of blues, ochres, and pinks is superb. A pink silk ribbon diagonally crosses the canvas, separating the worlds of the mother and the child. Edma contemplates her child in rapture, resting her head on her hand in a natural gesture devoid of affectedness that lends the painting charm and realism. The pastel tones of the whites, ochres, blues, and pinks blend to create a tender, delicate atmosphere in keeping with the fragility of a newborn child.

It is not surprising that this painting was one of the few to be acclaimed at the first Impressionist exhibit, held at the studios of the photographer Nadar in 1874. On April 29, Jules Castagnary wrote an excellent review in the magazine *Le Siècle* lauding Morisot's artistic merits. But behind this painting is something more: Edma's mood. Morisot renders with significant sensibility the pleasure that a mother can feel when contemplating her child, a universal and profound sentiment.

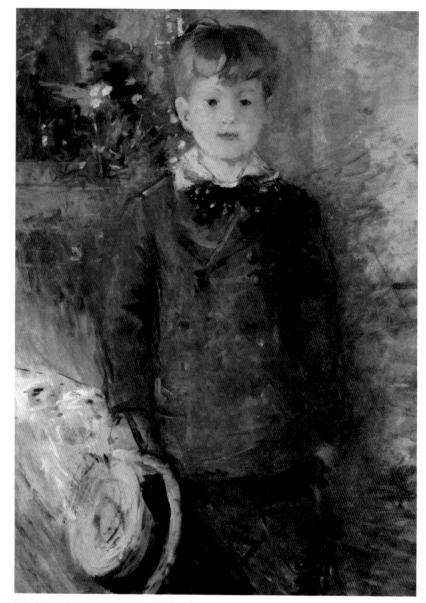

Portrait of a Boy in Gray

(~1880)
oil on canvas
33.9 x 24.4 in (86 x 62 cm)
Private collection, Geneva

The boy featured in this painting is Marcel Gobillard, the son of Morisot's sister Yves. He is wearing a suit and a handkerchief around the collar of his shirt, and has one hand in his pocket while holding a hat in the other. Morisot chose subdued, earthy colors. The light is distributed in different zones throughout the painting that are separated in a subtle manner, without contrasts; the light is strongest next to the hat. To give depth, the artist added a mirror with flowers in short, precise brushstrokes that contrasts with the diffused colors of the suit and the background. The psychology of the boy is superbly rendered. He adopts a soldierlike stance, arms at his sides, gazing straight ahead, showing the self-consciousness of a child aware that he is being portrayed.

The painting is highly sincere, one of the artist's best, and the figure of the boy is emphasized by the fact that he occupies nearly the entire of the canvas. The conventions of the time were adverse to a woman painting a portrait of a male, and *Portrait of a Boy in Gray*.

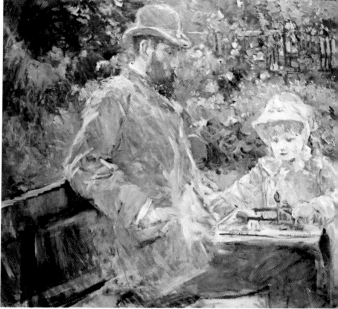

Eugène Manet and His Daughter in Bougival

(1881)
oil on canvas
28.7 x 36.2 in
(73 x 92 cm)
Private collection

In 1880, Berthe Morisot and her husband, Eugène, spent the summer in Beuzeval, and in 1881, they decided to go to Bougival for the summer. There, Morisot painted this poetic view of their yard in which father and daughter are playing with a toy. Charles Baudelaire's call for a modern art that would render spontaneous, everyday scenes and provide a fleeting sensation was heeded by the Impressionists. As in many of her works, Morisot reflects Baudelaire's aesthetic ideas in this painting.

View from the Terrace at Mézy

(1890)
oil on canvas
20.9 x 25.6 in
(53 x 65 cm)
Private collection, Washington

On February 27, 1890, Stéphan Mallarmé gave a presentation on Villiers de l'Isle-Adam at the home of Eugène Manet and Berthe Morisot. That year, they decided to spend the summer in Mézy. In this luminous landscape, the trees are comprised of pure yellows, with red brushstrokes on the trunks and the leaves tinged with greens approaching blue. Yet the colors in the distance are very soft. This is a daring and stunning work.

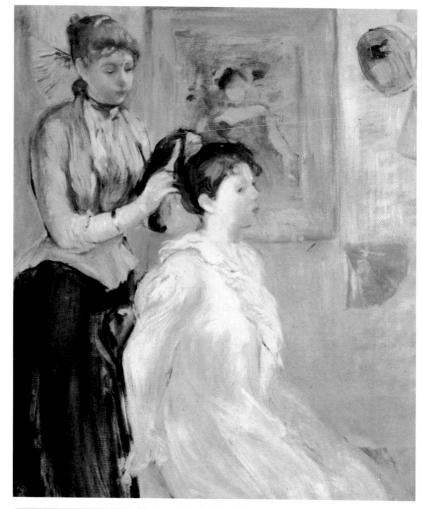

The Coiffure

(1894)
oil on canvas
21.7 x 18.1 in (55 x 46 cm)
Museo Nacional de
Bellas Artes, Buenos Aires

Morisot painted this work a year before her death. In 1894, although profoundly affected by her husband's death, she continued to work actively. This is an intimist painting with a very warm, orange background. In the foreground, the coiffeuse, engrossed in her work, is wearing a black skirt that contrasts with the diaphanous white robe worn by the model. There is also an interesting contrast between the blond hair of the coiffeuse and the black hair of the other woman. Morisot chose an excellent angle for the model. The arm in the foreground is slightly bent, lending the young woman a somewhat tense yet very natural position, considering that her hair is being styled. The dense volumes of the robe, executed in long, sinuous brushstrokes with tinges of blue, are superb. This was typical of Morisot, who was very skillful when working with whites, a lesson she learned from Guichard.

The light, as usual, is distributed in a diffuse manner. The Impressionists detested such highly defined areas of light and shadow as executed in the studio by academic painters. They were much more interested in studying how forms dissolve in light and in the air. In the background, in order to balance the masses, Morisot added a portrait and several Japanese fans to adorn the wall.

These details illustrate the taste of Morisot and of the Impressionists in general, who were enthralled by Japanese prints, as they represented unusual, spontaneous aspects of life that were in keeping with the subjects the Impressionists painted and defended, in contrast to rigid academic rules. Hence, once the Impressionists discovered the beauty of the prints, they collected them avidly. This painting represents Berthe Morisot's last reflection on humanity—that is, female vanity.

EMMA SANDYS

A Fashionable Lady, *colored chalk on tinted paper, 1873, private collection.*

Influenced by the work of her father, the painter Anthony Sandys, Emma Sandys entered the world of art at an early age. In her early period, she executed numerous commissioned portraits of children, specializing in a particular style in which the expressiveness in the eyes of her models is striking.

Under the influence of Eugène Delacroix and Théodore Géricault's Romanticism, Sandys particularly focused on expressiveness in her portraits. Her paintings were organized according to a balance created through an interplay of light and colors. Their classicist conception allowed her to use large, contrasting tonal planes of light and shadow. In her portraits of women, she used brilliant colors to define and outline the figure, while the background often appeared in a rather dark tone that enhanced the brilliance of the human figure, always the protagonist of her paintings.

Like many artists employing a chiaroscuro technique, Sandys used different stylistic resources to make her figures transmit their sentiments and transcend their physical characteristics and clothing. The selection of color was also an important resource for the artist, who used a system of complementary contrasts, dressing her models in bright clothing

- **1843** Emma Sandys is born, the daughter of a professional artist. She begins her studies at a very early age, watching her father work. He eventually became her teacher.

- **1858** Defines herself as a portraitist and executes a series of portraits of all of her relatives.

- **1862** With academic aims, she travels to Italy with her father and her brother.

- **1863** Exhibits her works in public for the first time.

- **1865** Becomes a professional portraitist.

- **1866** Moves to London to work with her brother, Anthony Frederick Augustus Sandys, also a painter.

- **1867** Exhibits in London for the first time along with her brother.

- **1869** Travels to Paris to learn about Impressionism.

- **1870** Takes a second trip to Italy.

- **1871** Participates in an international art exhibit held in London.

- **1874** Her London studio burns down, the fire destroying some of her works.

- **1876** Dies in London. According to some sources, she died in 1877.

and handkerchiefs or stoles that intentionally contrasted with the dress.

The women in Emma Sandys's art have certain constant characteristics: They are distinguished and have delicate skin, an introspective expression, a rather lost gaze, fine sensuality, a fragile appearance, an air of sophistication, and at times a certain timelessness and a touch of idealization. Yet they are always human. The framework in which these women are represented is sumptuous, nearly majestic, something that has led critics to see a refined symbolism, arising from the same sources that Edward Burne-Jones used.

Elaine

(1862-1865)
oil on panel
National Trust, London

Attracted by the expressive capacity of the human gaze, Emma Sandys constantly explored the pictorial possibilities offered by her figures' eyes. In this painting, the model leans back against a richly brocaded fabric, in a contemplative mood with a deep, absorbed, and dreamy gaze toward infinity. The figure has large, shining eyes, and her expression lends the work timelessness.

As viewers of the 1860s would have known, Elaine was the heroine of Tennyson's *Idylls of the King*; her love for Lancelot is unrequited. In the painting, the artist wanted to represent reality in an innovative manner, combining early 19th-century academic realism (which concentrated on formal aspects and the treatment of basic values such as the line, light, color, detail, volume) with the random representation of everyday life introduced by Impressionism, with its penchant for capturing a precise instant in the manner of a snapshot. This painting offers a vision of women very similar to that in the works of Eva Gonzalès and Mary Cassatt, although the latter two employed a far more realist aesthetic.

Like these two artists in France, Sandys focused on female subjects. Yet far from sharing their intimist aesthetic, she preferred to adopt a more poetic vision, placing her figures in reflective moods. The artist adopted a Romantic language to lend the woman a deep, somewhat transcendental image. The sumptuous setting imbues the painting with a decorative sense that balances the work. The complex clothing worn by the figure is integrated into a floral setting consisting of the brocaded pattern on the tapestry in the background and the fine coiffure, while the face, simple, pale, and delicate, emanates serenity and light.

Right: This is the portrait of a personal friend of Emma Sandys. The complex, sophisticated background conveys a sense of luxury and opulence, matching with the formal complexity of the dress. Sandys represents the model in a sumptuous, elegant dress, purposely emphasizing the jewelry and embroidery details. She employs a classical compositional style, placing the figure in a dark room, as is nearly always the case in her works. The window behind the woman provides a sense of space. This single element of perspective creates depth and leads the eye into the background.

The woman poses meditatively under tenuous light that allows the artist to create a portrait approaching the academic neoclassical aesthetic of the 18th century. The half light in the room, contrasting with the luminous landscape seen through the window, creates a chiaroscuro effect that was certainly original for a work from the 19th century. The static pose of the figure lends it a majestic and somewhat idealized air.

Preparing for the Ball

(1867)
oil on canvas
Private collection

In this painting, the model is represented from two different points of view: the real image and the one reflected in the mirror, allowing the artist to render two versions with different light and colors. In the "real" image, the woman is in profile, looking at herself in the mirror; her reflection is in full foreshortening. The artist plays with the compositional possibilities offered by the mirror to create a double portrait and make the woman's image more decisive. The real woman, turning her face away from the viewer, is rendered in a Romantic canon and projects a sense of absence. The reflected woman, on the other hand, shows herself openly to the public, not without a certain arrogance and vanity.

Emma Sandys uses this dual reading of her work allegorically. She is probably representing the duality between the sentimental and romantic vision of women and the representative quality of beauty. This double vision of a single figure enhances the person, projecting a sophisticated, elegant, and idealized image. As in other portraits by Sandys, the artist plays with the juxtaposition of light and dark colors to emphasize the classicist conception of the work. The model is well illuminated, dressed in clothing that accentuates the brightness, while the room is immersed in half light, partially broken by the presence of several brilliant decorative elements that the artist used wisely to avoid excessive density. The figure is dressed in colorful garments in order to create a greater sensation of luminosity using such complementary colors as green and red.

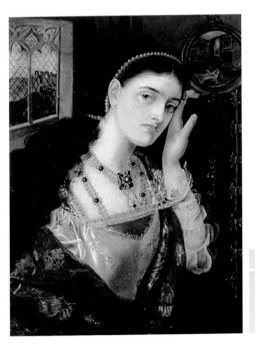

Viola

(1870)
oil on canvas
Walker Art Gallery, London

Woman with a Yellow Dress

(1870)
oil on canvas
Private collection

Though this painting generally maintains the constant features of Sandys's art, there is an evident change in approach and in the treatment of the figure's projected image as well as the colors used. The woman, somewhat less sophisticated than those usually rendered by Sandys, is equally distant, despite her furtive gaze toward the viewer. Her head is much less adorned. The background is a reproduction of a medieval tapestry at the museum of the Norwich Castle. Its dark colors, contrasted with the yellow dress, once again allows the artist to emphasize the figure.

The use of this type of framing permits the viewer to get much closer to the character. It is thus possible to see in detail the characteristics that identify the painting of this artist. The chosen background, apart from enriching the painting and putting the personage into context, gives her a noble and cultured character. It has been elaborated with dark colors, which gives magnificent contrast to the pale face and the vibrant yellow dress. The richly detailed and colored face and the elegance of the dress constitutes an exhibition of the artist's way of treating volume, light, and color, always with great delicacy. All this gives the portrayed an image of quality and it is no wonder that her portraits were very much appreciated.

LUCY MADOX BROWN

Mathilde Blind *(detail)*, chalk on gray paper, 1872, Newnham College, Cambridge, U.K.

- **1843** Born in Paris on July 19. She is the daughter of the artist Ford Madox Brown and his first wife, Elizabeth Bromley.
- **1846** Her mother dies.
- **1869** Travels to Belgium and Cologne with William Morris and his wife.
- **1870** Exhibits at the Royal Academy in London.
- **1871** Exhibits at the Dudley Gallery in London.
- **1873** Travels to Italy where she meets William Michael Rossetti, a writer and the brother of the painter Dante Gabriel Rossetti.
- **1874** She marries William Rossetti.
- **1875** Her first child is born. Four more will follow, the last a set of twins born in 1881.
- **1885** Diagnosed with tuberculosis.
- **1894** Dies of tuberculosis in April in San Remo, Italy.

The daughter of a precursor of the Pre-Raphaelites, Lucy Madox Brown began painting under the tutelage of her father, Ford Madox Brown. She considered herself his disciple and assistant.

Lucy Madox Brown's artistic career was very brief. She exhibited only from 1869 to 1874, when she married a William Michael Rossetti, a brother of Dante Gabriel Rossetti. She then stopped painting professionally.

The training received by Madox Brown from her father was quite technical, though the artist also acquired a Romantic theory of art that led her to travel throughout Europe, thanks to which she was able to study the work of the great classical artists. This is why her style, initially Pre-Raphaelite, gained a more cosmopolitan air.

Madox Brown's art is characterized by a very direct language based on the expressive qualities of her figures. In her paintings, the artist created an atmospheric sensation that simplified the reading of the work, focusing attention on the figure and completing the painting with rich neoclassical or gothic architectural details. She conceived of these rich settings as an interior architecture of the work itself, drawing the viewer into the work through a complex interplay of tones.

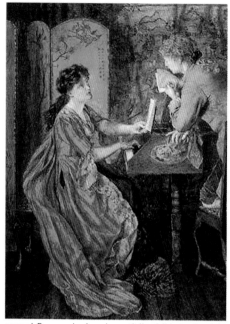

The Duet

(1870)
watercolors
Private collection

In this painting, Lucy Madox Brown renders a complex scene in which two figures are rehearsing a song. The artist, accustomed to treating portraits in a realist manner tending toward absolute simplification of the setting and background in order to enhance the direct expressiveness of her figures, creates here an elaborate interior in which the quality of colors and tones construct a pictorial space.

The protagonist, seated at a piano, is looking at the standing figure. The woman, slightly turned to the front and wearing a loose red dress, is the focus of attention. She is portrayed in a very expressive manner in comparison to the second figure, who is only partially visible to the right, cut off by the frame. The two are taking a short break and conversing. The scene seems to be lit by the light radiating from the faces of the two singers. The most illuminated area is between the two characters, enhancing the expressive capacity of the moment. The spectator's attention is drawn to the center of the painting and then directed to the pianist's bright red dress. With these ingredients, the painting comprises an intimist scene of two figures belonging to an upper-class society and located in a distinguished room imbued with luxury, lyricism, and Romanticism.

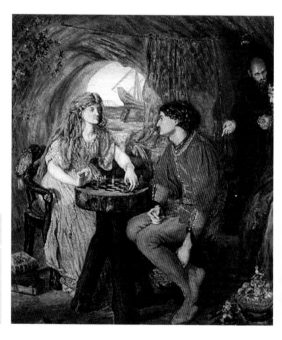

Ferdinand and Miranda Playing Chess

(1871)
oil on canvas
26.8 x 24 in (68 x 61 cm)
Private collection

Mathilde Blind

(1872)
chalk on gray paper
Newnham College,
Cambridge, U.K.

In this portrait of a friend of hers, Lucy Madox Brown used a local color aesthetic. The woman is slightly turned toward the right, interrupting her domestic task to pose for the portrait. The model appears natural, devoid of idealization and free of moralizing or allegorical pretenses. The sitter is rendered with an air of great serenity.

Madox Brown composed this painting based on absolute simplification. Ceding all protagonism to the model, the artist dispensed with all superfluous elements that could distract the viewer. For this reason, the contours of the sitter stand out against a plain background in a single color with little texture. Despite her father's Pre-Raphaelite influence, this painting is in Madox Brown's Romantic style, which fell within the English Romantic tradition. It is a portraitist exercise that follows James McNeill Whistler's proposals, lacking allegories or second readings. The influence of this American painter is also evident in other works by Madox Brown, in which art is rendered as a simple aesthetic exercise, with the serene atmosphere and compositional balance to be found in Whistler's work. Thus, the figures that appear in Madox' works are artistically elaborate, with a style similar to that of the Pre-Raphaelites (Edward Burne-Jones, Dante Gabriel Rossetti), but with the difference that Madox Brown do not pretend any idealism or symbolism.

Left: Lucy Madox Brown's professional career was very short. It began after her first exhibit at the Dudley Gallery in London in 1869. Madox Brown, who had simply been her father's assistant until this time, received very favorable reviews, and the art merchant Albert Goodwin encouraged her to continue to paint in a professional manner. From then on, she adopted the Pre-Raphaelite aesthetic that she had acquired from her father, though her subject matter was always historical.

In this work, Ferdinand and Miranda from William Shakespeare's *The Tempest* play a game of chess in an imaginary cave near the sea. (The model for Ferdinand was the artist's half-brother Oliver Madox Brown; Miranda is her half-sister Catherine; and Prospero is William Michael Rossetti.) The setting is certainly original, lending the simple cave the elegance of a fine hall through the costumes and the chessboard. The contrast between nature and social sophistication is strong but not damaging. The entrance to the cave is located above Miranda's head, and she appears as a beautiful model in the purest Pre-Raphaelite style. The zone consisting of Miranda and the aperture to the outer world, the only bright area in the work, immediately attracts the viewer. Madox Brown, aware of this, dressed Ferdinand completely in red, an effort to lead the spectator's attention along a specific trajectory through the work.

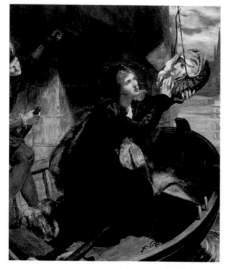

Margaret Roper Rescuing the Head of Her Father

(1873)
oil on canvas
24.8 x 19.3 in (63 x 49 cm)
Private collection

The Pre-Raphaelite artists adopted historical figures as subjects of their works, in juxtaposition and response to a progressively industrialized world. Here, the daughter of Sir Thomas More retrieves the head of her father, executed for refusing to grant Henry VIII's divorce. His severed head was displayed at London Bridge, and Margaret, at great personal risk, removed it for Christian burial. To English artists, the classical ideal of beauty had become a way to hide or escape from the hideousness that the industrialization had brought. Lucy Madox Brown, who assimilated this aesthetic philosophy when working with her father from childhood, applied it to her artwork, though without the same idealization of beauty. In this painting, she portrays the woman with the same Pre-Raphaelite canons that her father had used: stylized neck, marked features, languid expression, delicate face, and slender body. The attractive woman makes the scene more incisive, contrasting with the gruesome task and emphasizing her bravery. In a reduced color range and a dark atmosphere, the artist creates a dramatic, spectacular air. Gray tones make the woman's face and her father's head, the principal elements in the scene, radiate light of their own. In complex scenes, the artist often used the expressive force of light to direct the viewer's gaze throughout the space of the painting. The spectator observes the expression of the protagonist and, guided by small details in brighter tones, travels through the painting, moving into the recesses of the landscape.

André

(1889)
chalk on colored paper
Private collection

During her artistic career, Lucy Madox Brown experimented with portraiture, using different techniques. In this work, she rendered the image of a young boy in an aesthetic approaching the Postimpressionism of the late 19th century. In her numerous travels, she adopted a new perception of art completely unlike the rigid realism that prevailed in 19th-century England. In Europe, the Impressionists had done away with the idea of objective truth in nature in painting, and the Postimpressionists defended the idea that art depends not only on what the artist saw but on the manner in which the artist interpreted reality.

Lucy Madox Brown, who came from a very different artistic world, was particularly receptive to this new way of conceiving art and incorporated it into her own experience. This work, executed shortly after she was diagnosed with tuberculosis, adopts this new language. The artist portrayed the sitter according to her own particular view. The elegantly dressed boy poses in a formal manner with a tired expression. The model adopted a reflective attitude, gazing at a point outside the frame of the painting. This work is remarkable for its chromatic range: It is monochromatic while giving rise to many nuances.

KITTY KIELLAND

Kitty Kielland in a photograph from approximately 1900.

Kitty Kielland was one of a group of painters who blended Impressionism with the pictorial tradition of her own countries.

Her work usually contained the monumentality of Nordic landscapes represented through personal criteria, rendering the artist's own vision of the world. Kielland's approach to landscape, which approximated her works to those of the Barbizon School, the cradle of Impressionism, was remarkable for its special luminosity.

As in the case of the Barbizon School, the artist was very attracted to landscapes, especially painted in open air. Although she also cultivated other themes, the landscapes are the most outstanding in her work. The precision and the great quantity of details she incorporates illustrates her great gift for observation, and proves that the pictures were painted in open air. The meticulousness, the light, and the color are characteristics always present.

The Scandinavian Kielland observed light from a very different viewpoint than that of the French Impressionists. Hence, while the painters of the Barbizon School were attracted by the magnificence of Normandy's seascapes, Kielland reflected the specific light that bathed the coasts of Norway.

- **1843** Christine Kitty Kielland is born in Stavanger, Norway, on October 8. (Her brother, Alexander Kielland, becomes a famous author.)

- **1860** Studies under the tutelage of Fanny Zeuthen, a local painter.

- **1870** Studies under Morten Müller in Christiania, Oslo.

- **1873** Studies at the Kunstschule in Karlsruhe under the Norwegian painter Hans Gude.

- **1875** Studies in Munich with Eilif Petersen and a year later with Hermann Baisch.

- **1878** Settles in Paris.

- **1879** Studies at the Académie Julian with Tony Robert-Fleury. Exhibits at the Parisian Salon continually until 1883.

- **1880** Until 1886, intermittently executes different studies with Léon Pelouseen Cernay-la-Ville and in England.

- **1881** Participates in an exhibit of Nordic art in Göteborg.

- **1883** Works as a professor at the Académie Colarossi in Paris.

- **1885** Exhibits at the World Exposition of Antwerp.

- **1887** Exhibits at the Parisian Salon.

- **1889** Elected member of the Norwegian art committee for the World Exposition in Paris, in which she participates as well, obtaining a silver medal. She moves to Christiania.

- **1893** Participates in the World's Columbian Exposition in Chicago.

- **1897** Participates in the Venice Biennial.

- **1899** An individual exhibit is held in Blomqvist, Christiania.

- **1900** Participates in the World Exposition in Paris.

- **1904** Individual exhibit at the Christiania Kunstforening.

- **1908** Receives the royal golden medal of merit in Norway.

- **1911** Individual exhibition at the Diorama Gallery in Christiania.

- **1914** Appointed honorary member of the Norwegian Society of Studies. Dies in Oslo on October 1.

Norway–Summer Night

(1886)
39.6 x 53.3 in (100.5 x 135.5 cm)
oil on canvas
Nasjonalgalleriet, Oslo

Kielland practiced a late Impressionism that approached Neoimpressionism. In this work, the artist employed a range of colors remarkable for their brilliance. The principal difference between the Impressionists and the Neoimpressionists lay in their methods of mixing colors to produce luminosity and tones. Hence, while the Impressionists mixed complementary colors on the palette to obtain neutral and grayish tones, the Neoimpressionists, rejecting this practice, mixed very similar colors to obtain purer and more brilliant tones.

In this work, painted during a stay at an artists' colony near Oslo, Kielland renders the particular phenomenon of Nordic light at night. In an area as close to the Arctic Circle as this one, the rays of the sun strike at a different angle and give rise to bright or "white" nights. Kielland, thoroughly acquainted with nature in her country, re-creates a summer night with a strikingly brilliant, silvery sky and its reflection on the waters. The artist used a tonal range that darkens in the grass and mountains and contrasts with the luminosity of the water and sky. It is this combination of different tonal planes that insinuates darkness, hinting that this is a nocturnal landscape. The range of colors used, rich with tonal nuances, transmits a light and twilight not only representing the landscape, but also characteristic of the atmosphere in that area in summer.

In this work, Kitty Kielland used a style close to that of the Barbizon landscapists, who were always concerned with the effect of light and color on the natural landscapes. Her brushstrokes describe a specific image of nature. With its cloud-covered sky, gray atmosphere, and filtered light, the composition demonstrates a sure hand and compositional and chromatic mastery. It seems clear that the artist studied Manet's work in depth and was attracted by his pictorial style, characterized by nearly calligraphic brushstrokes that perfectly reflect the light.

Torvmyr

(~1890)
oil on canvas
Stavanger Faste Galleri,
Copenhagen, Denmark

In this work, Kielland adopted a vision approaching that of the French artist, executing the painting on the basis of various grounds of light. Beginning with the tonal luminosity of the grass, the work is organized into contrasting zones in which light and shadows are highly defined. Under leaden clouds that occupy three-quarters of the painting, the surface of the land is small compared to the enormous pictorial weight of the sky, which becomes the protagonist of the painting. To counteract this effect, the green color of the grass and the dark mountains are separated by a small river that reflects the sky.

Although this is a composition with a low horizon line, and the sky exercises a great weight on the surface, the painting does not transmit oppression or dejection. On the contrary, it is an open, sweeping landscape that engulfs the viewer in its vastness. The painter attempts to impress the spectator with the stormy sky, causing the eye to follow a path descending toward the serenity of the meadow in shades of green.

Snack Jaeger

(~1900)
oil on canvas

Though Kielland was primarily a landscapist; her oeuvre of Impressionist works included domestic scenes as well. This painting illustrates a man seated in an armchair next to a table, consulting some documents. The painting re-creates a tranquil moment in which the only active elements seem to be the sheets of paper.

Kielland creates an introverted atmosphere with predominantly subdued colors, with the soft light enhancing the sensation of a closed space. All the aspects of the illumination are meticulously and realistically executed, and there is a wide range of hues. The color balance is perfect. The central table is like a mirror on which the light from the window is reflected, and the entire room echoes with an interplay of light and shadows.

This reflected light constitutes a distinctive characteristic of Kielland's art. In landscapes with stormy skies or, as in this case, in a dimly lit room, the artist paints a scene illuminated by afternoon light. In this painting, the shadows cast by the furniture are elongated, as occurs in the early morning and late afternoon. Kielland admired the effect of late-afternoon light and studied it in depth for her paintings. In addition to its harmonious light and color, this work contains certain details that enrich the scene and make it more lively, like the lamp hanging over the table, the bouquet of yellow flowers, and the painting on the wall to the left.

MARY CASSATT

Mary Cassatt (1872).

Invited by Edgar Degas, Mary Cassatt exhibited for the first time at the Impressionist Exhibit of 1874. Until then, women Impressionists had tended to paint everyday family scenes. But Mary Cassatt, who had been involved in engraving and whose work in this field has now been recognized, freed herself from social conventions and decided to accompany Edgar Degas and Pierre Auguste Renoir on their pictorial excursions to the outskirts of Paris. With them, she experimented with compositions influenced by Japanese prints, showing her interest in gestural details and dispensing with static poses. Her American origins made some Parisian critics uneasy, as they considered her too cosmopolitan. Cassatt was the only painter from the United States to become fully integrated into the Impressionist movement, since James McNeill Whistler and Winslow Homer, who also visited France at that time, were attracted by English artistic circles. Cassatt's artwork is based on the spontaneity of her scenes. In her Parisian theater scenes, her capacity to capture the spontaneous gestures of an audience placed in a luxurious atmosphere is striking. This unique treatment of gesture was well received by the public, who considered her works "tranquil scenes painted with a charming delicacy," in the words of the art critic Joris Karl Huysmans. This is particularly true of her works with family scenes, in which the representation of the mother with her child, due to the surroundings and the posture of the characters, give the works a glow of warm candidness.

- **1844** Mary Stevenson Cassatt is born in Pittsburgh, Pennsylvania, to a well-off family.
- **1860** Begins studies at the Pennsylvania Academy of the Fine Arts in Philadelphia. Her father, a banker descended from a French immigrant family, is strongly opposed to her becoming an artist.
- **1866** Moves to Europe to complete her training, visiting museums and copying the classics.
- **1868** Participates in the Paris Salon with *The Mandolin Player*. She also participated in the Salons of 1872-1874 and 1876.
- **1870** Returns to the United States in September due to the Franco-Prussian War.
- **1874** After visiting Europe again (Italy, Spain—where she lived for a time and where she became very interested in the works of Velázquez—and Belgium), she settles in Paris to continue her studies. Enters the studio of the academic painter Charles Chaplin. Participates in the Paris Salon with her work *Offering the Panal to the Bullfighter*.
- **1877** Meets Edgar Degas at the Louvre, and the two become lifelong friends.
- **1878** In the Academy exhibition of this year, her work *Little Girl in a Blue Armchair* is rejected.
- **1879** Invited by her friends Degas and Camille Pissarro, she participates in the fifth Impressionist Exhibit with a series of engravings designed for a magazine that was never published.
- **1881** Obtains excellent reviews at the Impressionist Exhibit.
- **1883** Participates in the exhibit by the Société des Imprésionistes, organized by Paul Durand-Ruel in London.
- **1886** Participates for the last time in the annual Impressionist Exhibit.
- **1894** Buys and restores the castle at Beaufresne, in Mesnil-Théribus.
- **1895** Exhibits at the Durand-Ruel Gallery in New York.
- **1907** A collective exhibition is held in Barcelona, where Cassatt participates with 5 paintings.
- **1911** Becomes partially blind.
- **1914** As a consequence of her increasing blindness, she is forced to stop painting. Maintains correspondence with her painting colleagues.
- **1926** Dies at Mesnil-Théribus, Oise.

Woman in a Loge

(1879)
oil on canvas
31.6 x 23 in (80.3 x 58.4 cm)
Philadelphia Museum of Art,
Pennsylvania

As opposed to Degas, who also showed the world of the theater in his works, Cassatt concentrated on the audience attending the performance. She considered that the greatest performance was provided by the audience itself, who went to the theater in their finest wear and considered it a magnificent social event.

In 1879, this work was removed from the Impressionist Exhibit for its exaltation of luxury and opulence. It represents a relaxed young woman, perhaps the artist's sister Lydia, in a loge, or box, fully enjoying herself. Just as in *Two Women in a Loge*, Cassatt places a mirror behind the woman to show the atmosphere in the theater. The painting renders a precise moment as in a snapshot. The intense, luminous colors harmonize with the woman's joyful expression and contribute to creating a festive atmosphere.

Mother About to Wash Her Sleepy Child

(1880)
oil on canvas
39.4 x 25.9 in (100.2 x 65.7 cm)
County Museum of Art, Los Angeles

Mary Cassatt did not concentrate solely on everyday family scenes or representations of women in their private lives, yet her paintings that do deal with these subjects contain no sentimentalism or moral overtones, as is often the case in works by Berthe Morisot. Cassatt reproduces scenes of home life in the same way she renders theater or outdoor scenes.

Hence, the model, concentrated on what she is doing, seems oblivious to the spectator. The scene is neither exaggerated nor made sublime. The details are treated with veracity and, although the image looks inward, reproducing the child's tears at the bath he is subjected to, the tenderness of the scene creates a pleasant feeling in the viewer. After 1870, the subject of mother and child became common in Cassatt's work, always representing a tranquil, informal vision of Parisian middle-class life.

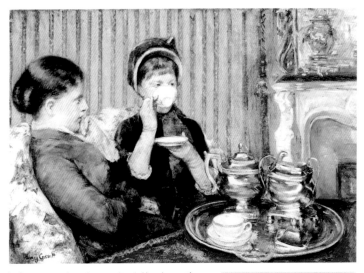

In this work, Cassatt renders the tea ritual. Her decorative sense converts this interior into a luxurious setting where two female figures sit in a contemplative mood. The artist's capacity to capture the details that reflect the mood of the moment is manifest in her manner of portraying the two women: While the hostess is pensively reclining in an arm-chair, the guest drinks her tea with style, her little finger in the air and her gaze lost in the distance, observing some-

Tea

(~1880)
oil on canvas
25.5 x 36.5 in (64.8 x 92.7 cm)
Museum of Fine Arts, Boston

thing that does not appear in the painting. Cassatt's art reveals her interest in the effects of light reflected on various surfaces. Here, the reflections give rise to a rich range of details that lend the scene realism. The meticulous reflection of light in the hostess' hair, for example, rein-forces the everyday atmosphere and increases the realism of the entire scene.

Two Young Women in the Loge

(1882)
oil on canvas
31.6 x 25.2 in (80.3 x 64 cm)
National Gallery of Art,
Washington, D.C.

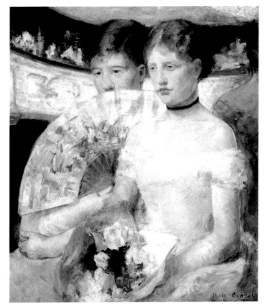

Music cafés and theaters were a prominent part of Parisian social life in the 1870s and 1880s. Like Degas and Renoir, Cassatt found the world of the theater very attractive. In this work, possibly portraying Mary Ellison, a Philadelphia friend, and Stèphane Mallarmé's daughter, the artist renders a luxurious theater loge that reflects a typi-cal aspect of Parisian social life. The two women observe the play with tension and timidity, con-scious that they are the focus of attention. (Unaccompanied women were permitted to sit in the loges.) In Cassatt's art, the expression of the models varies according to the nature of the composition. Behind these young women, a mirror enlarges the scene and reveals the luxurious, lively atmos-phere. The semicircular shape of the fan is complemented by the bouquet of flowers.

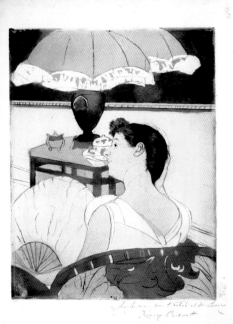

The Lamp

(1891)
etching
12.7 x 10 in (32.2 x 25.3 cm)
Art Institute of Chicago, Illinois

With subjects based on women's everyday lives, Cassatt executed a series of ten etchings imitating the Japanese ukiyo-e technique. In this one, a woman is seated in a room next to a table lamp. The decorative nature of the work is enhanced by the woman's elegant position, bent slightly forward with her back to the viewer.

The artist was an avid collector of Japanese engravings, and she soon experimented with new techniques in the application of color, encouraged by Degas and Pissarro. She reproduced the methodology used in ukiyo-e, executing a series of works, each of which was unique. She was directly involved in the entire creation and printing process and showed a great facility for working with tones and intensities of colors. Her engravings met with great success among both critics and the public.

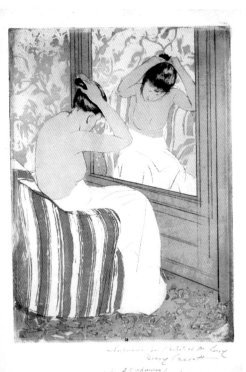

The Coiffure

(1891)
drypoint and aquatint
16.9 x 11.8 in (43 x 30.7 cm)
Chester Dale Collection,
National Gallery of Art,
Washington, D.C.

Cassatt's work reflects a strong influence of Japanese engravings. A woman contemplating herself in a mirror is one of the most popular subjects in Japanese art, and Cassatt interpreted it with a greater decorative sense. Simplicity and harmony predominate, and the artist renders this everyday scene with intimist serenity. The use of flat colors alternatively increases and decreases the intensity between the different elements represented, re-creating the atmosphere of a delicate, feminine room.

In 1890, Cassatt and Morisot worked together, executing various preliminary drawings of the same subject that were very similar. Though in all of them, the model is to the right, Cassatt decided to invert the drawing when it was transferred to the copper plate for this work.

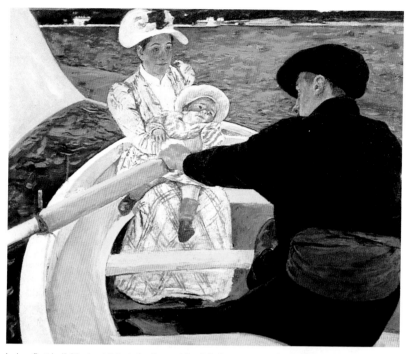

In her first individual exhibit at the Durand-Ruel Gallery in New York in 1895, Mary Cassatt exhibited this painting as the central piece. Executed in Antibes, a village in southern France where she had spent some time painting, the compositional structure and general conception of the work is clearly influenced by Japanese engravings, for which the artist had a strong penchant. This interpretation shows her complete assimilation of this Asian art and its incorporation into her own personal style.

The Boating Party

(1894)
oil on canvas
35.4 x 46.2 in (90 x 117.3 cm)
National Gallery of Art,
Washington, DC

The large black area in the foreground transfers the weight of the painting toward the right, from which the rest of the work is developed. This dark spot provides contrast, enhancing the luminosity of the two figures on the left that emerge from the blue background of the water. The studied visual effects, shortened boat, and abstraction of the water demonstrate the artist's technical maturity. The placement of the figures also produces a contrasting effect—the rower indifferently turning his back to the public, as opposed to the studied position of mother and child. This work, painted outdoors, brought Cassatt full acceptance by the Impressionists, who until then had criticized her for her excessively cosmopolitan air and her American origins.

mary Cassat

Lady at the Tea Table

(1885)
oil on canvas
28.7 x 24 in (73 x 61 cm)
Metropolitan Museum
of Art, New York

In this work, Cassatt strays from traditional compositions, placing the female figure in an ambiguous middle ground. The predominance of black, unusually extensive for an Impressionist work, is attenuated by the chromatic richness of details. The artist plays with the tones of the fore- and backgrounds, creating a series of colorist reflections that are distributed throughout the work.

For the effect of light on the tea set, the artist employs a blue tone also present in the tablecloth, the handkerchief, and the wall in the background. With this technique, she attempts to harmonize the whole with the black dress, enhancing the contrast between the pictorial force of the female figure and the delicate details of the rest of the painting.

The woman is Mrs. Robert Moore Riddle, a cousin of Mary Cassatt's mother; the tea set was a gift to the Cassatts from Mrs. Riddle's daughter. The representation of women in everyday activities was a constant in Impressionist women's paintings. In Cassatt's case, these portraits show a greater interest in expression and color range. The artist daringly experiments in this composition, where a heavy black predominates and color and light are distributed to harmonize and compensate for it. Also very important is the gold in the tea set, appearing throughout the lower half of the painting. The fragments of rectangular shapes on the wall framing the woman's head are remarkable elements.

Fanny Churberg

Fanny Churberg at the age of 30, photographed by G. & A. Overbeck in Düsseldorf, National Antiquities Museum, Düsseldorf.

- **1845** Born February 12 in Vaasa, Österbotten (Finland).

- **1865-1866** Studies art privately in Helsinki with the Finnish painters Alexandra Frosterus, Emma Gyldén, and Berndt Lindholm.

- **1867-1868** Studies in Düsseldorf under the landscapist Carl Ludwig.

- **1876** Studies in Paris with the Swedish landscape painter Wilhelm von Gegerfelt. Often walks in raincoat and boots, studying the changes brought by heavy rain. Contemporaries describe her art as masculine.

- **1878** Visits the Paris Exposition Universelle.

- **1879** Obtains first prize in landscape awarded by the Finnish Art Society of Helsinki.

- **1880** Gives up painting at the age of 35, due to health problems and, possibly, bad reviews.

- **1886-1892** Dedicates herself to writing art reviews for Finnish magazines and newspapers.

- **1892** Dies May 5 in Helsinki.

Fanny Churberg was the elder daughter of Dr. Churberg, a doctor of medicine from Vaasa. Her privileged economic position allowed her to pursue artistic studies and to dedicate herself to painting professionally. She studied under a number of landscape artists in Helsinki, Düsseldorf, and Paris, and, whenever she could, she spent the summer in Finland with her family.

Fanny Churberg was a passionate woman with a strong character. She harnessed her romantic spirit to express her landscapes, although she was never sentimental. She was fully committed to painting and other activities of a social nature. Hence, in 1881 she became one of the founding members of the Friends of Finnish Handicraft, an organization that aided economically disadvantaged women. She also worked for the Fennomanien, a group that fostered the Finnish people's appreciation of their language, culture, and country.

Churberg had a predilection for the Finnish landscape, especially for autumn and winter scenes. She most enjoyed conveying on canvas such dramatic natural settings as wild forests, rocks, and waterfalls, probably because they allowed her to unleash her strong emotions. She also painted some still lifes, which reveal her technical mastery and expertise.

Her work clearly shows that she was no conventional artist.

Churberg was always a nonconformist, a rebel, so much so that in 1870, wild natural instincts brought her a certain notoriety. In 1875, she visited Paris and her style developed toward a more daring and energetic type of brushwork, which her contemporaries found difficult to embrace. In 1880 she made a radical decision and abandoned painting in order to work as an art critic.

It was only in 1919 that the expressionist work of Fanny Churberg first gained recognition. Today, it is regarded as an outstanding contribution to Finnish art history.

Rapakivi Rocks

(1871)
oil on canvas
11.6 x 13.4 in (29.5 x 34 cm)
Museum of Finnish Art
Ateneum, Helsinki

Fanny Churberg painted this canvas while she was studying in Düsseldorf under the landscape painter Carl Ludwig, who from 1877 taught at the Fine Arts School of Stüttgart and in 1884 was nominated a member of the Berlin Academy. Fanny Churberg was infatuated with the Finnish landscape. She felt most comfortable rendering spectacular scenes of nature such as the wild forest with rocks that appear in this work. The Romantic painters cultivated this type of subject matter; examples are the painting known as *High Mountains* (1824), by Caspar David Friedrich, and *Rocky Gorge in Winter* (1825), by Karl Blechen. In these works, nature is viewed from a broad perspective and highlighted in all its splendor.

Steep rock faces had also caught the attention of several painters associated with the Barbizon School, one of whose primary concerns was the landscape painted in open air, with great attention to light and color effects. Camille Corot, Théodore Caruelle d'Aligny, and Narcisse Diaz had all painted the rocks at Fontainebleau, and Gustave Courbet painted *The Rock at Hautpierre* in 1869. But unlike French painting (which was unknown to her at the time), Churberg's composition was far more modern and lends greater protagonism to rocks.

In this work, the point of view is close and there is barely any sky visible in a landscape charged with powerful emotions. The artist's way of seeing nature was romantic and fervent, but not sentimental. The brushstroke, on the other hand, is free and spontaneous and her palette contains a wealth of hues, which is revealed in this harsh landscape bathed in northern light. The subject of this canvas allowed the artist to distribute the areas of bare rock and the trees into a type of mosaic formed by their colors and textures. The resultant whole is attractive and the chromatism is correctly balanced.

In 1875, Fanny Churberg was studying in Paris. There she was able to see the still-life works of the French painter Jean-Baptiste-Siméon Chardin and to discover the way light and color could be combined in order to obtain maximum intensity. Already by the 18th century, there was a deep admiration for the technique and talent of Chardin, who contributed significantly to elevating the still life to one of the greatest of artistic genres. His two best-known still lifes are *A Lean Diet with Cooking Utensils* and *A Still Life with Meat,* painted in 1731 (both at the Musée du Louvre, Paris). The former combines fish with cooking utensils, while the latter shows pieces of meat together with commonplace cooking utensils such as bronze ladles, mortars, and pots.

Without doubt, the treatment of the light in this still life recalls the works of Chardin. The observer's eye delights in the contrasts and effects of the light and materials on ordinary objects. Subtle modeling of the highlights and shadows lends both vegetables and fish a rich, palpable texture. The highlights reflected off the copper pitcher and the fish's scales in the foreground, as well as off the vegetables in the background, contribute significantly to the effect. Light and shadow restructure the space, and the light colors are placed against dark backgrounds.

Like Chardin, Fanny Churberg arranges the elements within a space by linking them to one another. They are interrelated both in terms of composition and color. The fundamental difference lies in that these shapes appear neither together nor apart, arranged in perfect harmony, trivial objects transformed into items of exquisite and artistic beauty.

The still lifes of this artist are regarded as masterpieces of Finnish art, both for their composition and balanced arrangement of elements and for the interplay of light and shadows. The work is equally remarkable for the excellent choice of color and the treatment afforded to each element to ensure its correct degree of protagonism, and for the detail and care taken in the execution of the drawing and the brushwork.

Still Life with Vegetables and Fish

(1876)
oil on canvas
15 x 22 in (38 x 56.5 cm)
Museum of Finnish Art
Ateneum, Helsinki

Spring Landscape

(1876)
oil on canvas
17.1 x 20.1 in (43.5 x 51 cm)
Museum of Finnish Art
Ateneum, Helsinki

Fanny Churberg painted this work when she was in Paris studying with the Swedish landscapist Wilhem von Gegerfelt. Her experience in France of painting en plein air yielded results as brilliant as this spring scene, an exceptional work for its force and intense facture, which is regarded as the first of her masterpieces.

The composition of this canvas recalls a painting by Camille Corot called *Ville-d'Avray, The Houses of Cabassud* (1835-1840, Musée du Louvre, Paris). However, there are a number of notable differences. Corot painted several houses with some trees situated on a very barren landscape, dominated by ochre hues. Fanny Churberg, on the other hand, re-creates in this work the colors of a wood in spring, with a varied symphony of warm colors, livened by the white of the trees in flower, which become the work's sole protagonist. In this canvas, one senses the explosive power of nature, a feature that characterizes many of Churberg's works. She executed this canvas with a fresh, loose stroke, which she combined in masterly fashion with a delicious range of colors.

Tones of copper, brown, and beige are used to define the different trees with varying intensities and to display a multitude of chromatic hues; hence the blissful harmony of the tall trees shaded with ochres, the fir trees painted in an intense dark green and the white treetops of the trees in blossom. The contrast to this splendid rendering of nature is provided by the sky, executed with diffuse and soft brushwork in a very pale shade of blue, over which some splashes of white represent the clouds. The light emanating from the sky instills a sensation of placidity and relaxed serenity in the composition, enhancing the colorist reading of the wood and balancing the white brushstrokes of the trees, which, like tiny sparkles, animate the entire area of the foreground and help lend depth to the landscape.

Waterfalls and cascades were one of the most popular motifs in Romantic painting. This subject was especially cultivated during the second half of the 18th century. One of the most popular subjects was the mythical waterfall of Tivoli, which caught the attention of the French painters Grenier de la Croix, Jean-Honoré Fragonard, and Jacques Antoine Vallin and the German painters Christian-Wilhem-Ernst Dietrich and Johann-Christian Reinhart. The artists reflected on canvas magnificent natural scenes that included waterfalls, forests, meadows, rivers, and lakes, such as in the splendid *The Schmadribach Falls* by Joseph Anton Koch (1811, Museum of Fine Arts, Leipzig).

Hence the motif of this waterfall is based on Romantic tradition, while the composition and formal language are very modern. In this work, Fanny Churberg focuses on one specific aspect. In Romantic painting, waterfalls and cascades are normally situated in imposing and picturesque surroundings. But this artist's brushes stop at one specific feature aspect as she attempts to capture the force of the water falling—to such an extent that the foam generated by the water takes up the greater part of the canvas. In fact, during the 1890s, Akseli Gallen-Kallela, Särnefelt, and Halonen developed a different approach in their heroic landscapes based on the pioneering work of Fanny Churberg, creating more vehement and dramatic works.

This extremely precise approach, as well as the daring brush-strokes, speaks of an original work impregnated with an impassioned spirit. This sensation is not merely enhanced by the theme itself but also by the way the artist has rendered it: The placidness of the water flowing downstream in the background provides a stark contrast to the commotion of the water falling, creating an effect of life, movement, and frenzy. Hence, this element—the fall of the water—acts as a counterpoint to the overall calmness of the landscape and gives way to a dramatic display of great energy.

Waterfall

(1877)
oil on canvas
11.8 x 18.9 in
(30 x 48 cm)
Museum of Finnish Art
Ateneum, Helsinki

Winter Landscape

(1880)
oil on canvas
15 x 22 in (38 x 56 cm)
Museum of Finnish Art
Ateneum, Helsinki

This was one of the last works to be painted by Fanny Churberg, since in 1880 she decided to abandon painting altogether and dedicate herself to writing reviews and articles on art. In 1875, she had visited Paris and the artists of the Barbizon School. Gustave Courbet and her painting teacher, Wilhem von Gegerfelt, had encouraged her to be more daring in her art. Despite the fact that her canvas *Landscape Lit by the Moon* had won first prize from the Finnish Art Society in 1878, she also came in for some harsh criticism.

In this canvas, Fanny Churberg presents a snow-covered landscape, austere and desolate, in which whites and grays dominate and the only touch of color appears in the form of a tiny human figure. The German painters Andreas and Oswald Achenbach, famous at the time for their landscape paintings, painted the mountainous landscapes of Norway with their rapids, rocks, and trees, but the tradition of the snow-covered landscape appears to have originated in German Romantic painting. In any case, Churburg showed no interest in snowy landscapes until she visited Paris. From that moment on, her brushstroke conveyed both the energy of her fervent temperament and the energy she got from what she had seen in France.

Nonetheless, given that Finnish society of her day liked a meticulous finish with a traditional palette, the works of Fanny Churberg were not very well understood. Her bold stroke, executed with large amounts of paint in the Impressionist style, is not found among her Danish, Icelandic, Swedish, or Norwegian contemporaries. The only painter to come anywhere near it was the Finnish Akseli Gallen-Kallela, who in 1884 painted *The Boy and the Crow,* in which a boy set in a green field is rendered with short and rough brushstrokes.

Fanny Churberg devoted herself wholly to painting, with complete dedication and, even though the Finnish expressionist Helene Schjerfbeck admired her struggle of powerful emotions, in the eyes of her contemporaries, Churberg surpassed conventional limitations. This work constitutes the finest example of the evolution the artist's work had undergone and the extent to which she assimilated everything she had observed during her stay in France.

ANNA BOCH

Théo van Rysselbergue, Anna Boch in Her Studio *(detail), oil on canvas, 37.5 x 25.5 in (95.2 x 64.8 cm), ~1890, Museum of Fine Arts, Springfield, Massachusetts.*

Anna Boch was born into a well-off family. Her father, Frédéric-Victor Boch, who had married his cousin Anna Marie Lucie Boch, founded a ceramic factory. Her brother, Eugène, also became a painter. She studied music and painting, learning art from Pierre-Louis Kuhnen and Euphrosine Beernaert, and in the studio of Isidore Verheyden.

In March 1885, she became the only woman to join the Cercle des Vingt, founded by the lawyer Octave Maus in Brussels to promote international avant-garde art. Boch took up modern art in 1886, when she met Théo van Rysselbergue, a passionate defender of Seurat's pointillist technique.

Boch participated in the annual exhibits of the Cercle des Vingt and had individual exhibits as well. She also played a distinguished role as a patron of the arts, encouraging her colleagues. She was one of the few people who bought paintings from Vincent van Gogh while he was still alive. Extraordinarily energetic, she worked until the end of her long life.

Before 1890, Boch began using a pointillist technique that she would later abandon for the more Impressionist style that was to characterize her works. Her paintings are solidly constructed, contain great force, and achieve volumes by contrasting different chromatic tones. There is an abundance of bright colors in her palette, with a tendency toward violet pinks and purples. Her canvases emanate inner peace and joie de vivre.

- **1848** Born on February 10 in Saint-Vaas, near La Louvière, Belgium.
- **1876** The artist Isidore Verheyden introduces her to landscape painting in open air and to the study of light and atmosphere.
- **1885** In March, she becomes part of the Cercle des Vingt. She is the only woman in the group.
- **1886** Participates for the first time in the Salon des Vingt, in Brussels, a group related to the Impressionists and the vanguard painters, and sells some of her works. Meets the artist Théo van Rysselberghe (1862-1926), a disciple of Georges Seurat.
- **1890** Purchases *Les Vignes Rouges à Mont-Majour* (Pushkin Museum, Moscow), painted in 1888, from Van Gogh. The following year, she purchases *La Vallée du Rhône*, which she loans to the artistic circle La Libre Esthétique in 1904 for their annual exhibit.
- **1893** The Cercle des Vingt breaks up, and in its place appears La Libre Esthéthique. Anna Boch continues to be active in this vanguard movement.
- **1900** Boch has acquired a true mastery of painting and begins exhibiting individually.
- **1902** In March of this year, the Belgian state buys her *Côte de Bretagne* (Musées Royaux, Brussels).
- **1903** In January, she leaves her home on Avenue Toison d'or and moves to No. 26 Rue de L'Abbaye. She is appointed Knight of the Ordre de Léopold.
- **1904** Participates in the foundation of the artistic circle Vie et Lumière, which upholds the principles of Impressionism.
- **1908** La Louvière appoints her an honorary member of the association Les Amis de l'Art.
- **1919** She is appointed Officier de la Couronne.
- **1923** Exhibits her works at the Cercle Artistique et Littéraire in Brussels. Exhibits in Brussels again in 1927 and 1928.
- **1928** Appointed Officier of the Ordre de Léopold.
- **1930** In June, the Museum of Amsterdam purchases *Femme Dans un Paysage*. The Galerie Georges Giroux holds an exhibit of her works in December.
- **1931** Participates in the Spring Salon in Brussels.
- **1934** Holds her last exhibit in March at the Petite Galerie on Avenue Louise in Brussels.
- **1936** On February 25, she dies at home.

Sunny Room

(1906-1908)
oil on canvas
32.7 x 21.7 in
(83 x 55 cm)
Musée Communa
des Beaux-Arts,
Verviers

Anna Boch took up pointillism when she met Théo van Rysselberghe. Her use of this technique, very controversial at the time, demonstrates the artist's active participation in avant-garde art. This painting has realistic yellows and ochres in the dunes that occupy a large part of the surface

Dunes in the Sun

(1903)
oil on canvas
24.4 x 37.4 in (62 x 95 cm)
Musée de Ixelles, Brussels

area. The background provides a visual respite, with the thin strip of cool blue sea contrasting with the rosy tones of the sky. This painting is bright and forceful. The light falls on the crests of the dunes, tinge-ing them with pure yellows, nearly ochres. The short blue brushstrokes are exquisite, providing volume, especially in the shadows of the dunes in bluish and violet tones. These blues recall the Fauvists, who scandalized the public with their violently brilliant colors and their colorful shadows, which they exaggerated to the limits of possibility.

Left: Anna Boch studied traditional painting, but in 1876, the artist Isidore Verheyden introduced her to painting in the open air and to the study of light and atmosphere. In 1886, when she participated for the first time in the Salon des Vingt and met Théo van Rysselberghe, a disciple of Georges Seurat's pointillism, Boch began to adopt this style. The technique did not exactly consist of points of color; rather, very short brushstrokes were translated into color mixtures by the human retina from a distance.

This painting is a good example of that technique, and reveals the poetry, force, and joie de vivre characteristic of the artist. Like all Impressionists, Boch sought to render the effects of light and atmospheric qualities. In this poetic corner of a house, the curtain near the flowers is bathed in sunlight and the light extends along the floor to illuminate the legs of the table and the enormous vase on the left. The remainder of the room, painted in purples, pinks, and blues, adds a great deal of charm to the painting. It has a rich tonal range that creates volume and provides the sensation of different textures. The table is glass, while the legs, with their sinuous Art Nouveau shapes, are made of gold-colored metal. The sofa upholstery is rich and dense, with a fringe of long tassels.

Another magnificent detail is the white bouquet of flowers, flooded in light, that stands out against a darker background in short, close-knit brushstrokes. The composition emphasizes the flowers by placing them in the center of the scene. The table, the sofa, the painting in the background, and the large vase are simply secondary elements around the sunlit curtains. The priority of the delicate bouquet of white and red flowers is not surprising. The artist indicated in her correspondence that she adored gardens and plants, and she painted other canvases solely on the subject of flowers. The painting is remarkable for its significant weight.

The Cliff at Sanary

oil on canvas
31.9 x 24 in
(81 x 61 cm)
Museum voor
Schone
Kunsten, Ghent

Sanary-sur-mer is a village on the Mediterranean coast near the Côte d'Azur and the town of Toulon. The painting illustrates the spirit of an era and, more specifically, of the Impressionists and Neoimpressionists, who tirelessly sought to render the various effects of light in different places. It was an experimental, traveling, adventuresome spirit, pursuing the most picturesque areas as subject matter. This Mediterranean landscape, so different from Brussels, reveals a good deal about the personality of Anna Boch, a great traveler. She also painted in Ohain, at some property she owned near Brussels, as well as in Knokke, Wiesbaden, Bad Kreuzenach, and Saint-Armand-les-Eaux, to cite some examples. Like many of her colleagues, she sought southern light, frequently traveling to Italy, France, and, in 1900, to Greece. These trips have helped art historians to date her works because, though she always signed them, she rarely wrote the date.

Her passion for setting up her easel in picturesque areas led her to purchase a car, a Minerve, in December 1907—surprising, considering the period and the fact that she was a woman. The car was driven by her chauffeur, Lepreux, and Boch was often accompanied by her brother, Eugène, also a painter. The chauffeur, inspired by the other two, would often paint when they were traveling.

At first sight, this landscape recalls another painting by the artist, *Côte de Bretagne* (1902, Royal Museum of Fine Arts, Bruxelles),which the Belgian state bought in March 1902 to exhibit in the Brussels Museum. Yet the works are actually quite different, in both their composition and light. The construction of this landscape is very solid. In the foreground are green Mediterranean pines desperately clinging to the rocks. In the middle ground are the cliff, bathed in blue water, and in the background, a sky in violet and lilac. The brushstrokes are loose and fresh, and the wide range of colors used produces the desired effects of depth. The artist always created volume through contrasts in light and tones. Anna Boch attained great chromatic richness and deep balance in this work. It is a cheerful canvas, full of energy and joy.

EVA GONZALÈS

Édouard Manet, Portrait of Eva Gonzalès (detail), oil on canvas, 75.2 x 52.4 in (191 x 133 cm), 1870, National Gallery, London.

Eva Gonzalès, a talented painter, began studying with Édouard Manet at the age of 20. She became artistically and sentimentally involved with him, displacing Berthe Morisot as his favorite model and companion and making Morisot jealous. Gonzalès's art evolved from scenes of domestic life to a new perspective of women, whom she portrayed from an intimist point of view that lent her works a free, independent character.

Gonzalès learned Manet's technique, but gave her works a more subtle, personal touch, largely due to the influence of the artist Charles Chaplin. She painted with emotion while remaining free from the romantic sentimentalism of her colleagues. Her paintings are characterized by their light, brilliant tones, with the white of women's dresses predominating. Richness of detail and the absence of elaborate backgrounds were techniques Gonzalès employed to lead the observer's eye toward the principal element of her works, the female body. Through her vision of women, Gonzalès introduced a new element into the Impressionist world—femininity. Eroticism as the habitual means of exalting women in painting was replaced in Gonzalès's artwork by a tender, delicate view re-creating everyday scenes in women's lives but deemphasizing their domestic and maternal facets.

Although Gonzalès's art is modest and its quality variable, it nonetheless earns a significant place among female French Impressionists.

- **1849** Born in Paris on April 19, the daughter of the novelist Emmanuel Gonzalès, who later became president of the Comité de la Société des Gens de Lettres.

- **1865** Begins her drawing studies under the fashionable painter Charles Chaplin.

- **1869** Works in a small studio on Rue Bréda in Paris and is part of a group of young writers and artists, through whom she becomes acquainted with Impressionism. Thanks to the art dealer Arthur Stevens she meets Édouard Manet, who gives her painting lessons as his sole pupil. From this time, she became the painter's favorite model, replacing of Berthe Morisot in that role.

- **1870** Participates in the Paris Salon for the first time, exhibiting various paintings, among them *The Little Soldier*, a pastel portrait of her sister Jeanne. Her pastel works are acclaimed by the critics, especially Émile Zola, Edmond Dureanty, Philippe Burty, and Zacharie Astruc. That same year, Manet exhibits a large portrait of her at the Salon (National Gallery, London).

- **1872** Works in Manet's studio. Although she is greatly influenced by him, from this point on she begins to develop a more personal style in keeping with the teachings of Charles Chaplin.

- **1876** She is accepted into the Salon as Manet's disciple, although Manet himself is rejected.

- **1879** After a three-year relationship, she marries the engraver Henri Guérard.

- **1883** In Paris, on April 5, her son, Jean Raimon, is born, and **Gonzalès**, at 34 years of age, dies during childbirth due to an embolism. It is just five days after the death of Manet.

Woman with a Fan

(1869-1870)
oil on canvas
11.2 x 17 in (29.85 x 43.18 cm)
Minneapolis Institute of Arts,
Minnesota

Although the influence of Japanese art can be discerned in this painting, the artist profoundly simplifies the setting to lend the figure the greatest possible protagonism. Unlike Mary Cassatt, Gonzalès seeks to avoid the somewhat unnatural impressions in portraits by placing her sitters in poses that indicate indifference to the observer. The women in Gonzalès's works are portrayed as if they were unaware of the artist and rarely gaze out at us. As a result, Gonzalès's compositions seem to capture real moments.

Romanticism, present in all of Gonzales's work, is evident here as an atmospheric impression inherent in the solitude of the figure. This romantic solitude, an unusual technique in paintings of women, is the artist's way of emphasizing the real situation of women in 19th-century Parisian society. Gonzalès executed scenes imbued with melancholy. Her models are painted with gradually increasing brightness and pictorial richness.

The Little Soldier

(1870)
oil on canvas
51.9 x 38.6 in (130 x 98 cm)
Musée Gaston Rapin,
Villeneuve-sur-Lot, France

Rosy Morning

(1874)
pastel
20.5 x 28.3 in (52 x 72 cm)
Musée d'Orsay, Paris

Gonzalès's portraits show women in different facets and in various expressive attitudes. In this painting, in which the figure (possibly Jeanne, Gonzalès's sister) is slightly turned toward the viewer, while the chair is turned toward the background, objects are employed by the artist to bring the intimate sense of the pictorial space closer to the viewer. The artist uses elements of perspective to increase the sensation of realism perceived through the woman's movement. Although this is a domestic scene, the model is in a carefully studied position. The luxurious chair and the woman's relaxed expression suggest the intimacy that the artist so cherished.

It can be said that Gonzalès rediscovers women in her paintings, although it is difficult not to associate this pastel with 18th-century classical paintings by artists such as Jean-Marc Nattier and Rosalba Carriera, which also focused on everyday scenes in women's lives. An anticipation of the nature of female scenes in the 20th century is evident in this type of delicate portrait, in which women appear to be conscious of their condition. Gonzalès's women recall certain works by Renoir. Both were influenced by Gustave Courbet in their interest in lending the represented person a nearly tactile aspect. Gonzalès's portraits reveal a fascination for tonal painting, clearly defining the female figure against the background and modeling its contours in light, brilliant colors.

Left: Clearly inspired by Manet's *The Fife Player*, from 1866, this painting steers clear of hackneyed scenes of children in the home to create a somber, severe portrait, clearly distanced from luminous "feminine" paintings. Though the compositional simplification was certainly acquired through the artist's work with Manet, and its similarity to *The Fife Player* is striking, this work can be considered an exercise executed under the influence of Japanese art. It is characterized by a linearity new to the artist, who represents the boy in a somewhat unnatural pose, in which portraitist objectives take precedence over the realism of her previous works: The artist does not seek to capture a concrete, spontaneous moment; rather, she simply attempts to execute a commissioned portrait. After this work, Gonzalès used scenes of greater expressive force, rendering more clearly the attitude, character, and expressiveness of the people represented.

Almost all the Impressionists frequently executed scenes of social life in Paris, as they were very interested in representing the atmosphere of modernity and the social relations within the upper middle class. In this painting, Gonzalès illustrates the contrast between women, treated with a great display of pictorial means, and men, represented in a more restrained manner. In her paintings, she directs the viewer's eye to her "message"—the figure or detail that conveys her objective—through an elegant combination of colors and light, especially the light striking the faces of the figures.

In this painting, the outlines of the gentleman fade into the background, and his face, intentionally represented in profile, is strikingly inexpressive compared with the woman's.

A Box at the Théâtre des Italiens

(1874)
oil on canvas
38.6 x 51.2 in (98 x 130 cm)
Musée d'Orsay, Paris

Her dress, full of fine gauze, is executed with great care and attention to detail, and the flowers, in which the artist plays with color, harmonizing them through the use of a single chromatic range, enhance the woman's expressive gaze. Gonzalès employs light as a fundamental element to emphasize the female figure's protagonism, creating a soft interplay of light and shadows on her face that accentuates its expressiveness and determines the relationship between the figures.

In this painting, Gonzalès uses white to compose a scene in which the model is in a fully relaxed pose. The expressive language used by the artist is less sumptuous than in other portraits she painted. But the coherence and harmony between the background and the foreground and the use of saturated whites create an image of enormous atmospheric transparency. The viewer clearly perceives the intimate and delicate atmosphere of a woman's bedroom and contemplates a woman imbued with sensuality and tenderness.

Morning Waking

(1876)
oil on canvas
32.1 x 39.4 in (81.5 x 100 cm)
Kunsthalle, Bremen, Germany

With this timeless vision of women, Gonzalès dissociates herself from the social attitudes of the female Impressionists, who seemed to accept willingly the role of secondary artists in a world where men were the protagonists. Manet, Pierre-August Renoir, and Edgar Degas accepted and encouraged the young female artists to learn and paint along with them, but the scant acknowledgment the women received from critics and art historians in general continued to relegate them to the background.

Eva Gonzalez

A Milliner

(~1877)
pastel
17.8 x 14.6 in (45.3 x 37 cm)
Art Institute of Chicago, Illinois

In this subject, previously painted by Degas and Manet, Gonzalès insists on representing a well-dressed yet lower-class woman at her daily tasks. The pastel colors, the light permeating the work, and the loose, fresh brushstrokes all transmit the woman's youth and the depth of her vitality, to which the deliberately placed bouquet of flowers contributes. But the young woman's expression and mood cannot conceal the privations brought about by her social status. Nevertheless, she is highly dignified and was painted with tenderness, as if Gonzalès were paying tribute to her.

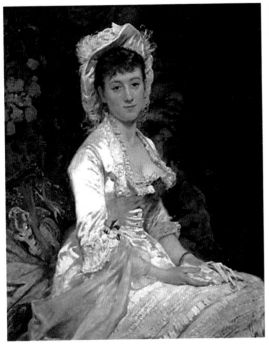

Woman in White

(1879)
oil on canvas
39.4 x 32.3 in (100 x 82 cm)
National Museum of Women in the Arts, Washington, D.C.

In this work, Gonzalès executes a very stereotypical portrait of a personal friend. The model's pose and her expression suggest a classicism in the composition that determines the character of this work. Particularly interested in bringing out the female features of the sitter, the artist uses a pictorial language devoid of tension, representing the model in a relaxed, passive, almost absent manner. This type of portrait and the sitter's expression recall Renoir's style in works such as *Mrs. Massonie* (Steinberg Collection, Saint Louis) or *Theater Booth* (Courtauld Institute Galleries, London), both executed only five years earlier than this one. Clearly drawn forms predominate in the work. The simplified outline of the face and the tonal richness with which the artist uses white allow her to emphasize the feminine figure with precision. The importance of details is a constant in Eva Gonzalès's portraits. In this one, the white dress gives rise to an exercise in light and shadows in which the delicate lace and the texture of the cloth enhance the woman's formal expressiveness.

LAURA ALMA-TADEMA

George Eliot, *pencil on paper, 4 x 4.5 in (10.2 x 11.4 cm), 1877, National Portrait Gallery, London.*

Laura Alma-Tadema trained under the tutelage of the painter Lawrence Alma-Tadema, whom she later married. She developed a style far removed from the sophisticated symbolism prevailing in European painting in the second half of the 19th century.

Basing her art on the Romantic tradition, Alma-Tadema adopted a realist aesthetic with which she composed highly elaborate literary scenes and spontaneous representations of everyday life.

Qualified at first as a painter of children and domestic scenes, Alma-Tadema created a very subtle symbolist style with which she rendered human passions in an innocent manner. Aspects such as love or friendship were reproduced by the artist in moralizing scenes painted with great realism, in which the figures behaved spontaneously. The artist enjoyed depicting a specific moment, with people gesticulating in the midst of a heated debate like actors in a play.

An admirer of classical English theater, she adopted a stagelike aesthetic in her scenes that allowed her to fill the composition with dynamism through the gestural capacity of the figures.

- **1852** In April, Laura Theresa Epps is born in London, the daughter of a psychologist. Her two sisters also become artists later in life— Emily studies under the Pre-Raphaelite landscape painter John Brett, and Ellen is a pupil of Ford Madox Brown.

- **1870** She studies under Lawrence Alma-Tadema.

- **1871** Marries Lawrence Alma-Tadema.

- **1873** Exhibits at the Parisian Salon.

- **1875** Exhibits at the Royal Glasgow Institute.

- **1876** Receives the gold medal at the Internationale Kunstausstellung exhibit held in Berlin.

- **1878** Obtains the silver medal at the World Exposition in Paris.

- **1879** Exhibits at the Royal Scottish Academy in Edinburgh.

- **1880** Exhibits at the Grosvenor Gallery in London.

- **1889** Exhibits at the New Gallery in London.

- **1893** Receives the silver medal at the World Columbian Exposition in Chicago.

- **1896** Is awarded a gold medal at a Berlin competition.

- **1900** Receives a second silver medal at the World Exposition in Paris for a small-size painting with the title *Contentement.*

- **1909** Dies in London on August 15.

In her paintings, Alma-Tadema tried to capture a sense of movement and transmit a specific sensation within a concrete atmosphere. Her domestic scenes reflected the typical air of a Victorian home through the atmospheric sensation that the artist meticulously developed.

A Knock at the Door

(1897)
oil on panel
25.12 x 17.6 in
(63.8 x 44.8 cm)
Currier Gallery of Art,
Manchester, New Hampshire

In this painting, the artist captures a spontaneous scene. Drawn toward a Romantic rendering, the artist paints a fleeting but extremely romantic moment. The young woman has just finished getting ready and has put on an elegant dress for the occasion when she hears her admirer knocking at the door. Carried away by her excitement and innate coquetry, she pauses at the mirror to touch up her sophisticated hairdo one last time before opening the door.

This is an ingenious, pleasant, and attractive domestic scene to which the artist has lent the subject profound feminine sensibility. In her works, Alma-Tadema demonstrated a penchant for the most emotive aspects of the human being and for everyday scenes—subject matter that abounded in the work of the Impressionists. Her artwork reflects situations, such as the one in this painting, which evoke a transient sentiment or emotion. It is a reflection on the tender moments of everyday life in which the moment and the psychological study of the persons rendered give rise to an interesting combination of freshness and feeling.

Here, the artist captures the frenzy and the joy of the young woman's first love, representing the protagonist in a studied manner and at a doubtlessly original moment. The woman, concentrating on her sentiments and actions, is rendered with her back to the viewer, showing an indifference totally justified by her overwhelming feelings of love and nervousness. Alma-Tadema places her figure in the center of the painting in a humble room.

In this setting, the figure emanates all of the expressiveness of the work. With her face indistinctly reflected in the mirror, the woman acquires a significance of her own through her gesture. The artist sublimates the figure in and of itself. Her dress is elegant and has a rich assortment of hues, the pleats are executed with singular meticulousness, falling vertically to enhance her slender, youthful image imbued with dynamism and vitality. This is juxtaposed with the setting, a humble, unpretentious room, and a palette combining cool and neutral colors. The artist did not achieve the warmth of the painting chromatically, but rather by using the viewer's feelings to blend what is visible (the figure, setting, colors, and light) with what can be intuited (feelings, nervousness, the young woman's excitement). This is a significant work of great creative and psychological value.

George Eliot

(1877)
pencil on paper
5 x 4.5 in (12.7 x 11.4 cm)
National Portrait Gallery,
London

During Laura Alma-Tadema's artistic beginnings, she developed a particular portraitist style based on realist art. In this drawing, the artist executes a simple exercise in pencil to portray a friend of the family, the famous English writer Mary Ann Evans (1819-1880), better known as George Eliot. It is probably a preliminary sketch for a later painting that she never executed. Despite the speed and spontaneity characteristic of all sketches, the artist's mastery is evident, rendering in few lines not only the most descriptive physical features but also the figure's expression, and through it, its overall character, an outstanding achievement.

Alma-Tadema's preliminary sketches and drawings were rather sophisticated, since, unlike most sketches, they were generally very elaborate studies. The artist, married to her former art teacher, always followed traditional steps in preparing her works. The figure is rendered in the foreground, revealing the compositional construction of her face. The sensation of corporeality evoked by the drawing is complemented by the meticulous manner in which pose and personality are rendered. George Eliot's representation in profile, the prominent nose, her upward gaze with head held high, the overall drawing with its dominant lines—nothing is gratuitous or conventional. Rather, all are carefully studied so that the lines and what lies behind them become a subliminal language that defines the sitter.

The gestural expression of this artist's figures is a determining factor in her works, which are characterized by movement and spontaneity. This drawing shows the artist's interest in studying the expressive capacities of her figures. She studied and modeled George Eliot's face in order to lend it greater expressiveness using a clean, firm line. Despite the simplicity of the medium and the general schematism, this is not a caricature, but a work prepared by a painter and therefore preliminary to a more ambitious piece.

Queen Catherine of France

(1888)
oil on canvas
Folger Library, London

This painting corresponds to a series executed by the artist on the principal heroines of William Shakespeare's works. The scene represents the third act of *Henry V*, at the moment when the queen asks a courtesan friend for advice. This series consisted of twenty-one paintings that were exhibited in 1888 in a show organized by the periodical *Graphic*. The painter felt drawn toward the author of *Hamlet*, as she found those aspects of human nature that most intrigued and obsessed her reflected in his work. Like Shakespeare, Alma-Tadema sought to delve into human behavior, especially in aspects having to do with moral and sentimental matters.

In this painting, the artist opted to render the famous author's vision rather than execute a subjective reading of the work. For this reason, she reproduced the argumentative force of the text by creating a typically English classical scene. The composition is very simple and direct, capturing a concrete moment in the work, something which greatly pleased the painter. Queen Catherine is represented frontally, dressed in a bright dress and addressing her friend and confidante.

To clearly differentiate the two figures and establish their separate roles, the courtesan is placed in the middle ground and is only partially visible. Wearing a dark dress, she is turned to the side, almost with her back to the viewer. It is interesting that her gaze focuses on the radiant figure of the queen, clearly the protagonist of the scene. The secondary figure is treated with greater chromatic discretion. The work is remarkable for the way in which it manages to make the figure of Catherine stand out. Without eclipsing any other elements involved in the scene, Alma-Tadema emphasizes Catherine, the main figure, not only through her physical aspect and vivid, brocaded garments, but also through a psychological study defining the person's character and her expression at this moment.

EVELYN DE MORGAN

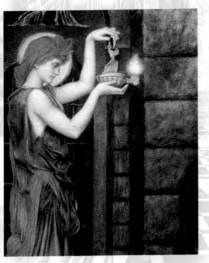

Hope in the Prison of Despair (detail), oil on canvas, 20.3 x 23.6 in (51.5 x 60 cm), 1887.

- **1855** Mary Evelyn Pickering is born.
- **1873** Studies at the Slade School of Fine Art in London.
- **1877** Exhibits at the Grosvenor Gallery.
- **1884** Exhibits at the Liverpool Autumn Exhibitions.
- **1887** Marries the artistic English ceramist William Frend De Morgan, who later becomes a novelist.
- **1888** Exhibits at the New Gallery in London.
- **1893** Settles in the Chelsea section of London, but because of her husband's health problems, they spend the following winters in Florence.
- **1906** Individual exhibit at the Bruton Galleries in London.
- **1916** Exhibit at the Red Cross Benefit in London.
- **1917** Her husband dies. The family is in a difficult economic situation. Evelyn completes two novels that her husband had left unfinished.
- **1919** Dies in London on May 2.

The niece of the Pre-Raphaelite painter John Roddam Spencer Stanhope, Evelyn De Morgan began to study painting at the age of 15 and received various academic distinctions at South Kensington and Slade Schools.

The artistic influence of her uncle was revealed in a leaning toward a symbolism based on classical compositional and aesthetic approaches. From a very early age, Evelyn De Morgan was drawn toward Italian Renaissance painting, from which she acquired some compositional style for her group portraits. She visited Italy in 1875, on a cultural trip during which she prepared for an exhibition she would hold a year later at the Dudley Gallery. This exhibit represented the beginning of the artist's professional career, and brought her excellent reviews and an invitation to hold an exhibition at the prestigious Grosvenor Gallery, where she would exhibit on a regular basis.

Evelyn De Morgan planned her artistic career in a studied manner. Her pictorial style combined symbolist connotations with a classicist vision and an Italianizing concept of painting that contrasted with the influence she received from Burne Jones. When she married the ceramist William De Morgan, Evelyn became familiar with the symbolist aesthetic being practiced in French and English art through him, quickly adopting an allegorical vision. Thus, apart from their physical appearance, the figures always suggest, evoke or represent some kind of spiritual value.

This artist's paintings are thoroughly studied. They have an air of monumentality, the feeling of a large work even when the canvas is actually modest in size, combined with a sophisticated language and sometimes even a degree of grandiloquence. The brushwork is meticulous and the figures are usually delicate and imbued with refined sensuality, lying somewhere between reality and the expression of an idea.

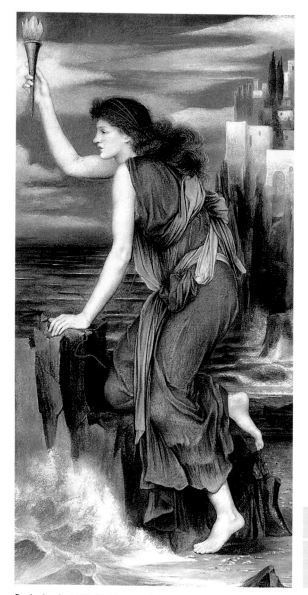

Hero Holding the Beacon for Leander

(1885)
oil on canvas

Beginning in 1880, De Morgan adopted a fully symbolist style. In this work, the artist represents the Greek heroine named Hero. According to mythology, she was a priestess of Aphrodite in Sestos, on the Thracian coast, who fell in love with a young mortal from Abydos named Leander. For this, Venus punished her, confining her to a desolate island.

To see his beloved, Leander would swim across the Hellespont every night, guided by a beacon that Hero held up in a tower. One night, the wind blew out the flame and Hero's lover, disoriented, was unable to find the coast and drowned from exhaustion. The waves washed the unfortunate man's body to the shore. When she saw it, Hero threw herself from the tower in despair.

The painting represents Hero with the torch lit, guiding her lover through a rough sea. Classical mythology provided an infinite source of inspiration for the symbolists, who sometimes reinterpreted the subject or altered certain elements to enhance their compositional interests. This representation of Hero is very dramatic, with the scene composed of a single tonal ground, in which only the pallid skin of the heroine seems to stand out. The artist centers the drama on the woman's pose and her frailness, heightened by the wild setting. The tonal contrast arising from the combination of cool colors of the general scene and the warmth emanating from the woman's body contributes to the creation of tension between the figure's hopeful gesture and the harshness of the elements.

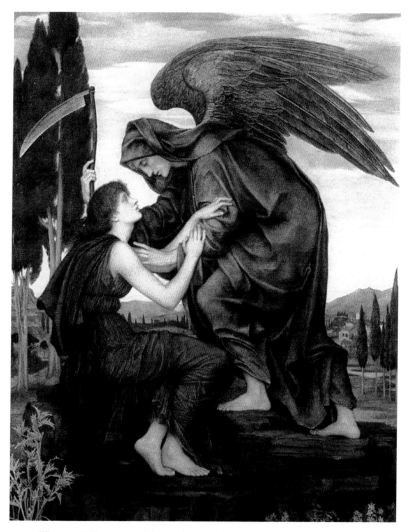

When symbolism appeared for the first time in Europe during the latter half of the 19th century, its first artistic creations were often illustrations for literary works. But soon, this pictorial movement, whose works illustrated symbolist authors such as Charles Baudelaire, Arthur Rimbaud, and Stéphane Mallarmé, began adopting a series of archetypes, figures, and typologies of its own. The angel of death is one of the symbolist archetypes that is most often represented.

The Angel of Death

oil on canvas
De Morgan Foundation, Battersea, London

Death, considered by the symbolists as the next, definitive stage after life, is represented here in a natural and serene manner, with neither undue transcendentalism nor idealization. Represented as a benevolent angel wearing a monk's cloak with a hood, she is kindly consoling and convincing the woman of this nontragic conception of death. Though the colors are serious and the setting has an air of mystery and reverence, the scene is devoid of those connotations that so abounded in paintings of death from other periods. The setting is clearly Romantic and the aesthetic realist with a view to lending veracity to this symbolist concept.

De Morgan conveys the idea of the angel of death as a sympathetic figure who brings about the transition to a new and better life, a concept in which Edward Burne-Jones was especially interested. De Morgan's style was heavily influenced by European art, and she was even recognized by the Parisian Salon of 1889 as an artist whose formal and aesthetic intuition coincided fully with that of the French symbolists.

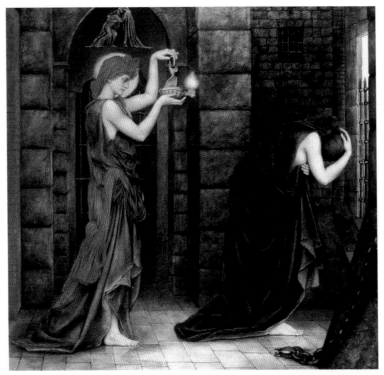

Hope in the Prison of Despair

(1887)
oil on canvas
20.3 x 23.6 in
(51.5 x 60 cm)

For the symbolists, each of the theological virtues represented a specific philosophical concept. In this work, De Morgan plays with contradictions, representing Hope within a scene that depicts despair oppressing the human soul. The setting is a stone prison, where the reflections of light on the walls, enhanced by the chromatic range, give rise to an unsettling atmosphere marked by distress and the impossibility of escape. The dejected human figure reflects this despair.

Within the philosophy of symbolist synthetism, De Morgan evokes a sentimentalism that leads her to compose an introspective, desolate scene where subjectivity prevails.

In this type of pictures, the painter has created an artificial scene that exactly suited what she needed in order to created what she wanted. The figure representing Hope, an asexual young man, slender, delicate, and sensual like the majority of figures created by the symbolists at that time, stands with a robe wrapped around his body, attempting to illuminate the cold interior of human despair.

The creation of scenes with a great deal of detail was no problem for De Morgan. Her realist approach allowed her to create architecture and backgrounds of great pictorial quality. In a classical style, she reproduced the theories of perspective of the Italian Renaissance.

Medea

(1889)
oil on canvas
53.7 x 35.4 in (136.5 x 90 cm)
Williamson Art Gallery and
Museum, Birkenhead, England

The influence of the Italian Renaissance on Evelyn De Morgan is evident in the formal approach she applied to her artwork. Though respecting the allegorical quality of painting, the artist generally created compositions that emphasized the classical aesthetic of the setting.

This work represents Medea, the daughter of Aeëtes, King of Colchis. She fell in love with Jason when he arrived with the Argonauts and helped him with her sorcery. They entered a relationship and fled to Yolcos. Through a mysterious bath, she rejuvenated Jason's father, Eson, then cunningly advised the daughters of Pelias to rejuvenate their father in a manner that caused his death. According to Euripides, when she visited Corinth with Jason, he promised to marry the daughter of Creon.

Medea, enraged, gave the bride a flammable dress that killed both her and her father, who tried to save her from the flames. Afterward, she killed the children she had had by Jason, fled to Athens, and went into hiding.

Here, Medea, surrounded by Renaissance architecture, walks toward the viewer in a long red tunic. The nature of the work recalls Raphael, especially his work *The School of Athens* (1510-1511 The Vatican, Stanza della Segnatura, Rome), in which the protagonist is walking under a series of arches while the rich architecture opens out toward the sides of the painting. In *Medea*, the figure is alone. The artist was preoccupied with perspective. As in the Renaissance, the importance of perspective based on the pattern of the flagstones is a decisive element in the aesthetic quality of the work. De Morgan seems to be exhibiting her technical abilities in all of the aspects involved in the execution of this painting: perspective, luminosity, and the suggestive corporeality of the model, who seems to go through the dress, a characteristic typical of symbolist art from this time.

Clytië

(1886-1887)
oil on canvas
37.4 x 15.9 in
(95 x 40.5 cm)
Private collection

Left: From the beginning, De Morgan was a prolific painter who worked in the various languages of the symbolist aesthetic. In this painting, she explores eroticism, representing the female body emerging from among the sunflowers. The symbolists studied the different facets of the human being and were especially attracted by everything related to morality and, in its absence, human decadence. One of the recurring themes in De Morgan's art was eroticism. In addition to clearly erotic subjects, the figures in most of her works were quite sensual.

In no other period in the history of art was eroticism represented in such a manner. The suggestive scenes created by Jean Auguste Dominique Ingres showed an admiration for femininity, but the symbolists introduced a much more explicit type of erotic language. The female body was conceived according to aesthetic criteria that sought to enhance the most suggestive anatomical attributes. To make the image more incisive, the female nude was represented with great naturalism and attention to all elements that could contribute to the eroticism of the work: curves, volumes, pose, hair. However, the artists avoided excess naturalism that would result in bad taste—for example, disrespectfully showing the woman's sexual organs or being blatantly insinuating and provocative.

This image is subtle, though not less incisive, incorporating certain elements such as the sunflowers that lend it an air of mystery and idealization, generating a sophisticated eroticism. In this work, De Morgan demonstrates that she has thoroughly assumed these concepts.

Lux in Tenebris

(1895)
oil on canvas
45.1 x 27 in
(114.5 x 68.5 cm)
De Morgan Foundation,
Battersea, London

In this painting, the artist attempts to unite two very different symbolist aesthetics, on one hand presenting an idealized figure according to the genuine criteria of the Pre-Raphaelites, on the other using a Tenebristic treatment in order to emphasize the character.

The allegory of beauty promoted by the Pre-Raphaelites appears here as a saving light that dissipates the darkness. De Morgan composed a very direct painting that presents the viewer with an easy reading. Beauty is rendered as the ideal redeemer before the darkness of human ugliness. There is a studied use of color and tones. The bright light is obtained through unusual brushstrokes that surround Beauty in a misty atmosphere, much like a halo.

During her artistic career, De Morgan kept a distance from English symbolist proposals. As her style matured, the artist gradually acquired a more cosmopolitan view of art. This was a determining factor in her work and led her to create her own aesthetic, in which Pre-Raphaelite pictorial models were combined with a formal approach similar to Gustave Moreau, Puvis de Chavannes, and Odilon Redon. De Morgan assimilated the Tenebrism that she had observed in French art and used it to compose fully allegorical scenes, while the Pre-Raphaelite pictorial tradition influenced the rendering of the figures.

SUZE ROBERTSON

Self-Portrait with Red Dress, *oil on panel, 19.7 x 15.8 in (50 x 40 cm), ~1883, Gemeentemuseum, The Hague.*

Suze Robertson was the youngest of nine siblings. Her father was a merchant, and she lost her mother when she was very young. She was then sent to boarding school. Later, she studied at the Academy of Fine Arts of The Hague, obtaining two awards. In her early period as an artist, she gave drawing lessons in secondary school until 1883, when she dedicated herself fully to painting.

She became a member of the group Pulchri Studio, participating in drawing sessions with Georg Hendrick Breitner, the leader of the Dutch Impressionists. Her work was within the sphere of The Hague School. Piet Mondrian admired Suze Robertson's powerful, expressive art. In 1890, she saw the work of Vincent van Gogh and admired it profoundly.

When her daughter was born in 1894, Robertson left artistic creation for several years, but she did give drawing and painting classes to maintain the family. In any case, Suze Robertson was a professional who earned a living through her artwork and committed herself to modernity.

After 1914, she suffered cyclical depressions that became a serious obstacle to her work.

- **1855** Born on December 17 in The Hague.

- **1874-1877** Studies at the Academy of Fine Arts of The Hague; teaches drawing in Rotterdam, then Amsterdam. Wins a bronze and a silver medal during her studies.

- **1880-1882** Takes private art lessons from Petrus van der Velden.

- **1892** Marries the painter Richard Bisschop (1849-1926).

- **1894** Gives birth to a daughter. Artistic activity reduced, although Robertson continues to teach.

- **1900** Wins a gold medal at the World Exposition in Paris and another at the International Exhibition of Women's Art in London.

- **1904** Obtains a bronze medal at the Louisiana Purchase Exposition in St. Louis.

- **1905** Obtains the gold medal in Arnhem and at the Rotterdamse Kunstkring in Rotterdam.

- **1910** Awarded a silver medal at the World Exposition in Brussels and a bronze medal at the Exposición Internacional del Cenario in Buenos Aires.

- **1911** Receives a silver medal at the International Exposition in Barcelona.

- **1913** Receives the gold medal at the Internationale Kunstausstellung in Munich.

- **1922** Dies in The Hague on October 18.

Even so, whenever her state of mind permitted, she would travel with her daughter and paint pastels en plein air. During her last years of life, her depressions stopped her from painting.

Robertson painted still lifes, interiors, and everyday country scenes. Her palette is warm but restricted, and her brushstroke is thick, free, and very expressive. Her work is generally harsh and tortuous, and her figures breathe melancholy and loneliness. Recently, her work has been rediscovered and is now held in high esteem.

The Spinner

(~1904)
oil on canvas
38.8 x 31.6 in
(98.5 x 80.3 cm
Gemeentemuseum,
The Hague

In this painting of a countrywoman spinning, Robertson employs a type of iconography, narrating country work and showing formal aspects, that is closely associated to the Hague School. In the mid-19th century, a group of Dutch painters, basing themselves on the French Barbizon School, became interested in the representation of nature and the life of people in the countryside. Johannes Warnardus Bilders, Johannes Bosboom, Jozef Israëls, Anton Mauve, the Maris brothers, Jan Hendrick Weissenbruch, Willem Roelofs, and others were members of this movement, which revived Dutch painting and which was characterized by earthen and gray tones and loose brushstrokes.

Suze Robertson was a member of the Pulchri Studio, a cooperative of painters that was a bulwark of the School of The Hague. The studio's objectives were to provide occasions for its members to paint from nature, to organize exhibits for the members to show their work, and to hold meetings to discuss art. Like her Dutch colleagues, Suze Robertson was inspired by the work carried out by women living in the countryside. Jacob Maris painted *Weaver on the Balcony* (1869) and Jozef Israëls executed *When One Grows Old* (1878), in which he represented an elderly woman warming herself at the fireplace, and *At Home*, an oil in somber tones showing a country woman carrying a basket and a child. Vincent van Gogh painted *Woman Peeling Potatoes* (~1882, Kröllev Museum, Otterlo) and Anton Mauve painted *Woman from Laren with Goat* (1885).

This socially inclined iconography interested not only Dutch painters but other European artists as well. The subject of the countrywoman carrying out her work was a recurring theme in Robertson's work between 1889 and 1916, and she often painted in the region of Gooi and later in Dongen and Herzee, two Brabant villages. In this canvas, she renders a simple woman, toughened by work, next to an enormous wooden wheel that moves the spinning distaff. She applies dark, Tenebrist earthen colors in loose and expressive brushstrokes.

Right: The position of this woman, with a white cloth over her legs, is practically identical to the painting above it, yet the conception is very personal. Pierre-Auguste Renoir painted several works of seminude women at their toilette, one of them entitled *Bather Arranging Her Hair*, executed in 1885 (National Gallery of Art, Washington, D.C.). In it, a woman sits turned slightly to the side with a white cloth covering her pubic area and legs. The model's position, with her arms raised to arrange her hair, lends the painting dynamism.

But in this panel by Robertson, as in the pastel, the model is slightly hunched, with her head bent forward in a more intimist atmosphere. The artist is not attempting to render an exuberant female nude, but rather a woman engrossed in her own thoughts. Unlike the pastel, the support here is wood and the medium, oil. This gives rise to a very different result. Robertson selects earthen colors and dark backgrounds sprinkled with brown and ochre brushstrokes. The nude's complexion is honeylike, and the forms of the body are created through precise dashes of yellows, reds, and grays. Even the white canvas contributes small points of color in a painting with a strange and melancholy air.

Nude

(~1900-1905)
pastel
10.9 x 8.8 in
(27.8 x 22.4 cm)
Museum voor Moderne
Kunst, Arnhem

The subject of the nude was a true taboo for women painters because they had been banned from using nude models. Such impositions, perpetuated during the course of centuries, slowly began to disappear during the second half of the 19th century.

In fact, in 1877, Suze Robertson became the first Dutch woman allowed to draw from nude models at the Rotterdam Academy. The female nude dates far back in the history of art. There is a ceramic vase attributed to Onesimos and dating to 480 B.C. with a painting of a nude woman about to bathe.

But what is interesting here is to consider the 19th-century context of this work. Jean Auguste Dominique Ingres painted *The Bather of Valpinçon* (1808, Louvre), representing a woman with her back turned, wearing a turban and seated on a soft white bed. It breathes serenity and beauty, with a somewhat distant, exotic model. Robertson, on the other hand, renders a woman seated on a stool and wearing a red turban and a cloth covering her legs. It is a more modest and much more familiar view. The forms are soft, and dark blue reigns supreme in this pastel painting, tingeing the sheets on which the model's hands rest in pale blue. The painting tends to be somber and the woman's attitude suggests that she is waiting or reflecting.

Nude

(~1900-1905)
oil on panel
10.7 x 8.5 in
(27.1 x 21.5 cm)
Gemeentemuseum,
The Hague

Nude

(~1900-1905)
oil on canvas
12 x 9.4 in
(30.5 x 23.8 cm)
Gemeentemuseum,
The Hague

In this work, Robertson paints a seminude girl viewed frontally, her head bent, her arms at her sides, and her hands in her lap. The image it transmits is one of great loneliness, and a highly unconventional sensation of lassitude and nearly unbearable dejection.

At this time (1903), Henri Matisse painted *Carmelina* (Museum of Fine Arts, Boston), representing a woman seated, at her toilette, viewed frontally and with her legs slightly spread, revealing a white cloth that partially covers one thigh. The model gazes at the viewer, showing herself with complete nonchalance. More intimist is Edward Munch's nude *Puberty* (1914, Nasjonalgalleriet, Oslo), also frontal, in which a girl on a bed conceals her pubic area while she gazes timidly at the viewer. Years later, a similar image was executed by Felice Casorati, *Woman and Armor* (1921), where a totally nude model covers her pubic area with her hands and looks down, bending her head. Suze Robertson creates a bleak image of a female nude, placing the figure against a black background that makes the painting even more devastating. The paint is dense and the brushstrokes on both the female body and the cloth covering her legs are daring and expressive.

Nude

(~1900-1905)
oil on panel
12 x 9.4 in
(30.5 x 23.8 cm)
Gemeentemuseum,
The Hague

In this panel, a woman, nude to the waist, is about to perform her daily toilette. Scenes of women at their toilette were a recurring theme, especially in the second half of the 19th century, more permissive in representations of the female nude. The Spanish artist Eduardo Rosales executed *Woman After the Bath*, one of the best Spanish nudes of the 19th century. In France, Henri de Toulouse-Lautrec painted *La Toilette* (Musée d'Orsay, Paris), Pierre-Auguste Renoir executed several canvases on women at their toilette, and Edgar Degas also worked on this subject in drawings and oil paintings such as *The Bath*, painted in approximately 1885, showing a woman bending over in a bath to pick up the soap, a delightful and original painting because the point of view is from above. Others choose tender, poetic images as in *After the Bath* (1897) by Theo van Rysselberghe. All of these female nudes transmit sensuality and eroticism. However, this painting by Robertson is so personal that it acquires another dimension. The black background, the simplicity of the stool, and even the dark ewer containing water to pour into the bowl for washing denote extreme austerity and sobriety. The brushstroke, chromatically very rich, has a great deal of impasto, and the black strokes that configure the contours and shading of the female anatomy lend the painting an expressionist quality. The expressionist movement broke forth with great force in the first years of the 20th century, and in it, female nudes became even harsher through the application of thick black strokes. The style was evident in *Self-Portrait* by Karl Schmidt-Rottluff (1913, Fine Arts Museum of San Francisco), who renders himself next to a nude model, and in works by other artists of this movement.

CECILIA BEAUX

Self-Portrait *(detail),1880-1885, National Portrait Gallery, Smithsonian Institution, Washington, D.C.*

At 47 years of age, Cecilia Beaux was considered one of the most important portraitists in the United States.

This artist, highly sensible and original, painted portraits of the upper class that are remarkable for both the period in which they were executed and their style. From the beginning, she managed to impress the critics and obtain many awards and honors. Though she did not lack commissions, she always preferred to paint relatives and friends, as this gave her greater liberty to experiment with innovative forms and techniques.

Influenced by European art, especially Impressionism, she admired Monet and Titian. She was a contemporary of John Singer Sargent and adopted many characteristics of his style.

Her artwork is characterized by wide brushstrokes applied loosely, a varied palette, an exquisite descriptive technique, and superb textures. Many of her paintings, with large areas of white or light colors, reveal an affinity with Whistler. Beaux preferred simplicity of form and often adopted points of view that produced unusual perspectives.

In her time, a woman could become a professional artist only if she was profoundly dedicated and ready to sacrifice matrimony and family. Perhaps it was because she was educated in the New England Puritan tradition that she lacked neither the discipline nor the willpower necessary to work hard and become exceptionally successful.

- **1855** Eliza Cecilia Beaux is born in Philadelphia. With her sister, she is raised by her maternal grandmother and aunts..Attends her first drawing classes in 1871 under Catherine Anne Drinker, a painter of historical and biblical scenes and a distant relative.
- **1872** Attends classes given by the Dutch artist Francis Adolph Van der Wielen. To pay for her art studies, she paints china and draws for a geological institute. Continues her studies with Camille Piton and exhibits at the Pennsylvania Academy of the Fine Arts.
- **1881** Studies under William Sartain (1843-1924), who introduces her to painting from nature.
- **1883** Opens her own studio in Philadelphia.
- **1887** Exhibits her painting *The Last Days of Childhood* at the Parisian Salon.
- **1888** Travels to Europe for the first time. Studies in Paris, at the Académie Julian. Travels to Brittany, where she is impressed by the artwork of Édouard Manet, the other Impressionists, and John Singer Sargent. Visits Switzerland, Italy, and France.
- **1889** Studies at the Académie Colarossi in Paris. Lives in England, then returns to Philadelphia.
- **1892** After her grandmother's death, she stays for long periods in New York, where she is close friends with the publisher and poet Richard W. Gilder, and his wife, the painter Helena de Kay Gilder. Exhibits at the National Academy of Design, which elects her as a member two years later.
- **1895** For twenty years as of this date, she works as a professor at the Pennsylvania Academy. She is the first woman to take up full-time employment there.
- **1896** Exhibits six portraits at the Paris Salon and is elected member of the Société Nationale des Beaux-Arts, an extraordinary honor.
- **1900** Moves to New York. Among her friends are Augustus St. Gaudens and John LaFarge.
- **1919** During World War I, she is one of the eight artists of the U.S. War Portraits Commission.
- **1924** After an accident, hip problems limit her activity as a painter. Writes her autobiography.
- **1925** As one of the leading artists in the United States, she is commissioned to paint a self-portrait for the gallery of artists at the Uffizi Gallery.
- **1942** Dies in Gloucester at her summer home.

The Dreamer

(1894)
oil on canvas
33 x 25 in (83.82 x 63.5 cm)
Butler Institute of American Art,
Youngstown, Ohio

This portrait of the artist's friend Caroline Kilby Smith, from Philadelphia, belongs to her early period. The painting was not a commission, and so Beaux shows great freedom of execution.

The image is that of a young woman engrossed in a daydream. Her pose is unusual for a formal portrait: She is seated in a chair, leaning to the side, her elbows on an armrest. Her body is pressed against the backrest and her two hands against her right cheek make her face stand out. With her dark hair and brown eyes, her light skin and red lips, she is an image of classical beauty resembling the models of Manet and Renoir. She wears a luxurious, impeccably white dress with a black ribbon around the collar. The strong contrasts in the foreground, between the dress and the woman's light skin, and the armrest, hair, and eyes, are not repeated in the background.

Behind the sitter, Beaux painted an interior in an Impressionist style with atmospheric tones and highlights that barely define the contours of objects. The warm colors of the background, including red and amber, are also different from those in the foreground. The point of view is low, revealing the lower part of an open window. This perspective is an example of certain anticonventional aspects that the artist employed in some of her paintings. *The Dreamer* was exhibited with success at the spring exhibit of the National Academy of Design in 1894 and two years later at the Parisian Salon.

New England Woman

(1895)
oil on canvas
Pennsylvania Academy of the Fine
Arts, Philadelphia

In this portrait of Jedediah H. Richards, the cousin of the artist's grandfather, Cecilia Beaux portrays a woman associated with the Puritan tradition. Her aspect can be inscribed within the prototype of the virtuous woman representative of the values of society at that time. The painting, which was not commissioned, allowed Beaux to exhibit her style and to give free rein to the impressions received during her stay in Europe and to her search for innovation.

Like the artist's mother, Jedediah Richards was a Puritan, a descendant of English immigrants arriving in the New World in the 17th century. The model is seated in a chair in her room with a distant attitude, raptly gazing toward the source of light on the left. Behind the sitter, in a peculiar point of view, is her bed, with a bedspread in the same pure white as her dress, which is chastely buttoned to the collar. In her right hand is a letter, which seems to be the cause of her serious, concentrated expression.

Woman with a Cat

(1895)
oil on canvas
18 x 22 in (45.7 x 55.9 cm)
Private collection

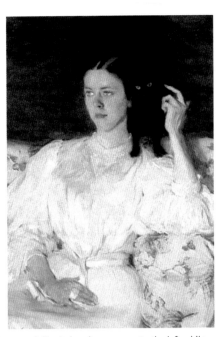

In this painting, Beaux shows a great mastery of tonal combination in the various whites of the woman's dress. The model is seated on a sofa upholstered in white with blue flowers. The strong contrast between the upper and lower halves of the painting is created by the predominance of light colors below and dark ones above. Only the woman's head, part of her left hand (with which she strokes the black cat on her shoulder), and above all, the woman and cat's eyes, stand out against the dark background. Curiously, it is not the woman who gazes at the viewer, but the cat, with its penetrating green eyes. In an ambiguous and perhaps mischievous gesture, the woman seems to be unconcerned with the viewer and directs her dreamy gaze to the left while she plays with the ribbons adorning her dress with her right hand. It is striking that both the woman and the cat have eyes of the same color.

Beaux seems to employ the cat and the contrast between the two halves of the painting as a subtle manner of revealing the woman's true intentions. Chastely dressed, the woman tenderly caresses the cat. With her averted gaze, she neither provokes nor attempts to seduce the viewer, so her decency is formally protected. Her delicate, sensual gestures and ambiguous ingenuity contribute to creating contrasts. Beaux breaks the contradiction through the cat's direct gaze: It looks with the same eyes as the woman's, yet it apparently does intend to surprise the observer and cause a reaction.

James Murdock Clark, Jr.

oil on canvas
13.7 x 9.7 in (34.9 x 24.7 cm)
Private collection

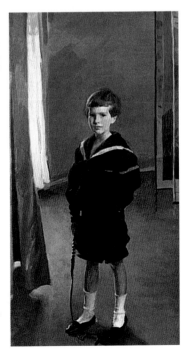

After obtaining great success as a portraitist, Cecilia Beaux not only painted her family members and friends, but above all people from the upper class, to which she felt she belonged. She received many requests for portraits, but was selective about accepting them, as she did not necessarily feel sympathy toward the possible sitters.

With his blue sailor suit with white and red trim, his white socks, patent leather shoes, and proper haircut, the sitter resembles a typical upper-class boy. The whip he is holding surely alludes to a horseback-riding hobby. His pose recalls classical portraits of princes and children from rich and powerful families. The setting is unusual: a section of a room devoid of paintings and furniture, with a grayish blue wall in the background. Curtains indicate the presence of a large window on the left, while a folding screen limits the space to the right. With her usual skillful treatment of light and the low point of view, Beaux again reveals her great mastery.

Man with the Cat

(1898/99)
oil on canvas
48 x 34.6 in (121.9 x 87.8 cm)
National Museum of American
Art, Smithsonian Institution,
Washington, D.C

This is a portrait of Beaux's brother-in-law, Henry Sturgis Drinker, seated in a chair next to a window and illuminated by the light streaming in. Dressed in an elegant, cream-colored suit, pink shirt, and dark tie, he is a gentleman of impeccable appearance. His impressive mustache, his relaxed pose, and his direct gaze give the impression of a natural, pleasant person with great dignity. He was married to the ar-tist's only sister and was the president of Lehigh University. The objects in the background are blurry and nearly abstract, and were painted in a very modern fashion, with restless brushstrokes that went be-yond the Impressionist canons that so influenced the artist. The sunny atmosphere of the room, full of light colors and illuminated by the natural light entering through the window, seems to be a reference to the serene and pleasant character of the sitter. Another allusion to his kindness is the cat sitting on his lap, enjoying the warm company of its owner with its eyes half shut.

After the Meeting

(1914)
oil on canvas
41 x 28.1 in (104 x 71.5 cm)
Toledo Museum of Art,
Ohio

Cardinal Mercier

(1919)
oil on canvas
78 x 51.7 in (198.1 x 131.4 cm)
National Museum of American Art, Smithsonian Institution, Washington, D.C

The three portraits Beaux painted on the request of the United States War Portraits Commission are executed in an official style that did not allow experimentation or much room for originality. This is a portrait of Cardinal Desiré Joseph Mercier (1851-1926) in the Flemish city of Mechelen, of which he was appointed archbishop in 1906 and cardinal in 1907. In addition to his scholastic influence, along the lines of Thomas Aquinas, and his influence on the clergy and laypeople of his time, he played an important role in contemporary history for his participation in World War I. During the war he acted as a representative of Belgium to the German army, which occupied his country and confined him to house arrest. Here he is rendered in his cardinal's outfit, with a black cassock with red trim and buttons. He is wearing a pectoral cross on a gold chain, a red sash, cape, and biretta. He is gazing to the right, beyond the frame of the painting, unconcerned with the viewer. His red cape stands out against the dark background. A window reveals a view of the city and a cloudy sky, seen as if they were painted from the bell tower. For its freely executed and somewhat abstract background, this painting is the most original of the three.

Left: This is a portrait of Dorothea Gilder, the daughter of Richard W. Gilder and Helena de Kay Gilder, friends of the artist. Beaux was almost 60 years old when she painted this young woman belonging to a new generation characterized by social liberty. There is an obvious difference between this portrait and the artist's early portraits of women, such as that of Jedediah H. Richards. Dorothea Gilder lived in New York and maintained constant relations with different intellectual circles. The sophisticated manner of representing the sitter seems to refer to this, with her elegant, black-and-white striped dress and black hat with a white feather.

Beaux shows the figure after a meeting of feminist suffragettes, fervent fighters struggling for women's right to vote, among other things. The artist seems to invite the spectator to participate in a conversation Gilder is having with a person outside the painting to the left. She is seated in an elegant upholstered armchair, almost with her back to the viewer, and directs her face and hand gestures toward the person she is speaking with. She is portrayed as a serious, committed person, deeply involved in the conversation. Beaux manages to freeze a spontaneous moment as in a snapshot. This vividness is emphasized by the combination of contrasts between black and white, in which Beaux, as always, demonstrates her mastery. The striped dress increases the effect of movement. The sitter's face, her light complexion, and the white glove of the gesticulating hand stand out against the black folding screen, which creates an intimate atmosphere and separates the conversing people from the group meeting in the background, in the upper left of the painting.

Admiral Sir David Beatty, Lord Beatty

(1920)
oil on canvas
62.4 x 45.7 in (158.6 x 116 cm)
National Museum of
American Art, Smithsonian
Institution, Washington, D.C.

Cecilia Beaux had to travel to London in order to paint the British admiral David Beatty (1871–1936). This distinguished military man served in Egypt, Sudan, and even China during the Boxer Rebellion in 1900. He was appointed rear admiral in 1910, and as such commanded the naval action during the first phase of World War I on the island of Helgoland in 1914 and on the warship *Doggerbank* in 1915. His squadron of cruisers was involved in the Battle of Jutland in 1916, and he was later the commander of the navy before he was appointed Lord of the Royal Navy and count in 1919. For his military success and crucial role in the battles, he was a war hero. Here he is rendered in uniform, though without his hat. His hands emerge from beneath a cape and rest on a symbolic sword. Serious and proud, he gazes fixedly at the viewer. In the background are the smoke and flashes of a naval battle, as was traditional in military portraits.

Georges Benjamin Clemenceau

(1920)
oil on canvas
47 x 36.7 in (119.2 x 93.3 cm)
National Museum of
American Art, Smithsonian
Institution, Washington, D.C.

The third commission that Beaux received from the United States War Portraits Commission was this one, of Clemenceau (1841-1929). She executed it in Paris, shortly after the Peace Treaty of Versailles (June 28, 1919) was signed, ending World War I. Clemenceau was the prime minister and minister of war in the difficult year of 1917, in the midst of the war. He managed to raise French morale, convinced the Allies to approve a unified command, and led the war until the final victory. During the negotiations of the peace treaty, he insisted on Germany's disarmament and was never satisfied with the final text of the treaty. He was the greatest antagonist of Woodrow Wilson, whose proposals he found too idealist. Curiously, he lost the presidential elections of 1920 for his indulgence toward Germany. He retired from politics and began writing books. Beaux portrayed Clemenceau behind his desk, dressed in a black suit and turned slightly away from the viewer. With the appearance of a proud statesman, he looks to the right of the painting rather than at the viewer. He rests his black-gloved hands on the desk near some papers and a black book. Beaux rendered him faithfully, with his trademark large white mustache and thick eyebrows over deep-set eyes. As is typical of her, she employed the background to provide contrast and make the model stand out. The bright window and gray wall are interrupted by a black curtain that forms a vertical strip in the center of the painting. Gray tones predominate, along with black and white, emphasizing the official air of the portrait.

MARIE BASHKIRTSEFF

Self-Portrait with Palette, *oil on canvas, 36.2 x 28.7 in (92 x 73 cm), Musée des Beaux-Arts Jules Chéret, Nice.*

Marie Bashkirtseff's artistic career was cut short by her untimely death at the age of 26 from tuberculosis. She practiced different disciplines, such as sculpture, singing, and painting. It was at the Académie Julien where she definitively consolidated her pictorial career. Her artwork was determined by the influence of this academic institution, the only art institute in Paris that allowed women into its studios and gave them the same training that men received at official schools of fine arts, which did not admit women until 1897.

Marie Bashkirtseff's oeuvre is characterized by sensitive portraiture, using the expressive capacity of the sitter's face as the principal element of each work. This expressiveness in her painting is combined with a highly realist aesthetic to create urban scenes and portraits of friends and relatives with a rational treatment of light and color. In Bashkirtseff works, the visual path is determined by the luminosity of the elements, which the artist uses to construct an easily comprehensible and direct pictorial space. She always seemed to keep in mind the impressions and nature of the viewer, and thus composed her works based entirely on the public's point of view.

Marie Bashkirtseff's death in 1884 brought her artistic career to a tragically early close. During World War II many of her works were lost, and only some sixty are extant today.

- **1858** On November 23, Marie Bashkirtseff is born in the town of Havrontsi, Poltava, in the province of the Ukraine, to a family of the lesser nobility.

- **1870** Leaves Russia with her mother after her parents separate. Following a period traveling throughout Europe, they settle in Nice with her grandfather and other relatives, where she leads a life of economic ease. From there, she takes several trips to various cities in Italy (Rome, Florence, Naples).

- **1873** Begins writing an intimate diary, a work of great literary value for feminist sympathizers.

- **1874** The first symptoms of tuberculosis appear.

- **1876** Begins her painting studies in her home in Nice. Takes a trip to Russia.

- **1877** Settles in Paris with her family. Studies in the female section of the Académie Julien, under the tutelage of Tony Robert-Fleury and, later, Jules Bastien-Lepage.

- **1880** As her illness grows worse, she begins losing her hearing. Participates in the Salon with the portrait of her cousin Dina, which she signs with the pseudonym Maria Constantinowa Russ.

- **1881** Under the pseudonym of Pauline Orrel, she publishes various articles in the Parisian press. Visits Spain. Exhibits the painting *The Studio*, which she signs with the pseudonym Andrey.

- **1882** Begins studying sculpture.

- **1883** Exhibits at the Parisian Salon with the work *Jean et Jacques*.

- **1884** Participates in the Salon with the work *The Meeting*. Dies of tuberculosis in Paris on October 31.

M. Bashkirtseff

Still Life

(~1880)
oil on canvas

Marie Bashkirtseff was experimenting with different pictorial genres when death overtook her in the midst of her creative development. She cannot simply be qualified as a portraitist or landscapist. Though she stood out for the great quantity of portraits, most of them of women, that she executed over the seven short years of her artistic career, she also painted landscapes and some still lifes.

The compositional originality of her anecdotal scenes of Parisian life is apparent in this still life as well. In a boldly vertical pictorial space, the artist places various plants in a staggered manner, forming a linear composition. In the foreground is a bright yellow pitcher that attracts the eye to the bottom of the ascending visual path. Throughout her work, Bashkirtseff shows an unequivocal interest in conducting the viewer's gaze. In this work, the pictorial trajectory moves from the bottom to the top, and the artist ensures that it is read correctly. The plants form a tonal gradation that culminates in the upper area, where the lightest-colored flowers are placed in order to compensate chromatically for the brilliance of the pots.

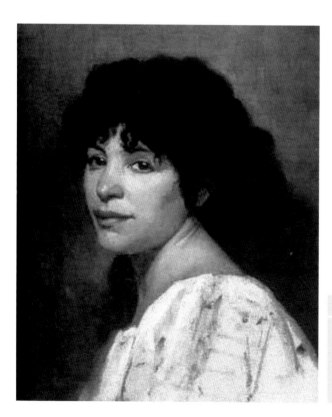

Oriental

(1882)
oil on canvas
Musée des Beaux-
Arts Jules Chéret,
Nice

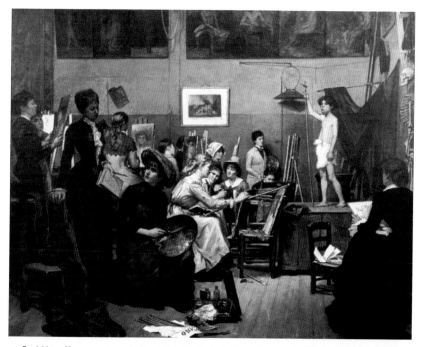

Bashkirtseff represents a studio at the Académie Julien, where she studied in the early 1880s. Though the artist was attracted to anecdotal urban scenes like those she observed while strolling through Paris, her naturalist tendency led her to execute a great number of portraits and compositions related to specific moments of her life in that city. In her private diary, the artist emphasized the importance of descriptive art as a documentary testimony of Parisian society.

The Julien Studio

(1881)
oil on canvas
57.1 x 72.8 in
(145 x 185 cm)
Museum of Fine Arts of
Dniepropetrovsk, Ukraine

In this painting, Bashkirtseff rendered the atmosphere of an art class with a model. Each figure has an individual personality. Bashkirtseff's work is very meticulous, revealing her preoccupation with details and light in dresses, coiffures, and expressions. The scene is full of movement and imbued with an all-embracing, warm atmosphere as in an Impressionist work.

In the center of the studio, the light falls intensely on the model and a painter in bright blue, who capture the viewer's attention. Bashkirtseff organized the composition around this brighter area, which is orderly and serene. Near the margins of the painting, the light diminishes and the figures, in progressively dimmer light, are unconcerned with what is happening in the principal area. A sense of spontaneity and an appropriate compositional treatment lend the scene realism and a theatrical air. The color is applied in a studied manner, in tones that create intimism, lend warmth to the studio, and emphasize the human quality of the students.

Left: Bashkirtseff was famous for her numerous portraits of women; this is a magnificent example. Using different media such as pastel or oil, she developed a portraitist style based on the expressive capacity of the subject's face. In this portrait, the model's slightly yellow complexion creates an effect of natural contrast with the intense black of her hair and the dark background, enriched by blues and purples. This strong contrast is used by the artist to enhance the brilliance of the face, perfectly modeled and executed with great realism, and to emphasize the expressive force of her caressing gaze.

The compositions are similar in the majority of her portraits. The model, in profile, turns her face slightly toward the viewer. This compositional style allows the artist to play with the tonal gradation caused by light and shadows, with greater brilliance in the center of the portrait and a gradual decrease in the luminosity until the half light of the background is reached.

Despite the humble condition of the figure and the complete absence of ornamental accessories, this woman's rich registers, the drawing of her facial features, and the forms and volumes of her face render her as a highly sensual person, gazing at the viewer as if imploring attention and help.

Autumn

(1883)
oil on canvas
38.2 x 46.1 in (97 x 117 cm)

Though Marie Bashkirtseff died very young, she explored different genres in her intense artistic activity. In this painting, she represents a bucolic autumn landscape, comprised of a rich, attractive range of warm ochres and browns. The composition is based on a diagonal created by a solitary path, flanked by trees, uniting two areas of different light. In the foreground, the proximity of the trees conceals the sunlight, which increases with distance. Bashkirtseff executes an exercise in perspective that leads the eye toward the depth of the painting through the intense light in the background.

There is also a middle ground consisting of a bridge under which a river can be imagined, visible through the trees to the right. The artist created two differentiated spaces, separated by the line of trees. Along the tree-lined path, there is a clear visual trajectory created by color and light; on the right, a fully independent and serene space is insinuated. Bashkirtseff uses this contrast to achieve an expressive effect. The painting is spectacular both for its composition and for the treatment of color, demonstrating the artist's capacity to delight the eye and engage the senses—two of her principal interests.

Many of Marie Bashkirtseff's paintings are eminently por-
traitist. In this work, two humbly dressed boys stroll down
the street, rendered in a nearly photographic style chro-
matically comprised of a single tonal range of grays and
blues, in which the brilliance of the faces and the white
handkerchief around the older boy's neck stand out.

The artist used a restrained compositional style and
somber colors, a contrast with the bright colors that a
scene with children should presumably have. The painting
is casual and spontaneous, as if the boys will not stay still long enough to let themselves
be painted, though the younger one, upon becoming aware of the artist's presence, seems
to pause to stare at her.

Bashkirtseff often experimented with this combination of spontaneity and form portrai-
ture. For example, here it is evident that the models' expressions and gestures were thor-
oughly studied, while the rest of the scene serves as a backdrop. This lends the work an
element of contrast that creates movement and atmosphere, conducting the eye to a spe-
cific focal point—in this case, the younger boy's face. By creating the illusion of a single
static detail, the artist imbues the rest of the work with movement.

Jean et Jacques

(1883)
oil on canvas
61 x 45.3 in (155 x 115 cm)
Newberry Library,
Chicago

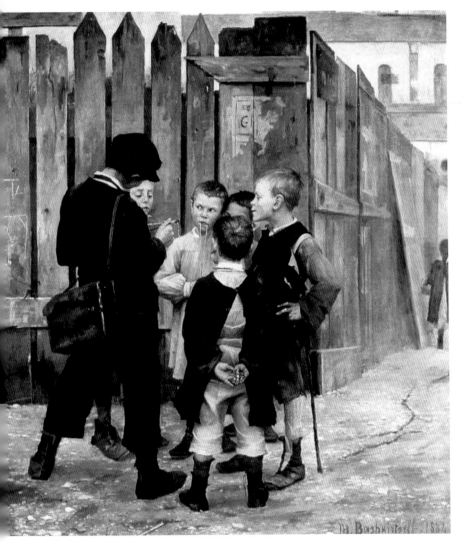

The Meeting

(1884)
oil on canvas
74.8 x 68.9 in
(190 x 175 cm)
Musée d'Orsay, Paris

This painting, signed and dated in Paris, depicts boys gathering in the street after school. In the background is a girl carrying a basket. Marie Bashkirtseff executed a realistic composition from a typically Impressionist point of view.

Though she observed the aesthetic principles of realism she learned from her studies at the Académie Julien, she was interested in Impressionism, which heralded a new manner of interpreting art with more commonplace scenes. Though she did not follow the pictorial approach of Monet or Renoir, Bashkirtseff was drawn to anecdotal scenes showing urban life. In this innovative vision, far removed from solemnity and idealization, the artist painted an everyday scene as if it were a technical exercise, although it is very expressive.

The painting is structured around the wooden fence behind the boys and reaching into the distance to create a sensation of depth. This elaborate background directs the eye toward the end of the street, balancing the portraitist style in which this group was conceived. In the center of the group, the boy in gray has a strikingly expressive face, his attentive yet mistrustful gaze fixed on the older playmate holding the notebook and pencil. Bashkirtseff distributes points of light in a studied manner throughout the boys' faces as a contrast with the pictorial weight of the older boy's dark outfit.

ELIZABETH ADELA ARMSTRONG FORBES

Stanhope Forbes, Elizabeth Adela Armstrong Forbes, *oil on canvas, 1882, Victoria and Albert Museum, London.*

Attracted by the magnificent landscape of her country, the Canadian Elizabeth Armstrong Forbes showed great skill in painting landscapes from an early stage of her career. Her interest in finding a new vision of nature had nothing to do with the experiments carried out by the Impressionists. It was singular, the result of her travels and the influence of James McNeill Whistler's art. Like him, Forbes moved to Europe and paid little attention to the artistic movements that prevailed in France and England at the time.

Her particular vision of nature was based on her interest in representing landscapes as a child would see them, thus recovering a pictorial style left behind by the European avantgarde movements of the late 19th century.

Forbes dedicated a good part of her artistic career to investigating technique, as demonstrated by her engraving studies executed with Whistler and Walter Sickert, and to seeking beautiful settings for her paintings and illustrations. In 1899, at the age of 40, she traveled the Pyrenees on bicycle to discover new landscapes, which she represented in her works from a sentimental and poetic point of view. It was in this melancholy atmosphere that the artist painted figures fully integrated into the natural setting.

- **1859** Born on December 29 in Kingston, a suburb of Ottawa, Canada. She is the daughter of a government official.
- **1875** Studies at the South Kensington School of Art in London. Returns home after her father's death.
- **1877** Moves to New York to study at the Art Students League, and later to Munich.
- **1882** Moves to Pont Aven, where many Impressionists are working.
- **1884** Spends the summer in the Dutch town of Zandvoort. Thanks to her engraving work, she enters the Royal Society of Painter Etchers, where she becomes friends with James McNeill Whistler.
- **1885** Spends the autumn in Newlyn, Cornwall, with her mother. Enters the Newlyn Artists' School, where she meets the painter Stanhope Forbes. Executes a series of interior scenes with women and children that are on display at the Royal Academy in London.
- **1886** Elected member of the Royal Institute of Painters in Watercolors.
- **1889** Marries Stanhope Forbes.
- **1891** Establishes a school of art in Newlyn with her husband.
- **1892** Her son, Alexander, is born.
- **1899** Writes and illustrates the children's book *King Arthur's Wood*.
- **1900** Her first individual exhibit is held at the Fine Arts Society in London. Elected a member of the Royal Watercolor Society.
- **1904** Holds an individual exhibit at the Leicester Gallery in London.
- **1912** On March 22, dies at her home in England. At her funeral, her many admirers and students proclaim her Queen of Newlyn.

Her art constitutes a revival of the classical pictorial tradition combined with nature, which the artist renders as if they were illustrations for children's stories.

Forbes was a multidisciplinary artist who illustrated stories and executed engravings and paintings.

Ring-a-Ring-o'Roses

Charcoal, watercolor, and gouache on paper
Penlee House Gallery & Museum, Cornwall, UK

With a childlike air executed in mixed media, this painting illustrates several characteristics typical of Forbes's artwork: the subject of children, everyday genre scenes, humble figures, the landscape, and her peculiar style of conceiving a painting like an illustration for a popular story, full of ingenuity, candidness, and sympathy. With regard to composition, the scene is balanced and excellently conceived, with a harmony that is enhanced by the soft chromatic range consisting of light, neutral tones.

Jean, Jeanne, and Jeannette

(~1880)
oil on canvas
Manchester City Art Gallery

A Zandvoort Fishergirl

(1884)
oil on canvas
Penlee House Gallery
& Museum, Cornwall

Though Forbes's favorite genre was the landscape, the portrait of this girl from Zandvoort is executed in the same romantic style that the artist used in her outdoor works. The expressiveness of the model's face reflects the artist's poetic vision. A humble young woman with a luminous beauty and an air of fatigue, she is portrayed with the same admiration that Winslow Homer felt for the fishermen of northern England.

In this painting, Forbes meticulously applies color to create a special light. In an atmospheric interior recalling the work of Gustave Caillebotte, the girl transmits a sensation of serenity and self-assurance, and is represented as if she were a heroine, with a character that contrasts with her childlike body and innocent expression. In this painting, the treatment of color stands out. The painting consists of a rich range of grays, with yellow and white as complementary colors. The luminosity is achieved through a mixture of gray and yellow, while the brilliant tone in the right background consists of a greenish gray lightened with white. The monochrome aspect of the work lends it a modern aesthetic.

Left: In this highly realistic painting, the artist meticulously renders different aspects of light and color. The white goat focuses the viewer's attention with its brilliance and establishes the different grounds; in one, a man appears in a small space between a stream and a path entering a forest. The artist often used elements such as paths or canals to create perspective and depth, but also to act as regulating elements in the painting. Allegorically, the path determines the trajectory that the spectator's eye should follow, almost always leading to a forest in Forbes's works. The foreground is a portrait imbued with a romantic ideal of country life. The beautiful young country girl, wearing simple clothing, strokes a goat while it eats wildflowers from a wheelbarrow. The decorative sense of the painting combines with a balanced, serene style in which the pictorial space is filled with color and detail, despite the apparently somber overall tones.

Woodland Scene

(~1885)
oil on canvas
Royal Cornwall Museum

The artist's privileged situation in Britain allowed her to make contact with different artistic circles and rediscover the Romantic movement. In this scene, Forbes realistically renders a typically English forest setting. The influence of Romanticism and the Pre-Raphaelites determine the tones and colorist composition, while the short brushstrokes strategically distributed throughout the pictorial space show a contemporary aesthetic.

One of the most remarkable characteristics of Forbes's art is her capacity to reinterpret classical subjects and compositional styles from a modern viewpoint. Though she was a contemporary of the Pre-Raphaelites, she considered her pictorial style to be derived from the Romanticism of Caspar David Friedrich and John Constable, from whom she adopted her manner of observing nature, though she dispenses with their monumentality. Compositionally, the painting is well balanced, both in its horizontal lines, with the horizon line and brushstrokes describing the lay of the land prevailing, and in its vertical lines, with the trees and the figures blending into nature.

Right: Forbes used an original triptych format to compose this highly decorative work. In the central panel, a woman reclines on a rock. This painting was executed in Ascain, a town in the French part of the Basque country, during the artist's vacations with her family in 1897. The model was a 15-year-old girl from the town.

The figure's protagonism is created through the brilliance of her dress, which contrasts with the dark ochre tones of the rest of the work. The artist evokes the English legend of will-o'-the-wisp, according to which a small flame accompanied travelers who had to cross the solitary forests of England. The painting is completed by the two lateral panels, which continue the central scene in the same chromatic range. The artist seeks to surround the viewer with this landscape. The frame is a plant relief that seems to grow out of the forest depicted in the triptych. This decorative idea follows the dictates of total art proclaimed by the Art Nouveau movement. (The carving on the frame reads, "Wee folk, good folk trooping all together: green jacket, red cap and white owl's feather.") The artist executed a painting and created a well-balanced decorative element at the same time, following the aesthetic upheld by the decorative artists of the late 19th century.

The Minuet

(1892)
oil on canvas
Penlee House Gallery
& Museum, Cornwall

Forbes executes this painting in an exercise of great realism in which the light entering from the window and reflecting off the floor provides a theatrical effect. This artist's oeuvre cannot be ascribed to any specific movement or style, but rather renders different visions of landscape and group portraiture. No other painter active during the end of the 19th century used such a classical compositional style, yet the artist knew perfectly how to combine that traditional approach to painting with the new pictorial ideas emphasizing the importance of light and color.

This painting represents a group of women at a specific time. The principal figure of the painting is the girl, near the center of the painting, wearing a yellow dress that attracts the viewer's attention. The woman accompanying her has an eminently tender gesture, while the girl looks attentively at the piano. During the 19th century, musical education was almost mandatory among the women of the middle and upper classes of society, who played and studied in the home. Forbes is hence among the many women painters who portrayed aspects of the domestic life of women of a specific sector of society, though she always included children as well.

Will o' the Wisp

(1897)
oil on canvas
27 x 44 in (68.6 x 111.8 cm)
Getty Collection, Los Angeles

Volendam, Holland, from the Zuidende

(1895)
oil on wood
10.5 x 6.6 in
(26.8 x 17.4 cm)
Tate Gallery, London

Though Forbes preferred not to become involved in any of the pictorial movements emerging in Europe around the end of the 19th century, her interest in studying and comprehending them allowed her to incorporate details approaching those movements. This balanced, typically Dutch landscape can be compared to early expressionist works for its intensity of color and the quality of the brushstroke. The spatial conception lends the work a homogenous image constructed around the strong verticality of the canal and its banks, which regulates the entire composition.

The painting is striking for its sense of depth and the harmony of light and color, with a bold colorist atmosphere far removed from somber English landscapes. The force of the light increases through the use of color, with the luminous effect concentrated on the water in the canal, represented as a mirror reflecting the sky.

Forbes's interest in the changing aspects of light have nothing to do with the Impressionist experiments of Manet or Renoir, who were both interested in rendering the effects of light on water. In this painting, the luminosity of the canal is used to provide a more generic, realist sensation and to direct the viewer's gaze toward the depths of the painting.

Marianne von Werefkin

Self-Portrait, *tempera on paper glued on card-board, 20.1 x 13.4 in (51 x 34 cm), 1908-1910, Städtische Galerie im Lenbachhaus, Munich.*

After three years of art studies in Moscow, which she began at the age of only 15, Marianne von Werefkin took a painting course in Saint Petersburg taught by Ilya Repin, a realist painter, and there she met the artist Alexej Jawlensky, who would become an insep-arable friend.

At her father's death, she settled in Munich with Jawlensky and was soon surrounded by avant-garde artists due to her profound liter-ary and artistic knowledge and her personal charm. Von Werefkin was the muse of Vasily Kandinsky, Franz Marc, and Jawlensky. She became a sort of priestess for her aesthetic ideas and color theories, through which she sought a new, different type of art. She hence played a fundamental role in the effervescent, early 20th-century Munich art scene, where Kandinsky was to reach abstraction.

When the First World War broke out, she sought refuge in Switzerland, accompanied by Jawlensky, his wife, Helene, and their child, Andreas. In 1918, the unconventional group settled in Ascona, Italy, seeking a benevolent climate that would benefit Jawlensky's delicate health. It was a difficult period, because von

- **1860** Born in Tula, Russia, on August 29. Her family is of the lesser nobility. Her father is a high official and her mother an amateur painter.

- **1886** Becomes a student of Ilya Repin.

- **1888** Her right index finger and thumb are permanently injured.

- **1890** Around this time, she takes a painting course in St. Petersburg, where she meets the painter Jawlensky, for whom she poses as a model several times. They become friends and he influences her artistically.

- **1891** Participates in the first exhibit of the Association of Artists of Saint Petersburg.

- **1896-1897** Moves to Munich and meets Vasily Kandinsky.

- **1901** Begins her diary, *Letters to a Stranger*, in which she describes her art theories.

- **1908-1912** Paints alongside Jawlensky, Gabriele Münter, and Kandinsky in Murnau. Participates in the New Association of Artists of Munich and in the Blaue Reiter exhibits.

- **1914-1917** Goes into exile in Switzerland. Comes into contact with the Dadaists.

- **1918-1922** Settles in Ascona, Italy, and breaks off her relationship with Alexej Jawlensky, which had lasted more than 30 years.

- **1938** Dies in Ascona on February 6.

Werefkin had been dispossessed of her income as a consequence of the Russian Revolution in 1917.

In 1920, she broke off her relationship with Jawlensky, who moved to Wiesbaden with his wife and son. Four years later, von Werefkin founded Der grosse Bär (The Large Bear), an association of artists of Ascona, where she remained until the end of her life.

Her expressionist art is characterized by original narrative saturated in color and imbued with a symbolic sense.

Her works are always passionate, with vibrant colors, and show the strong and unconventional character of the artist.

Dance Hall

(~1908)
gouache and colored
pencil on cardboard
22 x 30.1 in (56 x 76.5 cm)
Private collection

This painting shows an aspect of leisure-time entertainment in elegant circles. The use of mixed media—here, gouache and colored pencil on cardboard—is the result of a deliberate search for a modern type of art far removed from conventional oil painting. Von Werefkin nearly always painted in tempera on cardboard and rarely dated her works.

When she was living in Russia, von Werefkin enjoyed a solid reputation as a realist. Nevertheless, she stopped painting for a time when she met Jawlensky, dedicating herself entirely to promoting his artistic career. In 1896, she decided to settle in Munich with her companion, where she met Kandinsky, Gabriele Münter, and other painters of the avant-garde. Her new contacts led her to consider a new pictorial language in which realist forms were diluted and color played a fundamental role. Between 1903 and 1905, von Werefkin and Jawlensky visited Paris and other places in France. The artwork of van Gogh, Gauguin, the Fauves, and even Odilon Redon deeply impressed von Werefkin, who took up painting once again in 1906.

This work reflects her new period, in which she sought an original pictorial language. She chose lemon yellow to dress the elegant women in the foreground, including the woman about to descend the stairs who is delicately gathering her skirt. The viewpoint is elevated so that the people on the dance floor appear to be wholly immersed in vibrant orange. This not only makes the public anonymous, but also evokes intimacy, warmth, and the effervescent atmosphere of the dance hall. The emotion that the bright orange may evoke contrasts with the coolness of the bluish exterior. The mixed media lends the painting a different texture, beautifully combining the sinuous, arabesque curves of the pencil with the blended colors of the background.

According to descriptions by her acquaintances, von Werefkin was a woman of great cultural knowledge and particular charm. Shortly after she began her career, painters and poets were already gathering at her studio in Blagodat, Russia, where they would recite the works of Charles Baudelaire, Edgar Allan Poe, and the German Romantics. When she arrived in Munich, artists of the international avant-garde met in her home because of her charisma and intellect.

Woman with Lantern

(~1910)
tempera on cardboard
27.6 x 40.6 in (70 x 103 cm)
Fondation Marianne
Werefkin, Ascona

Von Werefkin was one of the first artists in the Munich circle to express her ideas on color, which she conceived of as an emotional factor without express fidelity to natural reality. She held that artists should paint what they felt and not what they saw. In 1901, she began writing a diary in French that she entitled *Letters to a Stranger*, in which she explained her art theories. "The means of rendering a received impression should be personal and independent of existing forms. Art is a sensation, a sentiment. The artist who converts a visual impression into a song of colors is a master of seeing."

Her ideas are expressed in this work in tempera on cardboard, in which the snow covering the hills is green and blue, the furrows and shadows are tinged in red, and the leafless wintry trees are as black as the phantasmagoric figure of the old lady. In fact, the subject of the painting is simple: An old lady goes to get some pigs that have gotten loose. Nevertheless, the treatment of forms and colors establishes a symbolic relationship with reality that imbues the painting with mystery, like the stories of Poe.

The Red Tree

(1910)
tempera on cardboard
29.9 x 22.4 in
(76 x 57 cm)
Fondation Marianne
Werefkin, Ascona

Von Werefkin executed this painting a year after spending the summer in Murnau with her friends Alexej Jawlensky, Vasily Kandinsky, and Gabriele Münter. The exchange of ideas and experiences was rich and intense for all involved. As mentioned, von Werefkin conceived of color as something independent of light or the clarity of objects, something that could act independently as a symbolic, synthetic, and emotional factor. Her aesthetic ideas impressed Franz Marc so much that he later wrote about them. Those concepts on color that were present among the European avant-garde are skillfully combined in this landscape, in the three pure colors: the yellow in the chimney smoke, the red of the treetops, and the blue of the high mountain. This painting also has a feature that evokes German Romantic painting: the female figure, seated under the tree in perfect symbiosis with the dense, colorist nature.

Von Werefkin's landscapes usually portray nature as magnificent and powerful in relation to the human being. There is also a symbolic sense in her paintings, a series of inner obsessions that the artist needed to express through painting. The symbol was very important for her, as she wrote in her *Letters to a Stranger*: "Sound, line, and color are extreme symbols. They are closely interrelated with the artist's sentiments of love that engendered them. Artists spend their entire lives freeing themselves from those symbols through expression." The elements that appear in this landscape (nature, the human being, a cottage) are symbolically important and have great universal value.

When von Werefkin lived in Saint Petersburg and was a student of Ilya Repin, she often painted scenes of country life. In 1906, she took up painting again and again executed paintings of everyday country life, as in *The Great Road*, from 1907, where there are three women; *The Cart Driver*, from the same year; *The Washerwomen*, executed between 1908 and 1909; and *Woman with Lantern*. She was the only member of the Blaue Reiter who rendered this type of subject matter.

Industrial Villa

(1912)
tempera on cardboard
27.8 x 33.3 in
(70.5 x 84.5 cm)
Fondation Marianne
Werefkin, Ascona

There are three motifs in this work: nature, industry, and the human being. This industrial village is located on a river. It is surrounded by a powerfully colorist landscape in which the plains take on a copper tone and the high blue mountains are silhouetted against a yellow and green sky. In the foreground, three men carrying a sack cross a bridge in front of a village immersed in twilight. The factory chimney, a symbol of industrialization par excellence, is as high as the old church's bell tower. This is a narrative scene accompanied by forms with latent meanings. The association of the magnificence of nature, the darkness of industry with its chimney emitting green smoke, and the toil of the man bent under a heavy sack are ahead of their time and offer an invitation to reflection.

Ave Maria

(~1927)
tempera on cardboard
29.1 x 22 in (74 x 56 cm)
Museo Comunale d'Arte
Moderna, Ascona

This painting belongs to the artist's Ascona period. When World War I broke out in 1914, all Russians residing in Germany were forced to leave the country within 48 hours, leaving all of their belongings behind and escorted by guards as if they were dangerous criminals. Von Werefkin, along with Jawlensky, his wife, and their child, sought refuge in Switzerland. They settled in Saint Prex and later moved to Zurich, where they established relations with the Dadaists of the Cabaret Voltaire. In 1918, doctors counseled Jawlensky to seek a warmer climate for his delicate health, so the unusual family moved to Ascona, Italy.

This painting shows a scene of daily life with a strong message. The parish priest, with his head held high, is walking toward the church, observed by prostitutes on the opposite side of the street. Von Werefkin juxtaposes two antagonistic worlds, which she sets in a narrow street in brilliant red with green and black shadows. The dramatic perspective of the houses is somewhat dreamy and the soft, rounded shapes of the buildings recall surrealism. The priest's black shadow, cast against the wall of a house, is striking because it is a stylistic resource often used in German expressionist cinema, as in Robert Wiene's *Dr. Caligari's Cabinet* (1919), and one that also appeared much later in Sergei Eisenstein's *Ivan the Terrible* (1943). As in her work *The Industrial Villa*, von Werefkin expresses a thought through images impregnated with content, force, and intense expressiveness.

MARY LIZZIE MACOMBER

My Angel, *Conté crayon,1900, University of Michigan, Department of the History of Art.*

- **1861** Born in Fall River, Massachusetts, on August 21. As a young woman, studies drawing under a local artist for several years before she enrolls in the art school at the Boston Museum of Fine Arts. She is obliged to quit studying for health reasons but later returns to her art studies. Meets Frank Duvenek and establishes a studio with him in Boston.

- **1889** Her painting *Ruth* is exhibited at the National Academy of Design.

- **1890** Visits England, where she becomes acquainted with the work of Millais and Burne-Jones.

- **1895** Participates in nine annual exhibits at the Art Institute of Chicago until 1903.

- **1903** Her studio catches fire and the majority of her oeuvre burns. This, however, doesn't discourage her from painting.

- **1914** Publishes a poetry book.

- **1916** Dies in Boston on February 4.

Mary Lizzie Macomber was the only female painter from the United States to join the Pre-Raphaelite movement. After visiting England, she felt attracted by the Victorian aesthetic prevailing in British art and soon discovered Dante Gabriel Rossetti's allegorical symbolism. Macomber was influenced by these two artistic tendencies and created her own style by combining the charm and serenity of the time with the profound and spiritual vision of art professed by Rossetti.

Like Burne-Jones and Millais, Mary Lizzie Macomber based her work on a return to medieval traditions that predominated in early Pre-Raphaelite works, translating it into her own language, which would eventually develop into a clear and direct symbolism. Macomber's artwork is somewhat eclectic and its formal construction borrows much from such Renaissance artists as Michelangelo and Leonardo da Vinci, as well as from the works of Rossetti and Millais.

Macomber first focused her art on representations of mythological figures or characters from novels rendered in almost commonplace attitudes and poses. As her art became more mature, it evolved toward full symbolism, distancing itself from the candid vision evoked in her early paintings.

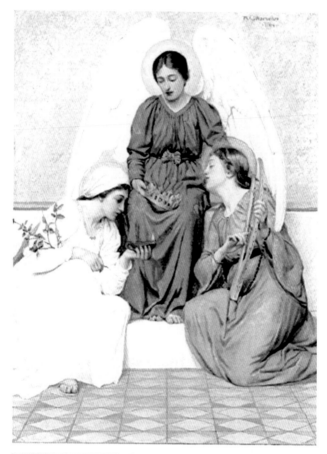

Faith, Charity, Hope

(~1900)
oil on canvas

This painting represents the three theological virtues, which the artist imagines as three young women. The Pre-Raphaelites often incorporated allegorical archetypes of the different virtues as a counterpoint that served to question human morality. Here, on the other hand, Macomber represents the three women in completely normal poses in an attempt to approximate the divine allegorical meanings of these figures to the public. This approximation between the world of allegory and that of humanity is used by the artist to construct a pictorial discourse legitimizing her particular supernatural world.

Under the arch formed by the wings of Charity, the three virtues are in a contemplative mood, completely unaware of the artist's presence. Macomber's oeuvre is characterized by representations of fantastic figures from a realist viewpoint. This contemporary vision, which the artist employs here, removes the work from allegorical abstraction and lends it a sentimentalism that expresses the intense emotion of her symbolist style.

In symbolism, the image of the three female figures recurs with different theological readings, though in this work, Macomber presents a more human view. The result of an idealized and devout conception, the painting is executed in light pastel tones, avoiding contrasts and intense colors and even blending contours. The artist's intention is to represent the virtues in a setting where softness and delicacy personify the candor and charm of the most transcendent spiritual values.

Night and Sleep

(1902)
oil on canvas
30 x 24.9 in
(76.2 x 63.2 cm)
Smithsonian
American Art
Museum,
Washington, D.C.

Although specialists do not agree on the authorship of this painting, the pictorial style clearly resembles that developed by Macomber beginning in 1890. She gradually acquired a realist quality combined with a more subtle symbolism as her art evolved. In this painting, clearly symbolist elements disappear nearly altogether to give way to a style in which allegory is represented through the compositional style, the use of light and shadow, and gesture.

Here, the artist represents the upper body of a female figure leaning toward the center and contemplating the reflection of a figure in the darkness that resembles a specter, while holding a small bright star in her hand from which a halo of light radiates. Macomber uses the half light to emphasize the woman's pale beauty. The expressive gaze of the serene, illuminated face increases through the intense contrast with the dark tone of the background.

On the other hand, the reflected image is somewhat disconcerting, as it is imprecise, resembling an allegory. The young woman's lines are elegant and her aspect is that of an ideal being, timeless and unsettling, in which a somewhat cold sensuality, the delicate gesture, and a clear allegorical reference relate her to certain paintings by Burne-Jones.

In the artwork of both Macomber and Burne-Jones—some of whose steps Macomber followed with notorious fidelity—the symbolism can be very subtle. The figures in this painting are devoid of the idealism and magnificence of Macomber's earlier periods. These are very human figures created from real life, though they are duly made up and characterized as if prepared to act in a play. The symbolism, imagery, and interplay of light and color are rendered in a delicate, subtle manner that dispenses with monumental or grandiloquent pictorial language. The aim is to render an idea, value, or symbol through a creative representation treated with vigor, measure, and great spirituality.

The Bearer of the Soul

(1915)
oil on canvas
University of Michigan

The elements that Macomber adopts for her allegories are often borrowed from popular tradition or children's literature. In this painting, the artist deals with the immortality of the human soul in a traditional and somewhat anecdotal vision. Using a fluid and diffuse brushstroke, she creates a composition based exclusively on color. The undefined image of this soul bearer is executed directly with the brush. It is a bright, evanescent figure, as if it were an angel in charge of collecting a human soul, represented here as a small, radiant figure, which the soul bearer transports like a lamp, holding it delicately in its hands while the soul's halo of light extends throughout the pictorial space.

The allegorical resource of a bright aura surrounding the bearer and permeating the entire surface of the painting was common among the symbolists. The use of a small winged figure to represent the soul is curious and is probably borrowed from medieval art. The artist's interpretation of the supernatural world is striking: It is represented in a dreamy manner as a vague, diaphanous world that can be felt but not touched.

For Mary Lizzie Macomber, symbolist painting represented an orderly, ethereal universe filled with allegorical figures, combining various impressions perceived by the artist's mind. Her peculiar mythological works have a well-defined iconography, where mythological figures are reflected with very human attitudes and gestures. This iconography is accompanied by a studied treatment of light and color, giving the viewer the sensation of contemplating a timeless world in an indefinite space devoid of all context. The artist was clearly more inclined to evoke a concept than to represent a real and tangible world.

ELIN DANIELSON

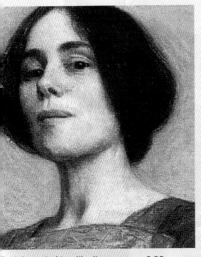

Self-Portrait *(detail), oil on canvas, 9.25 x 10.82 in (23.5 x 27.5 cm), ~1890 Turku Art Museum, Finland.*

- **1861** On September 3, Elin Kleopatra Danielson is born into a middle-class farming family in Noormarkku, Finland.

- **1876** Moves to Helsinki to study at the Finnish Art Society Drawing School.

- **1878** Studies at the academy of Adolf Von Becker.

- **1883** Moves to Paris to study at the Colarossi Academy.

- **1885** Returns to Finland.

- **1888** Settles definitively in Paris, where she frequents Impressionist circles.

- **1895** Takes an academic trip to Italy.

- **1898** Moves to Italy. Participates in numerous artistic events in Finland and Italy.

- **1919** Dies in Italy.

Elin Danielson was a person with a strong, independent character who discovered her artistic vocation as a child and began to practice art early. At the age of 15, she left her family to move to Helsinki alone and later to Paris and Italy.

She arrived in France in 1883 at the age of 22. There she entered into contact with the Parisian Impressionist circle, at the time in its apogee. The works of Renoir and Degas fascinated her for their spontaneity, and the Impressionist style would determine her painting. Her work would also be influenced by the works of ancient masters such as Rembrandt and Titian, whom she found deeply interesting.

In Paris the artist led a bohemian life, adopting an attitude similar to a female version of the 19th-century dandy who observed his society from a safe distance, constantly analyzing the new social reality of his country. Always open to new ideas, when she arrived in Paris, she was attracted by the different artistic circles and styles prevailing at the time. Therefore, it is not surprising to find an eclecticism in her oeuvre that makes it difficult to ascribed her to a specific artistic school.

Despite the clear inclination for Impressionism that can be observed in her works, Danielson undertook numerous voyages that allowed her to come into contact with other pictorial languages. After her first trip to Italy, her artwork became more serene and balanced, and she began experimenting with a more traditional vision of landscape and portraiture.

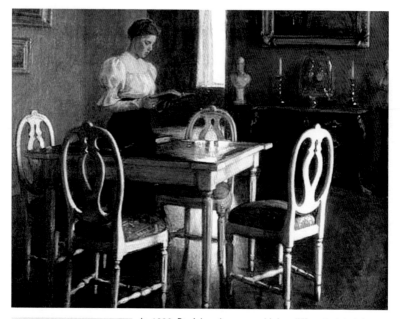

Reading Time

(1890)
oil on canvas
16.5 x 21.3 in (42 x 54 cm)

In 1890, Danielson began combining different pictorial styles. This painting, in a quite traditional style, represents an everyday domestic scene. In a very realistic aesthetic, the image describes a typical dining room of the time, where a well-dressed woman stands reading at the table. The artist used an intense beam of light to reproduce the effect of the light entering from the right, presumably through a large window. The details are meticulous in the path of light striking the various elements in the room. In the foreground is a table and some chairs that are brightly lit, especially the right chair, which creates a contrast with the rest of the painting for its brilliance and constitutes the greatest focus of attention.

The remainder of the composition is a study of light, with the greatest role played by the table and chairs. The console in the background is adorned with candleholders and a bell jar covering a clock, each element shining differently and conceived with great realism. Curiously, the young woman is outside of the most illuminated area and, though her face and blouse can be clearly seen, the half light detracts from her importance.

Despite the traditional style of this painting, the artist's interest in an idea that was fully upheld by the Impressionists is evident: namely, that art not need be grandiose or have a transcendental subject. Any scene, any everyday, commonplace activity in anyone's life, every second and every circumstance, when seen through the eyes of an artist, constitutes a source of inspiration that can give rise to an interesting work. Elin Danielson, who was impressed by the work of some Impressionists and who frequented their circles, participating in their gatherings, demonstrates a clear support of that idea, though her style had still to evolve and acquire a degree of maturity.

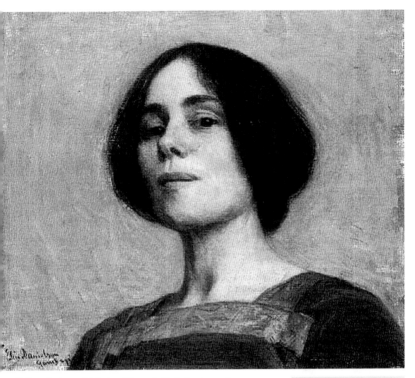

Although the artist had not been in Paris for long, she was eager to explore the art world and experience the events in the city. She showed promising painting skills and a great interest in modern, unconventional art, with a technique that emulated certain Impressionist masters and adopted a great deal of their ideology, according to which light, color, and brushstroke play the principal roles.

Self-Portrait

(~1890)
oil on canvas
9.25 x 10.82 in
(23.5 x 27.5 cm)
Turku Art Museum,
Finland

This is evident in the present work, in which the artist represented herself from a very photographic viewpoint, and certainly the difficulty of executing a self-portrait from this angle would indicate that she probably used a photograph. The sitter is portrayed as in a snapshot of an everyday scene. Well dressed though not overdone, with a natural, spontaneous, somewhat sophisticated expression, she is represented as she is, with a minute study of character and expression that transcends what the spectator sees. The point of view could be interpreted as an attempt to manifest her pride in being a free, independent woman, extremely eager to keep up with the latest innovations.

Self-absorbed, the artist designed a bright yet plain background, so that no one element could distract the viewer's attention. The intense color of the hair acts as a frame around the face, which is in the center of the painting and constitutes its greatest point of interest. The dress, similarly, acts as a sort of pedestal. The image is certainly modern and attractive. It illustrates the artist's personality and the inquiring character that she had demonstrated since her youth.

Accustomed to portraiture with a more classical conception and more traditional appearance, the artist was nonetheless searching for a new conceptual and formal pictorial language, as evinced in this work. Danielson renders herself as a modern woman with clear ideas and a decisive personality. The image is well structured, with an excellent drawing and a technique that reveals a sure hand. There are no signs of hesitation; the work is highly unified and finely balanced in color.

At the Breakfast Table

(1890)
oil on canvas
26.4 x 37 in (67 x 94 cm)
Gallen-Kallelan Museum,
Spoo, Finland

In this work, Danielson represents an everyday scene, proba-
bly reproduced in her studio, with an innovative vision with-
in the Impressionist aesthetic. In accordance with her
strong, independent, and free character, the artist was
strongly attracted by the bohemian atmosphere that she
found in Parisian artistic circles, and she reproduced it in a
realist and spontaneous manner with singular success.

This work represents a woman, seated at a table after a
meal, with a completely relaxed attitude. To better transmit
the sensation of freedom, the artist has given her a loose white dress and posed her leaning
on the table, resting her head on one hand and smoking. The modernity of this work surpasses
aesthetic criteria and heralds a new manner of understanding the world.

When she arrived in Paris, Danielson, who had struggled to defend her freedom throughout
her life, realized that there was a dual morality existing in that city. In official society, women
were considered a mere complement to men. Yet in the Parisian art world, the presence of
women was significant and well accepted. In the world of art, culture, theater, and intellectu-
ality, women were present and well established, playing important roles and behaving with
great confidence.

Danielson describes a new type of woman in this painting, far removed from the traditional,
domestic, and charming concept that other female Impressionist painters such as Berthe
Morissot, Mary Cassatt, and Marie Bracquemond constantly put forth in their works. The
woman in this painting, in an informal, uninhibited atmosphere, far from the conventional
role of mother, disregards stereotypes and established norms. With her weary gesture and
introverted air, she is living in her bohemian world of liberty, which is the only thing that
seems to matter to her. In this light, in addition to showing the stylistically innovative atmos-
phere that the artist upheld, this painting represents a claim in defense of women's right to
freedom, to being themselves and removing all of the "corsets" that imprisoned them.

This Italian landscape, painted by Danielson after her first trip to Italy in 1895, shows the influence that she personally received in Paris from Impressionist painters. Her admiration for the direct painting practiced by Gustave Courbet and John Constable, and by the artists of the Barbizon School such as Camille Corot and Jean-François Millet, led her to adopt a landscape style based on depth and color. This work, showing her great interest in naturalism, is far removed from her char-

Italian Landscape

(~1896)
oil on canvas
Kirpilä Art Collection,
Helsinki

acteristically dense Parisian atmosphere and scenes of everyday urban life. Though she used a meticulously studied brushstroke akin to Impressionism, Danielson conceived this landscape in a highly realist manner. She managed to create a sensation of monumentality in the green meadow through the capricious shapes of the trees, the beautiful symphony of colors, and the treatment of light, elements that lend the work great formal balance. As a counterpoint and to emphasize the idea of life inherent to spring, a small flock of sheep grazes under the two trees that provide a focal point at the left of the painting.

This compositional style allowed the artist to experiment with studied approaches, something that Parisian subjects did not permit. In this painting, Danielson established a visual path that begins in the central group of trees and sheep and moves toward the right to the tree in the foreground. Considering the artist's ideology and her constant concern with personal freedom, it is evident that she used this vision of nature to manifest her preoccupation for living devoid of barriers, breathing fresh air, and freeing herself of the perverse connotations of certain levels of society that urban images evoked.

In juxtaposition to her dark works, the light that this painting radiates is an exclamation in favor of everything that was an objective in her life. This work should therefore not be contemplated only with artistic criteria. It must be interpreted in this other light as well. Due to the social situation of women, they often had to recur to a subtle language in their works in order to transmit a message. This painting is certainly a good example of this subtlety.

Self-Portrait

(~1900)
oil on canvas

In this painting, Danielson represents herself in her studio with her palette in hand. The tones are homogenous, so that the soft light entering through the window behind the sitter, filtering through a cloth hung as a curtain, becomes an atmospheric element that determines the character of the work. During her stay in Paris, the artist's style tended toward eclecticism—understandable since, in her insatiable desire to explore everything that was going on in the city, she entered into contact with all the artistic circles and was thus exposed to a great deal of influences.

In this work, the artist shows her interest in the different effects of light. Her figure is backlit, which, in addition to serving a preestablished expressive interest, lends the image an air of mystery and idealization. To focus attention on the face, the artist executed the dress in black, illuminating and emphasizing the two elements that really interested her: the face, reflecting her personality, and the hands with the palette, referring to her artistic passion.

Like Monet, Danielson attempts to reflect the atmosphere of her studio, where the work is set. The painting thus constitutes an experiment in light and color that aims to create a specific atmospheric effect. Danielson portrayed herself in a very traditional manner, with a serious expression imbued with character, her pose idealized in a nearly photographic aesthetic. Danielson showed herself as she was, a strong woman, proud of her profession and her independence. The absence of intense tones and vivid colors would indicate that this is an intimist work in which the artist takes refuge in her haven, protected from the artistic extravagance of Paris, though the formal approach clearly reveals the spontaneous view of reality of which the Impressionists were so fond.

Margaret MacDonald

The May Queen (detail), watercolor, 12.75 x 26.77 in (32.4 x 68 cm), 1900 Glasgow Museums and Art Galleries, Scotland.

- **1864** Born in Tipton, near Wolverhampton, on November 5.
- **1884** Studies at the Glasgow School of Art.
- **1896** With her sister Frances, she sets up a studio in Glasgow. The first exhibit of The Four is held at the Arts and Crafts Society.
- **1898** Elected a member of the Royal Scottish Society of Painters in Watercolours, where she exhibits intermittently until 1922.
- **1899** Exhibits at the International Society of Sculptors, Painters, and Gravers in London and at the International Exhibit of Art in Venice.
- **1900** Marries Charles Rennie Mackintosh. Exhibits at the Wiener Sezession in Vienna.
- **1902** Exhibits at the Esposizione Internazionale d'Arte Decorativa Moderna in Turin.
- **1909** Participates in an exhibit of women artists at the International Society of Sculptors, Painters, and Gravers in London.
- **1914** Moves to Chelsea, a borough of London.
- **1927** Moves to Collioure in southern France, on the border with Spain. Returns sporadically to London, accompanying her husband, who undergoes treatment for cancer.
- **1928** Charles Rennie Mackintosh dies. Margaret settles definitively in London.
- **1933** On January 7, she dies in her studio in Chelsea.

Married to Charles Rennie Mackintosh and the sister of Frances MacNair, the artist Margaret MacDonald was a member of the group called The Four, or the Glasgow Four.

A graphic designer, interior decorator, and painter, her marriage with Mackintosh was very productive in the artistic sphere. She created a completely new aesthetic language based on the decorative spirit that she used to complement the new style of architecture created by her husband and James Herbert MacNair, her sister's husband. Though at the group's first exhibit, held at the 1896 Arts and Crafts Exhibit, they were qualified by the director of The Studio as "the Spook School," their furniture and graphic designs were recognized as original, if eccentric.

Margaret MacDonald considered herself influenced by the symbolism of Edward Burne-Jones and John Everett Millais, though this is not evident in her work. She did execute symbolist subjects, but in her own personal style. Hence, for example, in her art-

work, the heroes of literature and mythology are represented in a flat manner, sharply outlined against serenely empty backgrounds and drawn in sinuous lines determined by a peculiar manner of understanding perspective.

Like the other representatives of the Glasgow Four, her early works were extremely flat and based on outlined figures, yet did not entirely dispense with depth. In 1910, her artwork reaches a turning point. MacDonald began to experiment with the capacity of color to develop a totally new concept of space and depth.

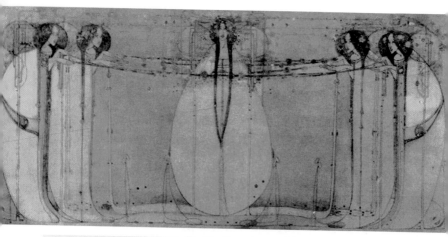

The May Queen

(1900)
watercolor
62.6 x 59.8 in (159 x 152 cm)
Glasgow Museums and Art
Galleries, Scotland

The May Queen is one of three panels executed by Margaret MacDonald for the Ladies' Luncheon Room in Glasgow. At the turn of the century, after Mackintosh had executed the architectural project of the Glasgow School of Art, the Glasgow Four worked together to create a tea room in the same city, where they put into practice their idea of integral creation. Mackintosh and MacNair executed the interior architecture and furniture, while the MacDonald sisters executed the entire decoration.

Margaret MacDonald composed a decorative panel based on the legend of the May Queen, a Germanic myth about Walpurgisnacht—the night of April 30 and morning of May 1, coinciding with the saint's day of the 8th-century saint and Benedictine nun Walpurgis, as well as with pagan spring rites. According to ancient legend, witches have total liberty on that night to hold their "witches' Sabbath" on Blocksberg Mountain, with the devil and the powers of evil. Goethe adopted the legend for a scene in *Faust*.

MacDonald composed this work with a great sense of symmetry. Placing the female figure in the center, she constructed the pictorial space around her garments, using an interplay of straight and curved lines that form flat geometrical shapes. The use of elements of perspective did not appear in MacDonald's art until years later. In these early works, graphic composition predominated, lending her art a fully two-dimensional aspect.

Right: Though this painting can be clearly ascribed to MacDonald's repertoire and reproduces elements frequent in her oeuvre, there are a series of unique factors as well.

Compositionally, the work is organized against a dark background on which there are different textures based on interwoven lines that suggest the waves of the sea at the bottom, the sky with clouds in the right central area, and an imperial tent in the middle left. It constitutes a magnificent display of graphic art that defines and separates areas with decorative functions.

At the bottom, submerged in the water, the inert heads of people devoured by the sea are visible. The imperial tent, adorned with rich damask drapery, is lined along the top with a frieze of masks representing delicate female faces, beautiful and sensual. The upper part is a bed formed by the winds, upon which a woman lies with her child. In this setting, standing on the right, a woman in ecstasy wearing a long dress decorated with multicolored flowers recalls paintings by Gustav Klimt. The strong contrast and rich chromaticism of vivid, intense, nearly aggressive colors contributes to make the image more incisive, something that the painter fully mastered as a graphic artist.

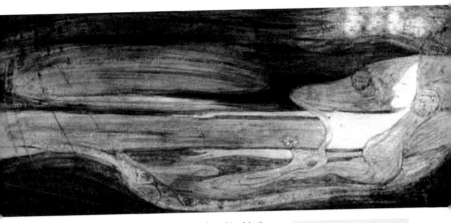

Though the first works executed by Margaret MacDonald with the Glasgow Four had no historicist influence, gradually the artist rediscovered the work of Millais and Burne-Jones, and she became attracted by the representation of beautiful heroines from literature.

In this painting, MacDonald reimagines Ophelia, floating on the water, in a wholly original manner. Ophelia is one of the most famous universal female figures in literature, taken from William Shakespeare's tragedy *Hamlet*. She is the prototype of a woman who, weak and dominated by love, victim of the incomprehensible neglect of her lover and family tragedy, goes mad and drowns while gathering wildflowers.

As in the painting of the same name by Millais, MacDonald represents a highly stylized Ophelia floating on the water. She plays with tonal contrasts to enhance the woman's contours. The composition has a clear linear predominance and the pictorial space is balanced by a large, light-colored area and several small angelic heads.

During her collaboration with Mackintosh, MacDonald was influenced by Aubrey Beardsley's work, prioritizing the linear emphasis and often playing with symmetry to balance her compositions. The structure of the work is very simple and the artist applies the watercolor in horizontal strips that lend it a degree of movement. She used very fine yet discernible outlines, revealing the underlying drawing. MacDonald's works often show great simplicity in their compositional design, with straightforward forms and the expressiveness of the figures based on color. In this painting, Ophelia is floating on dark waters, yet she seems to radiate light.

Ophelia

(1908)
waterolor
Private collection

The Opera of the Seas

(~1915)
watercolor
Private collection

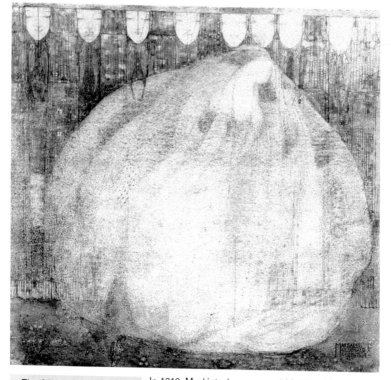

The Mysterious Garden

(1911)
watercolor
Private collection

In 1910, Mackintosh encouraged MacDonald to dedicate herself fully to watercolor. This painting is part of a series by the artist on the obscure legends and myths written by Maurice Maeterlinck.

With an indistinct central form, the artist plays with the technical possibilities of watercolor, using highly diluted pigment applied in long, fluid brushstrokes. During her years as a graphic artist, MacDonald adopted a vocabulary of her own with graphic shapes and symbols that she would later apply to her paintings. Gradually she abandoned the linearity that had characterized her early works, and her painting acquired a sense of volume. MacDonald began playing with aspects of perspective, so that her artwork gained depth.

The use of highly diluted watercolor allowed the artist to play with the effects of light and gradation, composing a series of ambiguous paintings in which the formal conception is diluted through color. MacDonald studied the work of J. M. W. Turner and was attracted by the watercolor technique used by this English painter. Luminosity and color take precedence over composition and form. This is a direct contrast with MacDonald's early works, where form and outlines play the leading role.

In *The Mysterious Garden,* the volumetric form, soft and pallid in tone, takes up a large proportion of the surface. The vaporousness of the entire composition and the frieze masks that limit the upper part make this watercolor an excellent example of MacDonald's later work, a combination of graphics and chromatism, of creativity and symbolism.

SUZANNE VALADON

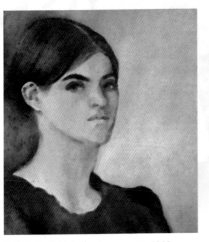

Self-Portrait *(detail), oil on canvas, 1883, Musée National d'Art Moderne, Centre Georges Pompidou, Paris.*

From childhood, Susanne Valadon had worked as an acrobat in the circus, but she quit the profession following an accident and began posing as a model. In time, she became known as "the beauty of Montmartre." After frequenting the studios of Edgar Degas, Pierre Auguste Renoir, Pierre Puvis de Chavannes and Henri Toulouse-Lautrec to pose, she was encouraged by Degas to take up painting and drawing professionally.

Valadon's artwork breathes an air of simplicity and freedom approaching the Nabis. She was completely self-taught, with surprisingly little influence exercised upon her by the artists she met. Only Toulouse-Lautrec, who encouraged her to show her first drawings to Degas, appears as a clear reference in Suzanne Valadon's works. A particular vision of the bohemian world of Montmartre and the use of graphic, defined outlines were elements common to the artwork of both. Among her favorite genres were the female nude, which she reinvented to a certain extent, rendering it with notable sincerity, frankness, and energy, and the portrait, to which she contributed gazes filled with expressiveness conveying innumerable sentiments and impressions. Interested in the techniques of the School of Pont-Aven, with its simplification of forms and the use of vivid colors, she clearly opted for realism, which took precedence over aesthetics in her work. Her use of vigorous lines and flat colors made her artwork personal and intuitive, transmitting great vitality.

- **1865** Born in Bourg de Bessibes-sur-Gartempe, near Limoges, Haute-Vienne, as Marie Clémentine Valadon, father unknown. She leads a difficult, destitute childhood.
- **1869** Moves to Paris with her mother.
- **1870** During the Franco-Prussian War, she lives in a hovel near the Bastille.
- **1880** Works as a strong lady and trapeze artist at the Cirque Molière, near Paris.
- **1882** Leaves the circus following a fall from the trapeze that leaves her temporarily paralyzed.
- **1883** Begins meeting important artists of the time, including Federico Zandomeneghi, Renoir, Degas, and Puvis de Chavannes, for whom she poses as a model. She has a son out of wedlock, Maurice Valadon, who will later become the artist Maurice Utrillo.
- **1884** Becomes personally involved with the Catalan art patron and painter Miquel Utrillo.
- **1885** Meets Toulouse-Lautrec, who falls passionately in love with her. Their romance lasts two years. With him, she frequents bohemian cafés and Art Nouveau artistic circles. Aware of Toulouse-Lautrec's aristocratic origins and his family's wealth, Valadon seeks to ensure her future financially. She feigns suicide to force him to marry her, but he discovers her intentions and their relationship ends.
- **1889** Exhibits at the World Exposition in Paris.
- **1893** In January, she begins a romance with Erik Satie, the pianist at the lively Paris nightclub Auberge du Clou, and she paints his portrait. This relationship lasts until June.
- **1894** Works intensely in Degas's workshop, and she maintains an excellent friendship with him that lasts until his death. Exhibits five drawings at the Société Salon des Beaux-Arts, in Paris.
- **1896** In order to have greater financial stability, she marries Paul Mousis, though their relationship falls apart before long.
- **1909** Exhibits at the Salon d'Automne. Divorces Mousis. Now 44, she begins a relationship with her son's friend, the painter André Utter, who is 23. They wed in 1914.
- **1920** She is elected a member of the Salon d'Automne.
- **1938** Dies in Paris on April 7.

Self-Portrait

(1883)
oil on canvas
Musée National d'Art Moderne
Georges Pompidou, Paris

Valadon painted many self-portraits during her artistic career. She posed long hours for Degas, Renoir, and Toulouse-Lautrec, and her figure was idealized by all of them. They were captivated by her beauty and her inquiring and lively character.

In this painting, Valadon renders her reflection in a mirror with a severe, rigid expression on her face. She includes a bowl of fruit, appearing on the lower right but more fully visible in the mirror. The fruit is intentionally placed to direct the viewer through the portrait visually and indicates that the reflected image was painted from the same viewpoint as the observer's.

The image that Valadon presents of herself is highly innovative within Parisian art in the latter 19th century, since the sitter receives less sumptuous treatment than in the typical spectacular portraits of the time. This new concept of a woman with a strong character and an air of independence was accepted only within the bohemian artistic atmosphere of Montmartre. The attire and important elements in Impressionist portraits, such as hairstyle, reveal a simplicity here that puts Valadon's work in line with a decidedly modern conception of art.

Bathing a Child

(1908)
drypoint
9.1 x 8.3 in (23 x 21.2 cm)
Fine Arts Museums of
San Francisco

On various occasions, Valadon used the subject of children to compose beautiful everyday scenes with a jovial air. In this etching, the artist structurally synthesizes the work by placing the two figures in an undefined space. The principal figure is the strongly built mother, who appears in the center, while the nude boy occupies the lower left. This composition, which Valadon uses in other paintings as well, concentrates the visual interest of the work on a single ground, allowing the nonexistent background to create an effect of contrast and increasing the expressive force of the scene.

The simplicity of forms also fulfills another objective. Valadon, who knew the technique of engraving well, dispensed with superfluous elements as well as textures and volumes. The volume of the bodies is simply created through the linear composition of the contours. The lines and contours of the figures constitute the structural elements of this work.

Toilette of Two Children in the Yard

(1910)
drypoint
13.4 x 15.5 in
(34 x 39.3 cm)
Fine Arts Museums
of San Francisco

The etching allowed Valadon to emphasize the great formal simplification that she applied to all of her pictorial works. The structure of this scene places the figures against an undefined background. Valadon represents each figure independently, without establishing a special relationship between them, allowing the figures themselves to define their roles within the painting.

The absence of a defined perspective is counterbalanced by the mother's inclined position and the girl observing her with her back to the viewer. The simplicity of both form and structure recalls the Nabis, who propounded expressive art based on the absence of superfluous elements that could detract from the emotional capacity of the work.

The inclusion of figures with their backs turned to the viewer was a constant in Valadon's works. With them, she created a sense of depth without having to use elements that describe perspective or excessively elaborate backgrounds that could cause an imbalance in the structural unity of the work.

With an expressive sense based on a sincere, direct style, Valadon renders a nude exhibiting an imperfect yet sensual body in an uninhibited pose, as if captured automatically, without the artist realizing what she was painting. The spontaneity of the scene suggests an intimate yet not overly forbidden moment. This erotic interpretation of the mundane constituted a new artistic vision of the nude, which previously had generally been represented in static images with tense bodies.

The Future Unveiled

(1912)
oil on canvas
51.2 x 64.2 in
(130 x 163 cm)
Musée de Petit Palais,
Geneva

Here, on the other hand, the model appears relaxed, reclining on the sofa, curiously observing the cards held by her companion and completely uninterested in the viewer. Valadon used an equivocal language to enhance the eroticism of the image. The color contrast reinforces this intention, and the painting directs the observer's eye to the woman's body. Her bright nudity radiantly stands out against the dense, dark background of the sofa.

The Montcorin Country Home in Irigny

(1918)
oil on canvas
20.1 x 24 in
(51 x 61 cm)
Frost & Rerd, London

This painting is a synthesis of the various stylistic perceptions that Valadon had absorbed from her colleagues. Against the background, she combines geometrical elements and well-defined volumes. The tree in the foreground divides the scene into two grounds. The colorist richness of the background contrasts with the simplicity of the tree in the foreground, whose protagonism lies in its placement within the painting and not in its qualities or formal expressiveness.

This landscape, one of the few Valadon ever painted, illustrates her need to reflect all of the elements of a scene with the same vitality and intensity. To encourage a free visual path, the painting avoids a rigid structure by use of a single element, the tree, which determines the entire composition. Through this lack of clearly defined structures, the painting is in keeping with the work of the new generation of artists working in Paris at the beginning of the 20th century. Though her beginnings were marked by her relation to the Impressionists, her artwork synthesizes the postulates proposed by the works of Henri Matisse, Paul Gauguin, and Toulouse-Lautrec.

The Abandoned Doll

(1921)
oil on canvas
51 x 32.3 in (129.6 x 82 cm)
National Museum of Women in the Arts, Washington, D.C.

This work illustrates Valadon's mature period, combining a series of elements to create an intimate scene. Both the woman's body and her dress recall nudes painted by Valadon at this time. The woman's strong, voluminous forms lend her a solid air, while the intense colors, echoing those in her still lifes from the time, provide the painting with highly expressive chromatic intensity. The painting constitutes a beautiful combination of solid forms and highly decorative elements.

The Blue Room

(1923)
oil on canvas
35.4 x 45.7 in
(90 x 116 cm)
Musée National d'Art
Moderne Georges
Pompidou, Paris

As was often the case, the artist outlined the figure to define its forms, then drew volume and applied color inside. The woman and her surroundings, elaborate and colorist, maintain a skillful chromatic balance full of rhythm and vitality. The intense colors imbue the painting with energy and transmit a casual, pleasant atmosphere akin to the style of Matisse. The woman's aggressive attitude, with a cigarette in her mouth and an uninhibited, defiant pose, recall the prostitutes painted by Valadon's former lover Toulouse-Lautrec. And the luxurious setting cannot but recall Renoir's nude odalisques, passive, luxurious, and confident. The pose recalls the artist's earlier painting *The Future Unveiled*.

The composition, the pose, the distribution of masses, the unity of the whole, the protagonism of the decorative elements, the definition of forms and resolution of volumes make this a mature piece, far from its apparent simplicity. Valadon put a great deal of emotion into this work, lending it profound expressiveness, though it is used to intensify an insignificant moment in everyday life.

Left: Valadon had a unique perception of everyday life that contrasted with the Impressionist vision of intimate, romantic scenes with women in the home occupied in some activity appropriate to their female condition. Valadon's domestic scenes always have the active component of a mother occupied with her children, as in this painting, where the mother is dressing her daughter after a bath.

In this work, the artist models the two figures using gentler outlines than those in previous works. As was often the case in Valadon's paintings, the general conception is very simple. The ingenuity of forms allows the use of intense tones, offering an image that recalls Gauguin's style. The painting is named after the doll that lies abandoned on the ground on a profusely decorated rug. The detail of the doll adds a deeper meaning to the work. The title of the painting makes the viewer observe the body of the girl more tenderly, as she symbolizes innocence and candor. Without the detail of the toy on the ground, her nudity might have created a sense of neglect.

Maurice Utrillo

(1921)
oil on canvas
25.78 x 20.47 in(65.5 x 52 cm)
Musée Maurice Utrillo,
Sannois, France

This work represents Suzanne Valadon's son, the painter Maurice Utrillo, at the age of 35. Before she had reached her eighteenth birthday, Valadon became pregnant with Maurice without knowing who the father was. Several years after the child was born, the Catalan art patron and painter Miquel Utrillo decided to take care of Suzanne, with whom he had had a long relationship, and her son, to whom he gave his last name in 1896, when the boy was 8 years old.

Maurice Utrillo began painting, following in his mother's footsteps, and entered the bohemian world of Montmartre, where he executed his first works of street scenes. Maurice's relationship with his mother was a mixture of love and passion. Typical of a person with mental problems, he had a constant inferiority complex, depression, and insecurity. Suzanne, apart from being his mother, was always his greatest supporter, friend, and benefactor. His strong feelings sometimes led the young artist to the verge of self-destruction. Maurice Utrillo was a person of difficult character who frequented the most bohemian artistic nightlife of Paris. As a consequence, at the age of 22, he was already an alcoholic, but was able to recover thanks to his mother, who sent him to a detoxification clinic. It was also due in large part to her influence that he decided to approach painting as a means of artistic expression rather than a dissipated and libertine way of life.

Valadon captures her son's character with a sure, energetic hand, his face reflecting an evident unease. The artist uses strokes to outline areas. The work is schematic and has vivid colors, a characteric trait of the works of Valadon. The expressiveness and beautiful description of the portrayed character is noteworthy. No one knew better than his mother the thoughts that tortured his inner world, and it would be difficult to find anyone capable of representing this in such a meaningful and precise manner.

Suzanne Valadon

LOUISE DE HEM

Self-Portrait, *pastel on paper, 54.7 x 42.5 in (139 x 108 cm), 1908, Stedelijk Museum, Ypres, Belgium.*

Ludovica Dehem, who signed her works as Louise de Hem, took her first drawing and painting classes at the Ypres Academy because women were not allowed to enroll in the Official School of Fine Arts. She compensated for the gaps in her studies by continuing her training in Brussels and at the famous Académie Julian in Paris, founded in 1860 by Rodolphe Julian, whose courses were highly academic. Two years later, after completing her studies in Paris, she returned to Ypres. Her first important commission was a portrait of Emile Hynderick, president of the cassation court—the Court of Appeals—which she later exhibited at the Ghent Salon with great success.

In 1904, she moved to Forest, a town near Brussels, where she had a house built in the Art Nouveau style, with a studio and an exhibition hall. At 41, she married Frédéric Lebbe, and after World War I, she gave up painting for good.

Louise de Hem painted still lifes, portraits, landscapes, and genre scenes. Her pastels were

- **1866** Ludovica Dehem is born in Ypres, Belgium, to Henri Dehem and Eulalie Bartier. She learns the basic principles of drawing and painting from her brother-in-law, Théodore Ceriez (1832-1904), a professor at the Ypres Academy.

- **1885** Exhibits a still life entitled *The Oysters* at the Salon in Spa.

- **1886** Continues her artistic studies in Brussels.

- **1887** Studies under Alfred Stevens, a realist Belgian painter who works for the Parisian upper middle class. She frequents the open studio of Ferdinand Cormon.

- **1889** Enrolls in the Académie Julian in Paris.

- **1891** At the beginning of the year, she returns to Ypres.

- **1900** Obtains a gold medal in London.

- **1902** Obtains a gold medal in Lille for her painting *Misery: The Destitute.*

- **1904** Obtains another gold medal in Paris, at the Salon des Artistes Françaises, for the painting *Japannes Doll.*

- **1908** Marries Frédéric Lebbe on May 2.

- **1911** Appointed Knight of the Order of Léopold.

- **1915** Participates in two exhibits in occupied Brussels.

- **1922** Dies in Brussels at the age of 56.

held in particularly high esteem. Her work can be ascribed within realism, a pictorial movement appearing in the Low Countries in 1848. Like other artists of her time, she showed particular sensibility for the social problems and religiousness of the Flemish people. She was granted awards and honors throughout her artistic career.

Return of a Procession in Flanders

(1891)
oil on canvas
51.4 x 38.6 in (130.5 x 98 cm)
Museo Stedelijk, Ypres,
Belgium

This is a scene of everyday life in Flanders. In the background is a church; in front of it stand members of the congregation, dressed in dark colors and preceded by girls wearing their first communion dresses. The artist renders healthy, rosy-cheeked girls from among the common folk, wearing white dresses and veils. The closest one is holding a prayer book, as appropriate in such liturgical ceremonies.

There are precedents for this type of scene in art from the Low Countries. Charles de Groux was a pioneer in evoking the life of the common people, immersing them in a pious atmosphere, as in *The Pilgrimage of Saint-Guidon to Anderlecht* (1856). Hippolyte Boulenger painted *The Saint-Hubert Mass* in 1871 and Constantin Meunier (1831-1905) focused on religious and monastic scenes early in his career. In this work, De Hem renders the piety and religious fervor of country people naturally and realistically.

The Wild Rosebush

(~1891)
oil on canvas
17.7 x 32.1 in
(45 x 81.5 cm)
Museo Stedelijk,
Ypres, Belgium

Louise de Hem executed this painting shortly after finishing her studies at the Académie Julian in Paris. Rodolphe Julian, the founder of that art institute, ensured practical and intensive training and provided models for his students to work on the human figure. Men and women studied in separate classrooms, and their works were evaluated by a team of professors, which in De Hem's case consisted of J. J. Benjamin-Constant and J. J. Lefèbvre.

This painting is one of the artist's first works on the human figure. It is an intimist composition showing great technical mastery. A young woman contemplates the beauty of a wild rose. The dark background contrasts with the pink light reflected from the young woman's hands and face and the flower petals, creating a chromatic association between the woman's complexion and the wild rose, both in a delicate, pale pink. Another superb aspect is the precision of the brushstroke in the highlights, suggesting that the flower vase is made of crystal. The elongated format of the canvas contributes to a sensation of serenity and mysticism, accentuated by the young woman's expression of rapture.

Misery: The Destitute

(1902)
oil on canvas
57.4 x 44.9 in
(146 x 114 cm)
Museo Stedelijk,
Ypres, Belgium

This painting won De Hem a gold medal in Lille. The artist renders an elderly lady and a young mother who is obliged by circumstances to bring her baby to an orphanage. Social concern was one of the most important aspects of the realist movement in Belgium, and this painting constitutes a good example. One of the first to reflect the current social problems was Charles de Groux, whose artwork was poorly received by critics. After primarily painting religious scenes, Constantin Meunier began concentrating on labor subjects after 1879, which would become fundamental in his oeuvre, as evident in *Triptych of the Mine*. In 1887, Léon Frédéric exhibited his polyptych, *The Ages of the Farmer*, at the Brussels Salon, and Félicien Rops, though he was a symbolist, protested against the moral and material misery of his time.

De Hem portrays an elderly lady, bent by the years and her sorrows, about to open a door, while a young mother tenderly holds her baby. The colors and shapes reinforce the drama of this image. The women's clothing is an immense black area of mourning and sorrow, leading the viewer to focus on the faces of the unfortunate women. The light is concentrated on the white handkerchiefs covering the heads of the old lady and the baby and illuminating their faces. The ochre and red brushstrokes on the baby's blanket follow the tonal harmony of the door and the wall in the background.

In the preliminary studies for this oil, there are slight differences from the final result: The position of the old lady's face was changed in order to better reveal her affliction, as was the mother's pose, who embraces the baby more strongly in the final work.

The artist provides a realistic view of urban misery and human feelings in this heartrending, tragic work. She shows the most vulnerable people in society: an elderly lady, a newborn baby, and a mother, not necessarily weak but vulnerable here.

Pandora's Box

pastel on paper
43.3 x 35.4 in
(110 x 90 cm).
Museo Stedelijk, Ypres,
Belgium

The Greeks explained the misery and calamities suffered by humanity through the myth of Pandora. Pandora, the first mortal woman, was created by Zeus and Hephaestus to take revenge on Prometheus for having revealed the secret of fire to humans. Pandora received beauty and ingenuity from the gods, but Hermes planted deceit in her heart. Zeus sent Pandora as a gift from the gods to Epimetheus, Prometheus's brother, who married her, blinded by her beauty. Pandora brought with her a mysterious box with a solemn warning: that it was not to be opened by anyone for any reason whatsoever. But curiosity proved stronger than obedience to Zeus. When Pandora and Epimetheus decided to open it, all of the evils existing in the world began to pour forth. Horrified, Pandora quickly shut the box again, just in time to retain the spirit of hope, which is all that remains to console humanity in the face of adversity.

The subject of Pandora was not very common at the time. Still, Dante Gabriel Rossetti had executed a painting of Pandora in about 1874, with a very different approach: His Pandora is a sensual woman with a cold gaze, terrible and threatening, with one hand shutting a box from which evil smoke still escapes. It is a misogynist view representing Pandora as the cause of all human misery. For this reason, the biblical figure of Eve has been repeatedly compared with the Greek Pandora. In 1910, Odilon Redon executed an oil of Pandora in the garden of Eden, thus associating her with Eve, and looking at the box with curiosity. Louise de Hem's approach is very different. In this luminous pastel in delicate colors, she reveals her mastery. Pandora is an isolated figure, the sole protagonist of the work. She is hesitant, about to make a decision, torn between curiosity and fear of Zeus's terrible warning.

KÄTHE KOLLWITZ

Self-Portrait, *ink and wash on green paper,*
1924, Cologne Museum.

The life and works of Käthe Kollwitz are
marked by tragedy: the death of her son dur-
ing World War I, the class struggle, the eco-
nomic crisis of her country, and the ideological
turmoil of German society. She herself would
write in her diaries: "I want to influence this
period in which humanity feels so disoriented
and is so needful of help".

Hence, the subject of her works, her style,
her manner of composing and her technique
are closely related to her tragic experiences
and circumstances. Her works represent com-
passion, terror, fear, loneliness, war, tragedy.
She rendered her art through the engraving
technique, as this allowed her to dispense with
color, helping her to increase the drama, artic-
ulate a highly expressive line, simplify forms,
and reduce elements extraneous to the subject
or the narrative to focus on the most impor-
tant aspects.

Her style is fully within the German expres-
sionist tradition, which had had a precursor
centuries earlier in Matthias Gothart Nithard
Grünewald (1475/80-1528) and would expand
in the 20th century with a specifically central
European idiom and a multitude of followers
(the groups Die Brücke and Die Blaue Reiter
are good examples) to the present. Since for
Kollwitz, art was action and struggle, her
works cannot be dissociated from social rest-
lessness and agitation. They are neither mere
decoration nor anecdotes, but rather passion-
ate works linked to life and the idea of society
for which she was struggling.

- **1867** On July 8, Käthe Schmidt is born in
Königsberg (Kaliningrad), in the German province
of East Prussia.
- **1884** Käthe, her sister, Lise, and her mother,
Katharina, travel for the first time to Berlin and
Munich. Käthe begins to study independently.
- **1885** Returns to Königsberg, where she studies
with Emil Neide for a brief period.
- **1888** Begins her art studies in Munich, at the
School of Art for Women. She shows an inclina-
tion to engraving.
- **1889** In Munich, studies with Ludwig
Herterich.
- **1891** Marries Karl Kollwitz, a physician, and
settles in Berlin. They will have two sons, Hans in
1892 and Peter in 1896.
- **1893** She exhibits a work for the first time at
the Free Art Exhibition in Berlin.
- **1898** Her series of engravings, *The Weavers*,
exhibited at the Free Art Exhibition in Berlin, is
nominated for a gold medal.
- **1904** She studies sculpture at the **Académie
Julian**, where she becomes interested in the work
of Théophile Alexandre Steinlen and Auguste
Rodin.
- **1907** Spends some time in Florence, receives
the Villa Romana Award, and travels to Rome.
- **1913** The first large catalogue describing her
graphic art is published, compiled by Johannes
Sievers.
- **1914** World War I breaks out. Her son Peter
enlists and shortly thereafter, on October 22, dies
in combat in Belgium. Kollwitz never recovers
from this tragic event. Her work takes an impor-
tant turn: The tragedy of parents and children—
already a focus of her work—in addition to self-
portraits becomes her principal subjects.
- **1917** A retrospective of her work is held at the
Galerie Paul Casserier in Berlin. Kollwitz becomes
interested in works by Ernst Barlach, who power-
fully influences her works thereafter.
- **1918** Becomes the first woman elected into
the Prussian Academy of the Arts, where she
would later work as a professor. Takes up sculp-
ture.
- **1927** On the 10th anniversary of the Russian
Revolution, she is invited to the Soviet Union.
- **1933** The Nazis under Hitler take power. Soon,
Kollwitz's work is considered "degenerate" and
banned from exhibition.
- **1943** Kollwitz flees her Berlin home after 50
years in the capital. Much of her work is destroyed
in an air raid.
- **1945** On April 22, she dies at the age of 77.

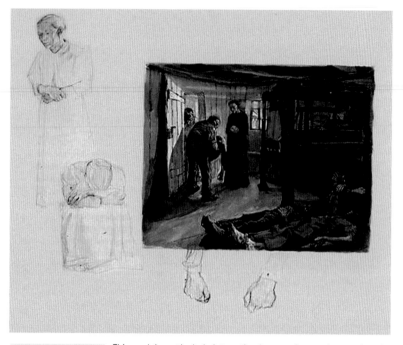

The End

(1897)
wash with graphite,
pen and ink
Staatliche
Kunstsammlungen,
Dresden

This work is particularly interesting because it contains a series of preliminary sketches in the margins. It reveals the facility with which the artist rendered volumes, postures, and the general schematism of the figures. She used very few lines to express the substantial essence of her work. These sketches and the initial idea are consolidated in the final work, in which the surface is filled in only to emphasize the heartrending expression of the scene.

The artist renders an interior in which men are carrying a corpse through a door in the rear that will join those already lying on the floor in the right foreground. The ochre colors (caused by transparency with the paper and by superposition of inks) and the dramatic foreshortenings of the dead bodies (which recall Mantegna and lead the viewer's eye away from the corpses to the standing figures), combined with the weight and tonal darkness of the work, are synonymous with a dismal, mortuary space of grief and devastation.

Revolt

(1899)
graphite, pen and colored ink
Käthe Kollwitz Museum,
Berlin

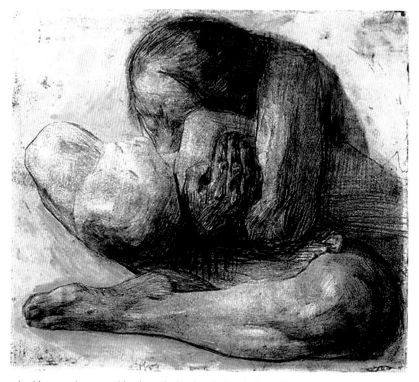

In this engraving, everything is meticulously calculated: the scale of the figures with respect to the size of the paper, the point of view, the perspective, the formal treatment. The most striking element is the composition, which blends the mother and her dead son into a single mass that, though it allows the viewer to differentiate them, does not separate them at all, as the artist is attempting to express with the greatest exactitude the terrible gravity of the moment: The death of the son inexorably leads to the death of a part of the mother. That circumstance is the only thing that really matters and constitutes Kollwitz's single obsession.

Woman with Her Dead Child
(1903) etching National Gallery of Art, Washington, D.C.

The faces are vague, the only expressiveness in the work arising from the lines and forms. The figures are impersonal, lost in a flattened mass and afflicted by desolation, with all of the weight of the grief and death that affects both figures equally. This is a substantial aspect throughout the work of Käthe Kollwitz and lends it a universal character, making her an artist of great influence on her contemporaries. Tragically, the painting was a premonition of what would happen to Kollwitz herself several years later, in 1914, when she lost her 18-year-old son Peter in combat during the First World War.

Left: A mob of rioters advances, leaving behind a trail of fire and destruction. There is neither peace nor compassion. There is no humanity in the pencil- and brushstrokes. What is represented is people consumed by rage. The blackness predominating in the scene is a symbol of the maddening terror and moral blindness of the rioters. There are no individuals, but rather a feverish, infuriated mob lacking anything resembling sanity.

The darker fringe along the horizon in the center of the scene balances the image, leaving two lighter spaces above and below, and constitutes a morphological resource that alleviates the expressive tension and focuses attention on the passionate movement of the rioters. On the horizon is fire and smoke. There is no glimmer of hope, not even in the distance.

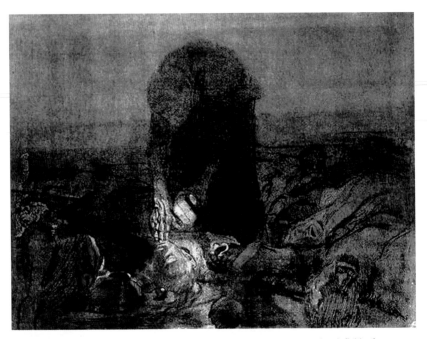

The Battlefield

(1907)
etching
Private collection

As the title indicates, this work represents a battlefield, after the combat has ended. A woman searches among the corpses for a loved one. The scene is dominated by darkness, except for a bright central light in which the woman's hand coincides with one of the corpses strewn about on the ground. The etching technique used by the artist is formidable, offering a variety of resources to create a highly expressive atmosphere of drama. The tortuous lines compound masses of bodies that can hardly be differentiated as they spread toward an obscure horizon.

Only the silhouette of the woman stands out. She is immersed in the darkness, her body bent nearly double under the gravity of the moment, a symbol of her exhaustion and physical and emotional collapse. Through its darkness, tortuous lines, predominant lack of definition, the ghastly aspect of the battlefield, and the gesture of the woman—alone, desolate, and avidly searching for confirmation of what she most fears—this work is a reflection of the appalling calamities of war.

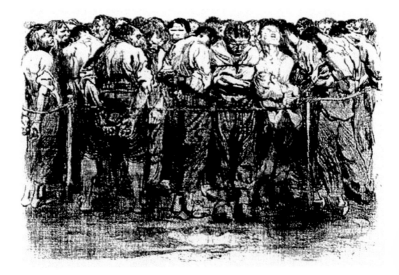

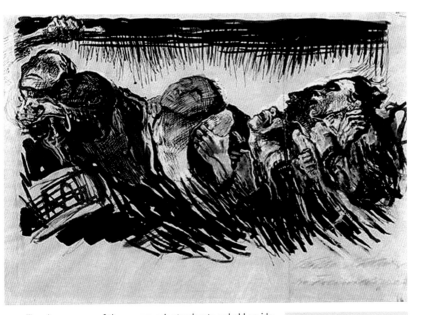

The Volunteers

(1920)
etching
Private collection

The phenomenon of the masses volunteering to uphold an ideological cause is expressed in this work through an accumulation of graphic elements and the exaggerated gestures of the strokes on the plate, lending the etching movement and rhythm. A few touches of color help differentiate the bodies, lights, and shadows.

This devastating image is based on an excellent, simplified technique in the application of acids on the copperplate. The composition, centered and elongated by the effect of the shadows along the upper edge, provides no respite for the figures moving from the earth toward the sky. The drama of their expression increases this effect. The scene inevitably recalls the iconographic treatment of Goya's Black Paintings and the technique of his engravings. There is no doubt as to the influence that this Spanish artist exercised on expressionism, as evinced in this work.

The Prisoners

(1908)
etching
Private collection

The accumulation of bodies forms an agglomeration in which it is difficult to distinguish each individual. The image expresses the indiscriminate action of human cruelty. People are treated as if they were merely masses of flesh.

The scene consists of a large group of people huddled together in a concentration of pain and suffering, awaiting a terrifying event or announcement that will arrive at any moment. The overhead light seems to be the only wisp of hope, and some figures are looking up at it amid the desperation, fear, and helplessness. Most of the others are immersed in a despair that makes them lower their heads. In this etching, Kollwitz reveals herself as a sculptor. The volumes represented in accumulation and their treatment are the preliminary steps to a sculptural vision of reality. In fact, toward the end of her life, the artist would become a renowned expressionist sculptor.

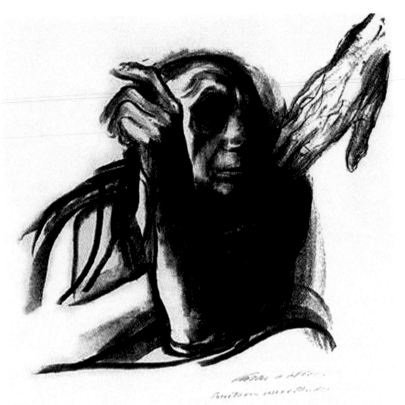

The Call of Death

(1934)
charcoal on paper
Käthe Kollwitz Museum,
Berlin

Although Käthe Kollwitz's death-related scenes are usually highly dramatic, this work is an exception that departs from her deep-rooted tendency toward social criticism. This is a self-portrait in which the artist receives the call of death in resigned silence and in peace, as if it were something natural for all mortal beings. No resistance to leaving life is insinuated. Indeed, it almost seems as if this assault were appreciated, as it will bring definitive peace, a well-deserved rest after a life of struggling and pain—it is accepted as a positive, necessary, desired event. The greatest intensity of the work lies in its composition of crossing diagonals formed by the face and from the hand of death to the artist's own, leading the viewer's gaze beyond the frame into a perfectly suggested absence, into the beyond.

FRANCES MACNAIR

Spring *(detail),* watercolor, 17.24 x 5.12 in (43.8 x 13 cm), 1898, Glasgow Museums and Art Galleries, Scotland.

- **1873** Born in Kidsgrove, Staffordshire, on August 24.

- **1890** Her family moves to Glasgow. Studies at the Glasgow School of Art until 1894.

- **1892** Obtains the bronze medal for a design executed in silver in a national art competition.

- **1895** She and her sister, Margaret MacDonald, also a painter, the architect Charles Rennie Mackintosh, and the designer Herbert MacNair create the group called The Four. .

- **1899** Marries Herbert MacNair.

- **1900** Her son, Sylvan, is born.

- **1901** Moves to Liverpool, where she and her husband give classes at the School of Architecture and Applied Art.

- **1908** Returns to Glasgow.

- **1910** Gives design classes at the Glasgow School of Art.

- **1921** Dies in Glasgow on December 12. After her death, Herbert destroys many of her works.

rances MacNair, née MacDonald, was part of the group known as the Glasgow Four, along with her husband, the architect Herbert MacNair, her sister, Margaret MacDonald, and Charles Rennie Mackintosh, eventually her brother-in-law.

MacNair's artwork is characterized by absolute sincerity and a stylistic originality based on linearity and symmetry that reveal the influence of Aubrey Beardsley and Jan Toorop. There is also an abundance of folkloric elements, among them various Celtic motifs.

Though the MacDonald sisters affirmed that they profoundly admired the work of Dante Gabriel Rossetti and Maurice Maeterlinck, the influence of these men is not noticeable in Frances MacNair's art. Her painting is strongly dominated by graphic creativity and her watercolors have unique structures, quite different from the norms of her time. Her works are often ovally compartmentalized, and the con-

stant use of abstract circular forms to frame figures makes them truly original.

Frances MacNair employed diluted watercolors with different wash and rinsing techniques, obtaining tenuous, diffuse tones. The artist adopted these techniques to construct the backgrounds of her paintings and to achieve an innovative atmospheric effect present in all of her works. This use of transparent pigment also allows the initial pencil or ink drawing to show through, though weakly. MacNair used this technique to emphasize the linearity of her art. Many of her works recall the artwork of Gustav Klimt.

FRANCES MACNAIR

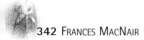

Bows, Beads, and Birds

watercolor
11.8 x 13.8 in (30 x 35 cm)
Private collection

In this painting, MacNair plays with different decorative elements to create a composition apparently based on fashion design. With curved lines clearly predominating, the artist reinterprets the image of the Three Graces, adapting it to the new stylistic movement of the Glasgow group. The work is conceived wholly on the basis of a curvilinear composition, lending it a sensation of movement that contrasts with the artwork of other symbolists. Each figure is independent, and the artist lends the garments a markedly symbolic character that has little to do with the expressiveness of the figures.

The woman with red bows on the left is dressed in a transparent garment that reveals her innocent nudity. The abundant bows distributed throughout the dress and on the veil are organized in horizontal strips. Her eyes are closed and her expression denotes timidity. The middle figure, on the other hand, appears presumptuous. Her dress is the most complex, with beads distributed throughout its surface. The third figure is free. Leaning back, she seems to be unconcerned with the viewer's presence; she is enraptured by allegorical birds that symbolize aesthetic freedom taking flight.

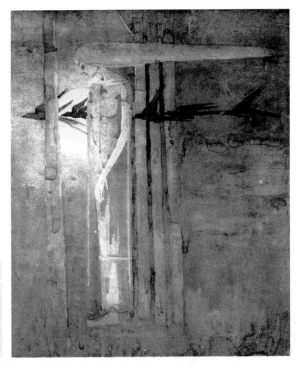

III Omen

(1893)
watercolor
Hunterian Art Gallery,
Glasgow, Scotland

The full title of this work is *III Omen: Girl in the East Wind with Ravens Crossing the Moon.* It is an allegory of a woman exposed to the changing winds of fortune and love. The aesthetic of The Four is reflected in this work by the massive presence of parallel straight lines that determine and define the pictorial space.

In this painting, the vertical line prevails. Two parallel ochre lines flank and nearly imprison the model's body, while the figure is placed among several schematic trees in the tone used for the background, which pervades the entire work. As a horizontal dividing line, MacNair paints a flock of black birds flying from right to left while the model's long hair flows behind her in the opposite direction, blown by the wind.

The artist employs various watercolor techniques, showing a particular interest in washes. Her frequent use of highly diluted watercolor to create backgrounds is extended in this work to cover the entire scene. The moon, at the middle left, illuminates the pictorial space, and the wash technique is applied to blend the light with the various elements in the scene.

A Pond

(1894)
watercolor
Private collection

Left: The profound decorative sense that MacNair lends her works is evident here. In her paintings, the artist, along with her husband and the Mackintosh couple, developed a new pictorial language based on highly linear forms and projections.

The artist shows a very original compositional style, in which the formal construction of the pictorial space is based on geometrical forms. She creates art verging on the architectural; the various elements are superimposed to construct an image. The position of the two human figures, leaning forward to form an arch or a bridge, increases the architectural aspect of the work. MacNair used symmetry and linear forms to create an ordered and rational space, in keeping with the aesthetic guidelines put forth by The Four. These characteristics are also found in the art of Margaret MacDonald.

The Moonlit Garden

(1895-1897)
watercolor
Glasgow University,
Glasgow, Scotland

MacNair's early works were generally two-dimensional. Only in later years did she began to use elements of perspective and volume. In this early painting, she experiments with different techniques and tones—but she does not try to achieve a three-dimensional quality. Ornamentation here, as was usual for her at this time, is completely flat. She creates fantastic abstract elements based on geometrical forms used to compose and distribute space.

In this painting, the composition is based on a single axis of symmetry that divides the painting into two virtually identical spaces. Within a circular shape, the artist draws a garden bathed in the yellowish light of the moon. On either side of the moon are three groups of figures kneeling in front of flowers. To guarantee balance and serenity, the artist has created an intimist scene, which contrasts curiously with the intense luminosity of the work.

This orientalizing conception of simplified space was characteristic of The Four and frequent in the artist's floral designs. The reproduction of plants and flowers as ornamentation was a constant in the MacDonald sisters' artwork. They both used plant motifs in a very linear, simplified manner to compose balanced, serene decorations with vertical and horizontal patterns.

Autumn

(1898)
watercolor
Glasgow Museums and
Art Galleries, Scotland

Though everyday scenes were not frequent in the symbolist art of the end of the 19th century, this painting represents a wedding in a very particular aesthetic. At the same time, it constitutes an allegory of love.

A Paradox

(1905)
watercolor
13.8 x 17.3 in (35 x 44 cm)
Private collection

The artist places a group of people in a circular configuration against a watery blue background. The elongated bride's dress determines the placement of the other figures, which slowly lose intensity and dissolve into the background as the distance grows between them and the luminosity radiated by the dress. The entire scene is regulated by circular lines that suggest movement, accompanied by flowers that are also circular, principally roses. (MacNair had designed these flowers years earlier, and she employed them in many of her drawings and paintings.)

Though the sensation of movement can be associated with the joy and effervescence of a wedding, the title refers to a paradox, which can be interpreted as the ephemeral nature of love. On another level, the suggested movement can refer to the changes that the figures undergo: The woman in the background and the bride are the same person, evoking the transition between opposite passions—love and hate, joy and sorrow, happiness and pain.

Left: In her paintings, MacNair used different symbolist typologies. In this one, the artist evokes autumn through diffuse forms and ochre tones. This painting belongs to a series on the seasons, all in this format, in which each season is personified as a woman. The artist uses the same compositional style for the four works, creating a mystical, mysterious atmosphere around the female figure.

Here, the colors used evoke autumn. The artist blends tones in circular shapes to create a homogenous painting. MacNair neither concentrates the meaning of the season in the woman nor in any other single element. It is rather the whole that conveys an autumnal sensation. In her allegorical paintings, MacNair, like MacDonald, transmits sensations through a balanced view of the whole and a tone that permeates the entire pictorial space.

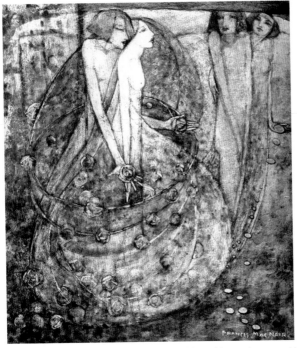

The Choice

(~1909)
watercolor
Hunterian Art Gallery,
Glasgow

Two clearly differentiated pictorial styles are present in Frances MacNair's artistic trajectory. During her first years as part of The Four, she painted in a linear, geometric style clearly influenced by the architectural work of her husband and of Charles Rennie Mackintosh.

Gradually MacNair created her own style, in which she combined that mathematical vision of pictorial composition with an artistic reading of the work.

In this painting, MacNair blends a linear vision with a style approaching an established pictorial tradition. She continues using the human body as a decorative element, though it is no longer subject to a geometrical conception. Two lovers in profile, turned slightly forward, are on the left, showing their slender nude torsos. They are observed by two young women on the right, who display a mixture of surprise, curiosity, and envy. In this painting, the figures are somewhat independent. In addition to the evident symbolism, the expressive force of the faces and gestures is striking, lending contrast and a counterpoint to the lightness and delicate, sensual stylization of the figures.

The Sleeping Princess

(1909-1915)
watercolor
Glasgow Museums and Art
Galleries, Scotland

In an appropriately elongated format, MacNair represents a princess who is sleeping yet not at all disheveled, as evident in her clothing and static coiffure. The influence of Aubrey Beardsley's work is visible in the use of defined outlines and a clear linearity. The dress, highly graphic in conception, recalls the works of Gustav Klimt. In their works, both artists used the same typology of stylized bodies and garments that acquire volume, forming a graphic composition somewhat independent of the subject. MacNair was a graphic designer as well, and as such, she introduced elements of design in her paintings. Like Beardsley, MacNair particularly focused on fashion design for her figures, which she adorned with sophisticated arabesques and other patterns, generally executed with painstaking precision. In this work, the skirt that expands as it flows downward until it creates its own space is used by the artist to represent decorative motifs of a distinctly allegorical nature.

PAULA MODERSOHN-BECKER

Paula Modersohn-Becker with Elisabeth Modersohn, about 1900.

The expressionist artist Paula Modersohn-Becker died prematurely at the age of 31. She died at the artist colony in rural Worpswede, where she had first settled early in her career. There she hoped to find the simplicity that she sought for her paintings, in which she evoked the spiritual values of realist subjects. Other artists at Worpswede held a Romantic view of country life in contrast to urban industrialization. This did not interest Modersohn-Becker; she liked large cities. She sought inspiration in Paris and was the first female German painter to settle there. She developed her own style, influenced by Paul Cézanne, Vincent van Gogh, Paul Gauguin, and the symbolists.

Her artwork reflects the conflict between her life in Worpswede, governed by her marriage and her fondness for simple people, and her artistic activity, for which the stimulus of Paris was essential.

During her short career, Modersohn-Becker hardly exhibited and sold only a few of her works, mostly to friends. In addition to landscapes and still lifes, she painted portraits of country people and, especially toward the end of her life, strange self-portraits that were highly simplified and primitive in style. She abandoned her high pictorial level to gain in expressiveness. During her last period in Paris, she developed an elaborate style with a somewhat contained use of colors, though her palette was open to vivid, radiant colors as well. Unfortunately, her untimely death cut that development short, and with it, the many possibilities that it promised.

- **1876** Paula Becker is born in Dresden, Germany. She is the daughter of Karl Becker, railway engineer, and Mathilde, from a rich, educated family with six children.
- **1888** The family moves to Bremen.
- **1892** Spends some time in England, at an aunt's house. Attends drawing classes at the London School of Arts.
- **1893-95** Following her father's advice, she studies to become a professor in Bremen, but continues to take private painting classes.
- **1896-98** Studies at the school of drawing and painting of the Berlin Association of Women Artists, founded to educate women in the fine arts.
- **1897** During vacations, she takes classes from the artist Fritz Mackensen (1866-1953), who retires to Worpswede, a village near Bremen in northern Germany.
- **1898** Moves to Worpswede. The world of agriculture and northern German landscapes become the subjects of her paintings. She meets the sensitive and famous landscapist Otto Modersohn (1865-1943), who also lives at the artist colony of Worpswede. Although there is mutual attraction, a relationship is impossible because he is married and has a daughter. She begins a cordial, lasting friendship with the sculptor Clara Westhoff (1875-1954), who would later study under Auguste Rodin in Paris.
- **1899** After a scathing review of her works at an exhibition in Bremen, Becker retires from public life but continues to paint. Until her death, there is hardly any public knowledge of her artwork.
- **1900** Travels to Paris, where she studies at the Académie Colarossi and attends an anatomy course at the École des Beaux-Arts. When she returns, she becomes friends with the poet Rainer Maria Rilke, the future husband of Clara Westhoff.
- **1901** After Otto Modersohn's wife dies, Paula Becker marries him.
- **1903** Travels to Paris, where she attends Impressionist and Japanese art exhibits with the Rilke couple.
- **1905** Travels to Paris again, studying at the Académie Julian.
- **1906** She rents a studio in Paris, and attends classes at the École des Beaux-Arts.
- **1907** She dies three weeks after the birth of her daughter, Mathilde. Rilke writes *Requiem for Paula Modersohn-Becker*.

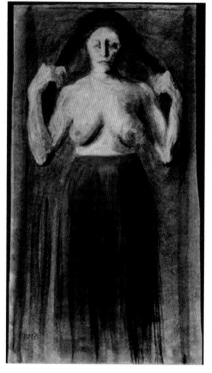

Partially Nude Woman Holding Her Hair Apart

(1898)
charcoal with black and brown
chalk on wove paper
3 x 1.7 in (7.63 x 4.27 cm)
National Gallery of Art,
Washington, D.C.

As a student of the Berlin Association of Artists and of Fritz Mackensen, Paula Modersohn-Becker drew a series of nudes that were mostly anatomical studies. This foreshadowed the artist's later simplicity and her manner of understanding the human being. She approached this woman and rendered her with dignity, respect, and realism. Only the nude bust and the face are illuminated and stand out from the darkness. The vertical line predominates in the lower half of the painting, especially in the hair and black skirt, lending the drawing a serious, nearly sorrowful air.

Gazing downward and with her hands in the air holding up her black hair, the model is wholly at the artist's mercy. This work is not erotic, and the woman's nudity is not the focus of the painting. The artist creates a work with a realism that goes beyond the mere reproduction of a visual image. She renders the model's emotional state, a very important aspect of Paula Modersohn-Becker's art as well as that of many of her contemporaries.

Tree

(1899)
oil on cardboard
24 x 14.2 in (61 x 36 cm)
Snite Museum of Art at the
University of Notre Dame, Indiana

In Modersohn-Becker's early works, from her first years at Worpswede, the landscape occupied a very important place. During this time, the swampy northern German landscape was a frequent motif, with elements such as ponds, canals, fields, plants, country houses, and trees. This painting is executed in the typical thick brushstrokes, striking black lines, and flat colors of expressionism. Begun in a realist style, *Tree* shows the abstraction that the artist increasingly sought as her work evolved.

Also striking is Modersohn-Becker's preference for horizontal and vertical elements, evident here in the dominant tree trunk, and the wide horizontal line that separates the flat middle ground from the background with its hill and sky. Brownish and reddish earth colors predominate over the sky in various shades of gray. This painting perfectly reflects the wild, rugged area near Worpswede during an autumn storm.

Girl Next to a Birch Tree

(1904)
oil on cardboard
Sammlung Böttcherstrasse,
Bremen, Germany

This is one of the several versions that Modersohn-Becker painted of a landscape with a birch tree after 1900. Although she incorporated a girl in this mature work, the general composition of all the paintings in this series is similar: The tree trunk in the foreground divides the work in two. The middle ground has another trunk and a field or meadow with a red rooftop in the rear, the house itself lying beyond the high horizon line. The colors of the foreground are dark, while the elements in the background are paler and the palette becomes lighter with the distance, reaching its lightest point in the white of the clouds.

In this aerial perspective, the girl by the tree stands out from the background but, in contrast to the artist's portraits, she is not clearly visible because she is in the shadows and her face is indistinct, such that neither her mood nor her appearance can be perceived. This is not a portrait of a figure in a natural setting, but rather a landscape with a figure as an integral part of it.

Country Girl from Worpswede Sitting in a Chair

(1905)
tempera on canvas
35.4 x 24 in (90 x 61 cm)
Kunsthalle, Bremen

The Nazis confiscated this portrait in 1937 as they considered it embarrassing, along with 70 other works by the artist, though in 1945 some of her works were exhibited in the Kunsthalle. Other works by her were destroyed or are lost. For its proximity to popular art, the painting recalls the naive art of Rousseau. Georges Bracque and Pablo Picasso, along with many other artists in Paris, were interested in Rousseau's art, because he had not had an academic education and he painted with the innocence of a child. This portrait combines this purity of measure and style and the artist's great skill in expressing the sitter's emotional state. The big-eyed girl is seated rigidly in a chair that is too large for her. With her blond hair, modest felt shoes, and regional outfit including striped dress, and her surroundings of a simple wall with a molding, she represents a typical country girl from northern Germany and is simultaneously a portrait of a specific individual.

Modersohn-Becker felt great tenderness toward her models and often wrote the story of their lives in her diary. After she returned from Paris in 1903, she wrote: "Return to Worpswede. I approach the people here again and feel their biblical simplicity." Perhaps this was the key to her greatness as a portraitist. She was perfectly capable of transmitting the awkwardness, immaturity, indecision, and general character of an adolescent girl as well as the mature experience of an old lady.

Still Life with Oranges, Lemon, and Tomato

(1906)
Staatliche Kunsthalle,
Karlsruhe, Germany

In this still life, Modersohn-Becker represents bananas, oranges in a white cardboard box, lemons, and a tomato placed on a simple white tablecloth. In many of its aspects, this painting shows the influence of Paul Cézanne. Modersohn-Becker applies several elements typical of Cézanne, such as the composition seen from above, the elements included, the yellowish orange tones mixed with browns in the fruit next to the white, gray, and blue of the tablecloth, and the manner of painting. This structuring of the surface through colors is very different from Impressionism's dissolution of forms, yet it is also less rigorously expressionist than other paintings by Modersohn-Becker.

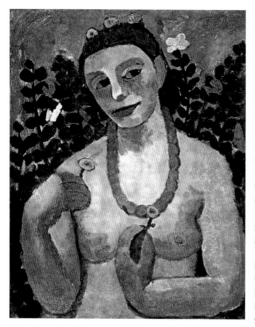

Self-Portrait with Amber Necklace

(1906)
oil on canvas
23.6 x 19.7 in (60 x 50 cm)
Kunstmuseum, Basel

In this mature self-portrait, Paula Modersohn-Becker not only shows her physical self but also her artistic personality. It was very unusual at the time to execute a nude self-portrait, and this painting was therefore controversial, eliciting both rejection and acceptance.

The work confirms the artist's belief in herself, her art, and her femininity, enhanced by the necklace and flowers. She is in a natural setting resembling paradise, surrounded by foliage. It is as if this place were the source of her art and creative energy. Resembling her portraits of simple people, this painting does not render her nudity as superficially erotic. Yet she portrays herself as a woman in full vitality with rosy breasts, and her smile of complicity is attractive and sensual. The flowers in the background and in her hands form a circle around her head like a halo. The amber necklace also rings her head, repeating the circular motif. Some of the flowers are shaped like hearts and indicate that the sitter feels good about herself.

Self-Portrait Looking Toward the Right with Hand on Chin

(1906)
oil on canvas
11.4 x 7.7 in (29 x 19.5 cm)
Niedersächsische Landesgalerie,
Hannover

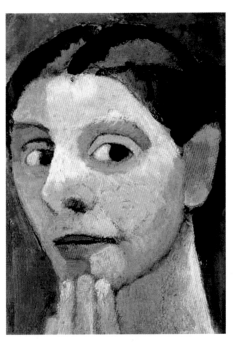

This work can be ascribed to the habit of many artists of portraying themselves, perhaps as an exercise in a dialogue with themselves. At this time, Paula Modersohn-Becker, who had earlier felt a strong attraction toward Otto Modersohn and had married him four years earlier, was suffering the effects of the couple's crisis. Their problems had motivated her to move to Paris in an attempt to find peace and gain distance. In approaching herself, she occupies the entire surface of the canvas with her face. This allows the definition of not only the facial features but also the personality: a young, delicate mindset full of hope, offering herself yet mistrustful, troubled yet tenacious.

Elderly Lady from an Alms House in a Flower Garden

(1906/07)
oil and chalk on canvas
37.4 x 30.7 in (95 x 78 cm)
Sammlung Böttcherstrasse, Bremen

In this portrait of an old woman in a garden of flowers, each element has a place within the harmonious composition as well as a symbolic role. The dense group of the woman, the flowers, and the bulging bottle placed upside down as decoration in the rural garden is bordered by a hedge in the foreground that encloses the scene and provides a horizon line in front of a golden and turquoise sky. The contrasts between warm, complementary colors such as red and yellow and cool colors such as green and violet predominate. Black outlines determine the shape of each element and transform them into two-dimensional objects, as is typical in expressionism. This flatness remains in the forms modeled by color such as the red jacket.

The subject of the painting is a woman integrated into the natural cycle of life. Modersohn-Becker uses symbols such as the poppy in its different stages of growth, beginning with the capsule, then the flower, and finally the wilted stage. In addition, the poppy and the foxglove held by the elderly lady were known as medicinal plants that had either positive or detrimental and even deadly effects, depending on the dosage. The elderly woman nearing the end of her life and the bottle as a symbol of female fertility that gives renewed life are framed within this garden of botanical symbols.

Mother Breastfeeding Her Child, *or* **Mother with Child,** *or* **Nursing Mother**

(1907)
oil on canvas
44.5 x 29.1 in (113 x 74 cm)
Nationalgalerie SMPK
(Staatliche Museen Preußischer Kulturbesitz), Berlin

This painting was executed in the artist's last year of life, when she returned to Worpswede after her husband had visited her in Paris and they had reconciled. She was pregnant at this time. Hence, her increasing focus on the subject of mother and child is not surprising. The woman is rendered as a goddess of fertility. Her dark skin, black hair, physiognomy, and nudity recall the women in Gauguin's paintings from the South Pacific. In contrast, the child breastfeeding in his mother's arms has rosy skin and blond hair. According to art historian Robert Suckale, this painting has elements of an icon in its accentuation of the female body in the center, in the nimbuslike disk on which she is kneeling, in the symmetrical framing between the two potted plants, but above all in the flatness and simplification. The disintegration of volume into color surfaces, the cubist blocks, and the decomposition of the figure into facets of light and dark areas, especially in the neck, arms, and chest, follow Cézanne's principle of modeling forms through color.

With this synthesis of a universal symbology, intimacy, and the enlarged forms attaining monumentality, Modersohn-Becker reveals her independent style, somewhere between the primitivism of Gauguin and Picasso—during the phase when he was influenced by ancient Iberian art and African art—and the German expressionist group Die Brücke.

LLUÏSA VIDAL

Self-Portrait *(detail), oil on panel, 14.2 x 10.6 in (36 x 27 cm), ~ 1899, Museu d'Art Modern, Barcelona.*

When Lluïsa Vidal exhibited at Els Quatre Gats in 1898 along with Isidre Nonell and Ricard Canals, a new generation of Catalan Art Nouveau artists was emerging. These artists were gradually moving toward the Noucentista movement that so characterized Catalan art and culture at that time, which was so rooted in other European avant-garde movements. This marked the beginnings of a new artistic movement of social criticism and protest.

Lluïsa Vidal was initiated into the world of art by her father, a cabinetmaker and active exponent of the decorative creativity of modernism, or Art Nouveau. The Vidals were devoted members of modernist art circles and organized festivals in the village of Sitges, which had become a leading center of the Catalan modernist movement. The town served as a meeting place for such important ideologists of this movement as Santiago Rusiñol, Ramon Casas, and Miquel Utrillo, with whom the artist often met.

During this time, Lluïsa Vidal, following her father's advice, decided to take up the decorative concept of art propounded by modernism. Using intense tones, she executed genre paintings based on portraits of people personally close to her. The paintings serve as an artistic chronicle of modernism.

But after her trip to Paris in 1901, Vidal came into contact with a new pictorial style that was more committed to the feminist cause. When she returned from the French capital, she became a popular illustrator of feminist publications and a defender of the transformation and reevaluation of women's roles.

- **1876** Lluïsa Vidal is born in Barcelona, a daughter of the furniture-maker Francesc Vidal i Jevellí. Begins her artistic studies with Joan González i Pellicer y Arcadi Mas i Fontdevila, then enrolls at the Llotja School of Applied Arts and Design in Barcelona.

- **1898** Exhibits for the first time at Els Quatre Gats, at the IV Exhibit of Fine Arts of Barcelona and at the Sala Parés Gallery.

- **1900** Visits the World Exposition of Paris. Exhibits at the Sala Parés.

- **1901** Moves to Paris for two years to study at the Académie Julian, where she is taught by Eugène Carrière. Makes a brief trip to London.

- **1906** Exhibits at the Fine Arts Exhibit in Madrid, where she receives honorable mention. Exhibits at the Sala Parés.

- **1907** Works as an illustrator for *Feminal*, a monthly supplement to the graphic review *La Illustració Catalana*. Participates in an art event at the Círculo Ecuestre de Barcelona. Receives a medal at the V International Art Exhibit of Barcelona.

- **1908** Gives drawing and painting classes. From this year and until 1915, she contributes continuously to the magazine *Feminal* with her illustrations.

- **1910** Shows her works at an exhibit to celebrate the centennial of Mexican independence in Mexico City.

- **1911** Founds an academy of drawing and painting in Barcelona. Participates in the First Exhibit of Work by Catalan Women. Receives a medal at the VI International Painting Exhibit of Barcelona.

- **1912** Participates in the Fine Arts Exhibit of Madrid.

- **1914** Receives a commission from the Barcelona City Council to execute a portrait of the poetess Josepa Massanès. Exhibits at the Sala Parés.

- **1915** Participates in the National Exhibit of Painting, Sculpture, and Architecture in Madrid.

- **1916** Participates in a pacifist art festival in Barcelona. Exhibits at the Sala Parés as part of a tribute to Pepita Teixidor.

- **1918** Dies in Barcelona on October 16 during the influenza epidemic.

Untitled

(1890-1900)
oil on canvas
32.3 x 26.8 in
(82 x 68 cm)
Private collection

Vidal left many works untitled. In this painting, she adopted a stark realist style. The composition represents a garden in which the artist plays with the ethereal nature of the plants and creates a decorative scene. In the center is a water fountain where two girls are playing, undisturbed by the fact that someone is painting them. Adopting a point of view distant from the center of the scene, Vidal is more interested in the magnificence of the garden than in the presence of the two girls. The artist opts for an approach resembling Romanticism, rendering the human being as an insignificant complement to nature rather than the protagonist of the scene.

The principal elements are organized around the vertical axis formed by the stylized structure of the fountain and the tree that predominates in the center of the painting. The approach is classical, with the scene focusing attention on the two girls and the fountain, leading the eye to the splendid large tree in the center and the network of branches and leaves that allow the orange twilight to filter through, affecting the illumination of the entire work.

During her early period, Vidal explored different compositional styles for the everyday modernist scenes she represented. In this work, a sense of detail permeates the work, clearly contrasting with the more diffuse style that would characterize her art years later.

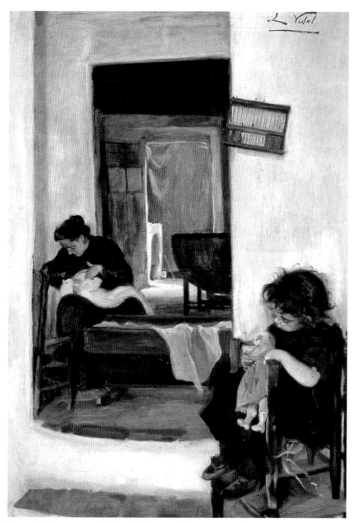

Though during the first years of her artistic career Lluïsa Vidal primarily focused on family portraits, she also explored other movements and pictorial genres. This work reveals the influence of her friend the painter Miquel Utrillo. The highly realistic scene, contrasting with the joy and self-possession of previous paintings by her, shows an interest in social differences and the problems of the lower classes that would soon lead to a social commitment in her art, as reflected in the highly modern intimism and simplicity of this work.

Maternity

(1897)
oil on canvas
45.3 x 30.7 in
(115 x 78 cm)
Mirabent Collection,
Sitges, Barcelona

The interior of a modest home is depicted through the geometric shapes of the doors and furniture. The artist renders an everyday scene in the life of a humble family. In the foreground, a plainly dressed, unkempt girl entertains herself with a doll, while in the middle ground, her mother breastfeeds a baby next to a rustic cradle. The work, set in a house in Sitges, faithfully reflects the traditional whitewashed walls and red earthen floor tiles typical of village dwellings along the Mediterranean.

Vidal was attracted by the interplay of light and shadows inside seaside village houses. The extreme luminosity of the white walls contrasts with the darkness of the house, where people take refuge from the heat of summer. The painting is an excellent reflection of the lives of many poor people, full of monotony, harshness, and hopelessness. Despite Vidal's youth—she was only 21 when she executed this painting—the sensibility that would later cause her to fill her canvases with social criticism and protest was beginning to manifest itself. This attractive work is excellent, both compositionally and aesthetically.

The Housewives

(1905)
oil on canvas
70.9 x 54.7 in
(180 x 139 cm)
Museu d'Art Modern
de Barcelona

After returning from Paris, Vidal observed domestic scenes in a different light. Nevertheless, her paintings extol women's work in the home from a feminist viewpoint.

Here, she renders a woman hanging out the wash while she cheerfully observes the artist. Next to her and finely dressed, her daughter assists her. The woman is proud of her condition as mother and wife. The point of view resembles that of a professional portrait and the protagonist is in the center of the painting, dressed in striking colors and with a joyful air.

Vidal used a focalization technique that made her painting approach French Impressionism in certain aspects, such as the treatment of light and color, spontaneity, attention to substance and details, and a relaxed treatment of accessory elements. Though the face of the woman is executed in great detail and her figure is handled with realism, the brushstroke becomes more vague as it moves away from the woman. The background of the painting is diffuse and, although some furniture and a door can easily be distinguished, their contours are indistinct. This makes the figures in the foreground stand out and provides context and atmosphere.

Right: Starting in the early 20th century, Vidal participated more actively in the feminist movement and became a chronicler of the social feminist movement in Catalonia. This is the portrait of an important Catalan writer who used a male pseudonym throughout her professional career to avoid being identified as a woman. Vidal was fascinated by these modern heroines of the literary world and executed a series of portraits of distinguished women writers, composers, and painters (including Dolors Monserdà, Narcisa Freixas, Carme Karr, and Francesca Bonnemaison).

The artist executed an agile portrait in Conté and pastel with an ethereal aura that causes the figure to be viewed in a rather mystical light. Vidal renders only the woman's bust, focusing on her face and her expressive gaze. The background is dispensed with and the torso is unfinished. The white highlights on the face contrast with the black hair in a great demonstration of the artist's mastery of the media. The contrast between these two colors enhances the sitter's bright, nearly watery eyes, rendered with great realism. An excellent portraitist in addition to a master of technique, Vidal captured the sitter's personality with singular sensibility.

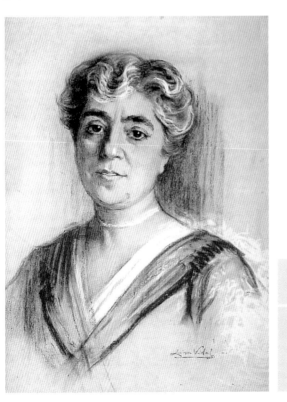

During the first years of the 20th century, Lluïsa Vidal executed a series of small seascapes like this scene of San Salvador Beach, in which she used a loose brushstroke and impasto. In this work, the large quantity of oil paint is visible particularly in the clouds and buildings. The painting exhibits an Impressionist style in which light is the protagonist. The luminosity of the sand and the radiant white of the houses in the village combine to create a composition based on different grounds of intense luminosity.

Sant Salvador Beach

(1902-1908)
oil on canvas
6.3 x 9.1 in (16 x 23 cm)
Private collection

The composition is very simple, dividing the painting into three horizontal strips. The foreground consists of a large expanse of sand in ochre tones that direct the eye toward the buildings in the central strip. The houses appear distant and diffuse, as if they were a mirage, under a troubling sky of storm clouds that are a focus of interest. A wide range of grays was used for these clouds, their white borders creating a contrast against the blue sky.

Víctor Català (Caterina Albert i Paradís)

(1914)
Conté pencil and pastel on paper
22 x 16.3 in (56 x 41.5 cm)
Private collection

Ricard Canals

(1907-1918)
oil on canvas
72.4 x 53.1 in
(184 x 135 cm)
Private collection

Throughout her artistic career, Vidal never abandoned her modernist style. This portrait of her friend, the artist Ricard Canals, takes a classical approach, though the execution and treatment are imbued with the aesthetic of the avant-garde art of the time. The composition has excellent contrasts accentuated by a wise combination of light and shadows. It shows the houses of Sitges, with the characteristics typical of Mediterranean coastal villages, their intense white façades contrasting with the refreshing shade of their interiors.

Ricard Canals is rendered in his studio in a dignified, self-possessed pose. Vidal represented him as if he were an important figure from a bygone age, seated in his most stately armchair next to his faithful dog. References to the sitter's social and economic status recall art from earlier periods—for example, Canals is rendered in a noble pose that reverts back to the classical portraiture styles of the 17th and 18th centuries. The realism is particularly striking in the rendering of textures. Canals is wearing a velvety suit described magnificently through highlights on the fabric. The same occurs with the dog's fur: The darkness of the animal's back is rich in detail and highlights.

Procession

(1908-1918)
oil on canvas
13 x 18.7 in
(33 x 47.5 cm)
Alemany Collection,
Barcelona

In this work, Vidal represents a popular religious event—the procession of Corpus Christi. The work is highly descriptive, treated with realism and a considerable degree of theatricality and solemnity.

In the foreground, one of the devout leads the procession, turning his head to observe those behind him. This figure serves as a reference and also incorporates the viewer into the scene, suggesting that the procession is divided into two parts. In the center, the priest stands out as the only colorist area in the painting, which is dark due to the effect created by the contrast with the bright buildings in the background. This contrast lends the procession greater sobriety and importance.

The chromatic range is employed hierarchically. The participants in the procession are executed in somber tones; the red of the ribbons in the medallions around their necks can hardly be distinguished. The priest, on the other hand, is wearing a white alb and an orange vestment. This liturgical ornamentation focuses the viewer's attention and initiates a visual path through the entire scene. The various principal elements are placed so that the classical structure of the painting is broken and it acquires the character of an artistic chronicle.

GABRIELE MÜNTER

Self-Portrait, *oil on canvas, 30 x 23 in (76.2 x 58.4 cm), 1909, Private collection, Stuttgart.*

Gabriele Münter was born in Berlin into an American family of German descent. In 1897, when she was 20 years old, she received her first drawing classes in Düsseldorf.

In 1901, she went to Munich with a view to continuing her artistic studies. There she came into contact with an artist association called Phalanx, run by Vasily Kandinsky, and enrolled in some painting courses. She became involved with Kandinsky, a relationship that would consolidate itself through the travels the couple undertook together between 1904 and 1908. In the end, she chose to live in Munich, although she spent long periods in Murnau, where Münter was to develop a highly intense creative activity. When the First World War broke out, she fled to Switzerland, and about a year later the couple finally parted company in order to pursue their own individual careers.

In 1917, Münter suffered a major creative breakdown, but, years later, she would once again take up her artistic career, encouraged by the art historian Johannes Eichner, who was to be her future romantic partner.

Gabriele Münter is one of the best-known expressionist artists in Germany. In 1907, she exhibited in the Salon des Indépendants of Paris and in the Salon d'Automne. One year later, she participated in the founding of the Neue Künstlervereinigung München, or NKVM (New

- **1877** Born February 19 in Berlin.
- **1897** Receives her first drawing classes in Düsseldorf.
- **1902** Enrolls in the art association Die Phalanx, created by Vasily Kandinsky.
- **1904-1908** Together with Kandinsky, she travels to the Netherlands, Tunis, Dresden, Rapallo, and Sèvres.
- **1909-1910** Participates in the founding of the Neue Künstlervereinigung München and in the exhibitions held by the association.
- **1911** Kandinsky, Marc, Macke, Kubin, and Gabriele Münter found the group Der Blaue Reiter.
- **1913** Encouraged by Herwarth Walden, she holds her first individual exhibit on January 6 in the Galeria Sturm, Berlin, where she presents 84 of her works painted between 1904 and 1913.
- **1914** Following the outbreak of World War I, she takes refuge in Switzerland together with Kandinsky.
- **1916** Definitively breaks off her relationship with Kandinsky.
- **1920** Returns to Germany.
- **1930** Meets the philosopher and art historian Johannes Eichner, who encourages her to continue painting.
- **1931** Makes her home in Murnau.
- **1957** Bequeaths several of her works to Kandinsky and an important collection of her works to the Lenbachhaus, Munich.
- **1962** Dies at her Murnau home on May 19.

Association of Artists of Munich). She abandoned the group in 1911 together with Vasily Kandinsky, Franz Marc, Auguste Macke, and Alfred Kubin, in order to found Der Blaue Reiter (The Blue Rider). She collaborated in numerous exhibitions. Her painting is characterized by the vivacity of her color that she exploited as a means of expression and by the search for synthetic shapes that she outlined in black.

She mostly painted landscapes and still lifes, in which she would often introduce religious imagery. Münter, like other artists, not only suffered two world wars but was also classified as degenerate when the Nazis rose to power.

Portrait of Marianne von Werefkin

(1909)
oil on canvas
31.9 x 21.7 in
(81 x 55 cm)
Städtische Galerie im
Lenbachhaus, Munich

For the force and impact of its colors, this work is considered a masterpiece of expressionism. In the spring of 1908, Gabriele Münter and Vasily Kandinsky discovered the town of Murnau. They found the place so picturesque that, at the insistence of Kandinsky, Münter bought a house there. Carried away by the enthusiasm of the moment, they invited their friends Alexej Jawlensky and Marianne von Werefkin, who decided to spend the summer together in Murnau.

In this canvas, Marianne von Werefkin is depicted and outlined against an intense yellowish background. She is wearing a large hat with flowers and a fuchsia-colored shawl that delimits a white dress dotted with strokes of soft colors. But the most striking aspect of the work is the green face shaded in a garnet tone, on which her shawl appears to reflect. This is an evident inheritance from fauvism, an ephemeral movement that began in 1906 and faded away one year later but was nevertheless fundamental to 20th-century painting, as it freed artists from realism and the conventional palette colors. In 1889, Gauguin had painted *The Yellow Christ*, which marked a turning point in the use of nondescriptive colors far from the faithfulness of nature. In 1905, Gauguin painted a portrait of his wife with a green shadow cast on her face. In the same year, André Derain painted a canvas of Henri Matisse in which half of his face is green and the other half is ochre, along with several touches of violet on his nose.

This liberation of color paved the way for immense creative possibilities that the expressionists would exploit aptly. In this canvas of long brushstrokes, Gabriele Münter not only uses color as an expressive medium, but also seeks a simplification of forms whose areas of color she outlines with a thick black contour. This technique allowed her to achieve a strong visual impact that lends the work immense energy and liveliness. The painting is also remarkable for the way in which the work has been conceived through a series of elements that the painter organizes into almost monochromatic zones, well defined and juxtaposed, which, in addition to building a painting, form an attractive multicolor mosaic.

Boating

(1910)
oil on canvas
48.2 x 28.5 in
(122.5 x 72.5 cm)
Milwaukee Art Center
Collection

Gabriele Münter presents an everyday life scene that takes place on Lake Staffel, whose waters bathe the shores of Murnau, near the Bavarian Alps. In this pyramidal composition, the artist portrays herself from behind, holding the oars next to a black dog. Kandinsky stands in the center, between Marianne von Werefkin and little Andreas, son of Alexej Jawlensky and Helene Nesnakomoff.

The angle of vision is very low because the artist painted it from her point of view while rowing. That explains why Kandinsky appears so starkly against a landscape that boasts arbitrary colors. The waters of the lake are dark gray and the blue mountains are illuminated by a strip of ochre, which gives way to an undefined and unreal sky. The colors are the means of expression, of emotion and of feelings and, for this reason, they need not be forced in order to be a faithful reflection of nature.

By the end of the summer of 1908, Münter wrote that she was seeking to monopolize the clarity and simplicity of the universe of Murnau and that the mountains were a mass of blue and gray, her favorite color. Both this and the portrait of Marianne von Werefkin are the result of that search for a new pictorial language, which the artist carried through, precisely, during those years when her production was innovative and intense. This work is remarkable for its framing, which makes the subject very immediate and close. In this respect, she followed the advice of Kandinsky: "One day Kandinsky suggested I represent small portions of landscape and not panoramas." Faithful to her principles, she avoids all unnecessary elements and searches for the synthesis of forms, which are enclosed within themselves, teeming with colors.

Still Life with Saint George

(1911)
oil on canvas
20.1 x 26.8 in
(51.1 x 68 cm)
Städtische Galerie im
Lenbachhaus, Munich

This still life reveals Münter's mystical and spiritual contribution to the group Der Blaue Reiter. In the top left corner, enthroned within a type vignette, is Saint George on horseback slaying the dragon, against a turquoise blue background and enveloped in an aura of intense red. On the other side stands a Virgin with Child, crowned with a cross of Lorraine, together with flowers in tones of red, salmon, and yellow, and some little figures and a large ceramic hen that take up the foreground. They are traditional and religious objects from the area, which Kandinsky and Münter collected with real passion. The couple was also fascinated by the technique of stained glass, which was very popular in Bavaria, where it was used for votive paintings in stations of the cross placed on the wayside of roads.

This fondness for the traditional and the naive is related to the interest the expressionists had for primitive art that they regarded as being far more genuine, authentic, and free of any corruption. In fact, Gabriele Münter had previously painted canvases of stations of the cross, such as in her work *Wegkreuz in Kochel*, painted in 1909, which depicts Christ on a white background.

This still life, dedicated to Saint George, was reproduced on a full page in the almanac made for the Blaue Reiter. Kandinsky's comment was philosophical: "The inharmonious exterior effect is in this case the cause of the harmonious interior effect." The painting's undeniable vanguardism is due to the fact that the objects in this still life are all out of context. It creates the impression that they are floating in an unreal atmosphere; however, they possess a markedly mystical character that makes them attractive and mysterious.

Kandinsky is depicted here, dressed in typical Bavarian attire, with the painter Erma Bossi, who was a member of the New Association of Artists of Munich. The setting is the dining room at the home of the painter, and Münter has situated the protagonists against a black background that provides a contrast to the white tablecloth spread over the table. The use of black and white in an almost pure state was adopted by van Gogh, who, according to Gabriele Münter, was a source of inspiration for many of her works. In this work, the perspective is merely hinted at, as is the case in the vast majority of expressionist paintings, which tended to represent flat scenes, ignoring any type of academic or traditional perspective. As is commonplace in this artist, the shapes have been synthesized so that the objects are still recognizable, but the artist has made no attempt lend a meticulous description to anything in the scene.

The presence of Erma Bossi in 1912 in the home of the Kandinskys reveals that the strong bond of friendship with her had not changed, despite the fact that only one year earlier Münter, Kandinsky, Marc, Macke, and Kubin had left the association to found the group Der Blaue Reiter, whose aim, according to Münter herself, was to create art that was nondeformed and original. In fact, this work originated from several studies drawn from nature, just like the portrait she dedicated to Paul Klee, in which he appears dressed in white pants and seated in an immense blue armchair. Notwithstanding, there is another sign that is also indicative of feeling and emotions: Kandinsky is shown speaking with his hand raised for emphasis, Erma Bossi, seated somewhat apart and resting her elbows, appears to be very attentive to Kandinsky's words, which are probably seductive.

Kandinsky with Erma Bossi at the Table

(1912)
oil on canvas
37.6 x 49.5 in
(95.5 x 125.5 cm)
Städtische Galerie im
Lenbachhaus, Munich

Reflection

(1917)
oil on canvas
26 x 39.2 in
(66 x 99.5 cm)
Städtische Galerie im
Lenbachhaus, Munich

The artist painted this intimist scene when she was in Stockholm. It was a difficult time. On August 3, 1914, Germany had declared war against Russia and France, and as a consequence the group Der Blaue Reiter had been dispersed. Franz Marc and August Macke enlisted in the army. Münter, Kandinsky, and other artists left Germany under rather tragic circumstances: An order was issued that Russian residents in Germany were to leave the country within forty-eight hours, which forced them to abandon their home, furniture, and paintings. Münter and Kandinsky sought refuge in Switzerland.

By 1915, tensions had begun to arise in their relationship, and they decided to part company. Münter decided to move to Norway, a neutral country in the conflict, while Kandinsky returned to Russia. In the spring of 1916, when Kandinsky returned to Moscow, the couple separated definitively. At the time Münter was painting this work, only one year after her friend Franz Marc had been killed in action, Kandinsky married Nina von Andreewsky. World War I was still raging.

In *Reflection,* unlike Münter's earlier works, the human figure acquires much protagonism, as a significant part of the surface of the work is occupied by a pensive woman gazing into infinity. Cool colors predominate, above all in the female figure painted in tones of black and white. A window in the background, slightly warmer, illuminates the icy interior, where flowers are tinted with blue and lilac, and with a bright red, reserved for the small sections. The shapes are synthetic and the black contour separating them visually reinforces the effect of cloisonnisme that both Gabriele Münter and Alexej Jawlensky took from Gauguin. This work, without doubt, marks a period of transition, since, by 1917, Münter had experienced a creative breakdown, and it would take her several years to recover.

Münter

HELEN MCNICOLL

Portrait of Helen McNicoll by Robert Harris, 1910.

- **1879** Born in Toronto, Canada.
- **1880** The McNicoll family moves to Montreal.
- **1882** Helen becomes deaf due to scarlet fever.
- **1892** She is diagnosed with deafness and diabetes.
- **1899** Begins her studies at the Art Association of Montreal, under William Brymner.
- **1900** Moves to Paris.
- **1901** Travels to England.
- **1902-1904** Studies at the Slade School of Art, University of London.
- **1905** Returns to England, after a brief working stay in France, and studies at St. Ives, where she meets her friend Dorothea Sharp.
- **1906** Holds an individual exhibit at the Montreal Art Association.
- **1908** She is granted the Jessie Dow Award by the Montreal Art Association.
- **1913** Elected a member of the British Royal Association of Art.
- **1914** Receives an award from the Women's Art Association and is elected a member of The Royal Canadian Academy of Art.
- **1915** Dies in Swanage, England, due to diabetes.

Although Impressionism as an artistic and cultural phenomenon developed almost exclusively in France, numerous artists of different nationalities followed the ideas of this movement, creating distinct versions adapted to their social milieu. Helen McNicoll's artwork has a luminous and peaceful aesthetic that seems to celebrate the natural beauty and magic of everyday life.

As opposed to the American painters who traveled to France to form part of the Impressionist world, McNicoll always maintained a Canadian identity in her works. Though she also traveled to Europe to see Impressionism firsthand, her works had the naturalist aesthetic of Canadian painting, which she employed above all in her country scenes, showing a particular view of the world as placid and orderly.

Helen McNicoll's art transmits a warmth that can be perceived in its light tones and brilliant colors. Her oeuvre includes everyday scenes that recall Eva Gonzalès and Mary Cassatt. She portrayed women with the same admiration as Gonzalès, emphasizing femininity as a personal gift, though her portraits became feminist pleas supporting the suffragettes.

Helen mcnicoll

Study of a Baby

(1900)
oil on canvas
24 x 20 in (61 x 50.8 cm)
Musée des Beaux-Arts,
Montreal, Quebec

In her works, McNicoll favored subjects that transmitted a placid view of life. Employing subjects where candidness predominated, she enjoyed representing scenes with children that would touch the viewer. This scene of the relationship between a baby and its mother is a good example. Through a spontaneous, indefinite brushstroke, the artist creates a space completely dominated by the image of the baby, who becomes the protagonist of the painting while the girl is relegated to the middle ground. The undefined background seeks to reproduce the optical effects of the human eye, which focuses on closer objects and tends to see them out of focus as they recede.

McNicoll uses a modern range of colors in which yellow predominates, tinged with different tones of white, ochre, and green, always very delicate, and the intense blue of the nursemaid's chair. She explored different tonal combinations, choosing unprecedented mixtures. This painting reflects a period in which she explored the different compositional possibilities of color. Thus, different hues of light are used with a palette based on complementary colors and the theories of the decomposition of light into the colors of the rainbow. Such mixtures show that the artist investigated the properties of color and light and its decomposition into the spectrum. In the distinct white tones that appear in the painting, McNicoll used green and blue to distinguish the quality of the light, while in the background, she used more complex mixtures to describe the various indistinct shapes of the furniture. Through this in-depth attention to color and light, she achieved a scene full of candor and tenderness, transmitting the attractive aspects of everyday family life and its atmosphere. The elements of the painting are limited almost exclusively to the figures, who represent the sentiments that the artist wanted to transmit.

Right: This painting, perhaps McNicoll's most complete, reveals a compositional maturity marked by the mastery of compositional design within the pictorial space. The artist created independent grounds that are unified through the attitude of the figures, two young girls picking flowers. Portraits of children were one of the artist's favorite subjects; she found their natural joy and spontaneity appealing. In this work, she represents this childlike freedom in a very modern view whose spontaneity, immediacy, and freshness recall a photograph full of movement. McNicoll represented this dynamism through the girls' flying dresses and the gestures of their arms and legs. The painting has a network of lines and color areas that are organized into specific sectors. On the left, a luxuriant wall of vegetation contrasts with the exuberant quantity of the flowers and the bare ground, while the sun shines brightly, striking the girls' dresses with all of its splendor. McNicoll wanted her art to reproduce all possible sensations, and she therefore created a complex set of contrasts between the different pictorial grounds.

Minding Baby

(~1911)
oil on canvas
20 x 24 in
(50.8 x 60.96 cm)
Private collection,
Toronto

In McNicoll's art, there is a particular use of light colors giving rise to a thorough study of color and light, one of the basic concepts of Impressionist art. This characteristic, present throughout the artist's entire pictorial production, allows outdoor scenes to be represented in a bright atmosphere rendering sunlight in all of its splendor and force.

In this painting with intensely bright colors indicating a moment of radiant sunlight, the viewer is practically blinded, perceiving the scene in two separate grounds. In the foreground, two girls are sitting in chairs and sewing while they watch a baby who peeks out from a carriage, all of them comfortably in the shade. In the background, the sun is so brilliant that it seems to blind the eye, the radiant light eliminating details. McNicoll, faithful to her Impressionist inclinations, skillfully renders the sensations caused by the light and successfuly transmits to the viewer the intense heat of the sun and the placid coolness of the shade.

She employed a style with loose, undefined brushstrokes in works based on sensations. She did not study the effect of the brush on the canvas, though she constantly explored the quality of light and color. For this reason, in her artwork there are different types of brushstrokes that add details corresponding to the way the light strikes objects. The painting, devised as a snapshot of everyday life, has the freshness and spontaneity of the scenes that the Impressionists so liked.

Picking Flowers

(~1912)
oil on canvas
37 x 31.02 in
(94 x 78.8 cm)
Art Gallery,
Ontario

In the Shade of the Tent

(1914)
oil on panel
32.87 x 39.8 in
(83.5 x 101.2 cm)
Musée des Beaux-Arts, Montreal, Quebec

McNicoll's work has a solitary, quiet nature that is a determining factor for the intimate, withdrawn, and introspective subject matter. Perhaps the artist's hearing problems led her to isolate herself from the outside world and become more contemplative. This may be why her artwork transmits a sensation of silence, not only in the subject but in the compositional conception.

McNicoll's work is visual and perfectly renders qualities of light very different from those, for example, of Manet's or Degas's paintings, although she felt deep admiration for those artists. Rather than studying the way the light struck objects or water, she was more interested in exploring its physical nature in order to transfer it onto the canvas. McNicoll assimilated the visual meaning of Impressionism and employed it in a manner very different from that used in France. In her paintings, she represented her personal visual perception, transmitting the sense of order and tranquility provided by silence. The artist's deafness brought her a degree of introspection that led her to explore the visual language of painting with greater sensibility than any other artist of her time.

This work reflects a structural tranquility achieved through a stupendous flood of light. Two women are relaxing in the shade of a tent. The artist used a more precise brushstroke than in previous works, so that she defined the volumes of the bodies more precisely and intuitively rendered the effects of the weather in the shade and in the sun. The placement of the darker areas in the foreground is of great value, as the multicolored nuances lend the painting a significant interplay of colors full of delicacy and imagination.

NATALIJA SERGEEVNA GONCHAROVA

Natalija Sergeevna Goncharova.

Influenced by the Impressionist movement, Goncharova found her true inspiration in Russian medieval art. She and her lover, the painter Mikhail Larionov, decided to explore a new pictorial style based on the fusion of traditional Russian art with the new approaches of European painting. The result of their research was the creation of the so-called Rayonism, a new style that represented everyday scenes and landscapes of Russia by deconstructing them through a network of lines and strokes, producing works with a markedly abstract character.

The new approach proposed by Goncharova and Larionov headed the avant-garde movement in Russia, introducing the modern notion of artistic autonomy. This concept of independence was implicitly based on historical tradition and introduced the notion of the arts as a self-sufficient interpretation of the visual world, absolving art from the need to subject itself to specific forms of knowledge or to the representation of reality that had predominated until then.

After joining Larionov, Goncharova's work acquired a new conception according to which

- **1881** Born in Negaevo, in Tula Province, to Natalia Nikolaevna Pushkin, the niece of the famous author.

- **1898** Studies at the Academy of Painting, Sculpture, and Architecture in Moscow.

- **1900** Meets the painter Mikhail Larionov.

- **1902** Completes her sculpture studies under Pavel Trubetzkoi.

- **1906** Participates in the exhibit of Russian art at the Salon d'Automne in Paris.

- **1908** Participates in the first Golden Fleece Exhibit in Moscow.

- **1912** She and Larionov found the Donkey's Tail art group. Her style and Larionov's evolve toward Rayonism.

- **1914** Exhibits in Moscow and Paris along with Larionov. She is in charge of the design for Sergei Diaghilev's ballet *Le Coq d'Or*.

- **1915** Travels to Lausanne, Switzerland, where she settles with Larionov to work on the design for Russian Ballet stage sets.

- **1919** Henceforth, she and Larionov dedicate themselves to designing scenography for theater and ballet, abandoning her work as a professional painter, though she continues to paint sporadically, experimenting with different styles.

- **1926** Designs the stage set for Diaghilev's ballet *The Firebird*.

- **1955** After having lived together for many years, she and Mikhail Larionov get married.

- **1962** She dies in Paris.

space and atmosphere gain solidity, constituted by a network of geometric planes that conceptualize volume. In this sense, Goncharova's Rayonism approached Cubism, opposed to a partial representation and a conception of the pictorial work as part of nature.

Goncharova is a key figure in avant-garde Russian art.

Still Life with Tiger Skin

(1908)
oil on canvas
55.1 x 53.7 in (140 x 136.5 cm)
Ludwig Collection, Cologne

Goncharova executed this highly decorative work two years before becoming involved with Rayonism. The composition is complex, as the artist includes three focal points that vie for protagonism from various aesthetic points of view: the background in intense red, the tiger skin, and the two paintings on the left.

Goncharova executed the composition of the background and tiger skin in a style recalling Fauvism, with flat colors and thick outlines. The images in the paintings, on the other hand, are the opposite, as the lines are fine. The idea of a painting within a painting suggests that the artist experimented with various European artistic movements from the early 20th century until she became the leading figure of the Russian avant-garde.

Right: This work, executed during the artist's evolution towards Rayonism, is halfway between her early figurative style and her new conception of art. She represents a highly balanced landscape in which the ochre tones homogenize and soften the intense, pre-Rayonist lines. The modernity of this work is harmoniously combined with its classical execution. The trees in the foreground acquire protagonism through their intense brown color. Through a complex mesh of light brushstrokes, the artist transmits the ethereal sensation of the leaves, whose detailed execution is striking in contrast with the rigid solidity of the trunks. The background is devoid of elements that could detract from the protagonism of the trees, and only several simple bushes in the distance break the monotony of the horizon. The brilliance of this work gives rise to a serene, relaxing sensation very different from later paintings by this artist.

In this painting, Goncharova applies the Rayonist principle, parceling these two women to deconstruct them into different tonal planes. The composition is executed in ochres and browns, but the blue wash in the sky breaks the equilibrium. Even in near abstraction, Goncharova does not stray far from figurative art. Rayonist lines define the contours of the figures. An interest in well-defined contours was a constant that evolved throughout the artist's oeuvre. The expressions on the faces are rather cool and pale because of their proximity to blue and black areas. The women's gazes are distant and somewhat absent. Goncharova did not find it easy to produce a model that would please the Russian avant-garde, as the various portraiture styles until then were far removed from the ideas she was putting forth.

Two Women

watercolor
13.8 x 9.8 in (35 x 25 cm)
Fine Arts Museums
of San Francisco

This work belongs to Goncharova's early period, during which she investigated the characteristics of traditional Russian art and often adopted the subjects of artisans or agricultural work. This style, which would later evolve into Russian Neo-Primitivism, contains figurative aspects that are treated in an ingenious and infantile manner approaching Naive art. Goncharova used this early tendency in her art to experiment with European pictorial movements such as expressionism, from which she adopted highly defined contours and a principally flat approach to color. In this painting, the artist dispensed with the thick outlines of her previous works, but the color insinuates the sensation of volume in a primitive and intentionally simple manner. Henceforth, the artist evolved toward abstraction, though she always continued with the nationalist subjects typical of her early period.

Fruit Harvest

(~1908)
oil on canvas
Private collection

Trees

(1908)
watercolors
13.4 x 17.9 in
(34 x 45.6 cm)
Jean Zimmerman
Collection

The Forest

(1913)
oil on canvas
52.2 x 38.2 in
(130 x 97 cm)

This painting, one of the first executed by Goncharova according to the new Rayonist principles, retains a figurative aspect that allows the viewer to recognize the elements in the scene.

The surface of the painting is segmented by lines forming tonal planes that intertwine, creating movement. This style, which would later be used many times by both Goncharova and Larionov, allowed the artist to work on color, distributing it in an expressive mosaic.

The forms created by this segmentation are the result of a thorough study. The interest in volume is evident in the conception of the composition as well as in the small planes into which the painting is divided. The artist executed the smallest details thoroughly, using color and light in a parallel fashion in each line.

Mikhail Larionov

(1913)
oil on canvas
41.3 x 30.7 in (105 x 78 cm)
Private collection

The different resources used in this work are combined to create an abstract art that approaches the vision of reality put forth by Russian socialist realism. In the various planes, the influence of the different abstract movements from the early 20th century is evident. The image of the figure shows a tendency toward movement, although in an orderly fashion. In the background is a series of broken lines in the Rayonist style that Larionov and Goncharova had developed in 1910. The apparently flat colors that the artist frequently used to distribute the different compositional planes were adopted from Russian primitivism.

The Cyclist

(1913)
oil on canvas
30.7 x 41.3 in (78 x 105 cm)
Russian Museum,
Saint Petersburg

This work, characteristic of Russian futurism, follows Italian futurist principles in creating a sensation of speed and movement. But like her Russian colleagues, Goncharova executed a work very different from the Italian model. Futurism was initially based on a desire to synthesize Impressionism, lending a dynamic order to accidental elements. With a distinctive graphic style, this painting is an example of the intellectualization of Russian art. The artist announces a type of art unrelated to perceivable reality and represents the machine and movement with an ingenuity that reveals the Russian avant-garde's Fauvist roots. The original idea of Rayonism as a synthesis of cubism, futurism, and Orphism reaches a self-imposed limit in works such as this consisting of imitating real objects in a somewhat abstract manner. Orphism is a term coined in 1912 by the poet Guillaume Apollinaire, and it refers to painting without references to figures, conceived as an exaltation of light and the dynamism of colors, as opposed to the constructivity of cubism. The components of this new Russian avant-garde art were complex, especially in its first years of gestation.

Cats

(1913)
oil on canvas
33.1 x 33.1 in
(84 x 84 cm)
Guggenheim
Museum,
New York

This composition is fully Rayonist. The deconstruction of the figure through aggressive lines forming different tonal planes creates an abstract work. Goncharova's previous experimentation with figurative elements yielded to what would become the new aesthetic of her art.

The image of a black cat forming an angle on the right establishes the composition. The cat is perceived as a series of prisms that deconstruct its real image. The use of yellow, strongly contrasting with black, lends the scene intensity, complemented by details in a suggestive pink tone.

Rayonism consisted of a new pictorial style in which Goncharova experimented with all of the elements of the painting, re-creating her own artistic vision and inspiring the new generation of Russian artists.

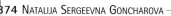

Spanish Dancer

(1916)
oil on canvas
78.7 x 35 in (200 x 89 cm)
Art Institute of Chicago

After 1913, Goncharova significantly reduced her pictorial production to dedicate herself to set and costume design for theater and ballet. Her experimentation with the new abstentionist tendencies, begun years earlier, gave way to a more relaxed style in which she recovered figurativism as a simple artistic exercise, far removed from theoretical pretensions.

The composition follows the same pattern as her costume designs. The dancer, whose figure is nearly completely covered by a long lace shawl, idealized and removed from reality, demonstrates the pictorial value of the dresses designed by the artist. The work also reveals Goncharova's great skill in set design, as she distributes the space in a decorative sense and achieves a very balanced work, both compositionally and chromatically.

Three Spanish Women

(1930-1931)
oil on canvas

Although after 1919 Goncharova largely stopped painting to dedicate herself to scenography for theater and ballet, she continued to execute works occasionally, experimenting with different pictorial styles. This figurative work is very different from the abstractions of her last years as a painter before going into set design. It contains academic formalism, and its conception includes a vision of perspective and detail far removed from her Rayonist ideas of the recent past. The three figures have placid expressions in an image that appears religious, probably the result of her experience with the theater. The execution of realist designs and sketches with elaborate studies of depth and perspective was a constant in the artist's works at this time. The women's dresses, the background, and the aesthetic values of the painting are executed with meticulous care.

OLGA ROZANOVA

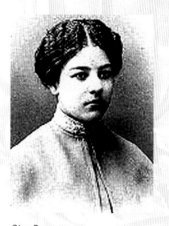

Olga Rozanova.

A poet, theoretician, and painter, Olga Rozanova experienced the ideas of Italian futurism as a preliminary phase on her way to suprematism—a nonfigurative tendency of painting, initiated by Kasimir Malevich. Abandoning the representation of the human figure, it presents other subjects or symbols in order to create an interest that the spectator feels rather than observes.

She was one of the precursors of the Russian avant-garde. Her paintings and drawings developed around the exploration of the expressiveness of color. The artist's association with Italian futurism gave way after 1916 to spectacular suprematist works.

Rozanova considered color as the essence of abstract art, and she justified abstract art and made it comprehensible to the public through her work. In the article "Cubism, Futurism, and Suprematism, she described her pictorial system as color painting. This new approach put forth a special treatment of the structure of the painting using the architectural value inherent in different superimposed planes of color. The exploration of this new abstract style provided the basis for Russian constructivism and cubo-futurism and introduced new theories on the absence of perspective and the rejection of pictorial figurativism.

Like Liubov Popova, Rozanova proposed a two-dimensional style far removed from sim-

- **1886** Olga Vladimirovna Rozanova is born in a small town near Vladimir.

- **1904** Studies until 1910 at the Bolshakov School of Art and the Stroganov School of Art in Moscow.

- **1905** Exhibits at Tramway V in Moscow.

- **1911** Moves to Saint Petersburg, where she remains until her death. From this year until 1914, she participates in the exhibits of the Union of Youth, a society in which she becomes deeply involved.

- **1912** Illustrates various futurist leaflets.

- **1913** An active member of the Union, she publishes the essay "On the Principles of New Art" in the third newspaper of Russia. In it, she explains her theory of color as the essential value of abstract art. Begins working with poet Alexei Kruchyonykh, who becomes her companion and collaborator.

- **1914** Participates in the Free International Futurist Exhibit held at the Galleria Sprovieri in Rome.

- **1915** Works on various fashion design series.

- **1916** Exhibits with the Knave of Diamonds group. Illustrates "The Universal War," a poem by Kruchenikh.

- **1917** Following the revolution, she begins a movement to reform art education.

- **1918** Along with Alexander Rodchenko, she directs the industrial art program at the IZO (Department of Fine Arts of the People's Commissariat for Education). Dies in Moscow of diphtheria.

ple realistm or figurative painting. This new concept of art would end with the artist's premature death. Though her art theories strongly influenced the following generation of Russian painters, she received few influences herself. Only a reflection of Kazimir Malevich's art is evident in her last works, when her abstract style became much more rigorous.

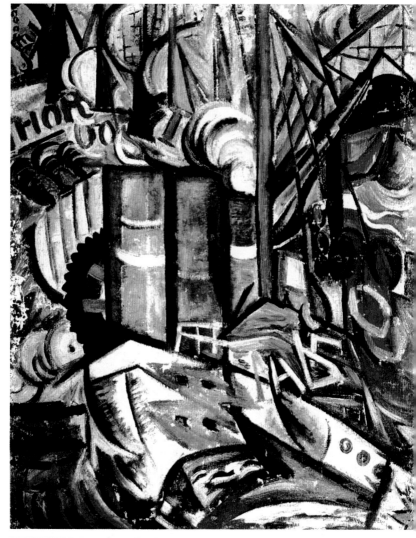

The Harbor

(1912)
oil on canvas
Private collection

Olga Rozanova was a poet as well as an artist. In this painting, she seeks a synthesis between the word and the image. The painting is a view of the port of Saint Petersburg. The foremost element in the composition is the steamboat in the foreground with three smoking chimneys. The forms that determine the composition insinuate a storm. The atmosphere is dense, filled with smoke and masts.

In this painting, Rozanova closely approaches the principles of Italian futurism. The intentional movement and rather chaotic scene evince the artist's knowledge of Filippo Tommaso Marinetti's theories, that saw buildings and other elements of civilization as sculptures that an artist must be able to depict artistically.The cubism that Pablo Picasso was producing in Paris is also assimilated, such that these two aesthetic movements are synthesized. In contrast to her Russian colleagues, Rozanova maintained the original character of futurism and acquired a more aggressive and informal aspect in her art.

Non-Objective, Abstract Composition

(1912)
oil on canvas
Phoenix Art Museum

Although the origins of the pictorial vanguard in Russia were eclipsed by the variety of original proposals put forth by the artists there, the contribution of futurism and, later, cubism were decisive. The first aesthetic approaches in search of a new art in Russia went from an absolute rejection of 19th-century figurative painting to a concept of the object as an element that can be decomposed and modeled according to the artist's expressive character.

In this first avant-garde stage, Rozanova put forth a new vision of painting as two-dimensional art, manifest in this work as various planes of intense color that create a false sensation of volume based on the color contrast between the different forms. The random superposition of planes corresponds to the conception of art as abstract, in contrast to figurative art. Rozanova did not want her artwork to follow a defined approach nor the academic norms that considered painting a simple representation of reality. For her, color in simple geometrical forms is the only compositional means, its expressiveness lying in contrasts and tonal opacity. The absence of movement and objective expressiveness is used by the artist to create an exclusively aesthetic pictorial language.

The City

(1913)
oil on canvas
28 x 21.7 in (71 x 55 cm)
State Art Museum,
Novgorod

The difference between Russian cubo-futurism and the Italian futurism initially put forth by Marinetti lies in the Russian artists' commitment to the emerging revolutionary proletariat cause, in contrast with the officiousness given to avant-garde art in Italy.

In this work, the artist renders a dense, chaotic city, though it does not attain the dispersion of the urban landscape present in Italian futurist works. The impression of the new socialist cities, in which industrialization caused buildings to be designed and constructed at a frenetic pace, is expressed by Rozanova in this painting as a disorderly composition of planes that flow together around a fragile human figure in the center. She lends the work a metaphorical sense, creating a small, orderly, and tranquil space on a lighter ground in the middle, in which the figure is protected from the apparent urban chaos. Although this painting has a marked abstract tendency, a detailed study reveals a more figurative pictorial sense structured on planes distributed in an abstract manner. The railway and various recognizable architectural structures are executed in a cubo-futurist style, though each element has its own realist aesthetic.

Man in the Street

(1913
oil on canvas
32.7 x 24.2 in
(83 x 61.5 cm)
Leonard Hutton Galleries,
New York

Four Aces

(1915)
oil on canvas
Private collection

Rozanova uses the simultaneous image of different cards from a deck to execute a series of highly original compositions. The different compositional planes so common in Russian abstract art appear here as parts of cards overlapping or cutting into one another to form a painting that combines the realism of the cards with an abstract composition.

Rozanova experimented with different expressive resources and degrees of abstraction throughout her artistic career. Although the inclusion of printed elements such as the cards can be interpreted as the result of Russian constructivism, she used these objects without an obvious meaning. She simply rendered them as a combination of lines and curves with red and black predominating. The incorporation of a touch of blue and yellow enriches the painting by adding a completely different element to the composition. The force of the slashing diagonal lines is another characteristic of the paintings in this series. Rozanova incorporated the idea of strong lines from the artwork of Giacomo Balla in order to create an effect of movement in object-space relations.

Left: In this painting, Rozanova figuratively portrays an elegantly dressed man wearing a hat and coat, though the figure loses its consistency and decomposes into the cubist abstraction of the whole. In addition to the cylindrical form of the top hat, the man's face, and his gray overcoat, various other figurative elements can be identified, such as several gray and black buildings, violet-blue windows, and the wheels of a car. The artist also makes an attempt to represent speed and movement and lend the whole composition a dynamic air, in accordance with a common principle among Russian artists and Italian futurists. Rozanova studies the possibilities of color and form independently of the nature of the work. She experiments with a classical composition, rendering the figure on different formal planes.

The fundamental preoccupation of new abstract painting based on cubism was the structural balance of the work as an autonomous space within which objects were ordered or planes were redistributed to attain a new aesthetic. This painting shows spatial ambiguity in the man's body, defined in a different manner on a faceted surface without becoming dispersed. The artist retains the features of a traditional concept of painting. Formalism is still patent and the image is perfectly oriented toward a rhythm of harmonious order, following an internal logic in congruence with the parts of the painting. As in cubist works, contrast attains an exalted place, overriding the importance of the subject matter.

Non-Objective Composition

(1917)
oil on canvas
28 x 25.2 in (71 x 64 cm)
Regional Art Museum,
Ulianovsk, Russia

Rozanova returned to a simple aesthetic composition. In this painting, she organized space through large color planes distributed on a gray background. The use of intense colors and geometric forms that organize the space, which the artist used in various compositions beginning in 1912, acquired a harmonic, balanced sense over time. Though Rozanova does not seek a definitive sense in her abstract works, her artistic evolution is evident in their more tranquil, reflective distribution.

Compositions based on different-colored geometrical planes constituted a new expressive and compositional resource for the new generation of avant-garde artists. Bauhaus theories reinforced this abstract tendency by applying it to architecture until Vasily Kandinsky used geometrical principles for artistic ends in works of great visual logic toward the end of the 1920s. Rozanova anticipated these geometrical tendencies and put forth a new, two-dimensional concept of art, lending it an architectural character that would later find its greatest expression in Liubov Popova's cubo-futurist art.

Here, the predominant red shape executed in a completely flat color is compensated by the inclusion of two smaller but more complex forms. The red rectangle and the blue triangle overlapping it balance the space of the painting, while the use of blue produces a contrast that complements the pictorial weight of the large red shape.

SONIA DELAUNAY

Sonia Delaunay in a photograph from approximately 1920.

The life and pictorial investigation of Sonia Delaunay are intertwined with those of her husband, Robert, also a painter. She and her husband developed the theory of simultaneity and Orphism. Her preoccupations focused on the dynamic decomposition of color. She made a personal interpretation of cubism that placed more importance on abstraction and the prismatic breakdown of color, with effects of blending, simultaneity through the juxtaposition of complementary colors, and dynamism as an influence from Italian futurism. She criticized analytic cubism for its lack of revolutionary ideas and its static nature.

For the Delaunay couple, the forms of objects were as many as the viewer could have based on changes in light and space. According to them, artist, spectator, object, and space were subject to continuous and unforeseeable movement.

Sonia Delaunay was a prolific artist. She never stopped painting, but for some years, she devoted her skill to set and costume design for Diaghilev's Russian ballets, as well as textile, fashion and object design, and interior design. She was one of the great pioneers in abstraction and the incorporation of abstract designs in other fields that had not yet been considered by artists. Her radical, severe style, with flat, brilliant colors, brought a real change to the sets of the Russian ballets. She also worked with the French architect Robert Mallet-Stevens on interior design and furniture. She was an active member of the avant-garde artistic community. She collaborated with the most representative artists of her time, from the Dadaist Tristan Tzara and the Russian ballet producer Sergei Diaghilev to Coco Chanel.

- **1886** Born November 14 in Giridisce, Ukraine.
- **1891** Adopted by her maternal uncle in Saint Petersburg, Henry Terk, an art collector.
- **1903-1904** Studies at the school of art in Karlsruhe, Germany, under Ludwig Schmid-Reutte.
- **1905** Moves to Paris, where she enrolls at the Académie de la Palette in the quarter of Montparnasse. Unimpressed with her professors, she begins painting on her own. To avoid returning to Russia, she contracts a marriage of convenience in 1908 with Wilhelm Uhde, a collector, art dealer, and gallery owner, which allows her to remain in Paris. This union lasts until she meets the young painter Robert Delaunay, who becomes her inseparable companion.
- **1910** Uhde arranges a divorce and Sonia and Robert get married in Paris. Sonia adopts Robert's pictorial style and adapts it to textile design. They become pioneers of Orphism, a modern movement exploring the dynamic decomposition of color in abstract terms. Their son is born in 1911.
- **1913** Creates her first simultaneous contrast canvases, her first abstract collages of paper and fabric, and her *Simultaneous Book*, which illustrates *Blaise Cendrars' La Prose du Transiberien* and *La petite Jeanne de France*.
- **1914** Sonia and Robert move to Madrid.
- **1915-1916** Lives in Portugal, where she becomes interested in studying color in popular customs and traditional ceramic.
- **1918** Designs the costumes for Diaghilev's ballet *Cleopatra*, for which her husband designs the sets.
- **1925** Presents La Boutique Simultanée in Paris, consisting of a collection of abstract clothing, accessories, and photographs of the artist dressed in her simultaneous clothes sitting in a Citroen b12, also painted in the simultaneous decorative style.
- **1937** The couple executes large-scale murals for the World Exposition of Paris. Sonia works for the air and railway transport pavilions.
- **1939** Participates in the founding of the Salon des Realistes Nouvelles, planned by her husband, to represent all the abstract experiments in the world.
- **1945** Robert dies. Sonia, in great danger as a Jew, goes into exile in southern France, protecting the artistic legacy of her husband and their friend Hans Arp. Once the war is over, she returns to Paris to continue her artistic career.
- **1964** The Delaunay legacy is exhibited at the Musée du Louvre.
- **1975** Receives the French Legion of Honor.
- **1979** On December 5, 1979, she dies in her studio at 94 years of age.

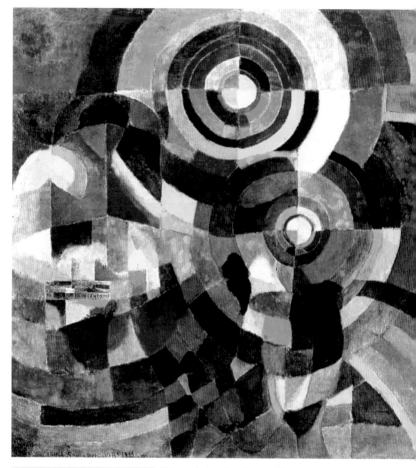

Electrical Prism

(1914)
oil on canvas
93.7 x 98.8 in (238 x 251 cm)
Musée National d'Art Moderne,
Centre Georges Pompidou, Paris

This work constitutes a significant example of a style that the artist developed for many years. This type of art shows the direct influence Delaunay had received from fauvism and cubism. Using combinations of shapes and colors, she created striking abstract paintings of great visual impact. Through a series of geometrical figures based on simple and nonconcrete shapes and juxtaposed vivid colors, she produced beautiful chromatic symphonies. Though some of these compositions, including this one, can be interpreted so that figurative forms appear to emerge, the artist was moved by a conceptual interest, suggesting rather than explaining, programming rather than deciding, investigating rather than asserting.

This composition has its own personality, yet, viewed as part of the artist's general trajectory, it reflects the influence of contemporary tendencies and illustrates a period in her art that would naturally evolve. Moving along similar lines, the artist continued to create this type of composition. Her movement toward a simpler style is evident, both conceptually as well as in the use of compositional elements. This painting is also an obvious example of Delaunay's talent in the field of graphic design. The general aesthetic, the combination of forms, and the explosion of color are exciting and dynamic.

Portuguese Market

(1915)
oil on canvas
35.6 x 35.6 in (90.5 x 90.5 cm)
Museum of Modern Art,
New York
Donation of Theodora
R. Racoosin

At the outbreak of World War I in 1914, the artist and her husband abandoned Paris and moved to Madrid, but shortly thereafter settled in Portugal, where she painted this work. The title, in addition to indicating the subject, helps to explain the artist's idea when she executed this work. Doubtless inspired by the busy movement and kaleidoscope of colors inherent to all markets, the artist, as a good designer would, showed great skill in capturing the atmosphere, which she combined with her talent in synthesis.

The figures of the marketplace are insinuated through abstract forms; the hustle and bustle give rise to dynamic, elegant lines; and color constitutes a firm base that predominates and lends atmosphere to the painting. This work, as always highly colorful and balanced in masses, allows the subject to be clearly discerned, though the artist disintegrated it in a manner similar to that used by the cubists, whose art she knew well and had criticized a great deal.

The painting exemplifies the manner in which the artist perceived reality. Beyond the shapes and colors, she re-created a specific reality, selecting what most interested her and rendering that which would best transmit her creative vision. Life continued to offer images perfect for transformation into true works of art, as filtered through the artist's creativity.

Paris

(1927)
oil on canvas

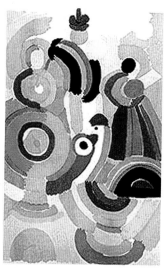

Though Robert Delaunay was recognized as the founder of Orphism and his ideas were decisive for new artistic trends in the early 20th century, it was Sonia Delaunay who provided the most important contribution to avant-garde art. No one comprehended and assimilated the ideas of her husband like she did. She was the artist who best rendered the theory of Orphism.

Based on the abstract proposals of Orphist cubism, this work is highly structured. Including the circular forms typical of Robert's art, there are several human figures creating a concrete space. The circular forms are intense in color and lend these figures corporeality. In the foreground is a bird, apparently a rooster, in a reference to France. Sonia's creative capacity in this work seems subordinated to the rigid dictatorship of Robert's abstractionism, though there are some personal details. The rich nuances of the palette and the simplified yet recognizable forms allow abstraction and figurativism to fuse in an original manner.

The Eiffel Tower, *or* Red Tower

(1923)
oil on canvas
35.4 x 53.1 in (90 x 135 cm)
Solomon R. Guggenheim
Museum, New York

In her paintings based on everyday scenes, the artist captured urban images and reinterpreted them. Here, the shapes, lines, elements, and colors have been combined with singular skill and beauty. The resulting works, in addition to their obvious aesthetic qualities, constitute evocative and idealized images, as if they were allegories presented in a peculiar, innovative, and modern style.

In this work, the Eiffel Tower emerges from a colored background in which a wide range of neutral tones, a rich mosaic of abstract shapes, evokes the architecture and atmosphere of the city. With its vivid red color and its placement in the foreground, the tower becomes a distinctive and personal element within this complex urban magma.

The artist used contrast as the principal means to make this work striking. There is a contrast between the amorphous forms of the background and the structure of the tower, based on straight lines and very strict, regular geometrical shapes that allow it to be differentiated and distinguished. These shapes also lend it a conceptual force, as if the tower were a symbol of order and perfection amid the hodgepodge of urban life. The triangular composition and slender lines of the tower lead the viewer's gaze to the top and reinforce this concept of order.

Right: The creative collaboration of the Delaunay couple led the work executed by both during the 1920s to be mistaken as that of a single artist. Even today, art historians observe the artistic production of Sonia and Robert jointly, as it is difficult to determine the authorship of certain works.

In this painting, Sonia's creative style is clearly visible. The conception of space and the imaginative design of shapes is characteristic of her aesthetic views. She conceived of space based on the figures portrayed and used apparently abstract elements as wholly original perspectival resources. The characteristic circular forms used by Robert are in the background, and the space is composed around a black-and-white figure that distributes space from the foreground to the abstract background.

Sonia maintained a figurative vision that she adapted to the abstract proposals of Orphism, taking advantage of the structure of forms and flat colors to create recognizable scenes. The artist's pictorial clarity arose from the experimentation with German expressionism that she had carried out before meeting her husband. Later, Sonia would channel this new vision of figurative painting toward the design of stamped textiles and the creation of costumes for the theater.

Composition

(1938)
oil on canvas
Albright-Knox Art
Gallery, Buffalo,
New York

Right: The collaboration between Robert and Sonia Delaunay led to such a homogenous pictorial style that their works were often considered as created by a single artist. In this work, Sonia used the circular forms characteristic of Robert's art to create an abstract composition, a style that they began to develop in 1912.

After Robert had practiced a Fauvist style with the clear influence of Georges Seurat and had adopted the theories of chromatic simultaneity, the evolution of cubist art toward pure abstraction permitted the Delaunays to experiment systematically with circular shapes and flat colors. In this manner, they put new ideas on chromatic simultaneity into practice, creating sensations of space and movement that arise from the interaction among form, composition, and color.

Sonia Delaunay acquired these new theories through her husband's experimentation, disciplining her artistic production and experimenting with the development of rhythmic images. The continual succession of forms and colors that appear in Sonia Delaunay's art compose a pictorial rhythm similar to a musical score. In this painting, there is a rhythmic intent in the formal interaction and the chromatic distribution. The broken continuity of colors and lines suggests a specific, changing rhythm that the artist emphasizes, encouraging the viewer to look beyond the simple aesthetic quality of the work.

Painting, *or* Group of Women

(1927)
oil on canvas

Textile Design on an Orphist Background

(~1970)
lithograph
18.1 x 12.5 in
(46.1 x 31.8 cm)

This painting, signed in pencil, in comparison with her works from the 1910s and 1920s, clearly shows the trajectory Sonia Delaunay followed throughout her long life. Though her fidelity to a specific style and criteria endured, the technique was simplified. The elements became simpler as well and the intense colors were applied so that they were flat though, as always, vivid tones dominated. The human figure, both in its form as well as in its colors and garments, acts as simply another element. Is it the figure that provides context for the background, or do the structured elements of the background provide the figure with context?

What does seem clear is the artist's manner of conceiving the work in accordance with a unique style, often appearing in her posters, based on simple geometrical forms that she represents with dense areas of color that are juxtaposed and combined, producing intense contrasts. In accordance with an eminently graphic interest, the expressive aspects of this work seem to carry a great deal more weight than the subject, the impression is more important than the detail, and, once more, the concept prevails above any other interests. This constitutes the quintessence of the principles that, throughout her artistic career, determined Sonia Delaunay's work.

GEORGIA O'KEEFFE

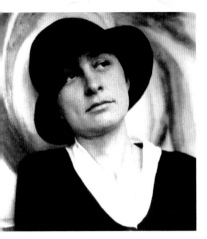

Georgia O'Keeffe in a photograph from 1917 by Alfred Stieglitz, who would become her husband years later. National Gallery of Art, Washington, D.C.

This independent avant-garde painter was a great investigator. From an early age, she showed a deep interest in nature, urban landscapes, and anatomy, which she observed attentively. Based on close-ups and unusual points of view and perspectives, her images tend toward abstraction, at times with a great synthesis of forms, and at others, especially in her cityscapes, with visions in which the volumes, light, and color combine to create a mysterious and diaphanous air.

Georgia O'Keeffe observed the world with a photographic vision that helped her to discover ideal elements on which to base her works. She synthesized forms, eliminated accessory elements, and, with a great mastery over color, created images that demonstrate the thousand possibilities that nature offers if observed through the eyes of an artist.

Her paintings are sensual, spectacular, conceptually studied, and carefully executed. They invariably include a touch of magic, a certain mystery, and the clear intention of rendering the profoundest reaches of the world of sensations.

Her unique artwork, lucid, minimalist, dramatic, and at times epic, reflects great talent and sensibility. Though she did not create a school, the works of many contemporary artists are based on her art.

- **1887** Born in rural Sun Prairie, Wisconsin, on November 15.
- **1905** After graduating, studies at the Art Institute of Chicago, directed by John Vanderpoel.
- **1907** Attends classes at the Art Students League in New York. Frequently visits the avant-garde Gallery 291, owned by the photographer and businessman Alfred Stieglitz. At 291, she gets to know European art, especially the work of Auguste Rodin and Henri Matisse.
- **1908** Wins the League's William Merritt Chase Still-Life Award with an oil painting.
- **1912** Studies at the University of Virginia in Charlottesville. During the spring semester, she attends an abstract art course given by Alon Bement, pupil of Arthur Wesley Dow, who instills in her revolutionary ideas with regard to art. She is interested in exploring the essence of forms. Begins giving art classes.
- **1915** Begins painting works based on natural elements, creating images that tend toward abstraction.
- **1916** Exhibits a series of charcoal drawings at Gallery 291.
- **1917** Impressed by her paintings, Stieglitz organizes her first individual exhibit.
- **1918** Thanks to a grant from Stieglitz, she is able to paint for a year in New York. She joins the group of avant-garde artists involved with Gallery 291 (Charles Demuth, Arthur G. Dove, Marsden Hartley, the photographer Paul Strand, and others).
- **1920** After this year, she paints series on specific subjects.
- **1924** Marries Alfred Stieglitz.
- **1929** Travels for the first time to New Mexico, where she is fascinated by the landscape and its myriad of possibilities for painting. She would return to this state many times.
- **1949** Three years after the death of her husband, she settles in New Mexico, where she continues to paint.
- **1953** Travels to Europe.
- **1970** The Whitney Museum of American Art in New York organizes her first retrospective exhibit. Her failing eyesight finally forces her to stop painting. She takes up sculpture.
- **1986** Dies in Santa Fe on March 6.

Blue Nude

(~1917)
watercolor on paper
15.7 x 10.1 in (40 x 25,6 cm)
Sheldon Memorial Art Gallery
and Sculpture Garden
University of Nebraska—Lincoln

This watercolor is one of several works that O'Keeffe painted when she taught art in Texas. The artist selected the techniques that best suited the objective of each painting. In a work like this one, in which the artist's interest is in representing a set of forms derived from the human body rather than the body itself, the evanescence and softness of the medium allows her to go beyond reality and concentrate solely on these exemplary, suggestive strokes. It is clearly a female nude, but despite the title of the work, O'Keeffe was not attempting to execute an anatomical study, but rather to arrive at an expressive, suggestive representation that goes beyond.

This was precisely one of the principal objectives of her works: to render a new interpretation of the visual world. Though the painting shows an inclination toward abstraction, the artist applied the color carefully, distributing the intensity in order to model and provide volume, so that the figure is perfectly represented. Later, O'Keeffe began painting enlarged views of details that provided the perfect base for abstract works.

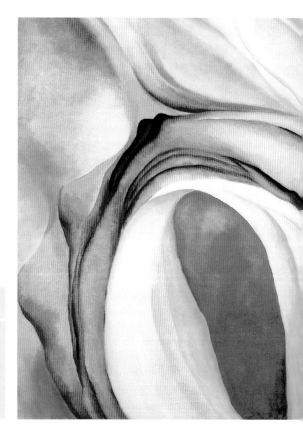

Music: Pink and Blue II

(1919)
oil on canvas
22.2 x 27.6 in
(56.5 x 70 cm)
Whitney Museum of
American Art, New York

The title refers to a strong storm, with a turbulent sky and a body of water being struck by lightning. Despite its abstraction, the subject gives rise to various interpretations that are neither contradictory nor mutually exclusive, and which the artist perhaps sought in order to create an ambiguous and symbolic image.

The Storm

(1922)
pastel
18.3 x 24.4 in
(46.4 x 61.9 cm)
Museum of Modern Art,
New York

One interpretation is the juxtaposition of two worlds struggling against each other: the threatening sky, drawn in dark colors, and the central area, shaped like a wedge with a lightning bolt. Rather than the bolt striking the water, the wedge seems to push itself into the bolt, represented in a dense blue threatened by the sky. Another interpretation is the barly concealed union of the male and female sexual organs, juxtaposed yet combined, confronting yet joined, with all of the ingredients necessary to evoke strength, delicacy, passion, and union. Both the composition and the colors transmit a dramatic air.

Although Georgia O'Keeffe always denied that her works had an erotic connotation, in this work it is irrefutable. The anatomical parts represented; the strategic point of view; the voluptuous forms of the earth and water; the powerful sky, with its lightning bolt, an unequivocal sign of force and passion; the virile member plunging into the depths of the water—the symbols are represented so obviously that there is no room for doubt. Corroborating this interpretation is the pictogramlike motif appearing in the lower left, representing the moon overlapping the sun and resembling a yin-yang symbol. The striking force of the painting is in no way at odds with its sensitive expressiveness, an element that is ever present in O'Keeffe's works.

Left: This work is from the period during which the artist was dedicated to abstraction, although this characteristic is manifest throughout her oeuvre with varying intensity. O'Keeffe was interested in forms and color, and especially in the essence of the subject matter. She was constantly searching for suggestive images in which rhythm, chromatic balance, and a great deal of sensuality constituted the principal characteristics. For these creations, O'Keeffe often used a photograph or photographic vision, selecting a detail and enlarging it to provide the basis of the painting. Generally, the elements of nature (flowers, landscapes, anatomy) were her principal sources of inspiration. This and other paintings appear to be based on intimate areas of the female body. The sensual lines, clean pastel colors, delicate tones, and overall softness suggest a subtle and elegant voluptuousness in a magical, mysterious, and disturbing world filled with charm, doubtless the consequence of the strong vitality that the artist always exhibited. Although, strangely enough, she always denied any erotic connotations in her works, it is clear that in this one, the expressive richness and polished technique serve to increase the emotional and passionate aspects of this evanescent and unequivocally sensual image.

East River, New York No. 2

(1927)
pastel on paper
9.8 x 28 in (25 x 71 cm)
Private collection

Left: Along with her flower paintings, O'Keeffe's works on New York were very famous. This is one that displays the greatest sensibility. It was executed in the pastel medium, technically suited to her objective: to create an evocative vision based on lines, volume, and light and dispensing with all other elements. She employed the richness of pastel to illuminate the cityscape with a variety of tones. Apparently, she used a restricted palette, yet upon close observation, a great subtlety is evident in the application of color in the hazy background area.

Light is the principal protagonist of this cityscape, and it is treated superbly, distributed among different, highly focused areas combined with others in which the image seems to fade out. It is a suggestive vision lying somewhere between a dream and a homage to the city, between formal aesthetics and expressive sublimation. Photography, which O'Keeffe so supported as an independent field of art, was one of her main sources of inspiration. Through it, she obtained a synthetic view that served as an excellent basis to develop forms and finished works of great dramatic force, clearly demonstrating the endless possibilities offered by the world in which we are immersed, if we have sufficient perspicacity and talent to discover them and use them. This work is fascinating.

New York at Night

(1929)
oil on canvas
39.4 x 18.9 in (100 x 48 cm)
Nebraska Art Association
Collection Thomas C. Woods Memorial
University of Nebraska–Lincoln

Georgia O'Keeffe was always fascinated by New York City, which she adored and regarded as the American city par excellence. This nocturnal view of Lexington Avenue is a combination of architectural forms, light reflections, immense volumes, and vast voids. It is like a still life constructed of awe-inspiring buildings and fascinating light effects, immersed in an evocative atmosphere. The artist's capacity to synthesize and her skill in selecting the elements most appropriate for her objectives define her style. This work was painted from the window of O'Keeffe's room on the thirtieth floor of the Shelton Hotel.

Red, White, and Blue

(1931)
oil on canvas
39.9 x 35.8 in (101.3 x 91 cm)
Museum of Modern Art, New York

When Georgia O'Keeffe visited New Mexico for the first time in 1929, she was so fascinated by the landscape and the myriad details of the desert that they came to occupy a significant part of her oeuvre. Her paintings of bones and dead animals that vultures and other animals had picked clean and that the burning desert sun had blanched were frequent motifs in her works. Two stripes flanking the painting and a cloth with folds directed diagonally toward the center provide context and serve as a backdrop for this skull in a composition characterized by symmetry. The work focuses on forms tending toward abstraction, and on rendering the central motif as if in a negative. The forms, profiles, and combination of textured areas with flat zones of saturated color pay homage to the desert, symbolized by the skull, a vivid image of the passage of time and the inclemency of nature. The work does not focus on details, and there is a clear tendency toward abstraction in its conception. As always, the artist focuses on the essence, based on synthesis, simplicity, and austerity of means, evoking symbolism through the line. The centralized placement of the skull and its symmetry, as well as the framing elements, lend it a sacred air, as if it were a relic, to which the black strip running down the center of the background contributes, seeming to act as a support. These bone images are forceful and mysterious.

Orchid

(1941)
pastel on cardboard
26.8 x 20.9 in (68 x 53 cm)
Inheritors of Georgia O'Keeffe

The subject of flowers was one of the most common in O'Keeffe's repertoire, not so much for her interest in realist naturalism but because many of their details provided an excellent basis from which to develop all sorts of forms, colors, and transparencies.

In her search to reveal the essence of things, O'Keeffe would photograph details of flowers, then enlarge them and study their forms and lines to develop her creations, always elegant, delicate, and chromatically harmonious.

This close-up of an orchid perfectly illustrates the artist's objective. By applying a criteria of synthesis, she focused on the essence of the flower, giving rise to curious forms, with myriad curves, gradations, contrasts, and rich hues, resulting in a delicate and sensual abstract image, imbued with both rhythm and tranquility. This approach to nature was a constant in her life, and by studying it, she created a series of singular paintings of exquisite attractiveness. It is astonishing that a person with a character as strong as O'Keeffe's could create images as relaxing and fascinating as these.

LIUBOV POPOVA

Liubov Popova in 1924.

- **1889** Liubov Sergeyvna Popova is born near Moscow.

- **1907-1908** Studies in Moscow at the studios of Zhukovski and Konstantin Yuon.

- **1910** Travels to Italy, where she works with Vladimir Tatlin.

- **1912** Settles in Paris.

- **1913** Returns to Russia and collaborates with Tatlin and Alexander Vesnin.

- **1914** Takes another trip to Italy and France, where she participates in various exhibits.

- **1918** Works as a professor of painting at the SVOMAS (State Free Art Studios) and VKhUTEMAS (Higher State Artistic and Technical Workshops) in Moscow. Marries art historian Boris von Eding; gives birth to a son. Von Eding dies in 1919.

- **1920** Appointed a member of the INKhUK (Institute of Artistic Culture) in Moscow.

- **1921** Participates in the exhibit 5 x 5 = 25. Turns to book illustration and porcelain and textile decoration.

- **1922** Participates in the first exhibit of Russian art at the Van Diemen Gallery in Berlin.

- **1924** Dies of scarlet fever in Moscow.

Popova was one of the most representative members of the Russian avant-garde. Her artwork is remarkable for its special treatment of color and space. Her concept of "painterly architectonics," or the architectural value of painting, consisted in considering painting as an energy resulting from the combination between the distribution of volumes, planes, lines, and the colors of the palette.

Her frequent use of varied tones to create new, spectral, and spatial interpretations of industrial design and set and costume design for theater contributed to the development of utilitarian constructivism. After working on stage sets and costume design for various theater productions, Popova began a process of experimentation in her artwork that delved into an innovative manner of treating color. With this new concept, Popova began creating a softer interaction of tones, using subtle color gradations and making the transitions between planes more gradual, leading to circular forms that produced an effect of movement. The artist dispensed with the perspectival aspect of color, so that the frontal planes in her paintings are not lighter than those in the background.

Her abstract paintings show two basic qualities: a focus on a dynamic composition dispensing with perspective, space, and volume, and an innovative way of imagining a pictorial work as flat surface, two-dimensional art, removed from three-dimensionality and therefore false.

Despite her untimely death, her paintings and aesthetic approaches influenced many artists of her generation.

Seated Female Nude

(1914)
oil on canvas
41.7 x 34.3 in
(106 x 87 cm)
Ludwig Collection,
Cologne

The fundamental concern of the new abstract painting based on cubism was the structural balance of the painting as an autonomous space in which things were ordered and planes redistributed in order to attain a new system of permanence. This female nude has a spatial ambiguity in which the body is rendered diversely on a highly fragmented surface, without losing the concentration of elements that constitute the principal motif. The painting has reminiscences of what could be called a traditional concept of painting. Hence, the figure complies with certain principles of volume and perspective that are evident to the viewer due to the contrast between the cool tones in the background and the warm tones of the woman's body.

This type of figurative representation would gradually disappear as the artist developed her two-dimensional concept of painting. After 1917, spatial characteristics entirely disappeared from Popova's art and flat abstraction became the principal protagonist of her paintings. The use of color would also evolve, presenting a new, more flexible and sensual response. This work clearly marks the beginning of a path taken by the artist that would quickly lead to the desired results.

One of Popova's principal contributions to the history of art was the innovative concept of pictorial works as two-dimensional art. In this painting, the concept gave rise to areas of intense flat colors, juxtaposed to create contrasts producing a false volumetric sensation. The red occupying a large area in the foreground regulates the entire work and determines a space in which the different color areas suggest movement.

Popova reflected her ideas here on the architectonic value of painting, based on the suggestion of movement and the studied use of a set of colors and contrasts. She had studied the theories of the Italian futurists on movement, but, like other Russian painters, rejected the chaotic Italian theory and the attempt to represent velocity as the central element of new art. Though movement is present in Popova's oeuvre, it acts as an inert element, as a consequence of the creation of contrasts achieved by placing different elements in warm tones against cool backgrounds, attaining a sensation of volatility. In this work, the red and blue planes appear to float and move lightly, impelled by the background composition. The artist learned to employ this technique after studying the futurist movement in Paris and Italy in depth.

Painterly Architectonics

(1920)
oil on canvas
22.6 x 17.3 in
(57.5 x 44 cm)
Ludwig Collection, Cologne

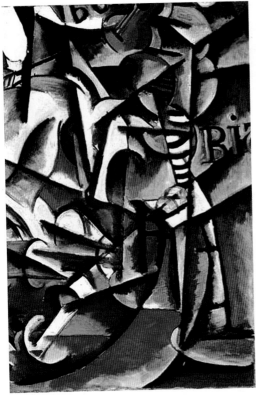

Portrait of a Woman

(1915)
oil on canvas
38.2 x 25.5 in (97 x 64.7 cm)
Guggenheim Museum,
New York
Gift of George Costakis

This painting shows Popova's evolution toward a new concept of painting. The formal figurativism that had determined her earlier works was beginning to decompose into various fragmented elements when she began this work. These fragments are spread throughout the pictorial surface like a puzzle and give rise to a visual itinerary representing different tonal planes.

The painting manages to maintain an elegant tension between the segmented elements and other signs and details of cubo-futurism. It creates a fantastic, balanced architecture that shows great proximity to the compositions of pure analytical cubism. A certain commitment to formalism is still evident, and the image is oriented toward a compositional rhythm, following a specific internal logic harmonizing the different elements of the painting. As in cubist art, chromatic counterpoints are so important that they take precedence over the subject matter.

This work marks the beginning of a new creative stage for Popova, though she continues to use a complicated superposition of planes and network of lines to construct a dense space acquired from cubism. The printed letters are a new element that activates the work as a sort of message.

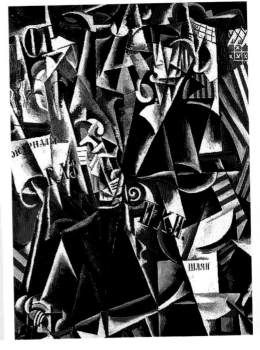

The Traveler

(1915)
oil on canvas
51 x 37.8 in
(129.5 x 96 cm)
Norton Simon Art
Foundation
Pasadena, California

Birsk

(1916)
oil on canvas
37.4 x 24.8 in
(95 x 63 cm)
The Guggenheim
Museum, New York
Gift of George Costakis

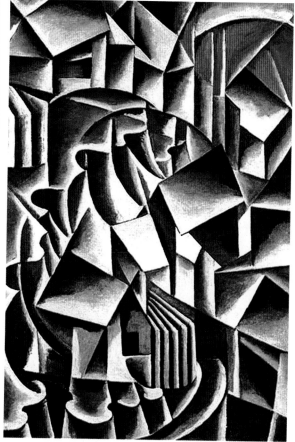

In her first cubo-futurist works, Popova employed all the different interpretations of cubist formulas being used in Europe. In this painting, the artist renders a version very close to the synthetic cubism that the initiators of the movement, Georges Braque and Pablo Picasso, had established some years earlier. The most distinctive characteristic of purist synthetic cubism is that the image is not an aggregate of components but rather corresponds with reality, and its components and their respective qualities are represented and organized according to an innate coherence.

Here, the abstract form was not achieved by dismemberment. It is rather a well-structured abstraction perfectly determined within the painting, employed to construct the principal images. Space is rendered as a structure on which various elements are placed in relief. The treatment of light is also affected by this analytical vision. The light is fragmented into each of the small segmented planes and was conceived wholly independently of the composition, without proceeding from a single light source, as each element is illuminated from a specific angle. Popova achieved this effect through a single tonal gradation used throughout the planes. This corresponds to a specific manner of understanding painting and gives rise to certain laws and aesthetic concepts. With these ingredients, the artist achieved a unified painting and a balanced composition.

Left: In Paris in 1912, Popova adopted cubism and then entered into contact with the Italian futurists. This painting is a significant work in the artist's cubo-futurist stage. The inclusion of small, flat figurative elements composed in the manner of a puzzle show the artist's capacity to synthesize the different artistic movements of the European avant-garde. The use of typography ties the work to constructivism, though the general character is clearly futurist, with its spatial aspect in which a sense of movement can be detected.

Popova also employed a new element that she adopted from certain works by Giacomo Balla: a network of strong lines alluding to movement of an object through space. The futurist interest in ephemeral optical sensations was based on Impressionism and applied the same pictorial view of landscapes and still lifes to modern engineering, mechanics, and cityscapes. On a unified compositional scheme, the artist skillfully applied color to obtain a work of varied, contrasting colors that are juxtaposed yet balanced.

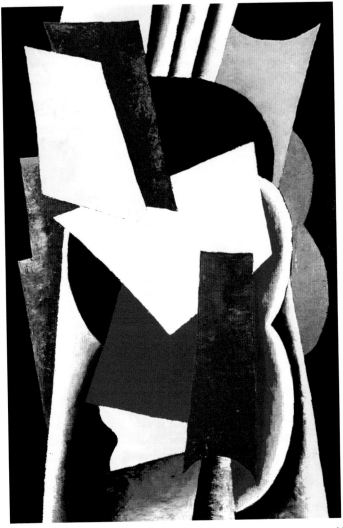

Still Life: Instruments

(1915-1916)
oil on canvas
41.5 x 27.2 in
(105.5 x 69.2 cm)
Thyssen-Bornemisza
Collection, Madrid

In 1916, Popova began to show the influence of Kasimir Malevich, resulting in a rigorously abstract style. Malevich was a Ukrainian painter who, influenced by Fauvism as well as the popular art of his country, adopted cubism, which he introduced in Moscow. In this work, the influence of cubism, suprematism, and futurism is visible. Popova focused here on geometrical synthesis and the expressive value of elementary shapes, developing a particular sense of formal rigor. For Popova, as for Malevich, representational art is a distraction for the senses, where the figurative image distracts the viewer from the true aim of art: the pure manifestation of sensibility. In this painting, the representation of an instrument, apparently a stringed one, is only a simple anecdotal detail that completely cedes protagonism to the various color planes that compose the work. The use of a black background in contrast with the various opaque, nearly flat tones that define the surface of the instruments is very modern and lends the pictorial space a sense of order and clarity. The absence of a relationship between the different color planes indicates an abstract intention in this work, in which Popova constructed a flat composition lacking all figurative norms. The artist's trajectory toward an entirely two-dimensional art prevented her from experimenting with elements such as light or perspective. The composition is based on a juxtaposition of color areas that, when duly combined, constitute a chromatic mosaic. In addition to rendering a symphony of colors, this mosaic contributes a sense of depth that makes the shapes seem to float at different levels. It is a stratagem to convert two-dimensionality into something suggesting a three-dimensional space.

TAMARA DE LEMPICKA

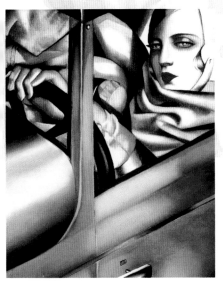

Self-Portrait, *oil on panel, 13.8 x 10.2 in (35 x 26 cm), 1925, Private collection.*

Tamara de Lempicka's work can be ascribed within the new concept of art in Europe and the United States in the 1920s. After World War I, the new bourgeoisie had such unprecedented economic power that art became an object of investment, and Lempicka took advantage of this.

When the Lempicki couple moved to Paris in 1918, they were completely ruined financially. Tamara, who was accustomed to a life of luxury, decided that painting could serve as the means to recover her previous lifestyle. After taking classes with André Lhote, she chose an art style that would please the new bourgeoisie, whom she presumed would be her best clients.

Lempicka understood the Neo-Cubism professed by Lhote as a reconciliation between avant-garde art and academicism, a return to figurative art without rejecting the modernity of the times. This interpretation was very well received by the public, which had a classical concept of art. The decorative aspect of Lempicka's work, very much in keeping with the art deco style, promoted the idea of an official style in juxtaposition to Pablo Picasso or Georges Braque's avant-garde art.

Her preferred genre was the portrait, in which, intrigued by the eroticism of Ingres's work, she reflected her own passion. Female nudes with a high erotic content were also a frequent subject and allowed the artist to manifest her own sexuality.

- **1898** Tamara Gorska is born in Warsaw on May 16.
- **1911** Travels to Italy, where she is drawn to the world of art.
- **1916** Marries Tadeusz Lempicki in Saint Petersburg (then Petrograd), Russia.
- **1917** The Lempicki family maintains a luxurious lifestyle. But following the Russian Revolution in October, Tadeusz is imprisoned and Tamara gains his freedom by having sex with the Consul of Petrograd. Tamara and Tadeusz move to Copenhagen.
- **1918** They move to Paris, where Tamara takes drawing classes from André Lhote, since she has decided to make a living from painting. Enters into contact with the artistic circles of the Salon des Indépendants, the Salon d'Automne, and the Salon de Moins de Trente Ans. Her daughter, Kizette, is born.
- **1925** Exhibits in the Salon des Tuileries and the Salon des Femmes Peintres. Travels to Italy with Kizette, where she exhibits and meets Gabriele d'Annunzio.
- **1927** *Kizette on the Balcony* wins the first prize at the Exposition Internationale des Beaux-Arts in Bordeaux.
- **1928** Tamara and Tadeusz divorce.
- **1929** With *Kizette, First Communion*, Tamara de Lempicka obtains the bronze medal at the Exposition Internationale in Poznan. Travels to the United States.
- **1933** Marries Baron Raoul Kuffner.
- **1939** Moves to the United States with her husband and exhibits at the Reinhart Gallery in Los Angeles.
- **1941** This year and the following, she exhibits in New York, San Francisco, and Milwaukee. Kizette marries Harold Foxball.
- **1962** Raoul Kuffner dies.
- **1973** A retrospective on Tamara de Lempicka's work is held at the Galerie de Luxembourg in Paris.
- **1974** Moves to Cuernavaca, Mexico.
- **1979** Harold Foxball dies, and Kizette moves to Mexico to take care of Tamara, who is seriously ill.
- **1980** Dies on March 18 in Cuernavaca.

Nude: Woman Partially Reclining

(1925)
oil on canvas
14.9 x 21.5 in (37.8 x 54.5 cm)
Private collection

Lempicka manifests her concept of the female body, extolling its femininity and exuberance. The pronounced curves, recalling the allegories of fertility of prehistoric sculptures, and the sensuality radiated by this body reveal the eroticism that the female nude called forth in the artist. The art deco movement used Ingres as a reference, as he employed the cone and the cylinder as basic geometrical shapes for his nudes.

Here, the geometrical planes are combined with the nudity of the body in an interplay of contrasts. The matte colors of the setting contrast with the luminosity of the body, which the artist further highlights by reducing the size of the head, which she represents with extreme coolness. In this work, Lempicka dispenses with movement and allows the body alone to express itself.

Group of Four Female Nudes

(1925)
oil on canvas
51.5 x 31.9 in
(130.8 x 81 cm)
Private collection

Lempicka was an open person, and her strong sense of sexuality led her to create various paintings where the female nude acts freely, devoid of hesitation and taboos. The nude is so important in this work that there is hardly space for anything else.

The great care the artist has taken in rendering these bodies, their curves, sophistication, and excellent distribution within the whole, are combined with strong eroticism. The painting is like an orgy in which sex is combined with beauty, voluptuousness matches the curves, passion is enhanced by the chromatic luminosity of the anatomies, and the sophistication of the women is idealized through their acute excitement.

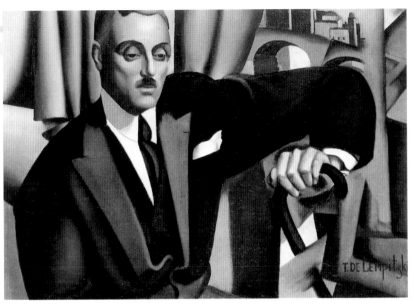

Lempicka executed numerous portraits of the nouveau riche who were so successful in Paris in the 1920s. Attracted by power and wealth, Lempicka soon realized that to become successful and recover her lost social status, she had to create extravagant and luxurious art that could attract the owners of large fortunes. These portraits reflect arrogance and luxury. To demonstrate their status, the nouveau riche were anxious to appear in works by Lempicka. Here, the elegantly dressed figure has a thoughtful expression and a distinguished appearance, and it fills the entire surface of the canvas. With their cool colors, works by this artist freeze an instant in time and convert it into something eternal.

Prince Eristoff

(1925)
oil on canvas
25.6 x 36.2 in (65 x 92 cm)
Private collection

Kizette on the Balcony

(1927)
oil on canvas
49.6 x 32.3 in (126 x 82 cm)
Musée National d'Art Moderne, Paris

In this portrait of her daughter, Lempicka combines two cubist styles of the 1920s. The interior of the house is executed in a modeled cubism, with the cubism adopted only in its compositional aspect and thus agreeable to the public. Volume is an important element in works by Lempicka; here the roundness of the legs and hands contrast with the violent, austere cubism of the buildings outside.

The Exposition Internationale des Arts Décoratifs et Industriels Modernes marked the apogee of the Neo-Cubism propounded by Lhote and the stylistic unity of his and Lempicka's works. The synthesis between cubism and academic figurative art was officially recognized as art deco when it was applied to the decorative arts.

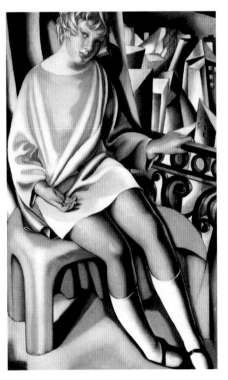

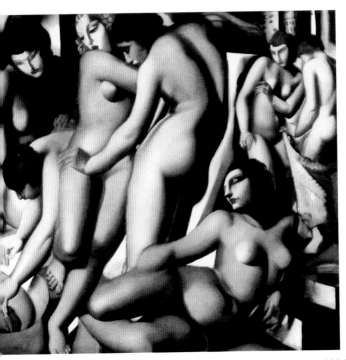

Women Bathing

(1929)
oil on canvas
Private collection

Through her teacher, Lhote, Lempicka came to know the art of Ingres, which became a basic reference for her portraits and nudes, as Ingres masterfully captured the sensuality and eroticism of the female body. In this painting, Lempicka was inspired by Ingres's *The Turkish Bath*. In both works, the women appear in an intimist scene of great eroticism. Each woman incites and provokes through her pose and gestures, employing her entire store of eroticism and giving rise to a lubricious and tempting atmosphere. This world of savage and mysterious sensuality is surrounded by a combination of shadows that, rather than providing playful light effects, serves as an allegory of morality. In certain points, the scene approaches total darkness, exaggerating the contrast between taboo and excitement.

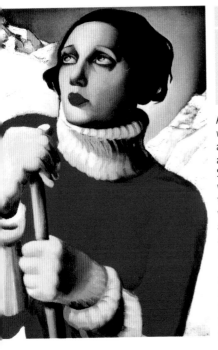

Saint Moritz

(1929)
oil on panel
13.8 x 10.2 in (35 x 26 cm)
Musée d'Orléans, Orléans

According to Lempicka herself, she was "the first woman to paint with clarity and definition." Her artwork from the 1920s contrasted with the abstract art that was being executed in France, Spain, and the United States. Aesthetically, her work was intended as decorative art, with beautiful figures and serene expressions that were well received among the detractors of abstract art. The use of light tones and luminous colors applied in fluid brushstrokes caused her paintings to be considered superb for their good taste.

The serene beauty of this woman against a snowy landscape perfectly renders the style of the economically powerful during that time. This made the artist a favorite with that class, people who were pleased to see their social position perfectly reflected in her works.

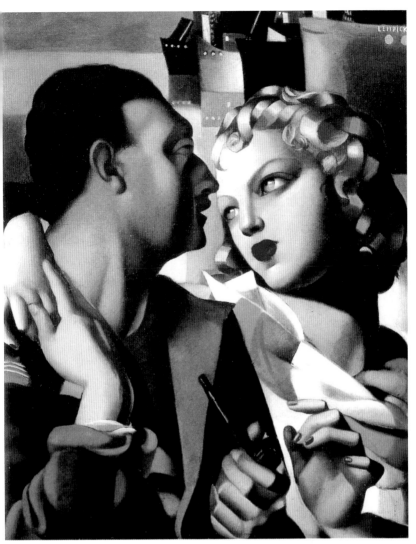

By 1931, Lempicka had already fully defined her style. In this work, the passion reflected in the woman's face is more realistic than in previous paintings, and her expression is more human. The artist studied the inclusion of realist elements, which she combined with details suggesting abstraction. The woman's hair is inspired by Lhote's Neo-Cubism, while her skin is treated in a meticulous realist manner.

After 1930, Lempicka began representing a more romantic vision of love. The couple here does not show the ambiguity of her earlier paintings. More importance is given to the expressiveness of gesture and gaze. The influence of Hollywood stereotypes marked Lempicka's works from the 1930s, as the artist assiduously worked with movie stars. In these paintings, women appear emotional and vulnerable. Men, on the other hand, as the one in *Idyll,* are represented with the characteristic coolness of previous works.

Idyll

(1931)
oil on canvas
16.1 x 12.8 in
(41 x 32.5 cm)
Private collection

Surrealist Hand

(~1945)
oil on canvas
27.2 x 19.6 in
(69.2 x 49.8 cm)
Private collection

As the title indicates, Lempicka, who had always tried to paint in the prevailing style of the time, did not balk at surrealism. Her surrealist works, on the border between realism and abstraction, are characterized by strong contrasts, with the vertical line predominating.

Though the artist was interested in keeping up with the latest trends, she did not show the same sureness and authority in her surrealist art as in her works from the 1920s and 1930s that had made her famous.

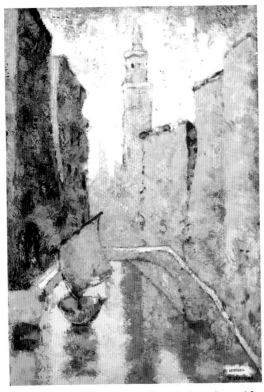

Venice in the Rain

(1960)
oil on canvas
26 x 35.8 in (66 x 91 cm)
Private collection, Hollywood

In her last artistic period, Lempicka repudiated her habitual figurative approaches. Her rejection of abstract art in the 1920s, which had led her to fame, no longer found a warm reception in the 1960s. Abstraction was the sign of the times, and she adopted it as the only way of surviving in the world of art.

In this work, the artist represents a romantic scene in a Venetian canal, timidly introducing highly geometrical, abstract elements. Ochre tones were common in her last works, as was the use of the spatula. This change of style was unnatural to her, a fact that was reflected in her paintings, which no longer transmitted the dynamism and force of her earlier works. Her tentative approaches to abstract art arrived late. Though accustomed to evolving her style according to artistic trends, Lempicka seems not to have noticed the eruption of pop art.

ALICE NEEL

Photograph of Alice Neel around 1970.

Creator of a particular portraitist style, Alice Neel chronicled 20th-century America through the figures she portrayed. Trained at the beginning of the century, she adopted expressionist aesthetic theories to create a style of impressions. She used the ideas that had been developed in the last years of the 19th century to find a style in which sensations or atmosphere acquired as much weight as the figurative value of a portrait.

Alice Neel's aesthetic was clearly influenced by Henri Matisse and Henri de Toulouse-Lautrec. Powerful outlines, intense colors, and vivid tones became the expressive means that Neel used to transmit the personality of her sitters.

The artist respected figurative realism, yet there was a vital component in her work that made it much more than a simple aesthetic exercise. During the first years of her career, she was fascinated by figures with strong characters, and she portrayed communist leaders and intellectuals from a sincere viewpoint. After her marriage to José Santiago, though, she rediscovered the value of anonymous figures as authentic testimonies of her time. Her art was based on the idea that the figure fully reflects his or her time, and she executed her entire oeuvre in keeping with this concept.

In perfect accordance with the expressionist parameters, the works of Neel can generally be interpreted in two ways—what the eyes see (the portrait of a character) and the evocation of a (tragic) reality of life, articulated around that character.

- **1900** Born in Merion Square, Pennsylvania, on January 28.
- **1921** Studies at the Philadelphia School of Design for Women.
- **1925** Marries the Cuban artist Carlos Enriquez and moves to Cuba.
- **1926** Her first child, a daughter, is born.
- **1927** Her daughter dies. She moves to New York.
- **1928** Her second daughter is born.
- **1930** She separates from her husband. Suffers from depression.
- **1932** Moves to Greenwich Village in New York with a sailor, Kenneth Doolittle.
- **1933** Participates in the Public Works of Art Project.
- **1934** Doolittle destroys many of her paintings in a jealous rage.
- **1935** Participates in the Works Progress Administration Federal Art Project.
- **1938** Exhibits at the Contemporary Arts Gallery in New York.
- **1939** Has a child by performer José Santiago.
- **1940** Meets filmmaker Sam Brody; separates from him after birth of son, 1941.
- **1944** Exhibits at the Pinacotheca Gallery in New York.
- **1950** Exhibits at the ACA Gallery in New York.
- **1951** Exhibits at the Playwrights Theater in New York.
- **1963** Exhibits for the first time at the Graham Gallery, New York, where she would exhibit repeatedly until 1980.
- **1971** Receives an honorary doctorate from Moore College of Art, formerly Philadelphia School of Design for Women.
- **1974** The Whitney Museum of American Art holds a retrospective of her work.
- **1975** Retrospective exhibit at the Georgia Museum of Art, Athens.
- **1976** She is appointed a member of the American Academy of Arts and Letters.
- **1978** Exhibits at the Artemisia Gallery in Chicago.
- **1979** Receives the National Women's Caucus for Art, Outstanding Achievement Award.
- **1980** Exhibits at the Boston University Art Gallery.
- **1981** Exhibits at the Union of Artists in Moscow.
- **1982** Exhibits at the Robert Miller Gallery in New York.
- **1984** Dies on October 13.

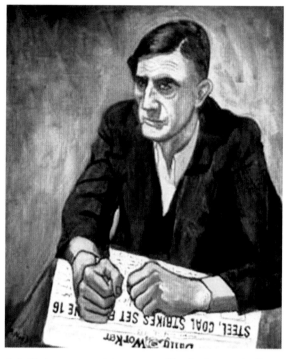

Pat Whalen

(1935)
oil on canvas
20.9 x 24.5 in
(53.2 x 62.3 cm)
Whitney Museum of
American Art, New York

Alice Neel's portraits often provide historical context through details that allow the work to be identified to a specific time. In this work, the artist recreates the Great Depression of the 1930s through the figure's gesture. In a very direct way, she captures the distressed, tense atmosphere that surrounds the person. Pat Whalen was a communist sympathizer, and the artist portrays him resting his fists on an issue of *The Daily Worker*, a communist newspaper. Alice Neel's artwork offers a social chronicle of her country within a highly expressive portraitist style. Through the figures' gestures, the viewer can directly feel the repercussions of specific historical events on regular people. In her early period, the artist focused on anonymous figures capable of transmitting this effect, employing style, composition, and color to achieve her objective.

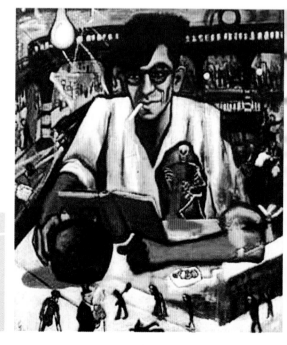

Kenneth Fearing

(1935)
oil on canvas
23.8 x 27.6 in
(60.5 x 70 cm)
Museum of Modern Art,
New York

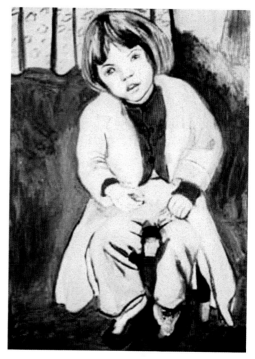

Girl in Pajama Suit

(1945)
oil on canvas
20.1 x 25.5 in (51 x 64.7 cm)
Colgate University,
Hamilton, New York

After her marriage to the Cuban artist José Santiago and the birth of their son in 1939, Neel developed a more tranquil pictorial style based on more tenuous tones. In this painting, the artist represents the girl in a very simple manner. In previous portraits, she had based the expressive capacity of her figures on gesture, while in this one, she emphasizes the innocence that the facial expression transmits, especially through color contrasts. The room is dimly lit, but the girl is brilliant, nearly monochromatic, in a light tone with only the dark shirt as an exception.

Here, Neel is using a technique in which the parts of the body with greatest expressive capacity are rendered disproportionately large. Hence, the girl has a rather large head, allowing the viewer to see her expression more clearly. Neel used this technique timidly, though in many of her paintings there are figures with hands or faces that are deliberately oversized so as to produce a specific visual effect.

Left: During the Depression of the 1930s, Alice Neel, like many of her colleagues, participated in different artistic projects promoted by the government. During this artistic collaboration with the national administration, Neel executed very original portraits in which she included elements verging on the surreal, as in this portrait of the poet Kenneth Fearing.

She places the writer in a dense, closed, somewhat oppressive setting, surrounded by a myriad of small figures constituting allegories of the economic depression the country was undergoing. Neel used a very particular style for this composition, with marked outlines and a dark tonal range that contributes to the atmospheric sensation.

The small allegorical figures recall the style of the Mexican artist Frida Kahlo, who often placed symbols and various creatures around her subjects, using a Naive style, to help the viewer interpret the work appropriately. Neel, a contemporary of Kahlo, used this style to create art with a message in which the minute figures spring from the artist's own imagination. Most of these symbols are at the bottom of the painting, although a skeleton surrounded by blood clearly demonstrates that death has installed itself within the subject's chest.

Around the figure, Neel invented an allegory of life, centered in its sordid and negative aspects—the human being is insignificant (symbolized by the small figures that ambulate on the table), and although it encloses itself in its particular world (which is what the character does), it is always threatened by the death he carries inside (the bloodied skeleton he carries implanted in his chest).

City Hospital

(1954)
ink and gouache on paper
20.1 x 26.6 in (51 x 67.5 cm)
Greenville County Museum
of Art, South Carolina

During the 1950s, Neel shed her former interest in communism and the participation in political activism to which she had been introduced by her husband and their friend the documentary film director Sam Brody.

After living some years in Cuba and losing her first daughter in 1927, Neel suffered from a depression that led her to return to the United States, where she was hounded by the government for sympathizing with the communist cause. She was also taken to court for executing various portraits of American communist leaders.

She lived in Spanish Harlem, New York, where she painted many scenes from everyday life, especially in the 1940s. This painting from 1954 is part of a series on the neighborhood. She renders a tender scene in which a black nurse attends a white woman on her deathbed. The majority of Neel's works on Spanish Harlem were executed in ink and gouache. This medium and technique allowed her to make quick drawings like this one, in which the expressive force is singularly evident in the figures' faces.

Swedish Girls

(1968)
oil on canvas
32.9 x 45.7 in (83.5 x 116 cm)
Columbus Museum, Georgia

During the course of her artistic career, Neel cultivated different facets of the portrait, working to achieve art that would make an impression on the spectator. In this work, the artist renders two girls of Nordic appearance, accentuating their distinctive features. She faithfully reproduces their blond hair, white skin, and light eyes, and she focuses on their ethnic origins rather than on the figures themselves. The artist does not merely paint two girls; rather, she renders the physical characteristics of two Scandinavians.

In Neel's child portraits, the figures are rendered with a sense of loneliness and vulnerability, which calls forth sentiments of tenderness in the viewer and thus attains a greater expressive effect. These two girls reflect candidness and innocence, and they are tinged with neglect, staring at the viewer with melancholy eyes. This work is painted from a slightly elevated point of view, allowing the artist to portray the figures in a position that would evoke sympathy in the viewer. That expressive quality is the prevailing element in this work.

Andy Warhol

(1970)
oil on canvas
36.4 x 54.6 in (92.5 x 138.7 cm)
Whitney Museum of American
Art, New York

Warhol, a unique figure and distinguished master of pop art, exercised great influence on the American art scene in the latter half of the 20th century. He met the majority of important artists, who made him an icon and, in portraits, portrayed him as such. Neel, on the other hand, showed Warhol in a much simpler manner. She sought to render an image of the person and not the famous artist, portraying him partially nude in an unfinished image. Aware of the complexity of painting the legendary artist, Neel opted for a style in keeping with his distinctive personality.

Warhol is shown frontally, with an absent, meditative expression, seated on a sofa that is only sketched in. The figure transmits humbleness. The technique used, the brushstroke, and the treatment of color produce a highly expressive image. It seems as if the artist wants to unsettle the spectator in this completely unconventional portrait, in which Warhol is "stripped bare" and rendered in a prosaic, demythologized image.

Gladiolas

(1976)
oil on canvas
28.9 x 41.5 in
(73.5 x 105.3 cm)
Whitney Museum of American
Art, New York

Though Neel was primarily a portraitist, the still lifes and New York cityscapes she executed offer a different insight into her work. Starting in the 1970s, the artist apparently began to appreciate the artistic possibilities of other genres. The composition of this work has a clearly decorative quality in which the artist re-creates the atmosphere of her portraits. This decorative value is omnipresent in Neel's oeuvre; her paintings often have elaborate backgrounds that form part of the pictorial narration. It is as if the artist, before painting the main subject of the work, created a studiously decorated setting in which to place it. *Gladiolas* represents a profusely decorated ceramic vase on a terra-cotta floor, with slight contrasts that allow the artist to use a series of tones within a single color range. The graduated placement of these tones enhances the contrast and is used by the artist to make her painting more expressive. In the background, behind the bouquet of gladiolas, is a sofa, perhaps a reference to Neel's portraits. In addition to complementing the decoration and providing context, the sofa serves as a background and provides the contrast necessary for the flowers to stand out. The artist seems to be playing with the viewer by using a portraitlike structure for this still life.

Meyer Schapiro

(1983)
oil on canvas
29.1 x 38.4 in
(74 x 97.5 cm)
Jewish Museum,
New York

Alice Neel continued to paint up to the last days of her life. During the first part of the 1980s until her death in 1984, she painted calmer works in which she concentrated on conveying on canvas the most human features of her models.

This portrait of the distinguished art historian Meyer Schapiro is a relaxed work; the sitter is depicted completely at ease, seated in a comfortable armchair. The painter faithfully reproduces the model's most expressive features, accentuating his experience and wisdom.

In her last paintings, the artist reveals a preoccupation with old age. From them, it can be inferred that her final years were pleasant and reflective ones; certainly, during that time the artist summarized her experiences in the portrait genre. This composition demonstrates the artist's sense of contentment and depicts Schapiro with all the features of old age that the painter desired for herself.

Frida Kahlo

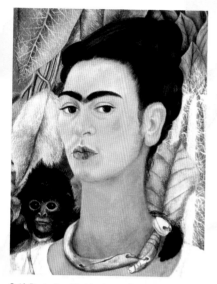

Self-Portrait with Monkey, *oil on masonite, 16 x 12 in (40.6 x 30.5 cm), 1938, Albright-Knox Art Gallery, Buffalo, New York. Donated by A. Conger Goodyear.*

Although Kahlo's artwork is classified as surrealist, there is an absence of fantastic or unreal elements in it. The artist describes her art as an interpretation of her own life, divulging the anguish of her personal reality rather than a blissful dream. The symbolist nature of Kahlo's work reflects her need to convey the torment of her private life. All of her paintings correspond to a moment of her life, described with sincerity through allegorical motifs and elements. Afflicted by polio from her childhood, which left one foot deformed, she was later involved in an accident: The bus she was traveling in was hit and crushed by a train, leaving her so badly injured that she was bedridden for more than a year. Her parents placed a mirror above her bed, and she could not stop looking at herself in it, so much so that she became her own object of study and her most common subject.

Kahlo entered the world of art through the photography studio of her father, who explored the landscapes and peoples of Mexico. Through his influence, she became familiar with genuine Mexican culture, which she converts into a romantic ideal and one of great pride. But she also acquired from her father a compositional sense in which her models pose as in a photograph, looking directly at the viewer.

- **1907** Magdalena Carmen Frida Kahlo Calderón was born on July 6 in Coyoacán, a suburb of Mexico City.

- **1913** Due to poliomyelitis, her right foot becomes deformed.

- **1922** Enters the Escuela Preparatoria Nacional (National Preparatory School), where she meets Diego Rivera.

- **1925** Involved in a serious bus accident. She is bedridden for a year, with serious damage to her back and pelvis.

- **1928** Becomes a member of the Mexican Communist Party, along with Rivera.

- **1929** Marries Diego Rivera. They move to Mexico City and then Cuernavaca.

- **1930** Has an abortion because she is not ready to have children because her pelvis has not fully recovered from the accident.

- **1932** Rivera and Kahlo move to Detroit, where Rivera has a commission. On July 4, Frida suffers a miscarriage at the Henry Ford Hospital.

- **1934** Due to complications, she has to abort a third pregnancy. Several toes of her right foot are amputated to avoid gangrene. Diego and Frida's sister Cristina fall in love.

- **1937** Leon Trotsky and his wife move to Mexico and Kahlo takes them in at Casa Azul, her parent's house in Coyoacán, Mexico DF.

- **1938** Individual exhibit at the Julien Levy Gallery of New York.

- **1939** Exhibits at the Renou & Colle Gallery, where she meets surrealist artists. Divorces Diego Rivera, only to remarry him a year later.

- **1942** Elected a member of the Seminar on Mexican Culture

- **1943** Appointed professor at La Esmeralda School of Art.

- **1946** Obtains the Mexican National Painting Award for *Moses*. Has a spinal column operation.

- **1950** Spends nine months in the hospital, undergoing seven operations on her spine.

- **1953** First individual exhibit in Mexico. Her right leg is amputated.

- **1954** Dies on July 13 at Casa Azul.

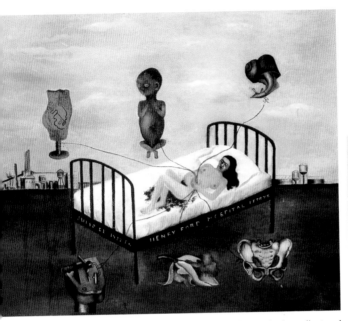

Henry Ford Hospital, or The Floating Bed

(1932)
oil on metal
12 x 15 in
(30.5 x 38 cm)
Dolores Olmedo Collection, Mexico City

The murals that Diego Rivera had executed in Mexico received excellent reviews. He received commissions from patrons in the United States, where he moved with Kahlo in November of 1930 for four years, first living in San Francisco and later in New York. She became a social attraction thanks to her exoticism and strong character. When Rivera received a commission for a mural for the Detroit Institute of Arts in April of 1932, Kahlo entered a state of anxiety that increased even more with her second abortion. She felt alone in Detroit, an industrial city that she did not care for, and her husband became distant following her pregnancy. In this work, a bed is suspended over an arid terrain with an ugly, industrial view of the city in the distance. Surrounding Frida's nude body on the bed appear the symbols of her tragedy.

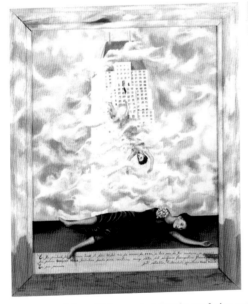

The Suicide of Dorothy Hale

(1938-1939)
oil on masonite
23.8 x 19.1 in (60.4 x 48.6 cm)
Phoenix Art Museum, Phoenix

When Kahlo's friend Dorothy Hale committed suicide by throwing herself from a very high window in the Hampshire House, in New York City, on the 21st of October 1938, at 6:00 in the morning, Clare Boothe Luce, the editor of the magazine *Vanity Fair*, commissioned Kahlo to paint a portrait of Hale.

In a peculiar view of the act of suicide, Kahlo's work represents her friend jumping from a skyscraper as a poetic, intense moment, evoking a serenity and bravery that was a product of the artist's idealization. The woman falls amid fog, symbolizing the confusing and turbulent personal circumstances that led her to commit suicide. The painting represents a sequence of events, and Hale appears again at the bottom of the painting after her fall. Her body is surrounded by pools of blood in a position that was too realistic for Clare Boothe Luce, who, upon seeing the painting, returned it to Kahlo, declaring their friendship over. The cadaver appears to be gazing at the viewer with an expression of tranquility that lends the composition a macabre character.

What I Saw in the Water, *or* What the Water Gave Me

(1938)
oil on canvas
35.8 x 27.8 in (91 x 70.5 cm)
Daniel Filipacchi Collection, Paris

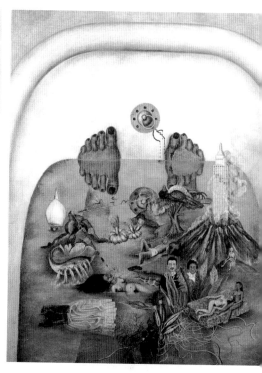

This work represents a series of elements and scenes related to Kahlo's life. It is an allegory on water, upon which everything passes. The artist's feet are rendered with painted toenails in an allusion to her femininity, with her right foot deformed and linked to the drain of the bathtub with the same artery as in *The Two Fridas*. A volcano engulfs a New York skyscraper, while a skeleton represents death at its base. The constant proximity to death that Kahlo felt led her to incorporate this motif in many of her works. On the lower right is a portrait of the artist's parents, along with an allusion to her painting *Two Nudes in a Forest*, from 1939, with two nude women on a bed stroking each other. Kahlo's sexual ambiguity frequently appeared in her works and can be associated with her intimate relationships with other women, represented as more intense than they really were. The dress on the lower left evokes her sister Cristina, who, despite her affair with Kahlo's husband, was the only person with whom the artist truly felt united.

The Two Fridas

(1939)
oil on canvas
68.3 x 68.1 in (173.5 x 173 cm)
Museo de Arte Moderno,
Mexico City

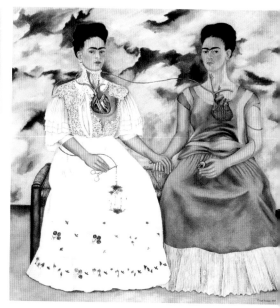

In this portrait, the artist represents herself through two figures united by a single artery. The Frida dressed in white, European style, and the Frida dressed in a Tehuana dress represent her dual roots. Her father, Wilhelm Kahlo, was a German photographer, and her mother, Matilde Calderón, was Mexican. Frida's romantic idea of Europe was a fantasy that she reserved for her most intimate moments; her Mexican heritage represented a revolutionary ideal that she converted into her lifestyle. She felt Mexican, with deep patriotic sentiments.

This work was executed shortly after her divorce from Diego Rivera. It reveals a long-pondered interest in their matrimonial crisis and separation. Frida's Mexican personality is the part of her that Diego adores and loves, while her European part is bleeding, rejected, and the cause of their rupture.

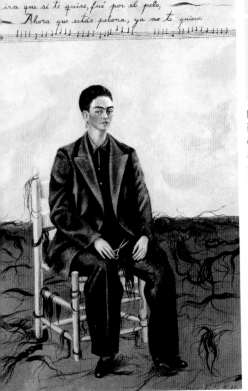

Self-Portrait with Cropped Hair

(1940)
oil on canvas
15.7 x 11 in (40 x 27.9 cm)
Museum of Modern Art, New York
Donated by Edgar Kaufmann

In this work, Kahlo enhances her sense of independence. Playing with sexual ambiguity, as she was doing in her private life as well, she is dressed as a man and has short hair. The inscription at the top reads, "Look, if I loved you, it was for your hair. Now that I see you hairless, I don't love you anymore." It reveals that Kahlo felt loved for her feminine attributes, of which she freed herself by cutting her hair and replacing the Tehuana dress with a man's dark suit.

The artist wanted to feel independent from her husband. She moved to a modest apartment in the city to paint and forget her husband's constant affairs, especially the one with her sister Cristina. This painting is one of the few in which her physical pain is eclipsed by the strong character reflected in her expression. The artist gazes steadily at the viewer with a defiant air, a clear plea for freedom from the conventions imposed by matrimony.

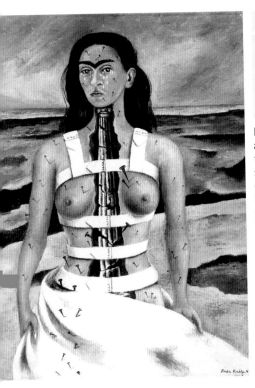

The Broken Spinal Column

(1944)
oil on canvas
15.7 x 12.1 in (40 x 30.7 cm)
Dolores Olmedo Collection,
Mexico City

In 1944, Kahlo's back pain became more acute and she had to wear the steel corset that had tortured her years earlier. In this self-portrait, she portrays herself with a gash in her torso revealing a completely fractured classical Greek column. Kahlo's suffering goes beyond the simply physical. The pain that the artist felt throughout her life was emotional, and in this painting, the only one where she is crying, she appears completely defeated. The figure appears alone, in an austere landscape, with her body tortured by nails that are larger around her pelvis, along her column, and at her heart. In this painting, the artist reveals the solitude of her pain in a graphic manner, representing for the first time an intimate vision of herself as someone who no longer rejects pain but accepts it as part of herself.

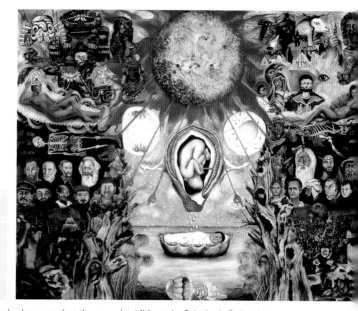

Moses, *or* The Sun's Core

(1945)
oil on masonite
24 x 29.8 in
(61 x 75.6 cm)
Private collection

In this work, which received an award at the annual exhibit at the Palacio de Bellas Artes in Mexico City, Frida re-creates her personal universe. In the center, under a sun that represents the artist herself, the abandoned baby Moses appears, representing Diego Rivera, in a sterile and solitary landscape symbolizing Frida's inability to have the child she so desired. To either side, in a hierarchical format, are a series of elements and portraits of people related to the artist. Objects of Aztec art, elements of traditional Mexican culture, portraits of Stalin, Marx, and Ghandi, images of Mexican saints and religious icons reveal the artist's personality with great sincerity, as they are the elements that most influenced her life.

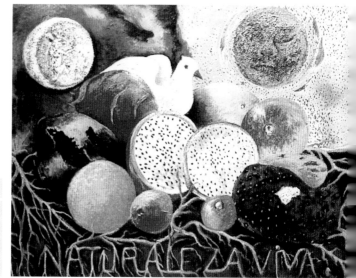

Living Still Life

(1952)
oil on canvas
María Félix Collection,
Mexico City

Kahlo's still lifes of the 1950s are allegories of life and sexuality. Here, the artist reflects on the contrasts in her life, which she was observing from a more contemplative, relaxed viewpoint. The sky is divided in two halves—day and night—and the inscription *"Naturaleza viva"* ("Living still life") is a play on words, as "still life" in Spanish is *naturaleza muerta* (dead nature). The operations on her spine left Kahlo bedridden, so she painted still lifes, which her sister Cristina prepared on her nightstand with produce from the garden. Near the end of her life, Kahlo introduced doves and flags in her works, to project the political, moralist dimension of her personality, a facet that she maintained up to her death. Indeed, just days before she died, she attended a demonstration in Mexico City, confined to a wheelchair and ailing.

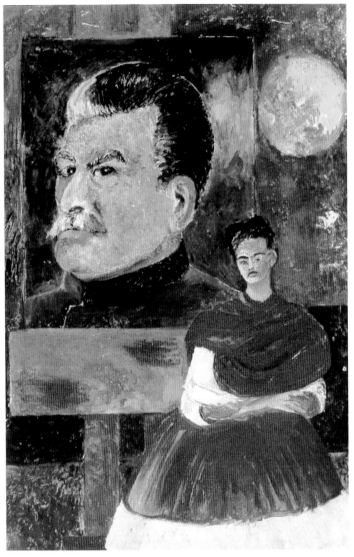

Frida and Stalin

(~1954)
oil on masonite
23.2 x 15.4 in
(59 x 39 cm)
Museo Frida
Kahlo, Mexico
City

As with her *Self-Portrait with Dr. Farill* (1951, Private collection), Kahlo executed this painting as a votive offering. In the other work, Dr. Farill is rendered playing the role of savior; here, the artist shows her faith in communism by representing Stalin as a saint.

From an early age, Kahlo politically allied herself in favor of Mexican postrevolutionary values and of the search for a nationalist identity. In her artwork, influences from Europe and the United States are limited and defined, while her native culture, with its strong pre-Columbian and Spanish roots, is constantly asserted and enhanced.

Communism was a romantic ideal for Kahlo. When she received Trotsky at her parent's home, her contact with the great figures of Marxism led her to sanctify that ideology, as demonstrated in this painting. Communism and Christianity are often symbolically juxtaposed in the artist's works. Her paintings carry a political message, although Kahlo commented, "My artwork is not revolutionary. I do not know why I should continue to consider it combative."

LEE KRASNER

Self-Portrait *(detail), oil on canvas, 22.3 x 25.1 in (56.62 x 63.82 cm), ~1930, Lee Krasner Estate.*

Lee Krasner was the only female American painter to form part of the first generation of artists in the New York School. After beginning her artistic career in figurative painting, she changed her style in the 1930s on the basis of her knowledge of contemporary European movements such as surrealism. Her first mature works contain certain features of cubism. Her style was influenced by Henri Matisse, who constituted an important source of inspiration throughout her lifetime, and by Piet Mondrian.

Meeting Jackson Pollock in 1941 was decisive, and they would later marry. His intuitive manner of painting helped Krasner free herself from formalism. She contributed to Pollock's success as well, backing him professionally and providing constructive criticism through her capacity to judge based on her own experience and knowledge. During the 1940s and the early 1950s, she executed various works that form part of the foremost examples of abstract expressionism.

In 1956, Krasner abruptly changed her style. Her art became more figurative, with allusions to people, animals, and plants. Almost coinciding with the tragic death of her husband, she began to be considered as something more than just the wife of Jackson Pollock, becoming successful and renowned in her own right.

In the work of the last part of her career, abstraction abounds, although she also incorporates shapes that can be interpreted according to the imagination of the spectator.

In addition to painting, she also executed collages in which she included fragments of her earlier paintings, destroying them in the process.

- **1908** Lena Krassner is born in Brooklyn, New York, into a cultured Russian Jewish family. Studies languages, literature, and art.
- **1926** Studies at the Woman's Art School, Cooper Union, and later at the Art Students League and the National Academy of Design.
- **1932** Graduates from the National Academy of Design. Works as a model and waitress.
- **1934** Works for the WPA Federal Art Project for nine years, becoming familiar with radical art and politics.
- **1937** Unhappy with her artistic development, she begins studying again, this time under Hans Hofmann (1880-1966), until 1940. He teaches her Art Nouveau ideology. Krasner radically revises her style. She begins to exhibit with the American Abstract Artists, a group founded in 1936 to protest the predominant style of socialist realism.
- **1941** While visiting an exhibit of Jackson Pollock's work that profoundly impresses her, she meets the artist.
- **1942** Exhibits with Pollock at the McMillan Gallery in New York. Begins working with Pollock, whose experiments with gesture and movement have a significant influence on her work. Through her knowledge and comprehension of contemporary art in the United States and Europe, she contributes to the evolution of Pollock's new style.
- **1945** Marries Pollock and moves with him to East Hampton on Long Island.
- **1949** Becomes a member of The Club, along with other artists of the New York School's first generation, such as Willem de Kooning, Franz Kline, and Ad Reinhardt.
- **1953** Begins to execute collages and becomes more involved with her artwork, while Pollock works very little on his own. Exhibits her collages in the following years with great success.
- **1956** Travels to Europe. Pollock dies in an auto accident.
- **1959** Krasner's mother dies. Begins painting the series *Umber and White*.
- **1962** Suffers a nearly fatal cerebral aneurysm. For two years she can hardly work because of her health problems.
- **1965** Has an individual exhibit at the Whitechapel Gallery in London.
- **1973** The Whitney Museum of American Art holds an individual exhibition of her work.
- **1984** Dies in New York, shortly after the opening of her first complete retrospective in the United States.

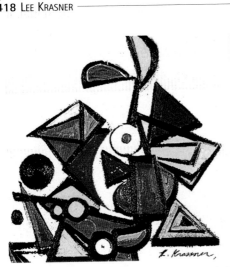

Composition

(1939)
oil on canvas
30 x 24 in (76.2 x 60.96 cm)
National Museum of
American Art
Smithsonian Institution
Washington, D.C.

Lee Krasner painted this abstract composition while studying under Hans Hofmann, perhaps the most important art teacher in the United States during the 1930s and 1940s, with an ideology that combined the theory of modern art with artistic liberty. Krasner learned about European art and contemporary movements before entering the most crucial phase of her career, characterized by the principles of abstract expressionism.

This is evident in this work, in which geometric forms apparently form part of a three-dimensional and mobile construction set against a white background. The shapes are linked by thick black lines that also define the contours. With their intense colors—yellow, blue, orange, purple, and red—they stand out against the white canvas. They consist above all of triangular and circular shapes that Krasner juxtaposes. Some of the triangles form rectangles together; some of the circles are superimposed over other elements. Employing semicircles, Krasner incorporates an intermediate shape between the circle and the triangle that is equipped with points and curves. The composition transmits the dynamic force of an artifact of fantasy. Though Krasner did not return to this style, the painting anticipates the sharp and round shapes characteristic of her mature work.

In this work, Krasner returns to a figurative style, though the work is still abstract and only suggests a nude figure. In the lower area, three legs and feet can be identified, as if they belonged to a seated figure. The composition becomes larger toward the top, forming a yellow cone standing out against the black background. In the upper area, two eyes can be discerned, one to the right of the central axis and the other on the black area. There is also a sort of face with a nose and mouth. Recalling Picasso's *Les Demoiselles d'Avignon* (1907), Krasner combines figurative art and dissociation, rendering several perspectives of a single element at once.

This painting was found on her easel in the summer of 1956, when she moved to Europe for the first time in her life to reflect on her marriage. Her relationship with Pollock had entered a crisis because of his drinking problem and depressions. After two years of abstinence and professional success, Pollock began drinking again in the early 1950s and stopped painting, while she was working with great creativity, executing collages that were well received by the public and that constituted her first artistic success.

During Krasner's stay in Europe, Pollock did not stop drinking. While in Paris in August, Krasner received notice of her husband's death in an automobile accident.

Prophesy

(~1956)
oil on cotton canvas
58.1 x 34 in
(147.64 x 86.36 cm)
Robert Miller Gallery,
New York

This work can be described as an "all-over painting," an expression that refers to a type of painting in which the entire surface area of the work is covered in a homogenous manner and traditional ideas of composition—such as the concept that a painting must be viewed from a specific position—are disregarded. This style was used for the first time by Jackson Pollock.

In this work, Krasner saturates the surface with organic forms that consist of patches of paint, undulating and straight brushstrokes, and color zones. The palette contains vivid tones of red and orange, which cover most of the painting, and dark browns and blacks for the smaller, denser elements such as points or lines. In the composition, structures that allude to eddies, streams, and plants formed by color and movement grow like metaphors of nature. Paintings of this type were labeled by critics as "controlled chaos."

Icarus

(1964)
oil on canvas
46 x 69 in
(116.84 x 175.26 cm)
Robert Miller Gallery,
New York

Water #9

(1969)
gouache on paper
21.5 x 17.5 in
(54.6 x 44.45) cm
Robert Miller Gallery, New York

In this gouache series, Krasner was inspired by water. In a format very different from her oil works, she painted the paper using only tones of blue and covering the entire surface. Darker blue is employed to create intense, undulating lines. Through these lines, various areas can be seen with different tones of blue, achieved through the application of pigments in various densities. The painting evokes the different effects of wind on water, or the flow of water in combination with light penetrating its surface. Throughout her life, Lee Krasner was inspired by nature and its variations through the seasons, hence the series she dedicated to this subject. Until 1975, she lived in The Springs, part of East Hampton, where she enjoyed a view of the sea. She left the Hamptons only in winter, which she would spend in her apartment in New York.

Rising Green

(~1972)
oil on canvas
86.8 x 69 in
(208.28 x 175.26 cm)
Metropolitan Museum of
Art, New York

The title, *Rising Green,* reveals the subject of this large-format painting. It consists of forms that seem to push upward, relating to the process of growth in nature. These elements are stylized, and the artist uses a combination of round and sharp forms, as in many of her works. Against the white background, some objects in dark green stand out, apparently leaves and the stem of a flower. Krasner omitted the veins of the leaves and painted a cone-shaped magenta flower and two buds. The outlines of the plants are surrounded and limited by geometric shapes in blue derived from triangles and circles. These simplified forms are inspired by the works of Matisse's mature period. They resemble the objects printed from paper cutouts that he used in his collage technique. Matisse—who also made collages in several of his works—eliminated outlines; Krasner defined her shapes with dark lines. This painting reflects Krasner's search for balance between color and line.

Imperative

(~1976)
collage on canvas
50 x 50 in (127 x 127 cm)
National Gallery of Art,
Washington, D.C.

As a radical and conceptual manifestation, Lee Krasner created a series of collages in 1976 under the title of *Eleven Ways to Use Words to See,* which she executed using old paintings that she had created during her studies with Hofmann. In only one year, she completed this series of monumental works with titles such as *Imperfect, Indicative,* or *Present Subjunctive. Imperative* is part of this series. It is made of pieces of paper and canvas cut and pasted onto a canvas she had painted some forty years earlier in charcoal and oil. For its reduction of forms to basic geometrical patterns, the painting seems to be influenced by Picasso and Braque's cubism. Krasner cut out various pieces in the triangular shapes and curved lines typical of her work. Some pieces overlap and others allow the bare canvas to be seen. This white surface provides the sensation that, in creating a new composition, the artist carried out an act of brutal destruction. In this series, Krasner combines her future and past experience with her roots and present point of view. In full "imperative" dialogue, this work by Krasner constitutes a setting in which early 20th century ideas of modernity seem to collide with postmodern ideas arising after 1950.

LEONOR FINI

Leonor Fini in a photograph.

Understood as a style emerging from the ideological evolution of Dadaism, surrealism was officially born in 1924, when the Surrealist Manifesto, edited by André Breton, was published. The publication of the magazine *La Revolution Surrealiste* and the creation of the Office of Surrealist Research, directed by Antonin Arntaud, legitimized a movement that continued for several decades of the 20th century.

This artistic movement, arising from the Freudian theories interpreting the human subconscious, attempted to express the real functioning of the mind when free of all moral conditioning and social pressure. Hence, surrealism was a provocative and extremely liberal style and met with the moral censure of traditional social structures still predominating in European and North American society. That restrictive morality was the principal reason why some women who were followers of Max Ernst, Salvador Dalí, or Giorgio de Chirico did not want to call themselves surrealists though they exhibited in surrealist circles and considered their works allegories of reality or reinterpretations of their personal experiences. Like Frida Kahlo, Leonora Carrington, or Charlotte Brontë, Leonor Fini belonged to the generation of women artists arising between the wars whose works had an affinity with surrealism but who did not consider themselves surrealists.

In Fini's artwork, there are many personal subjects that the artist reveals to the public,

- **1908** Born in Buenos Aires, Argentina. Leonor Fini's mother is an Italian immigrant from Trieste of German and Slovene origins. Her father was born in Argentina, a descendent of Italians and Spaniards.

- **1916** Leonor and her mother move to Trieste, Italy, fleeing her father's violent abuse. Young Leonor must dress as a boy for several years to hide from her father's friends, who have come to Europe to kidnap her and bring her back to Argentina.

- **1925** Showing precocious artistic talent, she participates in a group exhibit in Trieste.

- **1929** Her first individual exhibit is held at the Galleria Barbaroux in Milan.

- **1932** Individual exhibit at the Galerie Bonjean in Paris.

- **1933** After living for some time in Milan, where she studies the works of Carlo Carra and Arturo Tosie, she moves to Paris. There she meets Jean Cassou, who promotes her art.

- **1938** Under the tutelage of Giorgio de Chirico and Paul Éluard, she exhibits at the Julian Levy Gallery in New York.

- **1940** Moves to Monte Carlo, where she resides throughout World War II. There she works as illustrator and portraitist and creates stage sets for opera, ballet, and theater. She also designs wardrobes for cinema productions.

- **1942** Exhibits at the Fantastic Art Exhibition in Zurich.

- **1972** The largest retrospective of her work is held in Japan.

- **1973** Writes and publishes *Histoire de Vibrisa.*

- **1976** Publishes her second literary work, *Conte pour Enfants Velus.*

- **1978** Publishes *Oneiropompe.*

- **1996** Dies on January 18 in a Paris hospital.

exhibiting her thoughts and reproducing aspects of her biography according to psychoanalytical theories. She is the painter who came closest to developing surrealism in a pure Dalí style. Her life as subject matter and her mind, closed into itself, as a medium served to create a direct style in which the artist completely unveiled her inner self.

La Confisière

(1932)
oil on canvas
35.25 x 26.58 in
(89.53 x 67.53 cm)
Weinstein Gallery,
San Francisco

During the first years of her career, Fini's art showed the influence of French painting from the early 20th century. After her traumatic arrival in Trieste, fleeing from her abusive father, Fini took refuge in painting, for which she soon showed extraordinary talent. Her mother, who always recognized and encouraged her daughter's talent, ensured that she could study the works of the great masters of Impressionism and expressionism, thanks to which she was able to gradually create her own style using elements of these movements.

In this work, the influences of Matisse and André Derain are visible. In a style very classical for the time, she renders a woman leaning against a counter. It is a timid scene, in which the protagonism of the light colors softens the intensity of the brushstroke. Fini was still very young when she created this work, though the compositional complexity reveals a fine artistic hand. This painting was executed a year before she moved to Paris, where she would become acquainted with the surrealist works of De Chirico, from whom she adopted the figurative intention and the peculiar photographic vision.

The Guardian of the Springs

(1967)
oil on canvas

The Countess of Noaille

(1952)
oil on canvas
35.5 x 25 in
(90.1 x 63.5 cm)
Weinstein Gallery,
San Francisco

Fini had a wealth of different artistic styles, one of which approached the symbolist Romanticism of Edward Burne-Jones, John Everett Millais, and Dante Gabriel Rossetti. In this work, the compositional approach is clearly influenced by British Pre-Raphaelite art.

Against a surrealist, desertlike background, a woman's beauty modernizes the standards imposed by Rossetti during the 19th century. Fini maintained the characteristic features popularized by Elizabeth Siddal, Rossetti's wife. A languid gaze, stylized neck, and accentuated facial features are constants in Fini's portraits. Here, the model has short hair, showing a new, more independent and sophisticated image of women. The clothing also reflects this modern type of Romanticism: The countess is wearing a lovely greenish dress and a brown fur cape. The clothing is extremely realist, providing an effect of corporeality that contrasts with the immense void of the background. The details of light and shadow on the cloth and the gold highlights of the cape enrich the image, and the luminosity of the figure's green eyes is striking.

Fini composed this portrait against an arid, austere backdrop. The inclusion of a desertlike background is a recurring feature of surrealist art. Such austerity and coolness were frequently used by Dalí and De Chirico as elements contrasting with the vitality of their figures.

Left: In this work, Fini employed elements from her different artistic periods. In a style recalling the pop art aesthetic that was invading Europe at the time this work was painted, she rendered a sophisticated woman next to some stylized crystal glasses. Since artistic glass was well received by the public throughout the 1960s, artisans in the crystal trade recovered many classical designs that they modernized by adding bright colors and exaggerated decoration. In this painting, Fini reflected the character of the time and composed the work in two equal spaces. On the left is a woman with a light face and dress that contrast with the predominantly blue background and her red hair. The artist used the white tones of the image to lend the figure a certain air of divinity. On the right are several crystal glasses in different colors, placed in the shape of a cross. Only one red, flower-shaped glass, different from the others, is set before the woman, contrasting strongly with her light dress and matching her hair. The painting certainly has meaning beyond what is visually portrayed. As Fini had studied and felt a strong inclination for Pre-Raphaelite art, which frequently rendered scenes of a particular religiosity based on Christian myths and legends, some art historians believe that this work could refer to the legend of the Holy Grail.

Coronation of the Happy Feline

(1974)
oil on panel
45.7 x 31.9 in
(116 x 81 cm)
Galerie Minsky,
San Francisco

This painting shows a particular style in which the artist plays with surrealism in an aesthetic language that recalls the Pre-Raphaelites. Though the English Victorian era came to an end before Fini was born, the aesthetic of British 19th-century art influenced her profoundly. She deeply admired the works of Burne-Jones and Rossetti, and she borrowed characteristics from them. The obscurantist, claustrophobic atmosphere of Pre-Raphaelite art appears in Fini's work along with a very English compositional style.

In this scene, a woman with a feline face solemnly places a crown on another who crouches over a cat. The ceremony is imbued with an aura of solemnity and mystery in the British style. The artist liked stories of princesses and knights and often adopted them in her works, to give free rein to her Romanticism and to paint works with the underlying concepts of beauty and love. The female bodies are erotic, with their slender forms exhibiting a delicate yet incisive nudity; the transparent clothing combines softness with suggestion. The artist employed this ethereal sensuality to render beings imbued with an aura of divinity, yet fully carnal.

Right: The constant presence of cats in Fini's work evinces her fascination with them. Throughout her life, she surrounded herself with cats, creating the image of a solitary, tormented soul. She reputedly took up to twenty-three cats with her on trips through Europe. During the 1930s, she discovered ancient Egyptian culture and its veneration of cats. Romantic by nature, the artist began venerating felines as divinities and began to include them in her works and life.

For Fini, the cat was a sinister companion incarnating a mythical duality. The image of the cat as a generous friend and inseparable companion contrasts with the demonic character attributed to it by popular culture. Aware of this peculiar vision of the animal, Fini did not hesitate to use it pictorially to lend her work ambiguity. The painting represents several cats enthroned on shelves, interspersed with sensual female figures wearing transparent clothes, creating a dreamlike symbolic image. The work combines delicacy with salaciousness, joining the divine concept of the animal with the ethereal, rather seductive bodies of the women. This is certainly an extraterrestrial world.

Though she insisted that she was not a surrealist, Fini's artwork shows a clear affinity with surrealism. Influenced by various pictorial styles of the past, her art acquired a contemporary character through her extensive knowledge of the artwork of surrealists such as De Chirico and Dalí. The graphic aesthetic of this painting recalls the Italian artist.

In a modern setting with a tulle curtain as a backdrop, the image represents a woman in the foreground watching a shadow play. The work has the darkness characteristic of Fini's oeuvre. The woman's delicately sensual, nude back is combined with the elegance of the lines and dresses of the two women behind the curtain. This uniformity enhances the contrast between the smooth lines and forms and the violence of the scene the women are acting out, which seems to depict dominance and submission. Fini distributed space according to a single light source from the upper right corner, while the tonal gradation leads to the darkness invading the foreground. The surface is superbly divided into two different yet interacting scenes that contrast and balance each other.

Outre Songe (Beyond a Dream)

(1978)
oil on panel
35 x 51.2 in
(89 x 130 cm)
Galerie Minsky,
San Francisco

Sunday Afternoon

(1980)
oil on panel
49.6 x 37 in
(126 x 94 cm)
Galerie Minsky ,
San Francisco

Paper

(1995)
gouache on paper
4.9 x 6.7 in
(12.5 x 17 cm)
Galerie Minsky,
San Francisco

In this painting, from Fini's last period, the artist dispenses with all personal allegories and seems to provide a compilation of the artistic styles she encountered during her first years in Europe. Born in Buenos Aires, the artist and her mother moved to Italy to escape from her father, who even sent minions to kidnap the young Leonor. In Trieste, Fini grew up in a boardinghouse where such figures as James Joyce and Rainer Maria Rilke spent some time. As a result, she was able to have indirect contact with Victorian England, to which she felt immediately attracted.

In this work, two women converse, dressed according to Victorian canons. One is accompanied by her two children. The artist used a new style here. In the 1980s, she began experimenting with watercolors and gouache, introducing mixed media with erratic strokes and diluted, elongated outlines. The result was a work in which the spatial structure has a graphic quality. The artist used bluish paper that serves as the only background, placing the two women in the center, their bodies and Victorian paleness standing out in contrast to the blue.

NELL BLAINE

Nell Blaine (wearing glasses), together with John Asbery, a poet and art critic, at a fashion party around the mid-1950s.

Although critics label Neil Blaine as a genre painter devoted to the production of still lifes and landscapes, her academic training allowed her to experiment with different pictorial genres. She gave those works an abstractionist aesthetic that gradually took on an almost figurative order.

From her artistic beginnings at Richmond School of Art in Virginia, Blaine spent most of her time on portraiture and graphic designs for posters. Her experiences in these spheres provided her with an entirely new perception of flat color and led her to utilize the color patch as a creative structure for her later compositions. Blaine experimented with a style of free brushwork. With it, she composed the forms of the work based on a structure of patches of colors that, without superposition, complemented one another, producing a variety of optical effects.

Blaine's painting went through a number of artistic periods, in which she experimented with the rhythmic effects of shape and color as well as with organic or matter painting. Even in her first works, she had already mastered the spatial distribution of the pictorial space, on which she developed her subject matter or, in some cases, deliberately omitted it.

This was a somewhat eclectic painter, evidence of which is apparent in many of her works, where a great variety of counterposed colors combine figurative motifs and abstract elements.

- **1922** Born July 10 in Richmond, Virginia.

- **1939** Studies at Richmond School of Art, presently called Virginia Commonwealth University.

- **1942** Studies with Hans Hofmann in New York.

- **1945** Takes classes at Atelier 17 with Stanley William Hayter. Individual exhibit held at the Jane Street Gallery, New York.

- **1947** Individual exhibit at the Virginia Museum of Fine Arts, Richmond.

- **1949** Individual exhibit at Southern Illinois University, Carbondale.

- **1950** Travels for the first time to Europe. During the 1950s, she spends periods of time in Italy and France in order to paint.

- **1952** Studies at the New School for Social Research in New York City.

- **1953** Individual exhibition at the Tibor de Nagy Gallery, New York, where she would exhibit the following year.

- **1956** Exhibits in the Pondexter Gallery, New York, where she would also exhibit in 1958, 1960, and 1976.

- **1957** Travels to Mexico.

- **1958** Individual exhibit at State University Teachers' College, New Paltz, New York.

- **1959** Travels to Italy, Egypt, Turkey, and Greece.

- **1964** Visits England, Portugal, Spain, and France.

- **1973** Individual exhibit at the University of Connecticut.

- **1978** Resides in Germany and later in Austria for two years.

- **1979** Exhibits at the Fischbach Gallery, New York, where she is to hold many exhibits (in 1983, 1985, 1987, 1989, 1991, 1993, and 1995).

- **1984** Returns to Austria and visits Switzerland.

- **1996** Holds a number of individual exhibits: Muscarelle Museum of Art, College of William and Mary, Williamsburg; Virginia Reynolds Gallery, Richmond, Virginia, etc. Nell dies this year.

- **2001** Retrospective at Tibor de Nagy Gallery, New York, under the title "Nell Blaine: The Abstract Work."

Abstraction (Blue, Red, and Yellow)

(1947)
gouache on paper
5.5 x 6.5 in
(14 x 16.5 cm)
Tibor de Nagy Gallery,
New York

Experimentation with very simple structures, both in color and in form, gave rise to entirely abstract works, in which the interplay of intense tones cohabits with flat colors in order to create an expressive and full pictorial space.

In this work, the artist used a strikingly intense blue color as the background. Over it, in apparently random fashion, are yellow, red, and white abstract forms. Blaine does not attempt to evoke any kind of complicated subject matter. Instead the artist conveys an idea, employing an entirely asymmetrical composition in order to reflect her concept of simple abstraction. Her completely free compositional style is based solely on tonal contrasts.

Here, Blaine executes a work without apparent meaning that can be observed by placing it in any position. With it the artist attains a simplified concept: The painting becomes a simple diversion of aesthetic appreciation in which the interaction of color is, or is not, attractive to the eye and to the viewer's interpretation. Large areas of flat color evoke a truly original sensation of physicality.

Wings

(1944)
gouache and collage on paper
5.5 x 3.2 in (14 x 8.1 cm)
Tibor de Nagy Gallery,
New York

This work clearly illustrates the artist's fascination with the work of Piet Mondrian. Blaine, also intrigued by Vasily Kandinsky's work, regarded formal simplicity as an invaluable aesthetic resource.

Here the artist contrasts the characteristic geometric shapes of Mondrian's painting with figures originating from the same geometrist conception, but interpreted in a freer manner and executed in flat colors. This work establishes counterpoints between the different pictorial elements—color, line, and form. Geometric structures suggest a formal decomposition, executed with flat colors of great chromatic intensity, and curved lines defy the prevailing presence of rectilinear shapes.

Blaine used collage to render this work, a technique that allows her to make complete figures that can be superimposed over the work. Thus, the painter adds a completely original element to the work. While collage is traditionally used to transmit complex visual messages based on the inclusion of selected images over a pictorial space, Blaine uses the technique to enhance the work's apparent simplistic uniformity.

Cortege

(1947)
oil on panel
14 x 10 in (35.6 x 25.4 cm)
Tibor de Nagy Gallery,
New York

During her abstract period, Blaine focused on composing figures in a unique way, even though they appear to form part of a rectangular structure. The artist has arranged these figures in an irregular fashion, creating a complex composition against a white background, which brings out the specific personality of each one.

In this work, Blaine begins to demonstrate interest in the volumetric capacity of color. She has used a very dark brown with some gradation, with which a slight effect of volume is achieved. This effect is enhanced by the thick contour line delimiting each figure. The distribution of the forms make them stand out against the background, in a completely free manner. Without following any particular criterion, the work appears to be a representation of a set of varied elements that have been placed over a light surface or that perhaps have been suspended in space. Using a photographlike approach, the artist presents three pieces that are only partially visible, cut off at the frame. In this way, Blaine expresses the spatial continuity of the painting and, therefore, of these undetermined figures, of which the work is merely a detail.

Still Life with Lace

(1959)
watercolor
14.8 x 10.6 in
(37.5 x 27 cm)

Throughout her artistic career, Blaine has executed numerous still lifes that reflect her different periods. This work is remarkable for its expressive strength and the formal simplicity of the composition.

Starting in the 1950s, the artist combined a form of abstractionism, inspired by Mondrian's formal simplicity, with a figurative pictorial style that stands out for its expressiveness. In this work, the artist simplifies the composition by focusing the tonal intensity in the center, at the red and yellow flowers. Blaine uses a dark background to lend more expressiveness to the vase and flowers. Likewise, the white tablecloth is executed with intense and irregular strokes that appear to be distributed around the flowers and give them additional dynamism.

This watercolor, which is strongly reminiscent of the expressionist style practiced at the beginning of the 20th century, has a compositional style unlike anything found in Blaine's earlier works. The painter also introduces a new method of utilizing a wider range of hues, which allows her to convey a sensation of volume, an aspect that was nonexistent in her abstract works.

Layered Clouds and Shore

(1982)
watercolor
7.9 x 10.9 in
(20.08 x 27.7 cm)
Tibor de Nagy Gallery,
New York

Blaine's creative versatility allowed her to experiment with all manner of pictorial subject matter, like this landscape, which the artist painted in watercolor wash. Her extraordinary vision of the pictorial composition, based on a structured combination of multiple patches of color, allows the artist in this work to conjugate the natural transparency of the watercolor medium with touches of more intense colors. The shore reveals how a meticulous distribution of patches of solid color allow tiny unpainted white spaces to define and outline the composition.

The artist renders the sea and the sky through more patches of watercolor applications. The varied tones that make up the sky barely merge with one another. The grayish tones, blues, and yellows are completed with white, which heightens the expressiveness of the landscape. Blaine uses a palette of colors that produce harmonized contrast through the wash technique, in which the different tones of the sky appear to merge. Although the artist uses the same tones to paint the water against the shore as she does for the sea and the sky, their expressive capacity is not subordinated to the surrounding colors. Instead, Blaine achieves a rhythmic sensation that sets off the calm continuity of color displayed in the clouds and on the horizon.

Campanula

(1986)
oil on canvas
27.4 x 21.9 in (69.5 x 55.5 cm)
Tibor de Nagy Gallery,
New York

During the last years, Nell Blaine adopts a more relaxed and reflective approach in her works. Distancing herself from the constant experimentation with shapes and colors of her earlier works, the painter once again turned to still life, which she reinterprets with her own particular vision, making use of the experience she had acquired throughout her artistic career. Set against a background of luminous tones, the work illustrates a generous flower arrangement whose colors and definition produce a contrast with the background. The artist deliberately leaves the background fuzzy in order to blend it with the white of the table, while the central element has been defined above all by the dark tones of the vase and the intense violet of the biggest flowers. Rather than color patches, here the artist employs an elongated stroke that allows forms and figures based on simple brushstrokes. Blaine plays with varying degrees of thickness of the paint and demonstrates her mastery over the watercolor medium, which allows her to exploit the medium's transparency so as to lend the worker great expressiveness. A dark, opaque tone describes the vase and the purple flowers; a more fluid stroke represents the fragile white and pinkish flowers in the center of the composition. The result is a very luminous and perfectly contrasted whole, in which the motif emerges from the canvas in order to gain relief. The artist, who has not concentrated on any details, demonstrates her interest in impacts of color, suggesting rather than explaining.

HELEN FRANKENTHALER

Helen Frankenthaler, working in her studio.

The American painter Helen Frankenthaler belongs to the second generation of abstract expressionists. She is not an action painter (that is, her paintings are not marked by the use of spontaneous techniques), but she is considered a key figure in the School of Color Field Painting, which was at its peak between the 1950s and 1960s.

In the early 1950s, this artist invented a specific technique to prime canvas with very fluid color, a procedure influenced by Jackson Pollock's methods. It was the art critic Clement Greenberg who pointed out the importance of Frankenthaler's work. Her technique was soon adopted by other artists and constituted the basis of color field painting. Greenberg advocated considering color field painting an independent style and a reaction to pop art. In any case, Frankenthaler's artwork differs considerably from that of her colleagues in color field painting, which often consisted of a series of works, as with Kenneth Noland and Morris Louis.

From the beginning, Frankenthaler developed a style based on free improvisation and lyricism. The soft colors of her early period became more intense and the forms more consolidated over time. Toward the end of the 1960s, for a time, she stopped painting landscape-related subjects to dedicate herself almost exclusively to abstract art. But in the mid-1970s, she took up nature scenes again, and in some of her works, a certain relation to the traditional 19th-century landscape is visible. She was also influenced by Arshile Gorky, Willem de Kooning, and cubism.

In addition to painting, she also worked in the fields of sculpture, ceramics, set design, and theater costume design.

- **1928** Born in New York on December 12.
- **1945** Completes her schooling at the Dalton School in New York. Studies under the Mexican painter Rufino Tamayo.
- **1946** Begins to study painting at Bennington College in Vermont and, in 1947, the Art Students League in New York with Vaclav Vytlacil.
- **1948** Travels to Europe, staying in London, Amsterdam, Brussels, Geneva, and Paris. Shares a studio with Sonya Rudikoff.
- **1949** Studies art history at Columbia University, New York, with Meyer Schapiro.
- **1950** Meets the art critic Clement Greenberg, through whom she meets the artists of the New York School, including such abstract expressionists as Franz Kline, Willem and Elaine de Kooning, Lee Krasner, and Jackson Pollock.
- **1951** Focuses on landscapes. She joins the artist's association The Club. Her first individual exhibit is held at the Tibor Gallery, owned by Nagy, and she participates in the exhibit "Ninth Street: Exhibition of Paintings and Sculpture," both in New York. Greenberg encourages her to study at Hans Hofmann's art school.
- **1952** Travels to Nova Scotia and Cape Breton, Canada, where she paints watercolor landscapes. Develops the technique of soak-staining in one of her first abstract paintings, *Mountain and Sea*.
- **1958** Marries Robert Motherwell, an abstract expressionist. She teaches at various universities in the United States until 1975.
- **1959** Her first exhibit is held at the André Emmerich Gallery in New York. Exhibits at Documenta II in Germany, at the V-Bienal in São Paulo, Brazil, and at the Première Biennale in Paris, where she receives first prize for her painting *Jacob's Ladder*.
- **1966** Represents the United States at the 23rd International Art Biennial in Venice.
- **1969** Retrospective at the Whitney Museum, New York.
- **1971** Divorces Robert Motherwell.
- **1972** Receives the Garrett Award.
- **1978** Establishes studio in Connecticut.
- **1985** Designs the stage set and the costumes for the Royal Ballet at the Royal Opera House in London. Individual show at the Guggenheim Museum, New York.
- **1986** Retrospective at the Museum of Modern Art, New York.
- **1994** Marries Stephen Dubruel.
- **1998** Retrospective at the Guggenheim Museum, New York.

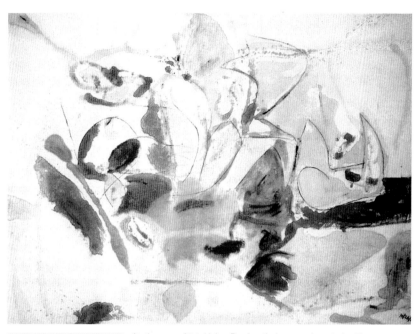

Mountains and Sea

(1952)
oil on canvas
72.6 x 99.3 in
(184.47 x 252.1 cm)
National Gallery of Art,
Washington, D.C.

At the age of 24, Helen Frankenthaler experimented with a new technique, used in this work, that would influence the development of modern art in the United States. The previous summer she had been in Nova Scotia painting landscapes. Although she painted this work in her studio in New York, there are references to nature. Yet it is not a landscape. On the canvas are some soft lines and areas of diaphanous colors, especially in blue, red, and turquoise, which move toward transparent, abstract shapes in the middle.

This work reveals Frankenthaler's first influences, among them Vasily Kandinsky, Joan Miró, and Arshile Gorky, and recalls Jackson Pollock's peculiar method, spontaneously dripping paint on a canvas placed on the ground. Frankenthaler diluted the paint in turpentine or kerosene so that the canvas absorbed it completely. Pollock's thick paint remained on the surface; in Frankenthaler's works, the paint loses its materiality, fusing with the support.

Helen Frankenthaler employed this method for the first time here. Called soak-staining, it is a closed aesthetic system that went against the approach prevailing at the time—thick impasto applied with vigorous brushstrokes. The critic Clement Greenberg noticed her technique and praised it, because he considered it a key element in modern art. This innovation became a norm for the second generation of the New York School and gave rise to the creation of an artistic group working in color field painting, with members such as Morris Louis (1912-1962), who, after seeing this work, broke with his style, exclaiming that Frankenthaler's art "became a bridge between Pollock and what was possible."

Provincetown. Summer Scene

(1961)
acrylic on canvas
mounted
on cardboard
20 x 24 in (50.9 x 61 cm)
National Museum of
American Art,
Smithsonian Institution,
Washington, D.C.

This painting is one of the first in which Helen Frankenthaler experimented with acrylic colors. Her use of the recently invented acrylic medium, water-based and quick-drying, was another step forward in her development and enhanced her artistic expressiveness. This summer scene of Provincetown consists of blue and red color fields with undefined contours, a wide yellow strip, and an area of mixed red and yellow.

Frankenthaler places free forms in her composition, directly on unprimed canvas, in a harmonic fashion yet with great tension. In this work, she uses only primary colors, which she leaves in a pure, unmixed state except in the upper area. Through this use of monochromatic colors, she achieves intensity and force. She breaks the brilliance of the colors in the mixture of red and yellow above. The artist signed the canvas prominently, in the lower left corner. Just ten years later, Frankenthaler had become one of the most important artists in the United States.

May 26, Backwards

(1961)
color lithograph on paper
31.1 x 22.5 in (79 x 57.1 cm)
National Museum of American Art,
Smithsonian Institution,
Washington, D.C.

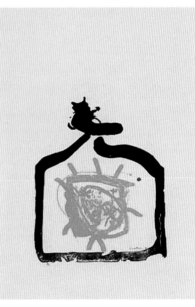

On cream-colored paper, Frankenthaler applies brown and ochre brushstrokes. With its irregular width, indistinct edges, and simple forms, this work recalls Chinese calligraphy. The elemental form of this lithograph is the closed square in the center executed in ochre. Outside this square, Frankenthaler repeats the shape in brown, opening it at the top and accentuating it with short, expressive brushstrokes. The ochre square contains spots and round brushstrokes in the same color. The brightness of the surrounding area is broken by short brushstrokes radiating in all directions. There is a striking, small red dot in the upper right, whimsically placed between the two squares.

The technique in which this painting was executed is color lithography. The artist painted it with a brush and greasy material on stone plates, a separate color on each plate. She used at least three different plates for each print run. This process is similar to painting on paper. The grease paint is mixed with carbonic lime, creating a surface that attracts grease and repels water. The areas with no paint are treated so that they absorb water and repel grease. Thus the surface of each plate, stained with its respective color, leaves the imprint of the drawing on the pressed paper.

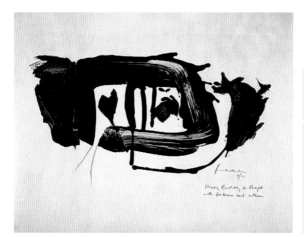

Untitled (Study for a Post Card for James Schuyler)

(1962)
acrylic, oil, and pencil
on a lithograph
20 x 25.7 in
(50.7 x 65.4 cm)
Museum of Fine Arts,
Boston

This work has an inscription stating that it is a study for a post card for James Schuyler. During her stay in Italy in 1960, Frankenthaler maintained a peculiar correspondence with the poet James Schuyler (1923-1991), who was part of the New York School of poets and artists. As critic and coeditor of the magazine *Art News*, and through his work at the Museum of Modern Art in New York, Schuyler was well informed about the world of contemporary artists, many of whom were his friends. He wrote Helen Frankenthaler a series of post cards with his own poems. She would paint them and return them to him. This gave her the idea for the lithographs Post Card for James Schuyler, with which she experimented from 1962 to 1967.

In this work, the brown brushstroke is striking, executed in a single, energetic movement in the form of a rectangle. Above the outlines, the artist applied the paint so that it would run if manipulated, giving rise to color fields fading in different directions, creating paths. Compact red areas painted in short brushstrokes fill the interior and transform the irregular outlines with areas and drops of paint. The red areas seek proximity to the brown shapes, as in the red shape on the left, or form a counterpoint by providing an independent yet similar shape, as in the area on the right. The remainder is empty, as is habitual in this artist's work beginning in the 1960s, in order to, in her words, allow the painting to breathe. Frankenthaler pencilled a note on this study, dedicating it as a birthday gift to a young man called Padget, who lived with her family, caring for the children.

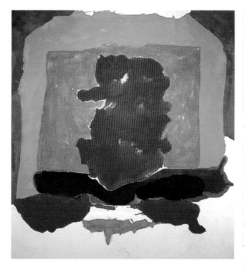

Small's Paradise

(1964)
acrylic on canvas
100 x 93.6 in (254 x 237.7 cm)
National Museum of American Art,
Smithsonian Institution, Washington, D.C.

The title of this work refers to a famous cabaret in Harlem, renowned for its improvised music, called gut-bucket, its beautiful dancers, and its dancing waiters. In this painting, there is a striking contrast between the organic and geometric forms of the figures. It is presided over by a sort of square doorway bordered by wide green strips; inside is an abstract orange area. The painting is full of color; free-standing patches appear to be symmetrically distributed around a fictitious central axis. The central shape, intensely orange in color, has irregular contours. The painting becomes very intense through the juxtaposition of complementary colors—red and green, orange and blue. The artist repeated her technique of impregnating the canvas with fluid pigments, creating color fields with faded edges. She used rollers and rags to control the acrylic paint, which she would dilute once it was poured. In a slow procedure, she poured the paint out in small quantities, intensified it, then allowed the canvas to absorb it to achieve combinations of color fields, surfaces saturated in color and transparencies.

Persian Garden

(1965-1966)
color lithograph on paper
25.9 x 20.1 in (65.8 x 51 cm)
National Museum of American
Art, Smithsonian Institution,
Washington, D.C.

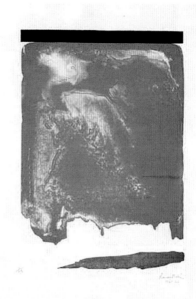

In this lithograph, Frankenthaler
once again renders a contrast
between rigorous geometric forms
and free, organic shapes, created by
manipulating the effects of color and
their relationship with the laws of
physics, and through artistic inter-
vention.

She juxtaposes a wide strip of
brown with a rectangular area of
ochre. The ochre occupies a consid-
erable area and is defined by three
straight edges, but the lower edge is
open, and the paint seems to have
run. It is not filled with dense color as in the heavy, static brown shape in the upper area. For this
reason, it insinuates lightness, movement, and a diaphanous nature, as the paper is visible
through it. The composition is completed in the lower area with an irregular horizontal strip that
only occupies three-quarters of the width of the painting and ends in an irregular point. It thus
constitutes a counterpoint to the wide compact strip in the upper area. The brushstroke is wide,
with gradation, gradually losing intensity. The quality of Frankenthaler work lies in its balance
between spontaneity and willpower, between intuition and calculation, as is evident in this work.

Robinson's Wrap

(1974)
acrylic on canvas
51 x 71 in
(129.54 x 180.34 cm)
Private collection

This acrylic painting belongs
to the artist's abstract peri-
od. The color areas on the
unprimed canvas are
remarkable, applied in lay-
ers in superimposed hori-
zontal brushstrokes. The last
layer appears to be in gray, covering most of a brown and blue layer that can barely be seen, and
leaving a wide area of red visible. Under the red area is the pure color of the canvas, lending the
painting agility. The large unpainted areas gain the same pictorial weight as the painted areas.

Frankenthaler did not usually execute studies for her paintings. Her pieces were based on color
and the surface. She is thus not an action painter like Pollock, who based his painting on his own
gestures and corporal movement. Like de Kooning, Frankenthaler avoided brushstrokes with con-
tours. The basis of her art is the process of applying paint on the canvas, its expansion, flow,
superimposition, and transparencies. This process appears casual and intuitive, when in reality it is
thoroughly studied. She uses the canvas as an essential part of the painting, bringing it into the
foreground through her technique of impregnating it instead of applying thick layers of paint. She
developed a manner of painting that seems free and improvised, establishing surprising and com-
plex relations between shapes within the composition.

Viewpoint II

(1979)
acrylic on canvas
81.3 x 94.5 in
(206.38 x 240.03 cm)
Butler Institute of
American Art,
Youngstown, Ohio

This evocative work is a good example of Frankenthaler's return to the landscape. The canvas is filled with colors, in brown, gray, and warm red tones. The surface is saturated in paint applied in different layers. As is typical in color field painting, the painting becomes pure color, nearly immaterial, allows contemplation, and creates a sensation of an infinite image that goes beyond the limits of the canvas. With its horizontal format, the work allows all sorts of interpretations, including the marine landscape referred to in the title.

In this dialogue with nature, this artist's work continues the American pictorial tradition of the landscape. Frankenthaler reinterprets it in the context of her time. The technique of pouring diluted paint onto the canvas allows the fluid pigment to create forms and textures, and is employed as a method to promote creativity. It can be understood as a metaphor of nature. As a result, the work is richly suggestive and gives the impression of infinite space.

Seeing the Moon on a Hot Summer Day

(1987)
acrylic on canvas
87.4 x 54.3 in (221.93 x 137.8 cm)
Private collection

This painting is an abstract and fantastic composition. Frankenthaler was inspired by "seeing the moon on a hot summer day," as the title indicates. Though this artist's vocabulary of images is neither specific nor figurative, it is often filled with visual allusions. The warm reds and oranges, along with the effect of indistinct elements, can be associated with the vibrant light of the sun. The highlights and reflections of the intense light are emphasized by the brushstrokes and areas in white. The shape of the moon seems to be reiterated several times, in red and white, as an area of color or just a halo. This resembles the effect of looking into an intense point of light and then closing one's eyes.

Combined with the exciting effect of the reds and oranges, this painting is striking, intense, poetic, and mystical. Though inspired in nature, the essence of *Seeing the Moon on a Hot Summer Day* perhaps consists of a daring dream of another world that only manages to enter into the human world through the visual arts, poetry, and music.

FAITH RINGGOLD

Faith Ringgold, photographed by Grace Welty, her studio assistant, a Mesa College alumna.

Author of various works on African-American art and culture, Faith Ringgold's painting speaks of Western art fused with traditional artistic expression of the African-American community. Born in Harlem, Faith Ringgold had firsthand experience of the strength of this artistic tradition, which she was later to combine with the most Westernized style of painting. Ringgold understands the cultural richness of Harlem, expressed with its own artistic language, as a continuation of the artistic traditions of her forebears.

Ringgold bases her painting on a simple and direct form of language that transmits ideas and feelings clearly. A witness to the changes that took place during the second half of the 20th century, Ringgold uses her work to present a sincere testimony of the different social attitudes of her people. To pursue this aim, she created her own particular style in which she assimilates the different aesthetic tendencies of the changing North American art scene.

Based on a formal simplicity and utilization of primitive color, Ringgold presents all manner of innovative and comprehensible narrative forms of painting. Her portraiture contributes a note of modernity that recalls the aesthetic of the 19th century.

- **1930** Faith Jones is born in Harlem in New York City, on October 8. Studies at City College of New York.

- **1950** Marries the jazz pianist Robert Earl Wallace. They have two daughters.

- **1955** Works as an art teacher in New York City schools until 1973.

- **1959** Divorces. Earns a master's degree from City College

- **1961** Travels around Europe.

- **1962** Marries Burdette Ringgold.

- **1971** Receives a Creative Artists Public Service Grant.

- **1976** Travels around Africa.

- **1978** Receives a National Endowment for the Arts grant. She receives it once again in 1989.

- **1983** Wins the Wonder Woman Award from Warner Communications.

- **1985** Professor of art at the University of California at San Diego.

- **1986** Given an honorary doctorate from Moore College of Art, Philadelphia.

- **1987** Guggenheim Fellowship. Receives honorary doctorate from College Wooster, Ohio.

- **1990** Napouli Foundation Award, France.

- **1991** Is elected artist of the year by the Studio Museum, Harlem. Her children's book *Tar Beach* wins the Coretta Scott King Award and is named a Caldecott Honor Book. Ringgold receives an honorary doctorate from Massachusetts College of Art, Boston, as well as from the City College of New York.

- **1992** Given an honorary doctorate from State University of New York at Brockport.

- **1993** Given an honorary doctorate from California College of Arts and Crafts, Oakland.

- **1994** Given an honorary doctorate from Rhode Island School of Design, Providence.

The Artist and Her Model *(The American People #17)*

(1966)
oil on canvas
27.4 x 21.9 in
(69.5 x 55.5 cm)
Private collection

During the 1960s, Ringgold painted her American People series, in which she portrayed American society through paintings of different subjects. In this series the artist alluded to social movements that criticized specific aspects of U.S. government policy and attempted to bring about change in the establishment.

This work shows a black painter, probably Ringgold herself, brush in hand, standing next to a nude white model. In certain social circles in the sixties, showing normal relationships among races was one way to protest racism. Ringgold, who had always demonstrated peacefully, here describes the ideal of nonviolent struggle by exemplifying the ideal society. Rather than exposing the cruel and harsh realities of the time, the artist seeks to magnify the benefits that would be derived from the change of mentality that she upheld.

In this series, the artist uses a very particular aesthetic, in which the predominant portrait style approaches caricature. Static subjects with oversized heads and almost blank expressions, whose simplification makes them appear exaggerated, are represented by the artist with a structural simplicity that allows her to convey her ideas to the spectator in a direct and incisive manner. In these paintings, the color has also been simplified substantially; the artist reveals her interest in making herself understood by the largest number of people possible. Here she has made the pictorial language very straightforward and accessible by means of large areas of flat colors that have been retouched with thick, elemental strokes that portray the expressiveness of the subjects of this work.

The artistic expressions that emerged in the United States during the 1970s highlighted protest against the established order. Unlike the aggressive style developed by artists who relied on a style of social protest that was both very hard and direct, Ringgold established a narrative type of painting, by way of which she launched a series of simple and clear messages.

The Flag Is Bleeding
(The American People #18)

(1967)
oil on canvas
72 x 96 in
(182.88 x 243.54 cm)
Private collection

In this work, the artist has placed three subjects, symbolizing the primary social demands of the day, protected behind the flag of the United States. A young white man, a white woman, and a young black man with arms linked stand united by a single ideal of country and society. In this simple way, the artist demonstrates her stand regarding women's liberation and equal rights for blacks. Ringgold presents the young African-American with his hand on his heart, indicating his loyalty to the flag, but wielding a knife in his right hand, alluding to the fight for these freedoms. This double-sided attitude of a single person representing the black community becomes both a denunciation and the artist's criticism of violent activism. Violent protest, according to Ringgold, threatens the very existence of the country.

Technically speaking, the conception of this work is based on a simple and direct language, with elements that are clearly understandable, using flat color and elements that verge on caricature. Has the painter chosen the message in order to create very simple, elemental paintings or, on the contrary, has she chosen so simple a technique and language in order to make her message more accessible and extensive? The latter is probably the closest interpretation.

Love in the School Yard *(Bitter Nest #1)*

(1988)
acrylic on canvas, fabric
68.7 x 84.3 in
(174.5 x 214 cm)
Phoenix Art Museum,
Arizona

In African-American tradition, women tell their family story in quilts that are passed from one generation to the next. Younger generations inherit a patchwork quilt, made up of different pieces of fabric, each of which recounts a story from the family's past. Faith Ringgold adopted this handicraft for her painting and has used the format for some of her most brilliant works.

This is an allegory of love represented through a street scene at a school gate. The artist evokes the birth of a family by presenting a couple on the street, the first step toward a relationship that will later result in a family. The artist pays homage to first love, which here is the result of a chance meeting, full of innocence, candor, and poetry. She has set the scene in the central piece of this patchwork, whose structure and pieces frame the painting. The meeting between these two people, love at first sight, is represented as the first in a series of scenes that recount the story of this couple. Here, in addition to friendship, the two young people convey hope. The couple are dressed in the style of the second half of the 20th century; there is a car of the time in the foreground. The scene, akin to a documentary, is executed in the fashion of a snapshot. The simplicity that dominates the whole and its accessible language allows the spectator to relate his or her own particular story to that of the couple shown in the work.

Right: In this painting, Ringgold creates an allegory of the arrival of the African-Americans in the United States. On an angry sea, the artist paints Africans who have just escaped from a slave ship and are heading for land in North America. In the foreground of this intensely dramatic piece stands a unique Statue of Liberty, painted as a black woman holding a black baby. This makes the painting a dramatization of the real nature of the United States. Ringgold evokes the arrival of her people in the United States based on the traditional image of the European immigrants arriving in New York at the turn of the century, who contemplated this symbol of freedom before disembarking on Ellis Island. The artist compares these two kinds of immigration—one voluntary and the other enslaved—under the same perspective of liberty.

Ringgold includes the smoke coming from the statue's torch, drifting toward the slave ship. This sends a double message to the observer: Liberty is the cause of the shipwreck, and the shipwreck itself is an opportunity to obtain freedom. The conception of the painting, as well as the technique and treatment of color, again show the artist's interest in finding a clear language, a language with roots in her people's ways of thought and expression.

Picasso's Studio
(The French Collection Part I, #7)

(1991)
acrylic on canvas, fabric
66.5 x 62 in
(169 x 157.5 cm)
Worcester Art Museum,
Massachusetts,
Charlotte E. W. Buffington
Fund

There is no doubt as to the artist's objective in this painting: It is clearly an homage to the painter Pablo Picasso, who is portrayed on the left side, painting in front of an easel in his studio. He is accompanied by several paintings that remind the viewer of some of his most famous periods and works, especially the blue period and *Les Demoiselles d'Avignon*. In her characteristic style, the artist has created a painting that is at once ingenuous and transcendent, in the manner of African paintings or sculptures. As is characteristic of Ringgold's work, the painting is structured like a tapestry or an altarpiece.

The simplification of the various elements, the use of flat colors, and the primitivism of the piece make it accessible. The artist uses the unusual style to synthesize two ways of seeing and feeling, two ways of expressing and perceiving art, and two concepts of what is essential and what is accessory. This piece by Ringgold is a perfect illustration of the possible and necessary dialogue between two substantially different cultures.

We Came to America

(1997)
acrylic on canvas,
fabric
74.5 x 79.5 in
(189.23 x 201.93 cm)
Private collection

Under a Blood Red Sky

(2000)
lithograph (edition of 40)
27.4 x 20.1 in
(69.5 x 51 cm)
Segura Publishing
Company, Tempe, Arizona

Throughout her artistic career, Faith Ringgold has consistently based her art on simplified forms that make her visual language understandable. In this piece, the artist employs a graphic quality reminiscent of advertising designs from the end of the 20th century. The print includes a wide, original frame that surrounds the subject of the painting. The frame consists of a light, narrow band of color surrounding the rectangular subject, with a legend written by the artist on the upper and lower bands of the frame.

The central motif is painted using flat colors, based on a simple scheme that is full of contrasts that draw attention to the work. The artist uses bright red for the background, blue for the tree trunks, and green for the branches. A small circular patch suggests the sun, and the black patches in the lower section invoke a group of tiny people, dwarfed by the size of the trees and the immensity of the red that floods the entire piece. The artist bases the concept of this work on the message written on the upper and lower borders, which establishes a complete graphic style. The expressive force of the drawing and the aggressive colors give the message more force, presenting it in a clear, direct way. The artist uses the simplified shapes of the trees and the small group of plainly silhouetted people to increase the feeling of formal simplicity and balance the prominence of the picture and the written word.

MONTSERRAT GUDIOL

Self-Portrait, *oil on canvas, 18.1 x 15 in (46 x 38 cm), 1953, Private collection, Barcelona.*

Montserrat Gudiol's work is characterized by a type of symbolism expressed through a very defined, free style, making her difficult to classify. Her figures, generally female, are represented outside of time and space.

Her work cannot be ascribed to any of the artistic movements of her time, though she accepts the aspects that comply with her vision of art. Her art is elegant and sensual, becoming more open toward the last decade of the 20th century. With the support of her father, Gudiol was self-taught. Her early works were somewhat conventional portraits. Then she moved on to drawings of a somewhat surreal nature, with organic elements revealing the influence of Hieronymus Bosch. Some already contain resigned, sorrowful men and women, a characteristic of many of her later works.

Realism is a constant throughout the artist's pictorial evolution, highly accentuated in some works, in others mixed with a degree of symbolism. Her works transmit a fear of the world and all that which perishes. The figures she represents are in their inner worlds, which in her later works gradually approach our everyday reality. The face, hands, and feet are meticulously executed to carry their expressiveness to an extreme.

Her extraordinary personality and the brilliance of her art make Montserrat Gudiol an idealist, and a unique artist who has paved her own path with complete liberty.

- **1933** Montserrat Gudiol i Coromines is born in Barcelona, the daughter of the art historian Josep Gudiol i Ricart.
- **1947** Encouraged by her father, she begins to teach herself painting.
- **1950** First exhibit of portraits at the casino in Ripoll (Girona).
- **1951** Works for three months in the studio of the painter Ramon Rogent, at the Galeries Laietanes in Barcelona.
- **1952** Travels through England, Scotland, and France.
- **1954** Travels through Austria, Switzerland, and Italy. Exhibits in Florida where she participates in the group exhibit "Feminine Painting." Wins the first prize in painting from the Barcelona Regional Council.
- **1959** Marries Francesc Boronat.
- **1960** Receives an award at the Exposició Nacional de Belles Arts in Barcelona.
- **1962** Becomes a professional painter, exhibiting in Madrid and Barcelona.
- **1964** Participates in the traveling exhibit "Modern Spanish Painting: Seven Catalonian Artists," which lasts until 1966 and is shown throughout the United States. Exhibits in Bilbao and Barcelona.
- **1966** Executes her first engravings.
- **1967** Exhibits in Barcelona, Johannesburg, and San Francisco.
- **1972** Executes her first lithographs.
- **1974** Exhibits at the Tamenaga Gallery in Tokyo.
- **1978** Participates in an exhibition of Spanish art in Taiwan. Exhibits in Prague and Paris.
- **1979** Exhibits in the exhibition hall of the Painters' Union of the USSR in Moscow.
- **1981** Elected a full member of the Acadèmia de Belles Arts de Sant Jordi in Barcelona. Exhibits at the Dreiseitel Gallery in Cologne.
- **1982** Exhibits at the Guild Gallery in New York, and at the De Vorzon Gallery in Los Angeles.
- **1984** Exhibits at the Walton-Gilbert Gallery in New York.
- **1988** Exhibits at the Dreiseitel Gallery in Cologne.

Two Figures

(~1954)
oil on panel
18.1 x 15 in (46 x 38 cm)
Private collection, Barcelona

This work is the first of a series of clearly surrealist oil paintings that Gudiol completed in 1958. The most obvious surrealist element is the strange creature lovingly embraced by the woman as if it were her child. The scene appears to take place inside a cave, from which the horizon is visible on the lower right, indicated by two rows of cypresses that recall Dalí.

This work is profoundly intimist, in both a physical and an emotional sense. The smooth colors define the woman in yellow and the man in a purplish tone, clearly symbolic colors. The figures, on a pedestal that appears to be partially artificial, partially natural, project upward. Their faces are languid and subtle and their eyes are closed, as if they had no need to see—a characteristic that cropped up in later works by the artist before she reached a more realistic stage.

In this period, she alternates warm colors with cooler, paler ones. The expressiveness of the feet, hands, and heads is striking. The hands are elegant and angular, with long, thin fingers, practically the same as others appearing throughout her artistic career. In this painting, she applies the technique that will define the majority of her works, with the texture and irregularities of the wood beneath the oil paint showing through.

Maternity

(1963)
oil on panel
22 x 16.1 in (56 x 41 cm)
Amos Cahan Collection,
New York

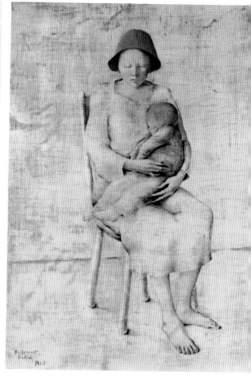

Beginning in 1960, the figures that were to become motifs in Gudiol's later works begin to emerge. The protagonists are almost always women, with some beggars or other men who are simply companions. Women are present throughout the artist's oeuvre, and the theme of maternity appears with some frequency.

The artist had confessed that she felt a great fear of life and all that which perishes. This painting, as most of her works, is set in an intimist world outside of time and space. Here, the background and the figure blend in, sharing an earthen tone, from which the mother's reddish hat stands out. The woman's face is inexpressive, though with a touch of sadness. She shows no tenderness and her eyes are closed, though they are not as almond-shaped as in previous works.

Two Women

(1965)
oil on panel
31.5 x 23.6 in (80 x 60 cm)
E. Isern Dalmau Collection,
Barcelona

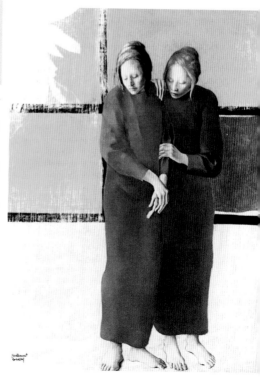

This work belongs to a brief period (1965-1967) in which Gudiol's figures were defined and precise, and their bodies have a different color than the background, which appears stained and watery.

The women's dresses are blue, standing out against a background highly unusual for Gudiol: parceled in a Mondrian style, with yellow filling three areas bounded by thick black lines. This configuration of space and color creates an appropriate setting within which the face, hands, and feet can express themselves. The painting is remarkable for its textures: The pigment in the background was not applied uniformly and the color seems to be scraped away, scratched or worn by the passage of time. The women's eyes are closed, and their postures and the position of their hands transmit melancholy and a degree of sorrow.

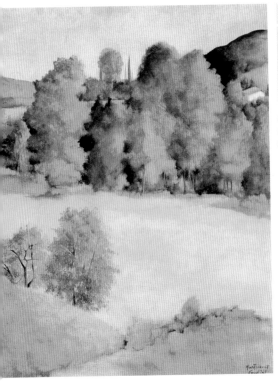

Landscape

(1969)
oil on panel
28 x 24 in (71 x 61 cm)
Private collection, Barcelona

After 1968 and until the beginning of the 1970s, Montserrat Gudiol again tended toward realism, with a new interest in landscapes, a genre nearly unexplored by the artist until then. In this work, unique in the artist's oeuvre, the only protagonist is the landscape. The palette contains greens and greenish ochres that create a Romantic air, as the contours of the forms vibrate delicately.

This landscape is a reflection of reality without interference, in a composition with a rational balance of forms and tones, devoid of symbolic connotations. Compositionally, *Landscape* is a simple work divided into different horizontal grounds.

Three Figures Wearing Hats

(1971)
oil on panel
34.6 x 30.3 in (88 x 77 cm)
E. Argilaga Collection, Reus, Tarragona

This painting forms one of a series of works executed between 1970 and 1972, characterized by figures whose bodies have undefined contours, while the faces are highly defined, as in this case, and, in other works, the hands and feet as well. There is no modeling, the bodies blend together, and the setting is undefined. The composition consists of a diagonal formed by the three heads, the faces more visible as the figures recede. The face of the closest figure, dressed in gray, is concealed by the gray hat. The face of the middle figure is partially visible. She is wearing a yellow hat that covers part of her face and a light ochre dress. The farthest figure, though she is also wearing a hat, reveals her entire face. She is nude, her breasts visible, and she gazes to the upper left. The artist uses the hats as a symbol of reality, to create a connection between these figures and the real world. In the background, a vertically placed ladder constitutes another symbol of reality.

After 1975, Montserrat Gudiol's work acquired an idealistic, highly personal character. This painting is an example of the presence of nature within the pictorial space. As in other works, the female figure is associated with plant motifs. The pot and the ivy climbing around it are realistic, while the woman has a phantasmagoric air, as if she were a spirit observing the plant. Her attire blends into the gray background with some violet tones, without revealing the contours of the figure, thus emphasizing the delicate, languid face. The expression recalls Dante Gabriel Rossetti's symbolism. The vision of an inner world confronting the reality of nature imbues Gudiol's artwork with a metaphysical air that she adopted from the Pre-Raphaelites.

Female Figure and Pot with Ivy

(1976)
oil on panel
31.9 x 39.4 in (81 x 100 cm)
Private collection,
Barcelona

Couple

(1984)
oil on panel
19.3 x 11.4 in (49 x 29 cm)
Private collection

Despite its dreamy, evocative air, this couple shows the influence of realism. The figures' poses, the passion with which the woman embraces her companion, the filmy garment that reveals her form, and the seminudity of the male figure can be ascribed to the naturalism upon which the artist bases this work. The excellent color scheme, the use of studied tones with a multitude of hues, the diaphanous quality of the painting, and the indistinct lower extremities exhance the symbolism of the scene and immerse the sensuality and eroticism of these figures in melancholy and distress, the leitmotiv of Gudiol's art.

Female Bust with Red Ball

(1985)
oil on panel
25.6 x 21.3 in (65 x 54 cm)
Josep Vigué Collection, Barcelona

This painting is part of a series of Gudiol's most genuine works. The woman, with a slightly indistinct face, is wearing a kerchief executed in bright brushstrokes. Her body must be imagined, as it disintegrates into the background. The painting shows the artist's constant reflection on women in a timeless, inexpressive, and intimist representation devoid of context. Though she is dressed, the woman contemplates the nudity of her soul, lending the painting a transcendent aspect.

The thoughtful, serious woman seems disoriented, abandoned in a world full of uncertainties, perplexed and at the mercy of fate. The ball she holds in her hand, clearly referring to an apple, enhances the mysterious, disturbing symbolism.

Girl in Yellow Dress

(1988)
oil on panel
25.6 x 39.4 in (65 x 100 cm)
Joan Torull Collection

Over the past years, Gudiol has simplified her technique, making it more spontaneous and linear and allowing light and volume to come to the fore. In this period, her female figures have a more modern air and attire. This painting represents a pensive young woman seated on the ground in the street, with only a plain wall and the sidewalk as the setting. The realistic figure is in counterpoint to the delicately applied paint. The attractive figure of the young woman is clearly distinct from the artist's previous female figures, which seem modeled from wax due to their lack of expressiveness. The woman's clothing, represented naturally, exudes sensuality, which the artist accentuates by revealing one of the figure's breasts.

JUDY CHICAGO

Judy Chicago.

In the 1970s, a movement began in the United States against the hierarchies existing between painting and sculpture and the arts considered the "lesser arts." The movement, Pattern and Decoration, positioned itself in clear juxtaposition to the reductionism of minimalist art. It defended a poetry of inclusion that sought to recover those creative procedures that were considered feminine and were thus devalued by critics and art historians, often in a disparaging manner. This fusion between the "major" and "minor" arts and the various types of crafts traditionally executed by women comprised so-called feminist art during the 1970s. It was based on the criticism of patriarchal and male chauvinist traditions. There were many female artists who believed in this new artistic philosophy. Judy Chicago and Miriam Schapiro were two of the greatest promoters of the movement, which organized all sorts of art theory meetings and performances centering around protest against the oppression suffered by women in Western society for centuries.

Judy Chicago created multidisciplinary artworks, experimenting with different means of expression and different supports and materials, which, in conjunction with her ideology, lent her great prestige in the art world. She was also considered by many a distinguished feminist. In her pictorial compositions, she employed techniques that had traditionally been reserved for comic books or photography, creating works combining sequences of movement and painted photomontages. In her art, the media is often employed to compose daring, crude, and scathing images.

- **1939** On July 20, Judy Cohen born in Chicago.
- **1961** Marries the writer Jerry Gerowitz.
- **1962** Graduates from the University of California in Los Angeles. Jerry Gerowitz dies in a traffic accident.
- **1964** Earns master's degree; teaches at the University of California.
- **1966** Teaches at the Institute of the University of California.
- **1969** Marries the sculptor Lloyd Hamrol. Teaches at the University of California in Fresno and establishes the first program of women's art. Individual exhibit at the Pasadena Art Museum, where she use the name of Judy Gerowitz.
- **1970** Marries the photographer Donald Woodman. Adopts the name Judy Chicago. Individual exhibit at the Faculty Club, California State College, Fullerton.
- **1971** Teaches at the California Institute of the Arts in Valencia, where she establishes a feminist art program directed by herself and Miriam Schapiro.
- **1972** Individual exhibit at the Jack Glenn Gallery, Corona del Mar, California.
- **1973** Cofounds the Feminist Studio Workshop and Woman's Building in Los Angeles.
- **1974** Individual exhibit at the Artemisia Gallery in Chicago.
- **1975** Individual exhibit at JPL Fine Arts, London.
- **1979** Individual exhibit at the San Francisco Museum of Modern Art. First exhibition of *Dinner Party* (now at Brooklyn Museum, New York).
- **1980** Individual exhibit at the Parco Gallery, Japan. Begins work on the Birth Project.
- **1981** Exhibits at the Fine Arts Gallery in Irvine, California.
- **1982** Individual exhibit at the Museum of Contemporary Art, Montreal.
- **1984** Individual exhibit at the ACA Galleries, New York.
- **1987** Individual exhibit at the Schirn Kunsthalle, Frankfurt, Germany.
- **1992** Receives an honorary doctorate from Russell Sage College in Troy, New York.
- **1993** Exhibits the Holocaust Project at the Spertus Museum in Chicago.
- **2000** Receives an honorary doctorate of art from Smith College, Northampton, Massachusetts. Receives an honorary doctorate in the humanities from Lehigh University, Bethlehem, Pennsylvania.

Rainbow Man

(1984)
sprayed acrylic and
oil on canvas
9 x 21 in (installed)
(22.86 x 53.34 cm)

The use of a triptych in the manner of a comic strip sequence allowed the artist to incorporate elements of movement and create a rich narrative language. In this composition, Judy Chicago alludes to the abuse of power exercised by men, especially against women, and the terrible consequences. Through a caricaturelike, powerful, and dehumanized figure, she illustrates men's abuse of power, while the twisting, allegorical rays of a rainbow attack him. She employed a direct and simple language to proclaim her message of social criticism.

This painting is an allegation, a social manifesto whose content the artist intensified by selecting an element as inoffensive as the rainbow. Despite its innocence, its traditional connotations of peace and prosperity, and the complete absence of aggressive connotations, the rainbow can no longer endure such oppression. It turns against the man, symbolizing power, and defeats him. The allegorical rainbow most probably personifies women.

Chicago's feminist art is complex and intentionally shocking in an attempt to indoctrinate and convince her followers of their capacity for fighting against the status quo. She does this using a technique that constitutes a rebellion in itself against established artistic canons. The chromatic stripes of the rainbow create a sensation of movement. Following the comic aesthetic, the linear forms of the rainbow are used as a dynamic element to enhance the expressive quality of the work and thus make the message more incisive and forceful.

During the second half of the 20th century, the world of art expanded to incorporate disciplines that had previously been considered second class, such as comic strips and photography. Judy Chicago adopted an aesthetic approaching comics in her series of paintings called Powerplay, to which this piece belongs. It has a direct, figurative style with a clear language. In the series, the artist used sprayed acrylic to achieve effects of gradation and blending that would be flat in appearance, allowing her to paint in an aesthetic traditional to comics. She not only created a new style, but also a new pictorial language that surprised people at first but soon gained followers.

Driving the World to Destruction

(1985)
sprayed acrylic
and oil on canvas
8.2 x 12.8 in (20.8 x 32.4 cm)
The Art Museum of Missoula, Montana

The muscular beings in this series interpret a visual language based on movement. Powerplay is a social criticism of the hierarchical system existing in the 1950s and 1960s, in which the woman was subjugated within a patriarchal system imposed by society. Chicago made this criticism when the United States was redefining itself as a nuclear power; meanwhile, domestically, the entire scheme of social classes was being questioned. At this time there was social struggle for the rights of different ethnic groups, pacifist and feminist groups were active, and new art movements were emerging. These constituted an art of protest of which Judy Chicago's work is a vivid exponent.

Through her style, forms, and color as well as the general aesthetic, she personalizes the ideological revolution and makes a call to people's conscience in favor of equal rights and a new social order. In this work, the man is represented as a fantastic being, a paradigm of evil. He is stubborn, hard, arrogant, and violent, leaving oppression and destruction in his wake. The artist based her entire ideology of protest on these connotations. Her comic-book style constituted a particularly suitable means of making her message more incisive.

Red Flat

(1971)
photolithograph (51/94)
20 x 24 in
(50.8 x 60.96 cm)
Museum of Menstruation
and Women's Health,
Maryland

In this work, Chicago represents a frequent event in the life of many women: the extraction of a tampon from the vagina during menstruation. In an ambivalent language, the bloody tampon resembles a penis. The artist commented that she wanted to represent that many women still knew nothing about sex and sexuality; her image thus evokes things that women are forced or obliged by men to do against their will, both in terms of sexual relations and in terms of the place in society into which they are relegated.

Judy Chicago was an influential activist for women's rights. Her daring, sincerity, and the force of her messages often led her to create shocking images whose visual crudeness made them unacceptable, if not scandalous, for many, yet she did not balk at this. Using innovative techniques—on this occasion an overexposed black-and-white photograph with a single detail of color painted in the center—she often represented images that would shock the viewer, comfortably settled in a social system established long ago, with its stereotypes, conventions, and oppression for certain strata of society. The resistance to change of some and the cowardice of others made it difficult to drive home the message of feminism to both men and women. Conscious of the fact that it would not be easy, the artist used images such as this one to provoke women and move them to struggle and attain the rights that society had denied them. The message was clear and the means used particularly incisive, since the effect sought was to shock the viewer. In 1998, the artist donated this work to the Museum of Menstruation.

The Coronation

sprayed acrylic in black
and white on paper
22 x 32.9 in
(55.8 x 83.6 cm)

Right: This work, signed by the artist and bearing the inscription, "In honor of the Schlesinger Library," constitutes an allegory. In a style and conception typical of graphic art, and in a restrained and absolutely symmetrical composition, the artist represents key physical elements of the female body. Although the image may seem aggressive and invoke rejection, this was not the artist's intention. In her struggle against the establishment and the status of women, she attempts to make women aware of themselves and acquire self-esteem and self-confidence in order to attain the place they deserve in society. It was a daring message that found many detractors at the time, including some women. Chicago reveals her technical skill and deep knowledge of the media. She uses graphic art, color, and an artistic language that make the message stronger. Technique and intentions are inseparable here. Despite her detractors, it is not surprising that Judy Chicago had many followers.

During her artistic trajectory, Judy Chicago has experimented with the fusion of different techniques, which she uses in an unconventional manner. In this work, she combined photography and paint to create an innovative aesthetic. The scene is set in a peaceful rural environment. The tranquil foreground contrasts with the horrifying events in the background, evoking the Holocaust.

Photomontage was a technique that the artist would use in many of her works. This type of subject matter was treated by the artist with great sincerity and daring. Through her artwork, Chicago became an activist who assimilated new artistic movements and ideas to articulate clear messages of social criticism. Her multidisciplinary abilities allowed her to mix many artistic media. Though the majority of her works are montages, installations, or performances, her talent in painting allows her to combine the most traditional styles with new artistic vision arising from the comic-book genre or photography.

The Banality of Evil/ Struthof

(1989)
sprayed acrylic, oil, and photography
30 x 43 in (76.2 x 109.2 cm)

Treblinka / Genocide

(1989)
sprayed acrylic, oil,
and photography
43.7 x 21.25 (111 x 54 cm)

This work is part of the Holocaust Project, a series of creations designed to criticize the different realities coexisting within society. The triptych evokes the horrors of the Holocaust through images of suffering, fire, loneliness, desperation, and calamities. This reality, represented in the foreground, contrasts with the skyline of a large American city full of skyscrapers in the background, its dark silhouette defined against an orange sky at sunset. Considering the artist's ideology and her ceaseless struggle to attain a better social order, the scene can be viewed as a parable. In opposition to modern, well-off society is the Holocaust, which we should deplore. Yet there are many more holocausts occurring today, and we must not close our eyes to these. The horrors of Fascism and the Nazis are repeated daily with other protagonists. Employing her usual visual and technical weapons, the artist once again puts society against the ropes and transmits a message of protest and criticism.

EMILIA CASTAÑEDA

Self-Portrait with Son, *oil on canvas, 51.2 x 38.2 in (130 x 97 cm), 1991, Private collection.*

Emilia Castañeda is a person with fine sensibility, developed feelings, subtle perception, and intense passion. The product of this is a style in which the artist draws the curtain of her intimate haven to sincerely reveal herself the way she is.

Whatever the theme, the paintings that characterize this painter depict dreams of a universe in which sensuality and poetry, beauty and desire, gentleness and frenzy are omnipresent, more or less evidently.

Castañeda is a great admirer of human beings, their body, mind, sex, and heart. She works with figures' physique with meticulousness and sensitivity until they attain a degree of sublimation that turns those figures into idealized evocation, a paradigm of perfection and beauty and, consequently, into irresistible objects of desire. To achieve this, the painter uses a very elaborate technique, in which the treatment of color, atmosphere, and symbolism are masterfully combined.

Castañeda's paintings represent not only the portrayal of day-to-day reality, but also a utopian universe that human beings dream of both consciously and unconsciously.

- **1943** Born in Madrid on November 7.
- **1956** Begins studying art at Victor Esteban Ripaux's academy.
- **1959** Enters the Llotja School of Arts and Crafts in Barcelona, supplementing her studies at the Sant Lluc Artistic Circle, also in Barcelona.
- **1964** Wins the 2nd Barcelona Award.
- **1968** Wins the VII Young Paintings Award in Barcelona.
- **1969** Wins the X Young Paintings Award in Barcelona. Completes her studies at the Massana School of Barcelona.
- **1970** Wins the XI Young Paintings Award in Barcelona and the Fortuny Medal Award.
- **1971** Completes her training by participating in many contests and exhibitions.
- **1975** Holds an individual exhibition at the Nonell Hall of Barcelona.
- **1976** Wins the Isidre Nonell Award, sponsored by the Sant Lluc Real Artistic Circle of Barcelona.
- **1977** Completes a painting of Saint George, a symbol of Barcelona, for the Barcelona City Council.
- **1978** Exhibition at the Bearn Gallery in Palma de Mallorca.
- **1981** Participates with extraordinary success at the International Fair in Washington. Exhibition at the Surrealism Museum in Chateau de Vaux, Melum, France. Exhibition at the Galerie d'Art in Lucete, Paris.
- **1982** Participates in the Salon des Indépendants, Paris.
- **1983** Exhibition at the Société Nationale des Beaux-Arts and at the Salon, Grand Palais in Paris. Exhibition at the Unbergung-Regensberg Gallery in Zurich. Exhibition at the Herbert-d'Uckermann in Grenoble.
- **1984** Exhibition at the Guiot Gallery, Marcel Bernhein in Paris.
- **1985** Exhibition at the Lleonart Gallery in Barcelona.
- **1986** Exhibition at the Scala Gallery in Barcelona.
- **1987** Exhibition at the Sokoa Gallery in Madrid.
- **1988** Exhibition at the Am Opernmring Gallery in Viena.
- **1995** Exhibition at Lincoln Center in New York.
- **1996** Exhibition at the Ambassador Galleries in New York.

Day and Night

(1994)
oil on canvas
63.77 x 44.88 in
(162 x 114 cm)
Private collection

Halfway between reality and fiction, sensation and desire, touching and longing, this work depicts a scene in which the artist examines sensuality and eroticism, hedonism and sophistication. They are combined with graceful colors, a careful composition, an imaginative setting, and the depiction of figures whose attitude can be perfectly understood: The white woman, an image of sensuality, is forsaken in a world full of tenderness, as if waiting for someone to quench her desire. Her body lies on an attractive black woman's lap. She is striking, not only in form, but also in exoticism. Nevertheless, she is completely oblivious to her partner's feelings, as demonstrated by her passive attitude and the fact that she is looking the other way, beyond the painting. The colorful varied fruit still life at the base of the painting adds to the air of sensuality and pleasure. The patchwork that covers part of the black woman's nudity highlights her exoticism and desirability.

The cockatoo is a symbol of the deception implied in the scene. The dream, desire, and longing are fantasy. Reality is something quite different. The artist has used her technical resources to underline the symbolism and each element's implied message. Therefore, the white woman's body is graceful, soft, and subtle, with complex tones to suggest spirituality, lightness, and evanescence. The black woman is more voluptuous, with more contrasted colors. The still life's rich color hints at the temptations of the object of desire. The cockatoo, cold and static, carefully observes "reality," revealing it as pure deceit.

At a glance, this painting can appear to be an erotic image, especially if the woman's pose is taken into account. But a closer look soon uncovers the message this painting conceals, of cruel harshness and courageous sincerity. The scene contrasts two diametrically opposed and repelling worlds, and reveals the need to flee from an abhorrent reality and withdraw to a distant dream world of fantasy and pleasure.

The Pleasure of Cruelty

(1994)
oil on canvas
51.18 x 51.18 in
(130 x 130 cm)
Private collection

All the elements that border this woman in the lower portion of the painting suggest a horrible, disgusting, and detestable world. Transcendent, the woman, in her purest essence (that is why she is nude and in a pose free from prejudice or conventionalism) is transported to an idyllic and sensual, suggestive and liberating world. It is another world, where well-being is possible, happiness is found within reach, and physical and moral beauty prevail. To make this painting's message more incisive, the artist has positioned the woman's figure diagonally, in a pose that provides a more intimate display of her femininity.

The body is very detailed, beautiful, and appealing, with fine lines and very detailed forms, and the work precisely defines the person's frame of mind, distant from the real world and submerged in a dream world where she is happy. In the foreground, there are a series of surrealist elements, which the woman flees from. The painter uses intense reds and forceful colors. Together, it is an eloquent illustration of the intensity of the artist's feelings and her passion for her work.

Bodeguita del Medio

(1996)
watercolor
13.7 x 19.68 in (35 x 50 cm)
Private collection

This watercolor was made on a trip the painter made to Cuba and is a typical image of a corner of a city there. The work is conceived with all the freshness and spontaneity of a snapshot, an idea that has been reinforced with flowing paint in which a few spots evoke more than they describe, suggest more than they specify. Nonetheless, some elements have been worked on meticulously, such as the people's faces and the details of the arcade. Chromatically, the painting is very well balanced with suggestive colors ranging from blue to magenta. This watercolor is a beautiful travel souvenir, filled with exoticism.

This painting perfectly illustrates the interest Castañeda has for the person. Here, the artist has focused on an Indian woman's face, from her features to her inner soul. The face is expressive and well structured; this woman's gaze captures the viewer and begin speaking to him. It seems taht the other woman, peering from the leading figure's side, wants to do the same, but she is not able to reveal her face. Everything else in the painting is complementary to these two figures and their juxtaposition, although it contributes to reinforcing the basic objective. A densely colored background makes the women's figures emerge; their colorful clothing lends them extra dimension.

In India

(1998)
watercolor
19.68 x 13.78 in (50 x 35 cm)
Private collection

Although nudes are most common inCastañeda 's catalog, she is always quite fascinated by still life, which she includes in much of her work. This painting's general conception, the diversity and originality of the elements used, their distribution and chromaticism provide spectacular intensity and effect to this composition. The softness of the colors, the way they have been juxtaposed, and the avoidance of all dark tones, including black, give this work a delicate character.

Autumn Fruit

(1998)
oil on canvas
31.5 x 63.4 in (80 x 161 cm)
Private collection

Although this is not a nude, this very detailed still life exudes the same sensuality as other works of the artist that are more explicit. The mysterious white cat adds the touch of exoticism and self-examination that the cockatoo offered in *Day and Night*.

Mystery in Venice

(2002)
oil on canvas
31.9 x 39.4 in
(81 x 100 cm)
Private collection

For a romantic, dreamy, symbolist, and sensual painter, Venice cannot go unnoticed and, in that, Emilia Castañeda is not an exception. The painter loves Venice and collects objects evoking the city: its enchantment, sophistication, mystery, and Carnival. In this work, a delicate young woman appears to emerge from a sea of transparent cloth. The young woman reveals her nude torso, yet guards her identity with tulle that covers her head and a mask behind which she hides. In the background, the silhouette of Venice's most emblematic buildings mark off the horizon beyond an evanescent sea sprinkled with glimmers of orange. The painter, immersed in a world of fascination, pays tribute to the city whose image, shrouded in darkness, suggests an allegorical view of an intensely longed-for, mesmerizing world. The mask in the foreground, with its mocking smile, reinforces the city's mystery and the painting's surreal vision.

Suspended in a Dream

(2002)
oil on canvas
45.3 x 57.5 in
(115 x 146 cm)
Private collection

In this work, the painter portrays a dream, full of enchantment and sensuality. In a blissful landscape, two lovers embrace. The love, passion, and surrender are portrayed intensely and expressively. A very elaborate light with a languid tone falls softly on the lovers' nude bodies, embracing them, binding the viewer's attention to them. The scene takes place in a landscape of luminous colors with a predominance of turquoise. In the middle plane, to the left, the flowering tree stands out over the background in a clear allusion to the spring that the love of two young people evokes. It is a scene full of poetry, the visual expression of a dream of love and joy.

In the Lips of Some

(2002)
pastel
51.2 x 39.4 in (130 x 100 cm)
Private collection

This composition has given the artist the possibility of making a very noteworthy study of male anatomy. The poses and the composition, although they reveal great modernity, are based on classic criteria. The result achieved is powerful, as are the figures, painted with very detailed forms in a balanced arrangement. The technique used has allowed Castañeda to obtain a very modeled texture and a warm, realistic, and sensual skin color. The beam of light that comes from the left enhances the anatomical volume. In the upper portion, toward the left, the work appears clear and specific. It is in this area that the artist demands the viewer's attention. The rest has been left vague or as a simple sketch. What is reality, and what is a dream?

GLÒRIA MUÑOZ

Glòria Muñoz in her studio in Barcelona (1998).

Always lively, researching, and very demanding, Glòria Muñoz is an artist who is endlessly interested in people and their inner worlds.

Her marriage to the son of a very prestigious painter incorporated her into an artistic family and allowed her to enter an exclusive world of artists. The knowledge that this gave her, along with her interest in finding new forms of expression, led her to create works that are deeply rooted in art from the beginning of the 20th century. Her works project confident and courageous images of modernity without abrupt breaks. The existential preoccupation combines with aesthetic and technique, giving rise to unique art.

Glòria Muñoz's works are surprising and can always be read in two different ways--both what the eyes see and what is really being transmitted. They include contrasting but complementary concepts: relaxation versus anguish, passion versus solitude, intimidation versus solace, privacy versus invocation. They present conventional themes in a unique way, adopting unusual mediums and studied compositions.

Muñoz is a multifaceted artist who possesses profound knowledge of her medium and a great command of technique. Her works, always full of content and meticulously elaborated, embrace the spectator.

- **1949** Glòria Muñoz Pfister is born in Barcelona on August 12 into an artistic family.
- **1972** Completes her education in art at the Escola Superior de Belles Arts Sant Jordi of Barcelona. Marries Josep, son of the prestigious painter, Josep Puigdengolas i Barella, who facilitates her path into the world of the most important artists in Barcelona at the time. She is interested by Catalan painters.
- **1975** Founds the Taller de Dibuix i Pintura in Barcelona, a center dedicated to art education.
- **1975** First solo exhibition at the Galería Grifé & Escoda in Barcelona.
- **1980** Completely focuses her painting on landscapes of the Empordà, Tuscany, the South of France, Granada, and Mallorca.
- **1984** Exhibition at the Galería Art-Sud of Toulouse, France.
- **1985** Gives classes at the Department of Fine Arts at the University of Barcelona. Exhibits at the Fundación Fortabat, of Buenos Aires, Argentina.
- **1988** Begins exhibiting regularly at the Sala Parés, one of the most prestigious galleries in Barcelona.
- **1990** Receives her doctorate in fine arts from the University of Barcelona.
- **1991** Exhibition at the Galería El Cisne, of Madrid.
- **1993** Establishes her studio at the Sant Bartomeu Church in Bell-lloc, at the convent of the cloistered Augustinian nuns of Peralada (Girona, Spain), where she begins painting a series entitled Empty Altars.
- **1994** Participates in the Art Asia '94 Exhibition in Hong Kong.
- **1995** Exhibits at the Joan Prats Gallery in New York.
- **1998** Exhibits at the Museu d'Art Modern in Tarragona, Spain.
- **1999** Participates in a collective exhibition at the David Messum Gallery in London.
- **2000** Named a member of the research team of the Minister of Education and Science of Madrid.
- **2001** Exhibits at the Lewis Gallery, Carmel, California.

Black Table and Snails

(1988)
oil on canvas
76.8 x 51.2 in (195 x 130 cm)
Private collection

In Glòria Muñoz's work, tables occupy a privileged position. Bear in mind that a table is more than an inert piece of furniture or a surface that supports objects; a table should be understood as a sphere or a world—a reality. It is like people's everyday routine, apparently trivial and monotonous, yet the stuff of life itself.

Despite being a familiar element, "table" is a generic term that defines an infinite number of pieces of furniture, diverse in form, dimension, and function. The table symbolizes the distinct and changeable life of every person. All types of elements are placed on the surface in a circumstantial and ephemeral way, fascinating, exotic, surprising, disagreeable, bothersome—Muñoz's tables are an allegory of the commonplace quality of the human condition.

Flowers for No Saint III

(1995)
oil on canvas
51.2 x 51.2 in
(130 x 130 cm)
Private collection

Nude, Bird with Fruit

(1996)
oil on canvas
57.5 x 38.2 in (146 x 97 cm)
Private collection

Glòria Muñoz has proven to have a weakness for tables, which should be attributed to how she associates them to life, and to the human condition. In this painting, the artist presents the keys to understanding the tables' meaning, as if the picture were a parable: An anonymous woman is presented in her most genuine essence—nude, posing next to a table. It is truly an introduction to Muñoz's paintings in which the table appears as the main element, evoking the person's life. The table is a surface on which all types of objects will be placed.

To explain and make the language more didactic, the artist has chosen a normal body, not particularly attractive or well proportioned. The figure is someone from the street, any commonplace person, with her everyday life, who longs to fly, just like the bird that appears here. The artist's message refers to the person in general, a being at the mercy of her circumstances, who cannot dominate or determine her path, her feelings, her desires.

Left: In 1993, taking advantage of the fact that the cloistered Augustinian nuns of Sant Bartomeu of Bell-lloc, Peralada, Girona, had abandoned their convent, the artist acquired the chapel to establish her studio there.

This gave her the opportunity to use many of its corners and details as subjects for her paintings. She started a series of paintings that she would call predestined, and entitled Empty Altars. They constituted a milestone in her artistic career. This painting is one of them.

The artist made the most of the chapel's empty and bare altar, showing the marks that the passing of time and neglect left on the altar. She draws attention to this with flowers that were once attractive and fragrant, but are now musty and slovenly. There is no doubt that this painting has a coded message related to the transcendence of objects beyond their physical appearance. Glòria Muñoz's painting illustrates this place in which silences and memories are plentiful, evoking comparisons between the present and the absent, the full and the empty, what is seen and what is alluded to, and life and death. The paintings in this series constitute a fundamental reference to the passing of time, the power of symbols, and that which separates the worldly from the spiritual.

Reddish Table and Window

(1999)
oil on canvas
78.74 x 31.5 in
(200 x 80 cm)
Private collection,
New York

The painter likes to adopt unusual formats for her work; this helps her to enhance the feelings she wants to transmit. This interior has an element Glòria Muñoz is particularly fond of: a table situated in the foreground. The framing is very cinematographic in the way the objects are distributed on the surface, lending the painting freshness and immediacy. The window, aside from contextualizing the scene by letting us see an interesting urban view, breaks the intimacy of the interior, opening it up to a distant background of great depth. The artist tends to combine contrasting yet complementary worlds and values. The painting's composition is perfectly balanced, and the color work is exemplary.

For its format and conception, this work should be considered a self-portrait in which the painter has subtly and exquisitely collected many concepts. The painting is a placid vision of an interior space that can be identified with the artist's own life. But her paintings do not transmit an indifferent distant vision; rather, they look into her most immediate and everyday surroundings, as if her mirror showed, not her face, but her inner world.

Space of Visions

(2000)
oil on canvas
31.5 x 78.74 in
(80 x 200 cm)
Private collection,
New York

In this work, perhaps without realizing it, the painter exclaims: "This is me." She shows an everyday environment, a light seen a thousand times over, a few paintings, some pots, the mirror she has looked in a hundred times, and an old table that surely holds a few secrets. It is the world in which she moves, with which she speaks, where many times she finds herself. The framing is original, the composition novel, and in this peaceful, intimate, sanctuarylike atmosphere, there is a natural but weak lighting with penetrating nuances that give depth to the painting.

The subject is original and suggestive. The foreground is weighty, yet curiously, the observer's gaze is drawn continuously and avidly toward the background. It is as if the artist, after showing her world, leaves the door open to her sanctuary. The majority of Glòria Muñoz's work has a double reading, and although the subjects seem at first glance to be normal and everyday, the paintings always imply content that transcends what can be seen visually. They are works to look at not with your eyes, but with your feelings. The artist has a very rich and intensely active inner world, and as with any master, this is clearly revealed in her works.

Ocean Space I

(2000)
oil on canvas
51.2 x 23.6 in
(130 x 60 cm)
Private collection

Starting in 1980, the painter began paying special attention to the subject of landscapes. El Empordà, situated in the extreme northeast of Spain, on the French border, was her main source of inspiration. El Cap de Creus, el Port de la Selva, Cadaqués, Castelló d'Empúries, and Peralada—where, years later, she would install her studio in an abandoned church—frequently form a part of her landscapes. This painting shows a view of the Mediterranean Sea. The artist chose a unique style for this work, which perfectly fits her idea: to show the sea itself, without clouds, not threatening to storm, neither during sunrise nor sunset but during a regular daily moment. It is the most conventional and familiar sea, the closest shore, that beach you've walked on, when the sun's rays strike the calm water and transform it into dazzling sparkles.

Portrayed by the artist like this, this seascape acquires great feeling and transcendence. The sea is familiar, yet it is a miniscule part of something immense, absolutely unattainable. Without many points of reference, the painter manages to create great depth and impact by making the most of the light—always expressed with a thousand nuances. More than a reflection of a specific moment, this work arouses a multitude of conflicted yet complementary feelings.

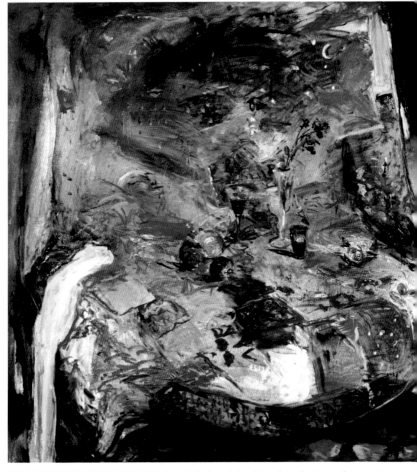

Indian Summer

(2001)
oil on canvas
59 x 59 in
(150 x 150 cm)
Fundació La Caixa, Barcelona

This is a typical work for this painter in terms of concept and composition, the variety of elements and the way they have been distributed, and even color. Yet this still life is very far from conventional still lives. Different objects are presented (a stylized glass with flowers, a glass, and a glass with wine, a few pomegranates, a white cloth, a book), spaced very far from one another on an upholstered divan. The cushion is covered with a mosaic of multicolor fabrics that create an initial sense of imbalance and disorder in the composition. But soon this vanishes before the meticulousness, care, and refined study that the artist made of the motif.

The folding bed and the background cloth, the rich colors and the general composition all reflect a very specific ambience, taste, and culture, and their variety and distribution also transmit a feeling of immediacy—they are arranged like a theater set or a landscape. This is corroborated with a perspective more characteristic of a landscape than a still life—the lighting reveals the entire scene evenly, without spotlighting one focal paint. This is a profoundly artistic work, created by someone who shows a truly unique command of technique.

JENNY SAVILLE

Self-Portrait, *pencil on paper, 1992, Friends of Glasgow School of Art, Scotland.*

Jenny Saville graduated from the prestigious Glasgow School of Art in 1992. She represents the new generation of British artists who emerged toward the end of the 20th century and who have a totally new concept of pictorial art, reinterpreting it in light of the photographic image.

The artwork of Jenny Saville focuses on the nude, represented in a completely corporeal fashion. In her paintings, the expressive force of the female body appears in a sincere and direct manner, without a trace of the spirituality of the classical nude. Saville works with models whose bodies do not correspond to a preconceived canon of beauty. She enjoys creating the forms, details, and aspects that can be derived from a human body, at times surrealist, at times disputably pleasant or even scatological, whether the artwork shows the human form pressing against glass or describes the flaccidity of its abundant flesh.

This vision of the female nude in which Saville reproduces the optical effects of a camera found an admirer in the British collector Charles Saatchi, who in 1992 offered the artist an eighteen-month contract to prepare an individual exhibit. His patronage allowed the young artist from Edinburgh to experiment with a new pictorial style and introduce more complex photographic techniques. As a result of that experimentation, Saville executed the series Contacts in 1995, where the image of a female body appears strongly pressed against a glass for the first time. This photographic series of sixteen digitally printed images mounted on sheets of Plexiglas garnered excellent reviews.

Propped

(1992)
oil on canvas
84 x 72 in
(213.5 x 186 cm)
Saatchi Gallery,
London

The new conception of the female nude proposed by Saville represents women in such a hyperrealist manner that it has nothing to do with the academic, transcendent nudes of Jean Auguste Dominique Ingres or Rembrandt. In her works, the artist also avoids everything to do with the canons of beauty socially imposed by present graphic publications exhibiting stylized female bodies photographed to show their perfection, touched up and made up, in poses studied to provide erotic connotations.

For Saville, the value, image, and essence of a body lies fundamentally within it, independent of whether or not it is physically attractive. What is important is the natural aspect, the forms, details, and overtones, whatever they may be. Eroticism, if it exists, is the fruit of the mind and must be implicit in one's own reality. In this representation of a woman seated on a fragile stool, Saville exploits the visual crudeness of a nude body with abundant flesh. The appearance is unkempt and certainly far from what is normally understood as a canon of beauty.

It is a natural yet surrealist image, difficult to accept for the majority of the public, educated in tastes far removed from what is represented here. The artist centers her vision of this body in the infinity of details. The wrinkles and folds in the skin are examined by Saville through a careful, meticulous brushstroke, enriching the image with a network of light and shadows on the skin. She uses the contrast between the body and the fragile stool to transmit a visual message vertically distributed within the painting. The stylized shape of the inanimate object disappears under the woman's plethora of forms. In such works, the artist does not disparage the human body; rather, she attempts to present it in a different, innovative light that is artistically daring.

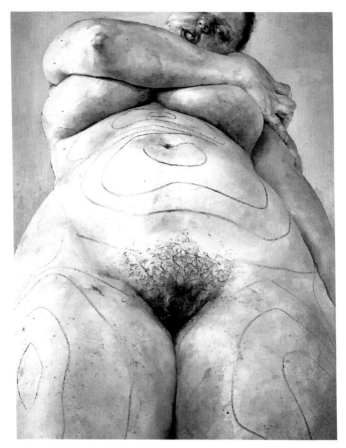

This painting is a self-portrait. The lines drawn on the nude body cor-
respond to zones that are defined on a body prior to liposuction. After
completing her studies in 1992, the artist began experimenting with
the human body, creating new theories on the way of conceiving it
that placed importance on volumes and various other factors.

In Western society, and especially European and North American
society since the late 20th century, the aesthetic tendencies dictated
by a new culture of the image and an exaggerated evaluation of the
human body have become psychological torture for millions of people
who are incapable of attaining the prototype of beauty. Saville, per-
fectly aware of this new aesthetic dictatorship imposed by the mass media, rebels against it
and the entire advertising environment that it entails through this type of work. She uses her
art as a means of expression to denounce the fallacy of that ideology and to propose other
values of the human being and other ways of seeing the body that are certainly different.

The artist researched the techniques of liposuction for some time, studying the entire
process minutely as well as its results and aftereffects. The result of her investigations was
this painting, which was quickly adopted by feminist groups as a manifesto in favor of the
individual liberty of women in the face of stereotypes and conventions imposed by tradition
and fashion.

To give her message more impact, Saville meticulously studied the composition. Her body
is nude and viewed frontally. The point of view is extremely low, so that the body is in pro-
nounced foreshortening beginning at the thighs. The two large thighs flank the foreground,
directing the eye to the woman's pubis, which occupies the most important position in the
work—the artist's clear affirmation of her womanhood. Behind the arm with which she
squeezes her breasts, Saville uses the little space left to direct a defiant gaze at the onlooker.
The painting is a vertical view of a body subject to the heavy lines imposed by aesthetics. The
language is direct and clear. The details of the body are shown under an intense light that
exaggerates the roundness of forms in order to make the message more incisive.

Plan

(1993)
oil on canvas
108 x 84 in
(274 x 213.5 cm)
Saatchi Gallery,
London

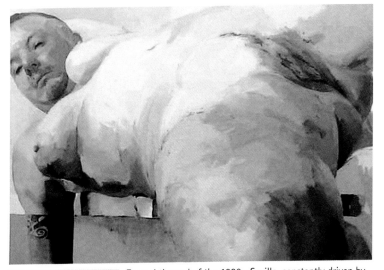

Matrix

(1999)
oil on canvas
84 x 120 in
(213.4 x 304.8 cm)
Saatchi Gallery, London

Toward the end of the 1990s, Saville, constantly driven by an insatiable desire to investigate, experimented with new subjects based on the nude. She has never ceased to search for new manners of representing the body that will permit her to delve into her ideology, which proclaims a manner of thinking and an order of things clearly unlike that prevailing in modern society.

In this painting, the artist deals with the subject of sexual duality or ambiguity in a conception of transsexuality that follows the artist's tendency to graphically represent the contradictions of present-day society.

The nude body is reclining. The face has masculine features, while the body, on a diagonal and extremely foreshortened, is female. In one of her most erotic paintings, the artist renders the female genitals in detail in the foreground. The man/woman's legs are spread apart so that the shaved pubis with its naked vulva is clearly in view. On the left, the large breasts hang under their own weight.

Saville, in a daring and aggressive manner, is denouncing 20th-century society's evaluation of sexuality, ruled by a new moral code that sincerely accepts homosexuality, yet at the same time often profanes it, converting it into a show for simple economic reasons. Conscious of this reality, she created this painting, in which the ambiguity and expressiveness of the body are used as a social chronicle of the times. The interplay of light and shadows on the skin is masterfully rendered. Using bright ochre tones, Saville magnificently transmits the corporeality of the nude, which fills the entire pictorial space. Beyond the technical and aesthetic aspects, the artist's intention is clear, and the force and firmness with which she selects her subject matter serves to make her protest more effective.